Relax. There will be no test.

Museums can ruin a perfectly good vacation. Or you can look into the eyes of *David* and see humanity stepping out of the Dark Ages and into the Renaissance. Ancient sights can give you heat stroke or goose bumps...depending upon your ability to resurrect the rubble.

Rick Steves' Europe 101 sorts Europe's tangle of people and events—from the pyramids to Picasso—into an orderly and fascinating parade to make your sightseeing more meaningful and fun.

After stripping history naked, this book dresses it up with just the personalities, stories, and sights that will be a part of your travels. We illustrate the story of Europe with the blockbuster sights that travelers can see today: churches, statues, paintings, historic sites, museums, and monuments. Throughout the book, lists of sights tie your new understanding of Europe right into your upcoming trip plans. This unique approach to art and history, supplemented with maps, timelines, and illustrations, makes this "professor in your pocket" a practical and essential tool in any thoughtful traveler's preparation for Europe.

Not going to Europe anytime soon? This book works great for armchair travelers, too. Thanks to its many full-color images, *Europe 101* is the next best thing to a plane ticket.

Beyond their formal university educations in European history, art, and culture, Rick Steves and Gene Openshaw have spent much of their adult lives roaming Europe, on their own and as tour guides. These two professional tourists understand what you need to know and—just as important—what you don't.

Rick Steves' Europe 101 is made to order for smart people who slept through their history and art classes before they knew they were going to Europe. It's a fun-to-read, practical book that makes Europe's history, art, and culture come alive. After reading this book, you'll step into a Gothic cathedral, excitedly nudge your travel partner, and whisper, "Isn't this a marvelous improvement over Romanesque?"

Europe, here you come!

EUROPE 101

History and Art for the Traveler

SEVENTH EDITION

Rick Steves
&
Gene Openshaw

AVALON
TRAVEL

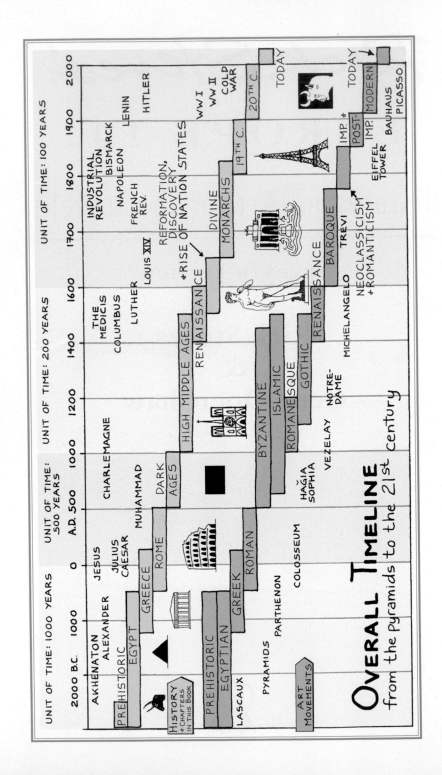

OVERALL TIMELINE
from the Pyramids to the 21st century

UNIT OF TIME: 1000 YEARS | UNIT OF TIME: 500 YEARS | UNIT OF TIME: 200 YEARS | UNIT OF TIME: 100 YEARS

2000 B.C. | 1000 | 0 | A.D. 500 | 1000 | 1200 | 1400 | 1600 | 1700 | 1800 | 1900 | 2000

HISTORY +CHAPTERS IN THIS BOOK

AKHENATON
ALEXANDER
JESUS
JULIUS CAESAR
MUHAMMAD
CHARLEMAGNE
THE MEDICIS
COLUMBUS
LUTHER
LOUIS XIV
INDUSTRIAL REVOLUTION
BISMARCK
NAPOLEON
FRENCH REV.
LENIN
HITLER
WW I
WW II
COLD WAR
TODAY

PREHISTORIC
EGYPT
GREECE
ROME
DARK AGES
HIGH MIDDLE AGES
RENAISSANCE
REFORMATION, DISCOVERY +RISE OF NATION STATES
DIVINE MONARCHS
19TH C.
20TH C.
TODAY

ART MOVEMENTS

PREHISTORIC
EGYPTIAN
GREEK
ROMAN
BYZANTINE
ISLAMIC
ROMANESQUE
GOTHIC
RENAISSANCE
BAROQUE
NEOCLASSICISM +ROMANTICISM
IMP. +
POST-IMP.
MODERN
TODAY

LASCAUX
PYRAMIDS
PARTHENON
COLOSSEUM
HAGIA SOPHIA
VEZELAY
NOTRE-DAME
MICHELANGELO
TREVI
EIFFEL TOWER
BAUHAUS
PICASSO

Contents

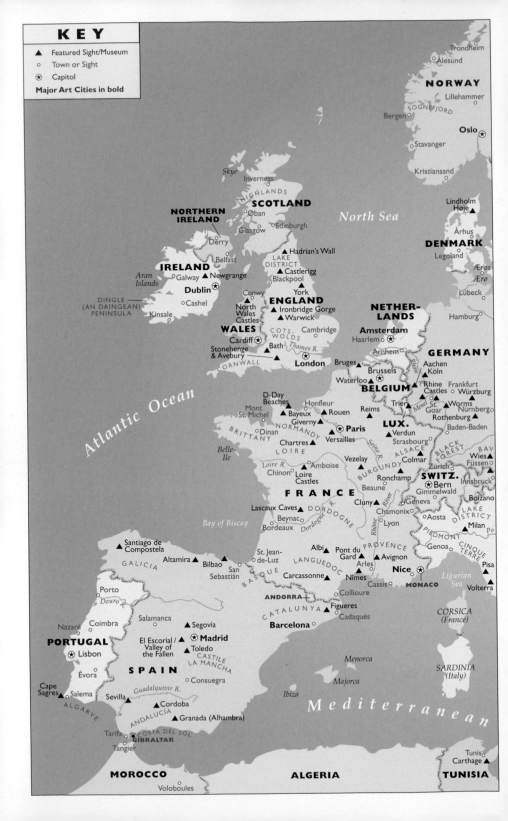

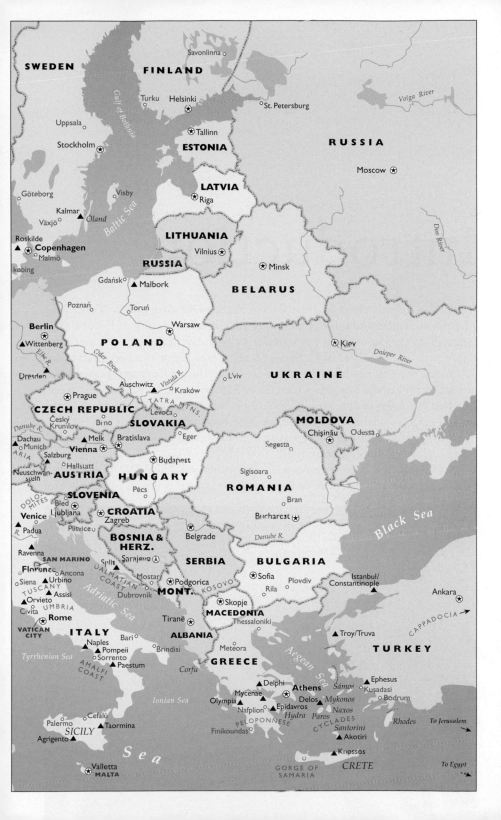

Introduction

Europe is a treasure chest of great art and history. Our goal: to sort it out. Take a minute to understand this book's layout. Its core tells the story of Europe's history and art chronologically from prehistory to today. Maps help you place historic events, and timelines in each chapter show how history and art interrelate.

Along the way, the history is illustrated with the art from that period, concentrating on just those sights a traveler to Europe would be most likely to see. The best examples of this art and history are listed throughout the book in the various "Sights" sidebars. These lists are based not only on historic importance, but also on popularity among tourists, accessibility to travelers, and arbitrary whims, because—heck, it's our book.

We've kept this book grunt-simple. Historians and scholars will be appalled at all the names and dates we've left out. But our goal is not to make you feel

Embrace Europe's art.

You'll enjoy Paris' Louvre Museum—if you're equipped with good information. Without it, you're...

like you just ate an encyclopedia, but to explain clearly just what's necessary to appreciate the Europe you'll see in your travels. Take Frederick the Great, for instance. Great as he was, he's just Frederick the So-So to the average tourist, so he isn't mentioned in this book. Louis XIV, however, gets special attention because nearly every traveler visits his palace at Versailles or the many palaces it inspired throughout Europe.

This book's section on Art Appreciation covers the basics of artists' techniques, common symbols and subjects, and tips on museum-going.

As you read, keep an eye on the big picture and don't get lost in the details. Once you're actually sightseeing in Europe, you can easily supplement this overview with on-the-spot information, tours, audioguides, and guidebooks.

And finally: no apologies. This book drives art snobs nuts. Its gross generalizations, sketchy dates, oversimplifications, and shoot-from-the-hip opinions really tweeze art highbrows. Our goal is to give you the practical basics (and no more) to bring meaning to your sightseeing. Use it as an introduction to Europe's wonders, not the final word. (By the way, we'd welcome any suggestions on making this book better and more helpful in future editions. E-mail us at rick @ricksteves.com.)

Now, raise your travel dreams to their upright and locked positions, and get ready for a fascinating story...the story of Europe.

Happy travels,
Rick and Gene

...a victim of the Louvre.

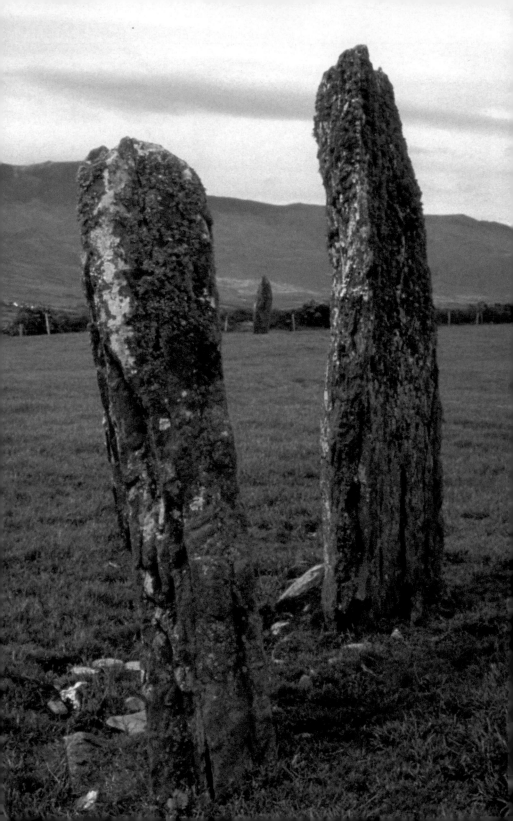

Prehistoric Europe

Paleolithic Era
(40,000–8000 B.C.)

Europe's story begins 40,000 years ago, when the first humans arrived. Before this, there was no tourism.

Armed with crude stone tools and fire, these nomads shivered through the last years of Europe's Ice Age, hunting wild animals and gathering plants. Despite their Stone Age lifestyle and limited vocabularies, these people were fully-formed *Homo sapiens,* the product of five million years of biological evolution rooted in eastern Africa. We know these "cavemen" by their possessions—stone axes, flint arrowheads, and bone needles for making clothes—many of which are beautifully decorated (and on display in museums across Europe).

The greatest legacy of the Paleolithic people is the cave paintings they made deep in limestone caverns, mostly in southern France and Spain.

These hunters painted their prey: bison, horses, reindeer, wolves, bears, and even animals that are now extinct, such as woolly mammoths and saber-toothed cats. The cavemen also drew geometric designs and mysterious squiggles and hash marks. One thing they rarely painted was themselves—there's scarcely a *Homo sapien* in sight.

These works are not crude doodles. The animals are so startlingly realistic that they're instantly recognizable. Most have thick black outlines filled in with red, yellow, or white paint made from natural pigments (such as charcoal and ocher)

The Venus of Willendorf, 23,000 B.C. (Natural History Museum, Vienna). *This four-inch-high limestone fertility symbol was one of many such statues made by prehistoric Europeans who may have worshipped Mother Nature. Five times as old as Egypt's pyramids, this faceless Pillsbury Dough Girl was found on the banks of the Danube in present-day Austria.*

Prehistoric Ages

Historians divide prehistory into ages to show our progression from the use of stone tools (lith = stone) to sophisticated metals.

Paleolithic	40,000–8000 B.C.
Mesolithic	8000–4500 B.C.
Neolithic	4500–2000 B.C.
Copper Age	3000–1800 B.C.
Bronze Age	1800–500 B.C.

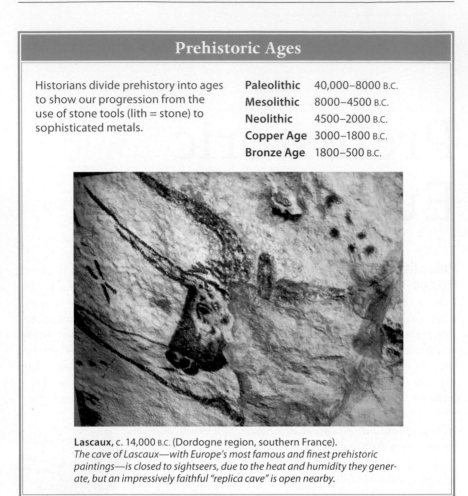

Lascaux, c. 14,000 B.C. (Dordogne region, southern France). The cave of Lascaux—with Europe's most famous and finest prehistoric paintings—is closed to sightseers, due to the heat and humidity they generate, but an impressively faithful "replica cave" is open nearby.

ground up and dissolved in cave water or vegetable oil. Some figures are laboriously etched in with a flint blade, following the natural contour of the rock. This "hunter style" of art is found chiseled and sanded onto rocks or dug into hillsides throughout Europe. Some of these paintings look like modern art, and have inspired some modern artists.

Imagine just the engineering problems of painting one of these caves. First, the scale was enormous—the main cavern at Lascaux (in France's Dordogne region) is a stone "canvas" the size of a football field. The cavemen had to haul their materials deep into one of these pitch-black, inaccessible places. (Despite being dubbed "cavemen," Paleolithic people probably did not actually live in the cold, damp caves they painted.) Assistants ground pigments, mixed paints, tended the torches, erected scaffolding to reach high up on the walls or ceilings...and then stepped aside for Cro-Magnon Michelangelos to climb up and create their prehistoric Sistine Chapels.

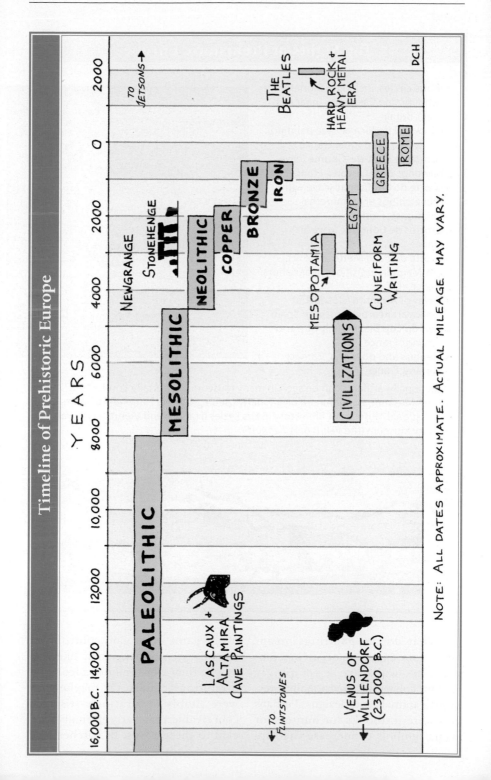

Timeline of Prehistoric Europe

YEARS

16,000 B.C. 14,000 12,000 10,000 8000 6000 4000 2000 0 2000

TO FLINTSTONES

TO JETSONS →

PALEOLITHIC

LASCAUX + ALTAMIRA CAVE PAINTINGS

VENUS OF WILLENDORF (23,000 B.C.)

MESOLITHIC

NEOLITHIC

COPPER

BRONZE

IRON

NEWGRANGE

STONEHENGE

CIVILIZATIONS

MESOPOTAMIA

EGYPT

CUNEIFORM WRITING

GREECE

ROME

THE BEATLES

HARD ROCK + HEAVY METAL ERA

DCH

NOTE: ALL DATES APPROXIMATE. ACTUAL MILEAGE MAY VARY.

Top Sights of Prehistoric Europe

- **Stone circles,** including Stonehenge, Avebury, and Castlerigg (near Keswick), Britain
- **Lascaux II** (replica of cave painting), Les Eyzies, Dordogne, France
- **Grotte de Font-de-Gaume** (cave painting), near Lascaux, France
- **Grotte de Rouffignac** (cave with roof etchings of mammoths), Rouffignac, France
- **Grottes de Cougnac** (cave art), France
- **Grotte du Pech Merle** (cave art, Cro-Magnon footprint), near Cahors, France
- **Caves of Altamira** (closed, but replica art nearby), northern Spain
- **Abri du Cap Blanc** (sculpture and carving), France
- **Menhirs and dolmens,** Carnac, Brittany, France

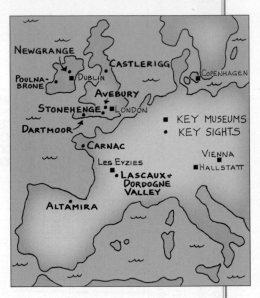

Additionally, artifacts can be seen in many museums, especially London's British Museum, Copenhagen's National Museum, Dublin's National Museum, the National Museum of Prehistory in Les Eyzies (France), and Vienna's Natural History Museum (the *Venus of Willendorf*).

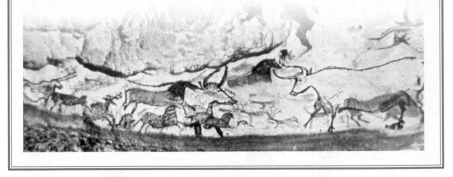

What do the paintings mean? There's no apparent order or composition—walls are a seemingly random collage of occasionally overlapping animals and designs. Perhaps they were textbooks for hunters, or magic symbols to increase the supply of game or to gain control over animals by capturing their likeness. Maybe they were religious icons for mysterious rituals. Or maybe they were simply decorations. It's even conceivable that early humans traveled to these caves, lit torches, and

watched the animals flicker to life, all for the sole purpose of being amazed and astounded—Europe's first tourist traps.

Today, you can visit the caves (or exact replicas nearby) and share a common thrill with a caveman.

From Hard Rock to Heavy Metal:
Mesolithic Era (8000–4500 B.C.) and Neolithic Era (4500–2000 B.C.)

As the ice fields slowly receded from northern Europe (c. 9000 B.C.), civilization heated up. Wandering hunter tribes learned to supplement their food supply by choosing prime spots to farm their own plants and raise their own animals.

You can track their transition from stone to metal in the evolution of their weaponry: stone axe, flint arrowhead, obsidian spear, copper hatchet, bronze dagger, powerful iron sword. They learned to make items more durable with less grunt work. Bone needles gave way to copper; crude wooden bowls were replaced by elaborately painted ceramic pots.

Historians divide prehistory into ages to show our progression from the use of stone tools (lith = stone) to more sophisticated metals. But these dates

Cycladic figurines, c. 3000 B.C. (Louvre, Paris). *Goddess, corpse, fertility charm, or prehistoric Barbie Doll? No one knows for sure.*

are approximate and the periods often overlap because not all of Europe progressed at the same rate. Scandinavia and the British Isles were enveloped in ice long after the Continent had turned to forest, and so these regions lagged behind the rest of Europe. Even today, some of the earth's peoples—the Bushmen of Africa, Australia's Aborigines, and England's punk rockers—still employ Stone Age technology.

As humans settled down to farm, their new lifestyle led to leisure time and cooperation, two elements that are key to the rise of civilization. Farmers in villages were more productive than nomads, as they had spare time to sing songs, tell stories, decorate pottery, organize religion, and construct permanent buildings. Working together, villagers could solve mutual problems or build large-scale projects—irrigation and drainage systems—that no one could do alone.

Cooperation led to governments, a greater exchange of knowledge and ideas, common languages, the rudiments of writing to preserve this new knowledge, and paid vacations.

These early people made small stone or wood statues of the (mostly) female form. The statues exaggerate the most feminine features: breasts, hips, butt, and genitals. Possibly these Neolithic

Barbie dolls were goddesses to be wor-
shipped, or perhaps they were used in
funeral rituals, but most likely they
were magical voodoo dolls to promote
fertility. Living at the mercy of nature,
people respected "Mother Nature,"
who took the form of a fertile woman.
By late Neolithic times, the figures
become more stylized—just a carved
stick with two lumps for breasts.

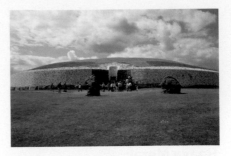

Newgrange, c. 3200 B.C. (near Trim, Ireland).

The most awe-inspiring and mys-
terious remains of Neolithic culture
are the megalithic ("big stone") struc-
tures that dot Europe, particularly in
the north (Britain, Ireland, western
France, and Scandinavia). The two
major types are menhirs and dolmens.
Menhirs are large, upright rocks, often
inscribed with a hunter or symbol (a
petroglyph). Menhirs can either stand
alone, be arranged in a circle (such as
England's Avebury and Stonehenge—
described below), or stand in a line
(as in Carnac, France). Dolmens are
tombs made of several upright stones
topped with a slab for a roof. These
were burial chambers for the great
warrior chiefs of the time, who were
thus carried into the next life and bur-
ied with all of their possessions (a
boon for modern-day archaeologists).
Originally covered with earth, many
dolmens are now exposed, clearly
showing the stone structure.

You'll also see burial
mounds, such as Ireland's
Newgrange (c. 3200 B.C.).
Made of 200,000 tons of
stone, the Newgrange
mound stretches more
than 300 feet in diameter.
Apparently, all this stone
was laboriously laid out
for the tomb's 15 minutes
of fame on a single day
of the year. On the win-
ter solstice, a ray of light
enters the tomb, creeps
down a narrow passage-
way and then briefly
illuminates the sacred
central chamber, presum-
ably to transport the sun
worshipper's soul from
this life to the next.

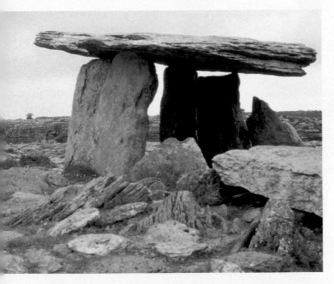

Poulnabrone Dolmen, c. 3500 B.C. (The Burren, Ireland).
*Dolmens are stone tombs; the Flintstones-style roof once
sheltered the bones of Neolithic royalty.*

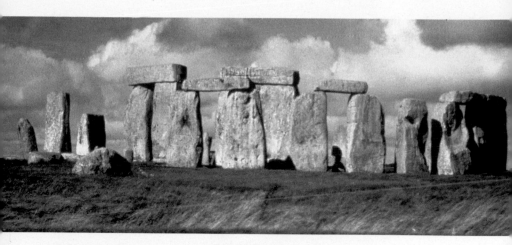

Stonehenge, c. 2000 B.C. (near Amesbury, England).
This 4,000-year-old celestial calendar told the earliest Brits just when to plant, when to harvest, and when to party. Even today, when the sun sets in the right spot...Druids boogie.

Stonehenge

The greatest megaliths are stone circles, consisting of many menhirs arranged in a pattern. Stonehenge (c. 2800–1500 B.C.) is the most famous of the roughly 300 circles that litter Britain. Made of stones weighing as much as 400 tons, it amazed medieval Europeans, who figured it was built by a race of giants. The bluish stones likely came from Wales, 240 miles away. (Close if you're taking a train, but far if you're packing a megalith.) While today's New Age pilgrims speculate that ancient congregations psychically levitated the slabs here, stodgy engineers contend that the huge stones were rafted from Wales, then rolled

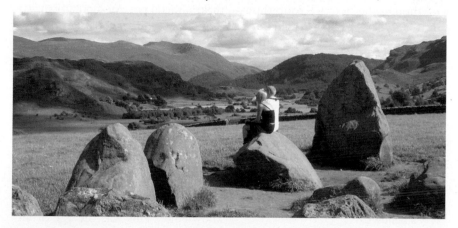

Castlerigg Stone Circle, c. 3000 B.C. (near Keswick, England's Lake District).
England is littered with Stonehenge-type stone circles. Most are desolate and filled with wonder.

inland on logs. Either way, it's an amazing achievement for primitive peoples.

Stonehenge was a calendar on a grand scale, designed to calculate the movement of the sun, moon, and stars, and even to predict eclipses in order to know when to plant, harvest, and, possibly, sacrifice virgins (though many experts doubt this). Stonehenge's pillars are placed so that the rising sun on the longest day of the year (the summer solstice) filters through and strikes the altar stones. An avenue of stones that could accommodate huge crowds leads up to the sanctuary, so the circle may have been used for rituals. No one knows for sure. Ultimately, most prehistoric art—ranging from finger-size goddesses to Hummer-size megaliths—is as mysterious as the human species.

The Age of Metals:
A Recipe for Success
(3000–500 B.C.)

Who first imagined you could melt rocks to make metal? Probably the Anatolians of Turkey, in about 6500 B.C., though the practice took thousands of years to spread through Europe. But as soon as it did, cutting-edge metal tools quickly left Flintstones technology back in the Stone Age. Making even the simplest metal, copper, is not easy. Here's the recipe:

- Mine copper ore.
- Build a furnace out of clay.
- Place ore inside, then light a fire.
- Super-heat to 2,300 degrees Fahrenheit (way beyond your basic campfire) by fanning flames with a bellows.
- Remove molten copper very quickly (only 12 seconds before

it cools), pour into a stone mold, and let cool.
- Reheat copper, then hammer with a stone into desired shape (such as an axe blade).
- Grind to a sharp edge, and polish.
- Use the resulting weapon to intimidate Stone Age losers.

Over time, artisans learned to mix in other metals (copper + tin = bronze) in order to lower the melting point, make it easier to work, and end up with a more durable and lethal product.

Armed with metalworking, Europe forged ahead. People learned to specialize, making assorted tools, cooking pots, statuettes, jewelry, keys, and the always-popular weapons. You'll see these copper odds and bronze ends throughout museums in Europe. Artisans produced, trade flourished, and cities grew. With the invention of the plow and wheel, things really started rolling.

But while Europeans in 3000 B.C. were still trying to figure out how to make a metal pot, Mesopotamian civilization was already cooking.

Mesopotamia:
The Cradle of Civilization
(3000 B.C.)

Ideally located with a warm climate, Mesopotamia—present-day Iraq—was the birthplace of Western civilization. This "Crossroads of the World," where Asia, Europe, and Africa meet, was perfect for receiving and spreading (through trade) all of the world's knowledge. This was the age of cities, with each one a separate kingdom: Ur, Uruk, and Lagash. Each city was,

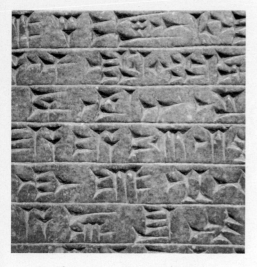

Cuneiform writing on a clay tablet.

in its own time, the hub of the known world.

City life spawned civilized living, and the Mesopotamians produced mankind's greatest invention: writing. Many of Europe's museums display clay tablets with this first cuneiform ("wedge-shaped") writing. With writing, knowledge could be preserved for the next generation and spread abroad to distant lands, allowing one civilization to build upon the advances of an earlier one.

Relax. You've just covered 40,000 years of history, from painted caves to copper toothpicks. And all this before the first pyramid was built.

Bust of Queen Nefertiti, 1340 B.C. (Egyptian Museum, Berlin).
This long-necked beauty— the wife of Pharaoh Akhenaton—is one of many Egyptian masterpieces on display in Europe.

Egypt

3000–1000 B.C.

Recorded history began in the year 3000 B.C., when writing first appeared—a landmark event that has reached its culmination in this book. But first things first.

Egypt was united in 3000 B.C., creating a remarkable civilization that thrived for 2,000 years. The Egypt we think of—pyramids, pharaohs, and guys who walk funny—represented a time of unprecedented stability, with very little change in government, religion, or the arts. Imagine two millennia of Eisenhower.

Though not in Europe, Egypt is included in *Europe 101* because its artifacts are scattered throughout Europe today: statues, hieroglyphs, broken columns, and mummies in museums, as well as obelisks in city squares. Also, Egypt had a huge impact on European culture through its contact with ancient Greece and Rome. Finally, a side-trip to Egypt is easy to tack onto a European trip.

Egypt, one of the world's first

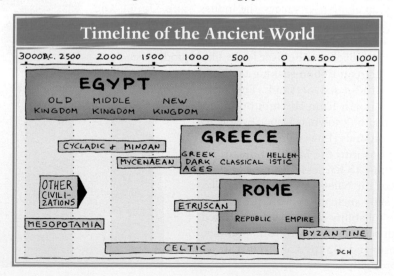

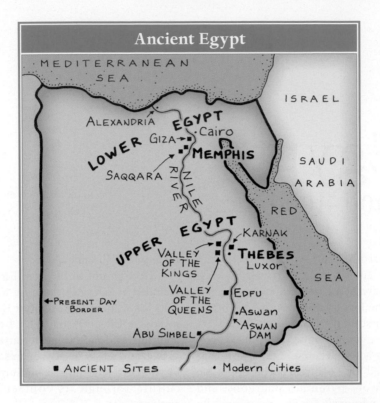

Ancient Egypt

civilizations, had a government, religion, art, free time, and a written language. The earliest great civilizations grew up along river valleys: the Indus, Tigris, Euphrates, and Nile.

In many ways, Egypt *is* the Nile. From an airplane, the river looks like a lush green ribbon snaking through an endless sea of sand. The Nile flows north from the mountains in the south (known as Upper Egypt) to the flatlands (Lower Egypt), where it empties into the Mediterranean. By learning to harness the annual flooding of the Nile—its water and fertilizing silt—ancient Egyptians prospered. The reliability of the Nile, combined with relative isolation from enemies, preserved Egypt's civilization as thoroughly as a mummy.

Pharaohs

Egypt was born in 3,000 B.C., when the Upper and Lower regions were united under a single king called a pharaoh. Egypt's

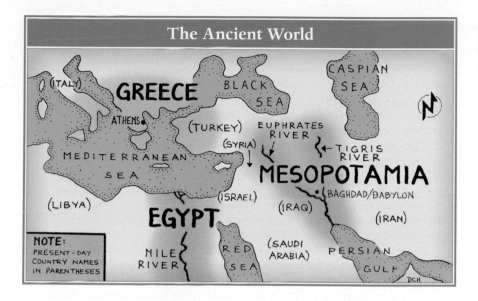

The Ancient World

NOTE: PRESENT-DAY COUNTRY NAMES IN PARENTHESES

history is full of pharaohs fighting to keep Egypt united, ruling from either Memphis (near modern Cairo, in the north) or Thebes (near modern Luxor, in the south).

The pharaoh was considered a god on earth, who preserved the cosmic order. He was the all-powerful link between the human world and the world of the ruling gods, so to challenge him was to challenge everything that held Egyptian society together. Because of this, the people of Egypt were generally pro–status quo, which allowed the pharaohs to rule virtually unchallenged for 2,000 years.

Pharaohs posed for colossal statues of themselves, which were mass-produced by the dozens and hoisted around the kingdom as a rallying point. A king who wore a combined crown (with two crowns superimposed, looking like a bowling pin in a chair) bragged that he was "Lord of the Two Lands," ruling both Upper Egypt (symbolized by the papyrus)

and Lower Egypt (the lotus). Intertwined lotus and papyrus flowers also symbolized unity. Other pharaoh statues sported a kilt and a simple striped-cloth headdress with a cobra amulet in the middle of their forehead, which symbolized their role as the sun god's representative on earth.

Each pharaoh had his personal symbol, as well as the traditional beard, which was a sign of power. Even Queen Hatshepsut, one of history's first woman rulers, was portrayed with a beard. Pharaohs carry a shepherd's crooked staff and whip to show that they cared for the contented Egyptian flock.

The strict hierarchy of ancient Egyptian

Three Kingdoms and Two Periods

Historians divide Egypt's core history into three 500-year kingdoms, followed by periods of decline and conquest:

• **Old Kingdom,** c. 2500–2000 B.C.: Upper and Lower Egypt are united, with the capital at Memphis (near modern Cairo). The Great Pyramids are built and sun worship is established. Kingdom ends with civil wars and famine.

• **Middle Kingdom,** c. 2000–1500 B.C.: Order is restored under rule from new capital in Thebes (near modern Luxor, 450 miles upstream from Cairo). Ends with invasion by the Hyksos people, who bring superior technology.

• **New Kingdom,** c. 1500–1000 B.C.: Egypt expands and dominates Middle East. Era of Queen Hatshepsut, Ramses II, Akhenaton, and Tutankhamen. Wars with Hittites and the so-called Sea Peoples (mysterious Mediterranean invaders who attacked Egypt by sea in about 1200 B.C.) drain the country.

• **Late Dynastic Period,** c. 1000–332 B.C.: Invasion, division, decline. Ends with conquest by Alexander the Great.

• **Greek and Roman Period,** c. 332 B.C.–A.D. 396: Alexander builds his capital at Alexandria, in the Nile Delta (100 miles north of Cairo). Greek-dominated Egypt flourishes as a cultural capital. Later, Julius Caesar conquers Egypt (47 B.C.) and beds Cleopatra. Romans carry off obelisks to beautify their city.

Timeline of Ancient Egypt

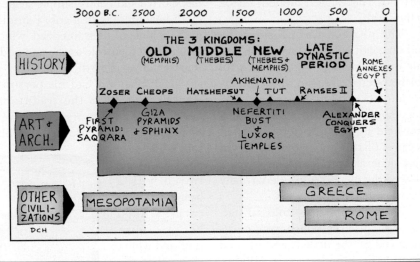

society is reflected in their art. At the bottom of society's pyramid, poor people are always shown barefoot. Priests wear leopard skins. Important people are depicted bigger than commoners. A pharaoh's image might be 20 times as tall as his subjects.

Akhenaton
(Egyptian Museum, Berlin). *With sensual curves and Mick Jagger lips, this depicts Egypt's great nonconformist pharaoh, who promoted monotheism and individuality in the arts.*

Phive Phamous Pharaohs
• **Zoser** (also spelled Djoser, 2667–2648 B.C.) put Egypt on the map with the world's first monumental stone building, the 20-story pyramid at Saqqara.
• **Cheops** (also called Khufu, 2551–2528 B.C.) built the Great Pyramid at Giza. 'Nuff said.
• **Queen Hatshepsut** (r. 1473–1458 B.C.) was a rare phemale pharaoh. Her impressive temple (see page 20) reflects the age when Egypt was the Middle East's powerhouse.

• **Akhenaton** (r. 1380–1362 B.C.), along with his wife Nefertiti, championed monotheism to his polytheistic subjects. He startled the conservative nobility and priesthood of his time by lumping the countless gods of the Egyptian pantheon into one all-powerful being, Aton the sun god. Akhenaton's reign was the one striking exception to Egypt's 2,000 years of political, religious, and artistic rigidity.

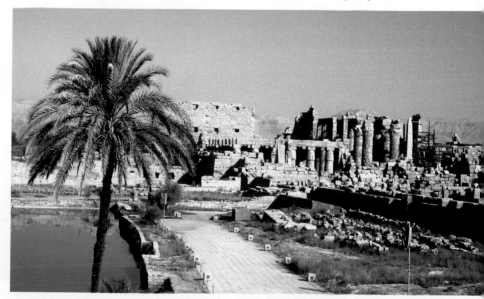

The wonders of ancient Luxor await you.

After Akhenaton's death, Egypt pulled their old gods out of the closet again during the reign of Akhenaton's son-in-law, pharaoh Tutankhamen ("King Tut," r. 1334–1325 B.C.). The boy-king ruled from about age 10 to age 19, under the direction of a powerful vizier. When Tut died (cause unknown), he was mummified and buried in a tomb in the Valley of the Kings for more than 3,000 years. In 1922, a British archaeologist stumbled onto Tut's tomb. It was a historical and literal treasure chest of jewels, a gold mask, and Tut's still-youthful body. Tutankhamen was just a mediocre pharaoh—basically an ancient Gerald Ford—who achieved fame only because his tomb was discovered intact, providing great insights for modern archaeologists. Much of what we know of Egypt came from this chance discovery.

• **Ramses II** (also spelled Ramesses, r. 1279–1212 B.C.) was the last great ruler before a millennium of decline. He may have been the pharaoh who was forced to deal with troublesome Hebrew slaves. According to the Bible, Moses told the king of Egypt, "Let my people go!" Pharaoh said "No!" So Moses cursed Egypt with plagues, freed the Israeli slaves, and led them out of Egypt to their homeland in Israel.

The Afterlife: The Eternity Express

Much of Egypt's energy and arts revolved around preparing people and their possessions for the afterlife.

In those days you *could* "take it with you." After you died, your soul lived on, enjoying its earthly possessions, which sometimes included your servants, who might be walled up alive with your body. The deceased was mummified to preserve the body until the soul awoke to join it in paradise.

To mummify a body, disembowel it (but leave the heart inside), and place the organs in a funerary vase. Pack the body cavities with pitch, and dry with natron, a natural form of sodium carbonate (and, I believe, the active ingredient in Twinkies). Then carefully bandage it head to toe with linen strips. Let sit for 2,000 years, and...*voilà!* Or just dump the corpse in the desert and let the hot, dry, bacteria-killing Egyptian sand do the work—you'll get the same results.

Waiting for the Eternity Express....

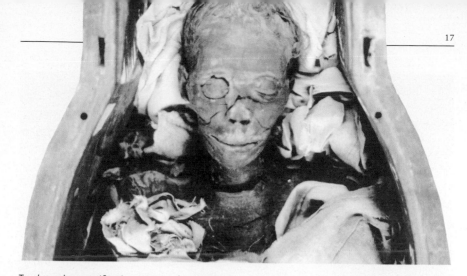

Tombs and mummification preserved corpses and possessions for the afterlife.

Mummies of VIPs were put in wooden coffins, which were placed inside stone coffins, along with the deceased's possessions, some symbolic servants (small *shabti* figurines), and maybe even the family pet. Cats were worshipped in life as incarnations of the peaceful goddess Bastet. In death, they were mummified, memorialized with statues, and given the adulation they've come to expect ever since.

All this spiritual baggage was then put inside a rectangular tomb, called a mastaba. The walls were painted with pictures of the deceased, his family, his résumé of accomplishments, and his possessions, in case the pharaoh's real goodies didn't make it (a primitive forerunner of baggage insurance). Magical spells from the Book of the Dead protected the body from demons and served as crib notes for the waking soul, who used these passwords to get past the guardians of eternity.

A statue of yourself at the ceremonial "front door" of the tomb allowed your hungry soul to come and go and enjoy the food offerings placed there by your descendants. Other statues of the deceased were scattered around. When a frightened and confused soul was crying for its mummy, these statues served as a temporary refuge on the journey to paradise. Everyone was buried on the west bank of the Nile— where the sun set and where paradise was. This is why all pyramids are on the Nile's west bank.

Only the wealthiest got such a full burial with all the works. But the result is that we now have Egyptian bodies that are as well preserved as Joan Rivers.

Pyramids

Pyramids are giant stone tombs built to preserve a king or queen's body and possessions until they reached paradise. These remarkable structures—some of which stood as tall as a 40-story building—are among mankind's greatest undertakings. The pyramids, which were built by master designers and hordes of both skilled and unskilled workers, took decades to complete.

The Pyramid of King Zoser at Saqqara, c. 2600 B.C. (near Cairo).
Zoser (not pictured) built the first of Egypt's great pyramids. The designer, Imhotep—who was deified by wowed Egyptians—is history's first known artist. Saqqara is a "step pyramid," designed as six mastabas stacked one on top of the other.

The three pyramids at Giza (c. 2500 B.C., near Cairo) are the most visited of the dozens of pharaohs' stairways to heaven. The biggest is the Pyramid of Cheops (or Khufu; also known simply as The Great Pyramid)—the only survivor of the original Seven Wonders of the Ancient World. It covers 13 acres (755 feet by 451 feet), weighs 5,750,000 tons, and rises 480 feet up from the desert floor. Historians figure it took 100,000 laborers working for 20 years to drag the 2,300,000 limestone blocks across the desert and raise them into place. The whole thing was originally whitewashed with a gleaming limestone veneer. In the heart of the pyramid, the pharaoh Cheops was placed in a stone coffin, surrounded by treasure.

Pyramids were booby-trapped and carefully designed to foil thieves. But ironically, they actually served as markers attracting grave robbers, who reasonably assumed that the bigger the pyramid, the better the loot it "protected." Time and time again, pharaohs woke up in heaven with absolutely nothing. So, later pharaohs preferred more hidden tombs buried in the Valley of the Kings in Thebes (modern Luxor). Mounted soldiers guarded the tombs. Most tombs were eventually looted, but some (like King Tut's) have been discovered in modern times, revealing 3,000-year-old riches and art that still look brand new. How many more unmarked tombs, with untold treasures, await discovery in silence and darkness?

The First Pyramid Scheme

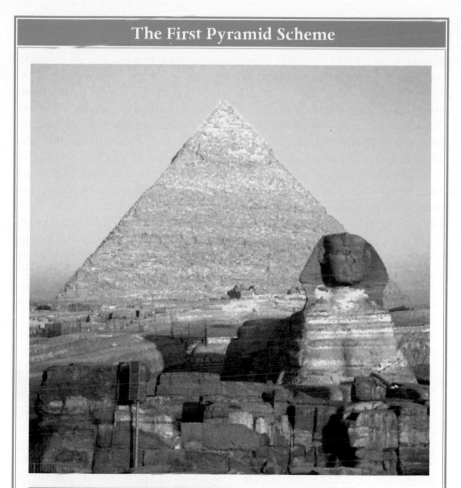

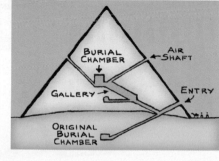

The Pyramid of Chephren, or Khafre, 2500 B.C. (Giza, near Cairo). *The second-largest of the three Great Pyramids once held the body of King Chephren. His likeness survives (vaguely) in the face of the 65-foot, lion-like Great Sphinx. The pyramids were huge tombs, designed to hold the dead pharaoh and his carry-on luggage until he entered eternity.*

Other Egyptian Architecture: Temples and Obelisks

Though known for its pyramids, Egypt also built remarkably sturdy temples that still stand today, mainly in and near Luxor. Some were cult temples that housed statues of gods (such as the Luxor and Karnak temples). Others were memorials to pharaohs. Queen Hatshepsut's enormous temple, built into a hillside, stands as a monumental symbol of Egypt when it was the Middle East's superpower.

Recipe for an Egyptian temple: Choose a god. Build a grand doorway and flank it with obelisks (pointed pillars) and colossal statues of pharaohs and gods. Priests would enter here and walk through a courtyard filled with thick columns. Mix in more columns in the huge pillared (hypo-style) hall. Finish with a shrine, where a statue of the god stood on a pedestal. Sprinkle in a few private rooms for priests.

Rich in clay, Egypt built its temple walls with thick brick and few windows. The outside was etched and painted with hieroglyphs and symbols. Because of a lack of wood, they made the roofs out of stone slabs, supported by stone columns placed close together to minimize the span. These enormous columns (up to 70 feet tall) often resemble stone flowers. Resting on circular bases, the "stems" rise up, blossoming into capitals that resemble the lotus flower (the symbol of Lower Egypt), the papyrus (Upper), or both flowers intertwined (to show unity).

Back then, it was an accomplishment just to have a roof over such

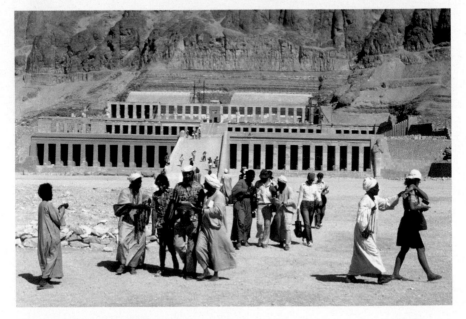

Queen Hatshepsut's Temple, c. 1450 B.C. (near Luxor, Egypt).
One way to keep a pharaoh alive was to remember him or her. While the tomb would be hidden for safety, the temple, such as Queen Hatshepsut's near Luxor, would be high profile for all to see and honor. Today, tourists probably remember the high-pressure merchants more than the queen.

huge buildings. A society's architectural sophistication can be judged by the distance it's able to span without a support. By this measure, Egypt wasn't very advanced. Later civilizations built more graceful temples with thinner columns spaced farther apart.

Hypostyle Hall, Temple of Amen-Re, 1280 B.C. (Karnak, Luxor). *It took a forest of thick columns placed close together to support the massive roof.*

Egypt also invented obelisks, the tapered monoliths that inspired our Washington Monument. Originally gracing temples, obelisks were dedicated to the sun god (to which they pointed) and incised with hieroglyphic promos for the current pharaoh. When Egypt was conquered by foreigners, these were the perfect souvenirs to bring home to decorate a city square.

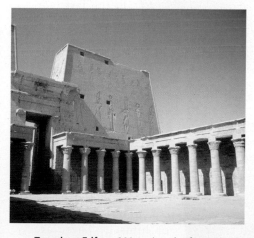

Temple at Edfu, c. 200 B.C. (south of Luxor). *Egypt's best-preserved ancient temple is a textbook example of a typical temple, with its monumental doorway, columns, and courtyard.*

Egyptian Art

Egyptian art served a society permeated by religion. It portrayed the Egyptian world, where the gods were in heaven, the pharaoh ruled on earth, and everyone wanted their soul to live on after death. The style changed little from 3000 through 1000 B.C., reflecting a stable society. Artists depicted the Egyptian gods, spread pharaoh propaganda, and preserved dead people's likenesses for eternity.

Egyptian art was more functional than beautiful. Statues walk awkwardly, facing forward with arms straight down at their sides. Paintings of people are stiff and flat. We see the torso from the front and everything else—arms, legs, face—in profile, creating the funny walk-like-an-Egyptian cliché. Egyptian artists followed a rigid "canon of proportions" that remained unchanged for centuries. The head had to be one-fourth the height of the body, for example, or the forearm always as long as the shin.

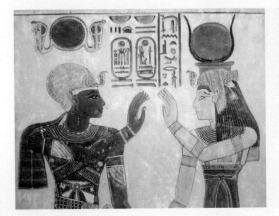

"Me pharaoh, you sun god. Together we rule. High five!"

To modern eyes, Egyptian art—two-dimensional, always facing forward, with strong outlines—might look crude. But "good" art is not necessarily lifelike. Egyptian art was a pictorial roll call of people and things that would be preserved in the afterlife, and it affirmed the divinity of the pharaoh and the relationships of the gods.

To accomplish its mission, Egyptian art was simplified, showing only what was necessary for easy ID. These were mug shots for eternity, easy to recognize quickly: chin up, no funny faces, nothing fancy. Like our modern "Deer Crossing" road signs, it showed things from their most characteristic and easy-to-recognize angles. Fish and birds are stretched out as if on a biologist's table, displaying every identifying trait, so that even scientists today can recognize the species.

Such clarity was important, because when Egyptians died, their souls had to make the long journey to the Egyptian paradise. No normal soul could make this dicey journey without a break. A statue or painting of the deceased was a place where the soul could rest. If you were rich, it was worth having your likeness on display everywhere you could, to provide your soul with the necessary pit stops on its long journey to salvation. To a soul caught in the fast lane of astral travel, a simple symbolic statue would be easier to spot than a detailed one.

If any pharaoh made it to heaven, it was Ramses II. He was a great builder of temples, palaces, tombs, and statues of himself. There are probably more Ramses statues in the world than there are cheesy fake

Top Egyptian Sights

In Europe
In Europe's museums, you can see: mummies (including mummified cats), tombs (mastabas and false doors), funereal statues (*shabtis* and false door statues), statues of pharaohs and gods, ceremonial stelae (standing rock slabs), obelisks, wall murals, and many examples of hieroglyphs. The best collections in Europe:
• London's British Museum (featuring the Rosetta Stone)
• Paris' Louvre Museum
• Rome's Vatican Museum
• Berlin's Egyptian Museum (starring Nefertiti, pictured on page 10)

In Egypt
Consider going straight to the source and visiting Egypt. Just a quick, direct flight from many major European cities, Egypt is about the most exciting side-trip you can plug into your European adventure; it's well worth the diarrhea. Sights are clustered around the two ancient capitals: Memphis (near Cairo) and Thebes (near Luxor):
• Egyptian Museum in Cairo
• The Great Pyramids at Giza (near Cairo)
• Zoser's Step Pyramid at Saqqara (near Cairo)
• Tombs in the Valley of the Kings at Luxor
• Temples at Luxor and Karnak

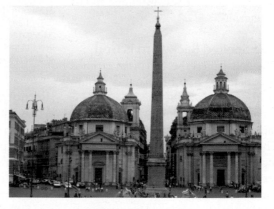

Egyptian Obelisk
(Piazza del Popolo, Rome). *Egyptian obelisks like this decorate squares from Rome to London. These are the oldest pieces of art many tourists will see in Europe.*

Davids. He was so concerned about achieving immortality that he even had his own name chiseled on other people's statues. Very cheeky.

Egyptian stiffness is sometimes softened by a human touch. After all, a lot of tomb decoration was like a family scrapbook, filled with snapshots of loved ones from a happy time, to be remembered for all eternity. This is especially true of the art of Akhenaton's reign. We see the royal family painted with more natural, lifelike, personal settings, such as a family portrait with Akhenaton, his wife Nefertiti, and their children. Ignoring the custom of portraying the most powerful subjects larger, his wife is shown as big as the king. Yet after this brief period of freedom, the old rigidity returned.

Fowling in the Marshes, 1350 B.C.
(British Museum, London).
Looking like he was just run over by a pyramid, this 2-D hunter is flat, as is most Egyptian art.

writing to man. The lioness portrays the fierce goddess Sekhmet. The hippo (with a lion head) is Tawaret, protectress of childbirth. Overseeing it all was the King of the Gods, Amen-Ra, the god of the sun. With his double-plumed headdress and scepter, he's portrayed as the alpha animal: man.

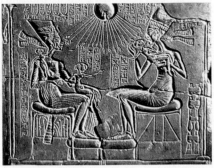

Stela of Akhenaton and Nefertiti, C. 1370 B.C.
(Egyptian Museum, Berlin).
Akhenaton was a monotheist. Here, under the one sun god, the royal children frolic on the laps of their regal mummy and daddy.

With their fervent hope for life after death, Egyptians created calm, dignified art that was intended to last for eternity.

Dog Spelled Backward Is God

The gods ruled the Egyptian cosmos like dictators in a big banana republic. Egyptians bribed their gods for favors, offering food, animals, or money, or by erecting statues to them. The Egyptians worshipped animals as incarnations of the gods. Back before technology made man top dog on earth, animals were stronger, swifter, or fiercer than puny *Homo sapiens*. Many European museums host a cosmic zoo of Egyptian gods.

The jackal was Anubis, the messenger of the gods who conducted human souls to the underworld after death. The falcon is Horus, the god of the living. (The pharaoh was also believed to be Horus on earth.) The clever baboon is Thoth, the gods' secretary, who gave

Hieroglyphs: Write Like an Egyptian

Egyptian writing, called hieroglyphics, used pictures that stood for sounds (phonograms). For example, a picture of a bird didn't mean "bird." Instead it was a sound, forming part of a larger word, like "burden."

A few hieroglyphs represent things

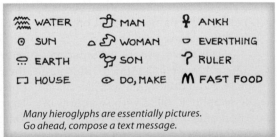

〰 WATER	𓀠 MAN	♀ ANKH
☉ SUN	WOMAN	EVERYTHING
EARTH	SON	RULER
HOUSE	DO, MAKE	FAST FOOD

Many hieroglyphs are essentially pictures. Go ahead, compose a text message.

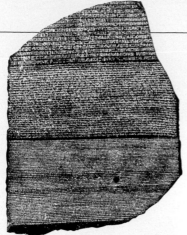

Rosetta Stone, 196 B.C.
(British Museum, London).
Found on the site of the ancient Hotel Rosetta, this inscription repeated the same message in three different scripts: "Don't wash clothes in the sink."

The Egyptian Legacy

Egyptian culture was forgotten as Greece and Rome picked up the torch of Western civilization. Knowledge of the ancient writing died, condemning the culture to obscurity. But Egypt influenced the rising Greek culture with its temples, formal statues, and technology. Egypt brought the world advances in irrigation, paper, astronomy, accounting, and beer. Since the discovery of the Rosetta Stone, Egyptology has boomed. And, with the more recent discovery of intact tombs, Europe's museums showcase their rich, complex, and fascinating culture. Centuries after its "demise," Egypt lives on.

and ideas (ideograms) the way some characters do in ancient Chinese writing: water (wavy lines), sun (circle with dot inside), man (seated man with arms) and mouth (football-shaped). One hieroglyph you'll still see often is the ankh, the key-shaped cross meaning "life" (which also symbolized eternal life). Egyptian statues are often shown clutching the ankh as though trying to hold onto life.

Hieroglyphs were a complete mystery to the world until 1799, when a black slab of rock known as the Rosetta Stone (196 B.C.) was unearthed in the Egyptian desert. It caused a sensation in Europe. The Stone contained a single inscription repeated in three different scripts: hieroglyphs, Greek, and a later form of Egyptian (called "demotic"). Scholars compared the two known languages on the Stone with the hieroglyphs...and finally broke the code.

Whether you're building a pyramid or sightseeing through all those tombs, cruising the Nile in a traditional felucca caps the day with a cool and relaxing break.

Venus de Milo, c. 100 B.C.
(Louvre Museum, Paris).
*This goddess of love, from the Greek island
of Milos, shows that the humanistic Greeks
pictured their gods in idealized human form.
Venus created a sensation across Europe when
discovered in 1820—and she still does today
in the Louvre.*

Greece

2000–150 B.C.

Our lives today would be quite different if it weren't for a few thousand Greeks who lived in a small city about 450 years before Christ was born: Athens. Democracy, theater, literature, mathematics, science, philosophy, and art all flourished in Athens during its 50-year "Golden Age"—a cultural boom time that set the tone for the rest of Western History to follow.

But classical Greece didn't just pop out of nowhere. Cursed with rocky soil, isolated by a rugged landscape, and scattered by invasions, the Greeks took centuries to unify. They prided themselves on creating order out of chaos. Greek civilization was built on the advances of earlier civilizations: Minoans, Mycenaeans, Dorians, and Ionians—the stew of peoples that eventually cooked up Greece.

The Pre-Greek World:
The Minoans (2000–1400 B.C.)
A safe, isolated location on the island of Crete (a 12-hour boat ride south of Athens), combined with impressive business savvy, enabled the Minoans to dominate the pre-Greek world. Unlike most early peoples, they were traders, not fighters. Sailing from their home base on Crete with a large merchant fleet, they exported wine, olive oil, pottery, and well-crafted jewelry. They returned home with the wealth of the Mediterranean, and built a lavish palace in Knossos, their capital.

From top to bottom, Minoan society was like one big transnational corporation: ruled by CEO kings, managed by CPA scholars, and blessed by bureaucrat priests. The only written records we have of their civilization are meticulous spreadsheets that show the micromanaged details of every business transaction. Thanks to their geographical remoteness and strong economy, the Minoans spent virtually nothing on their defense budget, and their cities and palaces had almost no fortifications.

No one knows where the Minoans originated, and their language has never been deciphered (not much literature survives), but they certainly were prosperous. Their palaces (at Knossos, Phaestus, and Akrotiri) were sprawling, serving as both corporate

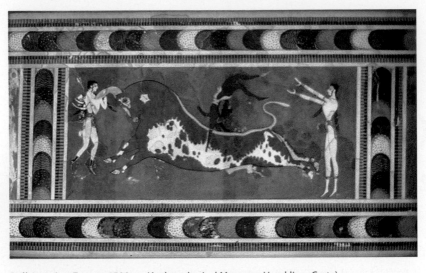

Bull-Leaping Fresco, 1500 B.C. (Archaeological Museum, Heraklion, Crete).
This image from the isle of Crete shows the grace of the easygoin' Minoan civilization that so mysteriously vanished. Some say sports like this had something to do with it....

headquarters and as the center of cultural life. With tapered columns, airy porticos, and lively frescoes, the palaces exude an atmosphere of intimacy and coziness.

Even the poorest on Crete lived well, in multi-room apartments with indoor plumbing. Blessed with ample leisure time, the Minoans were avid sports fans. Surviving frescoes show athletes staring down a charging bull, then—shoop—at the last minute, somersaulting gracefully over the bull's horns, to land upright on their feet again.

Theirs was a delicate, sensual, happy-go-lucky society that apparently worshipped an easygoing Mother Earth and her all-girl pantheon of goddesses. The Snake Goddess was especially popular, shown as a bare-breasted, snake-handling woman who guarded the home. There was rela-

tive equality between rich and poor, as well as between the sexes. Though the king was a man, women could be priests and business leaders, and they competed alongside men in boxing and bull-jumping. Minoan inheritance was probably matrilineal (meaning estates were handed down from mothers to daughters).

The colorful frescoes from Minoan palace walls are unique in the ancient world. Remember that most early cultures painted and sculpted things with a particular function in mind: as propaganda for a king, to commemorate a famous battle, or to represent a god. But the Minoans were among the first to love beauty for its own sake. The frescoes are pure decoration, their creators' delighting in everyday Minoans going about everyday life. Tanned, relaxed, good-looking men and women are shown dancing, fishing,

Precious little survives of this intriguing civilization. The scant remains of the Minoan palace at Knossos are easier to appreciate after visiting Heraklion's excellent Archaeological Museum. Perhaps the most interesting Minoan sight is the ruin of the Akrotiri settlement (with frescoes) on the island of Santorini.

or strolling with goddesses through a garden of exotic animals. The Minoans seemed more concerned with the good life than with the afterlife. Judging from their carefree art, life here was like an ancient Pepsi commercial.

At their peak (c. 1500 B.C.), the Minoans dominated the Greek mainland and neighboring islands, where they built large palaces. Greek legend has it that King Minos demanded a yearly sacrifice of young Greeks to the dreadful Minotaur (half bull, half man), who lived in a labyrinth on the grounds of the palace in Knossos. However, the Minoans' domination was probably more cultural than political. The later Greeks would inherit the Minoans' business skills, social equality, love of art for art's sake, and faith in rational thought over brute military strength. Some scholars hail the Minoans as the first truly "European" civilization.

In about 1450 B.C., the Minoan civilization suddenly collapsed. Overnight, the great palaces became ghost towns, and no one knows why. Some think the eruption of the Santorini volcano (home of Atlantis?) caused earthquakes and a tsunami that swept the Minoans into oblivion. Physically and economically weakened, they were easily overrun and absorbed by a tribe of warlike people from the mainland—the Mycenaeans.

Mycenae
(1600–1200 B.C.)

After the fall of the Minoans, the Greek mainland was dominated by the Mycenaeans (my-sen-AY-ans), a fusion of local tribes centered in the city of Mycenae (my-SEEN-ay). Culturally, they were the anti-Minoans— warriors not traders, chieftains not bureaucrats,

Mask (not) of Agamemnon, 16th century B.C. (National Archaeological Museum, Athens). *King Agamemnon's much-sought-after actual mask—the holy grail for generations of archaeologists—was never found. But this one dates from about the same time, close enough to become known as "the Mask of Agamemnon."*

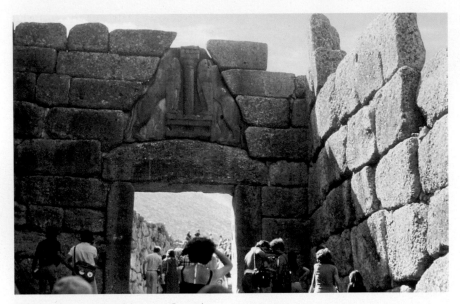

The Lion Gate, 1250 B.C. (Mycenae, Greece).
This gateway to the Mycenaean citadel shows the heavy, fortified style of this militaristic society from Trojan War times. Centuries later, the early Greeks—thinking no people could build with such huge stones—called Mycenaean architecture "Cyclopean." Mycenae is two hours south of Athens by bus.

bull-killers not bull-jumpers. The militaristic Mycenaeans, who predated the Golden Age Greeks by about a thousand years, must have seemed as ancient and mysterious to Socrates and Plato as Socrates and Plato seem to us.

Their ruins at the capital of Mycenae (about two hours by bus south of Athens) tell the story. Buildings are fortress-like, the city has thick defensive walls, and statues are stiff and crude.

The impressive Lion Gate guards the entrance. Mycenaean architects used the weak corbelled arch, less sturdy than the rounded Roman arch developed later. A simple horizontal stone spans the door, while heavy stones above it timidly inch in to bridge the gap. Filling the triangular hole is a thin plug featuring two lions flanking a (Minoan-style) column. Apart from its rather fragile technology, the architecture is really massive. In fact, early Greeks called Mycenaean architecture "Cyclopean," because they believed that only giants could have built with such colossal blocks.

Mycenaean kings were elaborately buried in tombs built like subterranean stone igloos. These *tholos* (as the tombs are called) were loaded with jewels, swords, and precious objects that fill museums today.

Sometime about the year 1200 B.C., the aggressive Mycenaeans launched an attack on a rich city on the Turkish coast, called Troy. After a long siege, Troy fell, and the Mycenaeans were now undisputed rulers of the Aegean. Then, just as suddenly—like the Minoans before them—the Mycenaeans

mysteriously disappeared, plunging Greece into its next, "dark" phase.

The Greek Dark Ages
(1200–800 B.C.)

Whatever the reason, once-powerful Mycenaean cities became deserted, writing was lost, roads crumbled, trade decreased, and bandits preyed on helpless villagers. Dark Age graves contain little gold, jewelry, or fine pottery. Divided by mountains into pockets of isolated, semi-barbaric, warring tribes, the Greeks took centuries to unify and get their civilization back on track.

What little we know about the Greek Dark Ages comes largely from legends passed down over generations and eventually compiled in the ninth century B.C. by a blind, talented, perhaps nonexistent man that tradition calls "Homer." His long poem *The Iliad* describes the battles and struggles of the early Greeks (actually, the "Mycenaeans") as they conquered Troy. *The Odyssey* tells of the weary soldiers' long, torturous trip back home. The Greeks saw these epics as a perfect metaphor for their own struggles to unify and build a stable homeland, and their stories helped shape a collective self-image.

Archaic Period
(800–500 B.C.)

By about 800 B.C., Greece's scattered tribes began settling down, experimenting with democracy, forming

Olympia

For more than a thousand years, the Olympic Games were held in their birthplace...Olympia. Besides the stadium, Olympia's Temple of Zeus was one of the great tourist destinations of the ancient world, boasting a then-world-famous 40-foot statue of Zeus by the great sculptor Phidias. It was one of the Seven Wonders of the Ancient World.

Olympia can still knock you on your discus. As you line up on that original starting block, crank up your imagination, light a torch, and refill the stadium with 40,000 fans (but get there early to avoid the tour-bus crowds).

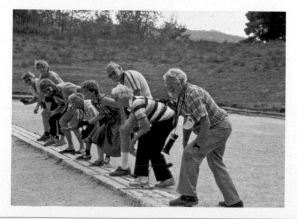

Through the ages, athletes and tourists alike have lined up on the starting block at Olympia. Greek runners toed this very mark during the first Olympic Games in 776 B.C.

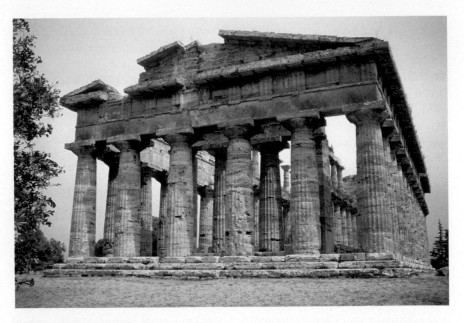

Temple of Neptune, 450 B.C. (Paestum, Italy).
You don't need to go to Greece to see great Greek ruins. This impressive temple is just south of Naples. Five hundred years before Christ, southern Italy was "Magna Graecia"...Greater Greece.

self-governing city-states, and making ties with other city-states. Scarcely two centuries later, they would be a united community and the center of the civilized world.

Living on islands or in valleys, the Greek-speaking people were divided by geography from their neighbors. They naturally formed governments around a single city rather than as a unified nation. An ideal city-state (or polis) was small enough to walk across in a day but large enough to have the necessary elements of a society: merchants, farmers, shoemakers, a debate team, and a good travel agent. A typical city-state had a combination fortress/worship site atop a hill called the acropolis (high city). The agora, or marketplace, sat at the base of the hill, with the people's homes and farms gathered around. Locals mingled

under a covered colonnade or portico (a stoa), which was used as a shady meeting place ideal for discussing politics. You can see each of these features today in the ancient center of Athens.

Cursed with dry and rocky soil, the Greeks were poor farmers but good craftsmen, sailors, and salesmen. As their population multiplied, they boarded ships to settle and trade in distant lands. Greek ruins still stand today in the places they colonized: southern Italy and Sicily, Egypt, France (Marseille), and Turkey. They absorbed culture from the more sophisticated Egyptians (style of statues) and Phoenicians (alphabet).

Many city-states followed a natural evolution in government: from rule by hereditary kings, to rich landowners (oligarchy), to popular tyrants (who seized power in times of crisis),

to rule by the citizens themselves—democracy (from demos, or "people"). These early democracies were far from democratic, however. Only free, landowning men with long bloodlines could vote, while slaves, former slaves, women, and foreigners could not.

These city-states were self-ruling mini-nations that jealously guarded their independence. Petty warfare between city-states was practically a sport. Outsiders (that is, anyone who didn't speak Greek) were considered "barbarians," a term that comes from the onomatopoetic Greek word that described what Greek ears heard when foreigners spoke—babbling that sounded like "bar bar bar"... barbarians.

Slowly, the Greeks unified. Bound by a common language and common religion, they formed trade leagues with neighboring city-states. Small city-states allied themselves with (or conquered) their neighbors to create ever-bigger political units. In the historic year 776 B.C., wars across the Greek world came to a halt, as athletes gathered in Olympia to strip buck naked and compete in the first Olympic Games. Increasingly, rival city-states battled their neighbors with the athlete's javelin rather than the soldier's spear.

Statues from Archaic times are crude, as stiff as the rock they're carved from. Rather than individuals, they are generic

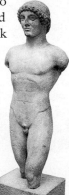

Kouros, C. 490 B.C. (British Museum, London).

people: called either *kore* (girl) or *kouros* (boy). Women are essentially columns with breasts. Like Egyptian art, the typical *kouros* statue poses awkwardly, face forward, with hands at his side and a forced smile on his face. The bodies appear to have been made on an assembly line, with universally interchangeable parts. Still, there is a timeless beauty to these works. With perfectly round heads, symmetrical pecs, and a navel in the center, these sturdy statues reflect the order and stability the troubled Greeks were striving for.

Sparta was Archaic Greece's largest city-state: At 3,000 square miles, it was bigger than Delaware. Sparta was a highly organized military state that conquered its neighbors and turned them into farm-working slaves. Bucking the democratic trend, Sparta was ruled by kings. Spartan men and women were raised to be warriors ruling over the working classes. At age seven, boys were taken from their families and raised in barracks, learning the art of war, discipline, and how to endure severe hardship. Spartan women were also schooled by the state, with lots of P.E. classes and a minimum of art history. Married couples could not live together until the man reached 30 years old. In wartime, Spartan mothers bid their sons farewell by saying, "Come home with your shield...or on it."

By the sixth century B.C., Greece's many small city-states had coalesced around two power centers: oppressive, no-frills, and militaristic Sparta; and its polar opposite, the democratic, luxury-loving, and business-friendly Athens.

The Rise of Athens

Ancient Athens was a typical city-state, population 80,000, gathered around its Acropolis (or "high town"), which was the religious center and fort of last defense. Below was the Agora, or marketplace, the economic and social center. Blessed with a harbor and good farmland, Athens prospered, exporting cash crops (wine and olive oil, pottery and other crafts) to neighboring cities and importing the best craftsmen, thinkers, and gyro sandwiches.

In 490 B.C., word spread throughout the Greek world: The Persians are coming! An army under King Darius I was sweeping into Greece to punish the city of Athens, which had dared to challenge his authority over Greek-speaking Ionia (in western Turkey). A few thousand plucky Athenians raced to head off the Persians in a crucial bottleneck valley, at the Battle of Marathon. Though outnumbered three to one, the crafty Greeks had a unique strategy. They confronted the Persians at the narrow point in the valley, where their relative troop strength was negated. Lining up side-by-side, they made a wall of shields (a phalanx) and pushed the Persians back. If a Greek soldier fell, a man behind him stepped up to take his place. Using teamwork and rational planning, the Athenians thwarted the invasion. An excited Greek soldier ran the 26.2 miles to Athens (the first marathon), gasped the good news...and died.

A decade later, Persia attacked again with an army of 150,000 men. This time, all of Greece put aside its petty differences to fight the common enemy. Leading the way was Athens, the maritime, economic, and intellectual capital of the Greek-speaking world. The one-two punch of Athens' ships and Sparta's soldiers drove the Persians out. Athens was hailed as Greece's protector and policeman, and the various city-states cemented their alliance by forming the Delian League. Every year, these city-states agreed to send tribute money to Athens in return for protection from invasion. For the next century, Athens thrived and dominated the Greek world, while Sparta fumed.

Golden Age Athens
(450–400 B.C.)

After the Persian War, the Athenians set about rebuilding their city. Grand public buildings and temples were decorated with painting and sculpture.

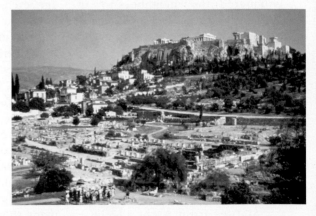

While modern Athens, with roughly four million people, is a sprawling urban mess, Old Athens retains its historic charm. This historic core of Athens includes the Acropolis (hilltop city), the Agora (ruins of the ancient market at the foot of the hill, with the well-preserved Temple of Hephaistos), and the Plaka (19th-century town and now the tourist, commercial, and nightlife center).

Delos: Fort Knox of the Ancient World

Five hundred years before Christ, the island of Delos—the legendary birthplace of Apollo—was the treasury of the Athens-dominated Delian League. This storehouse of wealth, controlled by the Athenians, was looted to finance the architectural glorification of their city. Delos was so important that the Cyclades islands were so named because they circled this pivotal island.

Today, Delos—an easy half-day side trip from Mykonos—is uninhabited...except for the daily boatloads of visitors. See the famous marble lions, wander through almost a square mile of crumbled greatness, and climb to the island's summit for a picnic. From the top of Delos, you'll enjoy a grand, 360-degree view of the Greek Isles, with the Fort Knox of the ancient world at your feet.

Amphitheaters hosted drama, music, and poetry festivals. The market place bustled with goods from all over the Mediterranean. Upwardly mobile Greeks flocked to Athens, and money from the Delian League fueled a cultural explosion. The incredible advances in art, architecture, politics, science, and philosophy during Greece's Golden Age (450–400 B.C.) set the pace for all of Western civilization to follow. And all this from a Greek town smaller than Muncie, Indiana.

Athens' leader, a charismatic nobleman named Pericles, set out to democratize Athens. As with many city-states, Athens' government had morphed from rule by king, to a council of nobles, and finally to rule by the people. In Golden Age Athens, every landowning man had a vote in the Assembly of citizens. Each of these citizens served his occasional one-year term on the 500-man city council, just like Americans report for jury duty. It was a direct democracy (not a representative democracy, where you elect others to serve), in which every man was expected to fill his duties of voting, community service, and military duty. Of course, Athens' "democracy" excluded women, slaves, freed slaves, and anyone not born in Athens. Like several of America's Founding Fathers, the ancient Greeks were great democrats...and slave owners, too. As many as one-third of the people in Athens were slaves.

The Greeks, who avidly studied the world and man's place in it, were not content with traditional answers and old values. Similar ideas were popping up all over the world in about 500 B.C.: Buddha in India, Confucius in China, and the Old Testament prophets in Palestine were all trying to relate everyday life to some larger scheme of things.

Most of all, the Greeks invented the very idea that nature is orderly and man is good—a rational creature who can solve problems. The Greeks dominated the ancient world through brain, not brawn. Their "Golden Mean" was a new ideal that stressed the importance of balance, order, and harmony in art and in life. At school, both the mind and the body were trained. The ideal Greek was well-rounded—an athlete and a bookworm, a lover and a philosopher, a carpenter who played the piano, a warrior and a poet.

In schools and in the Agora, Golden Age Greeks debated many of the questions that still occupy the human mind. Socrates questioned traditional, superstitious beliefs. His motto, "Know thyself," epitomizes Greek curiosity about who we are and what we know for sure. Branded a threat to Athens' youth, Socrates com-mitted suicide rather than compromise his ideals.

His follower Plato wrote down many of Socrates' words. Plato taught that the physical world is only a pale reflection of true reality (the way a shadow on the wall is a poor version of the 3-D, full-color world we see). The greater reality is the unseen, mathematical orderliness that underlies the fleeting physical world. Plato's pupil Aristotle (c. 340 B.C.), an avid biologist, emphasized study of the physical world rather than the intangible one.

Both Plato and Aristotle founded universities that would attract Europe's great minds for centuries. And their ideas would resurface much later, after Europe had been Christianized. The theologian St. Augustine believed (like Plato) in an unseen "City of God" that was more real than the earthly "City of Man." St. Thomas Aquinas used Aristotle's logic to analyze Christian dogma.

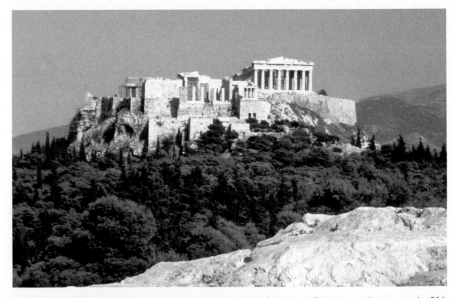

Athens' **Acropolis,** which crowns today's modern city, was the center of Western civilization in the fifth century B.C. While today's city of Athens might be overrated, its historic hilltop is not.

Who's Who in Greek Society

The Italian Renaissance painter Raphael imagined the great minds of ancient Greece gathered together in a kind of ancient Mensa society called the School of Athens. It's a Who's Who of all the Greek greats (some of whom have the features of Renaissance artists; see pages 203–205):

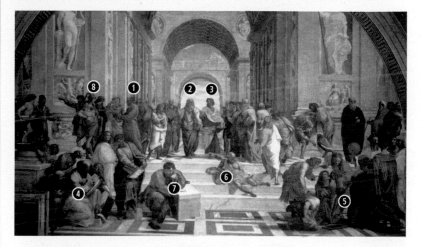

Raphael, **School of Athens,** A.D. 1509 (Vatican Museum, Rome).

❶ **Socrates** questioned the status quo, angered authorities, and took his own life rather than change his teachings.

❷ **Plato** (Socrates' follower) studied non-material, timeless, mathematical ideas. He gestures upward, to the realm of pure ideas.

❸ **Aristotle** (Plato's follower) championed the empirical sciences. He points downward, indicating the importance of the physical world.

❹ **Pythagoras** gave us $a^2 + b^2 = c^2$.

❺ **Euclid** laid out geometry as we know it.

❻ **Diogenes** lived homeless in the Agora, turning from materialism to concentrate on ethical living.

❼ **Heraclitus** believed everything changes, saying, "You can't step in the same river twice."

❽ **Alexander the Great** truly earned his title.

Absent from the School of Athens on Picture Day

Pericles was a charismatic nobleman who championed democracy.

Aristophanes, Sophocles, and **Euripides** wrote comedies and tragedies that are still performed today.

Hippocrates made medicine a hard science. He rejected superstition and considered disease a result of natural causes rather than supernatural.

Phidias designed the statuary of the Parthenon.

Praxiteles, the greatest Athenian sculptor, sculpted lifelike yet beautiful human figures.

Delphi

The ancient Greeks wondered where the center of the universe was. To find out, Zeus, the king of all the gods, threw out two eagles in opposite directions. After circling the earth, they came back and met at a point that was declared to be the world's navel: Delphi. In the days of Socrates, this was where the gods spoke to the people.

From throughout greater Greece, people would come to the temples of Delphi with lavish gifts to exchange for wisdom from the gods. A priestess, the Oracle of Delphi, would lapse into a trance and speak the language of the gods while a priest translated. These priests surveyed whoever came. Organizing this knowledge, they actually had a good idea about the political, military, and economic situation of the entire area. Their savvy advice was good enough to be accepted as divine. Delphi grew politically powerful, religiously righteous, and filthy rich.

Today, Delphi's staggering setting does more than its history to make it the most popular day trip among tourists from Athens (about four hours away). Along with plenty of photogenic ruins to explore, Delphi has one of Greece's best archaeological museums.

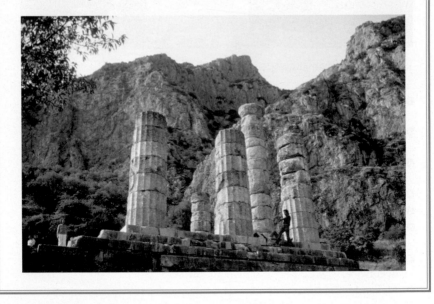

Greek Temples

Greek temples housed a statue of a god or goddess. Since the people worshipped outside, its exterior was the important part and the interior was small and simple. Generally, only priests were allowed to go inside, where they'd present your offering to the god's statue in the hope that the god would grant your wish.

The earliest temples were built of mud, brick, and wood. With greater prosperity, stone came into use. But even with new materials, the Greeks

GREEK TEMPLE

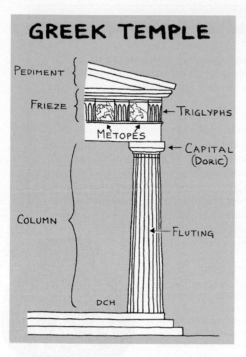

PEDIMENT

FRIEZE ← TRIGLYPHS

METOPES

← CAPITAL (DORIC)

COLUMN

← FLUTING

DCH

panels—called the frieze— running around the building.

In the diagram (at left), a column topped with a Doric capital supports a beam that holds up the roof. The upper part of the beam is the frieze, consisting of alternating triglyphs (grooved panels) and metopes (square areas filled with low relief sculpture). Sometimes, as in the Parthenon, the frieze is one continuous band of sculpture.

The columns supporting the roof of a temple provided a pleasant, shady stoa (covered walkway) under the broad eaves. Rather than single-piece columns, the Greeks usually built them of stacked slices of stone (drums), each with a plug to keep it in line. Columns sit on a base, and are topped with a capital. Capitals reduce the span you need to bridge with a crossbeam, allowing the columns to be slimmer and farther apart, which is the mark of a more elegant building.

kept the old styles. Stone columns looked like the logs that once supported the eaves (perhaps with the fluting reminiscent of carved-out bark). Handy for decorative panels, the small areas between the beam ends—jutting out along the eaves (called metopes)—were retained even though they no longer had a structural purpose.

Most temples have similar features. Temples are rectangular, surrounded by rows of columns and topped by slanted roofs. The triangle-shaped roof forms a gable—typically filled with statues—called the pediment. A typical pediment might feature a sculpted gang of gods doing their divine mischief. Under the eaves, there is often a set of sculpted low-relief

Greek Columns: Doric, Ionic, Corinthian

Most Greek buildings follow one of three styles, or "orders," that determine their proportions and overall look. The styles are most obvious in their columns and capitals. With a little tutoring, you can impress your travel

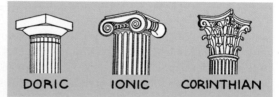

DORIC IONIC CORINTHIAN

*Classical Greek architecture evolved through three orders: **Doric** (simple and stocky capital), **Ionic** (rolled capital), and **Corinthian** (leafy, ornate capital). As a memory aid, remember that the orders gain syllables as they evolve: Doric, Ionic, Corinthian.*

A Day in the Life of Ancient Greece

Imagine a Greece without rubble, without ruins; when statues had arms and buildings had roofs; when the gray marble columns were painted bright colors; when flesh-and-blood people were busy farming, trading, voting, and going to the theater.

The morning sun is rising over the Acropolis as Isosceles wakes and starts his day. He strolls into the courtyard of his mud-brick home, where a slave girl arrives with a jar of water on her head for the morning wash. After a simple breakfast of bread and goat cheese, Isosceles heads off for a morning workout at the gymnasium (from *gymnos,* meaning "naked").

Meanwhile, his wife Pilates and daughter Ulna scour the marketplace for tonight's dinner: fish fried in olive oil, wheat bread, and wine. They wear the typical two-piece, pleated dress. Tomorrow is a religious festival, and mother and daughter plan to parade up to the Acropolis with food offerings for the goddess statue at the temple. After shopping, Ulna is sent to school for classes in music, the three Rs, and gymnastics.

Isosceles strolls to the Agora. In the shade of a colonnade, he strikes a business deal to buy more farmland in the countryside for his slaves to work. Just then, his old navy buddy Epiglottis shows up and invites him to a symposium. Heavy drinking in the middle of the day?!

Greece hosted the ancient Olympic Games for more than a thousand years. Periodically, when interest waned, they'd introduce new, more challenging sports.

Peer pressure forces Isosceles to the home of the famous orator Esophagus, where he eats, drinks, and socializes with his colleagues. After a few glasses of wine, Isosceles catches the eye of young Antipathy, a teenage boy who could use a little "mentoring." (Homosexual contact between older and younger men was considered a valuable teaching tool.) Later, Isosceles staggers to an Assembly meeting and casts his vote to raise Sparta's annual payment to the Delian League.

Work done, Isosceles heads home to dinner, then goes to the theater. It's Aristophanes' latest comedy, *Clouds,* and Isosceles roars with laughter at the in-jokes that spoof his old friend, Socrates.

partner by looking at most any column and instantly labeling it as Doric, Ionic, or Corinthian.

The earliest and simplest style is Doric. Columns are thick, sturdy, and smooth (or lightly fluted), topped by an unadorned capital. (The Doric tribe, of which the Spartans were members, was known for its austere lifestyle.)

The columns are thick, but still more graceful than those of the massive Egyptian temples.

Born among the Ionian Greeks of today's western Turkey, the later Ionic style reflects grace, ease, and freedom. An Ionic column is more slender, with a rolled, scroll-like capital. Whereas Doric columns are staid, Ionic is

groovy. The Ionic style reflects a conscious effort to decorate and beautify the temple, but the ornamentation is reserved and never extravagant. For instance, the "scrolls" on the capitals give the impression of splaying under the weight of the roof, rather than being a bold decoration for art's sake.

A third order, Corinthian, was developed during the Hellenistic and Roman periods. A Corinthian column's flowery capital of acanthus leaves is blatantly ornamental. The evolution of the orders, from simple and austere to decorative and free, parallels the changes in Greek society. From Roman times to the 21st century, much post-Greek architecture uses these same classical orders for decoration.

The Parthenon (447–432 B.C.)

A "classic" example of Doric simplicity, the Parthenon is the finest temple from the ancient world. Simple, balanced, and orderly, it sums up the Greek Golden Age.

The Parthenon is the temple dedicated to Athena, goddess of wisdom and the patroness of Athens, and this structure was the crowning glory of Athens' urban-renewal plan. Standing like a beacon on the highest point of Athens' Acropolis, it originally came with a 40-foot-tall gold-and-ivory statue of Athena—once considered a "wonder of the ancient world." The sophisticated architecture of the building, which was completed in only nine years, succeeds in giving the temple an impressive harmony.

Ringing the building are Doric columns. They swell slightly in the middle to create the illusion that the roof is compressing them, which makes the building look more solid, weighty, and important. The architects used other eye-pleasing optical illusions. The base of the temple, which appears flat, actually bows up in the middle to overcome the illusion of sagging that a straight horizontal line would give. (If you and your travel partner stand on the same step at opposite ends, you'll see each other only from the knees up.) Also, the columns bend inward just a hair. If you extended the outer columns upward a mile, they would come together. These design elements

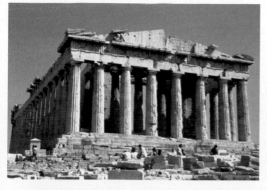

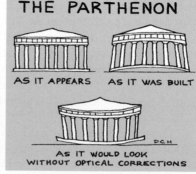

THE PARTHENON

AS IT APPEARS AS IT WAS BUILT

AS IT WOULD LOOK
WITHOUT OPTICAL CORRECTIONS

The Parthenon, 450 B.C. (Athens).
This temple, crowning Athens' Acropolis, is a "classic" example of Doric elegance, simplicity, and harmony.

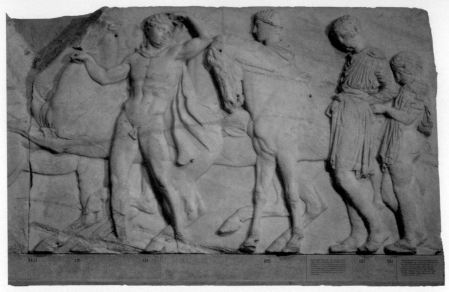

Parthenon Frieze (detail), 450 B.C. (British Museum, London).

make the building look more cohesive, harmonious, and balanced.

The Parthenon stood nearly intact until the 17th century, when it was partially destroyed by an explosion during a Venetian–Turkish war.

The Parthenon's exterior was originally decorated with statues and relief carvings designed by the sculptor Phidias. Stripped, chiseled, and sawed off the building in 1816, these sculptures (the so-called Elgin Marbles) are now displayed in London's British Museum. The Brits feel they rescued and preserved the sculpture, though the Greek government continues to complain about losing its marbles. The statuary the Brits left behind is now inside the museum on the Acropolis, safe from Athens' acidic air and England's archaeologists.

The pediment once held statues of the gods. Athena—goddess of wisdom, and the symbol of Athenian brainpower—was at the peak of the triangle. It depicted the birth of Athena, rising fully grown and fully armed from the split-open head of Zeus to inaugurate the Golden Age of Athens.

The frieze of relief panels depicts the parade of citizens on Athens' holiest day, marking the birth of the city. Men on horseback, chariots, musicians, children, and animals for sacrifice are all heading in the same direction: up the Acropolis to the Parthenon. At the heart of the procession are teenage girls. Dressed in pleated robes, they carry the sacred robe to clothe the statue of Athena for the coming year. All these panels were originally painted in realistic colors.

Greek Theater

Greek theaters were so well made that some are still used for performances today. Taking advantage of their hilly terrain, the Greeks built theaters into the natural slope of the hillsides. The acoustics of these theaters are marvelous and their settings dramatic, with a backdrop of earth, sea, and sky.

The Triumph of Greece

The Parthenon's metope reliefs sum up the Greeks' long journey from barbaric Dark Ages to the civilized Golden Age. A pack of brutish centaurs—wild half-man/half-horse creatures—crashes a human wedding feast, where they try to carry off the womenfolk. The centaurs get the upper hand. The humans lose face. But the humans rally and drive off the centaurs. Civilization has triumphed over barbarism, order over chaos, and rational man over his animal origins.

Plays were as important to the cultured Greeks as gladiator gore was to the cruder Romans. Actors wore masks with a hole for the mouth (such as the grinning mask of comedy or the drooping mouth of tragedy). The Greeks' epic tragedies were studies in psychology far ahead of their time. For example, Sophocles' play *Oedipus Rex*—about a man who unwittingly kills his father and sleeps with his mother, then blinds himself in shame—was appropriated by Sigmund Freud 2,300 years later as the perfect example of the unconscious childhood desire that Freud dubbed the "Oedipus complex." Greek plays examined us inside, outside, and beyond (fate—the final frontier). They set the standard for theater.

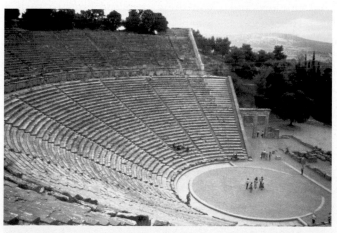

Greek Theater, c. 350 B.C. (Epidavros, Greece).
This theater, in Epidavros (near Nafplion, two hours south of Athens), is remarkable for its still-incredible acoustics. Plays performed here more than 2,000 years ago are still playing...and you can hear actors perfectly from the top row.

Golden Age Art

Greek art is known for its symmetry, harmony, and classic simplicity. It shows the Greeks' love of rationality, order, and balance.

Sculpture

The Greeks featured the human body in all its naked splendor. The anatomy is accurate, and the poses are relaxed and natural. Greek sculptors learned to capture people in motion, and to show them from different angles, not just face-on. The classic Greek pose—called *contrapposto,* or counter-poise—has a person resting weight on one leg while the other is relaxed or moving slightly. This pose captures a balance between timeless stability and fleeting motion that the Greeks found beautiful. Following the "Golden Mean," statues strike a happy medium between rigid Archaic art and the unrestrained flamboyance of later Hellenistic art.

The optimistic Greeks pictured their gods as idealized humans (and their humans as godlike). They believed the human body expressed the human spirit. A well-proportioned statue em-"bodied" the balance and orderliness of the Greek universe. If the statue has clothes, the robes drape down naturally, following the body's curves. The intricate folds become beautiful in themselves. Golden Age artists sought the perfect balance between down-to-earth humans (with human flaws and quirks) and the idealized perfection of a Greek god.

As you sightsee, realize that the "Greek" statues filling Europe's museums are mostly chalky, lifeless Roman copies with blank stares and Vatican-issued fig leaves. When you see an original, you'll be impressed by its vibrancy.

Painting and Pottery

In their day, Greek painters were perhaps more famous than their sculpting counterparts, but less of their work has survived.

Greek painting was revolutionized by the discovery of foreshortening. (You foreshortened the last time you drew receding lines to turn a square into a 3-D box.) Now a subject could be shown from any angle, not just from the most convenient frontal pose. The artist could record things as

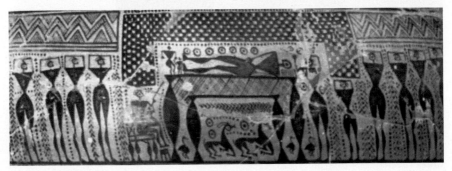

Dipylon Vase (detail), c. 700 B.C. (National Archaeological Museum, Athens).
Wasp-waisted figures pull out their hair in sadness at a funeral procession. With triangle torsos and square arms, under decorative geometric patterns, these orderly figures epitomize the early stage of Greek art called Geometric style.

The Evolution of Greek Art

Greece's evolution from warring tribes (Archaic) to enlightened city-states (Golden Age) to world domination (Hellenism) is reflected in their statues and architecture. The evolution is so distinct that college art professors can reasonably expect their students to look at a piece of Greek art for the first time and say, within 10 years, when it was made.

Watch Greek statues morph in clear steps from rigid (Archaic) to balanced (Golden Age) to exuberant (Hellenistic). Remember this, because in 2,000 years, we'll see the same evolution from stiff Gothic to balanced Renaissance to wild, emotional Baroque.

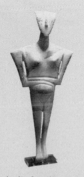

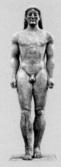

Cycladic fertility symbols, dating from c. 3000 B.C., are generic size-6 supermodels.

Kouros ("Boy"), from the sixth century B.C., has legs but doesn't move.

Kouros' younger friend, also called Kouros (c. 500 B.C.), is loosening up.

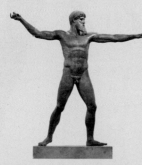

Poseidon (or maybe Zeus), c. 460 B.C. (National Archaeological Museum, Athens, Greece). *Poseidon, lost at sea for more than 2,000 years (and recovered without his trident), zeroes in on the Golden Age.*

Apollo Belvedere, c. 350 B.C. (Vatican Museum). *With perfect anatomy, the Golden Age Apollo Belvedere is perfectly balanced between motion and rest.*

Laocoön, c. 150 B.C. (Vatican Museum). *Hellenistic Laocoön struggles mightily to maintain his balance as he thinks, "Snakes? Why did it have to be snakes?"*

Greek Mastery of the Human Form

For a better sense of the Greeks' mastery of the human form, let's look at three examples:

Myron, **The Discus Thrower** (Roman replica), c. 450 B.C. (National Museum of Rome). *Frisbee anyone?*

The Discus Thrower

An athlete winds up, about to unleash his pent-up energy and hurl the discus. The sculptor has frozen the moment for us, so that we can examine the inner workings of the wonder called Man. The perfect pecs and washboard abs make this human godlike. Geometrically, you could draw a perfect circle around him, with his hipbone at the center. He's natural yet ideal, twisting yet balanced, moving while at rest. For the Greeks, the universe was a rational place, and the human body was the perfect embodiment of the order found in nature. *The Discus Thrower*, with his geometrical perfection and godlike air, sums up all that is best in the classical world.

Leochares, **Apollo Belvedere** (Roman replica), c. 350 B.C. (Vatican Museum, Rome).

Venus de Milo

Split the *Venus de Milo* down the middle from nose to toes and see how the two halves balance each other. *Venus* rests on her right foot, then lifts her left leg, setting her whole body in motion. As the left leg rises, her right shoulder droops down. And as her knee points one way, her head turns the other. *Venus* Is a harmonious balance of opposites, orbiting slowly around a vertical axis, giving her body a balanced S-curve that the Greeks found beautiful.

Venus' face is anatomically accurate, but it's somewhat idealized, a goddess, too generic and too perfect. This isn't any particular woman, but Everywoman—all the idealized features that appealed to the Greeks.

What were her missing arms doing? Some say her right arm held her dress, while her left arm was raised. Others say she was hugging a male statue or leaning on a column. I say she was picking her navel.

Artist unknown,
Venus de Milo, c. 100 B.C.
(Louvre Museum, Paris).

Apollo Belvedere

Apollo Belvedere, the sun god, is hunting. He's been running through the woods, and now he spots his prey. Keeping his eye on the animal, he slows down and prepares to put a (missing) arrow into his (missing) bow. The optimistic Greeks conceived of their gods in human form...and buck naked. The anatomy is perfect; his pose is natural. Instead of standing at attention, face forward with his arms at his sides (Egyptian style), Apollo is on the move, coming to rest, with his weight on one leg.

The Greeks loved balance. Apollo is moving, but not out of control. He eyes his target, but hasn't attacked yet. He's realistic but with idealized, godlike features. And the smoothness of his muscles is balanced by the rough folds of his cloak.

they happened, even putting his individual stamp on the work by showing it from his personal perspective.

The best Greek painting you're likely to see will be on the vases that fill art museums from Oslo to Lisbon. (The vases were used to hold oil or wine, rather than flowers.) Putter around Greek pottery. Sample an ancient slice of life by studying the scenes brought to virtual life by these vase paintings.

Pottery, usually painted red and black, was a popular export product for the sea-trading Greeks. The earliest pots featured geometric patterns (eighth century B.C.). Later, a painted black silhouette on the natural orange clay became popular. And then, the style changed to red figures on a black background.

The flourishing of art and culture that accompanied the Golden Age couldn't last forever....

The Decline of Athens

Many Greek city-states came to resent the tribute money they were obliged to send to Athens, supposedly to protect them from an invasion that never came. Rallying behind Sparta, they ganged up on Athens. Lasting a generation, the resulting Peloponnesian Wars toppled Athens (404 B.C.), drained Greece, and ended the Golden Age. In 339 B.C., Athens, Sparta, and all the rest of the city-states were conquered by powerful Greek-speaking invaders from the north—the Macedonians.

The brief Golden Age of Greece (c. 450–400 B.C.) had been a balancing point between the aristocratic, traditional, and stiff Archaic period (c. 800–

500 B.C.) and the democratic, original, realistic, and wildly individualistic era that followed: the Hellenistic age.

Hellenism
(c. 333–31 B.C.)

Alexander the Great of Macedonia (356–323 B.C.) single-handedly spread the ideas of the small Greek peninsula throughout the Mediterranean and Near East, ushering in the Hellenistic period (*Hellene* is Greek for "Greek").

After King Philip of Macedonia conquered Greece, he was succeeded by his 20-year-old son, Alexander. Alexander had been tutored by the Greek philosopher Aristotle, who hooked the future king on Greek culture. Alexander supposedly went to bed each night with two things under his pillow: a dagger and a copy of *The Iliad*. As is often the case with legends, this story likely isn't literally true, but carries a strong symbolic truth: Alexander loved Greek high culture...but was pragmatic about the importance of military power.

In 334 B.C., Alexander and a well-trained army of 40,000 headed east. Their busy itinerary included

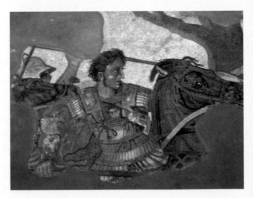

Battle of Alexander, second century B.C. (National Archaeological Museum, Naples, Italy).

Ephesus

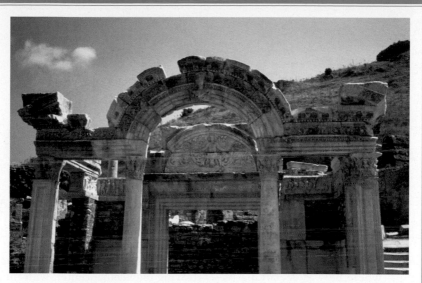

The **Temple of Hadrian,** from A.D. 138, is a popular stop at Ephesus, on the west coast of Turkey.

The ruins of Asia Minor's largest metropolis, once the home of the Ephesians of New Testament fame, are unforgettable. Ephesus is actually on the Turkish mainland, only a 90-minute boat ride from the beautiful Greek island of Sámos.

Ephesus was at its peak in about A.D. 100, when it was the capital of the Roman province of Asia. Its population numbered in the hundreds of thousands. You can marvel at the giant 25,000-seat theater, park your chariot outside a grand (restored) library, and hike up the marble-cobbled main street—an ancient cancan of elegant ruins casually surviving just another century. You can even sit on a 2,000-year-old toilet.

A trip to Efes (Turkish for Ephesus) is a great excuse to enjoy a slice of Turkey. You'll experience more cultural change by taking the short boat ride from the Greek islands to Turkey than you will by flying all the way from the US to Greece. If you can just bust out of Europe for a while, you won't need museum pieces...history and culture are everywhere.

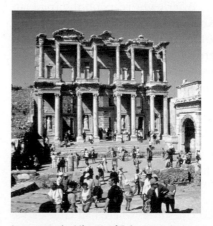

In A.D. 100, the **Library of Celcus** at Ephesus held 12,000 scrolls of papyrus.

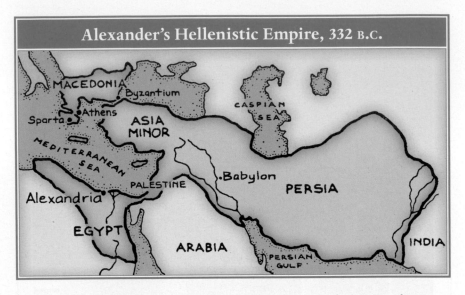

Alexander's Hellenistic Empire, 332 B.C.

conquering today's Turkey, Palestine, Egypt (where he was declared a living god), Iraq, and Iran, and moving into India. Alexander was a daring general, a benevolent conqueror, and a good administrator. As he conquered, he founded new cities on the Greek model, spread the Greek language, and opened Greek schools.

After eight years on the road, an exhausted Alexander turned back for home. He died en route, in Babylon (probably of malaria), at the age of 32, but by then he had created the largest empire ever. (What have you accomplished lately?) For the next three centuries, much of the Mediterranean and Asia—the entire known civilized world—was dominated by Greek rulers and Greek culture. "Greece" stretched from Italy to Egypt to India.

Greek was the common language, and cities everywhere had Greek-style public squares, schools, and governments. Their citizens observed Greek holidays and studied Greek literature.

Alexandria (in today's Egypt) became a thriving intellectual center, with more than a million people, a flourishing art and literature scene, and the greatest library anywhere. No ship was allowed to enter the port without surrendering its books to be copied.

Hellenistic Art

Hellenistic art reflects the changes in Greek society. Rather than noble, idealized gods, the Hellenistic artists gave us real people with real emotions. Some are candid snapshots of everyday life, like a boy stooped over to pull a thorn from his foot. Others show people in extreme moments, as they struggle to overcome life's obstacles. We see the thrill of victory (like the *Winged Victory*) and the agony of defeat *(Laocoön)*. Arms flail, muscles strain, eyes bulge. Clothes and hair are whipped by the wind. Figures are frozen in motion, in wild, unbalanced poses that dramatize their inner thoughts.

Hellenistic artists put away the

Top Museums of Ancient Greece

- National Archaeological Museum, Athens (pictured below)
- British Museum (Parthenon sculpture), London
- Louvre Museum *(Venus de Milo, Winged Victory of Samothrace)*, Paris
- Vatican Museum *(Apollo Belvedere, Laocoön)*, Rome
- Pergamon Museum (altar from Ephesus), Berlin

Athens' National Archaeological Museum

Far and away the world's best collection of ancient Greek art, this museum takes you chronologically from 7000 B.C. to A.D. 500 through beautifully displayed and well-described exhibits (and in air-conditioned comfort).

As is the case in nearly every culture (Turkey, Greece, Italy, Catalunya, Mexico...you name it), it's smart to bone up on the history and art in the capital city's big museum before tackling the ruins that dot the countryside. Take this museum as seriously as you can. Trace the evolution of Greek art, study a guidebook, take a guided tour, and examine the ancient lifestyles painted on the vases. After gaining a rudimentary knowledge of Greek art here, head for the hills and resurrect all that B.C. rubble. (A self-guided tour of this museum is included in the chapter on traveling in Athens at www.ricksteves.com/athens.)

Diogenes, History's First Hippie

One unique Hellenistic culture featured a passion for creativity and individuality. A group from this period called the Cynics were history's first hippies. Led by the philosopher Diogenes (c. 412–323 B.C.), they rejected all authority, institutions, and materialism, while promoting high thinking and simple living. Diogenes is said to have lived in a discarded bathtub and owned only a bowl to collect handouts. Fed up with worrying about his bowl, he tossed it out and just held out his hand. According to another legend, one day Alexander the Great stood before Diogenes and declared, "I am Alexander the Great and I can give you anything. What is your desire?" The smart aleck answered, "For you to stop blocking my sunshine." The lesson? Throughout history, colorful characters come and go who are separated from us only by time.

airbrush. For the first time in history, we see human beings in all their gritty human glory: wrinkles, male-pattern baldness, saggy boobs, and middle-age spread. Unlike the full-frontal Egyptian statues, figures are shown in less-than-noble poses. Groups of statues (like *Laocoön* and his sons) create a theatrical mini-drama that heightens the emotion. (This same exuberant, emotive style reappears in about 2,000 years as Baroque art.)

To get a good sense of Hellenism, consider two of the best examples of the age: *Laocoön* and the *Winged Victory*.

Laocoön

Laocoön (lay-AWK-oh-wahn), the high priest of Troy, warned his fellow Trojans: "Beware of Greeks bearing gifts."

He tried to convince his people not to bring the Trojan Horse (with Greek soldiers hidden inside) into their city. But the gods wanted the Greeks to win, so they sent huge snakes to crush him and his two sons to death.

A powerful example of the Hellenistic style, the sculpture *Laocoön* is a fire hose of exuberance. We see Laocoön and his sons at the height of their terror, when they realize that, no matter how hard they struggle, they—and their entire race—are doomed.

The figures (carved from four blocks of marble pieced together seamlessly) are powerful, not light and graceful. The poses are as twisted as possible, accentuating every rippling muscle and bulging vein. Follow the line of motion from Laocoön's

left foot, up his leg, through his body, and out his right arm. Where Golden Age art is balanced and graceful, this work is unbridled motion and gritty emotion.

Laocoön, the most famous Greek statue of its day, was lost for more than a thousand years. Then, in 1506, it was unexpectedly unearthed in Rome. The Romans paraded it through the streets before an awestruck populace. One of those who saw it was the young Michelangelo, and it was a revelation to him. Two years later, he started work on the Sistine Chapel, and art history was about to take another turn.

Laocoön, c. 150 B.C. (Vatican Museum, Rome).

The Winged Victory of Samothrace

This statue stood on a hilltop on the island of Samothrace—as if on the prow of a ship—to celebrate a great naval victory. Her clothes are wind-blown and sea-sprayed, clinging to her body tightly enough to win a wet T-shirt contest. Originally, her right arm was stretched high, celebrating the victory like a Super Bowl champion, waving a "we're-number-one" finger.

This is the *Venus de Milo* gone Hellenistic. As *Victory* strides forward, the wind blows her and her wings back. Her feet are firmly on the ground, but her wings (and missing arms) stretch upward. She is a pillar of vertical strength, while the clothes curve and whip around her. These opposing forces create a feeling of great energy, making her the lightest two-ton piece of rock in captivity.

The earlier Golden Age Greeks might have considered this statue ugly. Her rippling excitement is a far cry from the dainty Parthenon maidens and the soft-focus beauty of *Venus*. And

the statue's off-balance pose, like an unfinished melody, leaves you hanging. But Hellenistic Greeks loved these cliff-hanging scenes of real-life humans struggling to make their mark.

The Greek Legacy

At the same time that Alexander was conquering the East, a new super-power was rising in the West: Rome. Eventually, Rome's legions conquered Greece (146 B.C.) and the Hellenized Mediterranean (31 B.C.). Yes, Rome conquered Greece, but culturally the Greeks conquered the Romans.

Roman governors ruled cosmo-politan Greek-speaking cities, and the Romans adopted the Greek gods, art styles, and fashions. Greek-style temple facades, with their columns and pediments, were pasted on the front of (Roman-arch) temples as a veneer of sophistication. Greek statues dotted Roman villas and public buildings. Pretentious Romans sprinkled their Latin conversation with Greek phrases as they enjoyed the plays of Sophocles

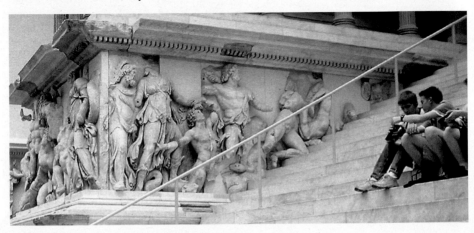

Altar of Zeus, 170 B.C. (Pergamon Museum, Berlin).
Expressive and action-packed, Hellenism was the Baroque of the ancient world. Here, a mythic brawl tumbles right out onto the temple stairs (or, in its current space, onto the museum stairs).

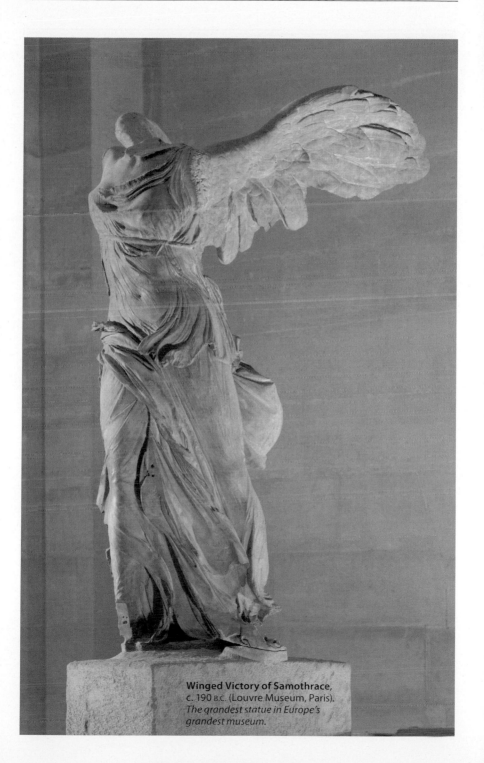

Winged Victory of Samothrace,
c. 190 B.C. (Louvre Museum, Paris).
*The grandest statue in Europe's
grandest museum.*

Top 10 Ancient Greek Sights (In Order)

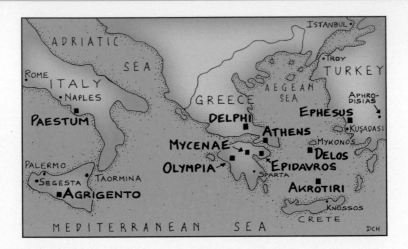

Here are our 10 favorite Greek ruins. The first five are must-sees. For maximum goose bumps and minimum heat stroke, see these and prioritize the rest. Be selective. Just because something is B.C. doesn't mean it must BE SEEN. Visit the top ancient sights, but don't neglect other facets of Greece's fascinating history and culture. Greece is the most touristed but least explored country in Europe. It seems that at any time, 90 percent of its tourists are packed into its top sights.

1. Athens' Acropolis and Agora, Greece
2. Delos, treasury of Delian League, near Mykonos, Greece
3. Olympia, site of first Olympic Games, Peloponnese, Greece
4. Delphi, site of the famous oracle, Greece
5. Ephesus, a Greek city turned Roman, Turkey
6. Paestum temple, just south of Naples, Italy
7. Mycenae, southeast of Athens, Peloponnese, Greece
8. Epidavros theater, Peloponnese, Greece
9. Agrigento temples, Sicily, Italy
10. Akrotiri ruins, from Minoan era, Santorini, Greece

and Aristophanes. Many a Greek slave was more cultured than his master, reduced to the role of warning his boss not to wear a plaid toga with polka-dot sandals.

Greek culture would live on, resurfacing throughout Western history and influencing Romans, medi-eval Christians, Renaissance sculptors, as well as the Neoclassical architects who designed Washington, D.C. in the Greek style.

As Romans lapped up what was good in Greece and made it their own, civilization took one more step westward.

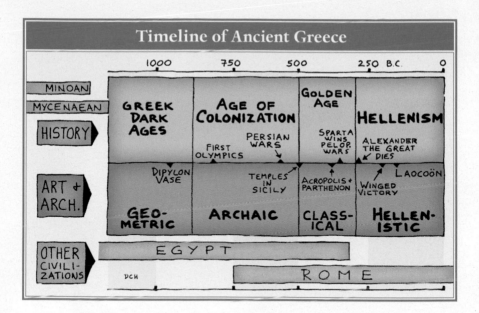

Timeline of Ancient Greece

Augustus of Prima Porta, C. A.D. 15 (Vatican Museum, Rome). *In this famous sculpture, the first Roman emperor, Augustus (the very-much-in-command founder of the* Pax Romana, *or Roman Peace), teaches his subjects how to hail a cab.*

SECVRITATAVG

AVGVS

Rome

500 B.C.–A.D. 500

Rome is history's supreme success story. By conquest, assimilation, and effective administration, Rome rose from a small Etruscan town to become the capital of a vast empire.

In a nutshell, classical Rome lasted for a thousand years, from 500 B.C. through A.D. 500. It grew for 500 years, peaked for 200, and fell for 300. For the first 500 years, Rome was a republic; for the second 500, an empire. Today, legions of tourists march across Europe to see the triumphal arches, ruined temples, gladiator arenas, and armless statues left behind by the grandest of civilizations.

The Origins Of Rome

Rome: A Breast-Fed Baby

Legend says that Rome was founded by twin brothers Romulus (hence "Rome") and Remus (hence "Uncle Remus"). Orphaned as babies in the wilderness, they were taken in and breast-fed by a generous she-

wolf. They grew up, conquered their neighbors, and gave the wilds a much-appreciated touch of civilization by building a wall—thus founding the city—in 753 B.C. This story must have seemed an appropriate metaphor for the Romans, as it explained how such a "civilized" people (as they considered

Etruscan She-Wolf, c. 500 B.C.
(Capitol Hill Museum, Rome).
While the bronze she-wolf in this statue is an Etruscan masterpiece, Romulus and Remus were added about 2,000 years later. This threesome has long been the symbol of Rome. You'll see copies everywhere in the Eternal City—atop columns, decorating fountains, on city medallions, and making cameo appearances in Roman paintings.

themselves) could have grown out of such "barbarian" surroundings.

Closer to fact, farmers and shepherds of the Latin tribe settled in the middle of the Italian peninsula, near the mouth of the Tiber River. The crude settlement was sandwiched between two sophisticated civilizations: Greek colonists to the south ("Magna Graecia," or Greater Greece), and the Etruscans of Tuscany. This location was ideal for trade—between two dynamic realms, on a river as far up as it was possible to sail, but at the first place narrow enough to cross by bridge. Baby Rome, originally ruled by an Etruscan king, was both dominated and nourished by Greek and Etruscan societies.

Under the Etruscan Sun (c. 800–500 B.C.)

Just before the rise of Rome, the Etruscan people of central Italy (who inhabited the area between today's Rome and Florence) had their own Golden Age of peace and prosperity. Their mix of Greek-style art and Roman-style customs helped lay a foundation of civilization for the flourishing of Rome.

More technologically advanced than their neighbors, the Etruscans mined gold and crafted it into some of the finest jewelry in the known world. Smooth-talking Etruscan salesmen (backed by no-nonsense warships) exported these crafts around the Mediterranean while importing Greek pottery and customs. Etruscan cities and trading ports dotted the coastline, and Etruscan holdings included a small Latin-speaking tribe on their southern border who lived in a tiny village—Rome.

Judging from the many luxury items that have survived, the Etruscans enjoyed the good life. Frescoes show vibrant, well-dressed men and women dining, dancing in gardens, or playing party games. Etruscan artists celebrated individual people, showing their wrinkles, crooked noses, silly smiles, and quirky haircuts.

Thousands upon thousands of surviving ceramic plates, cups, and vases tell us that hosting a banquet for your friends was a symbol that you'd arrived. Men and women ate together (gasp!), propped on their elbows on dining couches, surrounded by colorful

Etruscan Sarcophagus (detail), sixth century B.C. (Louvre Museum, Paris).

Etruscan Sights

As you travel through Italy—particularly in Tuscany (from "Etruscan"), roughly the area between Florence and Rome—you'll see Etruscan tombs, pottery, and jewelry. Hardly any Etruscan writings survive. Historians can read the Etruscans' Greek-style alphabet and some individual words, but they've yet to fully grasp the language. Places where you can see Etruscan sights and artifacts include:

- **Rome:** Traces of original Etruscan engineering projects (e.g., the Circus Maximus), and fine collections of Etruscan artifacts in both the Vatican Museum and Villa Giulia Museum
- **Orvieto:** Archaeological Museum (coins, dinnerware, and a sarcophagus), necropolis, and underground tunnels and caves
- **Volterra:** Etruscan gate (Porta dell'Arco, from fourth century B.C.) and a fine Etruscan Museum (funerary urns and more)
- **Chiusi:** Museum, tombs, and tunnels
- **Cortona:** Museum and dome-shaped tombs
- **Tarquinia** (near Rome): Necropolis
- **Cerveteri** (near Rome): Tombs and frescoes
- **Paris:** Sarcophagi and artifacts at the Louvre Museum
- **Copenhagen:** Artifacts at Ny Carlsberg Glyptothek

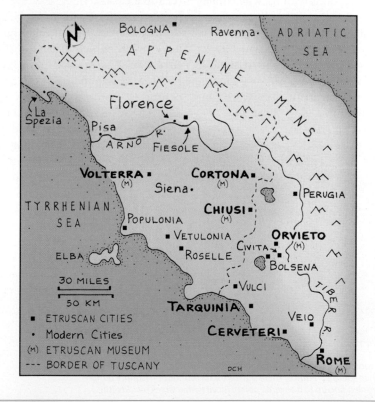

frescoes and terra-cotta tiles. Their plates and cups were either imported from Greece or made in the Greek style: painted red and black and decorated with nymphs, soldiers, sphinxes, and gods. Flute players entertained the guests, who were waited on by elegant and well-treated slaves.

Much of what we know of the Etruscans comes from their tombs, often clustered in a necropolis (literally, "city of the dead"). The tomb was your home in the hereafter, fully furnished for the afterlife, complete with all of the deceased's belongings. The sarcophagus might have a statue on the lid showing the dearly departed at a banquet as he reclines on a dining couch and spoons with his wife. Smiles are on their faces, as they live the good life for all eternity.

Seven decades of wars with Greeks (545–474 B.C.) drained the Etruscans, just as a new Italian power was emerging...Rome. Etruscan cities were conquered by Rome's legions (the last in 264 B.C.), the survivors intermarried

with Romans, their kids grew up speaking Latin, and so their culture became Romanized. By Julius Caesar's time (c. 50 B.C.), the few remaining ethnic Etruscans were reduced to serving their masters as Rome's professional soothsayers, flute players, jewelers, and street-corner preachers, such as the ethnic Etruscan who called out to Caesar, "Beware the Ides of March..."

But Etruscan culture lived on in Rome's religion (its pantheon of gods and divination rituals), its realistic art, its banqueting lifestyle, and its taste for all things Greek—the mix that became our "Western civilization."

The Roman Republic
(c. 500 B.C.–A.D. 1)

In 509 B.C., the Etruscan king raped a Roman woman. Her outraged husband led a revolt, which drove out Rome's Etruscan masters and gave birth to the Roman Republic. For the next five centuries, Rome would be ruled not by a king, but by 300 elected senators and a code of law.

To establish equal treatment, Romans publicly displayed their "Laws of the Twelve Tables" in the Forum (450 B.C.). Even school kids knew the procedures for a trial, as well as standard penalties for crimes.

Rome's roots are reflected in the design of the 2,000-year-old **Maison Carrée** *in Nîmes in southern France. There's an Etruscan foundation (square temple with steps leading up to a covered porch) faced with a Greek overlay (the parade of columns).*

Conquest by Brawn

From the beginning of the Roman Republic, war was the business of the state. The energetic Latins expanded outward from the city, conquering and assimilating the Italian peninsula and beyond. First came "Magna Graecia" to the south, then the Etruscans to the north. By 265 B.C., Rome ruled a united Italy that stretched from Tuscany all the way to Sicily. Next, Rome's legions easily conquered the less-organized but more-cultured Greek civilization that had dominated the Mediterranean for centuries.

Conquering generals returned to Rome with their booty and shook it all over the city. They'd build triumphal arches and parade under them with their troops. Dut duttah-dah!

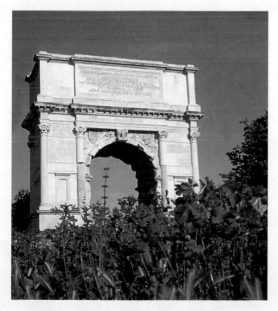

Arch of Titus, A.D. 81 (Forum, Rome).
Emperors built grand triumphal arches to milk their military victories for propaganda purposes. You'll find these arches scattered from Germany to Morocco. Later world leaders copied the idea; for example, Napoleon, who built Paris' Arc de Triomphe.

The trumpets would sound, and the Via Sacra—Rome's Main Street—would be lined with citizens waving branches and torches. First came porters, who carried chests of captured gold and jewels. Then a parade of exotic animals from the conquered lands—elephants, giraffes, hippopotamuses—which brought "oohs" from the crowd. Next came the P.O.W.s in chains, to be sold into slavery. The captive king was rolled through on a platform so that the people could taunt and spit at him. Finally, the conquering hero himself would drive through in his four-horse chariot, with rose petals strewn in his path. The whole procession ran the length of Rome's Forum and up the face of Capitol Hill to the Temple of Saturn, to present the newfound wealth and slaves that would fuel the growing economy of Rome.

With a booming economy and a standing army of half a million soldiers, Rome was ready for the next challenge—Carthage.

Hannibal, Elephants, and the Punic Wars

Between 264 and 146 B.C., Rome fought three so-called Punic Wars with Carthage, its rival in North Africa, for mastery of the Mediterranean. Final score: Rome 3, Carthage 0.

The balance of power hung precariously in the Second Punic War (218–201 B.C.), when Hannibal of Carthage launched a surprise attack on Rome. Rather than

take the obvious route directly across the Mediterranean, he crossed from North Africa into Spain. With an army of 50,000 men and 50 elephants, Hannibal marched 1,200 miles overland, crossed the Alps, and forcefully penetrated Italy from the rear. For 15 years, he was the scourge of the Italian peninsula...but he could never quite take the city of Rome. The Romans finally pried Hannibal off the peninsula by attacking Carthage. Hannibal rushed back to his hometown and lost the war.

In the mismatched Third Punic War (149–146 B.C.), the Romans not only sacked and burned Carthage, they salted the earth upon which the city was built, ensuring that nothing could ever grow there again—no crops, no soldiers, no rebellion. Carthage was finished. Rome ruled.

Conquest by Brain

The Romans conquered not only because they were good soldiers, but also because they were good administrators and businessmen. With the exception of Carthage, they were relatively benevolent conquerors ("Hold the salt, please!"), welcoming their subjects into the family. People conquered by Rome knew they had joined the winning team and that political stability would replace barbarian invasions.

Wherever they settled, the Romans built an infrastructure

of roads, post offices, schools (teaching in Latin), police stations, and water-supply systems. Now with a standard language and currency, Roman merchants traded their wine, salt, and olive oil for foreign goods. Rome invested heavily in cities that were strategic for trade. For example, the Roman-built city of Arles (in southern France) was a crucial link in the Roman trade route from Italy to Spain, so they built a bridge across the Rhône River and fortified the town.

Wherever they went, the Romans impressed the "barbaric" locals with massive engineering projects that dwarfed their crude mud huts. Even today, tourists are impressed by vast Roman structures such as stadiums (including the arenas in Nîmes and Arles, France); temples (the Maison Carrée in Nîmes, France); palaces (Diocletian's retirement palace in Split, Croatia); aqueducts (the Pont du Gard near Avignon, France, and the aqueduct in Segovia, Spain); theaters (the Roman Theater in Orange, France); gates (the Porta Nigra in

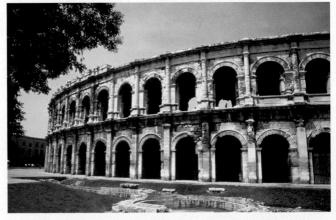

The **Arena in Nîmes** is one reason why many scholars claim the best-preserved ancient Roman buildings are in southern France.

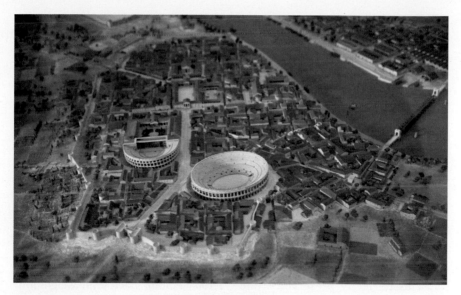

Roman City Model (Ancient History Museum, Arles, France).
The Roman-built city of Arles (pop. 100,000 back then) enjoyed a formidable wall, an arena, a 10,000-seat theater, a bridge across the Rhône River, and an impressive main street. The city of today (pop. 50,000) still thrives within the original Roman outlines.

Trier, Germany); and fortified walls (Hadrian's Wall in northern England).

A typical Roman city (such as Florence, Pompeii, Ostia, Nîmes, or Arles) was a garrison town, laid out on a grid plan with two main roads: one running north–south (the *cardus*), the other east–west (the *decumanus*). Approaching the city on your chariot, you'd pass through the cemetery, which was located outside of town for hygienic reasons. You'd enter the main gate and speed past warehouses and apartment houses to the main intersection, where you'd find the town square, called the forum. Facing the square were the most important temples, which were dedicated to the patron gods of the city. Towering halls of justice called basilicas housed busy attorneys, who attended to Rome's almost sacred dedication to the rule of law. The next

grandest buildings were bathhouses (like today's fitness clubs), which attended to Rome's almost sacred dedication to personal vigor. Nearby were the businesses catering to the citizens' needs: the marketplace, bakeries, banks, slave auctions, and the brothels (*lupinare*—named for the she-wolf that suckled Romulus and Remus). Many cities with a Roman foundation retain some of these same elements today. For example, the center of Florence still has its grid of Roman streets, and its Piazza della Repubblica marks what was once the original Roman forum.

As they conquered, the Romans also absorbed elements of the conquered culture into their own. They adopted Etruscan gods, decorated their villas with Greek statues, and fronted temples with Egyptian obelisks.

Romans of the Republic felt a spirit of Manifest Destiny similar to what Americans felt upon settling the West. As the Roman writer Livy put it: "The gods desire that the City of Rome shall be the capital of all the countries of the world."

The Pont du Gard (A.D. 50)

Throughout the ancient world, aqueducts were stone flags that heralded the greatness of Rome. The Pont du Gard in southern France—the world's tallest surviving aqueduct bridge—still proclaims the engineering prowess of those people.

This perfectly preserved stone bridge *(pont)* was the critical link of a 30-mile canal that supplied nine million gallons of water per day (about 100 gallons per second) to the city of Nîmes. The water came from the mountains, traveled most of the way through underground channels, crossed this stone bridge that spans a river canyon, then traveled the remaining 15 miles to Nîmes. The water ran along the top of the bridge in a four-foot-by-six-foot chamber. The total journey took 24 hours. Gently dropping one inch for every 350 feet it traveled, the water snaked through the hills and across the canyons of the rugged countryside.

This is a lot of stone just to carry water. The Pont du Gard is about 160 feet high, and was originally about 1,100 feet long. Each stone weighs four to six tons. The structure stands with no mortar, taking full advantage of the innovative Roman arch, which is made strong by gravity. The arches of

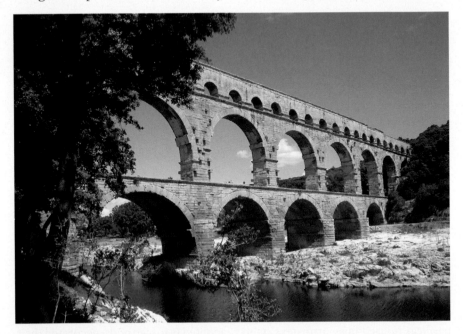

Pont du Gard, A.D. 50 (near Nîmes, France).
This is the most photogenic link in a 30-mile-long aqueduct the Romans built to bring water to their city of Nîmes.

the Pont du Gard are twice the width of standard Roman aqueducts, and the main arch is the largest the Romans ever built—80 feet across.

But Romans loved the *aqua vitae,* or water of life. Whenever possible, they drank fresh spring water, and they used large amounts for the hot tubs, swimming pools, and steam rooms in which they took their daily baths. For about 150 years, the Pont du Gard quenched the thirsty city of Nîmes, one of ancient Europe's largest cities.

Spartacus and Civil War

Rome was master of Europe and the Mediterranean. The spoils of war, cheap grain, and thousands of captured slaves poured in. The traditional economy, once based on small farms and energetic businessmen, had been transformed into an economy of military conquest, plantations worked by slaves, and bureaucrat city dwellers living off the tributes from conquered lands. Romans bickered among themselves over their slice of the pie. Rich, landowning "patricians" wrangled with working-class "plebes" and with the growing population of slaves, who demanded more respect.

In 73 B.C., a slave named Spartacus—a freeborn man who'd been forced to fight as a gladiator—escaped and started a rebellion. Fleeing to the slopes of Mount Vesuvius, he amassed an army of 70,000 angry slaves. For two years, they ravaged the countryside, picking up hoes and hacking up masters, before Rome's legions crushed the revolt. Spartacus himself was killed in battle, but 6,000 of his rebels were rounded up and crucified, hanging from crosses lining a 100-mile

stretch of the Appian Way as a warning. One of the soldiers who helped suppress the revolt was an up-and-coming young officer named Julius Caesar.

Julius Caesar (100–44 B.C.)

Amid the chaos of civil war and class warfare, charismatic generals who could provide wealth and security became dictators—men such as Sulla, Crassus, Pompey...and Caesar.

Julius Caesar gained celebrity by marching his legions northward through France (known as "Gaul"), Germany, Belgium, and Holland. He erected a temple to Jupiter on the future site of Paris' Notre-Dame Cathedral, and he even sailed to the isle of Britain (where his successors would build a regional capital at

Julius Caesar (National Archaeological Museum, Naples, Italy).
Hamstrung by an idealistic republican form of government, Caesar made dramatic reforms that led to a no-nonsense empire—ruled by a dictator.

Londinium, mineral baths at Bath, and Hadrian's Wall to keep out those pesky Scots). In addition to his conquests, Caesar was a cunning politician, charismatic speaker, author of *The Gallic Wars*, and lover of Cleopatra, Queen of Egypt.

With enormous popular support and the backing of his troops, Caesar outmaneuvered his rivals and seized the reins of power (49 B.C.). He outwardly praised the cherished laws of the Republic, but in fact, he ruled as a virtual dictator. In his four-year reign, Caesar rammed through many reforms that centralized the government around a single ruler. He even named a month (July) after himself.

But Caesar underestimated those who loved the old Republic, namely disgruntled Republicans who feared that he would make himself a king. At the peak of his power, on the Ides of March (March 15, 44 B.C.), a band of assassins surrounded Caesar during a Senate meeting. He cried out for help as one by one they stepped up to take turns stabbing him while the senators sat in silence and watched. One of the killers was his own adopted son, Brutus. An astonished Caesar died, saying, "*Et tu, Brute?*"—"You too, Brutus?"

Emperor Augustus Caesar (63 B.C.–A.D. 14)

Julius Caesar died, but the concept of one-man rule lived on in his grandnephew, Octavian (whom he had also adopted as his son). Octavian killed Brutus, eliminated his rivals (Mark Antony and Cleopatra), united Rome's warring factions, and took the title "Augustus." He established a dynasty to lead Rome, ensuring that the family name—Caesar—became a title that would resonate throughout history: Caesar, Kaiser, Czar.

Augustus was the first of the emperors who would control Rome for the next 500 years—ruling like a king, with the backing of the army and the rubber-stamp approval of the Senate. Instead of a Republic, Rome was now an Empire: a collection of many diverse territories ruled by a single man.

While Augustus, like Julius, had an appetite for power (and also named a month in his own honor), he was more sensitive to the Senate and its traditions. Augustus was a down-to-earth man who lived simply, worked hard, read books, and listened to underlings. He declared himself the *Pontifex Maximus* (high priest) and tried to legislate morality. He reformed the government, restored temples, donated to the arts, and undertook huge public building projects. Augustus proudly boasted: "I found Rome a city of brick and left it a city of marble."

Augustus, A.D. 14
(National Museum of Rome, Rome).
Augustus, the emperor, is shown here wearing the hooded robe of the Empire's high priest—or Pontifex Maximus.

The Roman Empire
(c. A.D. 1–500)

Pax Romana: The Roman Peace
(A.D. 1–200)

Augustus' reign marks the start of 200 years of peace, prosperity, and expansion known as the *Pax Romana*. At its peak (c. A.D. 117), Rome ruled an empire of 54 million people, stretching from Scotland in the north to Egypt in the south, and from Spain in the west to the cradle of civilization (modern-day Iraq) in the east. To the northeast, Rome was bounded by the Rhine and Danube Rivers. Roman maps labeled the Mediterranean *"Mare Nostrum"*—"Our Sea." At its peak, the word "Rome" meant not just the city, but the entire civilized Western world.

Trade thrived. Conquered peoples were welcomed into the fold of prosperity, linked by roads, common laws, common gods, education, and the Latin language. In this "global economy," the Italian peninsula became just one province of many in a worldwide empire, ruled by an emperor who had likely been born elsewhere.

And all of the wealth of this vast empire flowed inward—like a drain—to the city of Rome. Rome was a bustling metropolis of more than a million people, a city faced with marble and gleaming bronze roofs, and studded with Greek-style statues. Aqueducts brought fresh water to drink, to fill the baths, and to delight the citizens with bubbling fountains. Men flocked to the stadiums to bet on gladiator games. Chariots raced through paved streets, dodging herds of goats. Hot and tired tourists asked directions to their hotel while their slaves lugged the luggage. The marketplaces brimmed with exotic fruits, vegetables, and animals from every corner of the empire. It was a dizzying maze of open-air plazas, pickpockets, temples, bathhouses, brothels, prostitutes, and street musicians. It was the wonder of the known world.

The Roman Empire even survived the often turbulent and naughty behavior of its emperors. (Their excesses of debauchery and cruelty are legendary, but the stories are likely exaggerated by early historians with a political axe to grind.) The *Pax Romana*'s unprecedented political stability was made possible in part by a relatively smooth succession of leaders. Most early peoples were ruled by kings and queens who insisted that they be succeeded by their own genetic offspring—whether qualified or not. Roman emperors, though they ruled with king-like powers, generally chose the most capable man and adopted him as a son. This is especially true of the finest emperors of the second century (including Trajan, Hadrian, and Marcus Aurelius), none of whom had a son.

A Who's Who of Roman Emperors

Augustus Caesar (ruled 27 B.C.–A.D. 14): After eliminating his rival Marc Antony (and his lover Cleopatra), Augustus united Rome and became the first Roman emperor. His reign marks the start of 200 years of peace and prosperity, the *Pax Romana*.

Tiberius (r. 14–37): Augustus' adopted son was the Caesar that Jesus Christ "rendered unto."

Caligula (r. 37–41): Caligula was not a nice person. He squandered Rome's money, had sex with his

Growth of Rome

Over seven centuries, Rome grew from a city into a huge empire.

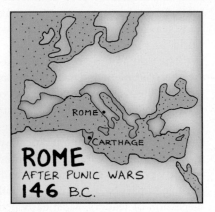

ROME
AFTER PUNIC WARS
146 B.C.

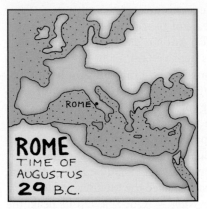

ROME
TIME OF
AUGUSTUS
29 B.C.

Rome's first major expansion came after winning the Punic Wars in 146 B.C.

By the time Rome was this big, the idealistic Republic had to make way for the no-nonsense Empire.

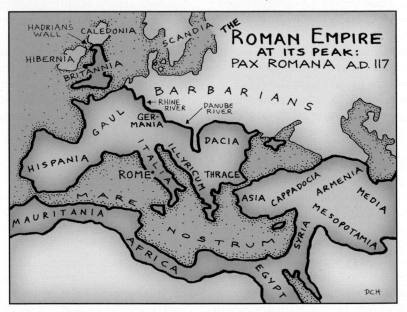

By the second century A.D., during the reign of Emperor Trajan, Rome reached its zenith... then slowly began to shrink.

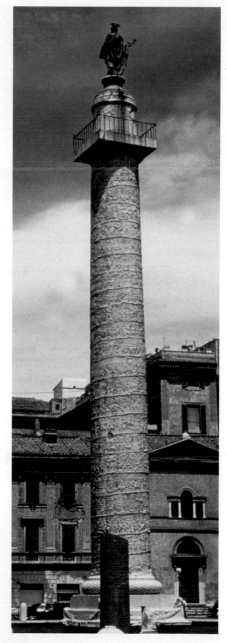

Caligula, A.D. 39 (Louvre Museum, Paris).

sisters, tortured his enemies, had men kneel before him as a god, and parked his chariot in handicap spaces. Caligula has become the archetype of a man with enough power to act out his basest fantasies. To no one's regret, assassins ambushed him and ran a sword through his privates.

NERO (r. 54–68): Rome's most notorious emperor killed his mother, kicked his pregnant wife to death, and crucified St. Peter. When Rome burned in A.D. 64, Nero was accused of torching the city so that he could clear land to build an even bigger house.

TITUS (r. 79–81): Titus completed the Colosseum and defeated the Jews in Palestine. His victory is commemorated by the Arch of Titus in the Forum (pictured on page 63). During his reign, Mount Vesuvius exploded, burying Pompeii and Herculaneum.

TRAJAN (r. 98–117): Rome's expansion peaked under Spanish-born Trajan, the first emperor to come from the provinces rather than Rome. This conquering hero stretched Rome's borders from Europe to North Africa to west Asia—creating a truly vast empire. The spoils of three continents funneled into Rome. His conquests are carved into the 120-foot Trajan's Column, a well-preserved monument in the center of Rome.

Trajan's Column, A.D. 113 (Rome).
In what's called a "continuous narration," proud Roman emperors would tell the dramatic tales of their heroic exploits and accomplishments with a relief, rolled like a scroll up a marble column.

Castel Sant'Angelo, C. A.D. 139 (Rome).
Built as Emperor Hadrian's tomb, it later served as the fortress of the pope. The bridge approaching it, Ponte Sant'Angelo, also dates from Roman times.

the time of Marcus Aurelius' reign marks Rome's tipping point, as the empire began its slow, three-century decline. The famous philosopher was a multitasker, writing his *Meditations* while at war securing the Danube frontier. His Danube campaign was commemorated by a column decorated with battle scenes (on Rome's Piazza Colonna). A rare equestrian statue of Aurelius (now in Rome's Capitol Hill Museum, with a copy in the adjacent square; see photo below) was spared destruction by Dark Age Christians who mistook it for Constantine, the first Christian emperor.

HADRIAN (r. 117–138): A voracious tourist, Hadrian visited every corner of the enormous empire, from Britain (where he built Hadrian's Wall), to Egypt (where he sailed the Nile), to Jerusalem (where he suppressed a Jewish revolt), to Athens (where he soaked up classical culture and played backgammon). He scaled Sicily's Mount Etna just to see what made a volcano tick. Back home, he beautified Rome with the Pantheon, his tomb (Castel Sant'Angelo, pictured above), and his villa at Tivoli, a mini–theme park of famous places he'd visited. His beard—the first worn by an emperor—shows him looking like the wise Greek philosopher he imagined himself to be.

MARCUS AURELIUS (r. 161–180): Beset by barbarian attacks and an awful plague,

COMMODUS (r. 180–192): Marcus Aurelius broke with tradition and

Marcus Aurelius, modern copy of the original c. A.D. 180 (Capitol Hill, Rome).

chose his blood son to succeed him. Commodus was a palace brat who ran around dressed in animal skins and wielding a club, pretending to be Hercules. As emperor, he ushered in a period of instability and decline.

SEPTIMIUS SEVERUS (r. 193–211): This African emperor-general's victories on the frontier earned him a grand triumphal arch in the Forum, but he couldn't stop the empire from starting to unravel.

CARACALLA (r. 211–217): To strengthen Rome, Caracalla extended citizenship to nearly all free men in the empire. But no amount of bathing at his huge Baths of Caracalla could wash away his dirty deed of murdering his brother and rival. Caracalla was one of a series of third-century emperors who were assassinated; he was stabbed in the back by an angry rival.

AURELIAN (r. 270–275): Aurelian built a wall around Rome. The capital hadn't needed a wall for the previous six centuries, but now the crumbling, stumbling city feared barbarian attacks.

DIOCLETIAN (r. 285–305): To try to control Rome's decline, Diocletian split the sprawling empire into two administrative halves. He ruled the east from Asia Minor. The city of Split, Croatia, was later built in and around his retirement palace. His works in Rome include the massive Baths of Diocletian (accessible today as the Octagonal Hall and Church of Santa Maria degli Angeli). Diocletian was an avid persecutor of Christians; it's poetic justice that his baths are now a church.

CONSTANTINE (r. 306–337): The first Christian emperor is known as Constantine the Great. In the belief that the Christian God helped him defeat his rival Maxentius in 312, he legalized Christianity. In Rome, the Arch of Constantine (pictured on page 87) celebrates Constantine's victory. The churches he built, such as San Giovanni in Laterano, celebrate Christianity's triumph. In 330, Constantine moved the capital of the Roman Empire to Constantinople (modern-day Istanbul), a decision that weakened Rome but built a solid foundation for the up-and-coming Byzantine Empire.

ROMULUS AUGUSTULUS (r. 475–476): Rome's last emperor, 14-year-old "Little Augustus" was forced to abdicate by a barbarian chieftain, and the reign of Rome's emperors was over.

Roman Architecture

Roman buildings are big and functional. Decoration was secondary. If ancient Romans visited the United States today as tourists, they might send home postcards of our greatest works of "art"—freeways. Romans built on a scale greater than any civilization before them, thanks to two engineering innovations: the arch and concrete.

The rounded arch symbolizes the rational thinking that allowed the Romans to conquer, administer, and build structures that amaze us today. If you make two stacks of heavy stone blocks, start to build an arch (supported with wooden scaffolding), then

Flat Stone vs. Round Arch

A flat stone or lintel is limited in span and strength. The stronger round arch made much of the grandeur of Rome possible.

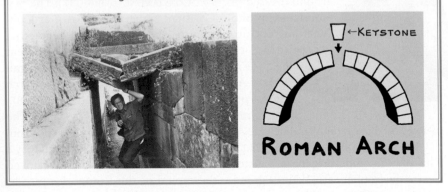

insert an inverted keystone where the stacks meet—*voilà!* The heavy stones not only support themselves but also a great deal of weight above the arch. The Romans didn't actually invent the rounded arch, but they exploited it far better than their predecessors. They stacked arches to make a colosseum, strung arches side by side to make an aqueduct, stretched out the legs of an arch to make a barrel-vaulted ceiling, rotated arches 360 degrees to construct domes, and made freestanding "triumphal" arches to celebrate conquering generals.

Concrete was the magic building ingredient. This mixture of volcanic ash, lime, water, and small rocks served as flooring, roofing, filler, glue, and support. Concrete lasted centuries longer than wood and was easier to use than stone.

Though we think of Rome as "a city of marble," most Roman buildings were made from brick. First, builders would make a shell of brick, then fill it in with poured concrete. Important

structures such as basilicas were faced with sheets of expensive marble, held on with nails. Turning something functional into art, the Romans specialized in decorating floors and walls with mosaics. Some buildings had central heating, fueled by slaves who stoked

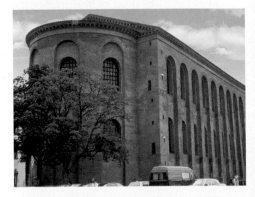

Constantine Basilica, fourth century A.D. (Trier, Germany).
This 200-foot-long basilica is the largest intact Roman building outside of Rome. Emperors once presided here on an altar-like throne, back when Trier (in today's Germany) was a regional capital of the splintering Empire. Like most Roman buildings, it was made of bricks and covered with a marble veneer. The marble was scavenged by barbarian peasants after the fall of Rome.

The Evolution of Arches

To see how far the Romans progressed, compare the rounded Roman arch with earlier civilizations' attempts to support a roof.

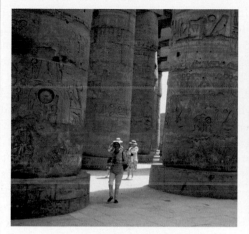

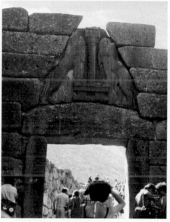

The **Egyptians** spaced thick pillars close together and could only span a small distance.

The **Mycenaeans** (ancient Greeks) used a corbelled arch (with a decorative plug). It was barely strong enough to support itself.

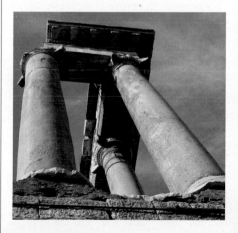

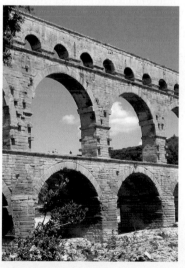

Golden Age Greeks used thinner columns and cross-beams.

By developing the round arch, the **Romans** were able to build circles around the Greeks.

underground fires to force hot air into a hollow space beneath the floor. The building's exterior might be enhanced with purely ornamental Greek-style columns and crossbeams. Picture the columns whitewashed, with gilded capitals, supporting brightly painted statues in the pediment, and then imagine the whole building capped with a gleaming bronze roof. The stately gray rubble of today's Roman ruins is like a faded black-and-white photograph of a 3-D Technicolor era.

For more insight into the great achievements of Roman engineering and architecture, let's consider two textbook examples.

The Colosseum
There is no better symbol of the "colossal" scale of Rome during the empire years. At the Colosseum, Roman gladiators battled foreign barbarians and exotic animals, presenting a microcosm of the Roman economy that now came from conquest and domination.

Built in A.D. 80, when the Roman Empire was approaching its peak, the Colosseum showcases Roman-pioneered concrete, brick, and their trademark round arches. When killing became a spectator sport, the Romans wanted to share the fun with as many people as possible, so they designed a venue that, in essence, stuck two Greek theaters together to create a freestanding amphitheater.

The exterior is a skeleton of 3.5 million cubic feet of travertine stone, stacked without mortar. It took 200 ox-drawn wagons shuttling back and forth every day for four years just to bring the stone here. (A thousand years later, the Colosseum became a quarry that offered free, pre-cut stones to anyone who could carry them away.) While the essential structure is typically Roman, the facade features the three orders of Greek columns: Doric (ground

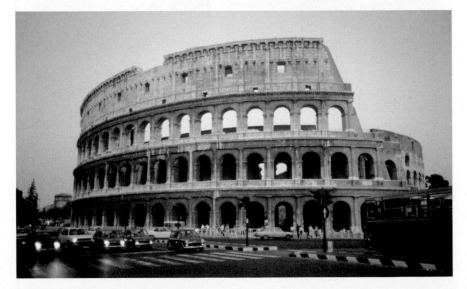

The Colosseum, A.D. 80 (Rome).

level), Ionic (second story), and Corinthian. Romans, while unsurpassed engineers, had a great respect for things Greek. They even placed copies of Greek statues in the arches, hoping to add a veneer of sophistication to this arena of death.

Entering the Flavian Amphitheater (its official name, for the emperor who had it built), fans would pass under a 100-foot-tall bronze statue of Nero that gleamed in the sunlight. This was the "colossus" that likely gave the building its popular nickname. Though Rome built some 200 similar arenas around the empire, only this one was called the Colosseum.

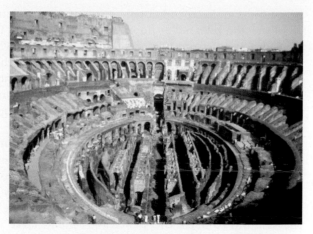

The tunnels we see inside Rome's Colosseum were once under the arena floor, serving as the "backstage." Elevators lifted good guys, bad guys, and animals up to arena level, to appear theatrically midfield. The emperor and the Vestal Virgins had special box seats on the 50-yard line.

Inside, the oval-shaped arena (280 by 165 feet) was originally covered with boards, then sprinkled with sand (*arena* in Latin). Like modern stadiums, the spectators ringed the playing area in bleacher seats that slanted up from the arena floor. It could accommodate 50,000 roaring fans (100,000 thumbs, up or down). The whole thing was topped with an enormous canvas awning to provide shade for the spectators—the first domed stadium. Romans filled and emptied the Colosseum as quickly and efficiently as we do our super-stadiums.

"Hail, Caesar! (*Ave, Cesare!*) We who are about to die salute you!" The gladiators would enter, parade around to the sound of trumpets, stop at the emperor's box, raise their weapons, shout, and salute—and then the fights would begin. The fights pitted men against men, men against beasts, and animals against animals. The spectacle began with a few warm-up acts: dogs bloodying themselves by attacking porcupines, female gladiators fighting each other, or dwarfs battling a one-legged man.

Then came the main event: the gladiators. Some wielded swords, with only a shield and a heavy helmet for protection. Others represented fighting fishermen, with a net to snare opponents and a trident to spear them. The gladiators were usually slaves, criminals, or poor people who got their chance for freedom, wealth, and fame in the ring. The best were rewarded like our modern sports stars, with fan clubs, great wealth, and, yes, product endorsements.

The animals were kept in cages

beneath the arena, then hoisted up in elevators and released at floor level. They'd pop out from behind blinds into the arena—the gladiator didn't know where, when, or by what he'd be attacked. (This brought howls of laughter from the hardened fans in the cheap seats.) Nets ringed the arena to protect the crowd.

For the grand 100-day opening, Romans enjoyed the slaughter of 2,000 men and 9,000 animals. Colosseum employees squirted perfumes around the stadium to mask the stench of blood.

If a gladiator fell helpless to the ground, his opponent would approach the emperor's box and ask: Should he live or die? Sometimes the emperor left the decision to the crowd, who would judge based on how valiantly the man had fought. They would make their decision: thumbs-up or thumbs-down. (Historians disagree on whether they actually used this colorful gesture to indicate their choice.) Imagine the psychological boost the otherwise downtrodden masses felt when the emperor granted them this thrilling decision.

Did they throw Christians to the lions like in the movies? Christians were definitely thrown to the lions, made to fight gladiators, crucified, and burned alive...but probably not in this particular stadium.

Rome was a nation of warriors that built an empire by conquest, and those battles were symbolically played out daily here in the Colosseum for the benefit of city-slicker bureaucrats. In an age when emperors kept their approval ratings up by following the axiom "give them bread and give them circuses," a big sports arena

was a good investment. The contests were always free, which helped keep Rome's growing mass of unemployed rabble off the streets. By affording his masses the power to give a deadly thumbs-down, the emperor earned a big thumbs-up.

The Pantheon

If your imagination is fried from trying to reconstruct ancient buildings out of today's rubble, visit the Pantheon, Rome's best-preserved monument. Here you can see the perfect mathematics and engineering—and unlimited slave power—that allowed Rome to conquer and rule its barbarian neighbors.

The Pantheon was a Roman temple dedicated to all *(pan)* of the gods *(theos)*. It was built by Agrippa in 27 B.C., then rebuilt by Hadrian in A.D. 126. Some say that Hadrian, an amateur architect, helped design it.

Entering through a forest of 40-foot columns, you stand under the Pantheon's solemn dome. The dome, the largest made until the Renaissance, is set on a circular base. The mathematical perfection of this dome-on-a-base design is a testament to Roman engineering. The dome is as high as it is wide: 142 feet from floor to rooftop and from side to side. To picture it, imagine a basketball set inside a wastebasket so that it just touches bottom.

The dome is made from concrete that gets lighter and thinner as it reaches the top. The walls at the base are 23 feet thick and made from heavy travertine concrete, while near the top they're less than five feet thick and made with a lighter volcanic rock (pumice) mixed in. At the top, the

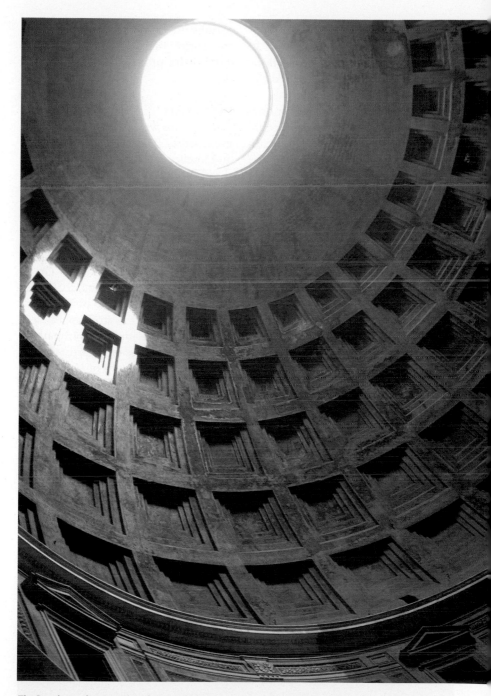

The **Pantheon dome,** with its famous skylight, gives you a feel for the magnificence and splendor of ancient Rome better than any other building.

oculus, or eye-in-the-sky, is the building's only light source and is almost 30 feet across. The 1,800-year-old floor has holes in it and slants toward the edges to let the rainwater drain.

In ancient times, this was a one-stop-shopping temple where you could worship any of the gods whose statues decorated the niches. Early in the Middle Ages, the Pantheon became a Christian church (dedicated to "all the martyrs" instead of "all the gods"), which saved it from architectural cannibalism and ensured its upkeep through the Dark Ages.

This is perhaps the most influential building in art history. Its dome was the model for Brunelleschi's cathedral dome in Florence, which launched the Renaissance, and for Michelangelo's dome of St. Peter's, which capped it all off. Even Washington, D.C.'s Capitol Building was inspired by this dome. The Pantheon also contains the world's

greatest Roman column, which spans the entire 142 feet from heaven to earth—the pillar of light from the oculus.

Roman Art

The Romans were great engineers, not great artists. The Greeks loved beauty and intellectual stimulation. If offered the choice of a ticket to either a symposium on Truth or a gladiatorial battle to the death, Romans would go for the gore.

But thanks to that lack of originality, the Romans collected, copied, and preserved Greek-style statues. Greek gods and perfect humans decorated Roman villas, baths, and public buildings. Romans ate this stuff up: the sensual beauty, the underplayed pathos, the very Greekness of it. Artists began cranking out knock-offs of Greek originals for mass consumption. Some are of extremely high quality, while others are

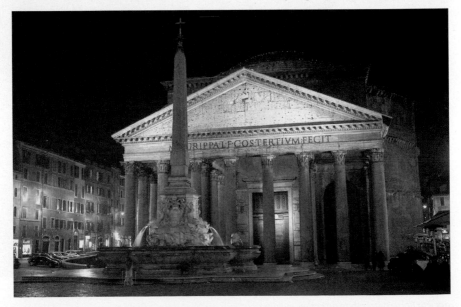

*Rome's **Pantheon**—the best preserved building from ancient times.*

more like cheesy fake *Davids* in a garden store. In fact, most of Europe's 2,500-year-old Greek Golden Age statues are actually 2,000-year-old Roman copies.

One art form in which the Romans actually surpassed the Greeks was the creation of ultra-realistic portraits. The Greeks were concerned with portraying idealized human "10s" without distinguishing individual characteristics. But Roman religion revered the man of the house (and his father and grandfather). Family solidarity required a realistic statue of daddy and grandpa in the house. Also, with the emperor considered a god on earth, you'd find his statue in every classroom and post office around the empire. Likely, too, wealthy Romans simply wanted their photo taken in marble, for the same reason we keep photo albums.

Roman Portrait Busts
(Capitol Hill Museum, Rome).
Since Romans worshipped both the father and the emperor, there was a great demand for portrait busts. The museum on Rome's Capitol Hill has more heads than a Grateful Dead concert in a cabbage patch.

The most common Roman statue is the bust, which shows just the chest up, minus the arms. In Europe's museums, you can have the time-travel experience of gazing into the eyes of many ordinary-looking people. Of course, some portraits were idealized

Christian fig leaves now cover the glories of Rome.

and prettied up, but most are realistic snapshots of downright ugly people, warts and all. We have a living history in the busts of famous emperors: They come alive as people, not just as faceless names from the past.

Remember, ancient statues originally looked much different than they do now. They were painted, often in gaudy colors, and fitted with fake glass eyes. And the fig leaves they sometimes wear? Those came centuries later, when prudish Christians decided that certain parts of the human anatomy were obscene and needed to be covered by plaster fig leaves.

Roman artists were also adept at carving mythological scenes on sarcophagi (marble coffins where remains were kept). Mosaics were also a specialty. These are designs or pictures made with small cubes of colored stone or glass pressed into wet plaster.

A Day in the Life of Ancient Rome

Rome has often been compared to America...without cars or electricity, but with slaves to make up for it. Rome's wealth made a lifestyle that was the envy of the known world. Let's look at a typical well-to-do Roman citizen and his family over the course of a day.

In the morning, Nebulus reviews the finances of the country farm with his caretaker/accountant/slave. He's interrupted by a "client," one of many poorer people dependent upon him for favors. The client, a shoemaker, wants permission from the government to open a new shop. He asks Nebulus to cut through the red tape. Nebulus promises to consult a lawyer friend in the basilica, or legal building.

Hungry, Nebulus stops at Burger Emp to grab a typical fast-food lunch. Most city dwellers don't cook in their cramped, wooden apartments because of the fire hazard. After a siesta, he walks to the baths for a workout and a little business networking. He discusses plans for donating money to build a new aqueduct for the city.

The children, Raucous and Ubiquitous, say goodbye to the pet dog and head off to school in the forum. Nothing funny happens on the way. At school, it's down to business. They learn the basic three Rs. When they get older, they'll study literature, Greek, and public speaking. (The saving grace of this dreary education is that they don't have to take Latin.)

Work done, Nebulus heads for the stadium called the Circus Maximus. The public is crazy about the chariot races. There are 12 per day, 240 days a year. Four teams dominate the competition (Reds, Whites, Blues, and Greens), and Nebulus has always been a die-hard Blue.

Back home, Nebulus' wife, Vapid, tends to the household affairs. She pauses in the bedroom to offer a prayer to her personal goddess for good weather for tonight. Meanwhile, the servants clean the house and send clothing to the laundry. Usual dress is a simple woolen tunic: two pieces of cloth, front and back, sewn together at the sides. But tonight they'll dress up for a dinner party. She'll wear silk, with a wreath of flowers, and Nebulus will wear

The Romans used mosaics to pave floors, walls, and ceilings.

Unlike in Greece, excellent examples of Roman painting have survived, mainly frescoes that served as "wallpaper" in villas. Country landscapes, playful nymphs, and sensuous nudes attest to the Roman love of earthly delights.

Roman Baths

Romans loved to sweat out last night's indulgences at the baths. After stripping in the locker rooms, they'd enter the steam baths of the *caldarium*, heated by wood furnaces stoked by slaves beneath the floor. They'd sit cheek to cheek in a room with low ceilings (to keep it steamy). Next, they'd pass to the *tepidarium*, where masseuses would rub them down and scrape them off with a stick (Romans didn't use soap). Finally, they'd continue on to the swimming pool, or *frigidarium*. Pretty cool.

The baths were more than washrooms. They were health clubs with

his best toga, a 20-foot-long white cloth. It's heavy and hard to put on, but it's all the rage. Nebulus dons his phallic-shaped necklace, which serves as an amulet against the evil eye and as a symbol of good luck in health, business, and bed.

At the dinner party, Vapid marvels over the chef's creation: ham soaked with honey, pasted in flour and baked. The guests toast each other with clay goblets bearing inscriptions like "Fill me up," and "Love me, baby!" Reclining on a couch, waited on by slaves, Nebulus orders a bowl of larks' tongues and a roast pig stuffed with live birds, then washes it down

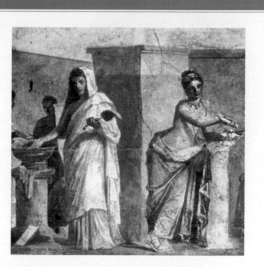

*The good life, frescoed on a wall at **Pompeii** (A.D. 79). The best of Pompeii's exquisite frescoes are in the National Archaeological Museum in Naples.*

with wine. He calls for a feather, vomits, and starts all over. He catches the eye of a dark-skinned slave dancer from Egypt and takes her to the bedroom just down the hall...

...Or so went the stories. In fact, the legendary Roman orgy was just that—legendary. Romans advocated moderation and fidelity. If anything, stuffiness and business sense were the rule. The family unit was considered sacred. Whatever decadence there was in Roman life was confined to the upper classes in the later empire.

exercising areas, equipment, and swimming pools. They had gardens for socializing. Libraries, shops, bars, fast-food vendors, pedicurists, barbers, and brothels catered to every Roman need. Most important, perhaps, the baths offered a spacious, cool-in-summer, warm-in-winter place for Romans to get out of their stuffy apartments, schmooze, or simply hang out.

Admission was virtually free, requiring only the smallest coin, and the baths were open to men and women. During Nero's reign, coed bathing was popular, but generally there were either separate rooms or separate entry times. Most Romans went daily.

Roman Religion

Religion permeated Roman life. The fickle gods were powers you bargained or dealt with. You'd do whatever it took to achieve the *pax deorum*, or peace with the gods. To gain a favor, you prayed and sacrificed to the proper

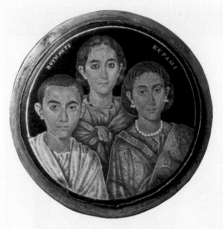

god, either at home on a small altar or at the temple. Here's one prayer that has survived: "I beseech you to avenge the theft committed against me. Punish with a terrible death whoever stole my tunic." For guidance, you might visit a seer (usually an ethnic Etruscan) who'd predict the future through interpreting omens, such as ripping open an animal to check the shape of the entrails. A scar on a goat's liver might mean an impending death in the family. A clap of thunder was enough to postpone a battle. A flock of birds overhead might mean you'd sell 20 percent more sandals next year.

There was a god for every moment of your life, some of them home-grown, some borrowed from other cultures (especially from the Greek pantheon). From the time of Julius Caesar, emperors were deified. Nearly 30,000 divinities have been identified. Jupiter was the king of the gods, based on his Greek counterpart, Zeus. Each profession had its patron god or goddess. In this high-maintenance religion, Roman homemakers would pray to Vesta, the goddess of the hearth. Farmers worshipped the many-breasted Artemis,

goddess of fertility. Statulinus helped children learn to stand, and Fabulina taught them their first words. Fornax stoked the oven, Pomona made fruit grow, Venus Cloacina unclogged your drains, and Sterculinus presided regally over his vast kingdom of manure. (Really.)

Rome's official pagan religion had no real spiritual content and did not offer any concept of an afterlife or of salvation. As the empire slowly crumbled, people turned more and more to Eastern religions, in search of answers and comfort. One of those was Christianity.

Rome allowed freedom of religion, Roman style. Their conquered subjects could continue worshipping their own gods, but were also expected to pay homage to the many Roman gods and deified emperors. Jews and Christians, who had a jealous God, were persecuted for their single-minded loyalty. Rome's pagan gods were gradually replaced by the rise of monotheistic religions from the East. In A.D. 312, Emperor Constantine legalized and embraced Christianity. By A.D. 390, the Christian God was the only legal god in Rome.

The Fall Of Rome
Rome Rots (Third Century A.D.)
Rome peaked in the second century A.D., under the capable emperors Trajan (r. 98–117), Hadrian (r. 117–138), and Marcus Aurelius (r. 161–180). But in the third century, known as the "Age of Iron and Rust," the great empire started to unravel.

First, the empire was devastated by a series of epidemics of plague and malaria. The economy, increasingly

dependent on booty (cheap resources) and slaves (cheap labor), began to falter. Rome consumed everything and produced nothing. Rulers found it impossible to maintain a 10,000-mile frontier as barbarians pecked away at the borders, hoping for their slice of Rome's pie. Taxation rose to oppressive levels, and inflation skyrocketed (to 1,000 percent during a 20-year period).

Sarcophagus of a Procession (detail), c. A.D. 270 (National Museum of Rome).
During one 50-year period, 18 Roman emperors were assassinated. Here, a youthful ruler (and his nervous-looking inner circle) seems to understand his reign will be short and not very sweet.

Politically, the government had become more like a banana republic than a great empire. The Roman army could virtually hand-pick an emperor to be their front man. At one point, the office of emperor was literally auctioned to the highest bidder. During one 50-year stretch, 18 emperors were saluted, then murdered, by fickle generals. The army was no longer a provider or protector; it was a dangerous and expensive problem.

Rome's slow-motion fall inspired emperors to try drastic solutions. Diocletian (r. 284–305) instituted a kind of caste system to maintain order, and split the empire into two administrative halves under two equal emperors. His successor Constantine (r. 306–337) eventually solidified the divide by moving the capital of the empire from decaying Rome to a newly expanded city he called Constantinople (today's Istanbul). Rome's intellectuals and merchants packed up and headed east. Almost instantly, the once-great city of

Rome became a minor player in imperial affairs. (The eastern, "Byzantine" half of the empire would thrive and live on for another thousand years.)

None of Rome's internal problems were catastrophic in themselves, but the combination of them sapped Rome's strength. The empire would stagger on for another 200 years, shrinking in size and wealth. Meanwhile, the city of Rome was becoming a den of thugs, thieves, prostitutes, barbarians...and Christians.

Constantine, the First Christian Emperor (r. 306–337)

Early followers of Jesus Christ had visited Rome following Jesus' death, but attracted only a handful of converts. Unlike most foreigners, these Christians were persecuted severely by the Romans, because their "jealous" god refused to give them permission to worship the Roman emperor as a god on earth. Many were crucified, burned, and fed to the lions. But

Bronze Head of Constantine
(Capitol Hill Museum, Rome).

by A.D. 300, their numbers were grow-
ing, especially among Rome's lower
classes, who were inspired by the idea

that anyone—slave, plebe, or barbar-
ian—could attain salvation. Finally,
they found a champion for their cause.

As the sun set on October 27, 312,
two rival Roman armies were pre-
paring to face off outside Rome to
determine the next ruler. The leader
Constantine gazed into the sun and
saw a mysterious sign, convincing
him that the Christian god was on his
side. The next day, he led his troops
into the Battle of Milvian Bridge and
emerged victorious. Constantine
assumed power and promptly legal-
ized the Christian faith. It was also a
pragmatic move, to gain the support
of a growing, prosperous, and poten-
tially law-abiding minority. The once-
persecuted cult quickly became a
Europe-wide religion, and Jupiter and
Juno were replaced by Jesus and Mary.
In A.D. 300, you could be killed for
being a Christian; by 400, you could

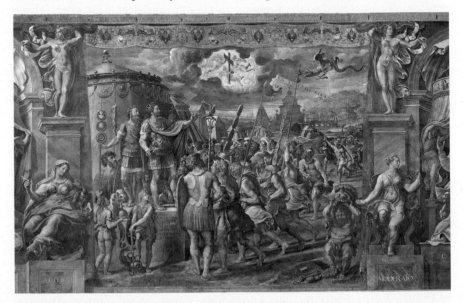

Raphael, **Constantine at Milvian Bridge** (Vatican Museum, Rome).
*Constantine spies a cross in the heavens, inspiring his troops to victory at the Battle of Milvian
Bridge—and Rome becomes Christian.*

Arch of Constantine, A.D. 315 (Forum, Rome).
If you are a Christian, were raised a Christian, or simply belong to a so-called "Christian nation," ponder this arch. It marks one of the great turning points in history—the military coup that made Christianity mainstream. With this one battle, a once-obscure Jewish sect with a handful of followers was now the state religion of the Western world.

tomb-lined tunnels with networks of galleries as many as five layers deep. They burrowed deep for two reasons: to get more mileage out of the donated land and to be near martyrs and saints already buried there. The tufa rock the Christians burrowed into was perfect for the job—it was soft and easy to cut, but became very hard when exposed to air. Bodies were wrapped in linen (like Christ). Since they figured the Second Coming was imminent, there was no interest in embalming the body.

After Emperor Constantine legalized Christianity, Christians had a new, interesting problem. There would be no more persecuted martyrs to bind them and inspire them. Thus the early martyrs and popes assumed more importance, and Christians began making pilgrimages to their burial places in the catacombs.

In the 800s, when barbarian invaders started ransacking the tombs,

be killed for not being one. Church enrollment boomed.

Catacombs

The catacombs are burial places for (mostly) Christians who died in ancient Roman times. By law, no one was allowed to be buried within the walls of Rome. While pagan Romans were into cremation, Christians preferred to be buried. But land was expensive and most Christians were poor. A few wealthy landowning Christians allowed their lands to be used as burial places.

The 40 or so known catacombs circle Rome about three miles from the center. From the first through the fifth centuries, Christians dug an estimated 360 miles of

Holy Stairs
(Scala Santa; Church of San Giovanni in Laterano, Rome).
In A.D. 326, Emperor Constantine's mother (St. Helena) brought home the steps Jesus was thought to have climbed on the day he was sentenced to death. Each day, hundreds of faithful pilgrims climb these steps on their knees.

Top Museums of Ancient Rome

- Vatican Museum, Rome
- National Museum of Rome
- Capitol Hill Museum, Rome
- E.U.R. Museum (scale model of ancient Rome), Rome
- National Archaeological Museum, Naples
- Louvre Museum, Paris
- Römisch-Germanisches Museum, Köln, Germany

Christians moved the relics of saints and martyrs to the safety of churches in the city center. For a thousand years, the catacombs were forgotten. In about 1850, they were excavated and became part of the Romantic Age's Grand Tour of Europe.

Finding abandoned plates and utensils from ritual meals in the candlelit galleries led romantics to guess that persecuted Christians hid out and lived in these catacombs. This romantic legend grew. But catacombs were not used for hiding out; they were

Through its last two centuries, the Roman Empire's dominant religion was Christianity. In early Christian times, Jesus was portrayed beardless and often with a lamb over his shoulders, as the good shepherd.

simply early Christian burial grounds. With a million people in Rome, the easiest way for the 10,000 or so early Christians to hide out was not to camp in the catacombs (which everyone, including the government, knew about), but to melt into the city.

The underground tunnels, while empty of bones, are rich in early Christian symbolism that functioned as a secret language. A dove symbolized the soul. You'll see it quenching its thirst (worshipping), with an olive branch (at rest), or happily perched (in paradise). Peacocks, known for their "incorruptible flesh," symbolized immortality. The shepherd with a lamb on his shoulders is the "good shepherd," the first portrayal of Christ. The fish was used as a symbol because the first letters of these words in Greek—"Jesus Christ, Son of God, Savior"—spelled "fish." And the anchor is a cross in disguise.

Fifth Century A.D.:
The Barbarians Come a-Sacking

Despite the efforts of Constantine and the Christians, Rome's downfall was inevitable. Let's recap the problems: false economy, plagues, corruption, emperor-of-the-month coups, crumbling infrastructure, an overextended army, and the constant pressure from "barbarian" tribes on the fringes. Christians blamed the fall on moral decay. Pagans blamed it on Christians neglecting the traditional gods. Historians blamed it on a shallow economy based on the spoils of war.

Rome's legions began backpedaling, and the empire

Top Roman Sights Outside of Italy

- Pont du Gard, near Avignon, France
- Amphitheater, theater, and arena in Nîmes and Arles, France
- Theater and Arch, Orange, France
- Aqueduct, Segovia, Spain
- Aquae Sulis spa and museum, Bath, Britain
- Hadrian's Wall (best near Haltwhistle), Britain
- Constantine's Basilica and Porta Nigra, Trier, Germany
- Diocletian's Palace, Split, Croatia

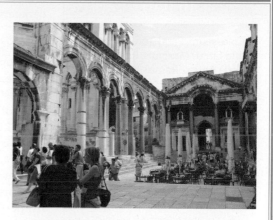

Emperor Diocletian's fourth-century retirement palace became the nucleus for today's city of Split, Croatia.

Examples of massive Roman engineering projects survive across Europe. This aqueduct is in Segovia, Spain.

Top Roman Sights in Italy

- Colosseum, Pantheon, Forum, and Circus Maximus, Rome
- Ostia Antica, Rome's ancient seaport
- Pompeii and Herculaneum, towns preserved by A.D. 79 eruption of Vesuvius
- Hadrian's Villa, Tivoli (near Rome)
- Theater and Arena, Verona

dwindled until "Rome" was little more than the city itself, surrounded by a protective wall. Barbarian tribes from Germany and Asia poured in to loot and plunder. The city was sacked by Visigoths (410) and vandalized by Vandals (455). The pope had to personally plead with Attila the Hun for mercy (451). A thousand years of tradition was disintegrating. Finally, in 476, the last emperor sold his title for a comfy pension, and Rome fell, plunging Europe into a thousand years of darkness.

Rome's Legacy

But Rome lived on. After Rome's fall, her urban nobility fled from the cities, establishing themselves as the feudal lords of medieval Europe's countryside. Latin, the Roman language, continued as the language of the educated and ruling classes. The Christian church preserved much of Rome's administration and sheer grandeur: Emperors became popes, senators became bishops, and the city of Rome remained the center of Christianity.

As the curators of Greek heritage, Rome preserved and passed down Greek statues, language, and culture. The Greco-Roman mastery of art lay dormant for a thousand years before awakening again in Europe's Renaissance—the rebirth of classical beauty. Rome's architecture spawned everything from cathedral domes and

Great Empires, False Affluence, Inevitable Decline

Rome provided an instructive case study for future "sole superpowers." Empires (nations whose power and influence stretch beyond their traditional ethnic borders), almost by definition, enjoy false economies based on slavery (or cheap labor) and booty (or cheap access to raw materials). They are propped up (from external threats and internal ones, too) by huge and costly militaries which develop economic and political appetites of their own. Rome's economy and stability were solid as long as the empire continued to expand. When Rome stopped expanding, the flow of booty and slaves that had fueled the economic affluence (and kept the populace docile) dried up, and the military became both an economic drain and a political headache. When a society reaches this point, it must do one of three things: begin living within its means, let its infrastructure rot, or delay its fall by building up a big deficit. Politically, the toughest pill to swallow is the first option. Rome opted to rot.

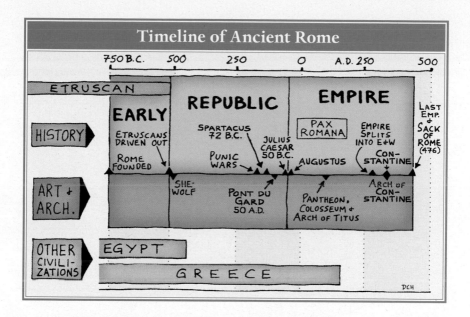

Timeline of Ancient Rome

750 B.C. 500 250 0 A.D. 250 500

ETRUSCAN

HISTORY
- EARLY
- REPUBLIC
- EMPIRE
- LAST EMP. + SACK OF ROME (476)
- ETRUSCANS DRIVEN OUT
- ROME FOUNDED
- SPARTACUS 72 B.C.
- PUNIC WARS
- JULIUS CAESAR 50 B.C.
- PAX ROMANA
- AUGUSTUS
- EMPIRE SPLITS INTO E+W
- CON- STANTINE

ART + ARCH.
- SHE-WOLF
- PONT DU GARD 50 A.D.
- PANTHEON, COLOSSEUM + ARCH OF TITUS
- ARCH OF CON- STANTINE

OTHER CIVILI-ZATIONS
- EGYPT
- GREECE

DCH

Neoclassical temples to today's stadiums and concrete patios. The Roman system of law provided the foundation for most Western governments that followed. Rome's myths and her pantheon of gods have enriched literature, and her bad emperors have given us...bad movies.

Summary of Ancient Western Civilization

You've just absorbed 3,500 years of history and art, from Egypt through Rome. That wasn't so bad, was it? Before you shake off the ancient dust and plunge into the Dark Ages, let's review.

Each of the ancient cultures influenced the following one. The early Mesopotamian cities came first, followed by the stable agricultural civilization of Egypt. The Minoans from Crete influenced the mainland Mycenaeans, who slowly evolved into the Greeks who brought about a Golden Age of culture. Alexander the Great spread this culture by conquest throughout the Hellenistic world, where it was later adopted by the growing Roman Empire. After Rome's thousand-year-long rise and fall, the sacking of Rome marked the end of ancient Europe.

While culture moved progressively westward from Mesopotamia to Rome, central and northern Europe remained populated by barbarian tribes wallowing in prehistory...not yet civilized enough to write down their own history.

Hell (detail), 13th century (Baptistery, Florence).

The "Dark" Ages

(A.D. 500–1000)

A thousand long years separate ancient and modern Europe. These "Middle Ages" lasted from about A.D. 500 to 1500. The first half is often called the Dark Ages (500–1000), and relatively little of cultural consequence survives. The second half of the era, which will be covered in the next chapter, is known as the High Middle Ages (1000–1500).

The Middle Ages were a time of knights in shining armor, peasants in poverty, and queens in castles. Muslims, Magyars, Vikings, and Byzantines loomed on Europe's fringes. Christian fervor produced soaring cathedrals, pious monks with shaved heads, and fanatic crusaders. And a rising secular culture of merchants, scholars, and budding capitalists eventually blossomed into the Renaissance.

It's no surprise that most tourists fill their scrapbooks with castles and cathedrals; these are the great physical accomplishments of medieval Europe. Visiting these places, it's easy to imagine the religious fervor that built the cathedrals—and the fear that built the castles.

But first let's wallow in the darkness for about 500 years.

By A.D. 500, Rome's infrastructure had collapsed. Like a great stone column crashing across the Continent, Rome's fall buried Europe and scattered civilization like so much dust. It would be 500 years before dazed Europeans began to pick themselves up from the rubble and build a new world. In the meantime, they lived lives of hardship and fear.

When the stability provided by the Roman Empire disappeared, bandits, barbarians, and wild animals roamed the countryside. Crops went unplanted, mail went undelivered, schools closed, roads crumbled. Farms

Were the Dark Ages Dark?

It's not politically correct in the 21st century to call the first half of the Middle Ages "dark." Dark was, after all, a phrase invented as an insult by proud and superior-feeling Renaissance humanists. Some say these centuries seem dark because so little from that age survives. Others say the early Middle Ages only seem dark because of our lack of knowledge about them. Those who call a dark and dreary medieval spade a spade justify it by couching the reference in

The Dark Ages, A.D. 500–1000

relative terms. Compared to the ages before and after, there just wasn't much happening: very little travel, trade, innovation, population growth, or confidence in the future. Certainly the year 1,000, which marks the end of the Dark Ages, is considered a turning point because from then onward, Europe showed its pluck. Learning, innovation (such as harnessing wind and water power with mills), commerce, and population were all up as European society began the arc upward that led to our modern age. For this reason (and with these caveats), in this book, we call the Dark Ages dark.

were reclaimed by forests. Cities were looted time and again, becoming ghost towns that were pillaged for pre-cut stone. Locals fled to villages in the countryside, located on easily defensible hilltops. The once-great city of Rome (with a population that had peaked at more than one million) shrank to a ramshackle town of fewer than 50,000 people.

People lived in small mud and wood huts, surviving on subsistence farming. For warmth, they slept with their animals, and they wore the same homespun wool clothes all year. A bad harvest was a sentence of death for an isolated community.

Skeletons unearthed by archaeologists show a people chronically

Civita di Bagnoregio, Italy.
As barbarian tribes swept across the fallen empire, villagers took advantage of the natural fortification provided by hill towns.

Rothenburg, Germany, has a museum devoted to the many creative ways "criminals" suffered during medieval times, when punishments were both cruel and unusual.

undernourished and ravaged by disease. Infant and child mortality rates soared. Wise elders of a village might be in their thirties.

Besides bandits, plagues, and famine, superstitious people of the Dark Ages had to contend with demons, devils, mischievous forest spirits, and the wrath of an angry God. The hideous gargoyles that adorn churches from that age come straight out of the imagination of these frightened people.

Medieval justice was harsh and tinged with superstition. Petty sinners were publicly humiliated with shame masks as punishment for gossiping, acting like pigs, or quarreling. More serious offenders would be dragged to the churchyard to face a "trial by ordeal" (usually with a priest in attendance). To decide their guilt or innocence, alleged criminals might be

forced to grab a red-hot iron or pull a stone from a cauldron of boiling water. If they were unharmed, they were innocent. If it hurt like heck, they were *really* punished—whipped, tortured, locked into wooden stocks, or simply executed. Suspected witches were tied up and thrown into a lake. If they floated, they were considered

Trial by Ordeal. *Two bishops lead a queen barefoot over a red-hot grate to determine whether she has been true to her husband (left). Notice the hand of God overseeing things.*

guilty and burnt accordingly. If they drowned...at least they died innocent.

For protection from bandits and a sense of security, helpless villagers huddled near stone castles. The basic castle consisted of a main building atop a hill or man-made mound, surrounded by a wall or a moat. Bigger castles might have more rings of defenses, with walls as much as 20 feet thick.

Life was clouded by the fear of invasions. Vikings from Scandinavia, Magyars from Hungary, Huns from Central Asia, and Moors from Spain all threatened Europe. In the days before hard and firm political boundaries, the demographic map of Eurasia was shifting constantly. Weaker tribes migrated away from bully tribes, resettling in more hospitable (or less desirable) lands. Imagine living in such an uncertain age when, for centuries, much of Europe finished off its prayers with, "...and deliver us from the Norsemen, amen."

The Vikings:
Raiders and Traders

The Vikings were a fierce shipbuilding people who swept down from present-day Scandinavia in the ninth and tenth centuries, terrorizing and paganizing Europe. The sight of their dragon-prowed ships on the horizon struck fear into the hearts of medieval Europeans from Ireland to the Black Sea.

Named for the Norse word *vik* (meaning "inlet"), the Vikings sailed their sleek ships out of their inlets on extensive raiding and trading voyages that took them up the Seine; deep into today's Russia; through the Mediterranean to Constantinople; and across the Atlantic to Greenland—eventually reaching the Americas centuries before Columbus.

History and Hollywood have

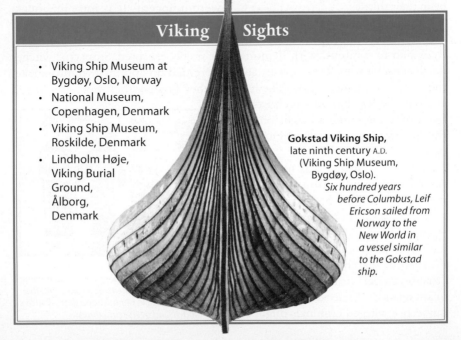

Viking Sights

- Viking Ship Museum at Bygdøy, Oslo, Norway
- National Museum, Copenhagen, Denmark
- Viking Ship Museum, Roskilde, Denmark
- Lindholm Høje, Viking Burial Ground, Ålborg, Denmark

Gokstad Viking Ship, late ninth century A.D. (Viking Ship Museum, Bygdøy, Oslo). *Six hundred years before Columbus, Leif Ericson sailed from Norway to the New World in a vessel similar to the Gokstad ship.*

Feudal Terms

Fealty: Loyalty
Fief: Land, in return for fealty
Lord: Upper man on the feudal ladder
Vassal: Lower man on the feudal ladder
Serfs: Near-slaves who worked the land of the lowest lord
King: At the top rung of the feudal ladder
Knight: Moves up two and over one, worth about as much as a bishop

painted a picture of the Vikings as fierce barbarians, but they had a gentle side, too. Many were farmers, fishermen, and craftsmen. Faced with a growing population and constrained by a lack of arable land, they traveled south not just to rape, pillage, and plunder, but to find greener pastures. Sometimes they did stay and colonize, such as in northwest France, which became known as Normandy ("Land of the Norsemen").

The Vikings worshipped many gods and had a rich mythology. Epic sagas told the heroic tales of gods such as Odin and Thor, who lived in Valhalla, the Viking heaven. Like the Egyptians, the Vikings believed in life after death: Chieftains were often interred in burial mounds, along with their ships and other prized possessions (beautiful jewelry, cooking pots, food, and Hagar the Horrible cartoons).

The Vikings' empire eventually faded away as they faced more organized enemies and the powerful influence of Christianity.

Feudalism

To give this chaotic world some order and security, a strict social and economic system evolved, called "feudalism." Here's how it worked: Peasants pledged part of their crop to a nobleman in return for protection, order, and farmland to work. That nobleman (vassal) promised loyalty (fealty) to a higher-up (lord) in return for use of the land (a fief). Each noble was in the service of a more powerful noble, and so on. One man's vassal was another man's lord.

Dark Age Europe had no national governments. Government was actually in the hands of local kings, nobles, barons, dukes, knights, and petty lords. Those with money kept a small private army. Might made right.

Feudal nobles were constantly... feuding. On sunny afternoons, knights suited up, tramped through their own peasants' crops, and raided the neighboring nobles' domains hoping to kidnap the lord. Most of medieval Europe toiled to survive, while sons of the rich spent their leisure hours playing chivalrous games. The pawns in this

Whirlwinds and Hunger and Plagues, Oh My!

Look at an actual ninth-century history book and you can see that the Dark Ages were a mix of magic, fear, fantasy, brutality, and ignorance. The years are boiled down to a few terrible and miraculous events, all told matter-of-factly. Some excerpts:

An account of the year A.D. 837: A gigantic whirlwind broke out and a comet appeared, emitting streams of light three cubits long before the amazed spectators. The pagans devastated Walicrum and abducted many women there, taking along huge sums of money.

The year 852: The steel of the pagans grew white-hot; an excessive heat of the sun; famine followed; there was no fodder for the beasts, but the feeding of pigs flourished.

The year 853: Great hunger in Saxony, with the result that many ate horses.

The year 857: A great plague with swelling of the bladder raged among the people and destroyed them with horrible festering, so that their limbs dropped off and fell away before death.

feudal chess match were, of course, the peasants.

Nobles hardly lived lives of luxury, though. Their castles were crude, cold, damp, and dark, with little privacy. (I've stayed in youth hostels like that.) Nobles were often illiterate—and proud of it. Their lives revolved around war, training for war, jousting, hunting, and feasting. The feasts often dissolved into weeklong bouts of drinking and rowdiness.

Christianization

Christianity had become Europe's most popular religion during Rome's last years. But after Rome fell, much of Europe—particularly northern Europe—reverted to its pagan ways. People worshiped trees and woodland spirits, and gave offerings to pagan gods. The Viking and Magyar invasions in the eighth and ninth centuries further paganized (and terrorized) northern Europe. It took centuries and

countless dedicated monks and missionaries to reconvert the locals.

In Ireland, a Latin-speaking Christian from Roman Britain set out to convert the pagan, sun-worshipping Celtic inhabitants. Confronting the pagan king, Patrick used a three-leafed shamrock to explain the Trinity—Father, Son, and Holy Ghost—and the king was baptized. Legends say Patrick drove Ireland's snakes (symbolic of pagan beliefs) into the sea.

Monks flocked to Ireland and Scotland like conscientious objectors to the dreary chaos of the Dark Ages. They withdrew to scattered, isolated monasteries, lived in stone igloo-like structures known as beehive huts, and tended the flickering candle of civilization. From their spiritual, intellectual bunkers, they slowly re-entered the Continent, converting and educating as they went.

Christianity began to spread throughout Europe, gathering con-

verts and momentum as it went, but it failed to stamp out folk religion entirely. Many pagan rituals also made the conversion to Christianity; magic was woven into the fabric of the new religion. The good spirits of folklore became the saints of the Church, and pagan feast days were renamed to become Christian holy days (hence the word "holiday"). Even today, we remember the Viking gods by the days of the week: Odin/Wotan (Wednes-day), Thor (Thurs-day), and Frigga (Fri-day). And at Christmastime, we celebrate much as the druids of Brit-ain celebrated the winter solstice, with trees and mistletoe.

Despite taking on some of these pagan elements, the Christian Church as a whole became a spiritual castle, a refuge from Dark Age chaos. Like a good shepherd, God cared for his vulnerable flock. (Remember that many of the earliest depictions of Jesus showed him as the good shepherd.) The Church soon dominated every aspect of medieval life. A sin was a crime and vice versa. Religious authorities were civil authorities, and bishops were often princes. Tithes were taxes. God brought prosper-ity...and he brought plagues. The Bible was the final word on all matters scientific, eco-nomic, social, and political. Thoughts of an afterlife con-cerned people more than their life on earth. Finally, by about the year 1000, all of Europe could once again be called Christian.

Rome's Legacy: The Church

The Christian Church carried on much of Rome's legacy: Roman senators became Christian bishops, scholars became monks, philosophers became theologians, Latin became the lan-guage of the Church, and the pope adopted the title originally held by the emperor: *Pontifex Maximus* (high priest). Christians took tithing seri-ously, routinely willing their land to the Church—but expecting years of prayer for their soul in return.

The Church's great wealth was invested in huge church buildings, dec-orated as ornately as anything Rome had ever seen. The pomp and pageantry of the Church's rituals are reminiscent of the glorious days of Caesar. Chris-tianity bridged the ancient and mod-ern worlds by carrying Rome's classical knowledge, learning, and administra-tion through the Middle Ages and pass-ing it along to the rising secular world

Sé (Cathedral), begun 1150 (Lisbon, Portugal). *Romanesque churches stood as figurative and literal fortresses of God. In Lisbon's 12th-century cathedral, crenellations gave defenders of the faith something to hide behind.*

Sightseers' Medieval Church

Knowing these terms will make your church visit a lot richer. Not every church will have every feature. Note that "cathedral" isn't a type of church architecture, but rather a governing center for a local bishop.

Aisles: The long, generally low-ceilinged arcades that flank the nave.

Ambulatory: The covered walkways of the aisles alongside the nave and behind the altar, taking you (and, in medieval times, pilgrims) past the chapels that often line the perimeter of a church.

Apse: The space beyond the altar, generally bordered with small chapels.

Barrel Vault: A continuous round-arched ceiling that resembles an extended upside-down U.

Chancel: The eastern (altar) end of a church, once reserved for dignitaries.

Chancel Screen (or Rood Screen): Screen designed to separate the exclusive chancel from the peasant-infested nave.

Chapels: Alcoves for worship within the church, each with its own simple altar. These often line the nave and/or the apse. Many are dedicated to a particular

during the Renaissance. (For more on the Christian faith and its hefty role in European history, see "Christian Themes and Symbols" on page 466.)

Churches stood like mighty fortresses in the war against Satan, and as a hint of the glories that awaited the faithful in heaven. Typically the only stone structure in a town and a landmark for miles around was the church. It was the political, religious, and even recreational center of the town.

The sheer grandeur of ancient Rome was preserved in the size and luxury of Christian churches. When Christianity became Rome's adopted religion, there was no suitable place to worship. Rome's pagan temples were too small, intended just for the priests and a statue of the god, not for the masses of Christians who gathered to share a ritual "meal" (Communion) together. So, new churches were modeled not after Rome's temples, but after the largest Roman secular structures: Roman law courts, or basilicas.

Architecture Cheat Sheet

saint. Many are also the private chapels of wealthy families.

Chapter House: A special room (often with dramatic vaulting and fancy carved reliefs) where the church or monastery administrators meet.

Choir: A cozy area, often screened off, located within the church nave and near the high altar where services are sung in a more intimate setting.

Clerestory: The upper story of a nave, generally with lots of windows and no public access.

Cloister: A square-shaped series of hallways surrounding an open-air courtyard, traditionally where monks and nuns got fresh air.

Facade: The outer wall of the church's main (west) entrance, viewable from outside and generally highly decorated.

Groin Vault: An arched ceiling formed where two equal barrel vaults meet at right angles. Less common usage: term for a medieval jock strap.

Nave: The long, central section of the church (running east to west, from the entrance to the altar) where the congregation stood through the service.

Rose Windows: Glorious round stained-glass windows filling the west portal, north transept, or south transept.

Sacristy: A separate room for storing special and sacred tools for worship; today many sacristies are used as a small church museum (or Treasury) showing off fancy jewels, robes, and relics.

Tracery: Elaborately carved stonework, often lacing together the pieces of a stained-glass window.

Transept: The north–south part of the church, which crosses (perpendicularly) the east–west nave. In a traditional Latin cross-shaped floor plan, the transept forms the "arms" of the cross.

Tympanum: The ornately carved triangular or semicircular area above the main door.

West Portal: The main entry to the church (on the west end, opposite the main altar).

Basilica Aemilia, 179 B.C. (Forum, Rome). *Notice the rows of stubby columns, outlining the nave and side aisles. The floor plan of pre-Christian law courts (or basilicas) became the model for churches (or basilicas).*

The basilica floor plan was used in nearly every medieval church: a long central hall (nave) flanked by narrower side aisles, all leading up to the altar. Many churches add a crossing transept to give the rectangular basilica the shape of a Latin cross. At the far end, beyond the altar, is often a semicircular area called the apse. Some churches have a choir in the center—a screened-off central zone around the high altar for more intimate services. The sheer size of Europe's great churches makes

you feel small. It reminds us of our place in the vast scheme of things.

The basilica layout was ideal for accommodating large congregations, especially the massive processions of pilgrims who came to worship Christian relics—the bones and possessions of saints that inspired the faithful and even produced miracles. Pilgrims would amble up one side aisle, around the altar, and out the other aisle, worshipping at each chapel along the way. Columns separated the walkways (ambulatories) from the long central nave where the congregation stood (sitting in church hadn't been invented yet).

Medieval churches are like a compass. The transept runs north to south. The congregation enters from the west and faces the altar, which is east, toward Jerusalem.

Monasteries:
The Preservation of Learning

The center of medieval intellectual life was the monastery. Here, Christians put away their material concerns (and back issues of *Playknave* and *Pentcastle*) and took vows of poverty, chastity, and obedience. The monks lived together in isolated communities, following a daily program of tasks that combined manual labor, study, meditation, and prayer.

This system was first roughed out in the sixth century by St. Benedict. In A.D. 529, Benedict founded a monastery at Monte Cassino, and with it, the highly influential Benedictine "order" (or group of monks committed to similar religious aims). Because Benedict established rules that became the norm for monastic living throughout Europe, he is considered the father of

Western monasticism. And because the monks of Dark Age Europe nursed Western civilization through its most difficult period, Benedict has been called the first great European. Echoing that sentiment, the Catholic Church proclaimed him the patron saint of all Europe in 1964.

Monks would plant gardens in the cloister (the central courtyard), chop wood, copy manuscripts, grind grain, and gather together for meals in the refectory (dining hall). Meals were generally eaten in silence while one monk read the Bible from a balcony. Several times a day—from matins in the morning through vespers at evening—they chanted a set regimen of prayers and Bible passages in Latin. Before bed, they'd meditate alone in their cells.

While many scholars chose to become monks, some monks were

Inspired by St. Benedict, the German cardinal who became pope in 2005 chose the same name. He hopes an increasingly secular Europe will return to fundamental Christian values, reminiscent of St. Benedict's goal during the Dark Ages so many centuries ago.

the younger sons of nobles, who'd received no inheritance or title and so were forced into church service. Monks were not necessarily priests (who have authority to say Mass and perform other church rituals), but simply those who wanted a stripped-down lifestyle closer to that of Jesus.

Monks were the keepers of technological knowledge: clocks, waterwheels, accounting, farming techniques, wine presses, metal forges, grinding mills, and cloth looms. They were also human photocopy machines.

Monks were charged with translating and hand-copying ancient texts, including works that were purely secular and even heretical. After the fall of Rome, fewer and fewer people learned even the most basic readin', writin', and 'rithmetic. Priests and monks astonished the illiterate masses with "2 + 2 = 4" back when letters and numbers seemed to have almost magi-

Book of Kells (detail), late eighth century A.D. (Trinity College, Dublin, Ireland).
Perhaps the finest art from Dark Age Europe is found in manuscripts that were "illuminated" (or illustrated) by monks.

cal powers. Our modern word "clerk," someone who works with words or numbers, comes from "cleric," which means a member of the clergy.

Copying texts was tedious. Monks with good penmanship dutifully copied Roman scrolls that they may not have even understood. To vent their creative spirits, monks would decorate title pages or chapter headings with imaginative calligraphy, designs, and cartoons. So-called "illuminated" (or illustrated) manuscripts became the top art form of Dark Age Europe. In the late eighth century, Irish monks created the well-known Book of Kells, a Gospel translated into Latin and painstakingly inked—along with beautiful illustrations—onto the skins of 185 calves. The illustrations blend

Intellectual life survived the Dark Ages in monasteries. Copying and translating Greek and Roman writings were common tasks for monks.

Roman, Celtic, and even Byzantine influences. The Book of Kells (now at Trinity College, Dublin) and the Lindisfarne Gospels (displayed in London's British Library) are the best examples of this monastic flowering from 500 to 900. Illuminated monk-uscripts like these helped preserve ancient Roman learning through the Dark Ages; they were virtual time capsules of knowledge that wouldn't be opened for a thousand years.

The year 529 was pivotal. The Platonic Academy in Athens—the Harvard of the ancient world—closed its doors after 900 years. Also in 529, the first monastic order, the Benedictines, was founded in Italy. From this point on, knowledge was the domain of the Church. Europe's best and brightest were priests and monks, focusing on heavenly rather than earthly concerns while secular knowledge slumbered.

Medieval Religious Art

The Church held Europe's wealth. It funded the greatest art of the early Middle Ages and, logically, that art served the Church. Artists painted and sculpted God, Jesus, Mary, angels, saints, and Bible scenes—Adam and Eve being tempted by the serpent, Noah building his ark, God overseeing the Last Judgment.

Early on, some hardline theologians called Iconoclasts even questioned whether it was okay to depict God or his Creation at all. After all, the Bible says thou shalt not

make any "graven images" that might be worshipped as false gods. Did that include paintings? A statue of Mary? Illustrated Bible stories? The debate lasted for centuries, especially among Christians outside of Western Europe.

But by the year 600, it was generally agreed that art had great value. It embellished places of worship, educating and inspiring the masses of illiterate Christians who couldn't even understand the language used to conduct church services (Latin). The church building itself became, through religious art, a kind of "book" in which the illiterate could "read" the stories of Christianity—as told in sculpture, stained glass, tapestries, and paintings.

Devout peasants could gaze on scenes of lost souls, naked and chained, being dragged off to hell...vividly driving home the point of the priest's sermon. On Jesus' right would be the blessed faces looking to heaven, hands obediently folded, content with the promise of a happy afterlife. "Escape

Hell, 13th century (San Giovanni Baptistery, Florence).
It seems as if every medieval church came with vivid depictions of where you'd end up if you didn't behave.

Iconoclasm: Europe's Destroyed Art

In your travels you'll see lots of vandalized art. The great art of Europe has weathered many waves of destruction. Just as American forces toppled statues of Saddam in Iraq, invaders of Europe (such as the Moors and Ottomans) celebrated their victories by knifing canvases and knocking off marble noses. The forces of atheists (whether from Napoleonic France or Soviet Russia) desecrated precious church art. Napoleon loved using great churches as stables. Throughout history and throughout the world, iconoclastic sects (whether the Taliban in Afghanistan, Moors in Spain, or eighth-century Christians in Italy) have found images offensive and have destroyed everything they could. Protestant Reformers such as Calvin had their bands of moralists trash Catholic churches. Savonarola boys gathered and burned anything too fleshy and hedonistic in Renaissance Florence—even Botticelli stoked Savonarola's fires with some of his own canvases.

Theology" was as attractive to feudal peasants (and their overlords) in medieval Europe as it is to modern-day peasants (and their overlords) in Central America.

Most every church in Europe had a painting on the main altar as a focus of worship. Mary, the mother of Christ (a.k.a. the Madonna, the Virgin, or Our Lady), was a cult figure, adored and prayed to by the faithful for bringing baby Jesus into the world. These altarpieces follow a set formula: The

Duccio di Buoninsegna, **Maestà**, 1311 (Uffizi Gallery, Florence).

figures float in an ethereal gold never-never land, as though medieval people couldn't imagine saints and angels inhabiting our dark and sinful earth. The holy wear gold plates on their heads. Faces are serene, generic, somber, iconic. People pose stiffly, facing directly out or to the side, never in between. Look-alike saints have to carry ID to be recognized: Peter has keys, Luke carries a Gospel, Mark a sword. Every robe has elegant folds. Realistic depth and perspective didn't matter, so the angels at the "back"

of Mary's throne are the same size as those holding the front. Mary—the most important person—is the biggest.

By modern standards, medieval art is crude, two-dimensional, and unrealistic. Figures look as if they've been cut out of paper and pasted into random groups. Scenes are often overcrowded.

Paintings were not intended to be realistic, but to make a theological point. Artists boiled down the subject to just what was necessary to convey the essence of the story. Pictures became symbols. A lion was a reminder of the Resurrection, not a lesson in zoology. Freed from the constraints of realism, the medieval artist could experiment with new (and often bizarre) color schemes, compositions, and proportions, exaggerating reality for spiritual effect.

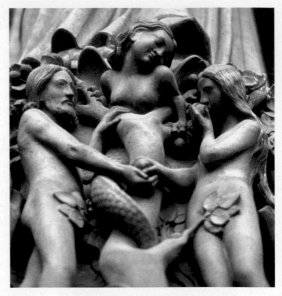

In the Middle Ages, most art decorated churches and told biblical stories. Here, next to the front door of Paris' Notre-Dame Cathedral, a seductive snake tempts Adam and Eve with an apple.

Medieval art, like Chinese, Byzantine, and Egyptian art, had no need to be original. A donor would commission an artist to create a replica of an existing piece of art, possibly with finer materials but with no interest in originality. The artist would have no problem with copying someone else's work. It's like our notion of music: For your wedding, you hire an organist and a singer—not to come up with new music, but to redo nicely something you already know you like.

Church architecture—designing God's house—was the most respected medieval art form. Arts such as sculpture and stained glass were deemed worthy or legitimate because they embellished the house of God. Statues were tucked into niches carved in the church wall. Stories were told in low relief, protruding only slightly from the wall or surrounding material (as opposed to freestanding statues).

A church's most creative sculpture is often found in the tympanum (the arched area above the door) or hiding in the capitals of the columns along the nave. Sculptors were allowed a little craziness here (see page 126), and it's fun to see their grotesque fantasies peeking through the capital's leaves, filling nooks, and sticking out of crannies.

While most medieval art was religious, plenty of secular art decorated castles. Unfortunately, little survives. While in medieval times, churches and church art were generally respected,

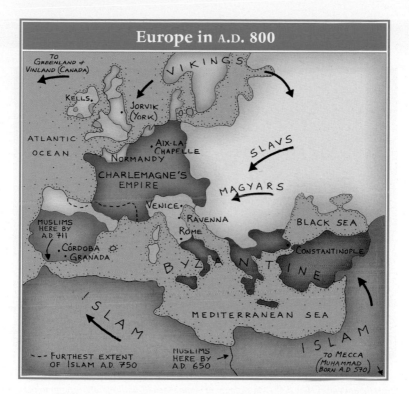

Europe in A.D. 800

protected, and saved, secular work was neglected, abandoned, or built over.

Candles in the Wind:
Dark Age Bright Spots

The whole world wasn't in a Dark Age. In Central America, the Mayans and Toltecs were building great cities and doing complex astronomical work. In China, the T'ang dynasty flourished. China provided many of the technological innovations that spurred Europe's recovery from the Dark Ages: paper, clockwork, looms, windmills, Top Ramen, spinning wheels, and gunpowder.

In Europe, the feisty flame of civilization flickered sporadically throughout the Dark Ages. In fact, there were many learned monks, enlightened nobles, and talented

artists. The ruler Charlemagne briefly united the core of Europe and orchestrated a mini-Renaissance (described on page 112). Meanwhile, on Europe's fringes sat two cultures that offered a glimpse of the unity, stability, and prosperity that were largely missing in Europe—these were the worlds of Byzantium and Islam.

The Byzantine Empire

The Byzantine Empire was the eastern half of the ancient Roman Empire— the half that didn't "fall" in A.D. 476. It remained Christian, Greek-speaking, and enlightened for another thousand years.

In the year 330, the center of the civilized West packed up and moved eastward. Constantine, the first Christian emperor, moved the

Top Byzantine Sights

*Europe's finest early Christian churches (dating from the sixth century) are in **Ravenna**, Italy (near Venice). Here in the Mausoleum of Galla Placidia, light sneaks through thinly sliced alabaster windows to help illuminate sumptuous mosaics.*

- Churches and mosaics, Ravenna, Italy
- St. Mark's Basilica, Venice
- Monreale Cathedral mosaics, Palermo, Sicily, Italy
- Hağia Sophia Museum and Chora Church, Istanbul, Turkey
- Mystra, near Sparta on the Peloponnesian Peninsula, Greece
- Meteora pinnacle monasteries, Greece
- Charlemagne's Chapel, Aachen, Germany
- Sacré-Cœur (neo-Byzantine basilica), Paris

Roman Empire's capital to the newly expanded city of Byzantium, which he humbly renamed Constantinople (modern-day Istanbul), taking with him Rome's educated elite. In a sense, this was the real end of ancient Rome. When the empire decayed and finally fell, plunging Western Europe into its "Dark" Ages, Constantinople lived on for a thousand years as a beacon of learning and culture.

We think of the Eastern Empire as Byzantine rather than Roman because it quickly took on an Eastern flavor. Its language, literature, and art were Greek. The church followed Eastern Orthodox ways, eventually splitting with the pope's Latin Church.

Throughout the medieval period, the Byzantine Empire had a powerful

St. Mark's Basilica in Venice is packed with intricate Byzantine-style mosaics. Imagine paving a football field with contact lenses.

influence on the West. Western Europeans considered distant and mysterious Constantinople to be the leading city in Christendom, and the Byzantine Emperor was thought of as the civilized world's supreme ruler. Byzantium remained linked economically to Europe by its sea trade with the city of Venice. Europe's Crusaders traveled to eastern lands and came home with tales (and looted wealth) of grand Byzantine cities. And when Christian Constantinople was finally overrun by the Muslim Turks in 1453, scholars and artists fled to the West, fueling the Renaissance.

Today, we find hints of Byzantium in the Eastern Orthodox Church, in mosaics and icons, and in the churches of Ravenna and Venice. Constantinople, today's Istanbul, is an exciting brew of ancient past and cosmopolitan present, Muslim East and Christian West.

Ravenna's Mosaics

In the sixth century, the Byzantine emperor Justinian (c. 482–565) traveled to Italy to try to liberate the land from barbarians and reassemble the empire. The magnificent churches of Ravenna (south of Venice) from this period rival Istanbul's. For a short time, order and stability reigned, as reflected in the mosaics of Ravenna's many fine sixth-century churches. God was shown in heaven—sitting on a celestial orb—and Justinian ruled here on earth, sporting both a halo and a crown to unite church and state.

In the Basilica of San Vitale's most famous mosaic, Justinian brings together both generals and bishops, all united by the straight line of eyes. On the opposite wall, the empress,

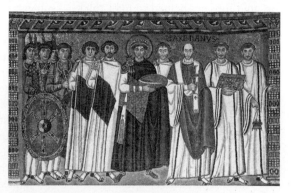

Mosaic of **Justinian I and Attendants,** c. 547 (Basilica of San Vitale, Ravenna, Italy).

Theodora, faces her husband along with her entourage. Formerly a dancer, Theodora became Justinian's mistress and later his wife. Decked out in jewels and pearls, she carries a chalice to consecrate a new church.

Mosaics were a Roman specialty carried on by Byzantium. The Romans used them to pave floors, walls, and ceilings. Byzantine mosaics show saints in the distinct iconic style: with halos, solemn faces, almond eyes, rumpled robes, and delicate hands raised in blessing—they always face forward. Surrounding it all is a gold background, made by baking gold leaf into tiny cubes of glass called *tesserae* (tiles). The uneven surfaces of the tiles give off a shimmering effect. The reflecting gold mosaics helped to light thick-walled, small-windowed, lantern-lit Byzantine churches, creating a golden glow that symbolized the divine light of heaven.

The Islamic World

In the seventh century A.D., zealous followers of Muhammad's new religion of Islam fanned out from Arabia. In 711, they landed on the tip of Europe (the Rock of Gibraltar), quickly conquered Spain and Portugal, and then dominated the Iberian Peninsula for seven centuries.

Spanish Muslims, called Moors, fostered high learning while the rest of Europe was still rutting in the mud. They built some of Europe's greatest cities, with mosques, palaces, and public baths. They paved streets, illuminating them with oil lamps at night, and piped in running water from the outskirts. Medicine, astronomy, literature, law, architecture, and *al-jibra* (algebra) all flourished under the Moors. Muslim Spain was influenced by the enlightened, ancient Greeks, and libraries bulged with translated manuscripts of Plato and Aristotle, works that would later inspire medieval Christians.

Muslim Spain's Golden Age was marked by a remarkable spirit of tolerance and cooperation among the three great monotheistic religions: Islam, Judaism, and Christianity. Christians and Jews were allowed religious freedom, relative equality (for a fee), and the opportunity to rise to positions of wealth and power. The universities rang with debate by scholars in Arabic, Latin, and Hebrew.

The peaceful co-existence between Spanish Muslims and their subjects couldn't last forever. Throughout the seven-century reign of the Moors, feisty enclaves of Christianity remained, whittling away at the Islamic empire. And all of Christendom rallied to retake Iberia from the Muslim Moors. To inspire (and anger) the Christian masses, church leaders cooked up the notion that the apostle James was buried in northwest Spain in a city they named for him, Santiago (St. James) de Compostela. Persistent Christian forces pushed the Moors gradually south. Towns with "de la

Top Muslim Sights in Europe

- Alhambra Palace, Granada, Spain
- Alcázar Palace, Sevilla, Spain
- La Mezquita (mosque/cathedral), Córdoba, Spain
- Tránsito Synagogue, Toledo, Spain
- Artifacts at the Gulbenkian Museum, Lisbon, Portugal
- Mosques and reconstructed Old Bridge, Mostar, Bosnia-Herzegovina
- Topkapi Palace, Istanbul, Turkey

The Alhambra, 14th century (Granada, Spain).
Imagine a few tapestries, carpets, ivory-studded wooden furniture, and some more paint, and the palace today looks much like it did for the Moorish kings.

Frontera" in their names (such as Arcos de la Frontera) were, at one time, on the Christian/Muslim frontier.

As Christians re-took a city, they'd rip down the mosque and replace it with a cathedral, sometimes turning the Muslim minaret (call-to-prayer tower) into the church's bell tower. Finally, in 1492, the last Moorish stronghold was conquered, and Spain was a fully Christian nation.

The Alhambra

Nowhere does the splendor of Moorish civilization shine so brightly than in this last and greatest Moorish palace.

The mathematical skill necessary to construct this palace was beyond anything the Europeans of the day could do. There's water everywhere—in pools and fountains, cascading and drip-dropping playfully, masking secret conversations. So rare and precious in most of the Islamic world, water was the purest symbol of life to the Moors.

Islamic artists specialized in intricate abstract designs. You'll rarely see pictures of people or animals, since the Islamic religion was wary of any "graven images" or idols forbidden by God (Allah). Geometric designs (stars, diamonds) and floral patterns (twining

*The last palace of the Muslim Moors (before they were forced out of Spain by the Reconquista) was the still-glorious **Alhambra** in Granada. In 1492, as the defeated Moorish king fled the city, he looked back at his palace and teared up. His mother scolded him, saying, "Don't weep like a woman for what you wouldn't fight for like a man."*

vines, flowers, arabesques) are popular. But the most common pattern is calligraphy. Walls are plastered with quotes from the Quran in Arabic, using elaborate lettering that combines the power of the message with the beauty of the design. Vases, car-

Mosques were richly decorated—but without graven images.

pets, glazed tile, glass tableware, and entire palace walls are covered top to bottom in complicated patterns. The intricate interweaving, repetition, and unending lines suggest the complex, infinite nature of God.

Spain's Moorish art is often a mix of Christian and Muslim. "Mozarabic" art was made by Christians under Muslim rule. "Mudejar" was made by Muslims under Christian rule.

Charlemagne (742?–814)

The reign of Charlemagne (SHAR-luh-mayn)—Charles the Great, king of the Franks—was another bright light in the Dark Ages. On Christmas Day in the year 800, Charlemagne knelt before the pope and was crowned with the title Holy Roman Emperor, briefly uniting the core of Western Europe

Charlemagne (Paris, France).
In the year 800, Charlemagne (a.k.a. Charles the Great, Karl der Grosse, and Carolus Magnus) established what later Europeans would refer to as the "First Reich."

now called the Carolingian Empire—the largest since Rome. (When 20th-century Nazis referred to their Third Reich, it was in relation to this "First Reich.")

Charlemagne's rule brought about a mini-Renaissance. A drowsy Europe quivered and drooled with excitement at this "Roman revival." Charlemagne's capital city of Aix-la-Chapelle (present-day Aachen, Germany, which is well worth a visit) became the first European capital. Trade and communication increased, and the court became a cultural center where artists and scholars worked to revive Roman ideals. Academia flourished, and classical works were studied and copied. It's said that Charlemagne could read a little (a rarity at the time) and went to bed each night with a slate to practice his writing.

Charlemagne personally set about to improve the lot of his people. He replaced the barbaric trial-by-ordeal with trial-by-judge, revised the monetary system, and built schools and churches. According to legend, his foot even became *the* foot, the standard form of measurement still in use today. In fact, Charlemagne's earliest

and reviving the faded glory of ancient Rome.

Throughout the Middle Ages, popes and kings struggled to establish their power. While popes were undisputed spiritual leaders, they needed the military support of a king to effectively wield power. And being crowned by a pope didn't look bad on a king's resume either. When Charlemagne was crowned by the pope, he created the ultimate alliance of spiritual and worldly authority. From Germany to Sicily, he established what is

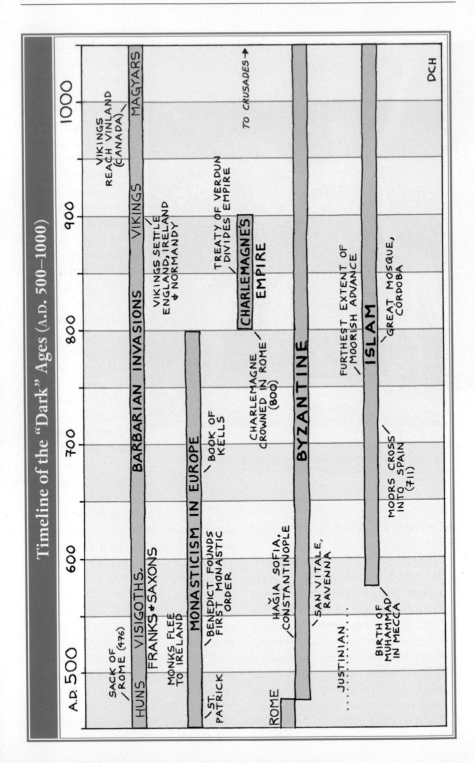

Timeline of the "Dark" Ages (A.D. 500–1000)

A.D. 500 — 600 — 700 — 800 — 900 — 1000

SACK OF ROME (476)

HUNS VISIGOTHS,
FRANKS + SAXONS

BARBARIAN INVASIONS VIKINGS MAGYARS

MONKS FLEE TO IRELAND

VIKINGS REACH VINLAND (CANADA)

VIKINGS SETTLE ENGLAND, IRELAND + NORMANDY

ST. PATRICK

MONASTICISM IN EUROPE

BENEDICT FOUNDS FIRST MONASTIC ORDER

BOOK OF KELLS

TREATY OF VERDUN DIVIDES EMPIRE

CHARLEMAGNE CROWNED IN ROME (800)

CHARLEMAGNE'S EMPIRE

TO CRUSADES →

ROME

HAGIA SOFIA, CONSTANTINOPLE

SAN VITALE, RAVENNA

BYZANTINE

JUSTINIAN...

FURTHEST EXTENT OF MOORISH ADVANCE

BIRTH OF MUHAMMAD IN MECCA

MOORS CROSS INTO SPAIN (711)

ISLAM

GREAT MOSQUE, CÓRDOBA

DCH

biographer says specifically that his highness was seven times as tall as the length of his foot (which would make his foot more like 10–11 inches long).

As the self-appointed protector of Christendom, Charlemagne was an enlightened but ruthless leader, determined to convert the pagan German tribes to Christianity. His chosen instrument of persuasion was the same used by later Crusaders—the sword. He invaded Germany and conquered it, tribe by tribe, giving the leaders a choice: Convert or die. Most chose the former, but many, still defiant, chose the latter— it's said that Charlemagne once ordered the decapitation of 4,500 pagans in one day. Eventually, resistance waned, and church membership soared.

Charlemagne was the top-dog ruler, but the Franks who succeeded him were wieners: The Treaty of Verdun (843) divided his empire among his three heirs (Charles, Louis, and Lothair) into realms that became Germany, France, and the smaller countries in between. This treaty, written in German and French rather than traditional Latin, has led some historians to call 843 the year of Europe's birth. It would be some time before Europe grew up, however, and in the meantime Charlemagne's successors returned to their quarreling ways, and darkness fell once again.

Later kings in Germany and Austria claimed to rule a revived Holy Roman Empire like Charlemagne's, but, as the great French writer Voltaire pointed out, their kingdoms were neither holy, nor Roman, nor empires. It was to be a long time before Europe enjoyed being ruled by another leader of Charlemagne's stature (and shoe size).

Charlemagne's reign was a turning point. Before his time, it seemed that darkness might dominate Europe forever. Afterward, hope for the restoration of learning and civilization was rekindled.

Conclusion

During much of the Dark Ages, Europe was a scattered and chaotic compost pile of barbarian tribes— Franks, Angles, Saxons—from which the modern nations we know today would sprout. Quietly, the seeds of modern Europe were planted. By the end of the Dark Ages, tribes were becoming nations. The Franks were becoming France, the Saxons settled Germany, and Angle-land was on its way to becoming England.

The High Middle Ages

(A.D. 1000–1500)

In about the year 1000, a glimmer of light shone through stained glass and lit up Dark Age Europe. Thus began the "High" Middle Ages, so-called because of the rising level of culture. Gothic cathedrals filled with stained glass and massive castles on hilltops are the grandest legacy of this era.

The Christian faith drove people to do the darnedest things. It inspired a saint to take off his clothes, and led rival popes to excommunicate each other. Crusaders mounted up and rode thousands of miles to slay Muslims, and the Inquisition burned heretics.

This was also the age when the first cracks appeared in Europe's monolithic Christian culture. Secular thought blossomed in universities and kings stood up to popes. The Renaissance loomed on the horizon and the Europe we know today was formed.

But first came the end of the world.

The Y1K Crisis

According to some scholars, much of Europe figured life would come to an end in Y1K. After all, the Biblical book of Revelation says an angel came down and bound the devil for 1000 years "after which he must be loosed a little season." In the 990s, business stopped and people focused only on salvation. The streets were filled with people whipping themselves in remorse.

The year 1000 came and went. So did 1001. Europe survived its Y1K crisis and began waking up from five centuries of slumber. The Viking invasions subsided, trade picked up, and Europeans, who finally owned chairs, could begin to plan for the future. There was even a medieval industrial revolution: Windmills harnessed the wind to reclaim farmland, and water power was used to grind grain with new efficiency. Herbs made natural medicines and perfumes. New and improved plows, harnesses, and crop rotation techniques increased farm productivity. Roads and bridges were built, boosting trade. Towns sprang up, offering peasants an exciting alternative to life under their feudal masters. Grand new buildings made of stone seemed to show confidence in a worthwhile future.

The power harnessed by Europe's mills could be used in countless ways. Most of Holland's windmills pumped water: The wind turned sails, which turned a giant Archimedes' screw that drained land by pushing water over a dike and into a canal or out to sea.

Europeans were no longer hopelessly isolated in a dark feudal struggle for subsistence. Europe perked up, experiencing the same enthusiasm that marked the United States' westward movement. For the previous 500 years, progress could have been graphed as a straight, horizontal line. During the High Middle Ages, that line

Today Europe's half-timbered medieval towns, such as Germany's **Rothenburg**, are carefully preserved.

began soaring upward. All these changes—economic, political, technological, and ideological—would culminate a few centuries later in the Renaissance.

The Crusades:
(1100–1300) A Christian Jihad

With the new millennium successfully underway, Europe was feeling its oats. Europe expressed this new energy in the aggressive "holiness" called the Crusades.

In 1095, Pope Urban II called for a crusade—an armed expedition (or Christian jihad)—to retake Jerusalem and the Holy Land from Muslims. The land of Jesus was considered sacred to European Christians; unfortunately, the Muslims held it in similar reverence. The result was two centuries'—and eight different crusades' worth—of bloodshed.

The Crusades were undertaken as a Christian mission, but people joined in on these holy wars of prophets and profits for a variety of reasons. Nobles hoped to conquer new land for fiefs, while their knights sought adventure, glory, and spoils. For merchants, the Crusades reopened lucrative trade routes to the fabled lands of spices, silks, and gems. And pious Christians believed they'd score points in heaven by converting—or slaughtering—heathens.

Back then, Christianity was more literal: Relics had magical power, and the streets Jesus walked on were divine. The papacy believed that owning this sacred land, even if it

meant killing infidels, was unquestionably fulfilling God's will. When the pope proposed the First Crusade in a public speech, the frenzied crowd chanted: "God wills it! God wills it!"

In the First Crusade, thousands of Europeans headed off to Jerusalem. Several different armies converged on the city—professional soldiers, armies of nobles from across Europe, armies of German princes, and a "People's Army" of impassioned peasants. They didn't wait until they arrived in the Holy Land to begin killing infidels, however. Almost any non-Christian they encountered along the way was eligible for execution: Crossing Germany, they slaughtered thousands of Jews.

By the time the crusaders reached Jerusalem, the Muslim inhabitants of the

In Spain and Portugal, graphic art that depicts **St. James "the Moor-slayer"** killing Muslims is commonplace. It stirred the spirits of Christian forces who worked for centuries to push the Muslims out of Iberia. Today, the growing Muslim population in this region is asking that these divisive, gory works be removed from public view.

city had re-opened it to Christians after forbidding their presence for centuries. But since the crusaders had come all that way, they ignored this welcome. Instead, they massacred 70,000 residents of Jerusalem, prayed, and then turned around and proudly headed for home.

Though bloody, the First Crusade was the only one that could be called a success. Jerusalem remained in Christian hands for nearly two centuries, but future popes periodically called for more crusades to retake other lands from the Muslims.

Life wasn't a bed of rosaries for crusaders. They had to put up money to fund their journey, forage (or pillage) for food along the way, and carry their own gear if their horses died. Provided they didn't die in battle, they were away from home for a couple of years. During that time, they traveled a long, weary way to a parched

Crusades (Library of the Arsenal, Paris).
Killing for God is nothing new.

land filled with understandably hostile defenders intent on protecting their own Holy Land.

The most misguided and corrupt crusade was the Fourth Crusade (1202–1204). The pope who ordered it was so certain of the necessity of this crusade that he even gave husbands permission to go without asking their wives. The holy warriors planned to travel east on boats from Venice but couldn't raise enough money to pay the Venetians, so they struck a deal: If the crusaders would conquer Zara—a Christian port on the Dalmatian Coast (today's Zadar, in present-day Croatia) and a rival of Venice—then Venice would supply the ships. The crusaders zapped Zara. They continued on to the Christian

(Byzantine) city of Constantinople to restore a king to power, in exchange for money. But the people of Constantinople refused to pay the promised cash. In retaliation, the crusaders sacked and looted this grand city.

The Eighth and final Crusade (historians quibble over the exact number of crusades) was launched in 1270. King Louis IX of France, later named a saint, was on the way to battle Muslims in Egypt when he fell ill. In his fevered state he called, "Jerusalem! Jerusalem! On to Jerusalem!"...and died. They never took Jerusalem, and Europe's crusader spirit mellowed and eventually petered out.

After two centuries, Jerusalem was back in Muslim hands, and the

Crusades were a dismal failure. Given their varied motives, languages, and national rivalries, the crusaders never functioned as a team. Some Crusades didn't even make it to the Holy Land. If they did achieve a victory, the soldiers went back home rather than consolidating their gains by settling in. Their Muslim opponents had the great advantage of fighting on their own turf, with lots of ready supplies. And they, too, had God on their side: They fought to keep bloodthirsty foreigners from desecrating the holy lands of Abraham, Isaac, and Muhammad.

The Crusades hardened a mutual distrust between Christians and Muslims that still exists. The papacy, which had promoted the Crusades, lost authority after throwing away lives and money.

But the Crusades did open a floodgate of new ideas from the East. They stimulated trade and put Europeans back in touch with the more enlightened Byzantine and Muslim worlds. Wishful-thinking crusaders brought back chests full of supposedly holy relics (pieces of Jesus' cross, John the Baptist's thighbone, and the skulls of an army of apostles), which inspired them to build massive cathedrals to showcase these treasures. Unable to conquer the Holy Land, it seemed European Christians would need to create one of their own. They learned eastern stone-working techniques that resulted in bigger, better cas-

tles. And the majestic flavor of sacred Byzantine icons showed up clearly in Western art.

The big winner in all of this? Venice.

Venice

Venice emerged from the Crusades as Europe's number one superpower. Sea-going Venetians grew rich by transporting crusaders on their missions, and, as the Crusades whetted Europeans' appetite for the luxury goods of the East, Venice established itself as the dominant middleman. Enterprising Venice prospered, expanding to control the entire Adriatic area politically, and thus became Europe's economic powerhouse.

The Venetian Republic's political and religious center, St. Mark's Square, reflects the wealth accrued during that time and the cosmopolitan nature of the city when it was the crossroads of East and West. Saint Mark's Basilica has Muslim-style onion domes and Byzantine-style mosaics. At the top of every hour, a bell atop the clock tower is rung by a pair of bronze Moors (African Muslims). The Doge's Palace,

Canaletto, **Doge's Palace,** 1750 (Uffizi Gallery, Florence). *Venice has changed little since this was painted.*

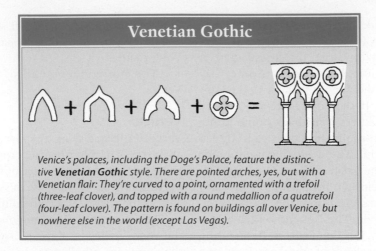

Venetian Gothic

*Venice's palaces, including the Doge's Palace, feature the distinctive **Venetian Gothic** style. There are pointed arches, yes, but with a Venetian flair: They're curved to a point, ornamented with a trefoil (three-leaf clover), and topped with a round medallion of a quatrefoil (four-leaf clover). The pattern is found on buildings all over Venice, but nowhere else in the world (except Las Vegas).*

where the city's main duke (or Doge) lived and ruled, was built to impress and intimidate foreign visitors. Nearby, on the Grand Canal, wealthy businessmen built their lavish palaces, funded by overseas trade. And overseeing the splendor of St. Mark's Square are four bronze horses on the church facade—a war trophy looted from Constantinople in the Fourth Crusade.

Venice prospered from about 1100 until 1500. Explorers such as Columbus and Vasco da Gama discovered new trade routes to the East around 1500, and, within a generation of those voyages, Venice's trade plummeted and trading power shifted to Spain and Portugal.

Medieval Art and Architecture

Devout medieval Christians dedicated their time, wealth, art, and architecture for the glory of God. The combination of Church wealth, political stability, and a reawakened spiritual fervor was channeled into building grand churches, first in the Romanesque, then in the Gothic style. Many

churches were filled with art that further celebrated the medieval peoples' faith. (For more on the evolution of medieval religious art, see page 104.)

Romanesque Architecture (1000–1200)

The Europe we know today began to emerge in the 11th century. And with it emerged Romanesque—what many historians call the first truly European art style.

In the 11th and 12th centuries, Europe in general was "Roman-esque" or Rome-like. The threat of invading cultures from outside of Europe had subsided. There was a vitality—with growing cities and vibrant trade—that hadn't been seen since ancient times.

All of Europe was Christianized. Monastic movements were at their peak. While individual monks may have taken vows of poverty, their orders were powerful, wealthy, and extravagant patrons of church building. And, as if people were thankful that the end of the first millennium didn't bring about the end of the world, there was a spike in religious

Top Romanesque Art and Architecture

- Basilica of Ste. Madeleine, Vézelay, Burgundy, France
- Bayeux Tapestry, Bayeux, France (pictured on page 143)
- St. Sernin Basilica and Augustins Museum, Toulouse, France
- Carcassonne and Sarlat (medieval towns), France
- St. Trophime Church and cloisters, Arles, France
- Fontenay Abbey, Burgundy, France
- Many village churches in Burgundy, France
- Cathedral, Leaning Tower, and Baptistery, Pisa, Italy
- Torcello Church, island of Torcello, Venetian lagoon, Italy
- White Tower, Tower of London, Great Britain
- Cathedral, Durham, Great Britain
- Lower Chapel of the Basilica of the Holy Blood, Bruges, Belgium
- Aix-la-Chapelle (Charlemagne's church and relics), Aachen, Germany
- Catalan Art Museum (best collection of Romanesque frescoes), Barcelona, Spain
- Churches scattered throughout Segovia, Spain

Basilica of Ste. Madeleine, 1104 (Vézelay, France). *In about 1100, Romanesque churches such as this one were Europe's biggest buildings, featuring round arches, heavy walls, small windows, and dim interiors.*

fervor. Societies were obsessed with building great places of worship. An unprecedented boom in church building swept Europe. From Italy to Scotland and Spain to Germany, churches were bigger and—with their columns and round arches—more Roman-looking than ever.

Romanesque churches were huge, designed to accommodate growing communities and to host traffic-jams of pilgrims. With the thriving cult of

relics and the popularity of pilgrimages, huge crowds would converge on churches on certain feast and saint's days. A continuous ambulatory was needed within churches that allowed for an easy and efficient flow of worshippers.

Because many churches were destroyed by rampaging Vikings, Magyars, and other marauding bully groups, there was also a need for rebuilding. And, since fires had been a

The Leaning Tower of Pisa

Around the year 1200, Pisa rivaled Venice as a sea-trading power. Filthy-rich from doing business with Muslims in the East, Pisa rebuilt their church. Of course, the church needed a bell tower.

No sooner had the building of the Tower begun (1173) when some brave soul turned to the architect and said, "Is it just me, or does that look crooked?" Yes, the heavy Tower, which rested on a very shallow 13-foot foundation, was obviously sinking on the south side into the marshy soil. Construction carried on anyway, with each successive architect trying to correct the problem by bending the building straight. The Tower kinks upward halfway up, and again at the belfry.

Two centuries later, the Tower was complete. It's almost 200 feet tall and 55 feet wide, weighing 14,000 tons. It leans at a 5-degree angle—15 feet off the vertical axis.

The style of the Tower is dubbed "Pisan Romanesque." Traditional Romanesque has a heavy fortress feel, but the Tower is light and elegant. Slender columns support tightly spaced arches, seeming to drape the massive Tower in a coat of delicate lace. The Tower and its accompanying church and baptistery are of brilliant white marble, scattered across a golf course–green lawn called the "Field of Miracles." (Lining this field of artistic pearls is a gauntlet of Europe's tackiest souvenir stands, as well as dozens of amateur mimes "propping up" the Leaning Tower as their friends take photos.)

For centuries, many experts tried to stop the Tower's slow-motion fall, but none succeeded. It got so bad that it was closed for repairs in 1990. Engineers have stabilized the Tower, and once again, it's open to the climbing public.

Brançion Church, 12th century (Brançion, France).

springing from grand columns were often decorated by geometric zigzags. Great tunnel-like barrel vaults created a dramatic visual effect, drawing worshippers to the altar. Often each column was crowned by a capital that had a unique and fanciful design—usually hiding playful or ghoulish creatures. The stout walls required to support the stone vaults or roofs meant the interiors were dark. Interiors were made more spacious and light by interrupting the long tunnel-like nave with a transept, which created a cross-shaped building.

huge problem, wooden rooftops were now made of stone...fireproof.

There was a new confidence as people saw a promising future and built for it. Across Europe, entire communities mobilized to build the grandest structures seen since Roman times. Romanesque churches were powerful and stately, like fortresses of God. And, like fortresses, they had thick walls, squat towers, few windows, dark interiors, and a minimum of decoration.

As you tour a Romanesque church, it helps to know a few architectural terms. A ceiling that arches overhead is called a "vault." A "barrel" vault creates a tunnel effect. A "groin" vault is made when two arches crisscross at right angles. A "rib" vault features a structural skeleton of arches supporting the rest of the stone.

The overall effect was one of massiveness and strength. And Romanesque architects gave these huge stone buildings style and character. Arches

The Romanesque period saw a revival of sculpture as part of the architecture. In earlier centuries, churches were decorated by surface carving and low reliefs, but free-standing sculpture was almost nonexistent. Now Bible figures stood in higher relief. Statues filled niches and decorated the west facade (the grand, often ornate main entrance) playing essentially the same role as the statue groups carved into the pediments of Greek temples.

The Romanesque tympanum (carved semicircular area over the doorway) welcomed and prepared the faithful as they entered their church. Throughout Europe it was often the same scene. You'll see it everywhere: The second coming of Christ, the king and judge...

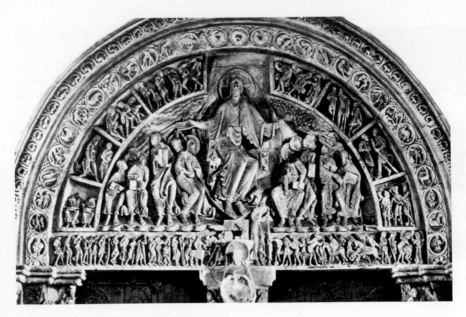

Tympanum, Basilica of Ste. Madeleine, 1104 (Vézelay, France).
A Romanesque church's most interesting art is generally in the semicircular tympanum above the grand doors. Notice how cluttered these narrative reliefs look—a far cry from the bold, freestanding statues of ancient Greece and Rome, and coming Renaissance.

sitting triumphantly on a throne surrounded by saints. It's Judgment Day. An angel is weighing the mortal souls. Below, graveyards are emptied as the good (relieved) are going to heaven and the bad (terrified) are going straight to hell. A wonderful creativity vents itself in the spooky scenes surrounding the damned. And the Church often injected a little politics here, showing people from all walks of life—kings, nobles, priests, knights, and fancy merchants, as well as peasants—cooking together in the devil's cauldron.

Gothic Architecture (1150–1400)

The interiors of Europe's magnificent Gothic cathedrals make it clear there's nothing dark about the High Middle Ages. Gothic churches are tall, spacious, and filled with the light of heaven. Centered in rich, stable northern France, the Gothic style replaced the gloomy,

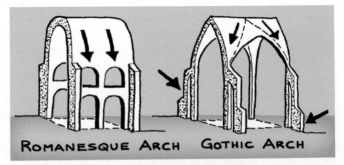

With round arches, the weight pushes down (requiring strong walls). With pointed arches, the weight pushes out (requiring strong buttresses).

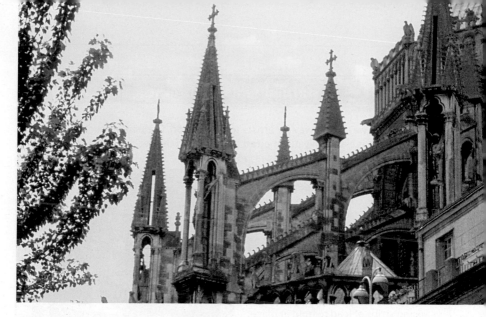

Flying buttresses—like these, at Paris' Notre-Dame Cathedral —freed up even more wall space for stained-glass windows.

heavy Romanesque churches with a new and exciting lightness and grace.

Gothic architects allowed churches to soar higher than ever by devising an ingenious skeleton of support. The key was using pointed arches rather than the round Roman arch of the Romanesque style. With a round arch, the weight of the massive stone roof sits squarely on the wall, so the wall must be very stout; these thick walls can support only small windows. But with pointed arches, the weight from the roof is directed out rather than down, making it possible to have larger windows and thinner, more graceful walls.

Gothic architects—masters at playing architectural forces against each other—reinforced the walls with buttresses to support the weight of the roof. They even went one step further than buttresses, inventing the so-called "flying" buttresses. These stood away from the walls but supported them,

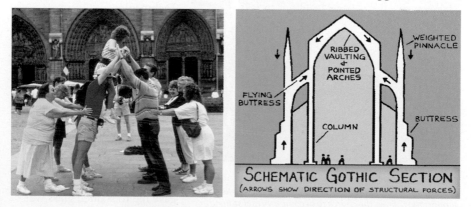

It takes 13 tourists to build a Gothic church: six columns, six buttresses, and one steeple.

Stained Glass Supreme

Stained glass was a new way for artists to glorify God. Craftsmen made glass—which is essentially just melted sand—using this recipe:

- Melt one part sand with two parts wood ash.
- Mix in oxidized metals to get different colors: Iron makes red, cobalt makes blue, copper green, manganese purple, cadmium yellow.
- Blow glass into a cylinder shape, cut lengthwise, and lay flat.
- Cut into pieces with an iron tool, or by heating and cooling a select spot to make it crack.
- Fit pieces together to form a figure, using strips of lead to hold in place.
- Place masterpiece so high on a wall that no one can read it.

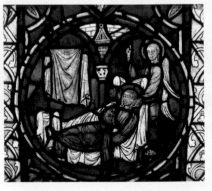

with bridges of stone pushing (or "flying") up against the outside of the church.

Inside, the Gothic church is supported by a sturdy network of columns that become pointed ribs

Sainte-Chapelle (supine view), 1246–1248 (Paris). *In pure Gothic, simple lines show the architectural skeleton of support that allows the church to become a virtual stained-glass lantern.*

coming together in crisscross patterns at the top of the roof (the area between the columns and ribs is just filler). Because the walls have hardly any structural, weight-bearing function, they created a new medium for artists: glorious stained-glass windows. Christians could now worship in cathedrals of light, bathed in glorious Technicolor.

"Let there be light." God's first words from the Bible show that light is divine. Abbot Suger, who "invented" the Gothic style in 1144 at St. Denis (just outside Paris—rebuilt and not worth visiting), wanted to create a cathedral of light. To medieval Christians, the way light animated and gave life to stained glass was a reflection of the way that

God animated and gave life to the world.

Gothic churches were the largest economic enterprises of Europe in the Middle Ages, and an unprecedented technical accomplishment. They were the life's work of entire communities, a labor of spiritual love supported by rich and poor alike that took generations to build—the very embodiment of spiritual dedication. Master masons supervised, but ordinary people did much of the grunt work for free, hauling huge stones from distant quarries, digging the 30-foot-deep trench for the foundation, and taking turns treading on the hamster-wheel that propelled the pulley system that lifted the enormous stones into place, one by one. Imagine the faith of the people who built Notre-Dame in Paris: They broke ground in 1163, hoping that one day their great-great-great-great-great-great grandchildren might attend the dedication ceremonies two centuries later.

Working in the Gothic style involved tremendous competition. Architects, sculptors, and painters traveled all over

King's College Chapel, 1446–1515 (Cambridge, England). *In this Perpendicular Gothic church, nearly all the wall space is devoted to brilliant stained glass. The essential ribbing on the ceiling is decorated with purely ornamental riblets, aptly called fan vaulting.*

Milan Duomo, 1386–1809 (Milan, Italy). *A stroll on the rooftop of Milan's Cathedral puts you amid the "flames" of Flamboyant Gothic.*

A Few Favorite Gothic Churches

Siena Duomo, 1215–1263 (Siena, Italy).
While they didn't soar as high as French Gothic, Italian Gothic churches wowed the faithful with ornate facades.

Reims Cathedral, 1211–1311 (Reims, France).
Through the centuries this has been the place French kings were crowned. Today it's most visited for its strikingly modern stained glass by Marc Chagall.

Milan Duomo, 1386–1809 (Milan, Italy).
With its forest of fancy columns, spires, and statues, Milan's cathedral is a textbook example of Flamboyant Gothic.

Notre-Dame Cathedral, 1163–1345 (Paris, France). *Notre-Dame comes with all the Gothic trademarks: taller spire, pointed arches, more windows, lighter interior.*

Sainte-Chapelle, 1242–1248 (Paris, France). *Built to house the crown of thorns, the interior of this church, with its vast expanses of stained glass, is a brilliant example of how Gothic created "cathedrals of light."*

Köln Cathedral, 1248–1880 (Cologne, Germany). *Germany's greatest Gothic church towers to the heavens and is much visited for both its precious relics and fine art.*

Europe to compare and study new churches, ensuring that Gothic church design was remarkably consistent. However, there were regional variations. In Norway, churches were made of wood with Viking ornamentation. In Italy, Gothic churches were shorter and more horizontal, perhaps in keeping with Italy's strong classical roots. This style is particularly evident in the great Italian Gothic cathedrals of Florence (capped by Renaissance domes), Siena, and Orvieto—not so tall, no flying buttresses, and more likely to please a Caesar. These churches make up for their stubbiness by sporting more colorfully decorated facades.

Gothic evolved. Over time, the basic support ribs became more elaborate and decorative. The crisscross arches on ceilings—an important structural element—were increasingly ornamented with a web of decorative arches, forming decorative fan-like patterns, often covered in gold. Stained-glass windows were set into intricate stone tracery. The last, most overripe stage in Gothic is called "Flamboyant," (or "flame-like"), with prickly pinnacles that make churches seem to flicker with spiritual radiance. You'll see the English version of Flamboyant Gothic, called

Perpendicular Gothic, in the fan-vaulted ceiling of the Henry VII Chapel of London's Westminster Abbey and at King's College Chapel in Cambridge (pictured on page 129).

Gothic Art: Painting and Sculpture

There was more to a Gothic church than its architecture. There was a delight in things of beauty. Abbot Suger's favorite saying, "Man may rise to an understanding of the divine through the senses," is the intellectual basis of the Gothic love of beautiful things. Church sacristies and museums are filled with finely carved and inlaid works of Gothic art.

Gothic sculpture protrudes

"**Norwegian Gothic.**" *Scandinavia was Christianized in the Middle Ages. Employing their ship-building techniques, lumber from their vast forests, and crude Viking-style dragon ornamentation, 12th- and 13th-century Norwegians created their own "wooden Gothic" stave churches. In 1300, Norway had about 800 of these churches. Highly flammable, only 28 have survived to modern times.*

Notre-Dame, 1163–1345 (Paris, France).
Notre-Dame's Gothic entrance honors St. Denis, a third-century Christian martyr. Denis defied the Roman authorities, so they chopped his head off. But those early Christians were hard to keep down. Denis got up, tucked his head under his arm, and walked away. He didn't stop until he found just the right place to meet his maker.

from the wall and shows a sense of calm, orderly composure. In contrast, Romanesque sculpture is cluttered, embedded deep in church walls and niches, and tells a story. Still, Gothic carvings are symbolic rather than realistic, and the sculpture remains supportive of the architecture—much different than the bold, freestanding works of the Renaissance.

No stone was left uncarved in decorating Gothic churches, whether statues in niches, tympanum arches over doorways, columns and capitals, pulpits, prayer chapels, or decorative gargoyles. No longer just pillars with faces, Gothic sculpture was more natural. The clothes drape naturally over the body, and the faces have personality and emotion. But this was still a sermon in stone, and every piece of sculpture had a symbolic message.

Painting still served the Church,

but there were hints of a budding realism. Saints, angels, and biblical characters are taken out of their gold-background heaven and placed here in the real world of rocks, trees, and sky. There are real people and early attempts at real emotions. Mary faints. Saints furrow their brows. And angels weep. Still, the 3-D perspective is crude. Painting a 3-D world on a 2-D surface is tough, and after a millennium of relative darkness, artists were rusty.

A Gothic church was carefully designed to be, and usually still is, a place of worship and not a museum. If you think of it as just a dead building to wander through and photograph, you'll see the nave but miss the boat. To best experience a Gothic church, see it in action and attend a service. Gothic cathedrals are especially exciting when filled with music. Attend a

Castles

While you can find castles throughout Europe, you'll enjoy the best concentration of medieval ramparts and dark dungeons by touring the Rhine in Germany or Wales in Britain.

On the Rhine

Ever since Roman times, when this was the Empire's northern boundary, the Rhine has been one of the world's busiest shipping rivers. These days, you'll see a steady flow of barges with 1,000- to 2,000-ton loads. While today tourist-packed buses, hot train tracks, and highways line both banks, in medieval times the safe way to travel was on (rather than along) the river.

The river is lined every few miles with dramatic castles on hilltops. Why so many? Many were "robber baron" castles, put there by petty rulers to levy tolls on passing river traffic. (In medieval times, Germany—the size of Montana—was fragmented into scores of independent little "countries.") A robber baron would put his castle on, or even in, the river. Then, often with the help of chains and a tower on the opposite bank, he'd stop each ship and get his toll. There were 10 customs stops along the 50-mile stretch of river between Mainz and Koblenz alone.

Most Rhine castles date from the 11th, 12th, and 13th centuries. Some were built to control and protect settlements, and others were the residences of kings. As times changed, so did the lifestyles of the rich and feudal. Many castles were abandoned for more comfortable mansions in the towns.

Many of the Rhine's mightiest castles were destroyed by the French not during war time but during peace time. (They didn't like the existence of such

*In the Middle Ages, mighty castles were built along rivers to levy tolls on passing ships. The Rhine has many such "robber baron" castles, including the small **Pfalz Castle**, which is actually built on the river. As a ship approached, it would hoist its chains. No pay...no pass.*

mighty fortressses on their border if war did break out. Call it "pre-emption.") And many Rhine castles were rebuilt in neo-Gothic style in the Romantic Age (the late 1800s) and are enjoyed today as restaurants, hotels, hostels, and museums. In fact, castles were both built and rebuilt throughout Europe in the Romantic Age—generally in a fanciful style with pointier spires and extra turrets exaggerating their "Gothic-ness."

In Wales

You'll find more great castles per square mile in northern Wales than just about anywhere else in Europe. There's a reason. In the 13th century, the Welsh, under two great princes named Llywelyn, created a united and independent Wales. The English King Edward I fought hard to end this Welsh sovereignty. In 1282 Llywelyn II was killed (and went to that place where everyone speaks Welsh). For the next 20 years, King Edward built or rebuilt an "Iron ring" of 17 great castles to consolidate his English foothold in troublesome North Wales. These were English islands in the middle of angry Wales. Most were built with a fortified grid-plan town attached and were filled with English settlers. (With this blatant abuse of Wales, you have to wonder, where was Greenpeace 700 years ago?)

The greatest of the castles (such as Conwy Castle) were masterpieces of medieval engineering, with round towers (tough to undermine by tunneling), a castle-within-a-castle defense (giving defenders a place to retreat and wreak havoc on the advancing enemy...or just wait for reinforcements), and sea access (safe to bring in boats to reinforce and restock).

*Built by King Edward I, **Conwy Castle** provided an English "Green Zone" amidst an angry Welsh insurgency.*

concert or enjoy an "evensong" service. Meditate, cup your hands behind your ears, and catch every echo as the music fills the church. Follow the praying hands of the arches with your eyes. Be dazzled by the warm light that bathes the interior in heavenly color.

Castles and Sieges

Medieval warfare was like a tortoise fighting a stone: Impregnable castles dotted Europe's landscape, so war was a drawn-out, costly struggle as one side laid siege to the other. The only good thing to be said was that casualties were few and far between. Boredom was the common enemy of attacker and defender.

Human battering rams were no match for the heavy doors of Europe's great castles.

The earliest castles were little more than a stockade on a hill, surrounded by a river. Later, stockades became stone walls and ditches became moats, and the castle we know took shape.

The typical castle was a simple stone building ("keep") on a hill ("motte"), surrounded by a wall that enclosed a yard (or "bailey") where the people lived. This mound-and-yard (or "motte-and-bailey") pattern was the basis of all medieval castles. Later castles were much bigger, with more rings of walls as much as 20 feet thick, once whitewashed and gleaming in the sun, flags flying high.

Outside the wall there was often a moat, a ditch filled with water (they put alligators in them only in fairy tales). The main gate was made of oak, plated with iron, and often protected by a portcullis, or iron grill. Above the gate were small windows for shooting at the enemy. The castle courtyard was like a small village, with a bakery, pharmacy, herb garden, livestock, a well, and even a brewery. During peacetime, a few hundred people lived here. But during wartime, as many as several thousand peasants would pack inside the walls, hoping to have enough provisions to outwait their attackers. The keep was the headquarters and home of the lord, and it was used as a dining hall,

The earliest crude and simple "motte-and-bailey" castles evolved into the mighty and complex stone fortresses tourists explore today.

*Germany's **Cochem Castle** is a classic—crowning an easy-to-defend hill above its town, and on a river (main medieval trade route). Visitors often think they've found the ideal medieval castle, not realizing that it —like so many others—was thoroughly rebuilt in the over-the-top, super-pointy Romantic style of the 19th century.*

ballroom, and as a last bastion when the outer walls fell in an attack.

Making war against such a formidable structure required a long, boring, starve-'em-out siege. The attacking army's main weapon was hunger, so they simply camped around the castle and waited for supplies to run out. This often took years, and given the poor communication and supply lines of the period, the attacker might well run out of supplies before the defenders.

The patience of military men has always been thin, so they developed a number of ingenious weapons to skip the long siege. Catapults, powered by tension or counterweights, lobbed huge boulders, red-hot irons, or rotten animal corpses over the walls. Under cover of archers armed with crossbows and six-foot longbows, armies would approach the castle and fill the moat with dirt or dig under the walls to undermine the foundations. They hammered at weak points in the wall and gate with a wood-and-iron battering ram. Finally, armed men would wheel up the "storming towers" (made of wood, covered with fire-resistant wet hides) and use them to scramble over the walls.

Meanwhile, the defenders inside gathered on the turrets to pour scalding water, oil, or pitch onto the invaders. Archers fired arrows, flung rocks, and hurled insults. Others were stationed along the walls to overturn ladders and

Europe's Top Castles

Salzburg Castle in Austria was so formidable it was never attacked (except by 21st-century tour groups).

Mighty and imposing **Burg Eltz,** hiding in the hills a short hike from the Mosel River, has Germany's best castle interior. The castle is still owned by its noble family, who puts out fresh flowers each week for the castle's many visitors. Note that in the German-speaking world, a Burg is generally a defensive fortress, while a Schloss is mainly a showy palace.

Château de Chillon sits regally on Lake Geneva, on Switzerland's southern border with France. It's a fairy-tale castle...unless you're imprisoned in its dungeon. The Romantic poet Lord Byron wrote his classic poem "The Prisoner of Chillon" after visiting the castle and hearing stories of its most famous prisoner.

Château de Chambord, in France's Loire Valley, was built after medieval times. Gunpowder had rendered medieval castles obsolete as military strongholds, and later rulers lived In pleasure palaces like this. Chambord was essentially a royal hunting lodge...with 440 rooms and 365 fireplaces.

Carcassonne, in southwestern France, is Europe's greatest medieval fortress city.

Kalmar Castle, strategically located on Sweden's east coast (south of Stockholm), evokes a time when Sweden was a well-armed superpower among European nations.

Other Favorite Castles

- **Rheinfels, Marksburg,** and a chorus line of other castles on the Rhine River, Germany
- **Reifenstein,** Vipiteno, Italy
- **Tower of London,** London, Britain
- **Warwick Castle,** Warwick, Britain
- **Caernarfon, Caerphilly, Conwy, Harlech, Beaumaris,** and **Criccieth,** all in Wales, Britain
- **Beynac,** Dordogne, France

When touring the castles and marveling at the suits of armor of medieval Europe, remember they came with people inside fighting for their lives. You'll see dented helmets, pierced chest plates, and cracked skulls. As the museum inscription says: "A skull wounded by a blow from a battleaxe or heavy sword....This one shows no trace of healing, and there can be no doubt that death must have occurred almost at once."

storm towers. Once attackers got inside the castle, fierce hand-to-hand combat sometimes ensued, but more likely, the defenders simply retreated behind the next inner wall, a "castle-within-a-castle" defense. If all else failed, they'd retreat to the keep, the bastion of last defense... starting the process all over again.

Warfare changed dramatically with the invention of gunpowder. When the Turks besieged Constantinople in 1453, they had a new weapon: a 19-ton cannon that fired 1,500-pound rocks more than a mile in the air. Within a century, the siege style

of warfare that had gone on almost unchanged for 2,000 years was a thing of the past. While medieval castles stood tall—proudly impregnable— later castles (built in the age of tower-busting artillery), hunker down.

Many of the castles you'll see in Europe today never had a strategic military function at all. After 1500, lords built castle-forts for protection and castle-palaces for domestic life. In the Romantic era of the 1800s, many castles, like those of Bavaria's "Mad" King Ludwig II, had no practical purpose and were merely fantasy abodes (see page 327). Today they're tourist attractions.

Knights, Ladies, Love, and War

King Arthur and the Knights of the Round Table (Lancelot, Galahad, Percival, and company) are the ideal of medieval life, when men were always chivalrous and women were always worthy of honor (and kidnapped by dragons). Even though Arthur and the knights are actually a fiction based on a minor historical figure, the myth played a big role in medieval thinking.

Knights of the Middle Ages followed an unwritten code of honor and chivalry that demanded valor in battle and service to their king, God, and ladylove. Originally intended for knights alone, it was quickly accepted by all nobility in Europe, whose lives revolved around war, religion, and loyalty to their masters.

However, despite this lofty code of honor, most knights were mercenary soldiers of fortune who sold their fighting skills to the highest bidder in return for land, a title, or money. Knights on horseback were much

more important than the average foot soldier. With the invention of stirrups, the rider could dig in and put more weight behind the lance he carried, so a single knight could charge and break the ranks of dozens of foot soldiers. Dressed in a heavily armored suit (so heavy that if he fell off, he was as helpless as a turtle on its back), a mounted knight was like a tank among infantry.

When there were no real wars to test their courage and skill, knights held tournaments, fighting each other individually or in teams. The most common event, the joust, sent two knights charging at each other on horseback, determined to unseat the other with a lance. Not surprisingly, many knights died in these "sporting"

contests, so an attempt was eventually made to try to minimize injury by using blunted or wooden weapons, saving the sport but diminishing the danger (like modern fencing). Still, as late as 1559, France lost a king (Henry II) when a wooden splinter pierced his visor during a joust.

The heroic deeds of knighthood were proclaimed in story and song by troubadours, wandering singer-storytellers of the Middle Ages. They entertained Europe's nobles with a combination of stirring fables, love songs on the lute, juggling, and stand-up comedy routines. In fact, the King Arthur legends were virtually invented by troubadours in the 1100s. But these tales created an ideal world of loving knights and lovely ladies that set the pattern of behavior for medieval nobility.

The "Real Camelot": Henry, Eleanor, and Courtly Love

The closest Europe ever came to a "real Camelot" was the court of King Henry II and Queen Eleanor of Aquitaine, rulers of a united England and France during the short-lived Angevin Empire (1150–1200). Henry was the perfect Arthur: strong and intelligent, with a dominating personality. Eleanor was the refined, strong-willed, and beautiful Guinevere, with a healthy dose of political savvy thrown in. Their son Richard the Lionhearted had, by contemporary accounts, the attributes of all the Knights of the Round Table rolled into one. Their court was Europe's center for troubadours and young knights, who spent their days jousting and their nights under the stars listening to stories and songs.

The Battle of Hastings

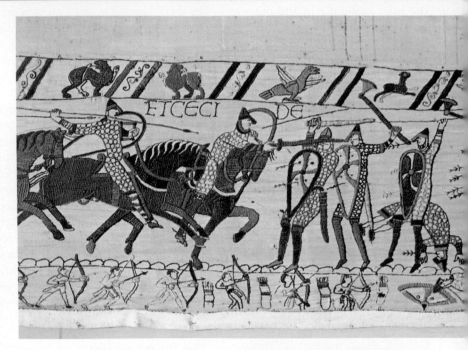

Knights weren't just about tournaments and chivalry—they were fighters, too. Europe's Middle Ages had epic, *Lord of the Rings*–style battles. And the most epic of all took place on the most memorable date of the Middle Ages: October 14, 1066. It was the pivotal Battle of Hastings, which came about because the celibate King Edward the Confessor of England had died without an heir, and two nobles claimed the throne.

Harold of England was chosen king by the traditional council, but his support was weak. Meanwhile, across the English Channel, William, Duke of Normandy, also claimed the throne. As the descendant of Vikings who'd once settled England (see page 96), William claimed he had royal blood. His enemies called him William the Bastard, because his mother was the Duke of Normandy's mistress.

William patiently assembled and trained a large army and sailed across the Channel. Harold raced south to meet him, his own army exhausted from battling enemies in the north. Near the town of Hastings in southern England, Harold formed his troops into a wall atop the highest hill and waited for William.

Early in the morning of October 14th, the Norman soldiers trudged up the hill, and the battle was on. It was a three-stage attack. First, archers rained arrows on the English. Next, foot soldiers attacked hand-to-hand. And finally, Norman soldiers on horseback charged, armed with a secret weapon—

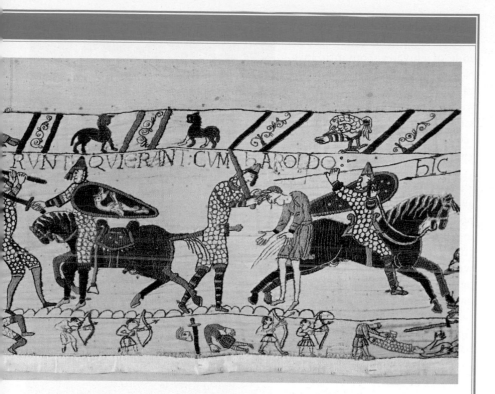

Bayeux Tapestry (detail), *c.* 1080 (Tapestry Museum, Bayeux, France). *King Harold's army is fiercely attacked and annihilated. This 900-year-old embroidery tells the story of the Battle of Hastings. Bayeux, where the tapestry is displayed, is a pleasant Normandy town just two hours by train from Paris.*

stirrups—which gave them a foothold to put force behind their lances. The two sides fought a fierce 14-hour battle, with heavy casualties. When Harold was killed, his demoralized forces broke ranks and were routed. William—now "the Conqueror"—marched on to London, where he was crowned King of England in Westminster Abbey on Christmas Day, 1066.

The Norman Conquest of England propelled the isolated isle of Britain into the European mainstream. William centralized the government and brought the Romanesque style of architecture (e.g., the White Tower at the Tower of London, and Durham Cathedral) that the English call "Norman." Historians speculate that, were it not for the stirrup, England would have remained on the fringe of Europe (like Scandinavia), French culture and language would have prevailed in the New World...and you'd be reading this book today in French. *Sacre bleu!* William's conquest also muddied the political waters, setting in motion 400 years of conflict between England and France that would not be resolved until the end of the Hundred Years' War in 1453.

It was here that a new element was added to the old warrior's code of chivalry: romantic love. Now the knight not only had to be valiant in war, but gentle in love as well, serving his lady as well as his king. The new code was known as "courtly love" (not to be confused with Courtney Love).

Love was a radical notion in a society where marriages were arranged by parents for money, political alliance, and social standing. It was the brainchild of highly educated ladies of the court who were tired of being treated as bargaining chips in the marriage game. They insisted that both parties, the man and the woman, had to consent in order for a marriage to be valid.

Queen Eleanor knew firsthand what an arranged marriage was like. She and Henry had been married to bring political unity to their respective kingdoms. Then Henry took a mistress (no big deal) and insisted on being seen with her in public (big deal).

The Lady and the Unicorn tapestry, c. 1490 (Cluny Museum, Paris).
You'll see tapestries all over Europe. In the High Middle Ages, they hung on walls, warming and decorating stone palaces and churches.

Queen Eleanor and her court drew up "rules" of love to "educate" young men about how they should act toward the ladies. Knights had to give up their baser passions, thinking always of what would please their beloveds. The new code demanded that the knight serve his lady first, even before God and king. In tournaments and battles, it was customary for the knight to wear a token from the lady, perhaps a handkerchief or a flower.

Troubadours' songs *(chansons d'amour)* were all about unconsummated love. The knight is head over heels for the lady but, alas, she is married or somehow beyond his reach. Nevertheless, the knight accepts this hopeless situation, pining for his true love and doing all in his power to please her, while knowing she can never be his. The songs alternate between the ecstasy of love and the bitterness of longing.

Historical fact shatters any illusions that Henry and Eleanor created a real-life Camelot, but the ideals of chivalry lived on long after knights on horseback were valuable soldiers.

How to Win a Maiden

Here are a few of the court's "Twelve Rules of Love" (from a 12th century book, *The Art of Courtly Love*):

- Marrying for money should be avoided like a deadly pestilence
- Thou shalt keep thyself chaste for the sake of thy beloved (a radical idea for the time)
- In practicing the solaces of love, thou shalt not exceed the desires of thy lover
- Thou shalt not be a revealer of love affairs
- Thou shalt be in all things polite and courteous
- Thou shalt be obedient in all things to the command of ladies, and strive in the service of Love

(By the 20th century, singer Paul McCartney—who actually sang, "I'm a lover, not a fighter"—was even knighted.) The duel replaced the tournament as a test of courage. Chivalry became a code of raised-pinky manners. The word "chivalry" itself, which is Latin for "horseman," became the word for "gentleman" in several languages: French *chevalier*, Spanish *caballero*, Italian *cavaliere*.

The **chastity belt** was another kind of fortification commonly used during the Crusades. Some women chose to wear these, not to appease their jealous husbands away on Crusades, but to protect themselves while their men were away.

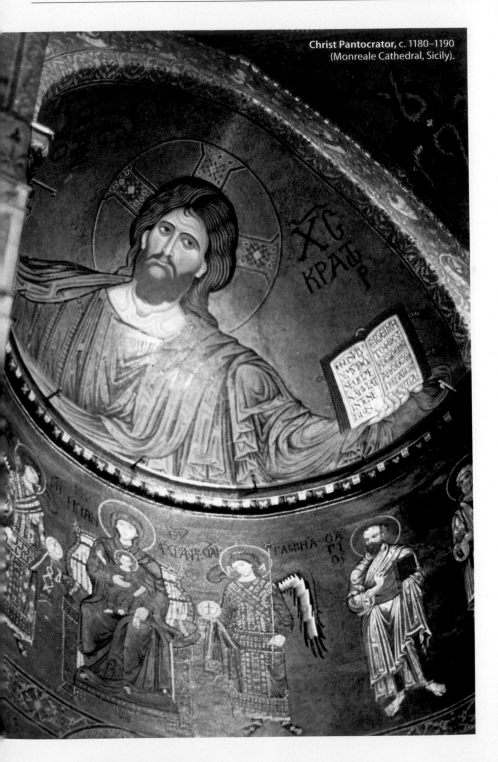

Christ Pantocrator, c. 1180–1190
(Monreale Cathedral, Sicily).

Medieval-style chivalry was dealt a satiric blow in literature by Miguel de Cervantes, creator of the tragicomic fictional main character of Don Quixote (written in 1610). Ridiculed by his contemporaries, Don Quixote holds fast to the old ideals, jousting with windmills when there are no other true knights left to fight.

The Age of Faith

European society of the 12th century was devoted to the Christian faith. It inspired knights to undertake the formidable Crusades, artists to re-create heaven in paintings and stained glass, and architects to build skyscraping cathedrals filled with the mystic light of heaven. They aimed for a golden age, blending faith and reason.

Riding the crest of the spiritual revival, a series of energetic popes reformed the Catholic Church, the monasteries, and communications networks, establishing the papacy as a political power to rival the kings. In many ways, the medieval Church operated like a nation without borders. It was Europe's greatest landowner, taxing through tithes, influencing political decisions on all levels, and attracting talented men to work in its service.

At Europe's budding universities, Christian theologians rediscovered the writings of classical, non-Christian philosophers. They used Aristotle's logic to analyze Church pronouncements— a system called "scholasticism" that saw no conflict between religious faith and human reason.

In France, a humble band of monks grew into a powerful spiritual and political entity. The Abbey of Cluny got its start as a reforming mon-astery (in 910), returning to the humility and poverty of the sixth-century Benedictines. It inspired a new interest in monasticism that swept through Europe. By the 12th century, there was a Europe-wide chain of Cluny franchise monasteries, all taking orders from the Abbot in Cluny. The Abbot answered only to the pope (not to the local bishop or secular leader), making him and the pope the two most powerful people in Europe. The Cluniacs convinced Europe's noble class to will their lands to their monastic order in return for perpetual prayers for their noble, yet needy and frightened souls. With all that income, a huge church built at Cluny functioned as the headquarters of 10,000 monks who ran almost a thousand monasteries and priories across Europe.

Church power swung like a big pendulum. When the church again became too rich and corrupt, there was a second wave of reform in the 13th century. Devout Christians flocked to monasteries in the countryside to focus on simplicity and poverty. Two brand-new orders, the Dominicans and Franciscans, rose in the 13th century.

The Dominican order, founded by St. Dominic in 1215, was a mobile army of monks whose mission was to preach Church doctrine wherever the pope felt they were needed. Their unswerving faith landed them unsavory tasks: St. Dominic and his troops tried to convert heretical groups such as the Cathars in southern France, and also managed the Inquisition. Today Dominicans focus on contemplation, study, and preaching. The many Dominican churches you'll see

throughout Europe are easy to recog-
nize by their simplicity.

St. Francis of Assisi (1182?–1226)

In about the year 1200, a simple yet
visionary and charismatic monk—St.
Francis of Assisi—caused a stir by chal-
lenging the decadence of Church gov-
ernment and society in general.

In 1206, a vision changed young
Francis' life, culminating in a dramatic
confrontation. He stripped naked
before the town leaders and threw his
clothes at his father, a wealthy mer-
chant. Turning his back on the com-
fortable material life, Francis donned
a simple brown robe and declared his
loyalty to God alone.

Adopting the poor, wandering
lifestyle of Jesus Christ, he preached a
message of non-materialism, love, and
a "slow down and smell God's roses"
lifestyle. In an Italy torn by Crusades
and feuding between towns and fami-
lies, Francis promoted peace and the
restoration of order. He set an example

Giotto, **St. Francis Receiving the Stigmata** (detail), c. 1300 (Basilica of St. Francis, Assisi, Italy).
*In this fresco, St. Francis receives the stigmata—five marks simulating the wounds of Christ. These
marks are thought to appear spontaneously on people of extraordinary faith.*

Basilica of St. Francis, 1228–1253 (Assisi, Italy). *A grand basilica honors a simple monk. Under reams of Giotti frescoes, you'll find the much-venerated tomb of St. Francis.*

Even determined Dominicans and Franciscans dressed in sackcloth couldn't resist the riches and power their popularity brought. Imagine the rich mortals of Europe throwing their wealth at austere monks in hopes of a better chance at salvation...what a headache for an ascetic.

The Roman Church was still Catholic (or universal), but the flock was tough to keep together.

by reconstructing a crumbled chapel.

Francis became a cult figure, attracting huge crowds. People had never seen anything like him—he preached sermons outdoors and in the local language (not Latin), making God accessible to all.

Idealistic young men flocked to join the beloved hippie of Assisi, and they wandered Italy like troubadours, spreading the joy of the Gospels to rich and poor. These "Franciscans" grew into a huge monastic order. Known as the Jugglers of God, they became a joyful part of the community and re-energized the Church. Eventually, even the pope embraced (some would say co-opted) the once-radical movement. Francis died and was buried in Assisi, leaving a legacy of humanism, equality, and love of nature that helped fertilize the cultural soil in which the Renaissance would take root. In 1939, Italy made Francis its patron saint.

The Heretical Cathars

The Church had to battle so-called "heretics," whose unorthodox beliefs threatened Church unity. Their weapon? The Inquisition. Started by Pope Gregory IX in 1231 to combat the "enemies of the Church," this network of Church courts tried and punished heretics and sinners, ranging from witches, devil worshippers, and adulterers to Jews, Muslims, and unorthodox Christians. Any Christian who worshipped outside of Roman Catholic dictates could be targeted. Later, the pope legalized the use of torture to "encourage" confessions. Among the Church's enemies were the Cathars.

The Cathars were a heretical group of Christians based in Languedoc (southern France) from the 11th through the 13th centuries. They saw life as a battle between good (the spiritual) and bad (the material). They considered material things evil, works of the devil. Cathars focused on the

*In Languedoc (southwestern France), you'll find remains of castles once used by the Cathars. The most dramatic is this one, **Peyrepertuse.***

teachings of St. John and recognized only baptism as a sacrament. Because they believed in reincarnation, they were vegetarians. While others called them "Cathars" (from the Greek word for "pure") or "Albigensians" (for their main city, Albi), they called themselves simply "friends of God."

Today, sightseers in Languedoc encounter the Cathars in the impressive castles they built during the Albigensian Crusades (1209–1240s), when the king of France wanted to consolidate his grip on southern France. The pope needed to make a strong point that the only acceptable kind of Christianity was the Roman kind. Both king and pope found self-serving reasons to wage a genocidal war against these people. After a terrible generation of torture and mass burnings, the last Cathar was burnt in 1321. Today tour-

ists find haunting castle ruins (once Cathar strongholds) high in the Pyrenees, and eat the hearty *salade Cathar.*

Popes vs. Kings

Throughout the Middle Ages, kings and princes played tug-of-war with popes and bishops for land, tax money, and power. Local kings and princes saw the rich and powerful Catholic Church as a meddler in their secular realm. Some feuded, while others shared power.

The conflict between pope and nobility came to a head in a battle of wills over who had the right to appoint bishops—a position of great power. King (Holy Roman Emperor) Henry IV of Germany miscalculated his place in the secular/sacred balance of power. Against Pope Gregory VII's wishes, he appointed a bishop in

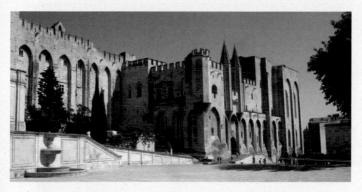

From 1309 to 1403, popes vacated the Vatican and ruled from the well-fortified **Palace of the Popes** in Avignon, France.

mansions for cardinals, residences for the entire Vatican bureaucracy, vast public squares, and the towering Palace of the Popes. For the next seven decades, the popes ruled from Avignon instead of Rome, as virtual puppets of the powerful French king. This period is known as The Babylonian Captivity.

his domain...and was then excommunicated. Despite his military might, Henry learned the hard lesson that his people only supported him so long as he was in good with the pope. Fighting for his political life, in 1077 he went to Canossa (in the Italian Alps) to beg forgiveness of the pope. The pope agreed to endorse Henry's Empire if Henry would use his armies to protect papal interests around Europe. (Ever since, Europeans say that a powerful person who finds himself humbled "went to Canossa.") The famous image of the otherwise mighty Holy Roman Emperor kneeling for hours in the snow outside Gregory's window reminded later leaders that the pope was supreme...at least for a while.

In the 14th century, the balance of power tipped the other way. The French King Philip IV—unhappy that the pope had threatened to excommunicate him—engineered the election of a Frenchman as pope. In 1309, Pope Clement V moved the papacy from Rome to Avignon, turning the city into a grand, fortified base for his power, by building a mighty wall,

In 1376, Catherine of Siena (later sainted) convinced Pope Gregory XI to return to Rome, but the French Connection was far from over. Gregory died, and an Italian was elected to replace him. Meanwhile, French cardinals met at Avignon and declared the election invalid, promptly electing a new pope who was—you'll never guess— a Frenchman. For 30 years, two rival popes ruled, one in Rome and one in Avignon, each one periodically excommunicating the other. No one knew whose ring to kiss. In 1409, an ecumenical council elected a third pope, creating an unwanted Holy Trinity. Finally, one pope was deposed, another resigned, and the third was dismissed, clearing the way for a single pope in 1417. The Great Western Schism (1378–1417), as the conflict was called, was finally healed.

The papacy finally returned to Rome, but the Schism damaged the authority and reputation of the Church. Increasingly, popes stuck to theological rather than temporal matters.

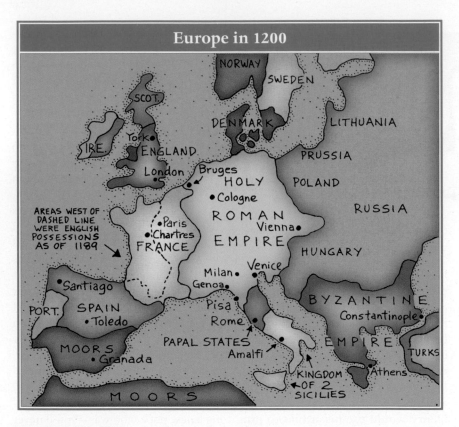

Europe in 1200

NORWAY
SWEDEN
SCOT.
DENMARK
LITHUANIA
York•
IRE. ENGLAND
PRUSSIA
London Bruges
HOLY POLAND
• Cologne
RUSSIA
AREAS WEST OF
DASHED LINE • Paris ROMAN
WERE ENGLISH Vienna•
POSSESSIONS • Chartres
AS OF 1189 FRANCE EMPIRE
 HUNGARY
 Venice
 Milan •
• Santiago Genoa•
 Pisa BYZANTINE
PORT. SPAIN Constantinople•
 • Toledo Rome •
MOORS PAPAL STATES EMPIRE
 • Granada Amalfi TURKS
 KINGDOM •Athens
 M O O R S ◄OF 2
 SICILIES

The Secular City

For more than 500 years, the Christian Church was the only wealthy, transnational organization in Europe. It dominated every aspect of European life—art, science, government, economy, and jurisprudence. But Europe would soon head down a more secular path.

Peasants were leaving their farms—and their feudal ties—and settling in self-governing, independent cities. This trend started in Italy, where sea-trading cities such as Venice, Genoa, Pisa, Naples, and Amalfi grew wealthy as middlemen between Europe and the East. In the north, the city of Bruges (in modern Belgium) served as the middleman in sea

trade between northern and southern Europe, and also became an economic powerhouse.

A new class emerged: middle-class businessmen, who manufactured goods and traded them. Trade spawned banking, and Europeans became capitalists, loaning money at interest to Europe's royalty.

In Italian cities, main squares began to feature not towering church spires, but the proud bell towers of city halls. They stood like exclamation points proclaiming the new humanist values sweeping through Europe, one of which was the notion that people could work together in communities to deal effectively with challenges. Slowly, secular community organizations

began to take on duties that, until then, the churches had assumed, such as caring for the sick and feeding the poor.

In the 1200s, a new phenomenon appeared in European cities: universities. Originally intended to teach theology, these centers of learning began embracing secular education. In these universities, scholars from across the Continent were able to come together and pool their knowledge, using Latin as a common language. They rediscovered the writings of classical non-Christian philosophers and began to study nature empirically, opening the door for scientific and philosophical concepts that had once been considered taboo or heretical.

Medieval theology had been founded on Augustine's notion of the "City of God"—that there is one Truth for both heaven and earth. Now, after 700 years of this, scholars turned their attention to the natural world, and the "City of Man" became as worthy of study as the City of God.

Robber Barons Become Bureaucrats

As feudalism gave way to urbanism, merchants clamored for government that was good for business. A cruise down the castle-lined Rhine River (each castle was a separate "kingdom" in its day) tells the story. In earlier times, a trading ship might have crossed dozens of "national" boundaries and paid dozens of customs duties just to take a load downstream (see sidebar on page 134). Businessmen welcomed a government that could keep the peace between feuding feudal nobles, and offer political stability, freer trade, uniform laws, coinage, and measurements.

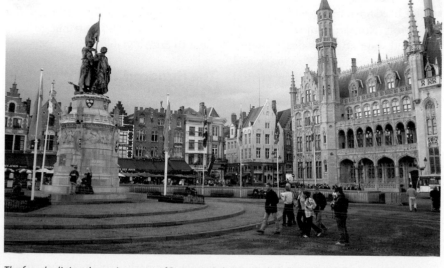

*The facades lining the main square of **Bruges** in Belgium recall the Middle Age days when it was a major trading power.*

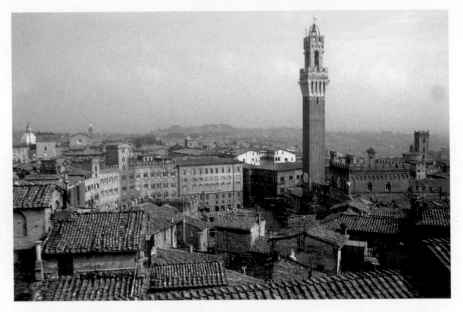

*The city-states of medieval Italy, such as **Siena**, were proud and independent. The biggest building overlooking Siena's main square is not a church steeple, but the city hall tower.*

The solution was larger political units, and the time was ripe for the emergence of Europe's large states.

The seeds of nations had been sowed by Charlemagne in A.D. 800. His "Holy Roman Empire"—which collapsed soon after his death—demonstrated the economic, military, and cultural advantages of a large central government.

A strong, long-lasting national government ultimately required a system of laws to prevent kings from becoming tyrants. In 1215, England's barons forced slimy King John (probably the evil King John in the Robin Hood legend) to sign the Magna Carta, the "Great Charter" that constitutionally guaranteed that the king was not above the law. This was the first shot in a long battle between kings and nobles—nobles who would later form the Parliaments in the new nation-states.

Ultimately, though, it was the demands of war that required bigger states. To survive, a country needed a large population and a strong government to raise a viable army.

The Hundred Years' War
(1337–1453)

For England and France, it took several generations of warfare to establish their identities as modern nation-states. Ever since the 1066 Battle of Hastings (described on page 142), France and England had had an uneasy relationship. In 1337, they began the Hundred Years' War to try to sort out who ruled what.

It would take about a hundred years to properly explain all the causes, battles, and political maneuverings of

Nations Without States

While we think of Europe as having fixed borders, there was a time when its ethnic make-up was in flux. Strong, warlike tribes moved around at will, grabbing desirable land and supplanting weaker tribes. In the fifth and sixth centuries, the Angles invaded Britain from the Continent—pushing the Celtic peoples, who were there first, to the island's least fertile corners. The nomadic Central Asian Magyars arrived in the Carpathian Basin (today's Hungary) in the late ninth century, and immediately began terrorizing the Slavs living there. At about the same time, the Norsemen (or "Normans") left their rocky Norway and settled in western France, trading their lutefisk and ale for tastier cheese and wine. Pushy, aggressive

Rampaging Magyars eventually became settled Hungarians.

newcomers made life so miserable for farmers in the Veneto region that they fled the Italian mainland and settled in the lagoon, establishing Venice.

As the stronger groups established the nations we know today (England, Hungary, France, Sweden, Italy, and so on), lines were drawn and smaller ethnic groups (Cornish, Britons, Basques, Catalans, and others) were left without their own land. When France and Spain drew the line that would form their border, they didn't bother to ask the Basques, whose lands were divided by that line, for their opinion. And when Austria lost the South Tirol to Italy after World War I, no one asked the German-speakers there how they felt either. All this turmoil left Europe with an ethnic make-up nowhere near as clean and concise as its modern political borders would indicate...and the predictable problems have spiced up our newscasts ever since.

the Hundred Years' War, but here's a quick summary: Before the era of the modern nation-state, the borders between France and England were fuzzy. Dukes and lords in both countries were aligned more along family lines than by national identity. French-speaking kings had ruled England, English kings owned the south of France, and English merchants dominated trade in the north. The French tried to horn in on the English wool

trade in Flanders, and English and French fishermen bickered over rights in the English Channel. Fueling the fire, the French supported the Scots in their fight with England. When the French king died without a male heir (1328), both French and English noble families claimed the crown, and the battle was on.

England, which had the biggest army in Europe, invaded France, the biggest and richest country in Europe.

Joan of Arc (1412–1431)

The cross-dressing teenager who rallied French soldiers to drive out English invaders was the illiterate daughter of a humble farmer. One summer day, in her dad's garden, 13-year-old Joan heard a heavenly voice accompanied by bright light. It was the first of several saints to talk to her during her short life.

In 1429, the young girl was instructed by the voices to save France from the English. Dressed in men's clothing, she traveled to see the king and predicted that the French armies would be defeated near Orleans. They were. Apparently King Charles VII was impressed by the teenage girl: He equipped her with an ancient sword and a banner saying "Jesus, Maria," and sent her to rally the troops.

Soon, "the Maid" *(la Pucelle)* was bivouacking amid rough soldiers, riding with them into battle, and suffering an arrow to the chest, while liberating the town of Orleans. On July 17, 1429, she held her banner high in the cathedral of Reims as Charles was officially proclaimed king of a resurgent France.

Joan and company next tried to retake Paris (1429), but the English held on. She suffered a crossbow wound through the thigh, and her reputation of invincibility was tarnished. During a battle at Compiegne (1430), she was captured and turned over to the English for 10,000 pounds. In Rouen, they chained her by

the neck inside an iron cage while the local French authorities (allied with the English) plotted against her. Inquisition authorities—insisting that Joan's voices were "false and diabolical"—tried and sentenced her as a witch and heretic.

On May 30, 1431, Joan of Arc was tied to a stake on Rouen's old market square. Then they lit the fire; she fixed her eyes on a crucifix and died chanting, "Jesus, Jesus, Jesus."

After her death, her place in history was slowly rehabilitated. French authorities proclaimed her trial illegal (1455), prominent writers and artists were inspired by her, and the Catholic Church finally beatified (1909) and canonized her (1920) as St. Joan of Arc.

The French resisted. Thanks to skilled archers using armor-penetrating longbows, England won big battles at Crécy (1346) and Poitiers (1356). The battle lines were always shifting, however: Local nobles from within France sided with England, and an army from Burgundy actually took Paris, captured the royal family, and recognized the English king as heir to the French throne. Despite an eventual truce, roving bands of English mercenaries stayed behind and looted French villages. The French responded with guerrilla tactics. Peasant rebellions against everyone in general added to

Time after time, great plagues swept across Europe, often leaving the majority of a town's population dead. In desperation, townsfolk made deals with God. If spared, they'd erect grandiose monuments of thanks. Today, these **plague columns** *(such as this one, in the Czech Republic) still decorate many town squares.*

the bloody mess.

In 1415, the English under Henry V scored a crucial victory at Agincourt, which gave England control of France from the Loire north. Things looked bleak for the French king, but he was aided by a young Joan of Arc, whose heavenly visions inspired the French to drive the invaders out. France lost most of its battles but won the war. Paris was liberated in 1436, and when Bordeaux fell to French forces (1453), the fighting ended without a treaty. England withdrew, the borders were settled, the two countries accepted the English Channel as their natural boundary, and England and France were on course to grow into modern nation-states.

The Bubonic Plague:
The Black Death

When was such a disaster ever seen? Even heard of? Houses were emptied, cities abandoned, countrysides untilled, fields heaped with corpses, and a vast, dreadful silence settled over all the world.
 —Petrarch, 14th-century Italian
 writer, who lived through the
 plague

The medieval equivalent of a nuclear holocaust, the bubonic plague—or "Black Death"—killed as many as one-third of Europe's people in three long years (1347–1350). The epidemic spread quickly, killed horribly, and then moved on, leaving whole cities devastated in its wake. The economic, physical, and emotional shock is unsurpassed in European history. Most saw the plague as not just a disease, but a heavenly

Hans Holbein, **The Danse Macabre.**
*Fourteenth-century Europeans believed everything was going to hell—which was an eternity
of people doing the chicken-dance.*

curse "sent down upon mankind for our correction by the just wrath of God." Whatever the cause, it killed with such power and swiftness that "the living could scarcely bury the dead."

In 1347, a Genoese ship landed in Sicily, carrying a deadly cargo: rats with the bacteria known as the bubonic plague. (The ship had become infected in Central Asia during battle, when a clever Mongol chieftain catapulted diseased animal corpses into the Genoese camp.) Within three years, the plague had spread through Italy, France, and most of Europe. An estimated 30 million Europeans died.

The disease is caused by a bacteria carried by fleas (which travel on rats). Humans get it when bitten by the fleas, and then spread it by coughing. The unsanitary conditions in medieval Europe allowed the disease to move rapidly northward. London, Vienna, Florence, and Avignon (the papal city at the time) were particularly hard hit. In Florence alone, 100,000 died within four months. In some cities, 90 percent of the population was wiped out.

The symptoms were quick and harsh. The first sign was sneezing (hence, "bless you"), followed by the appearance of lumps or "buboes"

Timeline of the High Middle Ages (1000–1500)

Medieval Sightseeing in a Modern World

Today's cities sprawl, but many were once contained within medieval walls. Here we see medieval Florence, on the Arno River, protected by a wall arcing around its historic center. Most walls were torn down long ago, as cities struggled to alleviate congestion in their old centers. In Paris, Kraków, Vienna, and many more cities, you can still see the legacy of these walls in the shape of the modern ring roads (or parks) that replaced them. To pare an otherwise overwhelming city down to size, mentally—or maybe even physically—trim your map to include only the area contained within this ring road (and, therefore, the old wall). Generally, nearly everything worth exploring lies within this easily walkable old city center.

(hence, "bubonic") in the groin or armpits, fever, constant vomiting (often blood), diarrhea, pneumonia, and, almost inevitably, death within three days.

So many died so quickly that there was no place to bury them. After the churchyards were full, people dug vast trenches where bodies were heaped in mass graves. The disease was so infectious that it seemed impossible to avoid. The most frightening part was that nothing could be done to help the afflicted, who were abandoned by the healthy to avoid contagion. When the plague had run its course, those who survived were left feeling as if they'd been punished by a terrible and vengeful God.

To ward off the plague, a fanatical sect called the Brotherhood of

the Flagellants tried to take the sins of Europe upon themselves. They marched through the cities, chanting repentance, and calling on the citizens to join them as they stripped to the waist and whipped themselves with knotted scourges. Thousands joined the hysteria, and the Brotherhood became more popular in some areas than the priests, whose rituals had been powerless during the plague. It was a strange and troubled time, and social neurosis swept across Europe. The popularity of witchcraft soared; devil appeasement and death cults had many people doing the *danse macabre*. Some figured, "What the heck? The end is near!"—and dove headlong into one last hedonistic fling.

The Black Death of 1347–1350 was only the worst of numerous

plagues in Europe. Eventually, this plague became just a lingering memory in Europe's collective subconscious. Petrarch, who witnessed the horror of those years, correctly prophesied: "Posterity, will you believe what we who lived through it can hardly accept?...Oh how happy will be future times, unacquainted with such miseries, perhaps counting our testimony as a mere fable!"

Europe Recovers...Slowly

Strange as it may sound, some good came out of all the loss of life. Although Europe's poorest were the first to die, the result was that the common worker could demand a better wage. Technology itself had not been affected by the plague, and there were now fewer people to divide the fruits of that technology. The survivors went on a materialistic and hedonistic buying spree, trying to forget the horrors they'd seen. Luxury goods—fancy clothes, good food and drink, lavish houses, entertainment—were in high demand. For the first time, the lower classes enjoyed such "luxury items" as chairs, dishes, and fireplaces.

Europe's troubles in the 1300s— the plague and the Hundred Years' War—actually thinned out and revitalized society. The European ship of state had to treat its bilge rats with a little more respect. The old feudal order was crumbling, and individuals could actually hope to chart their own destiny. A lean Europe was primed and ready to ride the waves of the future. Serfs up.

Michelangelo, **David,** 1504
(Accademia, Florence).
*The face of the Renaissance. Man was the
shaper of his destiny, no longer merely a
plaything of the supernatural.*

The Renaissance

(1400–1600)

Michelangelo's *David* and *Pietà*, the Sistine Chapel, Leonardo's *Mona Lisa*, Botticelli's *Venus*, St. Peter's Basilica.... These heavyweights of world art are just a small part of the two-centuries-long cultural explosion that historians call the Renaissance.

"Renaissance" means rebirth. A thousand years after Rome fell (plunging Europe into a relatively "Dark" Age), the Renaissance was the rebirth of the classical values of ancient Greece and Rome. Northern Italians, taking a fresh, new, secular view of life, considered themselves citizens of a new Rome.

The new Renaissance Man was the shaper of his destiny and no longer a mere plaything of the supernatural. The belief in the importance of the individual skyrocketed, and life became much more than a preparation for the hereafter. Renaissance men and women were optimistic and confident in their basic goodness and in their power to solve problems. This new "humanistic" attitude brought about a tremendous burst of original thinking and creativity that gave our civilization

its most exciting and fertile period of art since that great Greek streak 2,000 years earlier.

The Renaissance also did more for tourism than any other period in history. All over Europe, but especially in Italy, today's visitors set their touristic sights on the accomplishments of the creative geniuses of the Renaissance.

Recipe for a Renaissance: Art, Democracy, Capitalism, and Science

The Renaissance was far more than just art. It was a cultural revolution that changed people's thinking about everything. In politics, it meant democracy and the emergence of nation-states. Economically, it brought budding capitalists and the middle class. In religion, it meant a move away from Church dominance and toward the assertion of man (humanism), along with a more personal faith (leading to the Protestant Reformation). Explorers such as Columbus and Magellan were literally expanding Europeans' horizons. Secular learning was revived after centuries of superstition and ignorance.

Scientists actually observed the workings of nature with their own eyes, rather than relying on the authority of dusty medieval texts.

Though humanist, the Renaissance was not an anti-Christian movement. It was not the repudiation of God but the assertion of Man. Artists saw themselves as an extension of God's creative powers. Rather than just bowing down in church, the Renaissance approach to glorifying God was to identify your talents and use them with all your ability—in other words, to glorify God by glorifying humanity. The Christian church even supported the Renaissance. The pope himself hired Raphael to paint Plato and Aristotle on the walls of the Vatican.

In medieval times, poverty and ignorance had made life "nasty, brutish, and short" (for lack of a better cliché). If ever religion was "the opiate of the masses," it was during the Middle Ages, when life on earth was considered just a preparation for a happier time in heaven. But with newfound prosperity, Renaissance men and women took pleasure in the material world. Self-confident and worldly, they took charge of their lives. In 1450, a Florentine author summed it up: "The world was created not for God, who had no need of it, but for man. Man is the most perfect work of God, the true marvel of His genius. Man has his end not in God, but in a knowledge of himself and his own creativity."

Renaissance Art

Renaissance art is a triumph of order and harmony. Artists re-mastered the technical secrets of the classical artists that had been lost during the Middle Ages, capturing anew the realism, three-dimensionality, and balance found in classical statues. Like the ancients, Renaissance sculptors portrayed idealized human bodies, caught in the perfect balance between motion and rest. Sculptors, painters, and poets alike turned for inspiration to these ancient Greek and Roman works as paragons of beauty.

You'll see lots of pagan gods and scenes from mythology. Like the ancient Greeks and Romans, the Renaissance gloried in the naked human body. Human beings are no longer scrawny, puny sinners, but strong, confident, rational creatures—almost gods on earth. The anatomy is realistic. In the Middle Ages, the dissection of corpses

Domenico Ghirlandaio, **Portrait of Duke Federico of Urbino** (Uffizi Gallery, Florence).
With the Renaissance, paintings could depict more than just saints and angels. This duke was suddenly as worthy of painting as the pope.

Tips on Sightseeing in Italy

- Churches offer some amazing art (usually free), a cool respite from heat, and a welcome seat. A modest dress code (no bare shoulders or shorts for men or women) is enforced at larger churches such as Venice's St. Mark's and the Vatican's St. Peter's Basilica. A coin box near a piece of art often illuminates the art for a coin (and a better photo). Whenever possible, let there be light.
- Advance reservations are advisible for some of the more famous museums (Florence's Uffizi Gallery) and mandatory at others (Leonardo's *The Last Supper* in Milan and the Borghese Gallery in Rome).
- Some sights are open throughout the evening, allowing easy viewing without crowds. For a listing of hours, use a good guidebook (we're partial to the Rick Steves' series) and confirm at the local tourist information office.
- Art historians and Italians refer to the great Florentine centuries by dropping a thousand years. The Trecento (300s), Quattrocento (400s), and Cinquecento (500s) were the 1300s, 1400s, and 1500s.
- In Italian museums, art is dated with A.C. (for *Avanti Cristo*, or B.C.) and D.C. (for *Dopo Cristo*, or A.D.). OK?
- Holidays seem to strike without warning, shutting down museums. And on days museums are open, individual rooms can begin closing about 30 to 60 minutes before the museum closes. If your heart is set on one museum or one piece of art, don't save it for the finale of your visit.
- Bathrooms at museums are usually free and clean.
- About half of the visitors at Italian museums are English (not Italian) speakers. If the only English you encounter at a museum explains how to pay, politely ask if there are plans to include English descriptions of the art. Think of it as a service to those who follow.

had been a sin and therefore a crime (the two were one and the same). But Renaissance artists were willing to sell their soul to the devil for artistic knowledge. Pass the scalpel.

You'll also see plenty of Christian themes: Madonna-and-Childs, martyrs, and saints. But unlike medieval works, these holy figures need no halos or symbols to identify them; they simply radiate purity and beauty. Renaissance artists brought Madonna down from her golden heaven, clothed her in flesh, and set her among the rocks, trees, and sky of the real world. As you look at these religious paintings, you feel like you're standing in the presence of the holies.

As democratic values spread, we start to see portraits of ordinary citizens—not just popes, kings, and saints. Renaissance artists embraced individual eccentricities and painted people warts and all.

Whatever the subject, Renaissance artists painted realistically. For the Florentines, "realism" was spelled "3-D" (heighth, width, and depth). Merging art and science, they used mathematics, the laws of perspective, and direct observation of nature to paint the 3-D world on a 2-D surface.

The key was to first establish a fixed horizon line in the painting.

The Problems of Perspective

Paolo Uccello, **Battle of San Romano,** 1455 (Uffizi Gallery, Florence).

This colorful battle scene is not so much a piece of art as an exercise in perspective. Paolo Uccello (ooh-CHEHL-loh, 1397–1475) has challenged himself with every possible problem. The broken lances at left set up a 3-D "grid" in which to place this crowded scene. The fallen horses and soldiers are experiments in "foreshortening"—shortening the things that are farther away from us (which therefore appear smaller) to create the illusion of distance. Some of the figures are definitely A-plus material, like the fallen gray horse in the center and the white horse at the far right walking away. But some are more like B-minus work: The red horse's kicking legs look like ham hocks at this angle, and the fallen soldier at far right would only be child-size if he stood up.

And then there's the D-minus "Is this painter on drugs?" work. The converging hedges in the background create a nice illusion of a distant hillside maybe 250 feet away. So what are those soldiers the size of the foreground figures doing there? And, jumping the hedge, is that rabbit 40 feet tall?

Paolo Uccello almost literally went crazy trying to master the three dimensions (thank God he was born before Einstein discovered one more). Uccello got so wrapped up in it he kind of lost...perspective.

Then the painter placed his figures in between that horizon and the viewer. Closer figures should appear bigger and lower down; distant figures are smaller, dimmer, and higher up.

Suddenly, the picture frame became like a window you looked through to see the wide world. And it showed the world from a specific point of view—the viewer's. Medieval art had always given God's ideal viewpoint. Space, time, and size hadn't mattered. The new perspective invited the viewer into the scene, showing it

from a distinctly human perspective. (For more on the laws of perspective, see page 464.)

Renaissance art is balanced and symmetrical. Statues stand *contrapposto* (weight balanced on one leg) or are designed around a central axis. Madonnas are flanked by saints, two to the left, two to the right, and so on. Like Greece's Golden Age, the Renaissance was poised midway between stiff formality and wild motion and emotion. Later, in the Baroque period (as in Greece's Hellenistic era), artists went overboard with wild poses and extreme emotions.

To appreciate the advances of Renaissance artists, mentally rewind a few hundred years. Medieval painting and sculpture had been symbolic, in order to tell Bible stories to the devout and illiterate masses. Medieval artists painted stiff, two-dimensional figures with no sense of movement. Backgrounds didn't matter. People were generic icons as seen from God's perspective. Medieval paintings often look crowded, crammed with objects and minute details. It took Renaissance artists to weed out the unnecessary details, arrange the figures believably in a 3-D landscape, and give them realistic human features.

Most of all, Renaissance art is simply...beautiful. Medieval art had been the church's servant, valuable only if it embellished the church, told a story, or stoked the spirit. But now, rich merchants wanted pretty pictures for their homes or statues to beautify their cities as a show of civic pride. Renaissance people rediscovered the beauty

*Brunelleschi's **Church of San Lorenzo** (1421, Florence) is typical of Renaissance architecture: balance, symmetry, arches, Corinthian columns, circles, and squares.*

From Medieval Art to the Renaissance

These three Madonna-and-Bambino paintings show baby steps in the march to realism.

Cimabue's purely Gothic piece is medieval and two-dimensional. There's no background. The angels are stacked up the sides, ornamenting Mary's throne like plastic clip-on toys, floating in the golden atmosphere. Mary's throne is crudely drawn, and Mary herself is a wispy cardboard-cutout figure seemingly floating just above the throne... nice try.

Just a generation later, Giotto's depiction of the same scene shows more interest in realistic depth. Giotto (described on page 171) creates a space and fills it: He builds a three-dimensional "stage"—the canopied

Cimabue, **Santa Trinità Madonna,** c.1280 (Uffizi Gallery, Florence).

Giotto, **Ognissanti Madonna,** 1310 (Uffizi Gallery, Florence).

throne—then peoples it with real beings. The throne has angels in front, prophets behind, and a canopy over the top, clearly defining the throne's three dimensions. The steps leading up to it lead from our space to Mary's, making the scene an extension of our world. But the real triumph here is Mary herself—big and monumental, like a Roman statue.

Beneath her robe, she has a real live body, with knees and breasts that stick out at us. This three-dimensionality was revolutionary in its day, a glimpse of the Renaissance a century before it began.

Raphael's version is a typical pyramid composition by the "Master of Grace." He brings Mary and Child down from heaven and into the material world. He gives baby Jesus (right) and John the Baptist a realistic, human playfulness. Raphael transforms a heavenly Madonna into an earthly Mary, whose physical beauty radiates spiritual purity. Most tourists burn out on the very common Madonna-and-Child scene long before they get to Raphael. Save yourself for Raphael.

Raphael, **La Belle Jardinière,** 1507 (Louvre Museum, Paris).

of the natural world and loved art for art's sake.

Renaissance Architecture

To Renaissance eyes, Gothic cathedrals looked tense, strained, and unstable. The Renaissance architect turned to his ancient Roman forefathers and developed (or rediscovered) a style that was geometrical, symmetrical, and sturdy. Domes and round arches replaced Gothic spires and pointed arches. They revived the traditional Doric–Ionic–Corinthian orders. You'll see Greek-style columns and crossbeams paired with Roman-style arches and domes.

Renaissance church design echoed the upbeat optimism and confidence of the time. The medieval Latin cross floor plan (symbolic of the Crucifixion) was replaced with the Greek cross floor plan (four equal arms contained in a circle—symbolizing the perfection of God and the goodness of man, who was made in his image). Most of all, where Gothic cathedrals had been dramatically vertical, Renaissance buildings are staid and horizontal.

Renaissance Florence:
Cradle of the Modern World

For almost two centuries (c. 1400–1600), Renaissance ideals were the rage of Europe. It all began in the industrious, proud, self-ruling town of Florence.

There was something dynamic about the Florentines. Pope Boniface VIII said there were five elements: earth, wind, fire, water...and Florentines. While ancient Rome "fell" in A.D. 476, the city of Florence never really followed suit. Throughout the Middle Ages, it remained a bustling trade

Top Renaissance Architecture in Italy

- Duomo dome (by Brunelleschi), Florence
- Hospital of the Innocents (by Brunelleschi), Florence
- Uffizi Gallery (the building), Florence
- Pazzi Chapel, Florence
- Church and tombs of the Church of San Lorenzo, Florence
- St. Peter's dome (by Michelangelo), Rome
- Tempietto, Rome
- Capitol Hill Square (by Michelangelo), Rome
- Urbino Palace, Urbino
- Many palaces in Venice
- Palmanova, a planned town north of Venice

center along the Arno River. Florentines bought wool from local shepherds, wove it into cloth, and sold it. Eventually, traders became bankers, who loaned money at interest to free-spending nobles and popes. The Florentine florin became the monetary standard of the Continent. Capitalism was born. And Florence prospered.

Florence was one of several bustling cities in northern Italy, the most urban corner of Europe at that time. Historians estimate that in 1400, one in four Italians were city dwellers, compared with a mere one in ten in England. Venice alone had 100,000 people and 3,000 ships. Italian cities had grown rich, serving as natural middlemen between the East with its luxury goods and the West with its raw materials. Cities attracted skilled craftsmen, creating a new social phenomenon: the middle class. Since Italian cities

Florence—the epicenter of a cultural explosion called the Renaissance—looks much the same today as when Michelangelo walked the streets.

were generally self-ruling (not tied to a pope or king), most of their citizens could read, write, and participate in government.

As prosperity rose, so did people's confidence in life and in themselves. In the Middle Ages, talented and ambitious men typically aspired to serve in the church. Now an active life of business and politics was considered just as meaningful and respectable as the passive, contemplative life of the monastery. Whether you were a middle-class craftsman, merchant, or banker, making money was not seen as shameful as long as the wealth was used properly. Guilds (labor unions for skilled craftsmen) were quite strong, and took great pride in beautifying their city with statues and fountains.

Florentines considered themselves descendants of the highly cultured people of the Roman Empire. They looked down on the Dark Ages that separated the glorious ancient world from their own glorious time. They scornfully labeled the art "Gothic," after the barbarians who'd looted Rome.

Florence's citizens were some of the greatest men in Western history: The artists Michelangelo, Leonardo, and Botticelli were all Florentines, along with explorer Amerigo Vespucci and political philosopher Machiavelli (whose book *The Prince* taught future politicians how "the ends justify the means"). The writers Dante, Petrarch, and Boccaccio practically invented the modern Italian language, which grew out of the popular Florentine dialect.

A remarkable Florentine who predated the Renaissance was...

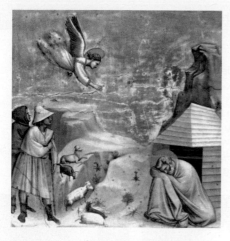

Giotto, **Return of Joachim to the Sheepfold,**
c. 1305 (Scrovegni Chapel, Padua, Italy).
*Working to achieve the illusion of 3-D, Giotto
painted sculptural people in realistic settings.
The background (the cliff) and foreground (the
sheep) give the scene lifelike depth.*

Giotto: Proto-Renaissance Man

Giotto di Bondone—better known
simply as Giotto (JOTT-oh, 1267–
1337)—is often considered the first
"Renaissance" painter, even though he
preceded the Renaissance by 100 years.
Working near the end of the High
Middle Ages, Giotto produced aston-
ishing paintings that were like nothing
anyone had seen in a thousand years.

Though much of Giotto's art is
Gothic (gold-leaf backgrounds, halos,
unrealistic scale, and no visible light
source), he also pioneered human
realism. Like a good filmmaker, he
"shows" us the action rather than
just "telling" it through picture sym-
bols. He sets the stage, then peoples
it with realistic human beings frozen
in moments of incredible drama (see
page 474 for an example).

Giotto was one of the first "celeb-
rity" artists, remarkable in an era

when most painters were about as
famous as the UPS guy. Giotto made
it into all the gossip columns. He died
in a plague that devastated Florence.
(If there had been no plague, would
the Renaissance have started 100 years
earlier?) The largest collections of his
work are in Padua's Scrovegni Chapel
(frescoed with more than 30 beauti-
fully preserved scenes from the lives of
Jesus and Mary) and in Assisi's Basilica
of St. Francis.

The Quattrocento

As Italy's prosperity grew, the Renais-
sance followed the money: Born in the
trading and banking capital of Flor-
ence, it migrated to Rome (as the pope
gave the Vatican a face-lift), settled in
Venice, then spread across Europe.
Florence got the ball rolling in the
1400s, a century known to historians
as the "Quattrocento."

There were *quattro* (four) artistic

Ghiberti, **"Gates of Paradise,"** 1425–1452
(original in Duomo Museum, Florence).

The Class of 1500

Think of the remarkable group of people living during that exciting time when Italy's Renaissance was sweeping the Continent—the Renaissance Generation.

In 1500, Michelangelo was 25 years old, just a few years older than the young monk in Germany named Martin Luther who would go on to start the Protestant Reformation. In England, you had Henry VIII, in Holland the humanist writer Erasmus. Christopher Columbus was discovering a distant world, which was named after a man from Florence—Amerigo Vespucci.

Many of these famous people hung out together. Michelangelo battled

Marty Luther: Voted Most Likely to Secede.

Chris Columbus: Post-graduation plans—to travel the world without falling off the edge.

Nicky Machiavelli: Served two terms as Student Body Tyrant.

Lenny da Vinci: Activities include Debate Team, Choir, Art Club, Math Club, Poetry Club, Honors Society...a true "Renaissance Man."

Henry VIII: Hank was elected King of the Prom, along with six Prom Queens.

Michelangelo Buonarroti: Mikey was expelled for sneaking a chisel on campus.

fellow Florentine Leonardo da Vinci in a painting contest. Leonardo spent time with the writer Niccolò Machiavelli, whose name has become synonymous with political maneuvering. Machiavelli was an advisor to Lorenzo the Magnificent. Lorenzo's son became Pope Leo X, who hired the painter Raphael. Raphael exchanged masterpieces with Albrecht Dürer in Germany. Dürer was personally converted to Protestantism by Martin Luther...who was excommunicated by Leo X...who had gone to school with Michelangelo. There were 100 million people in Europe back then, but it was a small world.

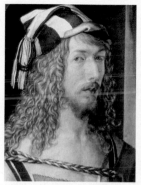

Al Dürer: German exchange student who refused to cut his hair.

Lorenzo the Magnificent: To his girlfriends, just Larry the So-So.

Pope Leo X: Tried to get Marty Luther expelled.

NOT AVAILABLE ON PICTURE DAY

Erasmus: Was the subject of the first knock-knock joke.

Amerigo Vespucci: Biggest ego—graffitied his name everywhere.

Savonarola: The school killjoy, ultimately hung and burned by his classmates.

And the Winner Is...

In 1401, Florence needed new doors for its Baptistery, and staged a competition. Brunelleschi's entry (on the right) and Ghiberti's entry (on the left) were the finalists. Both artists catch the crucial moment when Abraham, obeying God's orders, prepares to slaughter and burn his only son as a sacrifice. At the last moment—after Abraham passed this test of faith—an angel of God appears to stop the bloodshed.

Today the originals (two different relief panels, both titled *Il Sacrificio di Abramo*) stand side by side in Florence's Bargello Museum. Is one panel clearly better than the other? Which do you like best? You be the judge.

(Ghiberti's, on the left, won.)

landmarks in the Quattrocento: Ghiberti's doors, Brunelleschi's dome, Masaccio's paintings, and Donatello's sculptures.

Ghiberti's Baptistery Doors

Some say the Renaissance began precisely in the year 1401, when Florence staged a citywide competition to build new bronze-paneled doors for a building called the Baptistery. All the greats entered, but 25-year-old Lorenzo Ghiberti (c. 1378–1455) won the job and built the north doors, which everyone loved. In 1425, the Baptistery needed

another set of doors on the east side, and this time there was literally no contest. Ghiberti was hired, and his so-called "Gates of Paradise" added a whole new dimension to art: depth.

In the "Jacob and Esau" panel (pictured opposite), a crowd of people mills around beneath a set of arches. Ghiberti makes the arches recede into the distance, creating the illusion of a three-dimensional scene. If you follow the lines of the floor tiles and banisters, you reach the "vanishing point" on the distant horizon where all the arches and tiles converge. Having established

Ghiberti, **Story of Jacob and Esau,** 1430
(Duomo Museum, Florence).
Receding arches create the illusion of distance.

this horizon line, Ghiberti places the other figures within the 3-D setting. Amazingly, this realistic scene is made from bronze only a few inches deep. Ghiberti created something that hadn't been seen for a thousand years—a representation of the three dimensional world on a (virtually) two-dimensional surface—and his fellow Florentines stood awestruck.

Brunelleschi's Dome

Filippo Brunelleschi (broon-uh-LES-kee, 1377–1446) lost the Baptistery gig (luckily for us) and consoled himself with a trip to Rome. There, he measured the 142-foot dome of the ancient Pantheon (described on page 78) and thought, "Hmm. Back in Florence, we have an unfinished church with a 140-foot hole in the roof—a drag on rainy Sundays. I wonder...."

Brunelleschi did the math, returned home, and convinced the city fathers that he could cap the medieval cathedral nicknamed the Duomo. There was one problem: The hole the dome would cover was too wide to be spanned by the traditional scaffolding used as support during the construction process. (An earlier architect suggested supporting the dome with a great mound of dirt inside the church...filled with coins, so peasants would later cart it away for free.)

Brunelleschi's solution was a dome within a dome, leaving a hollow space between to make it lighter. The dome grew up igloo-style, supporting itself as it proceeded from the base. First, Brunelleschi built grand white skeletal ribs, then filled them in with interlocking bricks in a herringbone pattern. Think of the sheer logistics: The dome weighs 80 million pounds—as much as the entire population of Florence today—and rises 30 stories up. Brunelleschi had to design special tools and machinery to hoist all that material up and piece it together...and he completed it in 16 short years.

The result was the wonder of the age, and the model for many domes to follow, from St. Peter's Basilica to the US Capitol. People gave it the ultimate compliment, saying "not even the ancients could have done it." Michelangelo, setting out to construct the dome of St. Peter's, said: "I'll make its sister...bigger, but not more beautiful." Brunelleschi's dome stands as a proud

symbol of man's ingenuity, proving that art and science can unite to make beauty (see below).

Masaccio's Paintings

Masaccio's fresco *The Trinity* (1427) blew a "hole in the wall" of Florence's Church of Santa Maria Novella. With simple pinks and blues, Masaccio (mah-SAH-choh) creates the illusion that we're standing in the church nave, looking up into a chapel flanked with classical columns. Inside the chapel, God the Father stands on an altar, holding up the cross of Christ. The checkerboard ceiling creates a 3-D tunnel effect, with rows of panels that appear to converge at the back. Some consider this the first modern painting, placing real figures in a real setting, seen from a single viewpoint— ours. We're no longer detached spectators, but an extension of the scene. Masaccio lets us stand in the presence of the Holy Trinity.

Little is known of Masaccio's short life (1401–1427). "Masaccio" is actually a nickname (often translated as "Big, Clumsy Thomas"), describing his personality as stumbling through life with careless abandon, not worrying about money, clothes, or fame...a sort of lovable doofus. He died young (younger than James Dean, Jimi Hendrix, Jim Morrison, or Kurt Cobain). In his short but influential career, Masaccio became the first painter since ancient times to portray Man in Nature— real humans with real emotions, in a spacious three-dimensional world.

What's truly amazing is that young Masaccio seemed to grasp the laws of perspective intuitively; he was a "natural," eyeballing and sketching freehand what later artists would have to plan out with a pencil and paper.

Across town in the Brancacci Chapel, Masaccio painted *Adam and Eve Banished from Eden* (pictured in sidebar, page 178). Man and Woman— as nude as they can be—turn their backs on the skinny,

Brunelleschi, **Cathedral Dome,** 1420–1436 (Florence).
Inspired by the ancient Pantheon, this dome in turn inspired later ones, from Michelangelo's to the present.

unrealistic, medieval Gate of Paradise and take their first step as mortal humans in the real world. For the first time in a thousand years of painting, real humans cast a real shadow, seemingly lit by the same light we are, the natural light through the window of the Brancacci Chapel. Eve wails from deep within. Adam buries his face in shame. These simple yet realistic human gestures speak louder than the religious symbols of medieval art.

Masaccio's people—sturdy, intelligent, and dignified—helped shape the

Masaccio, **The Trinity**, 1425–1427 (Church of Santa Maria Novella, Florence). *The mathematically correct architectural backdrop of this early Renaissance fresco gives it a believable three-dimensionality.*

self-images of Renaissance men and women. Many have an expression of understated astonishment, like people awakening to a new and challenging world.

Donatello's Sculpture

Donato di Niccolò di Betto Bardi—best known simply as Donatello (1386–1466)—was the first great Renaissance genius, a model for Michelangelo and others. He created the first truly lifelike statues of people since Roman times. Donatello's work is highly personal. His statues are not idealized gods but real people—sometimes real ugly people. In the true spirit of Renaissance humanism, Donatello appreciated the beauty of flesh-and-blood human beings.

Habakkuk shows the wiry man who struggles under the heavy burden of being a prophet. His long, muscled neck leads to a bald, pumpkin-like head—Italians call the statue *Lo Zuccone* (roughly, "The Pumpkin-head"). With several days' growth of beard and crossed eyes, the ugly face looks crazed. This is no confident Charlton Heston–style prophet, but a man who's spent too much time alone, fasting in the wilderness. Donatello, the eccentric prophet of a new style, identified with this statue—talking, swearing, and yelling at it.

Donatello's personality was also a model for later artists. He was moody and irascible, lived alone, and was married only to his work. He developed the role of the "mad genius" that Michelangelo would later perfect.

Donatello's masterpiece is *David*, the first freestanding nude statue sculpted in a thousand years (pictured

Three Expulsions: Medieval, Early Renaissance, and High Renaissance

In these three depictions of the expulsion of Adam and Eve from the Garden of Eden, compare medieval, early Renaissance, and High Renaissance views of the same scene. Notice the artistic differences, as well as the way man's view of himself in relation to God changes. In the

medieval example, Adam and Eve are puny, bug-like creatures, ashamed of their naked- ness and helpless before God. In Masaccio's painting, you feel the agony of a lifelike, suffering Adam and Eve. Michelangelo shows a strong, self-assured Adam with a gesture that almost says, "All right, already, we're going!" While Adam knows he and Eve will survive, Eve wonders, "Shouldn't we be wearing our money belts?"

Medieval: **Church of St. Michael,** 1015 (Hildesheim, Germany).

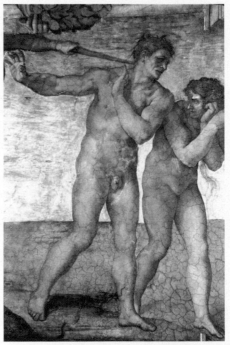

High Renaissance: Michelangelo, **Sistine Chapel,** 1508–1512 (Vatican Museum, Rome).

Early Renaissance: Masaccio, **Brancacci Chapel,** 1425 (Florence).

Donatello, **Habakkuk,** 1423–1426
(Duomo Museum, Florence).

grew up admiring it. (To compare Donatello's masterpiece with Michelangelo's later *David,* see the sidebar on page 270.)

The Springtime of the Renaissance: Lorenzo "The Magnificent" de' Medici

Politics, banking, and power helped fuel the Renaissance. On paper, Florence was a republic, ruled by elected citizens rather than by nobles. But in reality, power lay in the hands of a few wealthy banking families. The most powerful was the Medici family (pronounced MED-uh-chee).

The Medici family—part *Sopranos,* part Kennedys, part John-D-and-Catherine-T Rockefeller art patrons—dominated Florentine politics for 300 years (c. 1434–1737). Originally a hardworking, middle-class family in the cloth and banking business, they used their wealth to rise into Europe's nobility, producing popes and queens. The Medici bank had branches throughout Europe, and the pope himself kept his checking account in the Rome branch.

Cosimo the Elder (r. 1434–1464) established the dynasty. A shrewd moneylender, he had free-spending popes and nobles in his pocket, becoming the richest man in Europe and the virtual dictator of Florence. But he also enjoyed great popularity among Florence's working class, and he spent the family's money beautifying the city as the patron of Brunelleschi, Donatello, and Ghiberti.

Cosimo's grandson, Lorenzo de' Medici (1449–1492), inherited the family's wealth and presided over Florence's Golden Age. Young (he was 20 when he took power), athletic, and

in sidebar, page 180). Although the subject matter comes from the Bible (the boy David killing the giant Goliath), it's just an excuse for a classical study of a male nude. The smooth-skinned shepherd boy sways gracefully, poking his sword playfully at the severed head of the giant Goliath. In the Middle Ages, the human body was considered shameful, something to be covered up. But in the Renaissance, a new class of rich and powerful merchants arose who bought art for personal enjoyment. Reading Plato's *Symposium,* they saw the ideal of Beauty in the form of a young man. This particular statue stood in the palace of Florence's leading family, the Medicis, where Michelangelo, practically an adopted son,

From Gothic to Renaissance: Sculpture Breaks Free

These four examples demonstrate how sculpture gradually emerged from the shadows of church architecture. ❶ At Chartres Cathedral, the stiff figures are embedded in the Gothic wall—little more than columns with faces and halos. ❷ Nanni di Banco's *Four Saints* has Renaissance solidity but sits deep in a niche. The scuplture still supports the architecture...but di Banco is sitting on the cusp of the revolution. ❸ Donatello helped sculpture emerge from the shadows of church architecture. His confident *St. George* steps right up to the edge of his niche and looks boldly into the future. The serene beauty of medieval art is being replaced by a defiant and determined new outlook. Bolstered by the new humanism, Renaissance Man is ready to venture away from the church: alert yet relaxed, strong yet refined, aggressive yet Christian. ❹ A few years later, Donatello's *David* stands on his own in the light of day: proud, naked, and ready to do a little fencing. The first freestanding male nude sculpted since Roman times, this boy David is unapologetically art for art's sake.

❶ **Chartres Cathedral Sculpture,** 1140 (Chartres, France). *"Going up."*

❷ Di Banco, **Four Saints,** 1413 (Orsanmichele Church, Florence).

❸ Donatello, **St. George,** 1416 (Orsanmichele Church, Florence).

❹ Donatello, **David,** 1430 (Bargello Museum, Florence).

intelligent, he was also a poet, horseman, musician, and leader. He wrote love songs for the lute and dirty limericks for carnival time. His marathon drinking bouts and illicit love affairs were legendary. He learned Greek and Latin and read the classics, yet his great passion was hunting. He was the archetypal Renaissance man—a man

of knowledge and action, a scholar and man of the world, a patron of the arts and a shrewd businessman. He was *"Il Magnifico"*—Lorenzo the Magnificent.

Lorenzo gathered Florence's most intelligent and talented men into an informal "Platonic Academy," based on that of ancient Greece, to meet over a glass of wine under the stars

Vasari, **Lorenzo the Magnificent,** 1533
(Uffizi Gallery, Florence).

at the Medici villa and discuss literature, art, music, and politics. (Witty conversation was considered an art in itself.) Their "neo-Platonic" philosophy stressed the goodness of man and the created world. They believed in a common truth behind all religion. The Academy was more than just an excuse to go out with the guys; the members were convinced that their discussions were changing the world and improving their souls.

Florence (Firenze) in 1450 was in a Firenz-y of activity. There was a can-do spirit of optimism in the air, led by prosperous merchants and bankers and a strong middle class. Lorenzo epitomized the Florentine spirit of optimism. Born on New Year's Day and raised in the lap of luxury, he grew up feeling there was nothing he couldn't do.

Even with all the art and philos-

ophy of the Renaissance, violence, disease, and warfare were present in medieval proportions. For the lower classes, life was as harsh as it had always been. Many artists and scholars wore swords and daggers as part of everyday dress. This was the time of the ruthless tactics of the Borgias (known for murdering their political enemies) and of other families battling for power. Once, Lorenzo himself barely escaped assassination in the cathedral during Easter Mass.

But Florentines saw themselves as part of a "new age," a great undertaking of discovery and progress in man's history. They were the ones who invented the term "Dark Ages" for the era that preceded their own. Lorenzo's personal charisma and support of the arts made Florence Europe's most enlightened city.

Brunelleschi, **Pazzi Chapel,** mid-15th century (Florence).
Renaissance architecture, like its classical inspiration, was enthusiastically symmetrical, with a passion for circles, squares, and columns.

Botticelli

As a member of Lorenzo the Magnificent's Platonic Academy, Sandro Botticelli (bot-ih-CHEL-lee, 1445–1510) painted the classical myths that the group studied. Like the ancients, he loved the nude body, which he considered God's greatest creation. Botticelli commanded as many as 100 florins for a single work, enough to live in high style for a year (which he did for many years). In Botticelli's art, we see the lightness, gaiety, and optimism of Lorenzo's court.

In Botticelli's *Allegory of Spring,* it's springtime in a citrus grove. Fresh breezes blow in (Mr. Blue, at right), causing the woman on the right to sprout flowers from her lips as she morphs into Flora, or Spring, who walks by and scatters flowers from her dress. At the left are Mercury and the

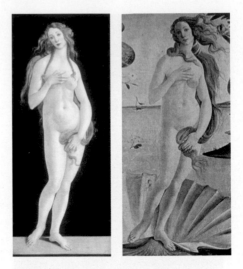

*While obviously the same study of the human body, Botticelli's **Eve** (left) was done before the Renaissance took hold, and therefore needed to have a sacred title. In his later **Birth of Venus** (right), created when the Florentine Renaissance had really taken off, Venus no longer needed to be disguised as Eve.*

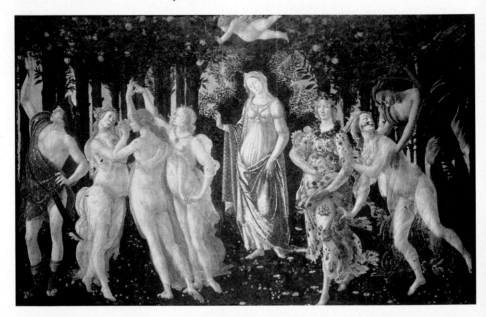

Botticelli, **Allegory of Spring,** 1482 (Uffizi Gallery, Florence).
Pagan Innocence. Botticelli was part of a band of youthful Florentines who saw beauty—even pre-Christian beauty—as an expression of the divine.

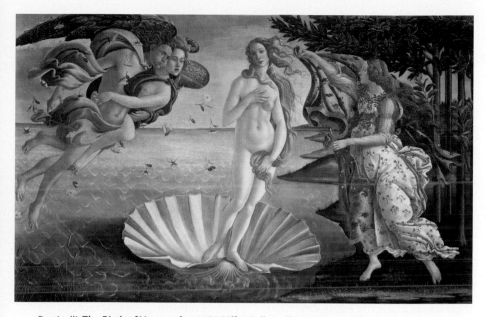

Botticelli, **The Birth of Venus,** after 1482 (Uffizi Gallery, Florence).

Three Graces, dancing a delicate maypole dance. The Graces may be symbolic of the three forms of love: love of beauty, love of people, and sexual love, suggested by the raised intertwined fingers. (They forgot love of peanut butter on toast.) In the center stands Venus, the Greek goddess of love. Above her flies a blindfolded Cupid, happily shooting his arrows of love without worrying whom they'll hit.

Here is the Renaissance in its first bloom, its "springtime" of innocence. Madonna is out, Venus is in. Adam and Eve no longer hide their nakedness, they almost revel in it. This art marks a return to the pre-Christian pagan world of classical Greece, where things of the flesh are not sinful. But this is certainly no orgy—just fresh-faced innocence and playfulness.

Botticelli paints with graceful outlines, pristine colors, and shadowless lighting. Not as sturdy and sculptural as Masaccio, Botticelli's figures have a pure, elegant, dreamlike quality, mixing Gothic grace with naked classicism.

Botticelli's most famous work is *The Birth of Venus* (known to tourists as "Venus on the Half Shell"). According to myth, the Goddess of Love was born from the foam of a wave. Still only half awake, this fragile newborn beauty floats ashore on a clam shell, blown by the winds, where her maid waits to dress her. The pose is the same S-curve of classical statues in *contrapposto*. The pastel colors make the world itself seem fresh and newly born.

This is the purest expression of Renaissance beauty. Venus' naked body is not erotic, it's innocent. Botticelli thought that physical beauty was a

way of appreciating God, so he locates God in the details: Venus' windblown hair, the translucent skin, the maid's braided hair, the slight ripple of the wind's abs, and the flowers tumbling in the slowest of slow motions, suspended like musical notes, caught at the peak of their brief life.

But where Botticelli saw God, others looked at this painting and saw... Miss September of 1482.

Savonarola and the End of the Florentine Renaissance

Unfortunately, the spring of Florence's Renaissance had to end. Lorenzo died young, the economy faltered, and corrupt Medici bankers got caught with their hands in the till. Many longed for a "renaissance" of good, old-fashioned medieval values.

Into town rode a monk named Girolamo Savonarola (1452–1498). A charismatic speaker, he preached medieval fire and brimstone for all those who embraced the "pagan" Renaissance spirit, whipping huge crowds into a frenzy with sharp images of the corruption of the world and the horror of hell it promised. "Down, down with all gold and decoration," he roared, "down where the body is food for the worms." He criticized the pope for his stable of mistresses, and offered hope for a glorious future—after the city and the church were purified. Packed houses heard him rail against the "prostitute church...the monster of abomination." Witnesses wrote that "the chapel echoed with weeping

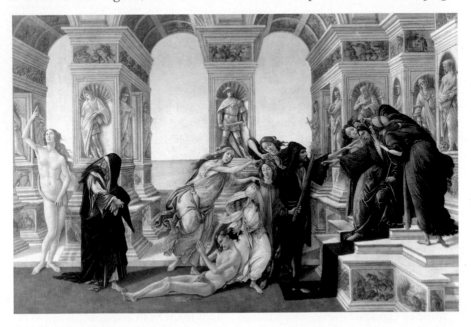

Botticelli, **Slander**, 1495 (Uffizi Gallery, Florence).
The Florentine Renaissance passed. The monk Savonarola turned the city into a theocracy. High thinking is clubbed and dragged ingloriously past Renaissance statues that look down from their perfectly proportional world with shock and disbelief. Venus (far left) looks up at God and seems to say, "No, not the Dark Ages again!"

Savonarola

and wailing," and afterward "everyone wandered the city streets dazed and speechless."

The Medici rulers were exiled, replaced by a theocracy with Jesus Christ at its head and Savonarola ruling in his absence (1494). Savonarola was a complex man. On the one hand, he cut taxes, reduced street crime, and restored some power to the citizens.

But he also passed strict morality laws prohibiting swearing, gambling, and racy clothes. These laws were enforced by roving vice squads of street thugs. He presided over huge bonfires where his believers burned "vanities" such as cosmetics, jewelry, wigs, and dice...as well as classical books and paintings. Under Savonarola's spell, Botticelli and other artists quit painting naked Venuses and concentrated on pristine Virgins.

Savonarola's excesses inevitably brought a backlash, and in 1498, Savonarola was arrested, tried, tortured, and condemned to die on Florence's main square (a plaque now marks the spot). The monk was publicly defrocked, then hanged—not American execution-style where the neck snaps, but slowly strangled, dangling from a rope, while teenage boys razzed him and threw rocks. As they lit a bonfire to burn the corpse, suddenly his arm shot up—like a final blessing or curse—and the terrified crowd stampeded, killing

several bystanders. Savonarola's ashes were thrown in the river. But even though he was gone, the damage had been done. Florence's springtime of the Renaissance, the 1400s, came to an end.

The High Renaissance in Rome

Florence saw the first blossoming of the Renaissance. But when the cultural climate turned chilly there and the pope in Rome decided to beautify his city, artists headed south, and the Renaissance shifted to Rome.

During the Quattrocento, the Holy City of Rome had been a dirty, decaying, crime-infested place, unfit for the hordes of pilgrims that visited each year. The once-glorious Forum was a cow pasture. Then a series of popes (including Lorenzo the Magnificent's own son and nephew) launched a building and beautification campaign. They used fat commissions (and outright orders) to lure Michelangelo, Raphael, and others to Rome. The best artists worked on churches (such as St. Peter's Basilica, described on page 237), decorated palaces (today's Vatican Museum), carved statues (Michelangelo's *Pietà* and *Moses*), and designed public spaces (Capitol Hill). Rome took Florentine art and wrote it in capital letters.

Never before had artists been asked to do so much—or been given so much money and freedom with which to do it. During the Middle Ages, artists were anonymous craftsmen who cranked out generic art that could have been signed with a bar code. During the High Renaissance, the artist could almost dictate his terms and

create what he wanted for whichever lucky prince landed him.

Artists of the Renaissance deserved the respect they got. To create realistic paintings and statues, they merged art and science. They studied anatomy like doctors, nature like biologists, and the laws of perspective like mathematicians. They were well-rounded Renaissance men. Leonardo, Michelangelo, and Raphael were revered as geniuses. Their presence at a party made the evening.

Michelangelo

Michelangelo Buonarroti (1475–1564) was the world's greatest sculptor, period. He was also one of history's best painters and architects, and a decent poet to boot. He mastered nature and strove to master himself. Michelangelo's art reflects the inner turmoil of his emotional and spiritual life; his biography and his work are one.

At age 14, young Michelangelo—relatively poor and uneducated—was recognized as a budding prodigy and taken in by none other than Lorenzo the Magnificent, who treated him like a son. Michelangelo's playmates were the Medici boys, who'd grow up to become Popes Leo X and Clement VII (and who would hire Michelangelo for some important commissions). For all the encouragement, education, and contacts Lorenzo gave him, Michelangelo's most important gift was simply a place at the dinner table, where he could absorb the words of the great men of the time and their love of classical thinking and art for art's sake.

Michelangelo, **Capitol Hill Square**, 1550 (Rome).
Michelangelo, typical of the Renaissance genius, was expected to be versatile...to sculpt, paint, and be a world-class architect on command. No problema. *He designed this ensemble of facades above the Roman Forum.*

After serving his apprenticeship, Michelangelo became dissatisfied with book knowledge and set out to study nature firsthand. He focused his quick mind on a single subject: the human body. Dissecting corpses was key to portraying the body realistically, but it was also strictly illegal at the time. Ignoring this, Michelangelo dissected.

By the time he was 30 years old, Michelangelo was Italy's best known artist. He sculpted *David* for the city of Florence and the *Pietà* for a French cardinal, and he frescoed the Sistine Chapel for the pope. Throughout his long life, Michelangelo's talents were in great demand. He worked for nine popes. As an adult, he divided his time between his hometown of Florence and Rome, where the money was. Michelangelo fiercely guarded his artistic freedom and boldly stood up to popes and kings over creative differences. And he prevailed.

Michelangelo, **David with Prisoners**, c. 1518 (Accademia Gallery, Florence).
With David *presiding at the "altar" and Michelangelo's* Prisoners *lining the "nave," hordes of "pilgrims" crowd into the Accademia Gallery, Florence's "cathedral of humanism."*

Michelangelo as Sculptor

Michelangelo's statues can be outwardly calm, stable, and balanced, but they seem to be charged with pent-up energy. They convey the inner restlessness and turmoil that marked his own life.

DAVID

Start with his ultimate masterwork. *David* gazes ahead with the new-found awareness and self-confidence of Renaissance man. This 14-foot-tall symbol of divine victory over evil represents a new century—and a whole new way of looking at the world.

In 1501, Michelangelo Buonarotti, age 26, was commissioned to carve a large-scale work for the Duomo. He was given a block of marble that other sculptors had rejected as too tall, shallow, and flawed to be of any value. But Michelangelo picked up his hammer and chisel, knocked a knot off what became *David's* heart, and started to work.

The figure comes from a Bible story. The Israelites, God's chosen people, are surrounded by barbarian warriors led by a brutish giant named Goliath. The giant challenges the Israelites to send out someone to fight him. Everyone is afraid except one young shepherd boy—David. Armed only with a sling, which he throws over his shoulder, David cradles some stones in his other hand and heads out to face Goliath.

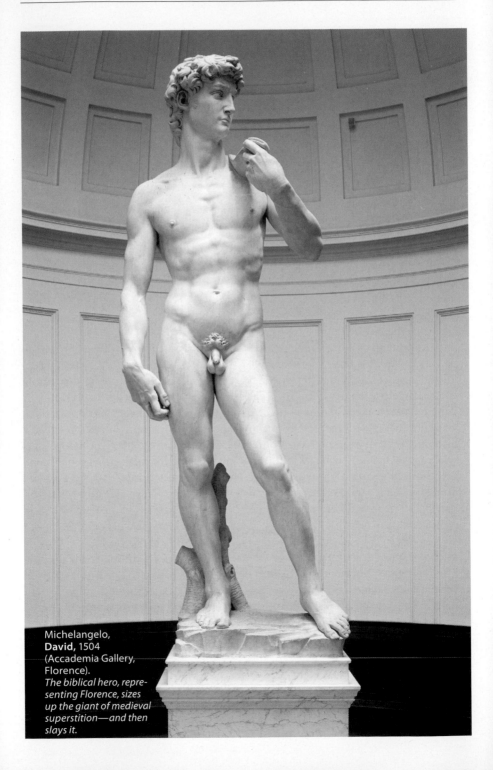

Michelangelo,
David, 1504
(Accademia Gallery,
Florence).
*The biblical hero, repre-
senting Florence, sizes
up the giant of medieval
superstition—and then
slays it.*

The statue captures David as he's sizing up his enemy. He stands relaxed but alert, leaning on one leg in a classical pose. In his powerful right hand, he fondles the stones he'll fling at the giant. His gaze is steady as he searches with intense concentration, but also with extreme confidence. Michelangelo has caught the precise moment when David is saying to himself, "I can take this guy."

David is a symbol of Renaissance optimism. He's no brute, but a civilized, thinking individual who can grapple with and overcome problems. He needs no armor, only his God-given body and wits. Look at his right hand, with the raised veins and strong, relaxed fingers. Many complained that it was too big and overdeveloped. But this is the hand of a man with the strength of God. No mere boy could slay the giant. But David, powered by God, could...and did.

Florentines identified with David. Like him, they considered themselves God-blessed underdogs fighting their city-state rivals. In a deeper sense, they were civilized Renaissance people slaying the ugly giant of medieval superstition, pessimism, and oppression. David, like Florence—and the Renaissance itself—is a celebration of humanism.

PRISONERS

These unfinished figures seem to be struggling to free themselves from the stone. They illustrate Michelangelo's approach to sculpting. He believed he was a tool of God, not creating the statue but simply revealing the powerful and beautiful figures God put in the marble. Michelangelo's job was to

Michelangelo, **Prisoner,** c. 1518 (Accademia Gallery, Florence). *Many of Michelangelo's statues were never finished, as if he freed the figure imprisoned in the rock, lost interest, and went on to his next project. These unfinished works show his passion to "free the body from the stone."*

chip away the excess, to reveal.

Whenever the spirit came upon him, Michelangelo worked in a frenzy—he was one of the first "mad geniuses." In his sweaty work clothes, covered with marble dust, he'd often work deep into the night wearing

Michelangelo, **Night,** 1526 (Medici Chapels, Florence). *Michelangelo clearly favored the male anatomy. His females are generally less interesting, looking like musclemen with coconut-shell breasts. Theories abound that Michelangelo was homosexual. While his private sex life (or lack thereof) ultimately remains a mystery, his public expressions of affection were clearly weighted toward men.*

a candle on his cap. He was known to shout at the stone in frustration: "Speak!" Unlike most sculptors, who marked out in advance what they planned to cut, Michelangelo always worked freehand, starting from the front and working back. These figures emerge from the stone (as his colleague Vasari put it) "as though surfacing from a pool of water."

Michelangelo may have left these statues unfinished because he was simply too busy. Or, having satisfied himself that he'd accomplished what he set out to do, he may have seen no point in polishing them into their shiny, finished state just to please his patron.

Notice Michelangelo's love of the human body. His greatest days were spent sketching the muscular, tanned, and sweating bodies of the workers in the Carrara marble quarries.

The *Prisoners'* heads and faces are the least-developed part—instead, they "speak" with their poses. Comparing the restless, claustrophobic *Prisoners* with the serene and confident *David* gives an idea of the astounding emotional range in Michelangelo's work.

At times, Michelangelo must have felt cursed by the "divine genius" within him. His *Prisoners* seem to show this divine genius trapped within the prison of the body, struggling to get out.

MICHELANGELO'S PIETÀS

A *pietà* (by definition) shows Mary with Jesus' dead body. Michelangelo sculpted three famous *pietàs*, one each in Rome, Florence, and Milan. In these sculptures—which range from sweet to tragic to ethereal—Michelangelo shows the journey of his genius.

"The" *Pietà* (see next page) was sculpted by Michelangelo when he was 24 years old. It was his first major commission, done for the Holy Year 1500.

Michelangelo, with his total mastery of realism, captures the sadness of the moment and makes the theological point of a *pietà* clear: Christ actually died. Eternally-youthful Mary holds her crucified son in her lap. Jesus is believably human, his warm fleshiness contrasting with the coarse backdrop of Mary's robe. Christ's lifeless right arm drooping down lets us know how heavy this corpse is. The precise veins, tendons, and sinews show that Michelangelo learned well from his studies of cadavers. Mary tilts her head down, looking at her dead son with sad tenderness.

Michelangelo, **Pietà del Duomo,** 1555 (Duomo Museum, Florence).

Realistic as this work is, its true power lies in the subtle "unreal" features. Life-size Christ looks childlike compared with larger-than-life Mary. Unnoticed at first, this accentuates the subconscious impression of Mary enfolding Jesus in her maternal love. Though the mother of a 33-year-old man, Mary still looks like a teenager, like the eternally youthful "handmaiden" of the Lord. She accepts God's will, even if it means giving up her son.

The statue is a solid pyramid of maternal tenderness. Yet within this, Christ's body tilts diagonally down to the right and Mary's hem flows with it. Subconsciously, we feel the weight of this dead God sliding from her lap to the ground.

This is Michelangelo's only signed work. The story goes that he

Michelangelo, "The" Pietà, 1499 (St. Peter's Basilica, Rome).

Michelangelo Must-Sees

If you're a fan of the world's greatest sculptor, you won't leave Europe until you've checked off each of these:

In Florence

❑ *David* and *Prisoners,* Accademia Gallery
❑ *Pietà del Duomo,* Duomo Museum
❑ *Night, Day,* and other statues done for the Medici tomb, Medici Chapels at the Church of San Lorenzo
❑ *Bacchus, Bruto,* and a minor *David,* Bargello Museum
❑ *Holy Family* easel painting, Uffizi Gallery
❑ "Michelangelo's House" (Casa Buonarroti) built on property Michelangelo once owned, containing some early works
❑ Michelangelo's tomb at Santa Croce Church

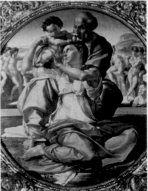

In Rome

❑ Sistine Chapel ceiling and *The Last Judgment,* Vatican Museum
❑ Dome of St. Peter's Basilica, Vatican
❑ *Pietà* (the famous one), inside St. Peter's Basilica, Vatican
❑ Capitol Hill Square (Campidoglio) atop Capitol Hill
❑ *Moses* and other statues from Pope Julius II tomb, St. Peter-in-Chains Church
❑ *Christ Bearing Cross,* Santa Maria sopra Minerva Church

Michelangelo, **Holy Family,** 1506 (Uffizi Gallery, Florence). *Michelangelo insisted he was a sculptor, not a painter. His only surviving easel painting shows solid, statuesque people posed in a sculptural group—the work of a sculptor with a brush.*

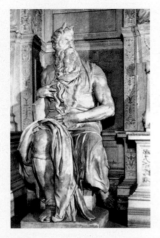

Elsewhere

❑ *Rondanini Pietà,* Sforza Castle, Milan
❑ *Madonna and Child* sculpture, Church of Our Lady, Bruges, Belgium
❑ *Slaves,* Louvre Museum, Paris
❑ *Entombment* (unfinished painting), National Gallery, London

Michelangelo, **Moses,** 1515 (St. Peter-in-Chains Church, Rome). *This powerful sculpture is one of the few figures finished for the monumental tomb of the egomaniac Pope Julius II. The tomb, which the pope planned to place inside St. Peter's Basilica, would have included 40 statues and taken Michelangelo several lifetimes to complete.*

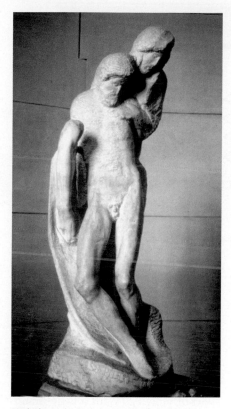

Michelangelo, **Rondanini Pietà**, 1564
(Sforza Castle, Milan).

overheard some pilgrims praising his *Pietà* but attributing it to a second-rate sculptor from a lesser city. He was so enraged that he grabbed his chisel and chipped into the ribbon running down Mary's chest: "Michelangelo Buonarroti of Florence did this."

In Michelangelo's *Pietà del Duomo* the Z shape of Christ's elongated, lifeless body accentuates his dead weight. The face of Nicodemus (at peak of pyramid) is a self-portrait of the aging Michelangelo.

In the unfinished *Rondanini Pietà*—which Michelangelo was working on when he died—Mary and Jesus are nearly weightless, rising like a single flame toward heaven. This nearly modern sculpture is reduced to its spiritual essence. Its elongated forms hint at the Mannerist period to follow.

Michelangelo as Painter: The Sistine Chapel Ceiling

Pope Julius II, as part of a massive effort to return Rome to its former splendor, asked a hesitant Michelangelo to paint an enormous fresco on the ceiling of the Sistine Chapel, which was both the pope's personal chapel and the place where all popes are elected. At first, Michelangelo said *"No, grazie,"* insisting he was a sculptor, not a painter. The Sistine ceiling was a vast undertaking, and he didn't want to do a half-vast job. But the pope pleaded, bribed, and threatened until Michelangelo finally consented, on the condition he be able to do it all his own way. He spent the next four years (1508–1512) craning his neck on scaffolding six stories up, covering the ceiling with frescoes that show the entire Christian history of the world.

In sheer physical terms, it's an astonishing achievement: 5,900 square feet, with the vast majority done by his own hand. (Most artists let assistants paint the background stuff.)

First, he had to design and erect scaffolding. All materials had to be hauled up on pulleys. Then, a section of ceiling would be plastered. When creating a fresco (painting on wet plaster), if you don't get it right the first time, you have to scrape the whole thing off and start over. And if you've ever struggled with a ceiling light fixture or worked underneath a car for even five minutes, you know

how heavy your arms get. The physical effort, the paint dripping in his eyes, the creative drain, and the mental stress from a pushy pope combined to almost kill Michelangelo.

When the ceiling was finished and revealed to the public, it simply blew 'em away. It both caps the Renaissance and turns it in a new direction, capturing the spirit of the age by mixing Old Testament prophets with classical figures. But the style is more dramatic, shocking, and emotional than the more balanced works that preceded it. Many art scholars contend that the Sistine Chapel's ceiling is the greatest-ever work of art by a single human being.

THE CREATION OF ADAM

The ceiling shows the history of the world from the Creation up to the coming of Jesus. We see a busy God creating the world, creating man and woman, driving them from Paradise, destroying the earth by flood, and so on; it adds up to more than 600 figures. This is a very personal work—the Gospel according to Michelangelo—

but its themes and subject matter are universal.

Michelangelo places God and man at the heart of this Renaissance version of creation. Adam, newly formed in the image of God, lounges dreamily in perfect naked innocence. God, with his entourage, swoops in with a swirl of activity. (With a little imagination, God's realm looks like a cross-section of a human brain...quite a strong humanist statement.) Their reaching hands are the center of this work. Adam's is limp and passive; God's is strong and forceful, his finger twitching with energy. Here is the very moment of creation, as a fatherly God passes the spark of life to man, the crowning work of his creation.

This is the spirit of the Renaissance—God is not a terrifying giant reaching down to puny and helpless man from way on high. Here they are on an equal plane. God and Adam balance each other, like two pieces of a jigsaw puzzle, or two long-separated continents, or like the yin and yang symbols finally coming

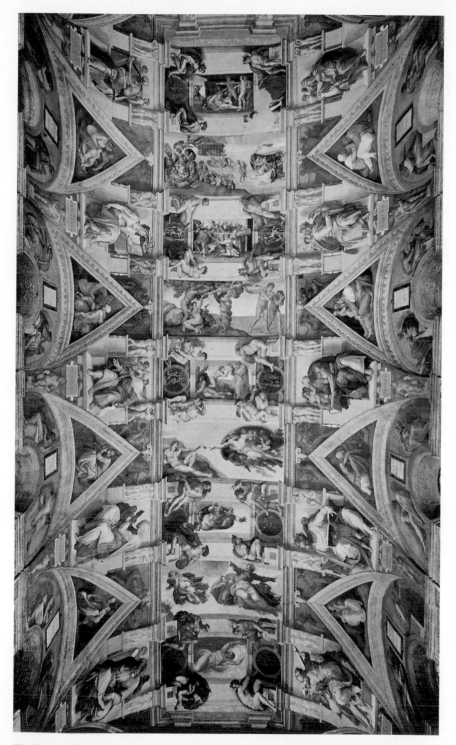

*The **Sistine Chapel ceiling** shows the story of Creation with a powerful God weaving in and out of each scene through that busy first week.*

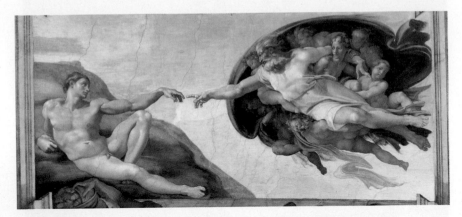

Michelangelo, **Creation of Adam,** c. 1510 (Sistine Chapel, Vatican Museum, Rome).

together and complementing each other, creating wholeness. God and man work together in the divine process of creation.

THE LAST JUDGMENT

Twenty-three years later (1535), Michelangelo returned to the Sistine Chapel to paint the altar wall. The mood of Europe—and of Michelan-

Michelangelo,
Study for Adam for the Sistine Chapel, 1510
(British Museum, London).
*The Florentines were sculptors at heart. Here
Michelangelo's sculptural orientation shows through.
Compare this with the finished product above.*

gelo—was completely different. The Protestant Reformation had forced the Catholic Church to clamp down on free thought, and religious wars raged. Renaissance optimism was fading. Michelangelo himself had begun to question the innate goodness of mankind.

It's Judgment Day, and Christ—the powerful figure in the center raising his vengeful arm—has come to find out who's been naughty and who's been nice. Beneath him, a band of trumpeting angels blows a wake-up call to the sleeping dead, who leave their graves and prepare to be judged. The righteous, on Christ's right hand (the left side of the picture), are carried up to the glories of heaven. The wicked on the other side are hurled down to hell, where gleeful demons wait to torture them.

It's a grim picture. No one, but no one, is smiling, not even in heaven. The saints around

Christ (even his own mom, Mary) shrink back in terror at the terrifying Judge.

One of the damned (to the right of the trumpeting angels) has an utterly lost expression, as if saying, "Why did I cheat on my wife?!" Two demons grab him around the ankles to pull him down to the bowels of hell, condemned to an eternity of constipation.

When *The Last Judgment* was unveiled to the public in 1541, the pope is said to have dropped to his knees and cried, "Lord, charge me not with my sins on the Day of Judgment!" The work changed the course of art. The complex composition, with more than

Michelangelo, **Sistine Chapel,** 1508–1512 (Vatican Museum, Rome).
The pictorial culmination of the Renaissance, Michelangelo's Sistine ceiling tells the history of the Christian world from Creation to Christ. He later painted The Last Judgment *behind the altar. Today, this room is newly restored, as brilliant as the day Michelangelo finished it.*

Michelangelo, **The Last Judgment**, 1534–1541 (Sistine Chapel, Vatican Museum, Rome).

300 figures swirling around the figure of Christ, was far beyond traditional Renaissance balance. The twisted figures shown from every imaginable angle challenged other painters to try and top this master of 3-D illusion. And the sheer terror and drama of the scene made Renaissance optimism look namby-pamby. Michelangelo had Baroque-en all the rules of the Renaissance, signaling a new era of art.

Michelangelo himself must have wondered how he would be judged: Had he used his God-given talents wisely? In the flayed skin held by St. Bartholomew is a barely recognizable face—the twisted self-portrait of a self-questioning Michelangelo.

Michelangelo as Architect

Whether Michelangelo died satisfied with his life's work we don't know. But he lived almost 90 years and was productive until the end. Michelangelo was 71 years old when the pope persuaded him to take over the construction of

Michelangelo, **The Last Judgment** (detail). *A disillusioned Michelangelo paints his own face in the wretched skin in St. Bartholomew's hand. With the Reformation, the Vatican is on the defensive. Renaissance optimism has ended.*

St. Peter's Basilica and cap it with a dome. His model was Brunelleschi's dome in Florence. Michelangelo's dome soars higher than a football field on end—430 feet from the floor of the cathedral to the top of the lantern. Under the dome, under the altar, and some 23 feet under the marble floor rest the bones of St. Peter, upon which this particular church was built. Michelangelo spent the last 20 years of his life building the great dome of St. Peter's. As a final show of independence and devotion to art, Michelangelo did it for free.

Michelangelo, Dome of St. Peter's Basilica, b. 1547 (Vatican, Rome).
You can climb to the top of Michelangelo's dome—more than 300 winding, sweaty feet up—for a commanding city view.

Leonardo da Vinci

Leonardo da Vinci (1452–1519) typified the well-rounded Renaissance man. He was renowned as a sculptor, engineer, inventor, scientist...and, eh, he wasn't a bad painter either. As a young man in Florence, he first attracted attention as the good-looking lute player who entertained at Lorenzo the Magnificent's parties.

For his education, Leonardo learned from nature, not just books, which made his observations often more accurate than those of contemporary scholars. From his notes, we know he dissected corpses, investigated the growth of fetuses in the womb, formulated laws of waves and currents, studied the growth of plants, and diagrammed the flight of birds and insects. He also designed military fortifications and sketched many inventions, foreshadowing the development of the airplane and submarine. Some claim he even envisioned a crude carry-on-the-plane-size convertible suitcase/rucksack. Leonardo wrote all this down in his personal code—backward and inside out as if reflected in a mirror—perhaps in case his thoughts could be construed as heretical.

Wealthy princes hired the elegant genius to paint or sculpt for them, or design new-fangled fortifications and waterways. Though learned and witty, Leonardo was considered something of a flake who often left projects unfinished. He worked at his own pace

Leonardo, **Self-Portrait,** c. 1512
(Real Library, Turin, Italy).

rather than at an employer's. None of Leonardo's sculptures and only about 20 of his paintings survive.

The Last Supper

This famous fresco survives—just barely—on a church wall in Milan. Leonardo's masterpiece is not just another version of this well-worn theme. Christ and his 12 apostles are eating their last meal before Jesus is arrested and executed. Jesus has just said that one of the disciples will betray him. Leonardo paints a psychological portrait of each of them at the very moment they ask, "Lord, is it I?"

Leonardo blends mathematical perfection and human realism. The painting covers one entire wall in a former convent dining room, positioned so it looks like an extension of the room. Nuns could eat dinner in the physical presence of Jesus. The lines of the walls recede toward the horizon

Leonardo da Vinci, **The Last Supper,** 1498 (Santa Maria delle Grazie, Milan).
Today this masterpiece suffers from Leonardo's use of an experimental (and not very successful) fresco technique. Although newly restored, the fresco remains faded and fragile. Admission is strictly limited. Follow your guidebook's instructions to get your reservation well in advance.

(following the laws of perspective) and come together at Christ's head, framed with a "halo" made by the window behind him. The viewer, unaware of Leonardo's use of math here, subconsciously feels that everything leads directly to Christ.

Making the tableau a nifty piece of Christian symbolism, Leonardo arranges the twelve into four groups of three: 3 (symbolizing the Trinity) x 4 (the Gospels) = 12 (the apostles). Each group moves like a wave, surging either toward Jesus or away from him. Despite this complex composition with its powerful subconscious undertones, the picture is not forced or sterile, but a probing depiction of real human beings.

Leonardo spent three years on *The Last Supper*. It's said that he went whole days without painting a stroke, just staring at the work. Then he'd grab a brush, rush up, flick on a dab of paint...and go back to staring.

Mona Lisa (1503–1506)

Leonardo was already an old man when King François I invited him to France. Determined to pack light, he took only a few things. One was a portrait he'd kept in his personal collection of Lisa del Giocondo, the wife of a wealthy Florentine merchant. We know it as a contraction of the Italian for "my lady Lisa"—*Mona Lisa*.

The famous smile attracts you first. Leonardo used a hazy technique called *sfumato*, blurring the edges of *Mona*'s mysterious smile. Try as you might, you can never quite see the corners of her mouth. Is she happy? Sad? Tender? Or is it a cynical supermodel's smirk? Every viewer reads it differently,

projecting his own mood onto *Mona*'s enigmatic face. *Mona* is a Rorschach inkblot...so, how are you feeling?

Mona may disappoint you in the flesh. She's smaller than you'd expect (20 inches by 30 inches), darker, engulfed in a huge room, hidden behind a glaring pane of glass, and ogled by hundreds of heavy-breathing tourists. So, you may ask, "Why so famous?" Take a closer look. Like a lover, you've got to take her for what she is, not what you'd like her to be.

Look past the smile and the eyes that really do follow you (as with most eyes in portraits) to some of the subtle Renaissance elements that make this masterpiece work. The body is surprisingly massive and statue-like, a perfectly balanced pyramid turned at

Leonardo's **Mona Lisa**, from 1505, is found in tourist shops throughout Paris (and in the Louvre—just follow the crowds).

Works of Leonardo da Vinci

- *Mona Lisa, Madonna of the Rocks,* and *John the Baptist,* Louvre Museum, Paris
- His home and models of inventions, Amboise, Loire, France
- *The Last Supper,* Santa Maria delle Grazie, Milan
- Gimmicky yet popular exhibits in many cities (including Florence) that show off working wooden models built from Leonardo's sketches
- *St. Jerome,* Pinacoteca Gallery, Vatican Museum, Rome
- *Annunciation* and *Adoration of the Magi,* Uffizi Gallery, Florence
- *Virgin and Child* (cartoon) and *Madonna of the Rocks,* National Gallery, London
- *Madonna and Child,* Alte Pinakothek, Munich, Germany
- *Lady with an Ermine,* Czartoryski Museum, Kraków, Poland

Leonardo, **Virgin and Child with St. John the Baptist and St. Anne,** c. 1499–1500 (National Gallery, London). *Baby Jesus enjoys a pyramid of maternal security (while St. Anne whispers into Mary's ear, "It's just not fair when a child's birthday falls on Christmas").*

an angle, so that we can appreciate its mass. Her arm rests lightly on the arm of a chair, almost on the level of the frame itself, like she's sitting in a window looking out at us. The folds of her sleeves and her gently folded hands are remarkably realistic and relaxed. The typical Leonardo landscape shows distance by getting hazier and hazier.

Mona Lisa has long been a people's favorite because of her secretive smile and the sense that this ordinary-looking noblewoman of low rank is "one of us." *Mona* was kidnapped early in the 20th century. Her safe recovery made headlines, boosting her fame even higher. Artistically, she epito-mizes the art of the Renaissance: balanced, serene, and true. Her smile and long-distance beauty are subtle and elusive, tempting but just out of reach, like a melody wafting in the wind.... *Mona* doesn't knock your socks off, but she winks at the patient viewer.

Raphael

Raffaello Sanzio—like most Renaissance greats, known by a simple nickname, Raphael (roff-eye-ELL, 1483–1520)—is considered the culmination of the High Renaissance. Raphael combined symmetry, grace, beauty, and emotion. He combined the elegance of Leonardo with the power

of Michelangelo.

Raphael lived a charmed life. He was handsome and sophisticated, and quickly became the favorite of princes and popes. He painted masterpieces effortlessly. Raphael was rich and famous, a celebrity in a high-class profession. He painted while wearing fine clothes, nibbling fresh fruit, sipping wine, and maybe even being entertained with live music. Afterward, he'd wash up before dinner and enjoy a high-society ball that evening. In a different decade, he might have been thrown out of the Church as a great sinner, but his love affairs and devil-may-care personality seemed to epitomize the optimistic spirit of the Renaissance.

Raphael's works are graceful but

Raphael, **Madonna of the Goldfinch**, 1505 (Uffizi Gallery, Florence).

never lightweight or frilly; they're strong, balanced, and harmonious in the best Renaissance tradition.

Madonna of the Goldfinch

Raphael perfected the style Leonardo pioneered. In typical Leonardo fashion, this group of Mary, John the Baptist, and Jesus is arranged in the shape of a pyramid, with Mary's head at the peak. Mary is a mountain of motherly love, enfolding the two playful tykes. Jesus poses *contrapposto* like a chubby Greek statue. Draw a line down the middle, through Mary's nose, and the painting balances perfectly, left and right. Even the trees in the background balance each other.

These things aren't immediately noticeable, but they help create the subconscious feeling that God's created world is perfect. Raphael's blended brush strokes varnish the work with an iridescent smoothness. The geometric perfection, serene landscape, and Mary's adorable face make this a masterpiece of sheer grace... but then you get smacked by an ironic fist: The kids innocently play with the cross, which foreshadows their gruesome deaths.

The School of Athens

In both style and subject matter, this fresco sums up the spirit of the Renaissance. Raphael imagines all the great thinkers of ancient Greece assembled together in one big rock 'n' roll heaven, engaged in highbrow jawboning. (See page 37 for help in ID-ing some of the figures.) What's astonishing is that these enlightened people— all pagans—were glorified on the walls of the Christian pope's personal library

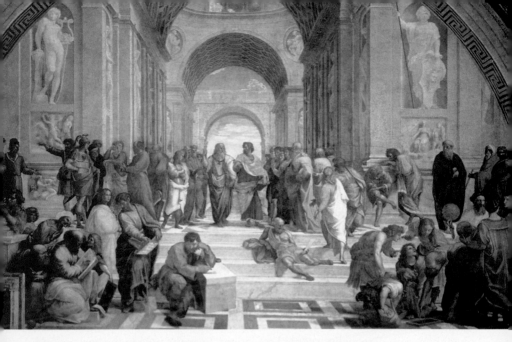

Raphael, **School of Athens,** 1510 (Raphael Rooms, Vatican Museum, Rome).
Renaissance thought united the Church and the great classical philosophers. Here, the Renaissance architecture provides a halo for the two central figures—Plato and Aristotle—the pre-Christian saints of knowledge.

(in today's Vatican Museum). Renaissance humanism ruled.

In the center are Plato and Aristotle, indicating their philosophy (Plato pointing up to the realm of ideas, Aristotle pointing down at the tangible world). There's their master, Socrates (midway to the left, in green), ticking off arguments on his fingers. And in the foreground at right, bald Euclid bends over a slate to demonstrate a geometrical formula.

Raphael proudly shows that Renaissance thinkers were as good as the ancients. There's Leonardo da Vinci, whom Raphael worshipped, in the role of Plato. Euclid is the architect Donato Bramante, who designed St. Peter's Basilica. (The arches in the background are actually a look at the church, then under construction.)

Raphael himself (next to last on the far right, with the black beret) looks out at us.

The composition, like Leonardo's *The Last Supper,* has figures grouped rhythmically around a center of calm. Raphael puts philosophers to the left, scientists to the right. All the lines of sight—the floor tiles, the walls, the arches—converge on the center at Plato and Aristotle. The small arch over their heads forms a "halo" above these two secular saints in the divine pursuit of knowledge. Raphael's perfectly balanced composition mimics the geometrical order the Renaissance God put into the world.

While Raphael was painting this room, Michelangelo was climbing the walls of the Sistine Chapel just down the hall. Raphael got a sneak peek at

Raphael Sights

- *School of Athens, Deliverance of St. Peter,* and others, Raphael Rooms, Vatican Museum, Rome
- *Transfiguration,* Pinacoteca Gallery, Vatican Museum, Rome
- Sistine Chapel tapestries- -these major works designed by Raphael hang in the Vatican Museum, Rome; his cartoons (designs) for them are at the Victoria and Albert Museum, London
- *Sistine Madonna* (with the famous little angels leaning on a ledge, see below), Old Masters Gallery, Dresden, Germany
- Raphael's tomb, Pantheon, Rome
- There's so much more. Most major art galleries have works of Raphael, including Florence's Uffizi Gallery, Madrid's Prado Museum, Paris' Louvre Museum, Munich's Alte Pinakothek, Vienna's Kunsthistorisches Museum, and St. Petersburg's Hermitage

Raphael, **Sistine Madonna** (detail), c. 1513–1514 (Old Masters Gallery, Dresden, Germany).

Michelangelo's powerful figures and dramatic scenes, and he was astonished. From this point on, Raphael began to beef up his delicate style to a more heroic level. He returned to *The School of Athens,* scraped off a section of fresco, and (putting his competitive spirit aside), he honored his artistic rival by adding one more figure to the scene: Michelangelo, the brooding, melancholy figure in front, leaning on a block of marble.

In his day, Raphael's fame was equal to Michelangelo's, and his influence on subsequent generations was perhaps even greater. Only in our generation have Michelangelo and Leonardo surpassed him in postcards sold. Raphael's work spawned so many imitators who cranked out sickly sweet,

Raphael, **The Transfiguration** (detail), 1520
(Pinacoteca, Vatican Museum, Rome).
As he was dying, Raphael set his sights on heaven and painted possibly his most beautiful work, this heavenly face of Jesus.

never recovered, and the center of the Renaissance shifted once again—this time northward, to Venice.

Renaissance Venice:
Europe's Rich Middleman

Venice was once Europe's richest city. As middleman in the seagoing trade between Asia and Europe, Venice reaped wealth from both sides. For 500 years (c. 1100–1600), Venice was known as "the Bride of the Sea" and the envy of all of Europe. Every year the leader of Venice, after renewing a kind of wedding vow, tossed a symbolic ring into the Adriatic.

Venice is an island two miles off the Italian coast. It got its start in about A.D. 400—when Rome was falling—as a kind of refugee camp for mainlanders. After suffering too many rape-pillage-and-plunders, these first Venetians got together and decided to move out into the lagoon, hoping the rampaging barbarians wouldn't like water. They built on muddy islands, pounding in entire forests of tree trunks for support,

generic Madonnas that we often take him for granted. Don't. He's the real deal.

Raphael's unexpected death in 1520 stunned Rome's high society. Then in 1527, the city of Rome got caught in the crossfire of Europe's wars. Renegade soldiers entered the city and brutally raped, pillaged, and vandalized for a solid month. Rome

and dredging canals for their "roads." Farming was impossible in the mud, so the Venetians traded fish and salt (for preserving meat) for their livelihood. Gradually, their trading took them to more and more distant lands.

Venice's **Rialto Bridge** gracefully spans the Grand Canal.

Venice gained religious prestige when it acquired the bones of St. Mark (A.D. 828) and built St. Mark's Basilica to showcase the relics. Presto! Venice became an important religious destination, and St. Mark's symbol—the winged lion—appeared everywhere.

When the Crusades created a demand in Europe for Eastern luxury goods, Venice was the natural go-between. Venetians set up a chain of ports and friendly cities in the eastern Mediterranean. Sea trade spawned other industries, including shipbuilding, warehousing, insurance, currency exchange, and banking. Besides its commercial empire, Venice had a powerful navy, and even hired generals to conquer much of northern Italy. Venice's Arsenal, the largest single factory in Europe, employed 16,000 people at its peak and could crank out a warship a day.

By 1450, Venice was Europe's superpower, with 180,000 citizens (far more than London) and a gross "national" product that exceeded that of entire countries. The Venetian ducat, because of its stability and high gold content, became the monetary standard for the Eastern world. (The Florentine florin was the West's.) The Rialto Bridge that spans the Grand Canal, which was originally a covered wooden drawbridge, was rebuilt as a grand stone arch. Products from as far away as Scotland and India passed through the Rialto's warehouses. Iron, copper, and cloth from northern Europe were traded for luxury goods from the East: jewels, silk, Persian rugs, leather, perfume, lemons, raisins, pepper, and other spices.

Venice was fully cosmopolitan. Turks in turbans rubbed elbows with Byzantine businessmen and German monks. Jews settled in the first "ghetto" (giving us the word for a neighborhood set aside for minorities). One of Venice's 5,000 Greek-speakers was Doménikos Theotokópoulos, who later became a famous painter in Spain...El Greco.

The Venetian empire was controlled by an oligarchy of wealthy families, headed by a duke who served for life, known as the Doge (pronounced "dozh," not "doggie").

Rich Venice taught the rest of Europe the good life: exotic food and wine, silk clothes, music, theater, sex, gambling, and laughter. Venice was a vibrant city of painted palaces, glittering canals, and impressed visitors.

Elegant Decay

Venice peaked in the year 1450. Then, a series of world events set in motion centuries of slow decline. In 1453, the

Doge's Palace, 1340 and today (Venice).
Venice was ruled from this palace. Today this Venetian Gothic building is packed with art master-pieces, history, and tourists. A current photograph proves that the town has changed (and sunk) little in six centuries, though the tower is clearly sliding to the right.

Muslim Turks captured and looted Constantinople. The Turks attacked Venetian ports, starting a series of draining wars that caused Venice's trade empire to unravel.

At the southern end of the Adriatic Sea, the Republic of Dubrovnik (in today's Croatia) began to rival Venice's shipbuilding industry, thanks largely to the success of the Dubrovnik-built argosy boat, the Cadillac of ships. Europe's major nations were glad to have a second major seafaring power in the Adriatic to dilute Venetian dominance.

The next blows came from the West, when explorers from Spain and Portugal discovered America and new sea-trade routes to the East. With her monopoly on Eastern trade broken, Venice lost clout and slowly faded.

But Venice's decline was a glorious one. Like so many cultures past their peak of economic expansion, Venice turned from business to the arts, from war to diplomacy, from buying gold to selling tacky souvenirs. The "Cinquecento" (CHINK-kwah-CHEHN-toh), as the Italians call the 1500s, was a time to enjoy the fruits of the previous centuries. Renaissance art flourished.

By the 1700s, Venice was a political backwater, but it had cemented its reputation as the Las Vegas of Europe. French and English nobles flocked to the city of Casanova (a real-life Venetian) to don masks and do the kinds of naughty things that were forbidden back home. Venice's long decline was hastened by two brutal plagues. Finally, Napoleon invaded from France (1797) and Venice became a possession of various European powers until modern Italy was created (1870).

The city today is older, crumbling, and sinking, but it looks much the same as it did during the grand days of the Renaissance. For that we can thank Venice's economic decline: The inhabitants were simply too poor to rebuild. Venice is Europe's best-preserved big city. It is the toast of the High Middle Ages and Renaissance in an elegant state of decay.

St. Mark's Basilica

St. Mark's Basilica, with its domes and glowing mosaics, is a mix of Eastern and Western influences.

It's a treasure chest of booty looted during Venice's glory days. There are round, Roman-style arches over the doorways, golden Byzantine mosaics, a roofline ringed with pointed French Gothic pinnacles, and Islamic onion domes on the roof. The columns flanking the doorways are a mishmash of different colors and capitals. Inside, the cathedral features altarpieces, chalices, and precious objects "appropriated" from other cultures during Venice's heyday. The style has been called "Early Ransack."

Horses of St. Mark's Basilica (Venice).

Above the main entrance are four bronze horses. Stepping lively and with smiles on their faces, they exude the energy and exuberance of Venice in its prime. Legend says they were made in the time of Alexander the Great, then taken by Nero to Rome. Constantine carried them off to his new capital in

St. Mark's Basilica, 1063–1073 (Venice).
Mark Twain called St. Mark's "a great warty bug taking a meditative walk."

Constantinople to adorn the chariot racecourse. In the Crusades (1204), Venetians stole them from their fellow Christians during the looting of Constantinople. What goes around comes around, and Napoleon came around (1797) and took the horses to Paris. When Napoleon's empire was toppled, they returned here, looking over Europe's grandest square. (Venetians have recently replaced them with copies, moving the precious originals out of the acidic modern air and into the church...where you can pay to see them.)

St. Mark's Square, stretching in front of the basilica, is big, but these days it feels intimate with its cafés and dueling orchestras. By day, it's great for people-watching and pigeon-chasing. By night, under lantern light, it transports you to another century, complete with its own romantic soundtrack.

Venice has been a major tourist center for centuries. Sit at an outdoor table and enjoy the schmaltzy music, where Casanova, Lord Byron, Charles Dickens, and Woody Allen have all paid too much for a drink.

Venetian Renaissance Art

Venice got wealthy by trading with the luxurious and exotic East. Its happy-go-lucky art style shows a taste for the finer things in life. Where the Florentines excelled in sculpture and architecture, Venetians revolutionized painting. Venetian canvases are bigger than what had come before, the colors brighter. Greek heroes and goddesses are as common as Madonnas and saints. "Lady Venice" often appears as a luxurious woman in triumph, lauded by the nations of the world. And there are nudes—not Michelangelo's lumps of noble, knotted muscle, but smooth-

Titian, **Venus and the Organ Player,** 1550 (Prado Museum, Madrid).
Rich Venetians dealt with the conflict between sacred artistic pursuits (for example, music) and worldly, sensual pursuits (for example, the naked lady). Here, the torn musician leers at Venus while keeping both hands on his organ.

skinned, sexy, golden centerfolds.

Venetian art emphasizes color over outline. The great Florentine painters were "sculptors with brushes." They drew strong outlines, then filled it in with color (to put it crudely), creating noble, solid figures that stood out from a distant landscape. Venetians "built" a figure by placing one layer of paint over another.

Two innovations fueled the Venetian style. First was the invention of oil paints, made by dissolving the pigments in a vegetable-oil base. (Florentines generally used egg yolk–based tempera.) Oil paint was more transparent, letting a lower coat bleed through and blend with earlier coats. And Venetians painted on canvas, rather than wood, giving a softer surface.

The result was paintings that were more colorful, with soft-focus outlines that blended into the background. (When Michelangelo met the great Venetian painter Titian, whose fame rivaled his own, he praised his work and then said, "But it's a pity you Venetians cannot draw.") Venetian artists took Leonardo's *sfumato* one step further. It's like a picture taken with a soft-focus lens on the camera, making everything glow and blend together, bathing it in light. This lighter and more graceful look suited the elegant city of lavish palaces and glittering canals. The same delicate, atmospheric haze that often hangs over the city of Venice also characterizes Venetian art.

In churches, palaces, and museums throughout the city (and in museums across Europe), you'll find paintings by Venice's Renaissance artists from the Cinquecento. Following is an artistic parade of key works by the top five painters of the Venetian Renaissance: Bellini, Giorgione, Titian, Veronese, and Tintoretto.

Giovanni Bellini

In contrast to Florentine-style sharp-focus 3-D, Bellini paints Mary Magdalene (see below) on a flat plane with a black velvet backdrop. Her features are soft, hazy, and atmospheric, glowing out of the darkness as though lit by soft candlelight. It's not sculptural line that's important here, but color—warm, golden, glowing flesh tones. The face emerges from the canvas like a cameo.

Bellini (c. 1430–1516) painted dozens of saints and Madonnas—all idealized and beautiful. Mary Magdalene is painted with her hair down, like the prostitute that legend says she was, yet

Giovanni Bellini, **Mary Magdalene,** detail of Madonna and Child Between St. Catherine and Mary Magdalene, c. 1500 (Accademia Gallery, Venice).

she has a childlike face, thoughtful and repentant. This is the perfect image of the innocent woman who sinned by loving too much.

Bellini was the teacher of two more Venetian greats, Giorgione and Titian (both described below), schooling them in the new medium of oil painting. Applying layer upon translucent layer, Bellini made creamy complexions with soft outlines, bathed in an even light. His gift to the Venetian Renaissance was the "haze" he put over his scenes, giving them an idealized, glowing, serene—and much copied—atmosphere.

Giorgione

Giorgione's *The Tempest* (see below) marks a trend new to Italian painting—the landscape—reveling in the sheer beauty of the natural world.

It's the calm before the storm. The atmosphere is heavy, luminous but ominous. There's a sense of mystery. Why is the woman breast-feeding her baby in the middle of the countryside? And the soldier—is he ogling her or protecting her? Will lightning strike? Do they know that the serenity of this beautiful landscape is about to be shattered by an approaching storm?

The mystery is heightened by contrasting elements. The armed soldier contrasts with the naked lady with her baby. The austere, ruined columns contrast with the lusciousness of Nature. And, most important, the stillness of the foreground scene is in direct opposition to the threatening storm in the background. The landscape itself is the main subject, creating a mood, regardless of what the painting is "about."

Giorgione (jor-JONE-ee, c. 1477–1510) was as mysterious as his few paintings, yet he left a lasting impression. From his teacher Bellini, he learned to use haziness to create a melancholy mood of beauty. Nothing beautiful lasts. Flowers fade, Mary Magdalenes grow old, Giorgione died at 33, and, in *The Tempest,* the fleeting stillness is about to be shattered by the slash of lightning—the true center of the composition.

Giorgione, **The Tempest,** 1505 (Accademia Gallery, Venice).
Florentine art tended to be sculptural, with strong outlines; Venice's Renaissance art, like the city, was colorful and romantically atmospheric.

Titian

Titian the Venetian (they rhyme) captures the lusty spirit of his hometown. Compare his *Venus of Urbino* with Botticelli's newly hatched *Birth of Venus* (page 183) and you get a good idea of the difference between the Florentine and Venetian Renaissance. Botticelli's was pure, innocent, and otherworldly. Titian's should have a staple in her belly button. This isn't a Venus, it's a pinup, serving no purpose but to please

Titian, **Venus of Urbino**, 1538 (Uffizi Gallery, Florence).

the eye (and other organs). While Botticelli's allegorical Venus is a message, this is a massage. The bed is used.

Titian's work is balanced in Renaissance style, but he does it using color rather than outline. The canvas is split down the middle by the curtain. The left half is dark, the right half warmer. The two halves are connected by a diagonal slash of luminous gold—the nude woman. The girl in the background is trying to find her some clothes.

Titian (c. 1490–1576) was one of the most prolific painters ever, cranking out a painting a month for almost 80 years. He excelled in every subject: portraits of kings; racy nudes for their bedrooms; creamy-faced Madonnas for churches; and pagan scenes from Greek mythology. He was cultured and witty, a fine musician and businessman—an all-around Renaissance kind of guy. Titian was famous and

adored by high society. Once, while painting a portrait of the powerful Emperor Charles V, Titian dropped a brush. Charles stooped and picked it up for him. This often-repeated (and possibly untrue) anecdote represented the triumph of artistic genius.

Titian, **Danaë**, 1554 (Prado Museum, Madrid). *Titian's patrons—wealthy and hedonistic merchants—just loved his work. In this painting, golden coins (symbolizing the fertilization of Zeus) fall from heaven onto a voluptuous woman reclined seductively on a lavish bed.*

Veronese, **Feast of the House of Levi,** 1564 (Accademia Gallery, Venice).

Paolo Veronese

Parrrrty!! Venice loves the good life, and the celebration is in full swing. Veronese's *Feast of the House of Levi* depicts a huge room with a great view of Venice. Everyone's dressed to kill in colorful silk and velvet robes. Conversation roars and the servants bring on the food and drink. Originally, the painting was entitled *The Last Supper,* but this bunch is a lot rowdier than Leonardo's crew.

Veronese (1528–1588) captures the Venetian attitude (more love, less attitude) as well as the style of Venetian Renaissance painting: bright colors, big canvases, and scenes of Venetian life.

With true Renaissance optimism, crazy Veronese (they rhyme) pictures Christ as a party animal. There's Christ in the center of it all, amid drunks, buffoons, dwarfs, soldiers, dogs, a cat, and a parrot. In the Renaissance, life was a good thing and beauty was to be enjoyed. Renaissance men and women saw the divine in the beauties of Nature and glorified God by glorifying man.

No way, said the Church. In its eyes, the new humanism was the same as the old hedonism. Veronese was hauled before the Inquisition. What did he mean by painting such a bawdy Last Supper? Veronese argued that it was just artistic license, so they asked to see his—it had expired. But the solution was simple. Rather than change the painting, Veronese changed the title: *The Last Supper* became the *Feast of the House of Levi.*

Jacopo Tintoretto

The event that put Venice on the map is frozen at its most dramatic moment. Muslim fundamentalists in Alexandria, Egypt, are about to burn St. Mark's body, when suddenly a hurricane appears miraculously, sending them running for cover. Meanwhile, Venetian merchants whisk the body away, eventually taking it to Venice where they'll build a church around it.

Tintoretto (1518–1594) makes us part of the action. The square tiles in the courtyard run straight away from us, an extension of our reality, as though we could step right into the scene—or the merchants could carry

Major Collections of Renaissance Painting

- Uffizi Gallery, Florence
- Pinacoteca Gallery, Vatican Museum, Rome
- Accademia Gallery, Venice
- Brera Gallery, Milan
- Louvre Museum, Paris
- National Gallery, London
- Kunsthistorisches Museum, Vienna
- Alte Pinakothek, Munich
- Prado Museum, Madrid

Botticelli, **Magnificent Madonna** (detail), c. 1481
(Uffizi Gallery, Florence).
Just beautiful.

Mark into ours.

Tintoretto wowed Venice with his innovations. The son of a silk dyer ("Tintoretto" is a nickname meaning "little dyer"), Tintoretto applied

Tintoretto, **The Transporting of St. Mark's Body,** 1548 (Accademia Gallery, Venice).

a blue-collar work ethic to painting, creating masterpieces until the end of his long life. He trained briefly under Titian, but their egos clashed. He was influenced more by Michelangelo's recently completed *Last Judgment* (see page 198), with its muscular, twisting, hovering nudes and epic scale. By age 30, Tintoretto was famous. Then he turned his back on fame. He married, had eight children (three of whom became his assistants), and dedicated himself to work and family, shunning publicity and living his whole life in his old Venice neighborhood. Deeply religious, he often painted for free.

Tintoretto's distinct style strongly influenced the Mannerist and Baroque art that followed the Renaissance. He captures dramatic scenes at their peak of emotion. Strong 3-D sucks you into the scene. The light is bright, the shadows are dark, and the colors are harsh, with a metallic "black-velvet" sheen, especially in contrast to the soft-focus haze of his fellow Venetians. Everyone twists and turns restlessly. We

view scenes at odd angles, often from the diagonal. And finally, Tintoretto's religious perspective always shines through. In his works, the miraculous and the ordinary mingle side by side, as God enters our everyday lives. (Tintoretto fans will want to visit Venice's Scuola San Rocco, a place so full of his work that it's often called Tintoretto's "Sistine Chapel.")

The Italian Renaissance Conquers Europe

By 1500, the optimism and humanism of Italy were spreading all over the Continent. Europe's kings and dukes imported Italian artists to build palaces and paint their portraits. Bishops wanted un-Gothic churches. Cities wanted monuments and fountains. French kings built Renaissance châteaus on the Loire, Polish kings refurbished their royal palace with an Italian Renaissance flair, and even the Russian tsar imported Italian expertise to remodel Moscow's Kremlin in the new style. And all of them wanted Italians, like the renowned Michelangelo, Leonardo, and Raphael.

The warm spirit of the Italian Renaissance blew north into the Netherlands, Belgium, and Germany.

The Northern Renaissance

In northern Europe, the Renaissance's effect was more an improvement on medieval art than a return to classical forms. Northern artists used Italian discoveries of perspective and anatomy, but kept their love of detail. Like craftsmen working on a fine Swiss watch or German cuckoo clock, they thought nothing of spending hours on end slaving over, say, the hairs on

a dog's head to get them just right—even when the dog was just a minor figure in a large canvas. Their appreciation of the many wonders of nature shows in their work.

The Flemish Primitives

Despite the "Primitive" label, painters from Flanders (in today's Belgium) produced some of the most refined art in Europe. It's called "Primitive" because these painters did not master 3-D perspective like the Italians. Expect some unnaturally cramped-looking rooms, oddly slanted tables, and flat, cardboard-cutout people with stiff posture. Even so, they're quite realistic, showing everyday bankers and farmers painted with clinical, warts-and-all precision.

Flemish artists used fine-point brushes to capture almost microscopic details: flower petals, wrinkled foreheads, intricately patterned clothes, the sparkle in a ruby. The closer you get to a painting, the better it looks. Like the Venetians, they painted using newfangled oil-based paint (while Italy still used egg-yolk tempera). They worked on wood before canvas became popular. In their portraits and altarpieces, they capture the ordinary beauty that radiates from flesh-and-blood people.

Jan van Eyck

While Jan van Eyck (c. 1385–1440) may not have been the first to paint using oils, he was almost certainly the first to achieve a high level of mastery in the medium. Living in Bruges during the city's heyday, van Eyck produced highly detailed works packed with medieval symbolism.

Called by some "The Shotgun

Wedding," van Eyck's *Arnolfini Wedding* (below) shows a well-dressed couple from Bruges joining hands to take their vows. The artist invites us to linger over the details. Feel the texture of the fabrics, count the terrier's hairs, trace the shadows generated by the window. Each object is painted at an ideal angle, with the details you'd see if you were standing right in front of it; the strings of beads hanging on the back wall are as crystal clear as the bracelets on the bride.

And to top it off, the round mirror on the far wall reflects the whole

scene backward in miniature, showing the loving couple and two mysterious visitors. Are they the concerned parents? The minister? Van Eyck himself at his easel? Or has the artist painted you, the viewer, into the scene?

Despite the details, the painting has "Primitive" 3-D. The tiny room looks unnaturally narrow and claustrophobic.

In van Eyck's day, everyone could read the hidden meaning of certain symbols: the chandelier with its one lit candle (love), the fruit on the windowsill (fertility), the dangling whisk broom (the bride's domestic responsibilities), and the terrier (Fido, or fidelity).

By the way, she may not be pregnant. The fashion of the day was to wear a pillow to look pregnant in hopes you'd soon get that way. At least, that's what they told their parents.

Jan van Eyck, **Arnolfini Wedding,** 1434 (National Gallery, London).
This early Northern Renaissance masterpiece shows the characteristic medieval attention to detail and the down-to-earth intimate style typical of Belgian and Dutch art.

Albrecht Dürer

If van Eyck anticipated the Northern Renaissance, Albrecht Dürer (1471–1528) enthusiastically embraced it. Dürer, a famous German painter and engraver, traveled to Venice, where he fell in love with all things Italian. Returning home, he painted in the "Italian Style." His people are full-bodied and muscular, "carved" with strong shading like a Michelangelo statue.

Dürer was also notable for his nearly microscopic attention to detail. He would take a simple topic, as if from the drawer of a botanist, and draw or paint

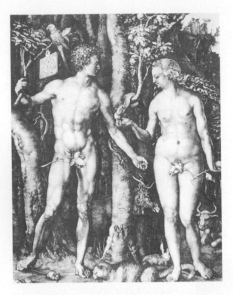

Albrecht Dürer, **Adam and Eve** (engraving), 1504 (Museum of Fine Arts, Boston).
This engraving illustrates Dürer's weighty realism, his passion for painstaking detail, and his art's reproducibility.

Albrecht Dürer, **Self-Portrait in Fur Coat,** 1500 (Alte Pinakothek, Munich).
Dürer's frank, forceful gaze seems to declare that artists deserve—and should demand—respect.

a feather or rabbit foot or a piece of turf as if for a scientific textbook. His passion for exacting detail fit well with his engravings and woodcuts. Using these early forms of reproducing art, Dürer became Europe's first "best-selling" artist through his "mass-produced" art. (For more on woodcuts and engraving, see page 460.)

Dürer also absorbed the confident self-image that Italian artists had of themselves. At that time, northern artists were still anonymous craftsmen, as they had generally been throughout the Middle Ages. But, like the Italians, Dürer saw things differently. His *Self-Portrait in Fur Coat* looks like Jesus Christ but is actually 28-year-old Dürer himself, gazing out, with his right hand solemnly giving a blessing. This is the ultimate image of humanism: the artist as an instrument of God's continued creation. Get close and enjoy the intricately braided hair, the skin texture, and the fur collar. Dürer practically invented the self-portrait as an art form. To the left of the head, he proudly signed the work with his famous monogram—"A.D." in the form of a pyramid.

Hieronymous Bosch

The work of Hieronymous Bosch (1450–1516) can be summed up in one word: wow. It's difficult to be more articulate because his unique vision lends itself to so many different interpretations. Bosch (rhymes with "Gosh!") was born, lived, and died in a small town in Holland, and that's about all we know of him, his life being as mysterious as his work. Here are some possible interpretations of Bosch's highly symbolic work. He was:

Bosch, **Garden of Delights,** central panel, 1510 (Prado Museum, Madrid).

(1) commenting on the decadence of his day; (2) celebrating the variety of life and human behavior; or (3) painting with toxins in a poorly ventilated room.

The *Garden of Delights* is a large three-paneled painting absolutely crammed with puny humans. Its message has been pondered for generations, but here's one working hypothesis: Bosch is saying that the pleasures of the world are fleeting, and the consequence of all this hedonism is an eternity in hell.

In the left panel, Adam and Eve are born innocent in the Garden of Eden. God himself performs their wedding ceremony, wrapping them in the glowing warmth of his aura. Inspired by the Age of Discovery, Bosch includes some exotic new plants and animals.

In the central panel (above),

humans enter the "Garden" of mortal life. Men on horseback ride round and round, searching for but never reaching the elusive Fountain of Youth. Two lovers sit in a bubble that—like love—could burst at any time. Just to their right is a big mussel shell, a symbol of the female sex, swallowing up a man. My favorite is the kneeling figure in front of the orange pavilion in the foreground—talk about "saying it with flowers!" Whether or not Bosch approved, you must admit that some of the folks in this Garden are having a delightful time.

The panel on the right, though, shows us where all this folderol is leading: hell. Bosch's hell is a burning,

In just a tiny bit of the monumental **Garden of Delights** *(right panel), we see a self-portrait of Bosch with a broken-eggshell body and tree-trunk legs crashing through wooden dinghies in a frozen lake with giant birds leading naked people around the brim of his hat. Gosch!*

post-holocaust wasteland of genetic mutants and meaningless rituals where sinners are tortured by half-human demons. Poetic justice reigns supreme, with every sinner getting his just desserts: A glutton is eaten and re-eaten eternally, while a musician is crucified on a musical instrument for neglecting his church duties. Other symbols are less obvious. Two big ears pierced with a knife blade mow down everyone in the way. At lower right, a pig dressed as a nun tries to seduce a man. A pink bagpipe symbolizes the male and female sex organs (call Freud for details).

Enough Art, Already!

The Renaissance produced so many timeless masterpieces that it's easy to overlook the great changes happening around Europe.

While Italian culture was triumphantly spreading across Europe, Italy itself was in serious decline. Italy's bankers (such as the Medicis in Florence) were bouncing checks. Italy's popes had harems of mistresses. Her once-great maritime cities were at war with the Turks and (with the rise of the Atlantic maritime powers) Italian ports now traded in an economic backwater. A weakened Italy was ripe for the picking. France and Spain invaded and ruled huge chunks of the peninsula. For the next two centuries, Italy ceased to be a major player in Europe. Meanwhile, Spain, Portugal, France, England, and Holland—nation-states under strong central rule—set sail for the future. And in Germany, someone was pounding on the door of the Church...

Timeline of the Renaissance

QUATTROCENTO • CINQUECENTO

80 · 1400 · 20 · 40 · 60 · 80 · 1500 · 20 · 40 · 60 · 80 · 1600 · 20

BAPT. DOORS CONTEST (1401)

RENAISSANCE: FLORENCE

COSIMO · · LORENZO MAG. · SAVONAROLA

BRANCACCI CHAPEL · · MASACCIO · · TRINITY

ALLEGORY OF SPRING · · BOTTICELLI · BIRTH OF VENUS

SLANDER

LUTHER'S 95 THESES

REFORMATION/RELIGIOUS WARS

COUNCIL OF TRENT

\ DUOMO DOME

· · · · BRUNELLESCHI

· · DONATELLO · · /DAVID

· · GHIBERTI · · · ·

JULIUS II

DAVID \ PRISONERS · ST. PETER'S DOME

MICHELANGELO

PIETA / SISTINE CEILING \ LAST JUDGMENT

SACK OF •ROME

← TO GIOTTO ←DUCCIO

LATE GOTHIC

← TO DOGES' PALACE + ST. MARKS

ECONOMIC PEAK OF VENICE

· · · · · LEONARDO

LAST SUPPER \ /MONA LISA

· · RAPHAEL · · · / SCHOOL OF ATHENS

RENAISSANCE: ROME

MANNERISM

BAROQUE

RENAISSANCE: VENICE

· · · GIO. BELLINI · · · ·

· · GIORGIONE · · · ·

· · · · · TITIAN · · · ·

· · · · VERONESE · · · ·

· · · · TINTORETTO · · · ·

FLEMISH PRIMITIVES

· · · · · VAN EYCK · · · · · \

ARNOLFINI WEDDING

NORTHERN RENAISSANCE

· · · BOSCH · · · · · \

GRUNEWALD'S ISENHEIM ALTARPIECE

· · · · DÜRER · · · · ·

\ GARDEN OF DELIGHTS

DCH

Jan Vermeer, **The Astronomer** (detail), 1668
(Louvre Museum, Paris).

Reformation, Discovery, and the Rise of Nation-States
(1500–1650)

In the early 1500s, Renaissance ideas were sweeping across the Continent, and Europe was entering the modern age. Christopher Columbus had discovered a whole New World. Martin Luther asserted that common people should be able to worship God directly, without Church intervention. And Johann Gutenberg's printing press made it possible to easily distribute literature to the masses. So you could now get to Asia without a camel, you could get to heaven without a pope, and you could own a book without being rich.

During this era, Europe's history increasingly became the history of individual nation-states—England, Spain, Portugal, Holland, and France— each with their own kings, wars, and distinct styles of art.

The Reformation
(c. 1517–1648)

Before the Renaissance, the Christian Church (ruled from Rome) was Europe's richest, most powerful, and best-organized institution, as well as its greatest landowner. The Church collected "taxes" through tithes, hired the best artists, and pushed penny-ante kings around. Average Europeans didn't think of themselves as "English" or "French" so much as just plain Christians.

But as the Church's worldliness led to corruption, a reforming spirit grew. Throw in political rivalries and jealousies, and "reforming" turned into splitting. New Christian faiths were formed, and Europe became divided between Protestants (the reformers who joined new churches) and Catholics (those loyal to the Church in Rome). Because religion and politics were intertwined, the religious split led to political upheaval and war. These tumultuous 100-plus years of reform, division, and warfare are called the Reformation.

The Causes of the Reformation

The Church certainly needed reform. Many priests were illiterate and immoral. Drunk, sex-addicted monks were stock characters in popular folk tales. Bishops—many of whom were also princes—meddled in politics and governed like petty tyrants. The clergy even sold important Church offices to

the highest bidder. The Church had lost touch with ordinary folk; Mass was celebrated in Latin, a language spoken only by the educated elite. The Church had also lost touch with its roots, showing not a hint of the humble poverty of the early Christians.

The pope had lost prestige among both kings and commoners. During their medieval heyday, popes could make or break kings. But after the popes moved to Avignon, France (1309–1377), they were seen as puppets of the French king, and their international influence suffered. When a second pope popped up back in Rome and each pope excommunicated the other, papal prestige sank to mud-wrestling depths. (For more on this, see page 150.)

And the world was changing. Science, capitalism, overseas exploration, and Renaissance ideas from Italy brought a new secular outlook. After Nicholas Copernicus (in 1543) and Galileo Galilei (in 1632) disproved the Church's traditional explanation of the earth-centered universe, nothing was accepted blindly. Gutenberg's printing press played a powerful role. Reformers risked death to print local-language versions of one especially radical book: the Bible.

Kings jumped on the Reformation bandwagon out of political greed. They saw the Church as a rival power within their borders. The Church was Europe's largest landowner. Tithes sent to Rome were taxes lost. The clergy was exempt from paying taxes and could ignore secular laws. Many kings wanted not only to reform the Church, but to break with it for good. The political rewards were obvious.

"I'd like two adulteries and a small order of lies to go."

In this German woodcut, people buy **indulgences** (letters of forgiveness) in the marketplace. This peddling of pardons bothered Martin Luther.

Martin Luther

The man who lit the fuse on this pow-
der keg of problems was a charismatic
monk from Germany. A fiery orator
and religious whistle-blower, Martin
Luther (1483–1546) sparked a century
of European wars by speaking out
against the Church in Rome.

Luther lived a turbulent life. In
early adulthood, the newly ordained
priest suffered a severe personal crisis
of faith before finally emerging "born
again." He moved to the left-leaning
town of Wittenberg, where he served
as both priest and theology profes-
sor at the university. The pews were
packed as Luther gave riveting ser-
mons, quoting directly from the Bible.
It became clear to everyone that there
were discrepancies between the Scrip-
tures and Church practices.

At that time, a friar arrived in
Wittenberg to raise money for the
Church. (The fundraising drive was to
pay for the city of Rome's Renaissance
face-lift—Michelangelo and Raphael
didn't come cheap.) The friar was sell-
ing "indulgences," which were letters
from the pope promising "forgiveness
for all thy sins, transgressions, and
excesses, how enormous so ever they
may be"...a bargain at twice the price.

You could even buy an indul-
gence for a dead relative. Here's a typi-
cal sales pitch: "Listen to the voices of
your dear dead relatives and friends
saying 'Pity us, pity us. We are in dire
torment.' Remember that you are able
to release them." The pitch ended with
a catchy jingle: "For as soon as the coin
in the coffer rings, the soul from Pur-
gatory springs."

Luther was outraged.

At first, he tried to reform Church

Lucas Cranach the Elder, **Martin Luther,** 1529
(Uffizi, Florence).
*This German monk was not cowed by a papal
bull.*

Albrecht Dürer, **Four Apostles,** 1526
(Alte Pinakothek, Munich).
*These are saints of a radical new religion—
Martin Luther's Protestantism. Dürer, a friend
of Luther's, strips these saints of their halos
and makes them fully human, with receding
hairlines, wrinkles, and suspicious eyes. With a
Bible in one hand and a sword in the other, Paul
(far right) is a fitting symbol of the dangers that
came with the Reformation.*

Gutenberg and the Printing Press

A silversmith by trade, Johann Gutenberg (c. 1398–1468) was used to working with metal. In 1450, he came up with the simple, profound idea of casting letters in metal. By setting these sturdy letters tightly in trays, inking the trays,

then pressing the inked type against paper, he could copy books faster than a thousand monks. The type was "movable," so when one job was done, the same letters could be used for a new one. With only a few minor improvements, Gutenberg's revolutionary method for printing was used until the early 19th century.

As we're buried by junk mail and unread magazines, it's hard to comprehend what a difference his invention made. Imagine not being able to afford a single book. You had to take a priest's word—in Latin—for what the Bible said. Then imagine being able to afford your own Bible...or any other book in print. The printing press opened the doors of knowledge, ultimately bringing power to the common people.

Dürer, **Four Horsemen of the Apocalypse,** 1498 (British Museum, London).
With the printing press, groundbreaking art like this woodcut could be mass-produced and spread to the people...but so could dangerous words and ideas.

With the printing press, news traveled faster—it really was news. Europe became smaller. If Martin Luther had nailed his 95 theses to the door of Wittenberg's Castle Church a hundred years earlier, few would have found out about it, and he likely would have become a martyr like Jan Hus (see page 229) and other early reformers. But Gutenberg's newfangled printing press was Luther's megaphone, and all of Europe listened.

Because of how the printing press empowered people and sped the spread of information, Gutenberg is considered by some to be the most influential person of his millennium.

abuses from within, not create a new church. He simply believed that the word of God lay not in the doctrine of the Church but in the Bible. And the Bible said nothing about buying forgiveness, only that God's grace was a free gift to believers.

Luther proposed that the subject should be debated openly. On October 31, 1517, Luther approached Wittenberg's Castle Church and nailed 95 "theses"—or topics for discussion—to the door (which served as the town bulletin board). Thesis #82 boldly asked: "If the pope redeems a number of souls for the sake of miserable money with which to buy a church, why doesn't he empty Purgatory for the sake of holy love?" Luther's propositions, mass-produced by the new printing presses, quickly became a hot topic.

Raphael, **Pope Leo X and Cardinals,** 1518 (Uffizi Gallery, Florence).

Not interested in debating, Pope Leo X called Luther a heretic and sent him a papal bull of excommunication. Not cowed, Luther burned the pope's letter—basically the Renaissance equivalent to burning your draft card, only much more serious. Holy Roman Emperor Charles V stepped in to arbitrate, calling an Imperial Diet (or congress) at the town of Worms in 1521. Disgusted by this Diet of Worms, Luther refused to swallow his beliefs. "Here I stand," he told the assembly. "Unless you can convince me by scripture or by clear reasoning, I am bound by my beliefs...I cannot and I will not recant. God help me. Amen."

Now a criminal as well as a heretic, Luther lived on the run as an outlaw. He was protected by sympathetic German princes who saw this as a chance to grab power from the Church. Luther's ideas spread like fire on gasoline. Lowly peasants felt empowered by how Luther stuck it to The Man. Scholars welcomed the free play of ideas. Local princes seized the opportunity to confiscate Church lands and establish their own state churches. All of Europe was splitting into two camps: "Catholic" (meaning "universal," which the Church in Rome claimed to be) and "Protestant" (not from "protest" but from one who "professes" certain beliefs).

The Reformation Across Europe

The Reformation raged across northern Europe. In Holland, Protestant extremists marched into Catholic churches, lopped off the heads of holy statues, stripped gold-leaf angels from the walls, urinated on Virgin Marys, and shattered stained-glass windows in a wave of anti-Catholic vandalism.

(This practice of destroying religious icons is called iconoclasm; see sidebar on page 105.) Holland's Catholic churches became Dutch Reformed, with whitewashed interiors that downplayed the "graven images" of ornate religious art. Priests were given stern warnings about preaching openly, and Catholic kids were razzed on their way to school. For the next two centuries (1578–1795), Catholicism in Amsterdam was illegal but tolerated.

Switzerland—with its deep roots in democracy and self-rule—was a haven for free thinkers. Ulrich Zwingli (1484–1531) of Zürich made it his mission to place a German-language Bible in everyone's hands. Soon, every Tom, Dick, and Heinrich could interpret scripture on his own and "carve his own path to Hell" (as Catholic smart alecks loved to say). With the local passion for Bible reading, Swiss literacy boomed, further fueling the spirit of democracy.

Geneva welcomed the exiled Frenchman John Calvin (1509–1564), who established a theocratic government. Like Luther, Calvin believed in salvation by God's grace, but he emphasized that only God's grace—and not our good works—can get us to heaven. He went so far as to say that God predestined some for heaven, some for hell. (Zealous Calvinists even

*During the time that Amsterdam's Catholics had to practice their faith in secret, hidden churches were common. This is the 17th-century **Church of our Lord in the Attic,** secretly built into a gutted townhouse in the Red Light District and open to visitors today.*

Jan Hus: A Century Before Luther

Jan Hus (c. 1369–1415) was the Czech Martin Luther. Like Luther, Hus was a college professor, a priest, and a dynamic speaker. Both preached in their people's language, not Latin. And both got in big trouble. But Hus was a century ahead of his time, which meant that while Luther survived, Hus was burned at the stake. Hus (and his followers, the Hussites) loosened Rome's grip on Christianity, and Luther finally broke it. Because of Hus' bold stance for religious freedom, he has become a symbol of the struggle of the Czech people for political freedom.

Jan Hus, a charismatic Czech priest and professor, tried to reform the Roman Catholic Church a hundred years before Martin Luther. This statue of the Czech national hero overlooks Prague's Old Town Square.

claimed to be able to pick out the lucky winners from the unlucky, sinful losers.) Calvin's French followers, called Huguenots, spread from Switzerland to Holland and Scotland, forming various Reformed and Presbyterian churches.

The English Reformation: Henry VIII

England's break with the Catholic Church was caused by one remarkable man: King Henry VIII. Charismatic Henry (r. 1509–1547) ascended the throne, united England's bickering nobles, and carried isolated England onto the world stage. As a young man, he was England's Renaissance king. He was handsome, athletic, highly sexed; a poet, a scholar, and a musician. He was also arrogant, cruel, gluttonous, and erratic.

In middle age, Henry stunned the Church by divorcing (gasp!) his queen, Catherine of Aragon, the daughter of Spain's Ferdinand and Isabel. In search

The Dissolution of the Monasteries

Through the centuries, secular and religious powers have been at odds. As people kept willing their land to monastic orders, the monasteries became so powerful they threatened kings. On numerous occasions in Europe, rulers solved this problem by "dissolving" the monasteries (simply taking their land and wealth and forcing the monks to disband). While Henry VIII is famous for leaving the Roman Church in order to get a divorce, he dissolved the monasteries across his realm because they rivaled his power. Today as you travel around England, you'll find the remains of once-magnificent monasteries and abbey churches decorating evocative parks.

*The monastery of **Lindisfarne** on Holy Island in northern England was dissolved in 1536 by Henry VIII.*

of love, sex, and a male heir—which Catherine had been unable to give him—Henry defied the pope and married young, shrewd Anne Boleyn. (Nine months later, Anne gave birth to...a

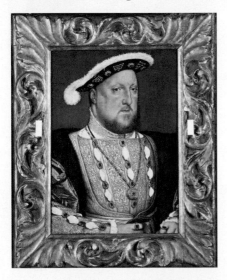

Hans Holbein the Younger, **Henry VIII**, 1536 (Thyssen-Bornemisza Museum, Madrid).

girl, the future Queen Elizabeth.)

The pope excommunicated Henry for his adultery and unauthorized divorce. Henry responded by "divorcing" England from the Catholic Church and establishing the Church of England (or Anglican Church). He banned monks, physically dismantled their abbeys, and pocketed Church land and wealth for the crown.

Henry's actions spilled over into neighboring Ireland. Taking advantage of the Reformation chaos, Ireland's earls of Kildare rebelled. Henry crushed the revolt and executed the earls. Their land was confiscated and given to English Protestants. The next four centuries would see a series of rebellions by Catholic, Gaelic-speaking Irish farmers fighting to free themselves from rule by Protestant, English-speaking landowners.

By the time of his death, 400-pound Henry had wed six wives,

Catholic and Protestant Differences

The differences between Protestant and Catholic doctrines have divided Christians for centuries. Both see Jesus Christ as the central figure in bringing salvation, but they take different approaches to this.

Protestants emphasize the direct relationship between the individual and God. Bible study and personal prayer make this connection. With this as their core, they don't consider church rituals or doctrines essential to salvation. Protestant clergy are either lay people or pastors (who can marry) hired to facilitate worship.

Tilman Riemenschneider, **Altar of the Holy Blood,** 1499–1504 (St. Jakob's Church, Rothenburg, Germany).

Catholics use church rituals and an ordained clergy to help individuals make their connection to God. Catholics receive forgiveness for their sins through the act of confession. They venerate saints and the Virgin Mary. They consider official pronouncements by the pope to be the word of God. Catholic priests must be celibate, and the Church recognizes organizations of monks and nuns.

As time goes by, the differences between Catholics and Protestants—and the bitterness—seem to be lessening.

executed several of them (including Anne Boleyn), killed trusted advisors, pursued costly wars, and produced only one male heir, who died young.

Henry's daughter Mary I (r. 1553–1558) inherited the crown. Fueled by her mother Catherine's fanatic Spanish Catholic devotion (the same kind that gave us the Inquisition), she was determined to return England to the Roman Church. She ordered more than 300 Protestant men, women, and children to be burned at the stake, earning her the nickname "Bloody Mary."

For the next hundred years, England was torn between Protestants and Catholics, as her kings and queens tried to impose their personal

religion on the people.

*At the Tower of London's **execution block,** the king's enemies (or Henry VIII's unwanted wives) would kneel before him for the final time. Severed heads were often stuck on sticks and displayed at London Bridge.*

The Counter-Reformation

The Vatican responded to the Protestant revolution with the Counter-Reformation, which was an attempt to put the universal Catholic Church back together using a carrot-and-stick approach. On the one hand, the Church worked diligently to weed out corruption from within, reach out to alienated members, do missionary work, and inspire the faithful with attractive Church art. On the other hand, when need be, the Church resorted to propaganda, intimidation, and outright force—doled out by the dreaded Inquisition.

The Church invited Catholics from all over to the Council of Trent (1545–1563), a series of conferences that addressed Protestant concerns, defined Church doctrine, and encouraged more careful training and supervision of the clergy. Defending the Council's decisions was a dedicated band of monks known as the Society of Jesus, or Jesuits. These "soldiers of God" fought heretical ideas with words and razor-sharp minds. Many went abroad as missionaries to newly discovered lands, dedicated to educating the natives and trying to communicate a strange, monotheistic religion to puzzled polytheists. At the same time the Catholic Church was losing members in Europe, it was gaining recruits in the Americas. Thanks largely to zealous Jesuits, Catholicism became a truly worldwide religion.

When gentle persuasion didn't work, Catholics turned to an institution dating back to medieval times—the Inquisition. This was a full-scale Church-run legal system, including policemen, interrogators, high-powered D.A.s, court-appointed (and poorly funded) defense attorneys, judges, plea-bargainers, jails, torturers, and executioners. The Inquisition hauled Protestants, Jews, and nonconformist Catholics before the courts on the slightest evidence of "heresy." To extract confessions, suspects were

"Throw another sinner on the barbie."

Roman Catholic angels zoom down from heaven to burn the heretical writings of Martin Luther and company.

locked away in solitary, tortured, and stripped of their property. It was the standard judicial practice of the day. Once the accused prisoners confessed, they were really punished. Punishments ranged from simply reciting a certain number of prayers, to fasting and alms-giving, to imprisonment, more torture, and death.

Jewish people were especially suspect, accused of everything from poisoning wells to ritually sacrificing Christian babies. In some cities they were forced to live in segregated neighborhoods, or ghettos. Occasionally, mob rule erupted, and thugs torched synagogues and confiscated Jewish property. In Spain, Jews faced a choice: be persecuted, relocate, or convert to Christianity.

It was in Spain that the Inquisition was first established (1478). Under the direction of Grand Inquisitor Tomás de Torquemada (1420–1498), the city of Sevilla hosted public rituals called an *auto da fé* (act of faith). Suspected heretics were paraded barefoot before the cathedral, made to publicly confess their sins, then burned at the stake. Over the next two centuries, thousands of heretics (some historians say hundreds, some say tens of thousands) were tried and killed in Spain.

The Religious Wars

The wars wore on. In Germany, Luther's protests threw the country into a century of turmoil. In the 1525 Peasant Revolt, poor farmers attacked their feudal masters with hoes and

When Faiths Collide

Albrecht Altdorfer, **The Battle of Issus,** 1529 (Alte Pinakothek, Munich).

The world is at war. The masses of soldiers are swept along in the currents and tides of a battle completely beyond their control. Their confused motion is reflected in the swirling sky. We see the battle from a great height, giving us a God-like perspective. Though the painting depicts an ancient battle between Greeks and Persians, it could as easily have been Europe in the 1500s. Peasants were battling masters, Christians were fighting Muslim Ottomans, and Catholics and Protestants were squaring off for a century of conflict. They each believe God is on their side as the armies melt into a huge landscape, leaving the impression that the battle goes on forever.

pitchforks, fighting for more food, political say-so, and respect. The revolt was brutally put down. Many local German nobles took the opportunity to go Protestant—some for religious reasons, but also to seize Church assets and powers.

The pope fought back, supported by the powerful Holy Roman Emperor, Charles V. (For more on Charles, see page 245.) In the chaos, Germany was ravaged, and the city of Rome itself was brutally sacked by renegade soldiers (1527). Luckily for Protestants, the Catholic forces were also preoccupied with fighting Ottoman invaders in southeastern Europe. The Treaty of Augsburg (1555), which allowed each German prince to choose the religion of his territory, brought a lull in the fighting, but it didn't last long.

On May 23, 1618, angry Czech Protestant nobles poured into Prague Castle and threw the two Catholic governors out of the window. This was the second of Prague's many "defenestrations" (from the Latin fenestra, or "window")—a uniquely Czech solution to political discord, in which offending politicians are literally tossed out the window. The two governors landed—fittingly—in a pile of horse manure... so despite the height, they suffered only broken arms.

Even so, this fateful event sparked the Thirty Years' War (1618–1648), which is often called the "first world war," with mercenary soldiers from just about every European country duking it out. It was fought mainly on German soil but also involved Bohemia (part of today's Czech Republic), Denmark, Sweden, France, and Spain. This was an ugly war. Petty kings

fought for personal glory. Soldiers-of-fortune fought for plunder, rape, and sadistic satisfaction. And both Protestants and Catholics alike were fueled by religious fervor, convinced that God was on their side and that the enemy was Satan himself.

All together, the religious wars lasted for more than 100 years (1527–1648). When they finally ended, Europe was devastated, a third of Germany was dead, and Western civilization realized what it should have known from the start: Catholics and Protestants would have to live together.

The Peace of Westphalia (1648) decreed that the leader of each country would decide the religion of his people. Generally, the northern countries—today's Scandinavia, the Netherlands, Belgium, northern Germany, and England—went Protestant. The southern ones—Spain, Portugal, Italy, and southern Germany—remained loyal to Rome. The line dividing Protestant from Catholic Europe was (and remains) almost the same line that separated barbarian Europe from Roman Europe way back when the Christians were still hiding out. Hmm.

Northern Protestant Europe eventually became capitalist and prosperous, while southern Catholic Europe remained backward and feudal. Why? A 20th-century sociologist theorized that Catholics—who confess regularly to a priest and receive forgiveness—are more content and inclined to accept the status quo. Meanwhile, guilt-ridden Protestants are driven to prove their worth by making money. Hence, Protestant countries became capitalist powerhouses, while Catholic countries languished. Double hmm.

Art of the Reformation and Counter-Reformation

The Reformation split Europe into two subcultures, Protestants and Catholics, with their two distinct art styles.

Protestants took very seriously the Bible's warning against worshipping "graven images" as false idols. They stripped their churches of Catholic statues of saints and the Virgin Mary, considering it just so much mumbo-jumbo. Protestant churches are often relatively bare inside, without the ornate art that fills Catholic churches. Protestant services are simpler as well—they lack the fancy robes, icons, incense, and processions of the Mass. But Protestants didn't hold back when it came to music. They loved big organs and orchestras. Choirmasters, composers, and organists (such as J. S. Bach, 1685–1795, who did it all) enjoyed a new, loftier status.

Protestant artists had to manage without the rich and powerful Catholic Church's patronage. Religious art fell out of favor, and Protestant art is entirely different from the flashy art that fills churches and palaces of the Catholic world. Protestant artists painted few Madonnas, saints, and angels cavorting in heaven; their subjects were more likely to be milkmaids, merchants, and farmers tilling the earth. Painters used more subdued colors and smaller canvases. Sculptors stuck to less-flamboyant poses. For more on the art of the mostly Protestant north, see "Northern Art" on page 256.

On the other hand, Catholic art of the Counter-Reformation was dazzling, designed to inspire the masses. Churches were plastered, spackled, painted, and drenched in gold, offering a glimpse of the heaven that awaited those who remained faithful.

Bartolomé Murillo, **Immaculate Conception of the Escorial,** c.1660–1665 (Prado Museum, Madrid).
The son of a barber of Seville, Murillo (1617–1682) cranked out dozens of radiant young Marys, helping make Catholic doctrine more appealing at a time when many people were defecting to Protestantism. His paintings view the world through a soft-focus lens, sentimentally wrapping everything in warm colors and gentle light.

Catholic artists favored the Baroque style (see page 268), using art as propaganda in the battle for the hearts and minds of Europe's Christians. Pretty pictures brought abstract doctrines to the level of the common man. The Virgin Mary was depicted as a pristine, pink-cheeked young woman—the very image of an "Immaculate" Conception. And at the other end of the carrot-and-stick, worshippers saw images of serpents with the face of Luther and of heretics dangling literally by a rosary above the fires of hell.

Religion Vanquishing Untruth
(Gesù Church, Rome).
This statue in the Jesuit home office shows the Church as an angry nun hauling back with a whip and just spanking a bunch of miserable Protestants.

*While the Reformation frowned on elaborate paintings, fancy music was just fine. Pipe organs were big in Protestant churches. This one fills an entire end of Haarlem's **Grote Kerk** in the Netherlands.*

Counter-Reformation Architecture

In addition to gaudy, elaborate artwork, Counter-Reformation-era Catholics built huge and imposing buildings that were intended to impress and humble visitors. Two of the best examples of this over-the-top architecture are St. Peter's Basilica (in Rome) and El Escorial in Spain (near Madrid).

St. Peter's Basilica

St. Peter's Basilica—the centerpiece of the Vatican—is the greatest church in Christendom. It represents the power and splendor of Rome's 2,000-year domination of the Western world. Built on the memory and grave of the first pope, St. Peter, this is where the grandeur of ancient Rome became the grandeur of Christianity.

By 1506, the original old St. Peter's Church was falling apart, and the new, larger church we see today was begun. Several architects worked on the church during its 120 years of construction (including Michelangelo,

St. Peter's Basilica (Vatican City, Rome).
Baroque art was born here, in the grandest church in Christendom.

as described in the previous chapter). Although begun during the Renaissance, St. Peter's was a symbol of Baroque grandeur, ornamentation, and Counter-Reformation propaganda by the time it was completed.

Entering the church, you're greeted with one of Europe's "wow" experiences. It's huge. The atrium itself is bigger than most churches. The altar stands two football fields away. The church covers six acres. Statues of babies that decorate the pillars are adult-size. The church can hold 60,000 standing worshippers (or 1,200 tour groups).

The ornate interior was largely decorated by Gian Lorenzo Bernini (1598–1680), the Michelangelo of the Baroque era. It's a riot of corkscrew columns, flamboyant statues, golden mosaic, striped marble, chapels, altarpieces, stained glass, and reliquaries. Bernini's crowning touch was the seven-story bronze canopy that arches over the main altar. (For more on Bernini, see page 269.)

Catholics of the Counter-Reformation era strolled through here as if they were in heaven itself. Stern Protestants got the heebie-jeebies.

El Escorial

The Monastery of St. Lawrence, called El Escorial (located 30 miles northwest of Madrid), is an austere symbol of Counter-Reformation power. Four hundred years ago, the enigmatic, introverted, and extremely Catholic King Philip II (1527–1598) ruled his bulky empire and directed the Inquisition from here. The giant, gloomy building made of gray-black stone looks more like a prison than a palace.

El Escorial's construction dominated the Spanish economy for a generation (1563–1584). Because of this bully in the national budget, Spain has almost nothing else to show from this most powerful period of her history. About 650 feet long and 500 feet wide, it has 2,600 windows, 1,200 doors, more than 100 miles of passages, and 1,600 overwhelmed tourists.

To Philip, the building embodied the wonders of Catholic learning, spirituality, and arts. To 16th-century followers of Martin Luther, it epitomized the evil of closed-minded Catholicism. To architects, the building—built on the cusp between styles—exudes both Counter-Reformation grandeur and understated Renaissance simplicity. Today, it's a time capsule of Spain's Golden Age, packed with Spanish history, art from the Counter-Reformation, royal tombs, and Inquisition ghosts.

The Age of Discovery and the Rise of Nation-States

The religious wars and Age of Discovery (during which Europe's powers literally circled the world in search of new trading routes) reshuffled Europe's political cards. The old-style baronies and dukedoms were replaced

El Escorial, outside of Madrid, was a stern symbol of the Counter-Reformation and Spanish power throughout 16th-century Europe.

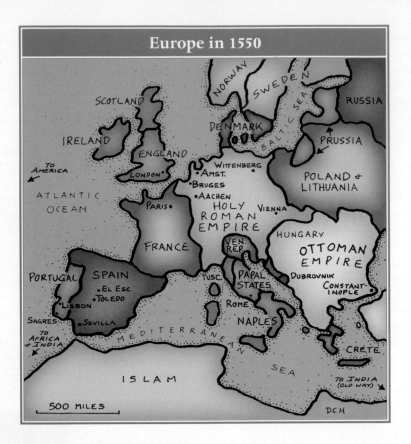

Europe in 1550

by larger political units called "nation-states"—England, Spain, Portugal, Holland, and France. Most were centered around a strong king (such as Henry VIII of England, François I of France, and Charles V of Spain) whose subjects were linked by a common language and culture.

In the Middle Ages, the nation had been a weak entity. Popes, nobles, and petty kings bickered for power while the common people went about their business, ignoring the affairs of state.

But Europe was changing. The newly discovered Americas and routes to the Far East opened a floodgate, bringing in waves of raw materials,

luxury goods, and cheap slave labor. To keep this trade alive, you needed a strong, efficient government that could finance large capitalist ventures. Fleets of merchant ships required a navy to protect them, which required more taxes to maintain, which required more efficient governments to collect and administer the taxes. The state grew.

Businessmen welcomed this strong central government. They liked common currency, standard measures, and fewer tariffs. Medieval trade had been stifled by the chaos of rural, feudal kingdoms. For the same reasons corporations today favor larger free-trade zones and fewer restrictions,

Europe's early merchant class favored a central government that provided the stable conditions for trade to flourish. In addition, new secular governments took over many of the jobs that had traditionally been carried out by the Church.

While France, England, Holland, Spain, and Portugal were centralizing power to create modern nation-states, Germany and Italy remained a decentralized, backward, feudal battleground. Why? Location, location, location. The nations situated along the Atlantic seaboard were exploring and exploiting a whole New World.

In the year 1450, you could buy a pound of pepper in Asia, carry it back to Europe by camel, and resell it to salivating European gourmets for a thousand times what you paid. European nations scrambled to find new routes to exotic Asia. Portugal and Spain led the way.

Portugal Sets Sail

From their location at the "Edge of the World," Portugal sent ships southward, hugging the coast of Africa. With each voyage, they inched farther into the unknown—across the "Sea of Darkness," through equatorial waters where sea serpents roamed, no winds blew, and the hot sun melted ships, made the ocean boil, and turned white men black. As the sailors returned to Portugal—alive and still white—they were debriefed by mission control at Cape Sagres, on the southernmost tip of Portugal. Here, the king's own son, Prince Henry the Navigator (1394–1460), established a maritime school. The sailors' reports were used to make state-of-the-art maps. A core of tech-savvy men expanded the knowledge of compasses, shipbuilding, navigation by the stars, and how to say "Do you have any cinnamon?" in a dozen new languages.

Besides the bottom line, explorers were driven by a love of science and a spirit of adventure. Some were also motivated by a strong desire to spread the Christian message to foreign lands.

Finally in 1498, Portugal's Vasco da Gama rounded the southern tip of Africa and continued on to India. When he arrived home in Lisbon, the few spices he'd brought back were worth a staggering

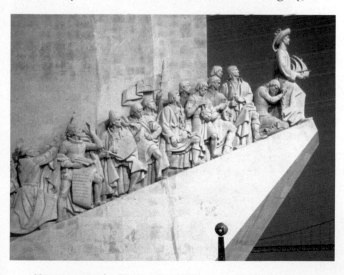

Monument to the Discoveries, 1960 (Belém, Lisbon, Portugal).
Henry the Navigator, his explorers, and plenty of support back home made Portugal a world power in the 16th century.

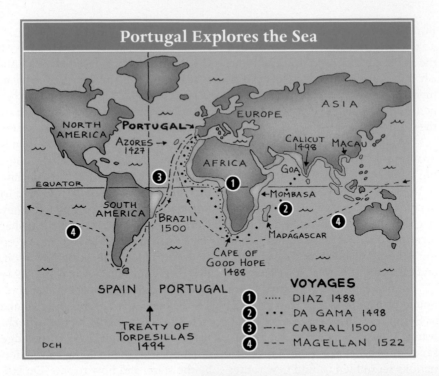

Portugal Explores the Sea

NORTH AMERICA
PORTUGAL
AZORES → 1427
EUROPE
ASIA
AFRICA
CALICUT 1498
MACAU
GOA
EQUATOR
SOUTH AMERICA
BRAZIL 1500
MOMBASA
MADAGASCAR
CAPE OF GOOD HOPE 1488
SPAIN | PORTUGAL

TREATY OF TORDESILLAS 1494

DCH

VOYAGES

①	DIAZ 1488
②	...	DA GAMA 1498
③	—·—	CABRAL 1500
④	---	MAGELLAN 1522

fortune. Italy's monopoly on trade with the Orient was broken, the states on the Atlantic seaboard emerged as the superpowers of trade, and Portugal's Golden Age was launched.

By 1560, you could sail from Lisbon to China without ever losing sight of Portuguese-claimed land. The riches of both Asia and the Americas poured into the tiny nation: pepper, cinnamon, and curry from India and Java; ivory, diamonds, and slaves from Africa (sold to New World plantations); and sugarcane, gold, and diamonds from Brazil. From everywhere came knowledge of new plants, animals, and customs.

Belém Tower, 1515–1521 (Belém, near Lisbon, Portugal). *This is the first sight Portuguese sailors saw when they returned home—bearing gold, spices, and venereal diseases—after sailing the globe.*

Manueline Architecture (c. 1500–1600)

With all its wealth, Portugal built impressive churches, monasteries, and palaces. The style is Portugal's own, called "Manueline" after the man who ruled Portugal at its peak: King Manuel I (r. 1495–1521).

Manueline art carves the Age of Discovery in stone. You'll see motifs of the sea and of sailors. Stone coils of rope wind around columns. Capitals are studded with carved pearls and coral. A clam shell serves as the keystone above an arched doorway, while anchors and nets drape down an elaborate window. Manuel's personal symbol was the armillary sphere, a globe of the earth used by sailors to navigate by the stars. Artichokes were a sailor's best friend, rich in Vitamin C to prevent scurvy on long two-year voyages.

These nautical motifs pay tribute to the sea trade that made Portugal rich, and to the rich families that financed the art. You'll see their ornamental shields and coats of arms decorated with castles, crosses, lions, flags, and crowns. And sculptors reveled in the exotic plants brought back from the far reaches of Portugal's trading empire: lotus flowers from China, pepper from India, and ears of corn from America.

Many Manueline-style buildings were built on the cusp between styles, sometimes featuring both flying Gothic buttresses and round Renaissance arches. Manueline was the frosting on that Gothic or Renaissance cake. Talented sculptors could carve stone columns, arches, windows, and walls with such elaborate detail that it looked like stucco, molded plaster...or frosting.

The best examples of the Manueline style are in the Lisbon suburb of Belém, particularly the Belém Tower and the cloisters of the Monastery of Jerónimos.

MONASTERY OF JERÓNIMOS

King Manuel I erected this giant white-limestone church and monastery that stretches 300 yards along the Lisbon waterfront as a "thank you" for the discoveries made by early Portuguese explorers. It was financed in part with "pepper money," a 5 percent tax on spices brought back from India. Manuel built it on the site of a humble chapel where anxious sailors would spend their last night in prayer before embarking

Monastery of Jerónimos (Belém, Lisbon).

on their frightening voyages. What is the style of Manuel's church? Guess.

Inside, slender palm-tree-like columns soar to the ceiling. There are rope-like arches, ships, and monsters that evoke the mystery of undiscovered lands. Exotic new animals peer out of the capitals.

The church houses the tomb of Vasco da Gama, who prayed at this site before sailing to tap the wealth of Asia. Two years later, he returned home to Vascomania.

The monastery cloister (an arcaded courtyard) is where monks strolled as they meditated in the open air. The sheer size of this religious complex is a testament to the religious motivation that—along with money—propelled the Age of Discovery. Monks often accompanied the sailor/pirates on their trading/pillaging trips, hoping to convert the heathen locals to Christianity. The cloister features lacy stone tracery with a variety of symbols that illustrate the complex new world looming on Europe's horizons.

The monastery features a memorial to Portugal's greatest poet, Luís de Camões, who chronicled the Age of Discovery. He wrote:

Arms and the heroes, from Lisbon's shore,
sailed through seas never dared before,
with awesome courage, forging their way
to the glorious kingdoms of the rising day.

The Rise of Spain

When Christopher Columbus sighted land in the Americas (1492), the world suddenly got bigger and rounder.

Europe's horizons were expanded, and Spain quickly became Europe's greatest nation.

Yes, "in fourteen hundred ninety-two, Columbus sailed the ocean blue..." but other things were happening, too. That was the same year that the Spanish rulers Ferdinand and Isabel drove the last Moors out of Spain and forced Jews to convert or be expelled. Spain emerged as a nation-state under a single king and queen (the so-called "Catholic Monarchs"), united under the banner of Christianity.

The monarchs, Ferdinand and Isabel, financed Columbus' expedition to seek a new western trade route to Asia. Spain sent other explorers, as well, such as the Florentine Amerigo Vespucci. In 1520, Ferdinand Magellan (a native Portuguese), sailed west with five ships and 270 men. They suffered through 30 months of mutinies, scurvy, and dinners of sawdust and ship rats before arriving home, having circumnavigated the globe (sans Magellan, who died en route).

In the New World, Spanish conquistadors (conquerors) scoured the continent for gold, finding large reserves in America's mountains. Armed with cannons, horses, and scary voodoo, they overcame vast nations of native peoples (many of whom were more civilized than the Spaniards). They put the natives to work on large plantations growing sugar, corn, and cotton to be shipped back to Spain.

In return, Spain exported Christianity. Spanish Christianity was super-intense, having been forged during centuries of warfare against the Muslim Moors. Now, fueled by the religious fervor of the Counter-Reformation, they

Christianized America. They converted the natives with "tough love," using both kind Jesuit priests and cruel conquistadors. Once-proud Aztecs, Incas, and Mayas—who'd built cities that dwarfed anything seen in Europe—were now reduced to shuffling peasants, hoeing potatoes, and humbly kneeling before the Christian God.

Spain's Golden Age (1500–1650)

Spain's bold sea explorers changed the geopolitics of Europe. The Spanish flag flew over most of South and Central America. In the Treaty of Tordesillas (1494), Spain and Portugal literally divvied up the colonial world, splitting it at 45 degrees West longitude and 135 degrees East longitude. (And, to this day, Brazil speaks Portuguese while the rest of South America speaks

Titian, **Charles V on Horseback at the Battle of Muhlberg,** 1548 (Prado Museum, Madrid).

Spanish.) Gold, silver, and farm products poured into Iberia. As colonial superpowers, Spain and Portugal dominated the economy of Europe. The aristocracy and the clergy swam in money. Art and courtly life flourished.

Ferdinand and Isabel's grandson, Charles V (known as Charles I to Spaniards, 1500–1558), inherited the Spanish crown. Through family ties, he also inherited the vast holdings of the Hapsburgs of Austria (see page 286), making Charles the most powerful man in the world. His "Holy Roman Empire" stretched from Spain to Vienna, from Holland to Sicily, from Bohemia to Bolivia. Unfortunately, Charles also inherited all the empire's problems, including battling Ottomans in Vienna and Protestants in Germany. When an exhausted Charles V retired from the throne after a 40-year reign to enter a monastery, his empire was split up among family members, with Spain and its possessions going to his son, Philip II (1527–1598).

Plateresque Facade, 1533 (University of Salamanca, Salamanca, Spain).

Following in the Wake of Christopher Columbus

Trace the major turning points in Columbus' life as you tour the Iberian Peninsula.

Cape Sagres, Portugal

A young Italian wool-weaver named Cristoforo Colombo (1451–1506) ran off to sea and was shipwrecked off Portugal. He washed ashore at the "Edge of the World," Cape Sagres. There, he studied how to avoid future shipwrecks at the school of Prince Henry the Navigator. (At the bleak Cape today, you can see a few ruins and a large wind-compass marked with stones on the ground, and then squint into the wind from the craggy cliffs.) Cristoforo married a captain's daughter and learned Portuguese and Spanish.

The Alhambra, Granada

Columbus (known as Cristóbal Colón in Spanish) presented a bold plan to King Ferdinand and Queen Isabel of Spain in this former palace of the Moors. They met inside the Grand Hall of the Ambassadors (whose walls are decorated with the Arabic phrase "Allah is victorious"), where the last Moorish sultan had sur-rendered just months before. Here, Columbus produced maps and pie charts to make his case that he could reach the East by sailing west.

Ferdinand and his advisors laughed and called Columbus mad—not because they thought the world was flat (most educated people knew other-wise), but because they thought Columbus had underestimated the size of the globe, and thus the length and cost of the journey. But Isabel said, *"Sí, señor."* Columbus fell to his knees (promising to pack light, wear a money belt, and use the most current guidebook available). Isabel gave him an ATM card with some cash as backup.

The Alcázar, Sevilla

On August 3, 1492, Columbus set sail from Palos (near Sevilla) with 90 men on three ships: the *Niña*, *Pinta*, and flagship *Santa María*. The Alcázar palace in Sevilla displays models of his three ships, plus the earliest known portrait of Columbus.

Columbus' destination was India, which he'd estimated was 3,000 miles away. Three thousand miles later, the superstitious crew was still at sea and ready to mutiny, having seen evil omens such as a falling meteor and a jittery compass. Fortunately, they hit land: an island in the Bahamas (October 12, 1492). Convinced he'd reached Asia, Columbus traded with the "Indians," dismantled

Philip II annexed Portugal, built El Escorial (described on page 239), and moved Spain's capital from tiny Toledo to a new planned city called Madrid. Philip presided over Spain as it fell from superpower to also-ran.

The Art of Spain's Golden Age

Gold from newly discovered America paid for Spain's rich collection of art. Churches and palaces are drenched in intricately carved stonework, called Plateresque—from the Spanish *plata*, or "silver," since it resembles intri-cate silver filigree work. This is the

the *Santa María* to build a fort, and headed home.

Royal Palace and Monument, Barcelona

In 1493, a triumphant Christopher Columbus was given a hero's welcome in Barcelona. He entered the Royal Palace, accompanied by six "Indians" and several statues made of pure New World gold. King Ferdinand and Queen Isabel rose from their thrones to welcome him with the title "Admiral of the Oceans." Columbus made three more voyages to the New World and made Spain rich. At the foot of Barcelona's famous Ramblas street, a 200-foot monument honors Columbus.

Tomb of Columbus, Sevilla

Inside Sevilla's Cathedral, four bronze kings carry the tomb of Christopher Columbus. His pallbearers represent the regions of newly-united Spain (you can identify them by their team shirts).

In his last years, Columbus gained a bad reputation as a tyrant in the New World, and was sent back to Spain in chains. He died on May 20, 1506, felled by gout and by "grief at seeing himself fallen from his high estate." (Diabetes or syphilis may have contributed.) Columbus died thinking he'd discovered a shortcut to Asia, unaware he'd opened up Europe to a New World.

Even after his death, Columbus logged a lot of Frequent Floater miles. He was buried first in Spain, then in Santo Domingo, then Cuba. Then in about 1900, when Cuba gained independence from Spain, he sailed home again to Sevilla. Are the remains actually his? Sevillans (and recent DNA tests) say yes.

The Tomb of Columbus
(Sevilla Cathedral, Spain).

Spanish equivalent of Portugal's Manueline style.

Wealthy Spanish aristocrats also bought wagonloads of the most popular art of the time: lush Italian Renaissance paintings by Raphael, Titian, Tintoretto, and others. They also loaded up on Dutch and Flemish paintings from the Low Countries, which were under Spanish rule. (That's why Madrid's Prado Museum has Europe's finest collection of paintings today.)

Back home, Spanish artists concentrated on religious scenes. Heaven and earth have always existed side by

side in Spain: religion and war, Grand Inquisitors and cruel conquistadors, spirituality and sensuality, holiness and horniness. This rich combination of heavenly mysticism and worldly beauty is typically Spanish.

The "Big Three" in Spanish painting are El Greco (see below), Diego Velázquez (described on page 274), and Francisco de Goya (described on page 322).

El Greco

The first great Spanish painter was Greek. Doménikos Theotokópoulos—known to Spaniards simply as El Greco, or "The Greek" (1541–1614)—was born in Greece, trained in Venice, then settled in Toledo, Spain. The combination of these three cultures, plus his own unique personality, produced a highly individual style. His paintings are Byzantine icons drenched in Venetian color and fused in the fires of Spanish mysticism. El Greco exemplifies the spiritual fervor of much Spanish art. His skinny saints seem to be stretched between heaven and earth, flickering like spiritual candles. The drama, the surreal colors, and the intentionally unnatural distortion have the intensity of a religious vision.

A simple chapel in Toledo holds El Greco's most-loved painting. *The Burial of the Count of Orgaz* couples heaven and earth in a way only The Greek could. It feels so right to see a painting left *in situ*—where the

artist placed it 400 years ago. The year depicted in the painting is 1312. You're at the burial of the good count, who's being laid to rest right here in this chapel. He was so holy, even saints Augustine and Stephen have come down from heaven to lower his body into the grave. (The painting's subtitle is "Such is the reward for those who serve God and his saints.")

More than 250 years later, in 1586, a local priest hired El Greco to make a painting of the burial to hang over the count's tomb. The funeral is attended by all of Toledo's most distinguished citizens. (El Greco used local aristocrats as models.) The painting

El Greco, **Burial of the Count of Orgaz**, 1586 (Church of Santo Tomé, Toledo, Spain).

is divided in two by a serene line of noble faces separating heaven above and earth below. Above the faces, the count's soul, symbolized by a little baby, rises up through a mystical birth canal to be reborn in heaven, where he's greeted by Jesus, Mary, and all the saints. A spiritual wind blows through as colors change and shapes stretch.

This is Counter-Reformation propaganda: Notice Jesus pointing to St. Peter, the symbol of the pope in Rome, who controls the keys to the Pearly Gates. Each face is a detailed portrait. El Greco himself (eyeballing you, seventh figure in from the left, above the open hand) is the only one not involved in the burial. The boy in the foreground is El Greco's son. On the handkerchief in the boy's pocket is El Greco's signature, written in Greek.

The Decline of Spain and Portugal

The fast money from the colonies kept both Spain and Portugal from seeing the dangers at home. They stopped growing their own crops and neglected their infrastructure. During the centuries when science and technology developed as never before in other European countries, Spain took a long siesta.

In the summer of 1588, Spain's seemingly unbeatable royal fleet of 122 ships—the Invincible Armada—sailed off to quickly conquer England. But as the battle unfolded, a burst of bad weather plus the cunning of England's Sir Francis Drake sank 72 of Spain's ships. Just like that, Britannia ruled the waves, and Spain spiraled downward, losing its colonies and becoming a debt-ridden, overextended, flabby

nation. England, Holland, and France were the rising sea-trading powers in the new global economy.

The Rise of England

As Spain's Armada sank, England rose to prominence. Long an isolated island-nation at the edge of Europe, England was now a true European power, feasting on New World spoils. Its leader was the bastard child of Henry VIII and his "adulteress," Anne Boleyn. Their daughter, Queen Elizabeth I (1533–1603), reigned over a cultural renaissance of sea exploration, scientific discovery, and literature known as the Elizabethan Age.

Elizabeth I was pale, stern-looking, red-haired (like her father), and wore big-shouldered power dresses. The "Virgin Queen" was married only to her country, but she flirtatiously wooed opponents to her side. ("I know I have the body of a weak and feeble woman,"

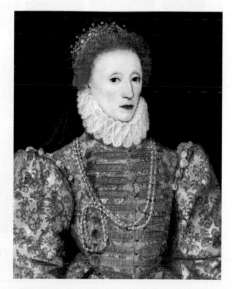

Elizabeth I, c.1575
(National Portrait Gallery, London).

Shakespeare's Globe

All the world's a stage,
And all the men and women merely players.
They have their exits and their entrances,
And one man, in his time, plays many parts.
—As You Like It

In 1599, The Globe opened just as the art form of theater was hitting the mass market. Yes, the ancient Greeks invented theater, but the English refined it more than anyone else. In Shakespeare's day, Londoners from every social level lined up to see actors pretending to be real people in made-up situations.

The Globe was London's biggest theater, seating 3,000. It featured a British specialty: a "thrust" stage, jutting out into the audience. The Globe premiered Shakespeare's greatest works—*Hamlet, Othello, King Lear, Macbeth*—in open-air summer afternoon performances, though occasionally at night by light of torches and buckets of tar-soaked ropes.

In 1612, The Globe burned down. In 1997, it was finally rebuilt. The new Shakespeare's Globe—round, half-timbered, thatched, using wooden pegs for nails—is a realistic replica, though smaller (seating 1,500) and constructed with fire-repellent materials. Performances are staged as authentically as possible almost nightly in summer.

Shakespeare's Globe in London—painstakingly constructed to be just as it was in Shakespeare's day—welcomes theatergoers who want to party like it's 1599.

she'd coo, "but I have the heart and stomach of a king.") In her official portraits, she looks ageless, always aware of her public image, resorting to makeup, dye, wigs, and flashy dresses to dazzle courtiers. During her reign, the Protestant Elizabeth kept religious animosity in check, even if it meant sending her own Catholic cousin, Mary Queen of Scots, to the execution block.

Elizabeth surrounded herself with intellectuals, explorers, and writers. Walter Raleigh introduced tobacco from America to a skeptical Queen Elizabeth. Francis Bacon experimented with the experimental method, the foundation of modern science. William Shakespeare—and, to a lesser degree, other writers such as John Donne and Christopher Marlowe— shaped the course of English literature and the English language itself.

Though famous in his day, William Shakespeare (1564–1616) was more a bohemian barfly than a renowned scholar. From humble roots, he rose to be an actor, poet, and playwright. Using borrowed plots, outrageous puns, and poetic language, Shakespeare wrote comedies (*Taming of the Shrew, As You Like It*), tragedies *(Hamlet, Othello, Macbeth, King Lear)*, and fanciful combinations (*The Tempest*). His works explored the full range of human emotions, and his characters are still fresh four centuries later.

Shakespeare is the world's greatest author in any language, period. (Okay, until this book....) In one fell swoop, he made the language of everyday people as important as Latin. In the process, he gave us phrases like "one fell swoop" that we quote without knowing it's Shakespeare.

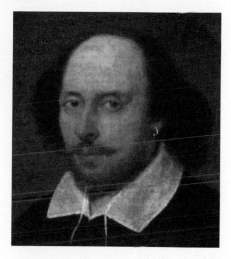

William Shakespeare, c.1610
(National Portrait Gallery, London).

The Golden Age of the Low Countries

The "Low Countries"—today's Belgium, Netherlands, and Luxembourg– are just that: flat, soggy, and easily overrun by invaders. But out of this poor, feudal landscape emerged three powerful cities that thrived on trade. Each had a prime location.

In the 15th century, a wealthy class of merchants motored their Dutch and Belgian cities through a Golden Age.

Amsterdam and Bruges sat where rivers flowed into the North Sea, while Brussels hugged a main trading highway. In their day, these cities were as rich as entire nations.

Bruges bustled even in medieval times. Known as the "Venice of the North" (for its canals and trading prowess), it served as the middleman in trade between northern and southern Europe. By 1400, Bruges' population was 35,000, as large as London's. Ships from Spain, England, Denmark, and Russia converged on Bruges to deal their goods. Factories cranked out cloth for export.

Bruges and other merchant towns in northern Europe formed the Hanseatic League, a network of trading partners located in what is now Belgium, Norway, Estonia, Poland, Germany, and Russia. Member cities worked to overcome the bad-for-business aspects of a fragmented Europe. They'd work together to provide safe passage and harbor for the ships of sister Hanseatic League towns. They developed crude but helpful forms of banking, credit, stock markets, and insurance. They shared special trade arrangements. For instance, a fishing port would work with a town

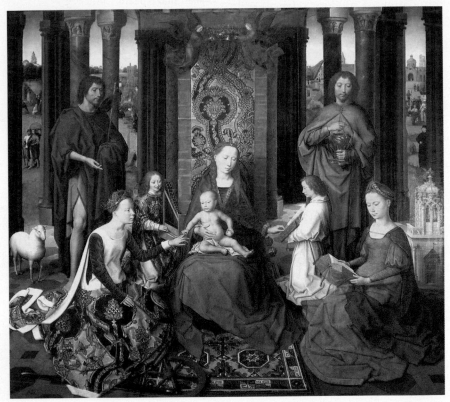

Hans Memling, **St. John Altarpiece,** 1474 (Memling Museum, Bruges, Belgium).
As money flowed into Bruges, residents invested in works by some of Europe's top artists. This Memling altarpiece—which stood in a church that doubled as a hospital—comforted the sick.

with a salt industry to preserve and sell their salted fish farther and wider than otherwise possible. Dominating sea trade in the region in the 15th century, the Hanseatic towns (such as Bruges, Lubeck, Riga, and Bergen, among others) flourished. Many of these towns with rich trade heritages have much to show off to tourists today.

Grand Place (Brussels).
When overland trade increased in the Middle Ages, the once-dinky town of Brussels grew big on business. This colorful cobblestone square remains the historic and geographical heart of Brussels. For a thousand years, merchants sold their wares here in open-air stalls. Today, shops and cafés sell chocolates, waffles, beer, mussels, fries, lace, and flowers.

In the 1400s, Bruges was northern Europe's richest, most cosmopolitan, and most cultured city. New ideas, fads, and painting techniques were imported and exported with each shipload. Beautiful paintings were soon an affordable luxury, like fancy clothes or furniture. Internationally known artists set up studios in Bruges, producing portraits and altarpieces for wealthy merchants from all over Europe. The artists Jan van Eyck and Hans Memling had studios here. Bruges was the only city in northern Europe to have a statue by Michelangelo.

By the 16th century, the harbor had silted up and Bruges' prosperity abruptly ended (until the town was rediscovered—beautifully moth-balled—by modern-day tourists). But before long, Bruges' neighbor to the north stepped forward to fill the void.

Holland

During its Golden Age in the 1600s, Amsterdam was the world's wealthiest city, an international sea-trading port, and a cradle of capitalism. Upwardly mobile middle-class businessmen inhabited a city laced with canals, lined with trees, and packed with town-houses topped with fancy gables. Immigrants, Jews, outcasts, and political rebels were drawn here by its tolerant atmosphere, while painters such as young Rembrandt captured that atmosphere on canvas.

Amsterdam began wheeling and dealing in about 1300. Located where a river spilled into the North Sea, the locals traded herring from the sea for beer barged downstream from Germany. They blocked the Amstel River with a dam and created a village called "Amstel-damme." Draining the marshy land, they sunk pilings and built a city from scratch. It was here that German river boats traded with ocean-going vessels from the North Sea. Dam

Gables

NECK BELL STEP

Along the rooftops, Amsterdam's famous gables are false fronts to enhance roofs that are, generally, sharply pitched. Gables come in all shapes and sizes, sometimes decorated with animal and human heads, garlands, urns, scrolls, and curlicues. Despite the infinite variety, you can recognize several generic types.

A simple point gable just follows the triangular shape of a normal pitched roof. Neck gables rise up vertically from a pair of sloping "shoulders." A bell gable is shaped like (duh) a bell. Step gables, triangular in shape and lined with steps, are especially popular in Belgium. (There's probably even a clark gable, but frankly, I don't give a damn.)

Square was the center of it all.

Back when "stock" meant whatever could be loaded and unloaded onto a boat, Amsterdammers loved to trade. Soon, rather than trading goats, chickens, and kegs of beer, they were exchanging slips of paper and "futures" at one of the world's first "stock" exchanges. Traders needed moneychangers, who needed bankers, who made money by lending money... and by 1600, Amsterdam had become one of the world's first great capitalist cities, loaning money to free-spending kings, dukes, and bishops.

Hardy Dutch sailors tried their hand at trade with the Far East. Financing it all was the Dutch East India Company, a privately owned import/export business subsidized by the state.

With a fleet of 500 ships, this was the first great multinational corporation. Over the next two centuries, the Company would send a half-million Dutch people abroad on business trips.

The Dutch East India Company sailed to India, Indonesia, and America (New York was originally New Amsterdam). They exchanged flashy glass beads they'd brought from home for spices, jewels, and the island of Manhattan. One of the Dutch traders' best-selling items was human beings. Selling Africans to Americans to work as slaves generated high quarterly profits for their satisfied shareholders. Holland invented the global economy.

Amsterdam in the 1600s was the "warehouse of the world." You could buy cinnamon from India, tea from

Ceylon, or coffee from Java. Blue-and-white porcelain from China inspired locals to make their own Delftware. With its wealth, Amsterdam built in grand style. It was a completely man-made city, protected by dikes, laced with canals, and built on trees (thousands of logs hammered vertically into the marshy soil). Even today, merchants' mansions lean shoulder to shoulder, overlooking the city's stately canals.

By 1650, Amsterdam's overseas trade was being eclipsed by new superpowers England and France. Inconclusive wars with these rivals drained the Dutch economy, destroyed the trading fleet, and demoralized the people. Within a century, Amsterdam had become a city of backwater bankers on a scale fitting Holland's small geographical size.

Seventeenth-century Amsterdam lives today in the architecture you'll cruise by.

Rembrandt, **De Staalmeesters (The Dutch Masters),** 1662, (Rijksmuseum, Amsterdam).
These were the kind of men that made Amsterdam a great trading power. They were members of a textile guild (clothes, but no cigars).

Northern Art

Money shapes art. While Spain and Italy had wealthy aristocrats and the powerful Catholic Church to purchase art, northern Europe's patrons were middle-class, hardworking, Protestant businessmen. They wanted simple, cheap, no-nonsense pictures to decorate their homes and offices. Greek gods and Virgin Marys were out, hometown folks and hometown places were in. Most of all, they wanted realistic portraits of themselves, to show off their success.

The canvases are smaller (and more affordable), and the colors are more subdued. Generally speaking, there are more paintings than statues. Northern artists sweated the details, encouraging the patient viewer to appreciate the beauty in everyday things. This is art meant not to wow or preach at you, but to be enjoyed and lingered over.

The favorite subjects of northern artists are portraits (often of groups), typical scenes from daily life, and still lifes of food and everyday objects.

PORTRAITS

Upwardly mobile city burghers were playing catch-up with the ruling class, and a great way to rise above society's small-fries was to commission a distinguished portrait of yourself.

In the great museums of the Netherlands, you'll stand eye-to-eye with lifelike (often life-size) portraits of the Dutch citizens who built the Golden Age: brewers, preachers, workers, housewives, and bureaucrats.

Northern artists made their portraits come alive with photo-realism.

Jan Steen, **The Topsy-Turvy World,** 1663 (Kunsthistorisches Museum, Vienna).
Without a king or the Catholic Church to pay for their work, Dutch artists painted fun, unpreachy, and affordable art for the urban middle class. This painting, also called "Beware of Luxury," has a common-sense moral: Wealth can erode character.

Frans Hals, **The Merry Drinker,** 1627
(Rijksmuseum, Amsterdam).
This jovial man, red-cheeked and smiling under his jaunty black hat, offers us a glass of wine, welcoming us to the exuberant Golden Age.

Rather than airbrushing out zits, they captured the dignity of these hard-working people in relaxed, "unposed" poses. Frans Hals, Rembrandt (described on page 259), Jan van Eyck (described on page 216), and Hans Holbein were masters at this.

Franz Hals (c. 1581–1666), using a few quick strokes, gives us not just a person, but a personality. Rather than posing his subject, making him stand for hours saying "cheese," Hals takes a camera-phone snapshot of a barfly in a blue-collar bar. The messy brushwork creates a blur that suggests the man is still moving. Two centuries later, the Impressionists learned from Hals' rushed brushwork.

SLICE-OF-LIFE ART

So-called "genre" paintings give us a snapshot of ordinary people going about their business.

Pieter Bruegel (c. 1525–1569)—the Norman Rockwell of the 16th century—was the undisputed master of the slice-of-life village scene. (His name is pronounced BROY-gull, and is sometimes spelled Brueghel. Many people confuse Pieter Bruegel the Elder with his less-famous sons, who added luster and an "h" to the family name.)

Bruegel painted peasants at play, simple and happy. While celebrating their rustic life, Bruegel also skewered their weaknesses, not to mock his subjects as hicks, but to demonstrate universal examples of human folly. We can sympathize with his characters, seeing a bit of ourselves in their foolish actions. Despite his many rural paintings, Bruegel was actually an urban trans-fest-ite who liked to wear peasants' clothing to observe country folk at play. His crowded and brightly colored scenes are fun.

The Peasant Wedding, Bruegel's most famous work (see next page), is less about the wedding than the food. It's a farmers' feeding frenzy as the barnful of wedding guests scramble to get their share of free eats. Two men bring in the next course, a tray of fresh pudding. The bagpiper pauses to check it out. A guy grabs bowls and passes them down the table, taking our attention with them. Everyone's going at it, including a kid in an oversize red cap who licks the bowl with his fingers. In the middle of it all, look who's been completely forgotten—the demure bride sitting in front of the blue-green cloth.

Pieter Bruegel the Elder, **The Peasant Wedding,** 1565 (Kunsthistorisches Museum, Vienna).
Scenes such as this—a crowded, colorful, detailed look at peasant life—were popular with the urban middle class in Belgium and the Netherlands.

Mentally compare Bruegel's peasants with Michelangelo's *David*. Renaissance humanists viewed human beings almost like Greek gods: strong, handsome, and noble. Northern artists saw the flip side of humanism—ordinary folks with their follies and travails.

and pepper. The carefully composed still life reflects the same sense of pride the Dutch have for their immaculate, well-decorated homes. Linger over the little things: the pewter ware, the seafood, the lemon peels, the rolls, and

STILL LIFES

Dutch artists pioneered the "still life," or painting of inanimate objects. This painting, a typical still life, lets you savor the fruits of Holland's rich trade network: lemons from Italy, pitchers from Germany, and spices from Asia, including those most exotic of spices...salt

Pieter Claesz, **Still Life with Turkey Pie,** 1627 (Rijksmuseum, Amsterdam).

the glowing goblets that cast a warm reflection on the tablecloth. Looking closely at the goblets, you can even see the faint reflections of the food and windows. The closer you get, the better it looks.

DUTCH MASTERS

To better appreciate northern European art, let's look at two masters of the Golden Age: Jan Vermeer and Rembrandt van Rijn.

Jan Vermeer

Jan Vermeer (1632–1675) painted Dutch women engaging in simple activities at home. The canvas is its own world, filled with the few things Vermeer wants us to focus on. Vermeer quiets the world down to where we can hear our own heartbeat, letting us appreciate the beauty in common things.

In Vermeer's *The Kitchen Maid*, the subject is ordinary— a kitchen maid—but you could look for hours at the tiny details and rich color tones. These are mundane objects, but they glow in a diffused light: the crunchy crust, the hanging basket, even the rusty nail in the wall with its tiny shadow. Vermeer had a unique ability to show with surface texture how things feel when you touch them.

Vermeer squares off a self-contained scene (framed by the table in the foreground, the wall in back, the window to the left, and the footstool at right), then fills the space with objects for our perusal. The maid is alive with Vermeer's distinctive

yellow and blue—the colors of many traditional Dutch homes—against a white backdrop. She is content, solid, and sturdy, performing this basic task like it's the most important thing in the world. Her full arms are built with patches of paint. Everything is lit by a crystal-clear light, letting us see these everyday things with fresh eyes.

Rembrandt van Rijn

Rembrandt (1606–1669) was the greatest Dutch painter, a master of portraits, still lifes, landscapes, and slices of life. He could put all these elements together to capture the depths of the human soul.

The son of a Leiden miller (who owned a waterwheel on the Rhine, hence the "van Rijn"), young

Jan Vermeer, **The Kitchen Maid**, c. 1658 (Rijksmuseum, Amsterdam).
Shhh...you can practically hear the milk pouring into the bowl. Amsterdam's Rijksmuseum has the best collection of Vermeers in the world—they own four of them (of about 30). Each canvas is a small jewel worth lingering over.

Best Northern Art

- Rijksmuseum (Dutch art, especially Rembrandt and Vermeer), Amsterdam
- Royal Museums of Fine Arts of Belgium, Brussels
- Alte Pinakothek (German art), Munich
- Kunsthistorisches Museum, Vienna
- Gemäldegalerie, Berlin
- Memling Museum, Bruges
- Groeninge Museum, Bruges
- Prado Museum, Madrid
- *Isenheim Altarpiece,* Unterlinden Museum, Colmar, France
- *The Last Judgment,* Hôtel Dieu, Beaune, France
- *Adoration of the Mystic Lamb,* St. Bavo's Church, Ghent, Belgium

Rembrandt took Amsterdam by storm. The commissions poured in for official portraits, and he was soon wealthy and married to Saskia van Uylenburgh. They moved to an expensive home and decorated it with their collection of art and exotic furniture.

In 1642, Saskia died, and Rembrandt's fortunes changed. The public's taste shifted and war devastated the art market. Rembrandt got a reputation as a freethinker who didn't always paint exactly the portrait his patron wanted. The commissions dried up. Rembrandt was forced to declare bankruptcy, which was the ultimate humiliation in success-oriented Amsterdam.

The silver lining is that Rembrandt was now free to paint what he wanted. A religious man, he painted Bible scenes. He'd hire Amsterdam's grubby street people to pose as Jesus or the holy saints, giving a down-to-earth look at the supernatural.

If you see a brown painting in Europe's museums, it's probably a Rembrandt. He favored a deep brown tone, lit by strong light glowing from the darkness. This allows Rembrandt to literally highlight the few crucial details he thinks are most important: a hand, a wrinkled forehead, a grief-stricken Mary. Rembrandt perfected chiaroscuro, the dramatic light/dark contrasts that Caravaggio pioneered (see page 273). When he shines his light on a subject, the effect is powerful and dramatic—one reason why Rembrandt is usually classified as a Baroque painter.

Rembrandt's numerous self-portraits, painted from youth till old age, show a man always changing—from wide-eyed youth, to wealthy businessman, to disillusioned soul, to defiant old man. The craggy *Self-Portrait*

Rembrandt, **Peter Denies Christ,** 1660 (Rijksmuseum, Amsterdam).

Group Portraits: Dull or Dynamic?

In 17th-century Amsterdam, companies of civic guards would commission artists to paint their portrait. Here are two companies, two artists. Everyone got his money's worth in van der Helst's typically (boring) posed portrait. Compare it to Rembrandt's exhilarating *Night Watch*—this is an action scene, capturing the can-do spirit of the Dutch Golden Age.

Bartholomeus van der Helst, **Schuttersmaaltijd,** 1648 (Rijksmuseum, Amsterdam).

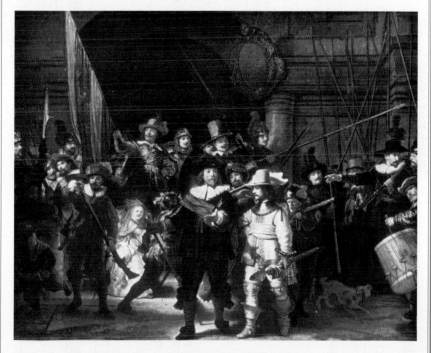

Rembrandt, **The Night Watch,** 1642 (Rijksmuseum, Amsterdam).

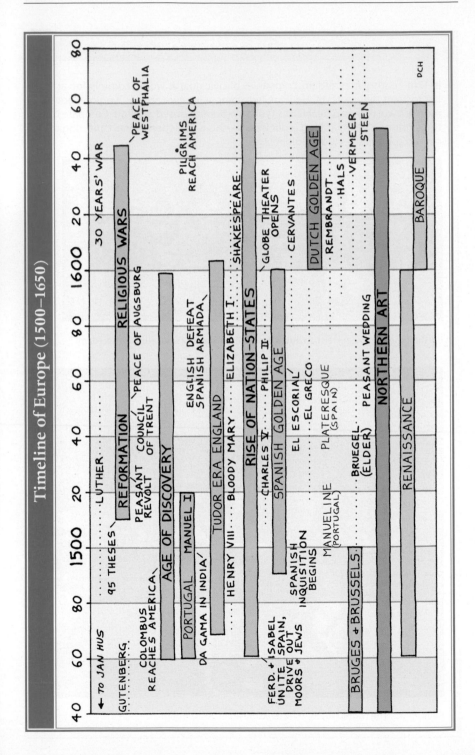

Timeline of Europe (1500–1650)

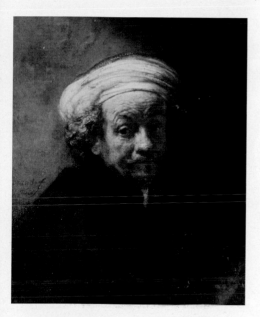

Rembrandt, **Self-Portrait as the Apostle Paul,** 1661 (Rijksmuseum, Amsterdam).

as the Apostle Paul was done when he was 55 going on 80. Here, Rembrandt surveys the wreckage of his independent life. He was bankrupt, his mistress had just died, and he had also buried several of his children. With lined forehead, bulbous nose, and messy hair, he peers out from under several coats of glazing. His look is...skeptical?

Weary? Resigned to life's misfortunes? Or amused? (He's looking at us, but remember that a self-portrait is done staring into a mirror.)

This man has seen it all—success, love, money, fatherhood, loss, poverty, death. He took these experiences and wove them into his art. Rembrandt died poor and misunderstood, but he remained very much his own man to the end.

In his last years, his greatest works were his self-portraits, showing a tired, wrinkled man stoically enduring life's misfortunes. His death effectively marked the end of the Dutch Golden Age.

Europe Divided

The year Rembrandt died in Holland (1669), work was begun in France by King Louis XIV on what would become Europe's grandest palace: Versailles.

The Reformation and religious wars had split Europe into two camps: the Protestant north and the Catholic south, with their respective art styles. The future belonged to a power that bridged north and south, democracy and monarchy. That nation was France.

Louis XIV, The Sun King.

Divine Monarchs and Revolution

(1650–1815)

In the 1600s, as nation-states coalesced around a central monarch, several assertive kings began testing the limits of power. These "divine" monarchs insisted they were all-powerful, claiming that their right to rule came directly from God. After a century of religious wars, an absolute monarch who promised stability and had the backing of the Catholic Church sounded good. Many Europeans said, "Absolutely!" Others weren't so sure.

The English Civil War:
King vs. Parliament

England had its share of strong monarchs, but it also had a long tradition of constitutional limits. As early as 1215, nobles forced King John to sign the Magna Carta, which set legal limits—in writing—on the king's powers. England's nobles met regularly in a parliament that advised and reined in the king. Henry VIII and Elizabeth I had to sweet-talk nobles and commoners to push their agendas through.

When Elizabeth, called the Virgin Queen, died in 1603—presumably still a virgin and definitely without an

heir—the crown passed to King James of Scotland (1566–1625). While religious (he launched the "King James" translation of the Bible), he alienated Anglicans (Church of England), harder-line Protestants (Puritans), and democrats everywhere by insisting that he ruled by divine right, directly

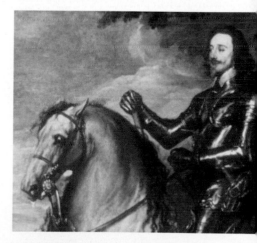

Anthony van Dyck, **Charles I on Horseback,** c. 1637 (National Gallery, London).
Picture Charles' sensitive face (with scholar's eyes and artist's long hair and beard) severed from his elegant body (in equestrian finery), and you've arrived quickly at the heart of the English Civil War.

from God. He passed this attitude directly to his son, Charles I (1600–1649).

Tired of tyranny, the English Parliament rebelled against King Charles I, and a Civil War broke out (1642–1648). Though the battle lines were confusing, the struggle was basically between city-dwelling Protestant Parliamentarians and rural Catholic traditionalists. The rebels' leader, Oliver Cromwell, vowed, "We will cut off the King's head with the crown on it." They did, and Cromwell took power. But after Cromwell's death, a bitterly divided country eventually "restored" the monarchy, inviting Charles' son to take the throne in 1660. This time around, however, the ruler's power came not from God, but from Parliament.

The Restoration was met with back-to-back disasters that leveled London.

During the Great Plague, people were dying faster than they could be buried.

London's Double Whammy: the Great Plague (1665) and the Great Fire (1666)

In the summer of 1665, the Grim Reaper—in the form of the bacteria *Yersinia pestis* (bubonic plague)—rode through London on fleas atop a black rat. It killed one in six people. It started as "the Poore's Plague," and wasn't taken seriously until it spread to richer neighborhoods. During that unusually hot summer, 5,000 died each week.

Like the bubonic plague that spread throughout Europe in the mid-14th-century, victims suffered several days of agony: fever, diarrhea, vomiting, and swollen lumps (buboes) in the groin. After their skin turned blotchy black (the "Black Death"), they died. Workers patrolled the streets crying "Bring out yer dead!" and carted them off to mass graves. The disease was blamed on dogs and cats, and paid dog-killers destroyed tens of thousands of pets—ironically bringing even more rats.

By fall, London was a ghost town, and throughout England, people avoided Londoners like the plague.

The following year, disaster struck again. On Sunday, September 2, 1666, stunned Londoners watched their city go up in flames. Started in a bakery shop near London Bridge and fanned by strong winds, the fire swept westward, engulfing the mostly wooden city and devouring Old St. Paul's Cathedral. In four days, 80 percent of the city was incinerated, including 13,000 houses and 89 churches. The good news? Incredibly, only nine people died, the fire cleansed a plague-infested city, and Christopher Wren was young, full of energy, and ready to rebuild London's skyline.

Christopher Wren and St. Paul's Cathedral

Almost before the ashes had cooled, a young architect named Christopher Wren (1632–1723) was in the mayor's office with exciting plans to reconstruct the city. Wren was the right man at the right time. Though the astronomy prof had never built a major building in his life, he'd proven his ability in every field he touched. He'd mapped the moon, experimented with opium as an anesthetic, taught trigonometry, and studied gravity with Isaac Newton.

Wren's main job was to rebuild venerable St. Paul's Cathedral, but he also proposed some 50 more churches. For the next four decades he worked to achieve his vision: a spacious St. Paul's, topped by a dome, surrounded by a flock of Wrens.

Though built in the Baroque era (described below), Wren's masterpiece has a little of everything. The big capitol-style dome is lined with Greek-style columns and flanked by Gothic towers. The overall effect is not of Baroque exuberance but classical restraint, a glorious demonstration of mathematics in stone.

Inside, this big church feels big. At 515 feet long and 250 feet wide, it's Europe's fourth-largest (after St. Peter's, Sevilla, and Milan). It's also relatively bare, with a cream-colored ceiling and clear glass windows. The church has the clean lines and geometric simplicity of the age of Newton, when reason was holy and God set the planets spinning in perfect geometrical motion.

For more than 40 years, Wren worked on this site, overseeing every detail of St. Paul's and the 65,000-ton dome. At age 75, he was fortunate to witness his son placing the cross on top of the dome, completing the masterpiece. On the floor directly beneath the dome is a brass grate, inscribed with Wren's name and epitaph, written in Latin: *Lector,*

Wren, **St. Paul's Cathedral,** 1632–1723 (London). *To this day, the magnificent dome of St. Paul's reminds Londoners of the genius of its architect, Christopher Wren.*

Mannerism

Art historians give the name Mannerism to a late 16th-century style of art in between Renaissance and Baroque. Raphael, Michelangelo, Leonardo, and Titian had mastered reality. How could later artists top that? Mannerists tried by emphasizing style (or "manner") over substance. Paintings showcase the artist's technique and smooth brushwork. Figures twist and squirm every which way, but their body language is gibberish, just an excuse for the painter to show off.

In this painting, the Mannerist artist Parmigianino (like the cheese; 1503–1540) exaggerates this Madonna's neck for effect, giving her an unnatural, swan-like beauty. She has the same pose and position of hands as Botticelli's *Venus* and the *Venus de' Medici*. Her body forms an arcing S-curve—down her neck as far as her elbow, then back the other way along Jesus' body to her knee, then down to her foot. The baby Jesus seems to be blissfully gliding down this slippery slide of sheer beauty.

Parmigianino, **The Madonna with the Long Neck,** 1535 (Uffizi Gallery, Florence). *"Wheee!"*

si monumentum requiris circumspice (Reader, if you seek his monument, look around you).

Baroque Art

After 100 years of religious wars and squabbles over who would rule whom and who would worship which way, Europe chose religious toleration, stability, strong absolute monarchs, and a pro-status-quo art (supporting kings and popes) called Baroque. Emotionally-charged Baroque contrasts with the simplicity and balance of Renaissance art.

While northern Protestants painted simple scenes, Catholics and kings turned to this exuberant new over-the-top style. The Baroque style features large canvases, bright colors, lots of flesh, rippling motion, wild emotions, grand themes...and pudgy winged babies, the sure sign of Baroque.

Cultured aristocrats wanted colorful wallpaper for their palaces. Greek gods and myths were in. And they were naked. Some of this stuff is definitely R-rated, for nudity and violence. You'll see the Rape of Proserpine, the Rape of the Sabine Women, the Rape of the Daughters of Leucippus, and on and on.

Baroque art overwhelms. Orna-

Skylight, **Toledo Cathedral** (Toledo, Spain). *Interior designers of the Baroque Age wanted more light. Colored walls were whitewashed. Stained-glass windows were replaced by clear panes. And, in Toledo, to brighten up their dark medieval cathedral, they actually cut out a skylight and encrusted it with Baroque decor.*

Gian Lorenzo Bernini: Father of Baroque

Bernini (1598–1680) virtually invented Baroque. He went on to remake the city of Rome in Baroque style. Rome bubbles with Bernini fountains and sculpture. He also spent 40 years at the Vatican embellishing St. Peter's Basilica and creating St. Peter's Square. This "Michelangelo of Baroque" was a sculptor, painter, and architect.

In his statues, Bernini carved out some of the classic features of Baroque art: He makes supernatural events seem realistic. He freezes the action at the most dramatic, emotional moment. The figures move and twist in unusual poses. He often sculpts more than one figure, forming a scene, rather than a stand-alone portrait. And the subject is classical. Even

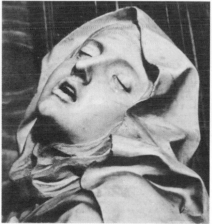

Bernini, **St. Teresa in Ecstasy** (detail), 1652 (Church of Santa Maria della Vittoria, Rome). *Teresa has just been stabbed with God's arrow of fire. Now, the angel pulls it out and watches her reaction. Teresa swoons, her eyes roll up, her hand goes limp, she parts her lips...and moans. Teresa, a 16th-century Spanish nun, later talked of the "sweetness" of "this intense pain," describing her oneness with God in ecstatic, even erotic, terms.*

mentation abounds. Abundance abounds. It plays on the emotions, titillates the senses, and carries us away. It made great Counter-Reformation propaganda for the Catholic Church and absolute monarchs to combat the dual threats of Protestantism and democracy.

While Renaissance art appeals to connoisseurs with its logic, Baroque appeals to the masses with emotion. If Renaissance art was meditation, Baroque art was theater.

David, David, and David

Three very different Italian masters produced iconic sculptures of David, the shepherd boy who felled a Goliath. Compare and contrast the artists' styles.

Donatello's *David* is young and graceful, casually gloating over the head of Goliath, almost Gothic in its elegance and smooth lines. The *contrapposto* stance of Donatello's *David* is similar to Michelangelo's later *David*, resting his weight on one leg in the classical style, but it gives him a feminine rather than masculine look. Gazing into his coy eyes and at his bulging belly is a very different experience from confronting Michelangelo's older and sturdier Renaissance man.

Michelangelo's *David* is pure Renaissance: more massive, heroic in size, and superhuman in strength and power. The tensed right hand, which grips a stone in readiness to hurl at Goliath, is more powerful than any human hand; it's symbolic of divine strength. A model of perfection, Michelangelo's *David* is far larger and grander than we mere mortals. We know he'll win. Renaissance man has arrived.

In his self-portrait, 25-year-old Bernini is ready to take on the world, slay the pretty-boy *David*s of the Renaissance, and invent Baroque. Unlike Michelangelo's rational, cool, restrained *David,* Bernini's is a doer: passionate, engaged, dramatic. While Renaissance *David* is simple and unadorned—carrying only a sling—Baroque Dave is "cluttered" with a braided sling, a hairy pouch, flowing cloth, and discarded armor. Bernini's *David*, with his tousled hair and set mouth, is one of us; the contest is less certain than with the other two *David*s.

Donatello's *David* (1430) represents the first inkling of the Renaissance, Michelangelo's *David* (1504) is textbook Renaissance, and Bernini's *David* (1623) is the epitome of Baroque.

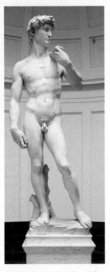

Donatello, **David,** 1430 (Bargello Museum, Florence).

Michelangelo, **David,** 1504 (Accademia Gallery, Florence).

Bernini, **David,** 1623 (Borghese Museum, Rome).

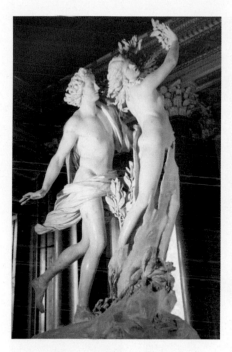

Bernini, **Apollo and Daphne,** 1625
(Borghese Museum, Rome).
*Bernini captures the exciting moment when
Apollo thinks he's caught the nymph Daphne.
But just as he's ready to pounce, she turns into a
tree—her fingers sprout leaves, her feet sprout
roots, and Apollo is in for one rude surprise.*

altarpieces, from pious devotion to rough sex.

Rubens was welcomed at every royal court in Catholic Europe. In his long career, he was famous, wealthy, well-traveled—an artist, diplomat, man about town, and friend of kings and princes. In his 50s, he got a second wind by marrying Hélène Fourment, a dimpled girl of 16. Her sweet face and ample proportions clearly inspired him, since he used her as a model for many of his classical goddesses.

An expert of composition, Rubens could arrange a pig pile of many figures into a harmonious unit. Each painting was powered with an energy that people called his "fury of the brush." Rubens turns the wind machine on

in strict Counter-Reformation times, there was always a place for groping, if the subject matter had a moral. And, besides, Bernini tends to show a lot of skin, but no genitals.

Peter Paul Rubens

Bernini's painting counterpart was Peter Paul Rubens (1577–1640), from Catholic Flanders (today's Belgium). Rubens studied in Rome, where he picked up the Italian fad of painting giant compositions on huge canvases. Rubens' work runs the gamut, from realistic portraits to lounging nudes, Greek myths to Catholic

Rubens, **The Three Graces** (detail), 1639
(Prado Museum, Madrid).
Rubens loved cellulite, especially that of his teenage wife (left), whose dimpled charm appears in many paintings.

Rubens, **The Rape of the Daughters of Leucippus,** c. 1618 (Alte Pinakothek, Munich).
Here you see typical elements of Rubens' work: fleshiness, emotion, action, bright colors, and a classi-
cal subject. The legendary twins Castor and Pollux crash a wedding and steal the brides as their own.
The chaos of flailing limbs and rearing horses is all held together in a subtle X-shaped composition.
Compare this Baroque vibrancy to the Renaissance composure of a Raphael Madonna-and-Child or
Leonardo's Mona Lisa.

high, and scenes ripple with motion, from the windblown clothes to steroid-juiced muscles to billowing flags under a troubled sky.

Rubens painted anything that would raise your pulse: battles, miracles, hunts, rapes, and, especially, fleshy "Rubenesque" women with

dimples on all four cheeks. But can we be sure it's Baroque? Ah yes, you'll find a few pudgy winged babies fluttering here and there.

In Rubens' work, everything is on a larger-than-life scale. Many canvases virtually fill entire walls, and you can see the seams where they stitched the

cloth pieces together.

How could he paint so many enormous canvases in one lifetime? He didn't. His Antwerp house (now a fine museum) was an art factory, designed to mass-produce masterpieces. After he laid out a painting, his apprentices worked from Rubens' sketches, painting the background and filling in the minor details. Rubens orchestrated the production from a balcony, and before a painting was carried outside his tall, narrow door, he would put on the finishing touches, whipping each figure to life with a flick of his furious brush.

Caravaggio

Michelangelo Merisi da Caravaggio shocked the art world with his ultra-realistic paintings. As we've seen, Baroque took reality and exaggerated it. While most artists amplified the prettiness, Caravaggio stressed the grittiness. Caravaggio's paintings look like a wet dog smells. Reality.

Caravaggio (kah-rah-VAH-jee-oh, 1573–1610) lived much of his life on the edge of society. Quick-tempered and opinionated, he killed a man over a dispute in a tennis match and spent years as an outlaw. Twelve years after he first picked up a brush, he died of a knife wound.

You'll recognize Caravaggio's works by the strong contrast between light and dark. Caravaggio paints a dark background, then shines a dramatic spotlight on the few things that tell the story. (Remember Rembrandt? Well, Rembrandt sure remembered Caravaggio.) The light is not glorious. It's a harsh, unflattering, "third-degree interrogation" light that cuts through everything, exposing the real person underneath. Caravaggio's psychological insight brings to mind the style of his contemporary, Shakespeare, who incorporated English lowlife into his plays.

Even when Caravaggio painted religious art for churches, he pulled no punches. He hired the homeless to pose as angels and grizzled alcoholics as his saints. He set Bible scenes in the seedy Roman taverns he frequented. As Caravaggio shows, the Bible happened to real people. His Madonnas lack halos and saints have dirty feet. We've come a long way since the first medieval altarpieces that wrapped

Caravaggio, **David with the Head of Goliath,** 1605 (Kunsthistorisches Museum, Vienna).
In Caravaggio's take on this familiar Bible story, David shoves the dripping head of the slain giant right at us. The painting, bled of color, is virtually a black-and-white crime-scene photo. Out of the deep darkness shine only a few crucial details. This David is no heroic Renaissance man like Michelangelo's famous statue, but a homeless teen. And the severed head of Goliath is none other than Caravaggio himself, an in-your-face self-portrait.

holy people in gold foil. From the torn shirts to the five o'clock shadows, Caravaggio paints very human miracles.

Caravaggio's uncompromising details, emotional subjects, odd compositions, and dramatic lighting set the tone for other Baroque painters.

Diego Velázquez

You'll see plenty of royal portraits in European museums. The court painter was the official "photographer" of the day, chronicling court events.

For 35 years, Diego Velázquez (veh-LAHS-kehs, 1599–1660) was the king of Spain's court painters. He was definitely a career man. Born in Sevilla, apprenticed early on, he married the master's daughter, moved to Madrid, impressed the king with his skill, and worked his way up the ladder at the king's court. He became the king's friend and art teacher and, eventually, he was knighted.

While his fellow Baroque-era artists painted larger-than-life rapes, seductions, and Madonnas, Velázquez painted what his boss, the king, told him to—mostly portraits.

Prince Balthasar Carlos on Horseback was exactly the kind of portrait Velázquez was called on to produce. The prince, age five, was the heir to the throne. But the charm of the painting is the contrast between the pose—the traditional equestrian pose of a powerful Roman conqueror—with the fact that this "conqueror" is only a cute, tiny tyke in a pink and gold suit. The seriousness on the little prince's face adds the crowning touch.

To keep the royal egos happy (and the paychecks coming), most court paintings were unrealistic, melodra-

Velázquez, **Prince Balthasar Carlos on Horseback,** 1635 (Prado Museum, Madrid).
To keep his boss—the king—happy, Velázquez had to paint the prince looking really good on a horse.

matic, and flattering. Yet Velázquez could break out of the mold. His realistic, down-to-earth paintings offer a rare, real look at royal Europe. To fully appreciate his genius, let's take a look at his most famous painting, a behind-the-scenes peek at the painting of a portrait.

Las Meninas (The Maids of Honor)

One hot summer day in 1656, Velázquez (with brush in hand and outrageous moustache) is painting a formal portrait of the king and queen. Velázquez stares out at the people he's painting—they would be standing where we are, and we see only their reflection in the mirror at the back of the room.

Baroque Architecture

*During the Baroque age, lavish churches—such as the **Hofkirche Chapel** at the Residenz in Würzburg—seemed designed to give worshippers a glimpse of heaven.*

The flamboyance of Baroque was perfect for the Catholic Church and powerful kings who wanted to impress the masses with beautiful palaces and glorious churches. Worshippers stepped into a world of glittering gold, precious stones, corkscrew columns, Virgin Marys, bronze saints, and a ceiling painted as if it opened up to heaven itself.

Baroque architecture uses Renaissance symmetry as its skeleton. But then it's slathered and spackled with cherubs, garlands, and billowy cumulus clouds done in stone, wood, and poured plaster. Where Renaissance art featured circles, Baroque has ovals and elliptical shapes. Where Renaissance has straight lines, Baroque twists them into curlicues. Clear windows replaced medieval stained glass—the better to light up the dazzling interior. If a medieval church was being remodeled in the Baroque style, its old-school frescoes would be whitewashed over so that the new features would pop. Subtlety was out, and the wow factor ruled. Baroque art showed that God is great and so is your king.

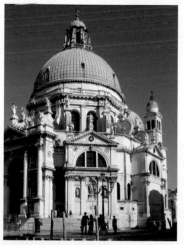

La Salute Church (Venice).

Velázquez, **Las Meninas (The Maids of Honor)**, 1656 (Prado Museum, Madrid).
Velázquez was the Spanish monarchs' official court painter. Proud and well-respected, he portrays himself (far left) on an equal footing with the royal family.

The monarchs' young daughter (the main figure in the center) watches her parents, attended by her *meninas* (girls), a female dwarf, and others in her royal posse. At that very moment, a member of court passes by the doorway in the distance, and he, too, pauses to look in on the progress of the portrait.

This is true Spanish history, frozen for posterity. Velázquez the journalist has told us more about this royal family than have volumes of history books. We're sucked right in, seemingly free to walk behind, around, and among them. This is art come to life. In fact, many art historians consider this the greatest single painting ever produced.

France:
Absolute Monarchs

In the year A.D. 497, the warrior Clovis knelt in Reims Cathedral (90 miles east of Paris) and was anointed King of France with holy oil supposedly transported from heaven by the dove of the Holy Spirit. For the next 13 centuries in an unbroken chain, this was the standard ritual for each of France's rulers—not merely crowned king but anointed by God. No wonder the French monarchs were always convinced they ruled by divine right.

By about 1500, a strong France had emerged, ruled by François I (1494–1547). Handsome, athletic François—a writer of poems, leader of knights, and lover of women—embodied the

Best Baroque Art and Architecture

- Versailles Palace, France
- St. Peter's Basilica (designed by Michelangelo, but decorated in textbook Baroque with Bernini's altar canopy, dove window, and statues), Vatican, Rome
- Il Gesù Church (with a scroll-shaped facade that was the model for Jesuit churches throughout Latin America), Rome
- Bernini's *St. Teresa in Ecstasy*, Church of Santa Maria della Vittoria, Rome
- Piazzas of Rome, especially St. Peter's Square
- Trevi Fountain, Rome
- Bernini fountains, Rome
- Hofkirche Chapel at the Residenz, Würzburg, Germany
- Schönbrunn Palace, Vienna
- Melk Abbey, Melk on Danube, Austria
- Old Town, Salzburg, Austria
- Charles Bridge and most of the Old Town, Prague (considered the best-preserved Baroque city in Central Europe), Czech Republic
- Paintings by Rubens in the Prado Museum (Madrid), Louvre Museum (Paris), National Gallery (London), and many other major museums
- Music by Bach, Haydn, Vivaldi, and Scarlatti

Nicola Salvi, **Trevi Fountain,** 1762 (Rome). *As the powerful figure of Neptune surveys his watery Baroque kingdom, tourists throw three coins in the fountain to ensure they'll return to Rome. Every year I go through this silly ritual...and it actually seems to work.*

Fake Dome, 1684 (Church of St. Ignazio, near the Pantheon, Rome). *Baroque artists were masters of illusion. This flat ceiling was painted to look like a dome from the pews.*

optimism of the Italian Renaissance. *"Le grand roi François"* centralized the government around his charismatic self and ruled the largest, wealthiest, and most populous nation in Europe. He rebuilt Paris from a medieval town of narrow lanes and ramshackle houses into a world-class capital. François adopted the "royal we" and affirmed his absolute right to rule every time he ordered something done, uttering his famous tag line: "For such is our pleasure!"

François I, King of France

Louis XIV, Master of Control

France's Louis XIV was Europe's king of kings, the absolute example of an absolute monarch. Louis ruled for 70 years (1643–1715), making France the political and cultural heartbeat of Europe. He strengthened the military, expanded France's borders, stimulated trade, and built a large and effective government.

Louis was a true Renaissance man, a century after the Renaissance. Although he was neither tall (5' 5") nor handsome, he seemed to strike people as both. He was charming, a great conversationalist, an excellent horseman, and an art lover. He played the guitar (acoustic) and loved ballroom dancing. He was perhaps the most polite king ever, listening closely to his subjects, putting commoners at ease with a joke, and tipping his hat to everyone

on the street.

The France that Louis inherited was the strongest nation in Europe, with 18 million people. (England had 5 million.) The economy, directed by Minister Colbert—the first man to take a balance sheet seriously—was healthy at home and growing, thanks to a large merchant marine and trade with the luxurious East and West Indies. Louis' well-organized tax-collectors kept the coffers full.

Louis was a hands-on king who personally ran affairs of state. All

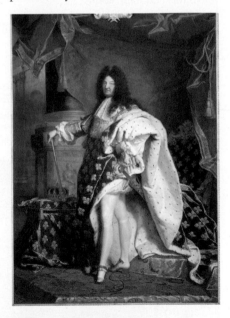

Hyacinthe Rigaud, **Louis XIV,** 1701 (Louvre Museum, Paris).
Louis XIV, who called himself the "Sun King," was every king's role model. He was Europe's leading power as a "divine monarch" throughout his long life and, even as an old man, looked good in tights.

decisions were made by him. Nobles, who in other countries were the center of power, became virtual slaves dependent on Louis XIV's generosity. For almost three-quarters of a century, he was the perfect embodiment of the absolute monarch. He summed it up best himself with his famous rhyme, "L'état, c'est moi!" (lay-tah say mwah): "The state, that's me!"

Versailles:
Europe's Palace of Palaces

Louis moved his court to Versailles, 12 miles outside Paris. There he built Europe's greatest palace, at the cost of six months' worth of the entire income of France. Swamps were filled in, hills were moved, and a river was rerouted to power the fountains—all to give Louis a palace fit for a divine king. The enormous palace was decorated in Baroque style, with chandeliers, tapestries, parquet floors, gold leaf, and

paintings on the ceilings. Outside, the manicured gardens stretched as far as the eye could see, dotted with fountains and studded with statues. The magnificent court at Versailles (the Oz and Hollywood of Europe) attracted the leading artists, thinkers, and nobles of the day. During the century that Versailles was France's capital (1682–1789), it was also the social, cultural, and intellectual capital of Europe.

At the center of it all was Louis XIV. Louis called himself the "Sun King," because he gave life and warmth to all that he touched. Versailles was the personal temple of this god on earth, decorated with statues and symbols of Apollo, the Greek god of the sun. State medallions showed the light and warmth of the sun bouncing off Louis' chest onto the people of France.

The palace today is certainly grand, but think of what we don't

Versailles
If you claim to be divinely ordained to rule your people as a god on earth, you'd better have a big house.

The Hall of Mirrors at Versailles

No one had ever seen anything like this hall when it was opened. Mirrors were still a great luxury at the time, and the number and size of these monsters were astounding. The hall is almost 250 feet long. There are 17 arched mirrors, matched by 17 windows reflecting a breathtaking view of the gardens.

Imagine dancing under candlelit chandeliers to a string quartet. At the far end of the room sits the king, on a canopied throne. Servants glide by with drinks and finger foods. Elegant guests wear heavy makeup, wigs, silk stockings, high heels, and fake moles...and that's just the men. They carry snuffboxes with dirty pictures on the lid. Ladies giggle and flirt. And everyone carries a mask on a stick to change identity in a second.

The mirrors reflect an age when beautiful people loved to look at themselves. It was no longer a sin to be proud of good looks and fine clothes, or to enjoy the good things in life: laughing, dancing, eating, drinking, flirting, and watching the sun set into the distant canal.

Versailles allowed the perfect escape from life's harsh realities. Even in his choice of art, Louis preferred the pretty pictures of Baroque to the naturalism of the Dutch and Flemish masters.

The Hall holds lots of history. In 1871, after the Prussians defeated the French, Otto von Bismarck declared the establishment of the German Empire in this room. And in 1919, Germany and the Allies signed the Treaty of Versailles, ending World War I (and, some say, starting World War II) right here, in the Hall of Mirrors.

This is where France's beautiful people partied. Pass the Fromage-Whiz.

see: the zoo with exotic animals in cages; the 1,500 fountains (only 300 remain); the works by Leonardo, Raphael, Titian, Rubens, and Caravaggio (now in the Louvre) that hung in halls and bedrooms; the gondolas with Venetian gondoliers poling along the canals at night, accompanied by barges with musicians; and the grand halls lit by a galaxy of candles for a ball.

There were as many as 5,000 nobles here at any one time, each with an entourage. They would buzz from games to parties to amorous rendezvous in sedan chair taxis. Servants ran about delivering secret messages and roast legs of lamb. Horse-drawn carriages clattered through the fancy gate with VIPs from all over Europe. Incredible as it seems, both the grounds and most of the palace were public terri

Bernini, **Bust of Louis XIV,** 1665 (Versailles).
"If Louis XIV had not existed, it would have been necessary to invent him."
—Voltaire

tory, where even the lowliest peasant could come to gawk (so long as they followed a dress code). Then, as now, there were hordes of tourists, pickpockets, palace workers, and men selling wind-up children's toys.

Louis' move from Paris to Versailles was partly personal –he loved the outdoors—and partly political. In order to rule with absolute power, he "domesticated" his nobles by reducing them to petty socialites. Once-powerful nobles were now obsolete in France's modern, centralized bureaucracy. They survived on favors from the king: pensions, military and church appointments, and arranged marriages. If Louis didn't look at you for weeks on end, you knew you had to seek an audience with him and apologize with many tears and much hugging of the royal knees. (Compare 17th-century France with England, where they'd just beheaded their king.)

Games were an important part of Louis' political strategy. By distracting the nobles with the pleasures of courtly life, he was free to run the government his way. Billiards was popular. Louis was a good pool player, a sore loser, and, as king—he rarely lost.

Every night, there was a dance, a concert, or you could catch the comic playwright Molière on stage, starring in one of his own plays. But the biggest distraction was gambling, usually a card game similar to blackjack. Louis lent money to the losers, making them even more indebted to him. The good life was an addiction, and Louis kept the medicine cabinet well-stocked.

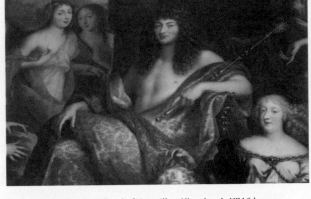

In the aristocratic la-la land of Versailles, **King Louis XIV** "domesticated" France's nobility. By reducing a ruling class to socialites, he cleverly and effectively rendered them impotent, removing any threat they could pose to his rule.

Louis' life was a work of art, and Versailles was the display case. Everything he did was a public event designed to show his subjects how it should be done. In the morning, the Sun King would rise from his canopied bed to symbolically warm his subjects. Nobles would look on in awe of his piety, nobility, and clean socks. At breakfast, they murmured with delight as he deftly decapitated his boiled egg with a knife. At dinner, servants and nobles laughed at the king's jokes like courtly Ed McMahons. A typical dinner consisted of four different soups, two whole birds stuffed with truffles, mutton, ham slices, fruit, pastries, compotes, and preserves. And when Louis went to bed at night, the once-mighty dukes and barons would fight over who got to hold the candle while he slipped into his royal jammies.

Versailles set the tone for Europe's high fashion. Men shaved their beards and put on stockings and silk clothes. When Louis started to go bald, big, curly wigs became the rage. A contemporary wrote, "It was possible to tell the women from the men only when it was time to go to bed."

One of the "fashions" was adultery, an accepted, almost obligatory social ritual. Louis himself was a playboy king who hunted animals by day and chased beautiful women at night. There was no attempt to hide the fact that the Sun King warmed more than one bed, for he was above the rules of mere mortals. Still, he remained faithful to the institution of marriage itself and fulfilled his obligation to the queen, Marie-Therese of Spain, by sleeping with her every night (after a rendezvous with one of his other lovers).

Unfortunately, "Louis *Quatorze* was addicted to wars," using France's military might to expand the nation's borders. His success made other countries jealous and nervous. Eventually, Holland, Spain, and Germany ganged up on Louis XIV. By the end of the Sun King's long life, he was tired of fighting. On his deathbed, he advised his

The Gardens of Versailles: Controlling Nature

The grounds surrounding the palace of Versailles are a sculptured forest and a king's playground. The gardens proved that the king, a divine-right ruler, could control nature like a god. The warmth from the Sun King was so great that he could even grow orange trees in chilly France. Kept in greenhouses, the trees were wheeled out on sunny days and scattered around the grounds. French people were proud to be ruled by the

The French king wowed his visitors with an orange grove on wheels. Controlling nature, only he could grow tropical plants just outside Paris.

only king who could sip an Orange Julius in the dead of winter.

The grounds seem to stretch out forever. Versailles was laid out along an eight-mile axis, one of the first instances of urban planning since Roman times and a model for future capitals, such as Washington, D.C. and Brasília. The grounds form an elaborate grid, planted with exotic trees, and dotted with other palaces, statues, fountains, and prefab Roman ruins.

The fountains were its most famous attraction, a marvel of both art and engineering. The centerpiece fountain showed the Sun God—Louis XIV—in his sunny chariot pulled by half-submerged horses, rising out of the mists of dawn. Most of the fountains were only turned on when the king walked by, but this one played constantly for the benefit of those watching from the palace. The fountains are gravity-powered. They work on the same principle as blocking a hose with your finger to make it squirt. Underground streams (pumped into Versailles by Seine River pressure) feed into smaller pipes at the fountains, which shoot the water high into the air.

Le Hameau (hiding in the gardens of Versailles) allowed poor little rich girls like Queen Marie-Antoinette an escape from the rigors of palace life. Here she could pretend she was a peasant girl, tending her perfumed sheep and manicured garden.

five-year-old great-grandson (the future Louis XV) to "be a peaceful king." "Don't imitate my extravagance," he said. "Alleviate the suffering of your people and do all the things I was unfortunate enough not to do."

Fourteen, Fifteen, Sixteen...

Three kings lived in Versailles during its century of glory. Louis XIV built it and made France dominant. Louis XV carried on the tradition, but France's power abroad was weakening, and there were rumblings of rebellion from within. Louis XVI was France's final Old Regime king, who lost his head during the Revolution. His predecessor both brought on and foresaw the impending danger.

Louis XV (r. 1715–1774) was just a tyke when crowned, and even when he grew up, he relied heavily on the advice of bureaucrats and his shrewd mistresses (such as Madame de Pompadour). He spent his time at Versailles, partying with Europe's beautiful people. Meanwhile, France's money was spent on costly wars abroad, including the French and Indian War in America. Louis looked to the horizon and uttered his prophetic phrase: *"Après moi—le déluge!"* ("After me—the flood!")

With a flood watch in effect, Louis XVI (r. 1774–1792), a shy bookworm, stubbornly clung to the rules of the Old Regime (the traditional chessboard society with king on top, pawns on bottom, and bishops

that walk diagonally). While peasants groaned in the fields, the rich enjoyed their mansions, parties, and dangerous liaisons. Louis and his bride, Marie-Antoinette, retreated into the idyllic gardens of Versailles while Revolutionary fires smoldered.

Other Absolute Monarchs

In the 1700s, France dominated Europe. Everyone who was anyone spoke French. The French set the tone in fashion, manners, and kissing. The three Louises were every king's role model. Every nation had its "Louis" and its own "Versailles." As you travel, you'll notice that most palaces, from La Granja in Spain to Peter the Great's Peterhof outside St. Petersburg, are modeled after Versailles with sculpted gardens and Halls of Mirrors. All of them try to match the splendor of the original, but none succeeds.

In Prussia (eastern Germany), King Frederick William copied France's centralized government and turned his loose collection of baronies into a monolithic European power. The

Royal Palace (Madrid).
In the 18th century, Spain was ruled by the French Bourbon family. Spain's King Philip V, the grandson of Louis XIV, was born in Versailles and spoke French. Homesick, he ordered this palace built as his own Versailles. It's big—more than 2,000 rooms, with tons of luxurious tapestries, a king's ransom of chandeliers, priceless porcelain, and bronze decor covered in gold leaf.

Palaces of the Divine and Absolute Monarchs

- Versailles, near Paris
- Schönbrunn Palace, outer Vienna
- Hofburg (Imperial Palace), downtown Vienna
- Royal Palace, downtown Madrid
- La Granja, near Madrid
- Residenz of the Prince Bishop, Würzburg, Germany
- Residenz, Munich
- Frederiksborg Slot, north of Copenhagen, Denmark
- Drottningholm, Stockholm, Sweden
- Peterhof, near St. Petersburg, Russia
- Versailles copycats such as Chenonceau in the Loire Valley (pictured below) and the châteaux of Vaux-le-Vicomte, Fontainebleau, and Chantilly near Paris

"Stop yawning! This is Baroque."
"But Dad, after a while, broke palaces all look alike."

Château of Chenonceau (Loire Valley, France).
The toast of France's Loire Valley, this 16th-century Renaissance palace arches gracefully over the Cher River. While earlier châteaux (or "castles") were built for defensive purposes, Chenonceau was the first great luxury palace—begun by François I and expanded by his successors.

"goose step" and Germany's strong military tradition came from Prussia.

Only Austria's impressive Schönbrunn Palace rivals Versailles. This summer residence of the Hapsburgs is located just outside Vienna.

The Hapsburgs of Austria

One family in Europe rivaled France's ruling dynasty: the Hapsburgs of Austria. Since the Middle Ages, the Hapsburgs had dominated Austria, much of Germany, and northern Italy. Initially calling themselves "Holy Roman Emperors" (to evoke the greatness of their ancestor, Charlemagne), they meticulously patched together one of the largest and most successful empires in all of European history. The Hapsburg management style was to make love, not war: They married their kids off to other ruling families, gaining power through international connections.

Emperor Maximilian I (1459–1519) put the Hapsburgs on Europe's fast track. He was a dynamic, larger-than-life Renaissance man—soldier, sculp-

tor, and statesman—but his biggest conquest came with a trip to the altar. His marriage to Mary of Burgundy wed two kingdoms together, and their grandson, Charles V, inherited a huge empire that included most of the German- and Spanish-speaking world. (For more on Charles V, see page 245.) When Charles retired, the sprawling kingdom was split east and west. From then on, Austria's rulers were content ruling their eastern empire. (The German name for Austria—Österreich—literally means "Empire of the East.")

As staunch Catholics, the Hapsburgs were at the leading edge of the Counter-Reformation, aggressively converting their subjects from the Baltics to the Adriatic. Located on Europe's eastern front, the Hapsburgs were also responsible for defending the Continent from attacking Muslims. Starting in the 14th century, invaders from the Ottoman Empire pushed gradually northward, laying siege to city after city as they came to control most of southeast Europe. By the 16th century, the Hapsburgs' only

Schönbrunn Palace (Vienna).
The Hapsburgs ruled a vast empire from this palace, a Versailles knock-off.

serious rival in Central Europe—Hungary—had been mostly overtaken by the Ottomans, compelling the Hungarians to relinquish their independence and put their fate in the Hapsburgs' hands.

In 1683, 200,000 Ottomans surrounded the Hapsburg capital, Vienna. The Ottomans were driven off, and in their hasty retreat they left behind bags full of exotic coffee beans, which helped fuel a beverage craze around Europe. Vienna's first coffeehouse opened (eventually followed by a Starbucks across the street).

Within a century, the Hapsburgs forced the Ottomans almost entirely out of Europe. (A few pockets of Turkish influence survived, such as in Bosnia-Herzegovina, which explains why there are still Muslims there today.) The Hapsburgs now controlled a vast swath of Central and Eastern Europe, including today's Austria, Hungary, the Czech Republic, Slovakia, Slovenia, and parts of Poland, Croatia, Bosnia-Herzegovina, Serbia, Romania, and Italy (Venice).

Vienna flourished, amassing a collection of fine art and monumental architecture to rival Louis XIV's (Vienna has been called the "Paris of the East"). While German was the official language, the Hapsburg Empire was surprisingly multiethnic and multilingual. During the Hapsburg era, native peasants (speaking their original languages, i.e., Czech, Polish, Hungarian, etc.) tended to live in the countryside, while German-speaking bureaucrats and businessmen populated the cities. As in any empire, roads were built to connect far-flung holdings.

Maria Theresa (r. 1740–1765) oversaw the peak of the Hapsburg Empire. Her rival, the Prussian emperor, said, "When at last the Hapsburgs get a great man, it's a woman." She (and her even more progressive son, Josef II, who ruled after her) taxed the church and the nobility and provided six years of obligatory education to all children and free health care to all in her realm. Maria Theresa's daughter, Marie Antoinette, wed Louis XVI of France. Though Marie lost her head in Paris, Maria Theresa's enlightened policies back in Vienna helped Austria slip through the "age of revolution" without turmoil.

Musical Vienna

Perhaps the greatest Hapsburg legacy is music. Vienna was to music what Athens was to sculpture, Florence to painting, and Milwaukee to beer. Maria Theresa welcomed the boy genius Mozart into her court, and her successors established Vienna as the music capital of Europe. At one point, "Papa" Haydn (so-called for his fatherly ways with young musicians) worked with Mozart, whose rival was Antonio Salieri, who gave lessons to Beethoven. A generation later, there were Schumann, Brahms, and Liszt. With so many talented people rubbing oboes, it's no wonder that Vienna changed music forever, raising it from simple entertainment to High Art.

Why Vienna? A walk through the city partly explains it. The peaceful gardens, the architecture, and the surrounding countryside inspired the composers. Beethoven was a familiar sight, striding through the streets, his hands behind his back, with a brooding

look on his face. He claimed he did his best composing away from the piano.

But the true root of all musical inspiration in Vienna was (as is usually the case) money. The Hapsburg aristocracy found music more interesting than politics. Empress Maria Theresa was a noted soprano, and her son Josef II played both violin and cello. Concerts were the social hub of high society. The leading families employed their own orchestras to play at their parties. Musicians from all over Europe flocked to Vienna in order to perform, conduct, compose, and give lessons. And they received honor unheard of back home.

Before 1750, music had been considered a common craft, like shoemaking, and musicians were treated accordingly. Composers wrote music to order, expecting it to be treated like Kleenex—used once, then thrown away.

Beginning with Haydn, however, the new breed of composers

Wolfgang Amadeus Mozart—who recently turned 250 years old—remains big business in Vienna and Salzburg.

saw music as a lasting art on par with painting and sculpture. Composers demanded respect from their employers. When Mozart became composer-in-residence for a Viennese prince, he was paid a princely sum and then told to eat his meals with the servants. Mozart turned on his heel and walked out, refusing from then on to accept an official position. Beethoven, it is said, considered himself to be superior to his employers: He was an artist; they were merely royalty.

Mozart (1756–1791) was adored as a cute, clever six-year-old who could play the harpsichord as well as anyone in Europe. As a boy genius, he performed far and wide. It's said Wolfgang had his cheeks kissed by more queens than anyone in history.

But as a grown man writing mature and difficult works, Mozart was neglected and often maligned. Vienna tended to fawn over its composers... but only as long as they cranked out pleasant tunes. The minute they tried something new, daring, or difficult, the public turned on them. When Mozart died, broke, at 35, his body was buried in an unmarked grave. Only later was his genius fully appreciated and a statue erected to honor him. As the saying goes, "To be popular in Vienna, it helps to be dead."

Beethoven (1770–1827), like Michelangelo before him, played the role of the temperamental genius to the hilt. His music and personality were uncompromising. A bachelor, he lived in rented rooms all his life—69 different ones at last count. He had some bad habits that explain his migratory existence, such as playing the piano at 2:00 a.m. and pouring

Stieler, **Ludwig van Beethoven,** 1819
(Beethoven House, Bonn, Germany).
Dut-dut-dut Dah-h-h-h. Dut-dut-dut Dah-h-h-h.

buckets of water on himself to cool off. His rooms were always a mess, with music, uneaten meals, and atonal chamber pots strewn about. But he was recognized in his own lifetime as a genius.

Today, Vienna clings to its elegant past and maintains much of its musical tradition. Rather than royalty, the Ministry of Culture and Education is the new patron. The State Opera, the Philharmonic Orchestra, the Vienna Boys' Choir, and the Society of Friends of Music still thrive as they did in Beethoven's time, and statues of many of the famous composers who were neglected in their day are now displayed proudly. If you dial 1509 on a telephone

in Vienna, you'll hear a perfect A note (440 Hz)—for tuning your instrument.

Rococo:
Uncontrolled Exuberance

The art of Louis XV and of all of those Versailles knock-offs was called Rococo (roh-KOH-koh). Like its Baroque predecessor, it's highly ornamented. But Rococo is like Baroque that got shrunk in the wash—lighter, frillier, and more delicate, with pastel colors.

Buildings are decorated with slender columns, ivory, gold, and mirrors. Where Baroque used oval shapes, Rococo twists it even further into medallions and curvy cartouches. Everything glows in whitewash, pastel pinks, and greens. Rococo captures the sensual world of the decadent French court. In paintings, we see their rosy-cheeked portraits and their fantasies: lords and ladies at play in classical gardens where mortals and gods cavort together.

In the world of music, opera was born. An opera is a sung play. It's a multimedia event, blending music, words, story, costume, and set design.

Boucher: Textbook Rococo.

Wies Church, 1745–1754 (Bavaria, Germany).
Rococo-nuts flock to this opulent church in a cow pasture.

Europeans especially loved Italian opera. The musical trills and lightweight plots captured the period's libertine ways and *joie de vivre*.

Wies Church

Perhaps the best single example of Rococo architecture is the Wies Church in Bavaria. This "Church in the Meadow" still looks as brilliant as the day it floated down from heaven. Overripe with decoration but bright and bursting with beauty, this church is a divine droplet, a curly curlicue... enthusiastically Rococo.

The ornate church, located south of Munich, is built around a crude wooden statue of Christ being whipped. No sooner was the statue made (1738), than it miraculously began to shed tears. Amazed pilgrims came from all around. They, too, wept and were miraculously healed. The statue became a celebrity, pilgrims donated lots of money, and two of Bavaria's top Rococo architects (the Zimmermann brothers) were hired to give the statue a proper home.

The decor looks like it came out of a heavenly spray can. The walls are whitewashed, and clear windows flood the church with light. The rest is a riot of corkscrew columns, pink tones, gold leaf, and a painting on the ceiling that seems to open up to heaven. Overseeing it all is Jesus Christ riding on a rainbow, with a smile on his face. A priest here once told me that faith, architecture, light, and music all combine to create the harmony of the Wies Church.

The Age of Enlightenment

The scientific experimentation begun in the Middle Ages and the Renaissance finally bloomed in the Age of Enlightenment. Copernicus (born 1473), Galileo (b. 1564), Johannes Kepler (b. 1571), and Isaac Newton (b. 1642) explained the solar system, disproving the church's view that the earth was the center of the universe. These discoveries suggested that the world operates in an orderly, rational way. Newton was able to explain the motion of the entire universe—from spinning planets to rolling rocks—with the simplest of formulas ($f = ma$; force equals mass times acceleration).

The scientific method was seen as a way to solve all problems, even moral and political ones. The philosophers

Isaac Newton

Galileo Galilei

Galileo Galilei (1564–1642) is known as the father of modern science. His ideas in the 1600s helped launch the Age of Enlightenment in the next century. He was among the first to blend mathematics with hands-on observation of nature to find practical applications.

Galileo was the first earthling to see the moons of Jupiter, using a homemade telescope. This discovery irked the Church, which insisted that only earth had a satellite. Legend has it that Galileo dropped cannonballs from the Leaning Tower of Pisa to see whether heavier objects fall faster than lighter ones, as Church scholars believed. (In fact, Galileo probably did the experiments in his lab.) What Galileo found is that—if you discount air resistance—a feather will fall at the same speed as a cannonball. The Church didn't like that, either.

Galileo Galilei

Finally, Galileo popularized the Copernican belief that the earth orbits around the sun. At the age of 70, Galileo was hauled before the Inquisition and forced to kneel and publicly proclaim that the earth did not move around the sun. As he walked away, legend has it, he whispered to his followers, "But it does move!"

His adoring students preserved his finger bone, now displayed in a jar in Florence's Science Museum, as a kind of sacred relic. Galileo's beliefs eventually triumphed over the Inquisition, and, appropriately, we have his middle finger raised upward for all those blind to science.

of the Enlightenment (roughly the 1700s) put every institution and every established school of thought to the test of reason. Superstition and ignorance were attacked. The Old Regime of divine monarchs, feudalism, and serfdom was picked to pieces. Thinkers and writers proposed a complete reorganization of society determined by reason, not by accident of birth. A kind of "religion of reason"

was created, and for the first time, many people—respected people—said, "Christianity is stupid."

In politics, the Frenchman Jean-Jacques Rousseau wrote that a government is no more than a "social contract" between the rulers and the ruled. If the government breaks that unspoken agreement by misrule, the people are justified in throwing the scoundrels out. John Locke and Voltaire wrote of

"natural laws" and "self-evident truths" in human relationships that make necessary a more democratic form of government. Many of these exact phrases (such as "life, liberty...") found their way into the US Declaration of Independence, a document based on the ideals of the Enlightenment. Despite owning slaves, Thomas Jefferson prided himself on being a part of this enlightened movement.

The kings of this period are called "enlightened despots." They ruled efficient, modern states and supported many ideas of the Enlightenment. Even at Versailles, the king and queen hosted salons where Voltaire and other political radicals shocked and titillated the nobility with scandalous talk. Ironically, this parlor chat planted the seeds of liberal thought that would grow into the Revolution. Europe was fast outgrowing its archaic shell. Enlight-

ened thoughts soon turned to violent actions.

The Old Regime and the New Reality

On July 4, 1776, American colonists announced a Declaration of Independence from Britain's King George III. They fought a Revolutionary War and eventually won their freedom. The Enlightenment ideas of a constitution based on democracy, freedom of religion, and protection of individual rights were put to the test...and proven to work. Europe's enlightened radicals took notes.

Meanwhile in Europe, effete aristocrats continued their lives of luxury, oblivious to the world changing around them. The wealthy donned their buckled shoes and eau de cologne and partied at Versailles or Schönbrunn. They vacationed in Venice, donning masks

Louis Le Nain, **Peasant Family in an Interior,** c. 1642 (Louvre Museum, Paris).

for anonymity at the brothels and casinos.

At aristocratic coffee klatches, the talk was all about democracy and enlightened ideas, but in reality the nobles refused to share power with the lower classes. Peasants toiling in the fields lived as virtual serfs, their lives unchanged since the Dark Ages. The growing urban middle class, often as wealthy and educated as the nobility, wanted more power. But the Old Regime lived on, and people were divided by birth, not by ability or wealth, into the rulers and the ruled. The pot simmered.

The French Revolution

The decay of France's Old Regime made especially fertile conditions for the seeds planted by the Enlightenment to grow. While the three-part feudal order of nobility, clergy, and peasantry survived legally, it no longer fit the European reality. Two percent of the country—the nobles and clergy—owned one-third of the land and paid no taxes. Meanwhile, there was a strong new class of Europeans—the middle class, or bourgeoisie—that was rich, educated, and ambitious, but had no say-so in government. France was ripe for revolt.

The National Assembly

The restless middle class got its chance in 1789 when King Louis XVI (the Sun King's great-great-great-grandson) called an assembly of representatives to raise funds. Ironically, France's money-crunch came because Louis had spent it all financing the American Revolution (not as a lover of democracy, but as a hater of England). Louis expected

Jacques-Louis David, **Oath of the Tennis Court,** 1791 (Louvre Museum, Paris).
After King Louis XVI refused to let the National Assembly convene in an official venue, they met at an indoor tennis court instead, volleyed new ideas about...and democracy in Europe began.

just the usual rubber stamp, but what he got was a taste of Enlightenment-style democracy.

As usual, the parliament met as three estates, or classes: nobility, clergy, and peasants. But the Third Estate of so-called peasants (formerly poor dumb farmers) now included the powerful and savvy middle class. In a bold and unheard-of move, the Third Estate, tired of being outvoted by the clergy and nobility, split and formed their own National Assembly. Amid the chaos of speeches, debate, and deal-making, they raised their hands, bravely pledging to stick together until a new constitution was written.

The Storming of the Bastille (Carnavalet Museum, Paris).

This was a revolutionary step. The king ordered the Assembly to dissolve, but they said *"Non."* When the king mobilized 25,000 troops in response, the masses felt betrayed. Traditionally, the king had been seen as the people's friend.

The National Assembly became a forum for all kinds of democratic ideas. They set about abolishing Church privileges, nationalizing nobles' land, and declaring the king irrelevant. The privileged classes protested feebly as the common people shouted, *"Liberté, Egalité, Fraternité."* This cry for "Liberty, Equality, Brotherhood" would soon be backed up with violence.

The Bastille

On a hot and muggy 14th of July, 1789, a mob of angry Parisians gathered around the Bastille. This stark prison, with its towers and 100-foot-high walls, dominated the Parisian skyline, a symbol of Old Regime oppression.

Two citizens managed to scale the walls and cut some chains, and the drawbridge crashed down. The mob poured through and terrified guards opened fire, killing dozens and wounding hundreds. At the battle's peak, more French soldiers appeared on the horizon...but whose side were they on? A loud cheer went up as they pointed their cannons at the Bastille and the prison surrendered. The mob opened the dark dungeons and brought seven prisoners into the light of day. The crowd then stormed City Hall (Hôtel de Ville) and arrested the mayor, who was literally torn apart. His head was stuck on a stick and carried through the city. The Revolution had begun.

The small but pivotal victory became a rallying cry throughout the Revolution: *"Vive le quatorze juillet!"* ("Long live July 14th!") The Bastille itself was soon dismantled, stone

by stone, and now nothing remains but the open space of Place de la Bastille. Today, the events of July 14 are celebrated in France every Bastille Day.

Mass Revolution

Like most revolutions, the French one started moderately and then got immoderate in a hurry. Before they knew it, even the instigators of Revolution—the prosperous and liberal middle class—were riding out of control on a lower-class stallion.

The head (left) of King Louis XVI (right).

The Bastille's violence spread to the countryside. Uppity peasants tenderized their masters with pitchforks, sacked luxurious châteaux, rousted the nobility, and burned the feudal documents that tied them to the land. The manorial system (serfdom) was physically destroyed.

Back in Paris, the masses were hungry and restless, and the price of bread was very high because of several bad harvests. Traditionally, France had subsidized the price to keep the people docile (as authoritarian regimes still do today). The poor called for bread. A rumor spread (probably false) that Queen Marie-Antoinette then sneered, "Let them eat cake!" ("Cake" was the burnt crusts peeled off the oven and generally fed only to the cattle.)

Enraged and hungry, 6,000 Parisian women (backed by armed men) marched through the rain to Versailles. During the night of October 5, 1789, a small band infiltrated the palace. King Louis XVI and Marie-Antoinette were cornered and arrested, then taken to Paris as enemies of the state. Some claim that, as they were carried off, Marie sang, "Louis, Louis, oh-oh...we gotta go now."

Power to the People

Imagine the jubilation! To finally be able to shout out things formerly whispered in fear. Members of every social class mingled in the streets and public squares. In Notre-Dame, a woman dressed up like the Statue of Liberty was worshipped as a symbol of the new secular religion of democracy. The common rabble partied while monarchs, bishops, and nobles—now quarantined in their palaces—fumed impotently.

The National Assembly was the de facto ruler of France. Day after day, new laws tore down the old order: abolishing serfdom, protecting free speech, confiscating the ill-gotten gains of the rich, and so on. A priority was abolishing medieval-style torture

and executions. The Assembly voted for a kinder, gentler execution device that would make France a model of compassion, namely a proposal from one Dr. Joseph Guillotin. His namesake, also known as "the national razor" or simply "the machine," could instantly make someone "a head shorter at the top."

On January 21, 1793, King Louis XVI was led to the Place de la Concorde in Paris and laid face-down on a slab beneath the guillotine blade. Shoop! A thousand years of monarchy (dating back before Charlemagne) was decapitated. Later that year, Marie-Antoinette also met her fate. Genteel to the end, she apologized to the executioner for stepping on his foot. The blade fell, the blood gushed, and her head was held high on a pole—as the crowd cheered, "Vive la nation!"

The Reign of Terror (1793–1794)

The Revolution snowballed out of control. During this "Reign of Terror," wave after wave of people were sent to the guillotine. Many were dukes, barons, and bishops. But others were Revolutionaries themselves. Whatever political party was currently in power would accuse its enemies of insufficient patriotism and have them executed. Flags waved furiously and the masses cheered as the blade dropped on thousands of necks.

Paris' main guillotine stood on the Place de la Concorde, then known as Place de la Révolution. The gloomy prison called the Conciergerie (on Ile de la Cité) was the last stop for this guillotine's 2,780 victims. Coolly walking the halls was the executioner, known affectionately as "Monsieur de Paris." The condemned milled about, waiting for the open-air cart to rumble them down the street through jeering crowds to Place de la Concorde.

When an unlucky soul was delivered for execution, three people worked the guillotine: One managed the blade, one held the blood bucket, and one caught the head, raising it high to the roaring crowd.

The Place de la Concorde was the execution site of King Louis XVI—excuse me, "Citizen Capet," as he was now known. Anne-Elizabeth Capet was de-capet-tated for the crime of being "sister of the tyrant." The noblewoman Charlotte Corday died for sneaking into the bathroom of the Revolutionary writer, Jean-Paul Marat, and stabbing him while he bathed. The charismatic Georges Danton once drove the Revolution with his fiery speeches but was later condemned for being insufficiently liberal, a nasty crime. As he knelt under the blade, he cynically joked, "My turn."

A 3,300-year-old obelisk of Luxor marks the place where the guillotine lopped off the head of Louis XVI and nearly 3,000 enemies of the Revolution. What was called the Place de la Révolution is now the Place de la Concorde.

"La Marseillaise"

There's a movement in France to soften the lyrics of their national anthem. Sing it now...before it's too late.

Dubbed "The Marseillaise in Stone" (1836), this sculpture— decorating Paris' Arc de Triomphe—stokes the French revolutionary spirit.

La Marseillaise

Allons enfants de la Patrie,	Let's go, children of the fatherland,
Le jour de gloire est arrivé.	The day of glory has arrived.
Contre nous de la tyrannie	The blood-covered flagpole of tyranny
L'étendard sanglant est levé,	Is raised against us,
L'étendard sanglant est levé.	Is raised against us.
Entendez-vous dans	Do you hear what's happening in our
* nos campagnes*	countryside?
Mugir les féroces soldats?	The ferocious soldiers are groaning
Qui viennent jusque dans nos bras	They're coming nearly into our grasp
Egorger nos fils et nos	They're slitting the throats of our sons and
* compagnes.*	our women.
Aux armes citoyens,	Grab your weapons, citizens,
Formez vos bataillons,	Form your battalions,
Marchons, marchons,	March on, march on,
Qu'un sang impur	So that their impure blood
Abreuve nos sillons.	Will fill our trenches.

And finally—oh, the irony—there was Maximilien de Robespierre, the ranting and raving head of the Revolution, the man who sent so many to the guillotine, and who was eventually toppled, humiliated, imprisoned, and beheaded.

War with Europe

The blade that dropped on Louis XVI rattled royal teacups throughout Europe. Royalty quivered, nobility shivered, and the middle classes and peasantry drooled with delight as the French created the "Declaration of the Rights of Man and of the Citizen." Fearing a similar fate, Europe's

Old Regime acted quickly. By 1793, it was pig-pile on France, and the French were battling Britain, Spain, the Netherlands, Austria, Piedmont, and Prussia all at the same time.

The Revolutionaries relished the fight. War helped solidify their new republic by banding against a common enemy. It also allowed them to "export Revolution" and spread their enlightened gospel abroad.

France's new army was composed of ordinary citizens from a universal draft. Led by brash young citizen-officers, they marched into battle singing a stirring, bloodthirsty new song, "La Marseillaise." Even when outnumbered, the French often defeated the apathetic soldiers-for-hire they faced. France vowed to liberate all Europe from Old Regime tyranny.

France was now ruled by a low-profile government called the Directory (1795–1799). The Directory was intentionally weak, to avoid the abuses of power and slaughter of the guillotine during the Reign of Terror. Unfortunately, the Directory was too weak to successfully prosecute an all-out war. They needed a revolutionary hero...an enlightened, charismatic, dashing general...an ambitious tactician who kept his feet on the ground, his eyes on the horizon, and a hand in his shirt.

Napoleon Bonaparte

Napoleon (1769–1821) was born of humble Italian heritage on the French-owned isle of Corsica. He attended military school in Paris, where he eventually lost his Italian accent.

Napoleon's personality was as complex as his place in history. While thought of as being short, Napoleon

Scratch 'n' Sniff
In past centuries, bathing was considered unhealthy. People typically bathed once or twice a year. It's said Napoleon used a bottle of cologne a day.

was actually of average height, with a classic, intense profile. He was well-read, a good writer, and a charming conversationalist who could win friends and influence people with ease. Although he was easily flattered, he never let flattery cloud his judgment. He had few of the vices that plague world conquerors; he cared little for expensive palaces, fancy clothes, and good food and drink. He worked himself as hard as he worked others. Nevertheless, he could be cold, distant, and ruthless with his enemies.

Above all else, he was egotistical and power-hungry, convinced of his inherent right to rule others.

The Rise of Napoleon

Napoleon won fans by fighting for democracy at home and abroad. "The Little Corporal" rose quickly through the ranks, serving in Italy, Egypt, and on the streets of Paris. In 1799, Napoleon returned from Egypt to Paris to a hero's welcome. Backed by an adoring public, he dissolved the Directory, established order, and gave himself the Roman-style title of "first consul." He married a pretty socialite named Josephine and was the toast of Paris. He was 30 years old.

Once in power, Napoleon

preached revolution and democracy. Church lands were confiscated and sold, and privileged classes were abolished. But he also suspended civil liberties and ruled as a dictator.

France went on the offensive. At the head of the million-man Great Army *(La Grande Armée),* Napoleon blitzed through Germany, Austria, Italy, Spain, and the Low Countries. As a general, he was daring. He relied on top-notch officers and improvised in the field with a mobile force of independently acting armies. His personal charisma on the battlefield was said to be worth 10,000 additional men. The

Jacques-Louis David, **Napoleon Crossing the Alps,** 1800 (Louvre Museum, Paris).
"We must not leave this world without leaving traces which remind posterity of us."
—Napoleon, Emperor of France

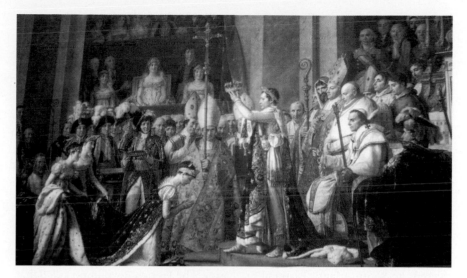

Jacques-Louis David, **The Coronation of Napoleon,** 1806–1807 (Louvre Museum, Paris). *Napoleon holds his crown while his wife Josephine kneels and his proud mom (not actually in attendance but painted in anyway) looks on from the balcony. The pope (seated behind Napoleon) came all the way from Rome to crown him. But no ordinary mortal was good enough for that job, so Napoleon crowned himself.*

French army had grown strong and tough during the wars of the Revolution, and Napoleon had no trouble conquering Europe. Soon, a grand Napoleonic Empire covered the Continent, with Paris as the "New Rome."

Everywhere he went, Napoleon toppled kings, princes, doges, and archbishops. In their place, he set up (more or less) democratic regimes. He smashed the barriers of class and privilege and opened up society to anyone with talent.

To some Europeans, Napoleon was a genius, a hero, a friend of the common people, and an enemy of oppression. (Beethoven had originally planned to dedicate his Third "Heroic" Symphony to him.) To others, he was the tyrant of his century—pompous, vain, and egotistical, imitating the very royalty he opposed.

By 1804, all of Europe was at his feet. Napoleon staged an elaborate ceremony in Notre-Dame, where he proclaimed Josephine an empress, and himself—the 35-year-old son of humble immigrants—as emperor.

Napoleon's Empire is Blown-aparte

In 1812, Napoleon led 600,000 soldiers to conquer Russia. The wily Russians retreated, destroying everything in their path, and Napoleon's army was left stranded without supplies. Then came Russia's special ally, the horribly cold winter. Napoleon was defeated, and he returned to Paris with 100,000 frostbitten survivors. The nightmares of that ill-fated invasion haunted soldiers' minds for generations.

With Napoleon reeling, all of

Europe ganged up on France. The French people took the hint, toppled Napoleon's government, and sent him on a permanent vacation to the island of Elba, off the Italian coast (1814).

As evidence of Napoleon's personal charisma, he soon returned from his exile-in-disgrace, bared his breast to the French people, and said, "Strike me down or follow me." They followed him into one last military fling. It was only after the crushing defeat by the British at Waterloo (1815) that Napoleon was finished.

Found guilty of war crimes, Napoleon was sentenced to exile on the remote South Atlantic island of St. Helena. There he played chess, talked to his dog, studied a little English, penned his memoirs, spoke his final word—"Josephine"—and died.

Napoleon's Legacy

Napoleon was the last of the enlightened despots of the Old Regime and the first of the modern popular dictators. He was a rationalist, an agnostic of the passing age of Voltaire and the Enlightenment, and the model heroic individual of the future Romantic world.

After Napoleon, France's kings returned to power (Louis XVIII). But these kings were limited by a constitution and by nagging visions of the guillotine. Knowing they'd better keep their wigs and leotards out of sight, they went to work every day like any businessmen: wearing suits and carrying briefcases.

Neoclassicism

Baroque had been the art of the Old Regime—of divine-right monarchs, powerful clergy, and landed aristocracy. The French Revolution killed that regime and its art, replacing it with a style more in tune with the Enlightenment. This new art was Neoclassical, modeled not on the aristocratic extravagance of Versailles or the Rococo excess of the Wies Church, but on the democratic simplicity of ancient Greece and Rome.

Archaeological discoveries had roused France's interest in the classical world. Pompeii, the Roman city buried by a volcano in A.D. 79, was rediscovered in 1748 and gave Europe its best look ever at Roman daily life, dress, customs, art, and architecture. Books on Roman and Greek life came into vogue. Parisian women wore Pompeiian hairdos. Artists studied ancient art, trying to capture the true Greek and Roman style. Ancient became modern, and classical was in.

In France, Neoclassical became the official style of the Revolution and the Napoleonic era. The French thought of themselves as citizens of a "New Rome" and wanted art to match. Baroque and Rococo palaces were

Napoleon's Tomb (Hotel des Invalides, Paris). *Napoleon's tomb rests in Paris beneath a golden dome.*

The Generation Gap

These two women from the 18th century could well have been mother and daughter, but their fashion choices mirror the different times they lived in. Boucher's *Madame Pompadour* is pure Rococo—opulent, playful, and light. The subject of the painting is more the dress than the woman, and the decoration nearly obliterates the form. David's *Madame Hamelin,* painted a generation later, is Neoclassical. In the age of revolution, Europe dumped its curls and ribbons for pure classical truth.

François Boucher,
Madame de Pompadour, 1756
(Alte Pinakothek, Munich).

Jacques-Louis David,
Madame Hamelin, 1800
(National Gallery, Washington, D.C.).

stripped of their raspberry-ripple frescoes and velvety wallpaper. Straightforward arches, columns, and cool colors replaced the gaudy ornamentation. Funded by the spoils of Napoleon's conquests in Europe, Paris was rebuilt and ornamented with gas lamps and new bridges. In Britain, whole cities were redone in the Georgian style—the British term for Neoclassical. Throughout Europe, but especially in Paris, today's tourists are fooled by classical-looking buildings (such as the Panthéon) that are actually Neoclassical, and thus only 200 years old.

The great painter Jacques-Louis David (dah-VEED, 1748–1825) was France's virtual dictator of fashion during this period. Marriage ceremonies, clothing styles, hairdos, and giant government propaganda spectacles were designed according to David's interpretation of Neoclassicism. He painted portraits of Paris' socialites dressed

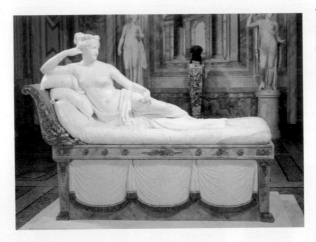

Antonio Canova, **Pauline Bonaparte as Venus,** 1808
(Borghese Gallery, Rome).
*Napoleon's sister went the full monty for the sculptor Canova,
scandalizing Europe. The mythological pose, the Roman couch, the
ancient hairdo, and the calm harmony make Pauline the epitome
of the Neoclassical style.*

The Arc de Triomphe

Napoleon started construction of the arch in 1809 in honor of his soldiers for their remarkable victory over Austria at the Battle of Austerlitz. It's obviously patterned after the ceremonial arches of ancient Roman conquerors (see page 73), but at 165 feet high, it's more than twice the size. The arch depicts Napoleon as a toga-clad emperor posing confidently before an awestruck Paris. Napoleon died prior to the Arc's completion, but it was finished in time for his 1840 funeral procession to pass underneath.

in Greek garb and Pompeii hairstyles, reclining on Roman couches. He also depicted heroic scenes from Greek history (*The Death of Socrates* and *The Oath of the Horatii*) that resonated in his own democratic times. His painting style was realistic, dignified, and simple, with clean lines and subdued colors, like a classical statue.

In America, the US Capitol and many state capitols are Neoclassical. Thomas Jefferson, a child of the Age of Reason, designed his residence, Monticello (of nickel-coin fame), in the Neoclassical style. "Enlightened" people everywhere rejected the gaudy ornamentation of Baroque in favor of austere arches and pure columns.

One of the best (and best-known) works of Neoclassicism is Paris' famous Arc de Triomphe.

Like its Roman ancestors, this arch has served as a parade gateway for triumphal armies (French or foe) and important ceremonies. In 1940, a large swastika flew from here as Nazis goose-stepped down the Champs-Elysées.

Neoclassical Architecture

- Neoclassical Room (David, Ingres), Louvre Museum, Paris
- Arc de Triomphe, Panthéon, and La Madeleine, Paris
- Royal Crescent and Circus, Bath, England
- Georgian mansions in Bath, York, Dublin, and Edinburgh
- Lutheran Cathedral and Senate Square, Helsinki, Finland

Royal Crescent (Bath, England).
In England, Neoclassical was called "Georgian," named for the kings of that age. In the 1770s, the Royal Crescent was one of several elegant Georgian row houses in the trendsetting resort town of Bath.

Helsinki's Lutheran Cathedral, *built in 1852, provided simplicity-craving Protestant Christians with a Neoclassical nirvana.*

Panthéon, 1791 (Paris).
Built during France's bold experiment in democracy and free-thinking, this was like a Greek Temple of Reason. Today, it's a secular mausoleum honoring the "Champions of French Liberty": Voltaire, Rousseau, Descartes, and others.

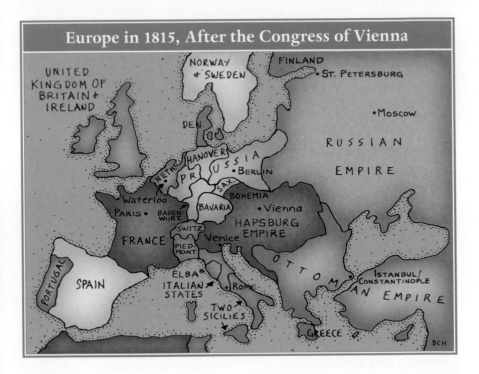

Europe in 1815, After the Congress of Vienna

In August 1944, Charles de Gaulle led Allied troops under this arch as they celebrated liberation. Today, France's national parades start or end at the Arc de Triomphe.

The Congress of Vienna
(1815)

Napoleon, steamrolling through Europe, had torn up boundaries and crushed monarchies. After his defeat, the Congress of Vienna met to put together the pieces of a broken Europe. The major powers—Austria, Russia, Prussia, Great Britain, and France—redrew national boundaries based on a dated doctrine of "legitimacy." Kings were restored and Napoleon's empire was dismantled. Austria was given new lands, and Prussia got bigger. (Watch out.)

The largest diplomatic summit of the time, the Congress of Vienna brought about a century of general peace and stability. But in many ways, they'd just turned the clock back to 18th-century time. Europe was once again owned by an elite club, mainly six ruling families: the Hapsburgs (Austria and eastward), Hanovers (Britain), Romanovs (Russia), Ottomans (Turkey), Hohenzollerns (Germany), and Bourbons (France). For the next century, this worked okay. But by the end of World War I, these families would be history.

Congratulations...

You've survived the wars, despots, and revolutions of Europe's age of kings. Next come the wars, despots, and revolutions of modern Europe.

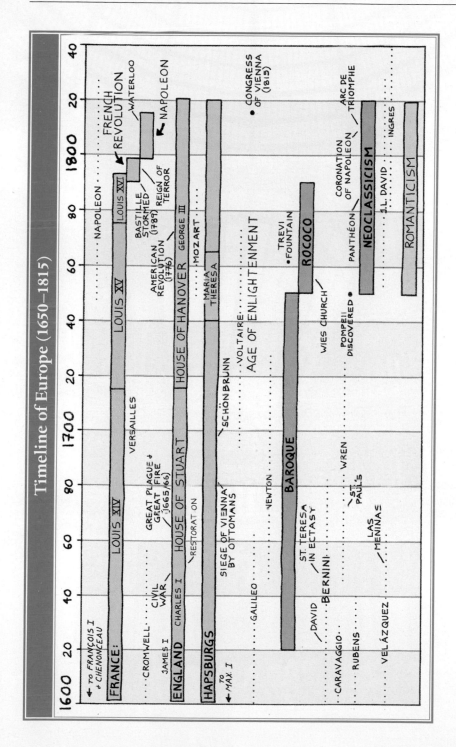

Galleria Umberto I (Naples, Italy).
In the age of iron and glass, Industrial Age architects built Europe's first grand shopping malls.

19th-Century Europe

Einstein and Geronimo. Napoleon and Karl Marx. The train, the bicycle, the horse and buggy, the automobile, and the balloon. Freud and Dickens. Darwin's *Origin of Species* and the Church's Immaculate Conception. Louis Pasteur and Billy the Kid. Beethoven and Scott Joplin.

The 19th century was a mix of old and new, side by side. Europe was entering the Industrial Age, with cities, factories, rapid transit, instant communication, and global networks. At the same time, it clung to the past with traditional, rural—almost medieval—attitudes and morals.

White-gloved duchesses waltzed the night away while bomb-throwing Socialists lurked outside. Factory workers punched the clock while Romantic poets wandered through nature, as lonely as clouds. It was the century when the Industrial Revolution and nationalism finally shattered the medieval mold of Europe.

In a sense, the 19th century—as we'll define it here—began in 1815

with Waterloo and ended in 1914 with the pull of an assassin's trigger, which ignited World War I and ushered in the modern world.

The Industrial Revolution (1800–1850)

In 1820, a trip from Paris to Vienna took weeks of hard travel on foot or by horse carriage. By 1850, you could board a train and be there the next day. Or you could simply "talk" in real time with your Viennese friends using a city-to-city telegraph line. Europe's world was suddenly smaller and faster.

In the Industrial Revolution, machines replaced people as the main economic force. While the scientific achievements of the Enlightenment had broadened human knowledge in the 1700s, it wasn't until the 1800s that those curious inventions were actually

put to good use.

The Industrial Revolution was born in western England's Severn River Valley. Blessed with abundant deposits of iron ore and coal as well as a river that made transportation easy, this valley gave the world its first cast-iron bridge (in 1779, at Ironbridge Gorge) and iron wheels on iron rails. Those wheels, plus the new steam engine invented by James Watt (1736–1819), were used to build the Locomotive steam train—a speedy new breakthrough in transportation.

The locomotive shifted the revolution into high gear. As more products could be shipped more quickly to more people, huge new trade markets opened up. Rails laced European nations together. From 1830 through 1860, one-sixth of the world's track was laid (the Eurailpass came later).

Soon, coal-burning machines were using steam power to smelt iron to make more machines, which could turn wool into clothes that were ready for immediate export. In 1831, Britain's Michael Faraday (1791–1867) discovered how to generate electricity by moving a magnet through a coil of copper wire, creating a new source of energy.

It wasn't the inventions alone that propelled the Industrial Revolution, but also the way they were applied. Efficiency experts studied how to manufacture products on a massive scale, creating an assembly line that used interchangeable parts (and interchangeable workers).

With Britain leading the way, Europe's economy quickly changed

Industrial Age Europe was crisscrossed with canals to provide transport for coal, raw materials, and finished products. Today, these waterways—with their sleepy old-time locks—provide relaxing, scenic routes for holiday canal boaters, while the tow-paths are enjoyed by bikers and hikers.

from agricultural to industrial, and farmers began flooding the cities hoping to snag a factory job.

Hungry for fuel to stoke their booming economy, Europe plundered the world for raw materials. They divvied up and colonized the under-developed world: the Americas, Africa, and Asia.

Europe's merchants and shippers powered a three-sided trading scheme, called triangular trade. They exported manufactured goods to Africa in exchange for enslaved Africans, who were then shipped to the Americas, where they were traded for raw materials—such as cotton, sugar, and tobacco—which were imported back to Britain for processing. While parties on all three sides made money, the big profit came home to Britain.

Although every European nation

The riches of England's Industrial Revolution came with problems. This 19th-century engraving shows poor, dirty, overcrowded slums housing masses of industrial workers under roaring smokestacks.

grabbed a slice of the world's economic quiche, Britain grabbed the biggest, building an empire that at its peak included almost a quarter of the world's land and people. England boasted, "The sun never sets on the British Empire." (While others added, "Because God can't trust the English in the dark.")

Socialism and Communism: Reaction to the Industrial Revolution

Technology gave Europe a false optimism. Seeing how quickly technology changed nature and lifestyles, people figured it was the answer to the world's problems.

Unfortunately, the Industrial Revolution had its downside: slums, over-crowded and soot-dusted cities, child labor, unemployment, overwork, and workers who were alienated from the fruits of their labors. Machines replaced honest laborers, and once-noble Man was viewed as a commodity. Quantity of wealth over shadowed quality of life. Even today, as we step out of this Industrial Age and into the Information Age, many of these problems persist.

The 19th-century Socialist movement tried to solve the social ills brought on by the Industrial Age. Socialists and trade unions worked to restrict the power of factory owners and distribute wealth more fairly.

Karl Marx (1818–1883) and Friedrich Engels (1820–1895), both from Germany, co-wrote

Communism's Fab Four keep watch over an international conference in 1935. The German writer Karl Marx (far left) and his co-author Friederich Engels inspired a later generation, including the Russian revolutionary Vladimir Lenin and the ruthless tyrant Josef Stalin.

the influential *Communist Manifesto* (1848). They spread the idealistic notion that workers, not factory owners, should benefit most from industry. They predicted that a worker (proletarian) revolution would overthrow the capitalist (bourgeois) establishment. Their writings sparked a rash of revolts across the Continent, though these were rather easily suppressed.

Though there was never a classic "worker's revolution," Socialist ideas wormed their way into politics, resulting in laws that benefited the working class. What was once considered radical—labor unions, restrictions on child labor, and bathroom breaks—is now standard practice, brought to you by Socialism.

Industrial Age Art

The Industrial Revolution gave artists new toys to play with: concrete, iron, and glass. Like a kid on Christmas morning with a new Erector set,

Europe went nuts. More buildings were constructed in the 19th century than in all previous centuries put together.

At world's fairs and exhibitions, giant structures of iron ribs and glass walls were proudly assembled and then promptly disassembled on rigid time schedules, just to prove it could be done. People traveled from all over Europe to marvel at London's short-lived Crystal Palace. Paris, also feeling its industrial oats, threw together its own Industrial Age stunt—the Eiffel Tower.

THE EIFFEL TOWER

Visitors to Paris may find *Mona Lisa* to be less than expected, but the 1,000-foot-tall Eiffel Tower rarely disappoints, even in an era of skyscrapers. Built on the 100th birthday of the French Revolution (and in the midst of an Industrial one), the tower served no function but to impress. The French

Industrial Revolution Sights

When England learned to make iron efficiently, the Industrial Age was born. It happened at **Ironbridge Gorge**. *This is the first iron bridge ever built (1779). The museums in Ironbridge Gorge take you back into the days when Britain was racing into the modern age and pulling the rest of the West with her.*

- Museums at Ironbridge Gorge, near Coventry, Britain
- Covent Garden, London
- National Railway Museum, York, Britain
- Blackpool Tower, Blackpool, Britain
- Eiffel Tower, Paris
- Orsay Museum, Paris
- Gallerias (grand iron-and-glass shopping arcades) in Milan and Naples, Italy
- Galeries Royales St. Hubert, Brussels, Belgium

Orsay Station/Museum, 1900 (Paris, France). *As you travel around Europe, you'll see huge iron-and-glass train stations, which are products of Europe's early industrial muscle. Paris' Orsay Station, slated for destruction in the 1970s, found new life as an art museum to show off the city's world-class collection of 19th-century art.*

planned to take down the tower after the celebration—many considered it ugly—but it became a symbol for Paris, and so it stands today.

Bridge-builder Gustave Eiffel won the contest for the 1889 Centennial World's Fair by beating out such rival proposals as a giant guillotine. To a generation hooked on technology, the tower was the marvel of the age, a symbol of progress and human ingenuity. Indeed, despite its 7,000 tons of metal and 50 tons of paint, the tower is so well-engineered that it weighs no more per square inch at its base than a linebacker on tiptoes.

Delicate and graceful when seen from afar, the Eiffel Tower is massive—even a bit scary—from close up. You don't appreciate its size until you walk toward it; like a mountain, it seems so close but takes forever to reach. There are three observation platforms, at 200, 400, and 900 feet. From the top level, you can see for 40 miles.

However impressive it may be by day, the tower is an awesome thing to see at twilight, when it becomes engorged with light, and virile Paris lies back and lets night be on top.

The Age of Nationalism

The Industrial Revolution helped fuel another revolution in Europe, as the last vestiges of the Old Regime were challenged by a rising spirit of nationalism.

As you travel in Europe, keep in mind that 150 years ago, Germany, Italy, Poland, and the Czech Republic, among other nations, did not yet exist. They were patchwork quilts of feudal baronies, dukedoms, and small kingdoms—"countries" such as Bavaria, Piedmont, Saxony, and Tirol. Or they were backwaters of vast empires. Rulers often spoke a different language than many of their subjects and lived in far-away palaces.

Nationalism—a patriotic desire for national unity and sovereignty—became the dream and the foremost political drive of the 1800s. Born in the Age of Enlightenment and inspired by the French Revolution, the

Gustave Eiffel, **Eiffel Tower,** 1889 (Paris).

movement grew, especially among the rising middle class. People began insisting on a government that spoke their language, was part of their ethnic heritage, sang their songs, and worshipped in their churches.

After Napoleon had stirred national spirit across Europe, the Congress of Vienna in 1815 tried to reinstate the old guard (see page 306). French kings were given northern Italy, and the Russian czar got a chunk of Poland. In Eastern Europe, the Hapsburgs continued ruling their vast empire (see page 286). German-speaking nobles in the cities (Prague, Budapest, and Kraków) dominated the "natives" (Czechs, Hungarians, and Poles) in the countryside.

The Industrial Revolution shook things up. When farmers and peasants moved into the cities to work in factories, they brought their local language and customs with them. In 1800, Prague did business exclusively in German. By 1900, nine out of every ten residents spoke Czech—and they expected their government and society to do the same.

Long pooh-poohed as foolish and backward, folk traditions of the countryside started to be taken more seriously. Writers used the vernacular language to write literature, painters captured their people's illustrious history on canvas, and composers built whole symphonies around humble folk themes. In politics, rabble-rousing patriots inspired their countrymen to rise up against the foreigners who ruled over them.

Nationalist pride was heating up all over the Continent, and Europe's ethnic stew was ready to boil over.

The Year of Revolution: 1848

In a single year— 1848—massive uprisings and revolutions swept Continental Europe. Inspired by the Socialist writings of Marx and Engels, and frustrated by an economic downturn, the people of Europe demanded their rights: France, Italy, Prussia, Austria... virtually every European nation except Russia and Britain were affected.

Most of the revolutions of 1848 were quickly put down, but they did set the stage for some long-term changes. For example, while Hungary's 1848 Revolution was brutally crushed, within 20 years Austria was forced to give Hungary some autonomy, creating the so-called Dual Monarchy of the Austro-Hungarian Empire.

While it would take a Great War for the Eastern countries to be fully free, change came more quickly for the Italians and the Germans.

Italy Unites: The Risorgimento

After Napoleon invaded Italy and conquered its kings and dukes, the old ruling order was restored. In Venice, Austrian rulers sipped cappuccinos on St. Mark's Square while their subjects—the Venetians—waited on them. French kings ruled Italy's northwest, and Spaniards ruled the south. But Napoleon had planted a seed: What if Italians could unite and rule themselves like Europe's many other modern nations? A movement to unite slowly grew, called the Risorgimento— "rising again."

It started with a secret society called the Carbonari, led by the professional revolutionary Giuseppe Mazzini. The Carbonari exchanged secret handshakes, printed flyers, planted bombs,

Italy Before Unification (c. 1850)

SAVOY TO FRANCE 1860

AUSTRIA

FRANCE

Milan
LOMBARDY
(1859)
Torino
PIEDMONT

VENETIA
(1866)
Venice

AUSTRIA

PARMA

Nice
TO →
FRANCE
1860

MOD

ROMAGNA

LUCCA

Florence
TUSCANY
(1860)

OTTOMAN
EMPIRE

A
D
R
I
A
T
I
C

S
E
A

KINGDOM
OF
SARDINIA-
PIEDMONT
(1849)

CORSICA
(FRANCE)

PAPAL
STATES
(1860)

Rome
(1870)

Naples

SARDINIA

KINGDOM OF
THE TWO SICILIES
(1860)

M E D I T E R R A N E A N
S E A

Palermo

SICILY

DCM

DATES IN PARENTHESES
INDICATE WHEN THE REGION
BECAME PART OF ITALY

and assassinated conservative rulers. Their small revolutions (1820–1821, 1831, 1848) were quickly crushed, but the cause just wouldn't die.

The growing movement coalesced around the Kingdom of Sardinia (in northern Italy) and its king, Victor Emmanuel II, who happened to be the only Italian-blooded king of the day. His prime minister, Camillo Cavour, cleverly persuaded France to drive Austria out of northern Italy, leaving it in Victor Emmanuel's hands.

The composer Giuseppe Verdi used opera to champion the Risor-

gimento. In a time when flying the Italian colors was still dangerous, opera houses rang with the sound of patriots singing along with anthemlike choruses. The letters in Verdi's name were used as a nationalistic slogan: *Victor Emmanuel Re* (king) *di Italia.*

In 1860, the daring Carbonari general, Giuseppe Garibaldi (1807–1882), steamed toward Naples with a thousand of his best soldiers, the "red shirts." Though greatly outnumbered, they marched on Naples...and the old Spanish-ruled government simply folded. Garibaldi sent a one-

*The **Victor Emmanuel Monument**—also known as "The Wedding Cake," "The Typewriter," or "The Dentures"—is the symbol of Italian unification in the center of Rome.*

word telegram to Victor Emmanuel: *"Obbedisco"* ("I obey"). An assembly of Italian statesmen crowned Victor Emmanuel II "King of Italy." Only the pope in Rome held out, protected by French troops. When the city finally fell to the unification forces on September 20, 1870, the Risorgimento was complete. Italy went ape.

The Risorgimento was largely the work of four men: Garibaldi (the sword), Mazzini (the spark), Cavour (the diplomat), and Victor Emmanuel II (the rallying point). Remember the names of these Italian Washingtons and Jeffersons. Throughout Italy you'll find streets, squares, and monuments named after them: Via Cavours, Piazza Garibaldis, and the most famous monument, Rome's giant, white Victor Emmanuel Monument.

The Unification of Germany

In 1850, Germany was 39 little countries. When it united 20 years later, it was Europe's number-one economic power.

During that period of growth, German iron and coal output multiplied sixfold, surpassing that of France. Cities, industries, and trade boomed. German unification seemed inevitable. The big question was: Would Germany be united under Prussia or Austria?

Otto von Bismarck (1815–1898)—the prime minister of Prussia and one of the greatest political geniuses of all time—knew the answer. Prussia (in northeast Germany) was a militaristic German state, basically the Sparta of 19th-century Europe, and it became the goose-stepping force behind German unity.

The original master of "realpolitik," Bismarck said, "Not by speeches and majority votes are the great questions of the day decided, but by blood and iron." He united Germany as if reading from a great political recipe book.

He cozied up to Prussia's liberals to win support in parliament. He built

*The great realistic politician of the 1800s, **Otto von Bismarck** created a united Germany.*

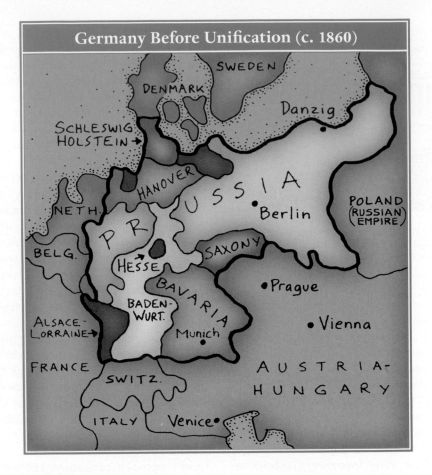

Germany Before Unification (c. 1860)

Prussia's mighty army using unconstitutional taxes. He leaked classified documents to the press to twist public opinion into just the political pretzel he needed.

In his foreign policy, Bismarck mixed brutal warfare and back-slapping diplomacy. He made alliances simply to break them, thereby creating a handy excuse to fight. He started wars with Austria and Denmark to acquire more territory and knock them down a peg. Once victorious, he generously made them his friends. He winked at Europe's great leaders, gained their confidence, and proceeded to make them history's fools.

The final step was to acquire the small German-speaking states on the border with France. The resulting Franco–Prussian War lasted only a few weeks, with Prussia winning easily. Bismarck's recipe for success had created the dish nobody in Europe wanted: a united Germany.

By 1871, once-fragmented Germany had become a Prussian-dominated, conservative, and militaristic German empire. The balance of power had been disturbed. The rest of Europe hoped the unification of Germany would not lead to a large war or two.

Romanticism

Europe's nationalism found expression in a pro-freedom/anti-authoritarian art movement called Romanticism.

During the Neoclassical (and Industrial) Age, hearts were muzzled and brains ruled. Science was in, machines were taming nature, and factory hours were taming humans. In reaction to these brainy ideals, a rare few began to embrace untamed nature and undomesticated emotions.

The movement known as Romanticism—which has little to do with chocolates and roses—questioned the clinical detachment of science, industrial pollution, and the personal restrictions of modern life. Romantics reveled in strong emotions, personal freedom, opium, and the beauties of nature.

Romanticism is an art style, but it went beyond art; it was a way of living. It meant placing feeling over intellect and passion over restrained judgment. Romantic poets escaped the dirty cities to commune with nature. They trusted their gut instincts and weren't afraid to cry, feel melancholy, shout for joy, or fall in love passionately, obsessively, outlandishly. Thumbing their noses at society's rules, they dressed in outrageous getups and forged their own paths through life. They admired the uniqueness of each person and the glories of the human spirit.

This anti-authority strain made Romanticism a natural ally of nationalism. Just as Romantics demanded

J. M. W. Turner, **Snow Storm: Steam-Boat off a Harbour's Mouth,** 1842 (Tate Britain, London). *In both seascapes and landscapes, Romantic artists such as Turner capture the awe-inspiring wonders and power of nature.*

Romanticism vs. Neoclassicism

In the artistic war between hearts and minds, Romanticism battled Neoclassicism. Both movements flourished in the early 1800s. Stressing motion and emotion, Romanticism was the flip side of cool, balanced Neoclassicism. Romanticism was a reaction to the stern logic and reason of the Enlightenment. Where Neoclassicism admired Europe's Greco-Roman roots, Romantics explored a country's indigenous customs, folklore, and nature. Neoclassical paintings (such as J. L. David's *Death of Socrates,* below) have placid subjects, painted with cool colors and a smooth surface. Romantic canvases (like Delacroix's) have bright colors and exotic subjects, and pulsate with motion. The rational rules of Neoclassicism were replaced by a spirit of discovery that encouraged artists to create not merely what the eyes saw, but also what the heart felt.

Eugène Delacroix, **The Death of Sardanapalus,** 1826 (Louvre Museum, Paris).

Delacroix's Romantic work (above) portrays death with over-the-top melodrama; David's understated Neoclassical work shows Socrates facing death... philosophically.

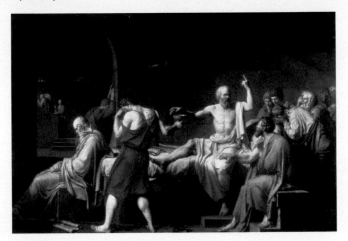

Jacques-Louis David, **Death of Socrates,** 1787 (Louvre Museum, Paris).

their right of personal expression, so did national groups, who wanted freedom from foreign control to follow their national destiny. Europe's peoples returned to their ethnic roots, as did Romantic artists, who incorporated folklore into their novels and folk music into their symphonies.

Romantics made a religion of nature. Taking a walk let them commune with their true self: the primitive, "noble savage" beneath the intellectual crust. Many people who abandoned Christianity in the 18th century found a replacement in nature. Until the Romantic era, mountains were seen only as troublesome obstacles. Now they attracted crowds of admirers who got high on their altitude and rugged power. Tony resorts, such as Interlaken in the Swiss Alps, were born. Why did people climb these mountains? Because they were there. Romanticism.

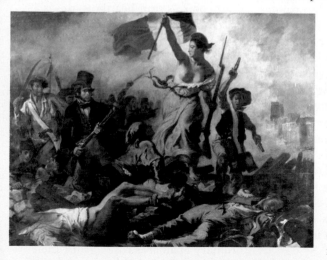

Eugène Delacroix, **Liberty Leading the People**, 1830 (Louvre Museum, Paris).
Liberty, in the form of a woman, carries a gun in one hand and a flag in the other, which was the winning combination for 19th-century nationalist movements.

Romantic art is colorful and flamboyant. It features storms at sea and stormy emotions, languishing harem girls and wind-whipped warriors. Landscapes are popular, sometimes serene but often churning with nature's sublime fury. Lovers embrace. People die before your eyes. Colors clash. The paint is laid on thick, with no worry about blending it into a creamy-smooth surface. Nature was awesome, emotions were truth, and the Romantic artists were the prophets of this new religion. Here are several of the best artists of this movement:

Eugène Delacroix

Eugène Delacroix (deh-lah-kwah, 1798–1863) is the essence of a Romantic painter. Solitary, moody, emotional, and endlessly imaginative, he broke all the Neoclassical rules. His exotic and emotional scenes, wild color schemes, and complex, unrestrained compositions bubble with enough movement and excitement to ring any viewer's emotional bells. In *Liberty Leading the People* (pictured left), the year is 1830. The Parisians have taken to the streets once again, *Les Miz*–style, to fight royalist oppressors. There's a hardbitten proletarian with a sword (far left), an intellectual with a top hat and a sawed-off shotgun, and even a little boy brandishing pistols. Leading them on through the smoke and over the dead and dying is the figure of Liberty, a strong woman waving the

French flag. Does this symbol of victory look familiar? It's the *Winged Victory*, wingless and topless (see page 55).

In *Liberty*, Delacroix uses only three major colors: the red, white, and blue of the French flag.

Théodore Géricault

Géricault's *The Raft of the Medusa* (pictured at right) was based on the actual sinking of the ship *Medusa* off the coast of Africa in 1816. About 150 passengers packed onto the raft, and after floating in the open seas for 12 days, suffering hardship and hunger—even resorting to cannibalism—only 15 survived. The story was made to order for a painter determined to shock the public and arouse its emotions. That painter was young Géricault (zhair-ee-koh, 1791–1824). He interviewed survivors and honed his craft by sketching dead bodies in the morgue and the twisted faces of lunatics in asylums, capturing the moment when all hope is lost.

Clinging to a raft is a tangle of shipwrecked people sprawled over each other. The writhing bodies are echoed in the churning clouds and choppy seas. The faces show the despair of being stranded in the middle of nowhere.

But wait. There's a stir in the crowd. Someone has spotted something. The bodies rise up in a pyramid of hope, culminating in a waving flag.

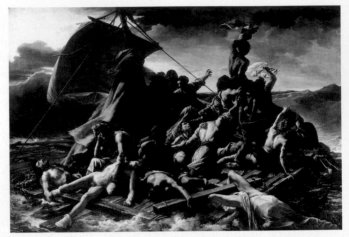

Théodore Géricault, **The Raft of the Medusa,** 1819 (Louvre Museum, Paris).

There on the distant horizon is the tiny ship, their last desperate hope...which did finally save them. Géricault uses rippling movement and powerful colors to catch us up in the excitement. If art controls your heartbeat, this is a masterpiece.

Francisco de Goya

As court painter to Spain's kings, Francisco de Goya (1746–1828) dutifully cranked out portraits and pretty pictures. But inside he was stirred by a longing for freedom. Increasingly, his portraits captured the arrogance and pettiness of his dim-bulb masters.

Goya's most gripping work, *The Third of May, 1808* (see next page), combines Romantic style with nationalist fervor. It chronicles the moment when ordinary Spaniards rose against their French oppressors (Napoleon's soldiers), only to be crushed. On the third of May, 1808, the French began reprisals. They took suspected rebels to a

Francisco de Goya, **The Third of May, 1808,** 1814 (Prado Museum, Madrid).
Romanticism expresses itself here in a powerful social statement against war and repression by faceless foreign invaders.

nearby hill and lined them up before a firing squad. In the painting, the rebels plead for mercy and get none. It's a faceless assembly line of death, cutting people down with all the compassion of a lawnmower. The Spaniards topple into a mass grave. The next victim spreads his arms Christ-like and asks, "Why?"

Goya casts a strong prison-yard floodlight on the main victim, focusing all our attention on his look of puzzled horror. The distorted features, the puddle of blood, the twisting bodies, the thick brushwork—all are features of the Romantic style that emphasized emotion over beauty.

Francisco de Goya, **Saturn Devouring His Son,** 1823 (Prado Museum, Madrid). *This gives "child's portion" a new meaning.*

In his last years, Goya lost his hearing and became bitter and disillusioned with life. He painted the walls of his house with nightmarish fantasies of witches and monsters and battling ogres. *Saturn Devouring His Son* (see previous page) details in ghastly, twisted lines and vivid, garish colors how time eventually devours us all. Remember, Romantic art encompasses the whole range of human emotions, not just sentimental love. It's as if Goya had finger-painted these grotesque figures in his own blood, mirroring the turmoil that racked his soul. (Romantic, huh?)

William Wordsworth and Britain's Romantic Poets

The cultural heartbeat of England's Romantic movement came not from bustling London but from a humble log cabin in England's Windermere Lake District. Here the poet William Wordsworth (1770–1850) lived at Dove Cottage, rejecting fast-paced city life.

Wordsworth would "wander lonely as a cloud" through the countryside, finding inspiration in "plain living and high thinking." He soon attracted a circle of like-minded creative friends who nourished their souls in nature.

The emotional highs the Romantics felt weren't all natural. Wordsworth's poet friends Samuel Taylor Coleridge and Thomas de Quincey got stoned on opium and wrote about it, combining their generation's standard painkiller drug with their tree-hugging passions.

Today the Lake District in northern England remains a popular retreat for nature lovers. Its hostels (more per square mile than any place on earth) are filled with rucksack romantics worshipping the natural wonders.

Romantic Music

Romantic-era music, like painting, is meant to stir the soul. Composers translated their inner feelings into sounds, creating music that is sometimes loud and clashing, sometimes soft and sweet—like the classic bipolar Romantic. Rather than following a strict 4/4 beat, the music surges and flows, meandering like our fleeting thoughts and emotions.

One of the top Romantic composers was Frédéric Chopin (1810–1849). When his Russian-occupied Polish homeland became unstable, Chopin fled to France at age 21. In Paris, he could finally shake off the "child prodigy" label and performance schedule

*Nineteenth-century Romantics communed with nature in England's **Windermere Lake District** as if on a pilgrimage. Two centuries later, the pristine beauty of this region still recharges the nature-loving souls of its many visitors.*

Chopin Monument (Łazienki Park, Warsaw, Poland). *While he spent his last 19 years in France and wrote most of his best-known music there, Chopin said his inspiration came from memories of the wind blowing through the willow trees of his native Poland.*

the violin and simultaneously conducted with wild gestures, whipping the crowd to "bewildering heights of frenzy till they were frantic with delight and emitting groans of ecstasy," according to composer Richard Wagner.

Johann Strauss Jr. (1825–1899) took the baton when his father died and raised the waltz to respectability. His *Tales from the Vienna Woods* and *Blue Danube* immortalized his beloved hometown.

Since Romanticism focused on "back to basics"— including rediscovering your ethnic roots—some Romantic musicians doubled as ethnomusicologists. The Hungarian composers Franz Liszt and, later, Béla Bartók, collected (and "borrowed") the folk and Roma (Gypsy) songs

he'd lived with since age seven. Cursed with stage fright, Chopin preferred playing at private parties for Paris' elite, including the painter Delacroix and pianist Franz Liszt. They were wowed by his ability to make a piano sing, particularly with his melodic, soul-stirring *Nocturnes*. Like a good Romantic artist, the brooding genius died young, of tuberculosis.

Meanwhile, the waltz craze— the Beatlemania of its time—swept through Vienna in the early 19th century. Many considered the waltz decadent because of the close contact of the partners and the passionate sound of the music. Dances lasted from dusk to dawn, night after night. Johann Strauss Sr. (1804–1849) played

Johann Strauss Jr. (Stadtpark, Vienna).

Romantic Art and Music Highlights

William Blake, **Elohim Creating Adam,** 1795
(Tate Britain, London).
*Blake, who hobnobbed with the heavenly hosts, painted
God creating Man.*

- Paintings in the Louvre's Romantic art room (Delacroix and Géricault), Paris
- Tate Britain (Blake and Turner), London
- Neo-Gothic Halls of Parliament, London
- Neuschwanstein and Linderhof castles, Bavaria, Germany
- The Rhine and the Loreley poem, Germany
- The Alps, Switzerland
- Poetry by Wordsworth, Shelley, Keats, Byron, and Blake
- Music by Chopin, the Strausses, Liszt, Bartók, Wagner, Beethoven, and Schumann
- Chopin's grave, Père Lachaise Cemetery, Paris
- Chopin Museum and Chopin Monument, Warsaw, Poland

Eugène Delacroix, **Frédéric Chopin,** 1838
(Louvre Museum, Paris).
*One Romantic artist's tribute to another. Each age
in art history has come with its own strong, unify-
ing aesthetic. For example, a Romantic painter
could relate better to a Romantic composer than
he could to a painter from a different era.*

of the Hungarian and Transylvanian countryside. Antonín Dvořák turned Czech folk tunes into high art. And to this day, Bedřich Smetana's *Vltava* (named for the river that runs through Prague) is the de facto national anthem of the Czech people.

In Germany, Richard Wagner (1813–1883) mined medieval legends of Rhine maidens, dragons, magic rings, and Norse gods for his epic opera *Der Ring des Nibelungen*. Wagner's work put nostalgic German traditions on a pedestal and awakened nationalist sentiment that would be exploited by Bismarck (and, later, by the

King Ludwig II of Bavaria was the epitome of a 19th-century Romantic king. As you travel through Munich and Bavaria, you'll see images of this ruler, who today is better known as "Mad" King Ludwig.

Kaisers and Hitler).

Richard Wagner's friend, King Ludwig II of Bavaria, built one of Europe's enduring examples of Romanticism.

Neuschwanstein Castle

Bavaria's fairy-tale castle of Neuschwanstein is textbook Romantic. Though it looks medieval, it was built with all the modern conveniences. King Ludwig II of Bavaria placed the castle on a hilltop not for defensive purposes...but because he liked the view. The builder was not an architect, but a theater set designer. Paintings of knights in armor and damsels in distress

Neuschwanstein Castle, 1869–1886 (near Füssen, Germany).

decorate the walls, all scenes from Richard Wagner's Romantic operas.

Ludwig II was dubbed "Mad" King Ludwig because of his Romantic excesses. Ludwig disdained the business of state and preferred to hang out with his friends: artists, poets, and musicians (including Richard Wagner). His dreams were not of empires and big armies, but of fairy-tale castles and candlelit concerts. Before his ultimate dream—Neuschwanstein Castle—was completed, he drowned mysteriously.

Ludwig almost bankrupted Bavaria building his Disneyesque castle, but Germany is now recouping its investment a hundredfold as huge crowds of tourists from all over the world pay to see Europe's most popular castle.

Historicism: The "Neo-" Styles

Much of what you see today in Europe, like Neuschwanstein Castle, isn't as old as you think. The 19th century saw the rise of historicism: Neo- styles (like

Neo-Gothic, Neo-Renaissance, and Neo-Romanesque) that capitalized on the newfound nostalgia for the pre-Industrial past.

As the Industrial Revolution picked up, new building techniques and materials made previous architectural styles obsolete, except as decoration. So, like the ancient Romans who used Greek facades on their buildings, 19th-century architects would build state-of-the-art buildings, then paste on fake Gothic arches or Renaissance columns.

Vienna's Ringstrasse exemplifies historicism. This 200-foot wide boulevard (where the medieval wall once stood) was ornamented in the 1860s with several new government buildings, each in a different retro style matching the building's function. The Parliament building is Neoclassical, celebrating ancient Greek democracy. The City Hall is Neo-Gothic, recalling when medieval burghers ran the city. The University, where humanist ideals flourished, is Neo-Renaissance, while the Burg Theater has the theatricality of Neo-Baroque. In 10 minutes, you can walk past centuries of styles, even though all of these buildings date from the same two-decade span.

All across Europe, old buildings in need of repair got an extreme makeover in Neo-styles. Many of the castles along the Rhine and Mosel Rivers, though built in the Middle Ages, were renovated in the 19th

*London's pointy, fanciful **Tower Bridge** looks medieval, but it's done in the over-the-top Neo-Gothic style that was popular in the mid-19th century. While true Gothic is generally made of stone, Neo-Gothic is easily identifiable by its brickwork.*

century (such as Cochem Castle, pictured on page 141). What we see today is often a fanciful Neo-medieval version, quite different from the original look. Paris' Notre-Dame (which is truly Gothic) was further embellished with Neo-Gothic gargoyles, spires, and statues.

In Britain, where the Industrial Revolution was born, construction boomed. The Houses of Parliament, the Law Courts on the Strand, railroad stations (to accommodate a revolutionary new form of transportation), churches, office buildings, and townhouses went up. Wrought iron was a popular decoration; everything had a railing, whether needed or not. Some of these buildings, such as Big Ben and the Houses of Parliament became instant classics. Many others—whether Neo-Gothic, Neoclassical, or Neo-

Romanesque—ended up looking Neo-Bland.

The Victorian Era (1837–1901)

Nineteenth-century Britain, the world's first industrial power, was dotted with smoke-belching factories and laced with railroads and modern roads. Overseas, she ruled a quarter of the earth, exploiting the natural resources of her colonies in Australia, Canada, India, the West Indies, and China. Ruling this vast empire was a five-foot-tall, plump, shy girl named Victoria.

Queen Victoria (1819–1901) reigned more than six decades. When her husband, Prince Albert, died in 1861, Britain's heartbroken queen lapsed into a deep depression, and insisted on wearing black for her last 40 years. But despite this extended

Houses of Parliament and Big Ben, 1860 (London).
Built at a time when Britain ruled the waves and a quarter of the world, this grand building was a Victorian showpiece.

mourning, Britain's Victorian Era was a time of peace and prosperity, and a Golden Age of science, literature, and middle-class morality.

Victorian London

Nineteenth-century London had four million people. It was the world's largest, busiest, richest, and most productive city. It was the hub of the most industrialized nation on earth and the nerve center of a vast colonial empire.

On a typical business day, London's streets bustled with bobbies, pickpockets, lamplighters, and prostitutes. Merchants sang songs to advertise their wares, including the quack doctor hawking his Elixir of Life and the popular muffin man, who rang his bell to attract children at tea time.

On the busy streets, London

Queen Victoria ruled the British Empire from 1837 to 1901.

looked like a real melting pot of humanity, but Victorian society was rigidly hierarchical: rich, middle-class, and poor.

The seamy underside of London was dirty, poor, disease-ridden, and dangerous. This contrast was everywhere. You could buy any commodity in the world on London's docks... and lose it to a thief just as quickly. It was the center of industrial growth, yet it was choked with coal dust and filth. London hosted the lavish social life of Prince Edward as well as the squalid existence of thousands of homeless urchins begging, stealing, and sleeping in the streets. Palaces and townhouses contrasted with sagging tenements; well-lit cafés opposed seedy pubs where the poor indulged in one of their few affordable pastimes, drunkenness.

Jack the Ripper—a serial killer in 1880's London—dispatches one of his victims. Several prostitutes were brutally slain, and "Jack" was never found.

Ireland's Great Potato Famine

While the British Empire was thriving, their Irish subjects were struggling. The Great Potato Famine (1845–1849) was caused by a fungus that destroyed Ireland's primary food crop. About a million people starved to death or died of related diseases. Another 1 to 2 million emigrated, most of them to America.

The poorest (who happened to be the Catholics) were hardest hit. Despite the potato famine, wealthy British landowners in Ireland continued to grow and export more expensive (and profitable) crops. Britain seemingly couldn't (or maybe wouldn't) do anything to help its starving citizens. (Ireland has been slow to forget Britain's indifference.)

During the course of five long years, Ireland was ruined. The population was cut by nearly a third (from 8.4 million to 6 million), many of their best and brightest had fled, and the island's economy—and spirit—took generations to recover.

*Permanently moored in the tiny port of New Ross, Ireland, the **Dunbrody Famine Ship** stands as a reminder of the countless hungry Irish who sailed to America during the Great Potato Famine. Often, boats like this would arrive in America with only half of their original human cargo—hence the nickname "coffin ships."*

London's wealthy had electric lights. But on the other side of the tracks, the gas lighting hardly cut through the dark on foggy nights and in narrow alleyways where Jack-the-Ripper types lurked. Brothels, gambling dens, and pubs were these districts' major businesses.

Work was scarce. A man might haul garbage, shovel coal, or make deliveries, but that was about it. Women and children labored in the factories for pennies. For those in debt, there was the workhouse, which was much like a prison work camp. For some, the alternative was the Queen's Army. Recruiting sergeants stood outside the pubs with shillings in their hands as bait for the down-and-out.

Private charities did little good.

John William Waterhouse, **The Lady of Shalott,** 1888 (Tate Britain, London).

It wasn't until major government reforms at the end of the century that the slums got some relief. The reforming spirit got a boost from the writings of Dickens, a poor boy who made good but never forgot his roots.

But all of the classes in Victorian London had one thing in common: a spirit of optimism. There was a vitality to the city that even the poor felt. There was a sense that technology could bring about a better life for all, that hard work and right living would be rewarded just as surely as laziness and vice would be punished. London was a busy, hard-driving, shrewd city that maintained an outer face of gentility, grace, and good cheer.

The Pre-Raphaelites

While Britain was steaming into the future, its art looked to the past. The Romantic love of all things medieval caught on with a group of British painters who called themselves "The Pre-Raphaelite Brotherhood." The gang included John Everett Millais, Dante Gabriel Rossetti, William Holman Hunt, John William Waterhouse, Edward Burne-Jones, and others.

Overdosed with gushy Victorian sentimentality, this band of 20-year-old artists said, "Enough!" and dedicated themselves to less saccharine art. They returned to a style "pre-Raphael," that is, "medieval" in its simplicity, melancholy mood, and subject matter.

The Pre-Raphaelites delighted in

painting damsels in billowing blouses, knights in tights, legendary lovers, and even a very human Virgin Mary as a delicate young woman. The women wear flowing dresses and have long, wavy hair and delicate, elongated, curving bodies.

This is art from the cult of femininity, worshipping Woman's haunting beauty, compassion, and depth of soul. (Proto-feminism or nouveau-chauvinism?) The artists' wives and lovers were their models and muses, and the art echoed their love lives. The people are surrounded by nature at its most beautiful.

The Pre-Raphaelites hated over acting. Their subjects—even in the face of great tragedy, high passions, and moral dilemmas—barely raise an eyebrow. Outwardly, they're reflective, accepting their fate. But their sinuous postures speak volumes—with lovers swooning into each other, and parting lovers swooning apart.

The colors (greens, blues, and reds) are bright and clear, with everything evenly lit. To get the luminous color, some painted a thin layer of bright paint over a pure white, still-wet undercoat, which subtly "shines" through. These canvases radiate a pure spirituality, like stained-glass windows.

France:
Napoleon III and the Belle Epoque

After the Revolution, France's monarchs were restored. But a series of popular uprisings (including revolutions in 1830 and 1848) served as warnings to kings to follow constitutional limits.

In 1852, the nephew of the famous Napoleon Bonaparte became a kind of elected king, ruling with the title "Emperor Napoleon III." Mixing king-like powers with modern democracy, Napoleon III suppressed opposition while promoting reforms.

Under Napoleon III, the city planner Baron Georges Haussmann modernized Paris. He cut new wide, straight boulevards to move goods and open up the crowded city...and also prevent barricades for future revolutions. Parks, railroad stations, and the Opéra Garnier made Paris the model for world capitals. Love him or hate him, Baron Haussmann made the Paris we see today.

France in the late 19th century enjoyed a belle époque—a "beautiful age" of peace, prosperity, and progress. The contented French lived off the wealth they'd accumulated as a world power since the days of Louis XIV. As in Victorian Britain, the middle class (or bourgeoisie) was king. They were affluent and educated. They spent quality time with their kids and indulged them with such formerly childish notions as merry-go-rounds, zoos, and Santa Claus (Père Noël). Some say the very notion of childhood was invented in the 19th century, when kids were no longer viewed simply as defective adults.

Gowned debutantes and white-gloved dandies waltzed the night away to the music of a chamber orchestra. Writers and artists courted the muse of caffeine in sidewalk cafés. The rich rode carriages to the opera. Even the poorest of society saw democracy steadily lowering social barriers and opening doors.

The system was working. The middle class ruled. *Vive le status quo!*

Honoré Daumier, **Celebrities of the Happy Medium,** 1832–1835
(Orsay Museum, Paris).
The political cartoonist Honoré Daumier caricatured the stuffy bourgeois establishment that controlled the Academy and the Salon. He captured the pomposity and self-righteousness of these self-appointed arbiters of taste by exaggerating their most distinct facial features. Their prudish expressions tightened as their fantasy world was about to be shattered.

Greek gods and goddesses that were in vogue. Neoclassicism (described on page 302) was still all the rage.

Aspiring artists in France sold their work at a large art fair called the Salon. Here, the buying public could wander in Wal-Mart-size galleries to choose their favorites. The Salon judging committees were tied to the prestigious art schools, and they determined what (and who) got in. The result? "Art by committee" that was often technically perfect but downright mediocre.

A small cadre of artists grew tired of the safe, predictable, Conservative art of the Salon. They yearned to be free to pursue their own ideas of beauty, which weren't necessarily those of the middle-class consumer. They decided the Salon needed a Reality check.

Conservative Art: The Academy and the Salon

France's art could be as "bourgeois" as the society that produced it. In Europe's new free-market economy, consumers called the shots, where kings and bishops had before. Changes in economics brought changes in art. In Renaissance times, artists had studied as apprentices under a master who was employed by a wealthy patron. In the 19th century, they went to art schools (such as the state-sponsored Academy of France), where they studied art history, theory, and technique. They learned to faithfully reproduce the creamy-skinned

Realism: New Art for New Times

The band of nonconformists called the Realists painted realistically (without anything prettied up) and

Gustave Courbet, **The Painter's Studio,** 1855
(Orsay Museum, Paris).

The Conservatives vs. the Realists

Both of these paintings date from 1863—just when French art styles began to diverge. Compare the approved Salon style with the anti-Salon rebel Manet.

Cabanel's *The Birth of Venus* is an idealized, pastel, Vaseline-on-the-lens beauty—soft-core pornography, the kind you see selling lingerie and perfume.

Manet's nude, on the other hand, doesn't gloss over anything. The pose is classic, used by Titian (see the *Venus of Urbino* on page 213) and countless others. But this is a Realist's take on the classics. The sharp outlines and harsh colors are new and shocking. Her hand is a clamp, and her stare is shockingly defiant, with not a hint of the seductive, hey-sailor look of most nudes. This prostitute, ignoring the flowers sent by her last customer, looks out as if to say, "Next." Manet replaced soft-core porn with hard-core art.

When Manet's nude hung in the Salon, the public hated it, attacking Manet in print...and literally attacking the canvas.

Cabanel, **The Birth of Venus,** 1863 (Orsay Museum, Paris).

Edouard Manet, **Olympia,** 1863 (Orsay Museum, Paris).

featured scenes that took place in the real world—not the fantasy world of Greek myth, but the landscapes, street scenes, and harsh surroundings of the working poor. The Salon wasn't pleased.

The Salon of 1855 rejected Realist Gustave Courbet's *The Painter's Studio* (pictured on previous page). In an age when Realist painters were equated with bomb-throwing Socialists, it took courage to buck the system.

Dismissed by the so-called experts, Courbet (koor-bay, 1819–1877) held his own one-man exhibit. He built a shed in the middle of Paris, defiantly hung his art out, and basically mooned the shocked public.

Courbet's painting takes us backstage, showing the gritty reality behind the creation of pretty pictures. We see Courbet himself in his studio, working diligently on a Realistic landscape, oblivious to the confusion around him.

Standing about are ordinary cit-
izens, not Greek heroes. The
woman who looks on is not a
nude Venus but a naked artist's
model. And the little boy with
an adoring look on his face?
Perhaps it's Courbet's inner
child, admiring the artist who
sticks to his guns, whether it's
popular or not.

Jean-François Millet, **The Gleaners,** 1867
(Orsay Museum, Paris).

Jean-François Millet's *The
Gleaners* (right) shows us three
gleaners, the poor women
who pick up the meager leav-
ings after a field has already
been harvested. Millet (mee-
yay, 1814–1875) grew up on a
humble farm. He didn't attend
the Academy and despised the uppity
Paris art scene. Instead of idealized
gods, goddesses, nymphs, and winged
babies, he painted simple rural scenes.
Millet was strongly affected by the
Socialist revolution of 1848, with its
affirmation of the working class. Here
he captures the innate dignity of these
stocky, tanned women who bend their
backs quietly in a large field for their
small reward.

The Seeds of Modern Art

Perhaps without realizing it, the Real-
ists had started the ball rolling for
a new movement in the art world:
modernism.

Paris of the late 19th century was
the undisputed art capital of Europe.
It was here that bold, experimental art-
ists began to push the boundaries of
art and re-envision their place in soci-
ety. Just as Michelangelo and Donatello
had done centuries before, artists began
thinking of their work as an expression
of themselves—not merely a craft, but

Art with a capital "A."

The Industrial Revolution had
changed things. The camera (first
developed in about 1830) could capture
reality faster, cheaper, and better than
a human with a paintbrush or chisel.
Click! The artist's traditional role as
preserver of a particular moment, per-
son, or scene became obsolete.

Technology widened the gulf
between the artist and the public. Peo-
ple could buy mass-produced goods
instead of handmade ones. In turn,
artists grew to disdain those who put a
price on art the same way they priced
pork, kerosene, or a day's work in the
factory.

Struggling to come to terms with
the modern industrial world, art left
technology behind, focusing its lens
on the hazy frontiers of the future...
and creating what we now call "mod-
ern" art.

While Parisians puttered along
through the blissful belle époque, a
bunch of hippies on the edge of town
were stirring things up.

The Painting that Started a Revolution

Claude Monet, **Impression: Sunrise,** 1873 (Marmottan Museum, Paris).

This is it: the painting that started the revolution...a simple, serene view of boats bobbing under an orange sun. At the first public showing by Monet, Renoir, Degas, and others in Paris in 1874, critics howled at this work and ridiculed the title. "Wallpaper," one called it. The messy brushstrokes and ordinary subject looked like a study, not a finished work. To insult the style, they dubbed it "Impressionism."

The misty harbor scene obviously made an impression on Monet, who faithfully rendered the fleeting moment in quick strokes of paint. The waves are simple horizontal brushstrokes. The sun's reflection on the water is a few thick, bold strokes of orange tipped with white. They zigzag down the canvas, the way a reflection shifts on moving water.

Impressionism

Light! Color! Vibrations! Impressionism was the greatest revolution in European art since the Renaissance and the first hint of the modern style to come. It features bright colors, easygoing open-air scenes, spontaneity, broad brushstrokes, and the play of light. You don't hang an Impressionist canvas—you tether it. Rather than gods, saints, and heavenly scenes, Impressionists painted cafés, poppy fields, Sunday picnics, and ordinary folk.

Impressionism was born in the Salon des Refusés (Salon of the Rejected), the "off-off-Broadway" of struggling Parisian artists. Their work had initially been dismissed by

the experts, who declaimed: "Sloppy!" "Clashing colors!" "Why did you leave it unfinished?!" A newspaper reported that after seeing an early Monet painting, one visitor went mad, rushed out into the street, and started biting innocent passers-by. (Caution is still advised near some avant-garde art galleries.)

Pierre-Auguste Renoir, **Boating on the Seine,** 1879–1880 (National Gallery, London).

But the Impressionists persevered and stuck together. Manet mentored Monet, who invited Renoir on painting excursions, who praised Degas' technique. In 1874, many like-minded artists exhibited work at their own Salon des Refusés, where they earned a name for themselves and for their bold new style.

Today, inspired by Monet and the other Impressionist innovators, artists set up their easels overlooking the harbor of Honfleur (in Normandy, a two-hour train trip from Paris). It was here in the 1870s that those first Impressionists declared, "Out of the studio and into nature!"

Although the term Impressionism was originally coined as an insult (like "Gothic"), it's actually an apt name. The artist, sometimes with only a few rapid brushstrokes, captures a candid, momentary impression of a subject.

Imagine Leonardo da Vinci and Claude Monet driving across the Nevada desert on a hot day. Ahead of his Ferrari, Leonardo sees heat rising from the asphalt, making the black road look like a bright, shimmering patch of silver. In spite of the way it appears, he knows the road is really black. He surveys the scene from all angles, then continues on to his studio, where he painstakingly paints a black road, disregarding the temporary impression of silver.

Monet excitedly stops his Peugeot, sets up his easel, and captures the impression of the

shimmering heat waves cutting a silver slice through the yellows and browns of the desert. We don't actually see objects or people, but rather the light that bounces off them.

A Renaissance artist painted what his mind knew was there; an Impressionist painted what he actually saw.

Impressionists broke out of the stuffy studio to paint on location. This was more feasible with the recent invention of oil paints in tubes. No more mess and fuss! Artists could set up outdoors and paint a quick scene right on the spot.

Picture Monet at work. He'd pack a picnic in his day bag and hike to a remote spot, carrying an easel, a canvas, brushes, a palette, tubes of paint, a folding chair, and an umbrella.

The key was to work fast, before the weather changed and the light shifted, completely changing the colors. Monet worked "wet-in-wet," applying new paint before the first layer dried, mixing colors on the canvas, and piling them up into a thick paste.

The Post-Impressionist van Gogh used the Impressionist technique of "building" a face with many colorful brushstrokes.

Impressionists "built" their subjects with a mosaic of individual dabs of paint that only blend together when you see the painting from a distance. The canvases shimmer because of a simple but revolutionary technique. Let's say you mix red, yellow, and green together—you'll get brown, right? But Impressionists didn't bother to mix them. They'd slap a thick brushstroke of yellow down, then a stroke of green next to it, then red next to that. Up close, all you see are the three sloppy strokes, but as you back up... *voilà!* Brown! The colors blend in the eye, at a distance. But while your eye is saying "brown," your subconscious is shouting, "Red! Yellow! Green! Yes!"

Today, Impressionism, far from radical, hangs in living rooms and corporate boardrooms and fills some of Europe's most popular galleries, such as Paris' Orsay Museum, which shows off Europe's single best Impressionist collection.

Let's consider the artists who invented Impressionism.

Edouard Manet

Edouard Manet (man-nay, 1832–1883) had an upper-class upbringing and some formal art training, and he'd been accepted by the Salon. He could have cranked out pretty nudes and been a successful painter. Instead, he surrounded himself with a group of young artists who were experimenting with new techniques. With his reputation and strong personality, he was their master, though he learned equally from them.

When Manet displayed his *Luncheon on the Grass* (see next page), a shocked public wondered: What are these scantily clad women doing with these men? Or rather, what will they

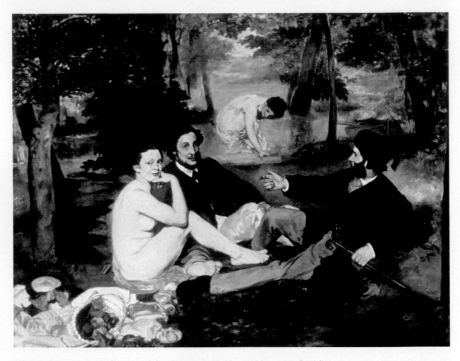

Edouard Manet, **Luncheon on the Grass,** 1863 (Orsay Museum, Paris).

be doing after the last baguette is eaten? The nude woman in a classical pose wasn't shocking; it was the presence of the fully clothed men in everyday dress that suddenly made the nude naked. The public judged the painting on moral rather than artistic terms.

Manet shows hints of the new Impressionist style: the messy brushwork of the leaves, the play of light on the pond, and the light that filters through the trees onto the woman who stoops in the haze. This is a true out-of-doors painting, not a studio production. Let the Impressionist revolution begin.

Claude Monet

Claude Monet (moh-nay, 1840–1926) is the father of Impressionism. He fully explored the possibilities of open-air painting and tried to faithfully reproduce nature's colors with bright blobs of paint. He pioneered the style and persevered amid the ridicule, inspiring his fellow Impressionists. Through his long career—whether painting landscapes, people, train stations, or his famous water lilies—his main subject was always...light.

Light plays endless games, so Monet often did a series of paintings of a single subject at different times of day. He went to Rouen, rented a room across from the cathedral, set up his easel...and waited. He had several canvases going at once, and each was unique. As the sun crossed the sky and the light changed on the facade, he'd move from his "morning" canvas to

*Compare the photo of the **Rouen Cathedral** (left) with the Impressionist painting by Claude Monet (Orsay Museum, Paris). We can see the artist's fascination with the play of light on the building. Detail fades away and we're left with a blurry, yet recognizable, impression of the cathedral. Impressionists used the physical subject as a rack upon which to hang their study of light, shadows, and color.*

his "noon" one. The time-lapse series (*The Cathedral of Rouen*, 1893) shows the facade at different times of day and in different atmospheric conditions, described in their titles: morning sun, in gray weather, bright sunlight, and so on.

The true subject is not the cathedral, but the full spectrum of light that reflects off of it. As Monet zeroes in on the play of colors and light, the physical subject—the cathedral—is dissolving. It's only a rack upon which to hang the light and color. Later artists would boldly throw away the rack, leaving purely abstract modern art in its place.

In his later years, Monet's eye-

sight failed. But like Beethoven going deaf, blind Monet wrote his final symphonies on a monumental scale. He

Monet, **Water Lilies**
(Marmottan Museum, Paris).

Giverny

In 1883, middle-aged Claude Monet and his big, happy family settled into a farmhouse at Giverny (zhee-vayr-nee). Monet built a pastoral paradise complete with a Japanese garden and a pond full of floating lilies (two of his favorite subjects). The gardens he planted are a lot like his paintings: brightly colored patches that are messy but balanced. Flowers were his brushstrokes, a bit untamed and slapdash, but part of a carefully composed design.

All kinds of people flock to Giverny. Gardeners admire the creative land-scape work, botanists find interesting new plants, and art lovers see paintings they've long admired come to life. Fans enjoy wandering around the house where Monet spent half his life and seeing the boat he puttered around in, as well as the henhouse where his family got their morning eggs. Giverny is very popular and worth a short side-trip from Paris if you like Monet more than you hate crowds.

Monet's Garden at Giverny (50 miles west of Paris) inspired much of Monsieur Lily Pad's art.

painted a series of huge, six-foot-tall canvases of water lilies from his own garden to hang in special rooms at the Orangerie Museum in Paris. In the museum, you're immersed on all sides by these *Water Lilies (Nymphéas)*. The lilies themselves are colorful patches of thick paint. They float on the sur-face of the pond, surrounded by reflec-tions of the blue sky, white clouds, and trees along the shore.

As the subjects of Monet's work became fuzzier, the colors and pat-terns predominated. When he died in 1926, he was famous. Monet built a bridge between Impressionism and abstract modern art.

More Impressionists: Renoir and Degas

Joining Monet's band of Impression-ists were Pierre-Auguste Renoir (rehn-wah, 1841–1919) and Edgar Degas (day-gah, 1834–1917). Together they discussed art, love, and life in the cheap cafés and bars of Montmartre (see sidebar on page 344). Where Monet championed the Impressionist style all his life, Renoir and Degas dabbled in other things. Renoir used smoother brushwork and painted in warmer col-ors. His paintings of rosy-cheeked kids have a hint of added sweetness that a hardcore Impressionist might find sappy. Meanwhile, Degas could draw

very well, and his technique is always more outlined than Monet's blobs-of-paint style. Degas' sketches and pastels rank right up there with his oil paintings.

On Sunday afternoons, working-class folk would dress up and head for the fields on Montmartre to dance, drink, and eat little crêpes *(galettes)* until dark. Renoir liked to go there to paint common Parisians living and loving in the afternoon sun. The sunlight filtering through the trees created a kaleidoscope of colors, like the 19th-century equivalent of a mirror ball throwing darts of light onto the dancers.

Renoir's work is lighthearted, with light colors, almost pastels. He captures the dappled light with quick blobs of yellow, staining the ground, the men's jackets, and the sun-dappled straw hat (right of center). Smell the powder on the ladies' faces. The painting glows with bright colors. Even the shadows on the ground, which should be gray or black, are colored a warm blue. Like a photographer who uses a slow shutter speed to show motion, Renoir paints a waltzing blur.

Degas, a rich kid from a family of bankers, got the best classical-style art training. Adoring Ingres' pure lines and cool colors, he painted in the Academic style. His work was exhibited in the Salon. He gained success and a good reputation, and then...he met the Impressionists.

Pierre-Auguste Renoir, **Dance at the Moulin de la Galette,** 1876 (Orsay Museum, Paris).
In good Impressionist style, Renoir captures not the photorealistic details, but the delightful swirling ambience of this afternoon scene on Paris' Montmartre.

Montmartre and the Moulin Rouge

During the belle époque, Paris' tiny hilltop village of Montmartre (420 feet high, marked by Sacré-Cœur basilica) was a "modern Acropolis" of nonconformism.

Freaks and bohemians of all sorts could literally look down on the bourgeois Paris they so detested. The village was a patchwork of struggling artists, poets, dreamers, and drunkards who came here for cheap rent, untaxed booze, rustic landscapes, and cabaret nightlife, and they partied to a bohemian beat.

The village's hotspot was the ramshackle Lapin Agile (or "Agile Rabbit," named for its logo), where entertainment ran the gamut from serious poetry to slapstick comedy to stirring liberal anthems.

The new Eiffel Tower at the 1889 World's Fair was nothing compared to the sight of pretty girls kicking their legs at Montmartre's newly opened Moulin Rouge (Red Windmill) nightclub. Ooh la la. The place seemed to sum up the belle époque—the age of opulence, sophistication, and worldliness. The big draw was amateur night, when working-class girls in risqué dresses danced Le Quadrille (dubbed "cancan" by a Brit). Wealthy Parisians slummed it by going there.

On most nights, you'd see a small man in a sleek black coat, checked pants, a green scarf, and a bowler hat peering through his pince-nez glasses at the dancers and making sketches of them—the artist Henri de Toulouse-Lautrec (too-loose-loh-trek, 1864–1901). Henri was the black sheep of a noble family. A cripple, he identified with other social outcasts: drunks, actors, circus freaks, and prostitutes.

Henri immortalized Jane Avril, one of the Moulin Rouge's most popular dancers. The elegant and melancholy woman stood out above the rabble of the Moulin Rouge. Her legs keep dancing while her mind is far away. Toulouse-Lautrec, the artist-ocrat, might have identified with her noble face, which was sad and weary of the nightlife, but immersed in it.

Henri de Toulouse-Lautrec, **Jane Avril Dancing,** 1891 (Orsay Museum, Paris).

Degas was fascinated with the camera, and his works look like unposed snapshots. In *The Glass of Absinthe,* a weary lady of the evening meets morning with a last lonely, coffin-nail drink in the glaring light of a four-in-the-morning café. The pale green drink forming the center of the composition is the toxic beverage called absinthe that fueled many artists...and burned out many more.

Post-Impressionism

After Impressionism, the modern art world splintered, never again to be contained by any one style. Post-Impressionism is just that—the art of the generation following the Impressionists. Though influenced by the Impressionists' bright colors and free spirit, they carved their own paths.

Paul Gauguin

Paul Gauguin (goh gan, 1848–1903)

Edgar Degas, **The Glass of Absinthe**, 1876 (Orsay Museum, Paris).

got the travel bug early in childhood and grew up wanting to be a sailor. Instead, he became a stockbroker. In his spare time, he hobnobbed with other young painters, including Vincent van Gogh. At the age of 35, he got fed up with it all, quit his job, abandoned his wife and family, and sailed away. In Tahiti, Gauguin found his Garden of Eden, where he was inspired by the tropical colors and beautiful native women. His simple life was matched by paintings as (deliberately) simple as a coloring book.

Paul Gauguin, **Arearea** (or **Joyousness**), 1892 (Orsay Museum, Paris).

Arearea (see previous page) uses heavy black outlines filled in with bright colors. The painting is flat and two-dimensional like a medieval altarpiece. Gauguin paints the native girls in their naked innocence. In the distance, a procession goes by with a large pagan idol. He captures a primitive world where religion permeates life...where idols, dogs, and women are holy.

Vincent van Gogh

Vincent van Gogh (pronounced "van-GO," or "van-HOCK" by the Dutch and the snooty, 1853–1890) used Impressionist techniques powered with passion. Painting what he felt as well as what he saw, his art truly reflects his life.

Van Gogh's subjects were simple: common people and landscapes. His style was untrained and crude. But by distorting and exaggerating certain colors and details, he gave his work spirit and emotion.

Perhaps the best examples of van Gogh's art are his self-portraits.

Van Gogh, **Self-Portrait, Paris,** 1887 (Orsay Museum, Paris).

Haunted and haunting, these show the man as well as his talent. We see in his eyes the burning love of all things and the desire to paint them on canvas.

VINCENT'S LIFE THROUGH ART

Vincent was the son of a Dutch minister. He felt a religious calling, and left home to spread the gospel in Holland and Belgium among the poorest of the poor, mainly peasants and miners. He painted these hardworking, dignified people in a crude, dark style reflecting the oppressiveness of their lives...

Van Gogh, **The Potato Eaters,** 1885 (Van Gogh Museum, Amsterdam).

Impressionist and Post-Impressionist Sights

- Orsay Museum, Paris
- Rodin Museum, Paris
- Marmottan Museum (Monet), Paris
- Orangerie Museum (more Monet), Paris
- Monet's Garden, Giverny, near Paris
- Toulouse-Lautrec Museum, Albi, France
- Tate Modern, London
- National Gallery, London

Vincent van Gogh Sights

- **Van Gogh Museum** (next to the Rijksmuseum), Amsterdam. Vincent's art is well displayed, in chronological order, making it clear how his itinerary through life was an artistic voyage as well.
- **Kröller-Müller Museum,** Arnhem, the Netherlands. This collection's many van Goghs are in a building tucked in the woods of a park.
- **Orsay Museum,** Paris. Most other major museums also have at least one or two van Gogh canvases.
- **Arles and St. Rémy,** France. If you're really on the van Gogh trail, you'll probably visit these places, where Vincent created the body of his work.

Vincent van Gogh, **Sunflowers,** 1888
(National Gallery, London).
Two years after painting these sunflowers, the artist killed himself.

Unfortunately, the towns have none of his paintings and surprisingly few memories of him, other than a café he once frequented (and painted). But nearby, the vast fields of sunflowers, gnarled cypress trees, and starry, starry nights of Provence will give you a sense of how this area inspired him.

- **Auvers-sur-Oise,** north of Paris. This town—where Vincent spent his final days—has an evocative trail leading to scenes that he, and the other artists who lived here, painted. Auvers-sur-Oise is his final resting place.

Van Gogh, **The Church at Auvers-sur-Oise,** 1890 (Orsay Museum, Paris).

and his own loneliness as he roamed northern Europe.

Encouraged by Theo, his art-dealer brother, Vincent moved to Paris. *Voilà!* The color! He met Monet, drank with Paul Gauguin and Henri de Toulouse-Lautrec, and soaked up the Impressionist style. At first, he painted like the others, but soon he developed his own style. By using thick, swirling brushstrokes, he infused life into even inanimate objects. Simple landscapes vibrate with an inner force that van Gogh believed inhabits all things.

The social life of Paris became too much for the solitary van Gogh. He moved to the south of France. At first, in the glow of the bright spring sunshine, he had a period of incredible creativity and happiness. He was overwhelmed by the bright colors, landscape vistas, and common people—it was an Impressionist's dream. Van Gogh's love of common people shines through in the paintings he did here, his subjects seeming to glow with, as he put it, "that something of the eternal which the halo used to symbolize."

Van Gogh, **The Sheaf-Binder,** 1889 (Van Gogh Museum, Amsterdam).

Over the next two years, an inspired Vincent would crank out more than 200 masterpieces.

But being alone in a strange country began to wear on him. An ugly man, he found it hard to get a date. He invited his friend Paul Gauguin to join him, but after two months together arguing passionately about art, nerves frayed.

On the night of December 23, 1888, Vincent van Gogh went ballistic. Drunk, self-doubting, clinically insane, and enraged at his friend Gauguin's smug superiority, he waved a knife in Gauguin's face, then cut off a piece of his own ear and

Van Gogh, **Van Gogh's Room at Arles,** 1889 (Orsay Museum, Paris).

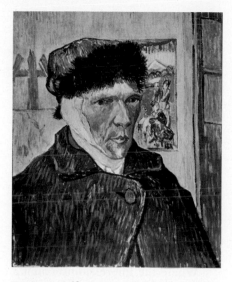

Van Gogh, **Self-Portrait with Bandaged Ear,** 1888–1889
(Courtauld Gallery, London).

gave it to a prostitute. Gauguin high-tailed it back to Paris, and the locals in Arles persuaded the mad Dutchman to get help. A week later, just released from the mental hospital, Vincent stood in front of a blank canvas and looked at himself in the mirror.

What he saw looking back was a calm man with an unflinching gaze, dressed in a heavy coat and fur-lined hat. The slightly stained bandage over his ear is neither hidden in shame nor worn as a badge of honor—it's just another accessory.

Van Gogh's paintings done in the peace of the mental hospital are more meditative—fewer bright landscapes, more closed-in scenes with deeper and almost surreal colors. Van Gogh, the preacher's son, saw painting as a calling, and he approached it with a spiritual intensity.

Van Gogh wavered between happiness and madness. He despaired of ever being sane enough to continue painting. In the spring of 1890, Vincent left Provence to be cared for by a doctor in Auvers-sur-Oise, north of Paris. On July 27, he wandered into a field and shot himself. He died two days later.

Van Gogh, **Wheatfield with Crows,** 1890 (Van Gogh Museum, Amsterdam).
Vincent's final canvas. Vincent van gone.

Georges-Pierre Seurat, **Bathers at Asnières**
(detail), 1883
(National Gallery, London).
Seurat used a technique called "pointillism," a
mosaic consisting entirely of colored dots.

Pointillism = Lots of Dots

Georges-Pierre Seurat (suh-rah, 1859–1891) spent Sundays in the park with his paints. His bright scenes bring the Impressionist dabs-of-paint style to its logical conclusion.

Viewed from about 15 feet away, this painting is a bright, sunny scene of people lounging on a riverbank. Up close it's lots of dots, like the pixels of a digital photo or the printed dots of a newspaper photo. The green grass is actually a shag rug of green, yellow, red, brown, purple, and white brushstrokes. Even the shadows are not dingy black, but warm blues, greens, and purples.

Paul Cézanne

Paul Cézanne (say-zahn, 1839–1906) brought Impressionism into the 20th century. After the color of Monet, the warmth of Renoir, and the passion of van Gogh, Cézanne's rather impersonal canvases can be difficult to appreciate. Bowls of fruit, landscapes, and

a few portraits were Cézanne's great subjects. Because of his style (not the content), he is often called the first modern painter.

A man of independent means, Cézanne ignored Paris, the critics, and the buying public. He worked to capture the best of both artistic worlds: the instantaneity of Impressionism and the realistic depth and solidity of earlier styles. Cézanne was virtually unknown and unappreciated in his lifetime. He worked alone, lived alone, and died alone, ignored by all but a few revolutionary young artists who understood his genius.

Where the Impressionists built a figure out of a mosaic of individual dabs of paint, Cézanne used cube-shaped blocks of paint to create a more solid, geometrical shape. It's no coincidence that his experiments in reducing forms to their geometric basics influenced the...Cubists.

Take a look at Cézanne's *The Card Players*. These aren't people. They're studies in color and pattern. The subject matter—two guys playing cards—is less important than the pleasingly

Paul Cézanne, **Apples and Oranges,** 1899
(Louvre Museum, Paris).
Cézanne once remarked that nature reveals itself
in the geometric forms of spheres, cylinders, and
cones.

Paul Cézanne, **The Card Players**, c. 1890–1895 (Orsay Museum, Paris).

two-dimensional wall of color—an abstract design. Cézanne juggled many technical balls of modern painting while still managing to make mountains look like mountains, and oranges look like oranges.

Auguste Rodin

Auguste Rodin (roh-dan, 1840–1917) was a modern Michelangelo, sculpting human figures on an epic scale, revealing through the body their deepest thoughts and feelings. They twist, squirm, and restlessly embrace each other, driven by the life force. Many have missing limbs and scarred skin, making ugliness noble. Rodin's people are always moving. Even the famous *Thinker* is moving. While he's plopped down solidly, his mind is a million miles away.

balanced pattern they make on the canvas, two sloping forms framing a cylinder (a bottle) in the center. Later, abstract artists would focus solely on the colors and shapes (see sidebar on page 373). The jacket of the player on the right is a patchwork of tans, greens, and browns. Even the "empty" space between the men—painted with fragmented chunks of color—is almost as tangible as they are. As one art scholar put it: "Cézanne confused intermingled forms and colors, achieving an extraordinarily luminous density in which lyricism is controlled by a rigorously constructed rhythm." Just what I said: chunks of color.

Another feature of Cézanne's work that's characteristic of modern art is that he uses the same size brushstroke to paint things in the foreground as things in the distance. The result is that the foreground and background blend together into what looks like a

Rodin blended Impressionist ideas with his classical training. The rough "unfinished" surfaces, particularly of his bronze works, reflect light the same way the thick brushwork of an Impressionist painting does.

Though Rodin chiseled some statues out of marble, he mainly worked in bronze. This doesn't mean he hammered and welded sheets of metal into shape. He followed the classic "lost wax" method used by the ancients. First he'd make the statue out of wet plaster, then make a mold of it. Fill the mold with molten bronze, remove the mold and—*voila!*—you've got a hollow bronze statue ready for polishing. Because you could use the same mold

again and again, there are identical (authorized) copies of Rodin master-pieces all over the world. Still, the best collection is at Paris' Rodin Museum, in a house he once lived in that's now inhabited by his statues.

Rodin's most famous work is *The Thinker.* Leaning slightly forward, tense and compact, every muscle working toward producing that one great thought, Man contemplates his fate. (No constipation jokes, please.)

This is not an intellectual, but a linebacker who's realizing there's more to life than frat parties. It's the first man evolving beyond his animal nature to think the first thought.

Auguste Rodin, **The Thinker,** 1906 (Rodin Museum, Paris). *Hmm...did I remember to put on my money belt this morning?*

It's anyone who's ever worked hard to reinvent himself or to make some-thing new or better. Said Rodin: "It is a statue of myself."

The *Fin de Siècle*

As the year 1900 loomed on the hori-zon, Europe was peaceful and prosper-ous, and reveled in being the capital of world culture. But, as we've seen, within this belle époque there were also strains of rebellion and non-conformism. This darker cousin of the belle époque is often labeled *fin de siè-cle* (end of century). Technology was changing everything, and, as the name suggests, it seemed to some that the world they had known was quickly coming to an end. For highly sophisticated, bored pleasure-seekers, it was time to party.

Art Nouveau

As Europe approached the dawn of a new *(nouveau)* century, it embraced a new art: Art Nouveau. On the one hand, it was very for-ward-looking and modern. But it was also a reaction against the sheer ugliness of the mass-produced, boxy, rigidly geometrical art of the Industrial Age. Art Nouveau artists returned to nature (which abhors a straight line) and were inspired by the curves of plants. And as in nature, no two objects are exactly the same, so the artist should be free to make his work unique.

During the Art Nouveau period, art came with organic curves. Lisbon's Gulbenkian Museum has a roomful of Art Nouveau jewelry by French designer René Lalique.

top. It was here that young artists first exhibited their "youth-style" art in 1897. Secessionist leader and poster boy Gustav Klimt (1862–1917) gained fame painting slender young women entwined together in florid embrace.

In Catalunya, in the northeast corner of Spain, Art Nouveau was known as Modernisme (a taste for what is modern), and Barcelona was the style's capital. Modernista architects seemed

Artists embraced new technology to design buildings, furniture, and fountains in the new style. Street lamps twist and bend like flower stems. Ironwork fountains sprout buds that squirt water. Dining rooms are paneled with leafy garlands of carved wood. Artists turned even everyday household objects into art.

Art Nouveau went international. In Paris, the Métro stations featured hard metal twisted into plant-like shapes. In Prague, Alfons Mucha created pictures of pretty girls entwined in vines, inspiring poster-art everywhere. In America, Louis Tiffany's natural-looking "flower-petal" stained-glass lamps were the rage.

In Vienna (and German-speaking countries), Art Nouveau was called Jugendstil (youth style). The innovators here were collectively called The Secession. Their motto was: "To each age its art, and to art its liberty." Their Vienna headquarters, also called The Secession, is nicknamed the "golden cabbage" for its bushy gilded roof-

Gustav Klimt, **Judith I**, 1901 (Belvedere Palace, Vienna). *Klimt took the decorative element of Art Nouveau to extremes. In many of his paintings, only the face and bits of body show through gilded ornamental friezes.*

Alfons Mucha, **Stained-Glass Window,** 1931 (St. Vitus' Cathedral, Prague, Czech Republic).
*This remarkable Art Nouveau window, by Czech patriot Alfons Mucha, shows a kneeling boy and a
prophesying elder—that's young King Wenceslas and his grandmother, St. Ludmila. The old woman,
with closed eyes, symbolizes the past and memory, while the young boy, with a penetrating stare,
represents the hope and future of the nation. Mucha's work is packed with meaning and technical
mastery...but it's also simply a joy to behold.*

Art Nouveau Sights

- Green iron grillwork at old Métro stops, Paris
- Orsay Museum (exhibits on mezzanine level), Paris
- The Secession building, Vienna
- Belvedere Palace art collection, Vienna
- Gaudí architecture (especially Casa Milà and Sagrada Família), Barcelona, Spain
- Alfons Mucha Museum, Prague, Czech Republic
- Paris, Barcelona, Vienna, Prague, Ljubljana (Slovenia), Brussels, Munich, Glasgow, Helsinki, and Ålesund (Norway)—all famous for their Art Nouveau architecture

Some of Paris' Metro stations still have their original iron-and-glass work.

determined to do everything possible to disrupt the rigid angles of the industrial world. Barcelona's Eixample neighborhood shimmers with the colorful, leafy, flowing, blooming shapes of Modernisme in doorways, entrances, facades, and ceilings.

Modernista architects experimented with new construction techniques—most importantly, concrete and rebar. They could make a hard stone building that curved and rippled like a wave. Then they sprinkled it with brightly colored glass and tile. The decoration was a clip-art collage of motifs from Barcelona's medieval glory days, such as Moorish themes, or fanciful Gothic crosses and knights.

Antoni Gaudí (gow-DEE, 1852–1926), Barcelona's most famous

Antoni Gaudí, **Sagrada Família,** begun 1883 (Barcelona, Spain).
While construction continues at a snail's pace, this fanciful church is open to the public.

Timeline of Europe (1800–1900)

Antoni Gaudí, **Casa Milà,** 1905 (Barcelona, Spain).

Modernista artist, took Art Nouveau to its curvaceous extreme. His Casa Milà apartment house has a much-photographed roller coaster of melting-ice-cream eaves. Gaudí's final opus, the soaring Sagrada Família church—an undertaking as immense as the biggest Gothic cathedrals—is still a work in progress.

Gaudí's buildings may look strange, but they're structurally very sound. Gaudí was inspired by the structure of the natural world: thigh bones, birds' wings, waves, caves. He's considered a pioneer, a prophet, and a dreamer who was lucky enough to see his dreams become concrete.

Just When Things Were Going So Well...

Modern nations were forming, democracy was on the march, and artists felt free to paint their inner children.

But Europe was coasting on centuries of accumulated wealth. In their colonies, the natives were restless. Unbridled capitalism stoked national greed. And Germany, the last of the powers to join the race, was a big and hungry bully without its own "place in the sun." The technology that made belle époque life so good could also make machine guns, nerve gas, and bomb-dropping airplanes. The 1900s would nearly be the century to end all centuries.

Edvard Munch, **The Scream**, 1893
(Edvard Munch Museum, Oslo).

The 20th Century

A.D. 1900: A new century dawns. Europe is the enlightened center of a global colonial empire, war is history, and science will wipe out poverty and disease. Rational Man is poised at a new era of peace and prosperity...

Right.

This cozy Victorian dream was soon shattered by two World Wars and rapid technological change. Politically, the last Old Regime kings were swept away, and totalitarian dictators took their place. In religion, atheists murdered God. In science, Einstein made everything merely "relative." Sigmund Freud washed ashore on the beach of a vast new continent inside each of us. Even the fundamental building blocks of the universe, atoms, were behaving erratically.

The 20th century—accelerated by technology and fragmented by war—was exciting and chaotic.

A Prelude to War

Beneath Europe's placid belle époque exterior, tension was growing. Germany's late entry onto the European game board upset the balance of power. When Germany united in 1870, it was suddenly the biggest, scariest kid on the block. An economic and military powerhouse, the adolescent country was hungry for overseas colonies—with their raw materials and ready consumers—to fuel its growing economy. By the late 19th century, most of the underdeveloped world (Africa, Asia, South America) was already controlled by other European powers. An aggressive Germany muscled in on others' turf, and Europe got edgy.

Fearful of German encroachment, Europe's other nations scrambled to ally with their neighbors. Everyone dove headlong into an international game of *Let's Make a Deal*. Since many alliances were secret, and often conflicting, no one knew for sure exactly where anyone else stood.

The European order established in 1815 by the Congress of Vienna (see page 306) was in danger of coming apart. A spirit of nationalism continued to sweep through the last remaining baronies and dukedoms, particularly in the Austro-Hungarian

Empire. National groups were calling for independence.

In early newsreel footage, all of Europe could see flickering images of wave after wave of German soldiers, goose-stepping past the camera in perfect synch, followed by gleaming, state-of-the-art cannons. War was of course unthinkable, but Europe's nations began to arm themselves. Tick, tick, tick....

World War I

Europe was ready to explode, but the spark that would set things off had nothing to do with Germany.

On June 28, 1914, in Sarajevo, the Hapsburg Archduke Ferdinand and his wife were assassinated by a teenage terrorist who wanted Serbia freed from Austro-Hungarian rule. The Hapsburg government in Vienna jumped at the opportunity to crush the troublesome Serbs. One by one, Europe's nations were dragged into this regional dispute by a web of alliances. Each had a self-serving interest.

Russia jumped in on the side of its Slavic cousin, Serbia. To counteract Russia (a growing threat to the east), Germany gave the Austro-Hungarian Empire a blank check of support. So, when the Austro-Hungarian Empire attacked Serbia, the Russians mobilized, and Germany responded by invading...France! France and Russia were allies, and Germany hoped to wipe out France by surprise, rather than risk getting embroiled in a two-front war. Britain came to France's aid, while Turkey backed the Germans and Austrians. Nation by nation, the conflict grew. Across Europe, generals scrambled for their geography books to see who they were fighting. The Great War had begun.

It didn't work out quite the way Germany planned. Instead of a quick war, everyone outflanked everyone else. It became a stalemate, and the two sides dug in for the long haul. A line soon stretched from the Atlantic to

Henri Rousseau, **War,** 1894 (Orsay Museum, Paris).

Europe 1914: On the Eve of World War I

ATLANTIC OCEAN — NORWAY — FINLAND — SWEDEN — GREAT BRITAIN — IRELAND — DEN. — NORTH SEA — Moscow — London — NETH. — Berlin — RUSSIA — BELG. — GERMAN EMPIRE — POLAND — Paris — Western Front — Vienna — Verdun — SWITZ. — AUSTRO-HUNG. EMPIRE — FRANCE — ITALY — Sarajevo — ROM. — PORT. — SERBIA — BLACK SEA — SPAIN — Rome — ALB. — BULG. — OTTOMAN EMPIRE (TURKEY) — GREECE — MEDITERRANEAN SEA

☐ ALLIES ◼ CENTRAL POWERS ☐ ITALY (SWITCHED FROM CENTRAL POWERS TO ALLIES IN 1915) ◼ NEUTRAL

the Alps, dividing the French and German forces: the Western Front. They dug trenches. Cold, rainy, muddy, and disease-ridden, the trenches became home for millions of men. Nobody planned it. It was simply human nature for soldiers ducking machine-gun bullets to burrow down. France and Germany settled into a battle of attrition.

For four years, generals waved their swords, and wave after wave of soldiers climbed out of their trenches, waded into "no man's land," and fell to their deaths. One side or other might capture a little territory, only to lose it again the next day. Leaders of both sides bashed their armies against each other, knowing there would be horrific losses but calculating that the other would tire of the bloodshed first and surrender. On a number

L'Ossuaire de Douaumont (near Verdun, France) is the tomb of 130,000 unidentified French and German soldiers whose last homes were the muddy trenches of Verdun. It's surrounded by a sprawling field of crosses.

bloody years for the Allies (France, England, Russia, and, ultimately, the US) to defeat Germany and the Austro-Hungarian Empire.

In 1918, the "war to end all wars" ground to a halt, leaving 10 million dead and Germany defeated. France and Britain were the "winners," but just barely. Half of all Frenchmen between the ages of 15

of occasions, France lost 70,000 people in a single day. (That's more than the US lost in the entire Vietnam War.)

Oh, it was awful. The war debuted new technology. Men on horseback battled tanks. Foot soldiers wielding bayonets faced the hail of machine gun fire. Chemical weapons (nerve gas) were first deployed. Huge cannons (like the Germans' "Big Bertha," which launched 1,800-pound shells) demolished distant villages of innocent civilians. Many of the war's generals had been heroes of 19th-century conflicts and underestimated the new weapons. Before the war, the machine gun had been called "the peacekeeper," because it was assumed that no sane commander would ever send his boys into its fire.

On the Eastern Front, Russia and Germany fought a more mobile war (using trains to move troops), but it was equally bloody. Meanwhile, the Austro-Hungarian Empire had trouble with the stubborn Serbs.

Europe dove into World War I expecting a quick finish. It took four

and 30 were casualties. A generation was lost, and France's days as a global superpower were over.

The Treaty of Versailles and a New Europe

After the war, the map of Europe was redrawn. The Treaty of Versailles that ended the war (signed in the Hall of Mirrors, 1919) punished Germany severely, leaving it crushed, humiliated, stripped of crucial provinces, and saddled with demoralizing war debts. For the next two decades, Adolf Hitler would feed off German resentment over the Treaty of Versailles.

Europe's old ruling families were deposed, replaced by nations whose borders were loosely defined by ethnic and cultural identity. The once-mighty Hapsburg Empire was carved up, creating smaller versions of Austria and Hungary, as well as a reconstituted Poland (which had been absorbed by other countries for the previous hundred years). Other former Hapsburg subjects banded together to form brand-new nations: The Czechs and

Slovaks forged Czechoslovakia, and the Serbs, Croats, Slovenes, and Bosnians created Yugoslavia. (Yugoslavia means "Land of the South Slavs," which ironically is what the teenage terrorist was gunning for when he killed Archduke Ferdinand back in 1914, starting the horrible war.) Both Czechoslovakia and Yugoslavia were useful for their time, but were destined to fail by century's end.

The Russian-controlled lands became Finland, Latvia, Estonia, Lithuania, and part of the new Poland.

In Russia, the ravages of the war had undermined the Romanov czar (king), who was driven from power in 1917 by Vladimir Lenin's Communists. This "October Revolution," inspired by the 19th-century writings of Karl Marx, was intended to take power from the undeserving rich and put it in the hands of ordinary workers. Originally idealistic, this movement became increasingly oppressive. The Communists established the Union of Soviet Socialist Republics (USSR), made up of federated states controlled from Moscow.

General Post Office (Dublin, Ireland). *This is not just any P.O. It was from here that Patrick Pearse read the Proclamation of Irish Independence in 1916, kicking off the Easter Rising. The building itself—a kind of Irish Alamo—was the rebel headquarters and scene of a bloody five-day siege that followed the proclamation. Its pillars remain pockmarked with bullet holes.*

Vladimir Lenin (1870–1924) was a poster boy of communism. His face decorated factories and public spaces throughout Eastern Europe and the USSR for many decades.

In Ireland, rebels took advantage of Britain's preoccupation with the war to fight for independence. On Easter Monday, 1916, 1,500 Irish "Volunteers" marched on Dublin, occupied the General Post Office, raised a green-white-and-orange flag, and proclaimed Ireland an independent republic. British troops easily crushed the tiny revolt and executed the ringleaders, but the brutality they used in doing so outraged the formerly indifferent Irish majority, and the spirit of revolt spread through the island. As the poet W. B. Yeats put it, "All changed, changed utterly: A terrible beauty is born."

Kemal Atatürk: Father of Modern Turkey

In World War I, a clueless Ottoman Empire had sided with Germany, and ended up a loser. After the war, Turkey would have been dominated by European powers but for the intervention of one remarkable man.

Kemal Atatürk (1881–1938) almost single-handedly created modern-day Turkey. He chased out foreign troops, established the Turkish Republic (1923), and immediately began an astonishing set of changes to the traditional Muslim country. In less than 10 years, Atatürk separated mosque and state, aligned Turkey with the West rather than the East, changed the alphabet from Arabic script to Roman letters, abolished polygamy, and gave women the vote (by comparison, Swiss women received the vote in 1971). Still highly revered in Turkey, he is the subject of just about every statue and public portrait, honored by the name his parliament bestowed upon him: Atatürk, which means "Father of the Turks." Locals still claim they see his face from time to time in the clouds that blow slowly over Anatolia.

Five years and a thousand deaths later, Ireland was granted independence from Britain (1921). The island was split in two. The southern three-quarters (mostly Catholic, Gaelic, and rural) became independent, while the northern quarter (predominantly Protestant, English, and industrial) voted to stay connected to Britain. (That division was the cause of the "Troubles" that plagued Ireland from the 1970s through the 1990s, and it still exists today.)

Finally, across the Atlantic, a new and growing global power was emerging—the United States of America.

Between the Wars: The Jazz Age

Europe tried to drown the horrors of the war years with wine and cynicism. In the Jazz Age (named for the popular musical import from America), the world turned upside down. Genteel ladies smoked cigarettes. Gangsters laid down the law. People made a fortune in the stock market one day and lost it the next. Hip-shaking dances like the Charleston were in vogue, and cocktail-hour discussions of Sigmund Freud and sex were common.

A Lost Generation of disillusioned writers and artists flocked to Paris to find themselves. Many came from

uptight, Prohibition-era America, as the dollar was strong and France was cheap. Paris between the wars became a *Who's Who* of international culture: American writers Ernest Hemingway, F. Scott Fitzgerald, and Gertrude Stein; painters Pablo Picasso and Salvador Dalí of Spain; composers Maurice Ravel, Erik Satie, and Igor Stravinsky; cabaret singer Maurice Chevalier; and the Existentialist philosopher Jean-Paul Sartre.

It was in this highly creative environment that modern art—which was inspired by the 19th-century Impressionists and Post-Impressionists—really took off.

Jean Dubuffet, **Dhôtel Nuancé d'Abricot,** 1947 (Pompidou Center, Paris). *"Modern art: A-a-argh-gh-gh!!"*

20th-Century Art, Part One
(1900–1950)

Some people hate modern art.

Why is it so bizarre? Why doesn't it look like the real world? Why does it look like my kid's preschool project? My dog could do a better job on the carpet.

Better to ask: Why is the modern world so bizarre? In the 20th century, the world changed by leaps, bounds, and somersaults. Modern art merely reflects the turbulence of that century of change.

With the camera, realistic art became obsolete. With mass production, handmade art became an economic dinosaur. Artists found themselves on the outside. They turned to art that was not functional or realistic, but that could be appreciated for its technique, personal message, and hidden meanings. Originality and innovation became more important than sheer beauty. Modern artists faced the same challenge as Michelangelo's successors: to be original at all costs. Their

Which would you pay $35 million for? The **Romanian Blouse** *by Henri Matisse (left), or the* **Samurai** *(right) by the five-year-old daughter of one of your co-authors?*

solution: If you can't please the public, shock it.

From Cubism to Surrealism to Expressionism to Fauvism, modern art is certainly a jumble of styles and "isms" with only one thing in common: They don't look like "real"-ism. But you can't judge art simply by how well it copies reality. Artists distort the real world intentionally. First, try to understand the artist's purpose, and then you can appreciate—or hate—with gusto.

Modern artists capture the "real" world in two different ways. Some depict the real world but distort things to express emotion (as van Gogh did). Others abandon the visible world altogether, using basic lines and patches of color to capture the unseen. Most modern art styles are variations on these two basic themes: expressive or abstract.

"The Moderns" (1900–1914)
As the 20th century began, Paris was Europe's art capital. The modern world was moving faster, with automobiles, factories, and mass communication. Einstein's theories were undermining the very notion of "reality." New ideas were bubbling everywhere, and artists, too, explored new ways of looking at things.

Henri Matisse
At age 20, a budding lawyer named Henri Matisse (muh-teese, 1869–1954) was struck down with appendicitis. Bedridden for a year, he turned to painting as a healing escape from pain and boredom. After recovering, he studied art in Paris and produced dark-colored, realistic still lifes and landscapes. But soon after, influenced by the Impressionists, he began to experiment with sunnier scenes and more vivid colors.

Matisse's works are not realistic. A man is a few black lines and blocks of paint. The colors are unnaturally bright. The illusion of distance and three-dimensionality that were so important to Renaissance Italians are nowhere in evidence. The landscape in

Marcel Duchamp, **Sad Young Man on a Train,** 1911–1912
(Peggy Guggenheim Collection, Venice).
Duchamp captures the blur of fast-paced modern life.

Matisse, **Odalisque in Red Culottes,** c. 1924 (Orangerie Museum, Paris).

line...and then let the viewer's mind fill in the rest.

Traditionally, the canvas was like a window that viewers looked through to see a slice of the real world stretching off into the distance, but a camera could now do that better. Matisse had no interest in competing with photography; his paintings shouldn't be viewed as poor imitations of reality, but as slightly abstract patterns of colors and shapes that are fascinating in their own right.

Matisse painted fruit, flowers, wallpaper, and interiors of sunlit rooms, often with a window opening onto a sunny landscape. Another favorite subject was the odalisque (harem concubine) sprawled in a seductive pose, with a simplified mask-like face.

Though fully "modern," Matisse built on elements from 19th-century

the distance is as bright and clear as the elements in the foreground, and the slanted lines meant to suggest depth are crudely done. Matisse, the master of leaving things out, could suggest a woman's body with a single curvy

Matisse, **Joy of Life,** 1905–1906 (Barnes Foundation, Merion, PA).

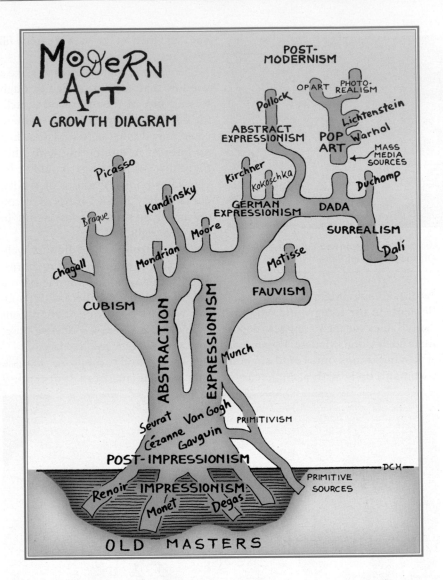

MoDeRN ArT

A GROWTH DIAGRAM

POST-MODERNISM

OP ART
PHOTO-REALISM
Lichtenstein
Warhol
POP ART
MASS MEDIA SOURCES
Duchamp
Pollock
ABSTRACT EXPRESSIONISM
Picasso
Kandinsky
Kirchner
Kokoschka
GERMAN EXPRESSIONISM
DADA
SURREALISM
Dali
Braque
Moore
Mondrian
Matisse
Chagall
CUBISM
ABSTRACTION
EXPRESSIONISM
FAUVISM
Munch
Seurat Van Gogh
Cézanne Gauguin
PRIMITIVISM
POST-IMPRESSIONISM
DCH
PRIMITIVE SOURCES
Renoir IMPRESSIONISM
Monet Degas
OLD MASTERS

art: the bright colors of Vincent van Gogh, the primitive figures of Paul Gauguin, and the Impressionist patches of paint that only blend together at a distance.

Primitives and Wild Beasts

Matisse was one of the Fauves (wild beasts) who tried to inject a bit of the jungle into bored, turn-of-the-century French society. The Fauves were inspired by African and Oceanic masks, voodoo dolls, and by the work of Gauguin in Tahiti (see page 345).

The result? Modern art that looked primitive. People are painted with a few dark outlines. They have long, mask-like faces with almond eyes. The colors are bright and clashing. And the scene has the deliberately

"flat" look of pre-Renaissance art.

The Fauves distorted the visible world so we could see it through more primitive eyes. Bored with the slick realism they'd learned in art school, they turned to a cruder style—a style in which even the simplest statues radiate mojo.

If the Fauves bent the art world, a young Spanish painter was about to break it into a million pieces...then glue it back together.

Pablo Picasso

Pablo Picasso (1881–1973) was the most famous and—OK, I'll say it—the greatest artist of the 20th century.

Picasso, **Self-Portrait**, 1901
(Picasso Museum, Paris).

Always exploring, he became the master of many styles (Cubism, Surrealism, Expressionism, and so on) and of many media (painting, sculpture, prints, ceramics, and assemblages), but always managed to make everything he touched look unmistakably like "a Picasso."

Picasso's teenage works are stunningly realistic, with wise insight into the people he painted. At 19, the Spaniard moved from Barcelona to Paris, where the artistic action was at the time. His early paintings from Paris are of beggars and other social outcasts, showing the empathy of a man who was himself a lonely outsider. These works mark his Blue Period (about 1905), so called because their dominant color matches their melancholy mood.

Picasso was jolted out of his Blue Period by the "flat" look of the Fauves. Not sat-

isfied with their take on 3-D, Picasso played with the "building blocks" of line and color to find new ways to reconstruct the real world on canvas.

At his studio in Montmartre (see page 344), Picasso and his neighbor Georges Braque worked together, in poverty so dire they often didn't know where their next bottle of wine was

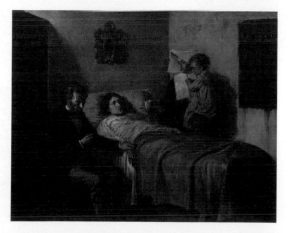

Pablo Picasso, **Science and Charity**, 1897
(Picasso Museum, Barcelona).
As a teenager, Picasso painted realistically.

Pablo Picasso, **The Ladies of Avignon**
(Les Demoiselles d'Avignon), 1907
(Museum of Modern Art, New York).
These five "ladies"—actually prostitutes in Barcelona's red light district—are the focus of what's often regarded as the first truly Cubist work.

Cubism because the painting looks as though it was built with blocks.

Having revolutionized the art world before he was 30, Picasso just kept changing with the times. He turned to more colorful and curved cubes to build his figures (Synthetic Cubism). After he married and had kids, he entered a Classical period (the 1920s) of more realistic, full-bodied women and children. As his relationships with women deteriorated, he vented his sexual demons by twisting the female body into grotesque balloon-animal shapes (1925–1931).

Throughout his life, Picasso always kept a grip on "reality." His favorite

coming from. They emerged with a new way to portray the world, called subject was people. The anatomy might be jumbled, but it's all there. In his mon-

Pablo Picasso, **La Joie de Vivre,** 1946 (Picasso Museum, Antibes, France).
It's 1946, the war is over, and France is liberated. Picasso paints his lover (23-year-old Françoise Gilot) and a merry band of satyrs, centaurs, and fauns, celebrating peace and freedom on a Riviera beach.

Cubism: Reality Shattered (1907–1912)

I throw a rock at a glass statue, shatter it, pick up the pieces, and glue them onto a canvas. I'm a Cubist.

Picasso shattered the Old World and put it back together in a new way. His subjects are somewhat recognizable (with the help of the titles), but they're built with geometric shards (or "cubes").

Cubism gives us several different perspectives on the same subject, all at once. For instance, we see the face of a woman simultaneously in profile and straight on, resulting in two eyes on the same side of the nose. This involves showing the traditional three dimensions, plus Einstein's new fourth dimension—the time it takes to walk around the subject to see other angles. Newfangled motion pictures could capture this moving, 4-D world, but how to do it on a 2-D canvas? Picasso did it with a collage of stills. A Cubist painting is a kind of Mercator projection, where the round world is sliced up like an orange peel and then laid as flat as possible.

Notice how the "cubes" often overlap. A single cube might contain both an arm (in the foreground) and a window behind it (in the background), both painted the same color. The foreground and the background are woven together, so that the subject dissolves into a pattern.

Pablo Picasso, **Seated Nude,** 1909
(Tate Modern, London).
During a frenzied period in Paris with painting buddy Georges Braque, Picasso jumbled realism into a new art style, called Cubism.

umental mural *Guernica* (see page 382), Picasso tweaks reality with the abstract and the expressive. We can clearly see what's happening, but Picasso's disjointed Cubist style only adds to the horror of war. It's as if the bombs had shattered every belief and decimated every moral principle, leaving civilization in a confused heap of rubble.

Picasso spent the final years of his life on the French Riviera, consorting with women half his age. There he created sunny, childlike pictures of birds, goats, fish, and frolicking beach-goers.

His simple doves became an international symbol of peace.

Picasso, **Bull's Head**, 1943 (Picasso Museum, Paris).

Picasso made collages, built statues out of wood, wire, even everyday household objects (like his famous bull's head made of a bicycle seat with handlebar horns). These kinds of multimedia works have become so standard today that we forget how revolutionary they were when Picasso invented them. His last works have the playfulness of someone much younger. As it is often said of Picasso, "When he was a child, he painted like a man. When he was old, he painted like a child."

Marc Chagall

Marc Chagall (shuh-GAWL, 1887–1985) arrived in Paris with the wide-eyed wonder of a country boy. In his art, lovers are weightless with bliss. Animals smile and wink. Musicians, poets, peasants, and dreamers ignore gravity, tumbling in slow-motion circles high above the rooftops. The colors are deep, dark, and earthy—a pool of mystery with figures bleeding through below the surface. (Chagall claimed his early poverty forced him to paint over used canvases, inspiring the overlapping Cubist images.)

Chagall's very personal style fuses many influences. He was raised in a small Belarusian village, which explains his somewhat naive outlook and fiddler-on-the-roof motifs—his simple figures are like Russian Orthodox icons, and the Old Testament themes in his work grew out of his Jewish

roots. Stylistically, he's thoroughly modern, employing Cubist shards, bright Fauve colors, and Primitive simplification. His otherworldly style was a natural for religious works, and so his murals and stained glass, which feature both Jewish and Christian motifs, decorate buildings around the world.

Abstract Art = Visual Music

Abstract art simplifies. A man becomes a stick figure. A squiggle is a wave. A streak of red expresses anger. Arches make you want a cheeseburger.

These are universal symbols that everyone from a caveman to a banker understands. Abstract artists capture

Marc Chagall, **Liberation** (detail), 1937–1952 (Pompidou Center, Paris).
Chagall said, "In art, as in life, everything is possible provided it is based on love." The floating couples, so common in his canvases, seem to echo that belief.

From Realism to Abstraction

Watch these card players evolve from realistic to abstract: Cézanne, a Post-Impressionist, paints the figures more or less realistically. Van Doesburg flattens the figures in his earlier painting, so the canvas is more a composition of geometric shapes...but the subject matter is still apparent. In his later painting, van Doesburg simplifies everything into a jumble of puzzle pieces, in which the card players are barely recognizable—the blocks of line and color themselves become the subject.

Paul Cézanne, **The Card Players**, 1892 (Louvre Museum, Paris).

Theo van Doesburg, **Card Players**, 1916.

Theo van Doesburg, **Card Players**, 1917.

the essence of reality in a few lines and colors, even things a camera can't: emotions, intellectual concepts, musical rhythms, and spiritual states of mind. Remember: With abstract art, you don't look "through" the canvas to see the visual world, but "at" it to read the symbolism of lines, shapes, and colors.

All art is simplification in some way or other. A tree, for instance, can never be painted with all its infinite details. A painting is a fake tree made from the building blocks of lines, colors, and shapes. By the 20th century, artists were content to leave reality to the camera. Like kids with colorful building blocks, they were free to do what they wished with lines, shapes, and colors. Sure, they could build a house or some other recognizable object, but they could also just stack and arrange the "blocks" into colorful patterns.

Abstract artists have been criticized for playing with their blocks and

avoiding reality. They reply that what they paint *is* reality—not the fleeting reality of the visible world that changes and passes away, but the eternal and unchanging world of geometrical relationships. The abstract artist simplifies the world into timeless shapes and colors.

Art scholars use special terminology for modern art. "Representational" art tries to faithfully reproduce (or "represent") a real object using lines, shapes, and colors as building blocks. "Abstract" art is to be appreciated solely for its lines, shapes, and colors, not what they're meant to represent. Most 20th-century art is a mix of: the real world (representation); its deliberate distortion for effect (expressionism); and the building blocks themselves (abstract).

It's helpful to compare abstract art to pure instrumental music. Some music is designed to imitate a sound heard in nature, such as a storm or a

Wassily Kandinsky, **Dreaming Improvisation**, 1913. *Reality is tossed out the window as the artist calls on us to enjoy more basic shapes and colors. We hope this is right side up.*

bird's call (representational). Other music is intended to express an emotion, such as the sadness caused by the death of a friend (expressionism). But most music is the perfect audio equivalent of abstract visual art. It simply plays with the beautiful shapes and colors of sound, the harmonious relationship of tones.

Are your eyes as open-minded as your ears?

Wassily Kandinsky

Wassily Kandinsky (1866–1944)—like a jazz musician improvising from a set scale—plays with colors and lines, creating patterns that are simply beautiful, even if they don't "mean" anything. The bright colors, bent lines, and lack of symmetry suggest that Kandinsky's

Abstract thinking.

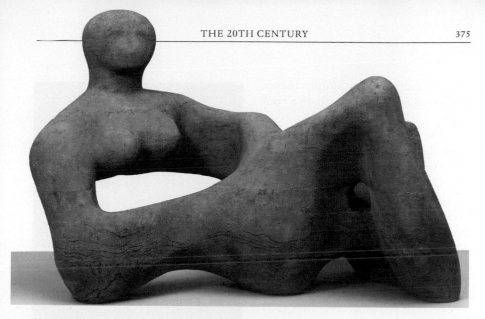

Henry Moore, **Recumbent Figure,** 1938 (Tate Modern, London).

world was passionate and intense. As Kandinsky himself would say, his art was like "visual music—just open your eyes and look." Notice titles like *Improvisation* and *Composition.*

Piet Mondrian

Like blueprints for modernism, Mon

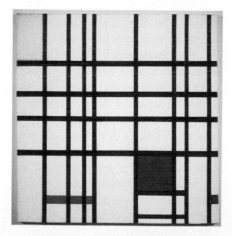

Piet Mondrian,
Composition with Yellow, Blue, and Red,
1937–1942
Oil on Canvas, 72.5 x 69 cm (28⅜" x 27¼")
©2007 Mondrian/Holtzman Trust c/o HCR International
Warrentown, VA.

drian's T-square style boils painting down to its basic building blocks (black lines, white canvas) and the three primary colors (red, yellow, and blue), all arranged in orderly patterns.

Mondrian (mahn-dree-AHN, 1872–1944) started out painting realistic landscapes of the orderly fields in his native Netherlands. Increasingly, he simplified them into horizontal and vertical patterns. For Mondrian, who was heavy into Eastern mysticism, up vs. down and left vs. right were the perfect metaphors for life's dualities: good vs. evil, body vs. spirit, man vs. woman. The canvas is a bird's-eye view of Mondrian's personal landscape.

Henry Moore

Twice a week, young Henry Moore (1898–1986) went to the British Museum to sketch ancient statues, especially reclining ones (like in the famous Parthenon pediment). His statues—mostly female, mostly reclining—catch the primitive power of carved stone. Moore captures the

human body in a few simple curves, with minimal changes to the rock itself.

The statues do look vaguely like what their titles say, but it's the stones themselves that are really interesting. Notice the texture and graininess of these mini-Stonehenges; feel the weight, the space they take up, and how the rock forms intermingle. Moore carves the human body with the epic scale and restless poses of Michelangelo but with the crude rocks and simple lines of the Primitives.

Expressionism

Ankle-deep in mud, a World War I soldier shivers in a trench, waiting to be ordered "over the top." He'll have to run through barbed wire, over fallen comrades, and into a hail of machine-gun fire, only to capture a few hundred yards of meaningless territory that will be lost the next day. This soldier was not thinking about art.

World War I left 10 million dead. It also killed the optimism and faith in mankind that had guided Europe since the Renaissance. Now, rationality just meant schemes, technology meant machines of death, and morality meant giving your life for an empty cause. As old moral values were challenged, so were artistic ones.

Cynicism and decadence settled over postwar Europe. Artists "expressed" their disgust by showing a distorted reality that emphasized the ugly. Using the lurid colors and simplified figures of the Fauves, they slapped paint on in thick brushstrokes and depicted a hypocritical, hard-edged, dog-eat-dog world that had lost its bearings. The people have a haunted look

George Grosz, **Suicide**, 1916 (Tate Modern, London).
Art © Estate of George Grosz/Licensed by VAGA, New York, NY.

in their eyes, the fixed stare of corpses and those who have to bury them.

Expressionism flourished in Germany and Austria from 1905 through 1935, employed by artists such as Ernst Ludwig Kirchner, Max Beckmann, George Grosz, Chaim Soutine, Otto Dix, Emil Nolde, and Oskar Kokoschka. Other expressionists— such as F. W. Murnau *(Nosferatu)* and Fritz Lang *(Metropolis)*—developed the same aesthetic for a new medium, film. The style carries van Gogh's emotionalism to the extreme.

In the proto-Expressionistic work *The Scream,* Norwegian artist Edvard Munch (pronounced "moonk," 1863–1944) bends and twists everything into

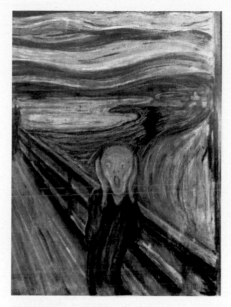

Edvard Munch, **The Scream**, 1893
(Edvard Munch Museum, Oslo).

a landscape of unexplained terror. We "hear" the scream in the lines of the canvas rising up from the twisted body, through the terrified skull, and out to the sky, echoing until it fills the entire nightmare world of the painting.

Compare the emotional power of *The Scream* with Théodore Géricault's *Raft of the Medusa* (on page 322). Both are a terror on canvas. But while Gericault's terror arises from a realistic portrayal of a grotesque event, Munch simply distorts the appearance of an everyday scene so we see it in a more

powerful way, from a different emotional perspective.

Dadaism

When they could grieve no longer, artists turned to grief's giddy twin, laughter. The war made all old values a joke, including artistic ones. The Dada movement, choosing a purposely childish name, made art that was intentionally outrageous: a moustache on the *Mona Lisa*, a pile of shredded paper, or a snow shovel signed by the artist and hung on the gallery wall. Perhaps the most outrageous was a modern version of a Renaissance "fountain"—a urinal (by Marcel Duchamp...or was it I. P. Freeley?).

It was a dig at all the pompous prewar artistic theories based on the noble intellect of Rational Women and Men. While the experts ranted on, Dadaists sat in the back of the class and made cultural fart noises.

Marcel Duchamp, **Fountain**, 1917 (Tate Modern, London). *Duchamp, the daddy of Dada, placed this urinal in a New York exhibit. By taking a common object, giving it a title, and calling it art, he makes us think about the object in a new way.*

Hey, I love this stuff. My mind says it's sophomoric, but my heart belongs to Dada.

Surrealism

A telephone made from a lobster, Greek statues wearing sunglasses, Venus sleepwalking among skeletons, melting clocks, shoes that become feet, and shapes that cast long shadows across film-noir landscapes. Take one mixed bag of reality, jumble it in a blender, serve it on a canvas, and you have Surrealism. (The name implies "beyond realism," as if reality isn't weird enough already.)

The Surrealist scatters seemingly unrelated things on the canvas, and we have to play connect-the-dots without numbers. If it comes together, the

Salvador Dalí, **The Persistence of Memory,** 1931 (Museum of Modern Art, New York). *This first-ever look at "flex time" sums up the Surrealists' attempt to shock us by taking familiar objects and placing them in an unfamiliar context.*

synergy of unrelated things can be pretty startling. But even if the juxtaposed images don't ultimately connect, the artist has made you think, rerouting your thoughts through new neural paths. If you don't "get" it...you got it.

Complicating the modern world was Freud's discovery of the unconscious mind. Surrealists were spokesmen for Freud's id, the untamed part of your personality that thinks dirty thoughts when your ego goes to sleep. The canvas is an uncensored, stream-of-consciousness landscape of these deep urges, revealed in the bizarre images of dreams. In dreams, sometimes one object can be two things at once: "I dreamt that you walked in with a cat...no, wait, maybe you were the cat...no...." Surrealists paint opposites like these and let them speak for themselves.

At the Salvador Dalí Theater-Museum in Figueres, Spain (near Barcelona), you can ponder the boat enjoyed by Dalí and his soulmate Gala—his emotional life-preserver (who kept him from going overboard).

Salvador Dalí (dah-LEE, 1904–1989), the most famous Surrealist, combined an extraordinarily realistic technique with an extraordinarily twisted mind. He painted unreal

scenes with crystal-clear photographic realism, making us believe they could really happen. Seeing familiar objects in an unfamiliar setting—like a grand piano adorned with disembodied heads of Lenin—creates an air of mystery, the feeling that anything can happen. That's both exciting and unsettling. Dalí's images—crucifixes, political and religious figures, naked bodies—were always sure to punch people's emotional buttons.

With collaborator Luis Buñuel, Dalí ventured into the medium of film. Their seminal movie *An Andalusian Dog (Un chien andalou)* still gives goose bumps to film students today. Other artists, such as Max Ernst from Germany and René Magritte from Belgium, developed their own intensely personal versions of Surrealism.

Hitler's PR men and spin-meisters masterfully crafted his image, casting the tyrant as the caring and charismatic savior of a troubled nation.

Totalitarianism

After World War I, there was a scramble for power as old regimes were toppled and revolutions bubbled. In the uncertainty, several nations turned to what historians label totalitarianism—a state that rules by controlling every aspect of their citizens' lives, even their minds. In the 1920s and 1930s, totalitarian regimes took hold in Germany (under Hitler), Italy (Mussolini), Spain (Franco), and the USSR (Stalin).

In a totalitarian state, the media, religion, art, fashion, and political parties all have to toe the party line—ostensibly for the greater good of all citizens. Everyone pledges allegiance to a single charismatic dictator. To generate loyalty, the state resorts to fear tactics, scaring people with what might happen without a powerful government to protect them. Totalitarians manipulate the media with propaganda, intimidate the opposition with violence, and work in secret.

The Soviet Union had been born (1917) as the champion of the common worker. But it was difficult to adapt industrial Marxism to a country still mired in medieval feudalism. Josef Stalin (1879–1953), who succeeded Vladimir Lenin as ruler of the Soviet Union, instituted the iron rule of totalitarianism.

Mussolini's Fascism

In Italy, a violent, nationalistic, anti-intellectual movement called Fascism was born.

World War I had left 650,000 Italians dead. In the postwar cynicism and anarchy, many radical political parties rose up: Communist, Socialist, Popular, and Fascist. Benito Mussolini (1883–1945), a popular writer for Socialist and labor-union newspapers, led the Fascists, stressing unity

This stamp from Ethiopia, licked by Mussolini in 1935, shows the fascist alliance of Hitler and the Italian dictator. The slogan reads: "Two peoples, one war."

and authority. ("Fascism" comes from the Latin *fasci*—bundles of rods: When fragile sticks are lashed together, they become unbreakable.)

Capitalizing on Italy's corrupt government, miserable economy, and high unemployment, Mussolini gained an audience. He scared Italians with the specter of the rising tide of communism (and won the support of rich industrialists). Though only a minority party, the Fascists intimidated the disorganized majority with organized violence by black-shirted gangs. In 1922, Mussolini marched on the capital of Rome, seized the government, and began his rule as dictator for the next two decades.

Calling himself "Il Duce" (The Duke), Mussolini—a kinder, gentler Hitler—set about rebuilding the country. Italy responded to the great worldwide Depression (1930s) with big public works projects (including

Francisco Franco

Rome's subway), and government investment in industry. As a tourist, you'll drive on a system of superfreeways *(autostradas)* commissioned by Il Duce's government. Rome's Olympic Games complex and the futuristic suburb of E.U.R. were built in fascist style. Mussolini solidified his reign among Catholics by striking an agreement with the pope, creating Vatican City as a separate state (1929).

On the other hand, Mussolini ruthlessly suppressed dissent, expanded the army, and invaded Ethiopia, trying to realize Italy's 19th-century dreams of a colonial empire.

Mussolini strengthened his position at home by forming alliances with other dictators abroad: Franco and Hitler.

Spain's Civil War

From 1936 to 1939, Spain suffered a bloody and bitter Civil War, as General Francisco Franco rose to power.

The war began when the Spanish military overthrew the democratically elected Republic. Nationalists (the army, monarchy, Catholic Church, and big business) and Republicans (the democratic government, urban areas, secularists, socialists, and labor unions) faced off. Unlike America's Civil War, which split America roughly north and south, Spain's war was between classes and ideologies, dividing cities, villages, and families. It was especially cruel, with atrocities and reprisals on both sides.

General Francisco Franco (1892–1975) led the Nationalists on a three-year campaign to conquer Spain, region by region, town by town. The Republicans fought back with an army cobbled together with volunteers and local militias.

The fighting was bitter. As Franco conquered a town, he'd line up labor organizers and shoot them. Republicans would retaliate by executing conservative Catholic priests. The war pitted factory workers against rich businessmen, and radical students against sunburned farmers loyal to their king. People suffered. You'll notice today that most Spaniards who lived through those years are very short—a product of malnutrition.

Spain's Civil War attracted international attention. Hitler and Mussolini sent troops and supplies to their fellow fascist leader. Hitler's Luftwaffe (air force) helped Franco bomb the town of Guernica (see next page). On the Republican side, hundreds of idealistic Americans (including Ernest Hemingway) steamed over to Spain to fight for democracy as part of the Abraham Lincoln Brigade.

After almost three years of warfare, several hundred thousand Spaniards had died. The fascists had won, and their dictator Franco would rule Spain with an iron hand for the next 37 years.

The Rise of Hitler

After World War I, Germany was a mess. Almost two million men had been lost, and the country was in ruins. War vets grumbled in their beer about how their leaders had sold them out.

The victorious Allies (France,

In the 1920s, Germany tried to pay off its war reparations by simply printing more money. The value of the Reichsmark plummeted until it took 4,000,000 marks to mail a letter. Such inflation demoralized the decent, hardworking core of German society, priming it to believe the promises of a tyrant who knew how to stir the masses. A decade later, Germany was marching in lockstep.

Britain, and the US) installed the democratic Weimar government in Germany. The government dutifully complied with the Treaty of Versailles, which had punished Germany severely.

Burdened by war debts, the fledgling government was hit by a severe economic crisis. By 1923, the value of the German currency had dropped from four marks to the US dollar to four trillion marks to the dollar. All savings and retirement funds were wiped out. It took a wheelbarrow full of paper marks to buy a pretzel. The hardworking German middle class lost faith in the government and society as a whole.

Many Germans thought the nation's moral fabric was unraveling. Communists rioted in the streets, anarchists tossed bombs, and transvestites paraded openly in smoky cabarets.

Picasso's *Guernica*

Pablo Picasso, **Guernica**, 1937 (Reina Sofía Museum, Madrid).

On April 27, 1937, Guernica—a proud Basque village in northern Spain—was the target of the world's first saturation-bombing raid. Franco gave permission to his fascist ally, Hitler, to use the town as a guinea pig to try out Germany's new air force. The raid leveled the town, causing destruction that was unheard of at the time (though by 1944 it would be commonplace).

News of the bombing reached Pablo Picasso, a Spaniard living in Paris. He scrapped earlier plans and immediately set to work sketching scenes of the destruction as he imagined it from newspaper accounts. In a matter of weeks, he put together a large mural (286 square feet).

In the mural, the bombs are falling, shattering the quiet village. A woman looks up at the sky (far right), horses scream (center), a man falls from the horse and dies, while a wounded woman drags herself through the streets. She tries to escape, but her leg is too thick, dragging her down, like trying to run from something in a nightmare. On the left, a bull—a symbol of Spain—ponders it all, watching over a mother and her dead baby...a modern *pietà*. A woman in the

center sticks her head out to see what's going on. The whole scene is lit from above by the stark light of a bare bulb. Picasso's painting threw a light on the brutality of Hitler and Franco.

This masterpiece combines Cubism, Surrealism, and abstraction to show the terror of the war. It's as if Picasso picked up the shattered shards and pasted them onto a canvas. The black-and-white tones are as gritty as the black-and-white newspaper photos that reported the bombing. The drab colors create a depressing, almost nauseating mood.

Guernica caused an immediate sensation. For the first time, the world could see the cold indifference of the rising fascist war machine. Picasso put a human face on what we now call "collateral damage" and gave the world a chilling prelude to World War II.

Today, *Guernica* is a virtual national monument of Spain and a comment on the futility and horror of war in general. Spain's national work of art spent the Franco years in exile, but now it's back in the country, as the powerful center-piece of the Reina Sofía Museum in Madrid, near the Prado Museum.

Nazi Campaign Poster.
This political ad tells voters they can free Germany from its chains...by voting for Hitler. Although he was legitimately elected at first, Hitler soon took advantage of a national tragedy (the burning of the Reichstag building in 1933) to declare himself dictator-for-life.

Radical political parties offered radical solutions. The German people were ready to believe even the promises of a charismatic madman...who soon rose to power.

Adolf Hitler (1883–1945) was a war veteran who was convinced the German people could have won World War I if their leaders hadn't "stabbed them in the back" by signing the hated Treaty of Versailles. (In fact, many historians say the ill-advised Treaty was both the end of World War I...and the start of World War II.)

With flashing eyes and a growling voice, Hitler was a dynamic speaker

who could shrewdly manipulate people's emotions. He railed against the burdens placed upon the poor German people and ridiculed the weakness of the Weimar government. He expertly capitalized on society's problems. When he couldn't find a solution, he found a scapegoat, mainly Jewish people, whom he blamed for everything. Germans listened.

For a while, Hitler and his small band of brown-shirted National Socialists (Nazis) were considered political extremists on the lunatic fringe. They attempted a coup (the 1923 Beer Hall Putsch), calling on the German people to march from Munich to Berlin and overthrow the government. The revolt got about 200 yards before Hitler was arrested by the local cops. He passed his jail time writing the book *Mein Kampf (My Struggle)*, detailing his master plan to make Germany great again.

The Nazi Party entered the political mainstream, and their influence slowly grew. Like the Fascists in Italy, the Nazis terrorized opponents with gangs of thugs and pumped out effective propaganda. Hitler courted rich industrialists, offering fascism as the only defense against communism.

When the worldwide Great Depression hit in 1929, Hitler's popularity rose. In 1932, the Nazi Party won 38 percent of the seats in Germany's parliament (the Reichstag). Though only a minority, the Nazis presented themselves as the only way to unify a crumbling Germany. Hitler was appointed chancellor (1933).

Two months later, the Reichstag building suffered a mysterious, devastating fire. It was blamed on terrorists

Germany's dictator.

Hitler lost no time in turning Germany into a monolithic slab of nationalistic rock. Dissenters were rounded up and sent to concentration camps. Jews were harassed in the streets, and their businesses and synagogues were trashed. The secret police (Gestapo) kept a watchful eye over everyone. Plumbers' unions, choral societies, school teachers, church pastors, filmmakers, and artists all had to account to Nazi party officials about how their work furthered the Third Reich. Unmarked graves were filled with dissenters, and Nazism became the religion of state.

Hitler proclaimed that his Third Reich would last a thousand years. He

Nazi Propaganda.
Translation: "Judaism is criminal." Signs like this were common in Hitler's Germany. Someone had to take the blame for the country's problems, and the Jews were a traditional scapegoat.

and thus hit Germany with a September 11th–size impact. Drinking the potent cocktail of fear and patriotism their government doled out, the frightened populace gave Chancellor Hitler sweeping powers to preserve national security. Hitler had become

Memorial to Politicians Who Opposed Hitler (Berlin).
As Hitler consolidated his power in the 1930s, he arrested 96 members of the German Parliament who opposed him. He sent them to concentration camps, where most perished. This monument, outside the renovated Reichstag where they once worked, is their memorial.

boasted it would surpass the *Reichs* (empires) of pre–World War I Germany (1871–1918) and the Holy Roman Empire (which lasted from Charlemagne to Napoleon, 800–1806). Leading the Reich was Hitler, called the Führer, or Guide.

In his own frothing way, Hitler was a genius. Germany prospered. The economy boomed and everyone was employed. He built autobahns, Volkswagens, and tanks. His goal of complete self-sufficiency (necessary to wage a world war) was right around the corner.

Fascist art celebrates a super-patriotic, ask-no-questions monolithic society.

Fascist Art

Under the fascist regimes of Germany, Italy, and Spain, art was propaganda, used to control the masses. Fascist art is on a monumental scale, to make the individual feel small and the state seem all-powerful.

The style harkens back to ancient Rome at the peak of its empire. Noble statues of muscular men stand *contrapposto* atop bridges and next to train stations. They used Rome's arches and political inscriptions. Where the Romans built more with marble, fascists tended to use concrete and modernized the style, making it sleeker, more streamlined, and less detailed. It's also more austere and impersonal, a style that leaves today's Europeans cold.

Fascists loved Roman symbols and spectacles. Mussolini's military was divided into legions and run by centurions. Like the Romans, both Italians and Germans saluted each other with the right arm raised, palm down.

Hitler, an amateur architect, worked with Albert Speer on the vast Parade Grounds in Nürnberg that could hold 250,000 people, as many as ancient Rome's chariot race course. And the Nazis' grandiose scheme for Berlin (never completed) included a huge dome more than twice as tall as St. Peter's Basilica.

Hitler and Mussolini were shameless hams. They posed arrogantly, hands on hips, at the head of large rallies in stadiums and public squares. Flags billowed, spotlights roamed, and troops would march through, wowing the crowds with the power of the nation. The masses whipped themselves into a frenzy chanting *"Duce, Duce!"* or *"Hail victory"—"Sieg Heil! Sieg Heil!! Sieg Heil!!!"*

E.U.R.

If Hitler and Mussolini had won the war, our world might look like E.U.R.

This concrete suburb of Rome was planned by Mussolini as part of an international exhibition to show off the wonders of a fascist society. But those wonders brought World War II instead, and Il Duce's celebration never happened. The unfinished

mega-project was completed in the 1950s, and today it houses government offices and big, obscure museums.

E.U.R. is laced with wide, pedestrian-unfriendly boulevards. Patriotic murals, blocky pillars, and stern squares decorate the soulless, planned grid and stark office blocks. Boulevards named for Astronomy, Electronics, Social Security, and Beethoven are more exhausting than inspirational.

E.U.R.'s tallest building, The Palace of the Civilization of Labor, is the essence of fascist architecture. It's a concrete block of arches and black-and-white simplicity, dotted with giant, no-questions-asked, patriotic statues. It's understandably nicknamed the "Square Colosseum."

The Palace of the Civilization of Labor, a.k.a. the "Square Colosseum," is the very fascist-feeling centerpiece of Mussolini's futuristic city, E.U.R., just a short subway ride from downtown Rome.

World War II

Throughout the late 1930s, Hitler convinced the German people they needed more "living space" *(Lebensraum)* and—as a superior race—were justified in taking it. Hitler said, "People who are lazy have no right to the soil. Soil is for he who tills it and pro-

tects it. There is no higher justice that decrees that a people must starve. There is only power, and power creates justice. We have more right to soil than all the other nations because we are so thickly populated. God helps him who helps himself." And the German people marched along to the beat.

Defying the Treaty of Versailles and world opinion, Hitler waged a careful campaign of "gradual encroachment." Each year he ranted and raved and threatened to go wild. Then he'd occupy a forbidden region, and pacifist, isolationist Europe would hope he was satisfied. Germany occupied the Saar region (1935) and the Rhineland (1936), annexed Austria and the Sudetenland region of Czechoslovakia (1938), and invaded the rest of Czechoslovakia (March 1939). The rest of Europe appeased him, fearing another war. But they were reaching their appeasement limit.

War Breaks Out

On September 1, 1939, Hitler invaded Poland to reach the free port city of Gdańsk (Danzig). The rest of Europe realized they had to take a stand. Britain, France, and others (the Allies) squared off against Germany and Italy (the Axis). And World War II began.

This war was the most destructive of the world's struggles. It was a global war (eventually involving Europe, the Americas, Australia, Africa, and Asia) and a total war (including wide-scale genocide and saturation bombing of civilians). It left Europe in ruins.

For Hitler, 1940 was a good year. By April he controlled Austria, Poland,

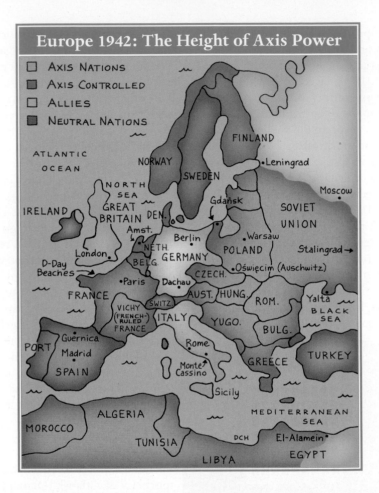

Europe 1942: The Height of Axis Power

□ AXIS NATIONS
■ AXIS CONTROLLED
□ ALLIES
■ NEUTRAL NATIONS

Czechoslovakia, Denmark, and Nor-
way. In May, impatient at what he
considered his slow progress, Hitler
launched his ingenious *Blitzkrieg* (light-
ning war). By air and land, his supe-
rior German army swept through the
Netherlands and Belgium. France was
overwhelmed, and more than 300,000
British and Allied troops barely escaped
across the English Channel from
Dunkirk. Within a month, Nazis were
goose-stepping down the Champs-
Elysées, and Hitler was playing tourist
at Napoleon's tomb.

Just like that, virtually all of

Europe was dominated by fascists.
Germany next mobilized to invade
Britain, softening the nation up with
a savage air assault (called the Battle
of Britain, or simply "the Blitz"). All
through the fall, winter, and spring of
1940–1941—including 57 consecutive
nights—Hermann Göring's *Luftwaffe*
(air force) pummeled a defenseless
London. More than 20,000 Brits
died, and whole neighborhoods were
leveled. Residents took refuge deep in
the Tube stations.

During those darkest days, as
France fell and Nazism spread across

Cabinet War Rooms (London).
As Nazi planes blitzed London, the British government hunkered down in this underground bunker in the center of the city. Today, you can see Churchill's bedroom, the map room, and the state-of-the-art technology—typewriters, telephones, and radios—just as they were in 1945.

now on, Hitler would have to fight a two-front war.

World War II was often a battle of industrial power, to see which nation could produce the latest weapons and armaments fastest and in the greatest numbers. And in this battle, the US was the clear victor. Having suffered a sneak attack by Hitler's ally, Japan, the US joined in the melee. America's fresh troops and manufacturing might would eventually prove the difference.

Two crucial battles in autumn of 1942 put the first chink in the fascist armor. In the deserts

the Continent, Britain's Prime Minister Winston Churchill refused to admit defeat. From his underground bunker, he rallied the Brits with inspiring speeches over the radio. All he could offer was "blood, toil, tears, and sweat...but a faith in ultimate victory." Facing a "New Dark Age" in Europe, Churchill pledged, "We will fight on the beaches...We will fight in the hills. We will never surrender."

Frustrated by British planes and the English Channel, Hitler turned eastward and sank his iron teeth deep into vast Russia. The Soviets suffered, but a harsh winter and the Russian scorched-earth policy (burning everything in their path—even in their own country—during their retreat, denying the invader anything to live off of) foiled the Nazis just as it had Napoleon's army 130 years earlier. The Third Reich had reached its peak. From

of North Africa, 300 British tanks under General Bernard Montgomery attacked the Nazis at El-Alamein, Egypt, and scored the Allies' first real victory against the Nazi *Wehrmacht* (war machine).

Then came the Battle of Stalingrad (today's Volgograd in the USSR). The Germans attacked this Soviet city, but their supplies were running low, the Soviets wouldn't give up, and winter began to set in. Hitler ordered his men to fight on anyway through the bitter cold. On the worst days, 50,000 men died. After six long months, the German troops defied Hitler's orders and surrendered, by which time eight hundred thousand Axis soldiers and more than a million Soviets had died. The Russian campaign put hard miles on the German war machine. And the Nazi war machine had lost its air of invincibility.

The Holocaust

As the war raged throughout Europe, Hitler and his cronies worked feverishly to come up with a solution to the so-called "Jewish Question": What to do with the people they considered genetically inferior to their own Aryan master race? In January of 1942, Nazi leaders met at a villa near Berlin to figure out how to implement their Final Solution *(Endlösung)*. For the next three and a half years, Nazi Germany made a concerted effort to systematically round up Jews, ship them to concentration camps, and execute them.

Some camps held political enemies and prisoners of war. Others were expressly built to exterminate "undesirables"—mostly Jews, but also Roma (Gypsies) and homosexuals. Some of the first to be executed were mentally and physically ill German citizens.

The most notorious was Auschwitz Concentration Camp, in the remote town of Oświęcim, Poland. Here German Nazis honed the mass-production of death to a science. Trainloads of prisoners from throughout Europe were brought in. They were sorted upon arrival. The weak were killed immediately in gas chambers. The strong were forced to work... generally to death.

About 4.5 million people were murdered in Poland, more than a million of them at Auschwitz. Europe-wide, the Holocaust claimed approximately 10 million lives, including six million Jews.

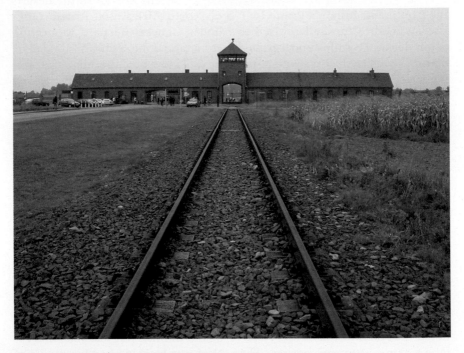

Birkenau Guard Tower (Auschwitz Concentration Camp, Oświęcim, Poland).
Today, Auschwitz is a museum, providing Europe's most powerful look at a concentration camp.

12507
MATUSIAK ROMAN
ur. 3.11.1914 r., robotnik
przybyl: 6.4.1941, zginął w1942 r.21879

12496
KOZA KAZIMIERZ
ur. 15.2.1916 r., monter
przybyl: 6.4.1941, zginął. 17.5.1942.

The Nazis tried to dehumanize concentration camp inmates and then worked them...generally to death.

As Europe continues to come to grips with the greatest atrocity in human history, the survivors and victims' families have chosen to forgive— but not to forget. The undying refrain of the Holocaust has become: "Never again."

The War in Italy

In 1943, the Allied assault on Hitler's European fortress began. More than 150,000 Americans and British sailed from North Africa to Sicily. They met little resistance from the Italians, most of whom actually welcomed them as liberators (Italy's toothless army had never been much of a factor in the war).

But Hitler dug in, and the Allies had to inch their way north through Italy against stiff German resistance. In a crucial battle, the Allies met some Germans who were holed up in St. Benedict's original monastery at Monte Cassino, south of Rome (see page 102). The Nazis wouldn't budge. In frustration, the Allies air-bombed the historic monastery to smithereens, killing dozens of civilians...but no Germans, who dug in deeper. Finally, after months of vicious, sometimes hand-to-hand combat, the Allies stormed the monastery, and the German resistance was broken. They zeroed in on the capital and—without a single bomb harming its historic treasures—Rome was liberated on June 4, 1944.

D-Day

In the wee hours of June 6, 1944, 150,000 Allied soldiers in southern England boarded ships and planes, and crossed the English Channel to Nazi-occupied France. Each one carried a

The Anne Frank House in Amsterdam

The Anne Frank House is a powerful immersion in the struggles and pains of the war years. The house's secret back rooms hid eight Amsterdam Jews from Nazi persecution, including 13-year-old Anne, her sister, parents, and four family friends. They survived in hiding for two years, thanks to non-Jewish friends who risked their lives to cover for them and supply them with food.

The tiny rooms sat at the back of a working business, hidden behind a fake bookcase. Imagine the Frank family's routine. By day, silence was enforced, so that no one could hear them in the offices. They had to whisper, tiptoe, and step around squeaky places in the floor. The windows were blacked out, so they couldn't even look outside. They read or studied, and Anne wrote in her diary. At night, when the offices closed, they snuck downstairs to listen to Winston Churchill's BBC broadcasts on the office radio. Everyone's spirits rose and sank with news of Allied victories and setbacks.

Anne's diaries make clear the tensions, petty quarrels, and domestic politics of eight people living under immense pressure. Despite their hardships, the group felt guilty: They had shelter, while so many other Jews had been rounded up and sent off. As the war progressed, they endured long nights when the

Arromanches near Omaha Beach (Normandy, France). *Along the 75 miles of Atlantic coast north of Bayeux, you'll find WWII museums, monuments, cemeteries, and battle remains left in tribute to the courage of the British, Canadian, and American armies who successfully carried out the largest military operation in history: D-Day.*

house shook from Allied air raids, and Anne cuddled up in her dad's bed. Boredom tinged with fear—existentialist hell.

After two years of hiding, they were discovered. Nazis burst in, trashed the place, and left Anne's diary lying on the floor. The eight Jews were processed in an efficient, bureaucratic manner, then placed on trains and sent to Auschwitz, a Nazi extermination camp in Poland. On the platform at Auschwitz, they were forcibly separated from each other and sent to different camps. Anne and her sister went to Bergen-Belsen, where they died of typhus only weeks before the camp was liberated. Of the eight people who went into hiding at the beginning of the war, only Anne's father, Otto, survived.

Otto had Anne's diary published, which was followed by many translations, a play, and a movie. The Franks' story was emblematic of all of Holland's Jews. Of 130,000 Dutch Jews, only 30,000 survived the war. Of Anne's school class of 87, only 20 survived. Though Anne and many others died in Nazi concentration camps, her diary survived, and continues to convey the resilience and perseverance of the human spirit to millions and millions of readers.

Secret entrance behind the bookshelf.

note from the Allied commander, General Dwight Eisenhower, which read: "The tide has turned. The free men of the world are marching together to victory."

The first soldiers spilled out of their transports into the cold waters off a beach in Normandy, code-named "Omaha." The weather was bad, seas were rough, and the advance bombing had failed to make a dent in German defenses. The soldiers, many seeing their first action, were dazed and confused. Nazi machine guns pinned them against the sea. Slowly, they crawled up the beach on their stomachs. A thousand died. They held on until the next wave of transports arrived.

All day long, wave upon wave of troops stormed the beaches. By day's end, the Allies had established their toe-hold in western France.

Before long, the Allies liberated Paris, and it appeared they had the Nazis on the ropes. Trying for a quick

World War II Sites

There are a number of World War II sites that tourists should see in Europe. While these battlefields, museums, and memorials are fascinating, it's also important to remember the urban centers the war destroyed—like the lovely, original old towns of Berlin, Köln, Munich, Rotterdam, Warsaw, or Dresden—which, though rebuilt, are gone forever.

War Sites
- D-Day landing sights, Normandy, France
- Caen Memorial Museum, Caen, Normandy
- Battle of Normandy Memorial Museum, Bayeux, Normandy
- American Cemeteries throughout Europe
- Cabinet War Rooms and Churchill Museum, London
- Imperial War Museum, London
- Kaiser Wilhelm Memorial Church, Berlin
- Käthe Kollwitz Museum, Berlin
- Frauenkirche, Dresden
- Warsaw Uprising Museum (and monuments around the city), Warsaw, Poland

Hitler, Nazi, and Fascist Sites
- Nazi Documentation Center and Parade Grounds, Nürnberg
- Hitler's Eagle's Nest, Berchtesgaden, Germany
- Haus der Kunst (exterior), Munich
- Mussolini's planned city, E.U.R., Rome
- Nazi Resistance Museums in Amsterdam, Oslo, and Copenhagen

Hitler's Eagle's Nest—given to the dictator for his 50th birthday—is perched high atop a Bavarian Alp above the town of Berchtesgaden.

knockout punch, thousands of Allies parachuted and glided down from the night sky behind enemy lines, on a daring mission to secure crucial Dutch bridges for an assault on the German heartland (The Battle of Arnhem, September, 1944). But after 10 days of intense fighting, the Arnhem crossing proved to be "a bridge too far," and the Allies had to pull back and regroup.

The Allied march on Berlin bogged down, and in the winter of 1944, they met a deadly surprise. An enormous, well-equipped, energetic German army appeared from out of nowhere, punched a "bulge" deep into Allied lines, and demanded surrender. The US general, Anthony McAuliffe, sent a defiant (and untranslatable) one-word response—"Nuts!"—and the

Berlin's **Memorial to the Murdered Jews of Europe,** built in 2005, is a moving monument to one of history's greatest tragedies.

Holocaust Sites

- Auschwitz Concentration Camp, Oświęcim, Poland
- Dachau Concentration Camp, near Munich, Germany
- Mauthausen Concentration Camp, Mauthausen, Austria
- Terezín Concentration Camp, Terezín (near Prague), Czech Republic
- Deportation Monument (behind Notre-Dame), Paris
- Oradour-sur-Glane (bombed and burned memorial ghost city), near Limoges, France
- Anne Frank House, Amsterdam
- Corrie ten Boom's "Hiding Place," Haarlem, Netherlands
- Former Warsaw Ghetto (several monuments and plaques), Warsaw, Poland
- Jewish Quarter museums and synagogues, Prague, Czech Republic
- Memorial to the Murdered Jews of Europe, Berlin
- Jewish Museum in Berlin

momentum shifted back to the Allies. The Battle of the Bulge was Germany's last great offensive.

The Nazis retreated across the Rhine River, but the Allies captured a crucial bridge at Remagen and streamed onto German soil. Soon, US tanks were speeding down the autobahns. General George Patton wired the good news back to Eisenhower: "General, I have just pissed in the Rhine."

As the Allies converged on Germany, it became apparent that territory conquered in the final days of the war would become part of the side that liberated it from the Nazis—either the democratic West or the communist East. Many German citizens fled west, preferring to surrender to the more-benevolent Americans and British

rather than the vengeful Russians.

Soviet soldiers did the dirty work of taking fortified Berlin. Hitler, defiant to the end, holed up in his underground bunker. In the last days of the war, Mussolini had been captured, killed, and hung upside down by his heels in a public square in Milan. To avoid similar humiliation, Adolf Hitler and his new bride, Eva Braun, committed suicide (pistol in mouth) and their bodies were burned beyond recognition. Germany formally surrendered on May 8, 1945, and—after five long years of war—Europe was free.

The death toll for World War II (including the war in Asia) totaled 80 million soldiers and civilians. The Soviet Union lost 23 million, Germany 7.5 million, Poland 5.5 million, Japan 2.6 million, China 10 million, France 560,000, Italy 460,000, and the US 420,000.

Postwar Europe (1945–2000)

World War II changed the balance of power across the globe. Europe was physically ruined, its days as a colonial giant were over, and the US emerged as the world's dominant political, military, and economic superpower.

Perhaps learning from the mistakes of World War I's Treaty of Versailles, the US helped rebuild Europe, with the idea that a healthy Germany is safer than a wounded Germany. America sent millions of dollars in aid and economic incentives to Europe as part of a long-term project known as the Marshall Plan. Though it took many years, soon Britain, France, Italy, and, eventually, a repentant Germany were humming along as democratic nations with free-market economies.

But Europe had been split in half by World War II. The eastern half remained under occupation by the Soviet Union. For 45 years, the US and the Soviet Union would compete—without ever actually doing battle—in a Cold War of espionage, propaganda, and weapons production that stretched from Korea to Cuba, from Vietnam to the moon.

Frauenkirche (Dresden, Germany). *Dresden, a cultural capital of Germany, was devastated by firebombs in World War II. The Frauenkirche lay in ruins for decades—until the 1990s, when $100 million of international donations financed the reconstruction of the church, using many of the original fragments. In 2005, this crowning symbol of the city opened its doors once again, with hopes for a new era of reconciliation and international peace.*

The Cold War

Even before the shooting stopped, it was evident that the postwar world would be bipolar, divided into an American sphere and a Soviet sphere.

Communism and Cold War Sights

- Museum of the Wall at Checkpoint Charlie (and other Wall-related sights), Berlin
- Museum of Communism, Prague
- House of Terror, Budapest
- Statue Park, Budapest
- Palace of Culture and Science (a "Stalin Gothic" skyscraper), Warsaw, Poland
- Nowa Huta planned worker town, suburb of Kraków, Poland
- "Roads to Freedom" exhibit (about Solidarity strikes) at the shipyard in Gdańsk, Poland
- Museum of Occupation, Tallinn, Estonia

*With the fall of communism, the statues of Lenin, Stalin, and triumphant workers were pulled down. Many are gathered in Budapest's quirky **Statue Park**. Locals are no longer required to embrace the Social Realist art that served as propaganda for the ideology that kept them down for so long.*

The Soviets "liberated" the Eastern European nations from the Nazis, installing Moscow-trained governments in each capital, and executing or imprisoning anyone who dared to call this freedom a sham. By the time Poles, Hungarians, Czechs, and Slovaks figured out what was happening to them, they were trapped in a police state that they weren't allowed to leave. The Soviets saw these peoples as buffers against another attack from the West.

A metaphorical Iron Curtain descended, ushering in a 40-year period of strict Soviet control. The Western nations banded together in a military alliance known as NATO (North Atlantic Treaty Organization), while the Eastern nations formed the Warsaw Pact. The region that had historically been known as Central Europe—which comprised Czechoslovakia, Poland, and Hungary—became known as Eastern Europe by most Americans. Germany and its capital city, Berlin, were split down the middle, with the Soviets in control of the East.

The Cold War began. The Soviet Union blockaded West Berlin in 1948,

hoping to gain control of the entire city. But an expensive American airlift shuttled in crucial supplies, the Soviets backed down, and West Berlin remained an island of the capitalist West in a sea of communist oppression. Subsidized by the West German government, West Berlin thrived as an enticing contrast to the bleak Eastern economies. To keep their people in (and the West out), the East German government built what it called an "anti-fascist protective rampart" in 1961. The rest of the world called it the Berlin Wall.

The Soviet Union, under the guise of peacekeeping and with a bogus coalition of Warsaw Pact forces, crushed revolutions in Hungary (1956) and Czechoslovakia (1968). Yugoslavia, which had been liberated from the Nazis by its own partisan army rather than the Soviets, enjoyed some degree of self-determination. Though communist, Yugoslavia never joined the Warsaw Pact and claimed to create a "third way" between East and West (for more on Yugoslavia, see page 403).

Life under communism was hard. While the West recovered, Eastern Europe's economy languished, stifled by Soviet-style bureaucracy. Because Eastern Europe devoted most of its resources to fighting the Cold War, many basic food staples were "in deficit." Long food lines and ration cards made grocery shopping an all-day exercise in frustration. To buy special items, such as a car, you might have to wait for years. Travel was severely restricted. For many Warsaw Pact residents, the best they could dream for was a trip to Yugoslavia or Hungary

(Eastern fun zones that allowed more Western distractions).

Public life was harsh and paranoid—your neighbors, friends, and even relatives might be informants recruited by the secret police to monitor your activities. But, perhaps surprisingly, private life was simple and rewarding. With no real incentive to get ahead at work, people had more time to spend with their families and pursuing hobbies.

Europe was caught between two superpowers—superpowers with nuclear weapons capable of liquidating all of its windmills, castles, pubs, and people in an instant. With one-legged pensioners and tombstone-covered hills as reminders, Europe knew the

Communist Propaganda Poster.
Social Realist art was intended to rouse nationalist and class feelings against the threat of the capitalist West. Workers are shown victorious through passionate dedication to their state, industry, and military. Communist art was a broken record of worker-triumph propaganda.

Max Lingner, **Building the Republic** (mosaic mural), 1952 (Berlin).
A generation of Eastern Europeans grew up with posters and murals celebrating conformity. In the utopian "dictatorship of the proletariat," all were equal and clapped to the rhythm of their communist ideology.

individuals don't matter. Distinguishing features are unimportant; people are represented as automatons proudly serving their nation.

The style is bold, colorful, and simple, perfect for posters. With flags blowing heroically in the wind, the art portrays the value of hard work, commitment to Socialist morality, and undying respect for the imperial power behind the ideological cloak, namely Russia—their liberator from the Nazis and from the evil Western world.

Soviet-style architecture is big, square, gray, and ugly. (The plumbing was bad, the wiring was shoddy, the walls were paper-thin, and the elevator was always broken.) Even today, visitors to Moscow are overwhelmed by the city's sheer size. City blocks are endless, the boulevards are eight lanes wide, and the subway system doesn't seem to make getting around the city any easier. As with other totalitarian art, the purpose was to make the individual feel puny and the state all-powerful.

Although art as propaganda is nothing new, only in the sphere of the Soviet Union was creativity channeled so effectively into one purpose. Art was justified only if it actually promoted the system. Abstract art, which

reality of war. As "Evil Empire" rhetoric raged between the planet's two aggressive superpowers, many Europeans feared their homeland would be the fighting ground for World War III.

Communist Art: Social Realism

The USSR (and, after World War II, its satellite states in Eastern Europe) attempted to control everyone and everything. They used whatever they could to achieve that end, including the media and art.

Soviet art was propaganda. Called Social Realism, the style draws repeatedly on a few Socialist or Marxist-Leninist themes. Noble, muscular workers rise up and break the chains of capitalism. Soldiers set their jaws and do battle with the evil bourgeois world. Women with man-size biceps proudly wield hammers in factories. Aside from a few important figureheads (Stalin, Lenin, and local communist heroes),

served no purpose in inspiring the masses, was discouraged. Even artistic mediums as nebulous as music were censored for what they did not promote.

The 1960s

Meanwhile, in the West, the 1960s began united in idealism. America's President John F. Kennedy pledged to put a man on the moon, and newly launched satellites signaled a united world. The rock band the Beatles sang exuberantly about love. Peaceful demonstrations championed racial equality, and the Vatican II Council preached liberation.

Your scruffy co-authors truckin' on during their inaugural "Europe Through the Gutter" trip.

became a cultural center of pop music, movie stars, mod fashions, and Austin Powers-style mojo. Amsterdam, featuring almost-legal marijuana, was a global magnet for hippies, freaks, and your co-authors.

But by decade's end, there were race riots, assassinations, student protests, and America's floundering war in distant Vietnam. Every postwar value was questioned by a rising, wealthy, populous, baby-boom generation. In households around the world, parents screamed, "Turn that down...and get a haircut!"

The world was shrinking, linked by mass communication and jet plane travel. Young Europeans hit the rails, bunking together in youth hostels and getting to know their neighbors. Europe was increasingly linked by two common languages: American English and rock-and-roll music. Thriving on postwar prosperity, London

Future generations will have to judge whether the Beatles will rank with artists such as Mozart and Beethoven, but no one can deny their historical significance. The British musical quartet burst onto the scene in the early 1960s to unheard-of popularity. With their long hair and loud music, they brought counterculture and revolutionary ideas to the middle class, affecting the values of a whole generation. Touring the globe, they served as a link between young people here, there, and everywhere. Today a small industry thrives in England by showing tourists Beatles sights.

Place St. Michel, Paris

In the spring of 1968—a time of social upheaval all over the world—young students battled riot batons and tear gas, took over a part of Paris, and declared it an independent state. By occupying public places, they were following in a long tradition of protest that stretched back to the *Les Miz*–style revolts of 1830, 1848, and 1870.

Students rioted in the streets of Paris.

Factory workers followed the students' call to arms and went on strike, toppling the government of Charles de Gaulle and forcing change. Eventually, the students were pacified, the university was reformed, and the Latin Quarter's original cobblestones were replaced with pavement, so malcontents could never again use the streets as weapons.

The Fall of Communism

In the 1980s, the Cold War began to thaw. The new pope, John Paul II (r. 1978–2005), was Polish, and his strong stand for freedom emboldened Eastern Europeans. Inspired by the pope, the Polish labor union, Solidarity (led by Lech Wałęsa), defied its communist government by going on strike in August of 1980. Their brave actions rippled across the Soviet Bloc.

In 1985, Mikhail Gorbachev became the first truly modern, post-Stalin, post–World War II Soviet leader. Gorbachev's democratic reforms and personal charisma made him the man of the decade. Under the banners of *perestroika* (restructuring) and *glasnost* (openness), Gorbachev allowed people to express their frustration with the Soviet system. "I ♥ Gorby" pins were common throughout Eastern Europe.

In reality, Gorbachev was driving a Soviet economic machine that didn't work and whose fuel tank was on "E." The Soviets had fought and lost a war of economic attrition with the

In clear Cyrillic: I ♥ Gorbachev.

On the ecstatic night of November 9, 1989, people-power finally tore down the Berlin Wall.

US—one which had also left America deeply in debt. Gorbachev's reforms were a last-ditch attempt to keep the Warsaw Pact together.

But Gorbachev had started something that he wouldn't be able to control. Throughout Eastern Europe, protesters began to get bolder. Attempting to hang on, their governments relaxed laws and opened borders. But the flood of freedom could not be contained.

In November of 1989, the unthinkable happened. The Berlin Wall—the very symbol of communist oppression—was opened up by the East German government. Joyous Berliners from both sides poured through. They scaled the Wall, hugged, exchanged beers, danced atop the Wall, and partied the night away.

One by one, Eastern Europe's communist regimes fell like dominoes. East German communist leaders were tried and convicted for abuse of power and corruption. The dictator of Romania, Nicolae Ceaușescu, and his wife Elena were executed. A liberal playwright (Václav Havel) became the president of Czechoslovakia, and an electrician (Lech Wałęsa) became the president of Poland. The Czechs and the Slovaks split peacefully into two separate countries—the Czech Republic and Slovakia—in what became known as the Velvet Divorce.

In 1991, the revolution reached the mother country, toppling Gorbachev himself and releasing Ukraine, Belarus, the Baltic states, Georgia, Armenia and other nations from Russia's embrace. Only in Yugoslavia did the transition from communism to capitalism prove violent.

Understanding Yugoslavia

Yugoslavia—or "Land of the South Slavs"—was born as a modern nation in the wake of World War I. Locals were fond of noting that while Yugoslavia had seven distinct peoples in six republics who spoke five languages and had three religions (Orthodox, Catholic, and Muslim) and two alphabets, it was one nation. But from the beginning, it was an unstable, cobbled-together nation doomed to fail.

Occupied by the Nazis during World War II, Yugoslavia was liber-ated not by the Soviets, but by a home-grown partisan army led by Marshal Tito. With a Slovene for a mother, a Croat for a father, a Serb for a wife, and a home in Belgrade, Tito was a true Yugoslav. He embraced communism but refused to ally himself with either Moscow or Washington, thus becoming a hero of the non-aligned world. As time went on, Tito also allowed some components of a free-market economy. To preserve the country's unity, Tito gave much local autonomy to the six main regions: Serbia,

Yugoslavia

- ∿ Former Yugoslavia Border
- ∿ Current Political Borders
- SLOVENE Languages
- ▨ "Serbian Krajina" (Serb-controlled 1991-1995)
- ⌐⌐⌐ Minority-Dominated Provinces Within Serbia

Croatia, Bosnia-Herzegovina, Slovenia, Montenegro, and Macedonia.

When Tito died in 1980, Yugoslavia unraveled. By the end of the decade, Serbian strongman Slobodan Milošević had exploited ethnic strife in the province of Kosovo to grab more centralized power. Fearing Milošević and the Serb majority, Slovenia and Croatia both declared independence in 1991. Slovenia—which was always the most Western-oriented and ethnically homogeneous of the Yugoslav republics—had only to weather a 10-day skirmish to secure its independence.

But the rest of Yugoslavia entered a bloody era. Croatia's minority of Serbs rose up in anger, egged on by Milošević. Bosnia-Herzegovina also declared its independence, and the uncertainty sparked ethnic conflict in that region, too. Each group simply wanted to control their own destiny, but because of complex and overlapping ethnic and political boundaries, this was impossible.

Warfare, bloodshed, genocide. As the wars raged on, Serbs, Croats, and Bosniaks were all guilty of "ethnic cleansing," a new term for the systematic removal of an ethnic group from a territory by expelling or killing them.

Yugoslavia's fighting continued through 1995, when an American-brokered peace finally calmed the region. Since then, what was a single nation has become seven independent countries: Slovenia, Croatia, Bosnia-

Herzegovina, Serbia, Montenegro, Kosovo, and the Republic of Macedonia.

Today, Slovenia and Croatia feel every bit as safe and welcoming as Western Europe, and even war-torn Bosnia-Herzegovina is seeing increased tourist traffic. But as physical wounds heal, psychological scars remain. As each of these countries makes its bid for European Union membership in the coming years, perhaps someday soon the people of the former Yugoslavia will be united once again.

Eastern Europe Recovers

In the 1990s, Western tourists flocked east and Eastern tourists west, joyfully rediscovering the half of Europe that had been forbidden to them. Devout Polish Catholics (with no money and a sack lunch) would endure two bleary nights in a bus seat just to make their dreams of visiting Rome come true. Prague, the best-preserved Baroque city in Europe, became the darling of German and British tourists, pulling in crowds to rival Salzburg or Edinburgh.

*In the early 1990s, the Serb-dominated Yugoslav National Army shelled historic yet militarily inconsequential **Dubrovnik**. Today, as you stand on its ramparts overlooking its sea of red-tile roofs, the brighter tiles mark the buildings destroyed in the shelling and rebuilt since (about 80 percent of the Old Town). These new rooftops are the only physical reminder of Dubrovnik's war years.*

Berlin: Once Broken, Now Mended and Thriving

*Germany's frenzied "wall-peckers" devoured the **Berlin Wall** as soon as the East German police went home. A few chunks like this survive—if you know where to look—preserved as a memorial to this sad period of German history.*

__Potsdamer Platz__, arguably Europe's busiest square in the 1920s, was a no-man's land through the Cold War when the Berlin Wall cut it in half. Since the Wall fell in 1989, Berlin has swiftly put itself back together: Where the wall once stood is marked by a line of cobbles in the road, and Potsdamer Platz is once again one of Europe's great people zones.

*With the fall of the Berlin Wall, much of communist-era East Germany was quickly replaced by Western alternatives. East Berliners, feeling a bit "ostalgic" (nostalgic for the Ost, or East), managed to keep their jaunty traffic symbols, nicknamed **Ampelmännchen** (little traffic-light men).*

*Germany's capital is again Berlin, and its **Reichstag** building is back in business. Long a bombed-out hulk in a wasteland created by the Berlin Wall, today it's renovated and capped by a glorious glass dome. Germany's new parliament building welcomes all... especially Germans, who can climb to the top and, both literally and symbolically, look over the shoulders of their legislators at work.*

The revolutions in the East unleashed a lifetime of pent-up entrepreneurial spirit. Hardworking Easterners rediscovered how to run their own businesses. Buildings that the state had owned for 40 years were sold to private owners, meaning that someone finally had an incentive—and the money—to paint the facade and fix the roof.

East Germany was assimilated into the sleeker West (with typical German tenderness).

A Commie with a Coke.
With the breakup of the Soviet Bloc in 1989, Western culture—and tourists—began flooding east.

Berlin, once again the capital of the country, shuffled itself back together with building projects that would have made Hitler proud. The Eastern economies grew steadily, and living standards drew closer to those in the West. Over time, many differences between East and West have faded into history.

20th-Century Art, Part Two
(1950–2000)

America emerged from World War II as the globe's superpower. With Europe in ruins, New York replaced Paris as the art capital of the world.

As converted war factories turned swords into kitchen appliances, America pumped out consumer goods for a booming population. Prosperity, a stable government, national television broadcasts, and a common fear of Soviet communism threatened to turn America into a completely homogeneous society.

Some artists rebelled against conformity and mindless consumerism. They created works of art that were the very opposite of the functional, mass-produced goods of the American marketplace.

Abstract Expressionism

The trend was toward bigger canvases, abstract designs, and experimentation with new materials and techniques. This style was called Abstract Expressionism, as it expressed emotions and ideas using color and form alone.

Jackson Pollock (1912–1956)—"Jack the Dripper"—attacked convention with a can of paint, dripping and splashing a dense web onto the canvas. Picture Pollock in his studio, jiving to the hi-fi, bouncing off the walls, throwing paint in alcohol-fueled inspiration. Of course, the artist loses some control this way—control over the paint flying in mid-air and over himself, now in an ecstatic trance. Painting becomes a whole-body activity, a dance between the artist and his materials. The act of creating is what's important, not the

Jackson Pollock, **Silver over Black, White, Yellow, and Red,** 1948
(Modern Art Museum, Pompidou Center, Paris, France).

final product. The canvas is only a record of the ecstasy of creation.

Other artists produced big, empty canvases with just a few lines or colors. What reality are they trying to show? In the modern world, we find ourselves insignificant specks in a vast and indifferent universe. Every morning, each of us must confront that big, blank, existentialist canvas and decide how we're going to make our mark on it. Like, wow.

Another influence was the simplicity of Japanese landscape painting. A Zen master studies and meditates for years to achieve the state of mind in which he can draw one pure line. These canvases, again, are only a record of that state of enlighten-ment. (What is the sound of one brush painting?)

On more familiar ground, post-war painters were following in the footsteps of artists such as Mondrian and Kandinsky (whose work they must have considered "busy"). The geometrical forms reflect the same search for order, but these artists painted to the 5/4 asymmetry of Dave Brubeck's "Take Five."

So-called Op Art, pioneered by Hungarian artist Victor Vasarely (1906–1997), paints optical illusions on a large scale. The bright colors and swirling lines play tricks with your eyes, like the way a spiral starts to spin when you stare at it. These obscure scientific experiments in color, line,

Andy Warhol, **Two Hundred Campbell's Soup Cans** (detail), 1962 (Andy Warhol Museum, Pittsburgh, Pennsylvania, USA).

and optics suddenly became trendy in the psychedelic '60s.

Pop Art

America's postwar wealth made the consumer king. Pop Art is created from the "pop"-ular objects of that throwaway society: a soup can, a car fender, mannequins, tacky plastic statues, movie icons, advertising posters. Pop Art mocked popular culture by embracing it in a tongue-in-cheek way. Take a Sears product, hang it in a museum, and you have to ask, "Is this art?" Are mass-produced objects beautiful? Or crap? Why do we work so hard to acquire them? Pop Art, like Dada, questioned society's values.

Andy Warhol (1928–1987)—who coined the expression "15 minutes of fame" and became a Pop star—concentrated on another mass-produced phenomenon: celebrities. He took publicity photos of famous people and repeated them. The repetition—like the constant bombardment we get from repeated images on television—cheapens even the most beautiful things.

Roy Lichtenstein, **Whaam!** 1963 (Tate Modern, London).
A child's comic book becomes a 70-square-foot piece of art: Pop Art. What would Raphael think?
© Estate of Roy Lichtenstein

Take a comic strip, blow it up, hang it on a wall, and charge a million bucks...whaam! Pop Art. Roy Lichtenstein (1923–1997) was supposedly inspired by his young son, who challenged him to do something as good as Mickey Mouse. The huge newsprint dots that make up his images never let us forget that his paintings—like all commercial art—are illusions, fakes. The work's humor comes from portraying a lowbrow subject (comics and ads) on the epic scale of a masterpiece.

Postmodernism (1970–present)

Art became big business. A van Gogh could sell for $50 million, and corporations funded big, colorful canvases for their boardrooms.

Artists continued to explore new frontiers. Like the Primitives before them, they were inspired by the art of the underdeveloped world in Africa and Asia. People of color, women, and gay people began to express themselves through their work, and even "representational" art (realistic paintings and statues) could finally come out of the closet after nearly a century of disdain. Graffiti became a viable art form to some (and a boon to paint-removal companies), and new technologies such as computers and the Internet offered exciting new tools and outlets.

The "modern" world became history. Picasso and his ilk were now gathering dust and boring art students everywhere. Minimalist painting and abstract sculpture were old-school. No single style or artist dominated.

Enter the "postmodern" world, as seen through the eyes of more current artists. Taking the Pop Artists' question "What is art?" to its natural extreme, Postmodernism sees every object as equally "artistic"—the real meaning comes from the context it's placed in.

Postmodernists take the jumble of elements we find in today's world and shamelessly cobble them together in new, often tongue-in-cheek ways. You see it in both high art and pop culture (which, according to Postmodernists, are equally valid). A Postmodern building might mix state-of-the-art technology, fake Greek columns, and a Social Realist statue of Lenin. Rap musicians "sample" beats, hooks, and riffs from soul, rock, and even classical music to create something totally new. The movie *Fiction* takes ki 1970s stereoty plunks ther

Roman arches next to traditional Venetian chimneys make a postmodern statement in Venice.

Modern and Postmodern Art Sights

- *Guernica*, Reina Sofía Museum, Madrid
- Picasso Museum, Barcelona, Spain
- Salvador Dalí Theater-Museum, Figueres, Spain
- Dalí House, Cadaqués, Spain
- Guggenheim Bilbao, Bilbao, Spain
- Picasso Museum, Paris
- Pompidou Center, Paris
- Grimaldi-Picasso Museum, Antibes, France
- Marc Chagall National Museum, Nice, France
- Matisse Museum, Nice, France
- Foundation Maeght, St. Paul-de-Vence, French Riviera
- Roadside art on French freeways
- Wallraf-Richartz Museum, Köln, Germany
- Museum of Fine Arts (lots of Paul Klee), Bern, Switzerland
- Collection de l'Art Brut, Lausanne, Switzerland
- Stedelijk Museum, Amsterdam
- Kröller-Müller Museum, near Arnhem, the Netherlands
- Tate Modern, London
- Guggenheim Collection, Venice
- Louisiana Museum, north of Copenhagen, Denmark
- Munch Museum (Expressionism), Oslo, Norway
- Modern Art Museum, Stockholm, Sweden
- Anywhere in Europe: Commercial galleries sell contemporary art. Temporary exhibits abound; often one wing of a museum is reserved just for such exhibits. Check local periodical entertainment guides, tourist information offices, and posters around town.

exander Calder, **Slender Ribs,** 1976
uisiana Museum, north of Copenhagen, Denmark).

into a gritty 1990s world.

Postmodern art constantly calls attention to its own artificiality. Ferris Bueller turns and talks directly to the movie audience, "breaking the frame" and letting us know he knows it's just a movie. The author Kurt Vonnegut makes himself a character in his own novels. A poet writes a poem about what it's like to write a poem. Postmodern art exposes its own inner workings for all to examine.

Postmodernism is, by definition, difficult to define. It recognizes how the meaning of everything can change, depending on the point of view and context. Hence, to avoid answering a direct question, US President Bill Clinton responds by pondering what the meaning of the word "is" is.

Postmodernist art is rarely about traditional canvases or sculptures. Artists traded paintbrushes for blowtorches (Joan Miró said he was out to "murder" painting), and blowtorches for computer mouses. Mixed-media work was the norm, combining painting, sculpture, photography, welding, film/slides/video, computer programming, new resins, plastics, industrial techniques, and lighting and sound systems.

As history's odometer flipped past the year 2000, here were some of the trends:

Installations: An entire room is given to an artist to prepare. Like entering an art funhouse, you walk in without quite knowing what to expect (I'm always thinking, "Is this safe?"). Using the latest technology, the artist engages all your senses by controlling the lights, sounds, and sometimes even smells.

Assemblages: Artists raid dumpsters, recycling junk into the building blocks for larger "assemblages." Each piece is intended to be interesting and tell its own story, and so is the whole sculpture. Weird, useless, Rube Goldberg-esque machines make fun of technology. Increasingly, artists are not creating an original work (painting a canvas or sculpting a stone) but assembling one from premade objects.

Natural Objects: Fearing for the health of earth's ecology, artists rediscovered the beauty of rocks, dirt, trees, even the sound of the wind. A rock in a museum or city square is certainly a strange sight.

The Occasional Canvas: This comes as a familiar relief. Enjoy the lines and colors, but also a new element: texture. The canvas acts like a tray, holding thick globs of paint, snippets from newspapers and magazines, and everyday household objects in a delightful array of colors, patterns, and shapes. Artists of the New Realism labor over painstaking, hyper-realistic canvases to recreate the glossy look of a photo or video image.

Interaction: Some exhibits require your participation, whether you push a button to get the contraption going, touch something, or just walk around the room. In some cases, the viewer "does" art rather than just staring at it. If art is really meant to change, it has to move you, literally.

Deconstruction: Late-20th century artists critiqued (or "deconstructed") society by examining underlying assumptions. One way do it is to take a familiar object crucifix) out of its normal co church), and place it in a ne

(a jar of urine). Video and film can deconstruct something by playing it over and over, ad nauseam.

Conceptual Art: The key is the *concept* of which object to pair with another to produce maximum effect. (Urine + crucifix = million-dollar masterpiece.)

Performance Art: This is a kind of mixed-media of live performance. Many artists—who in another day would have painted canvases—have turned to music, dance, theater, and performance art. This art form is often interactive, by dropping the illusion of a performance and encouraging audience participation.

Playful Art: Children love the art being produced today. If it doesn't put a smile on your face, well, then you must be a jaded grump like me, who has seen the same repetitious crap

r medieval wench-dunking?

passed off as "daring" since Warhol stole it from Duchamp. I mean, it's *so* 20th-century.

Modern and Postmodern Architecture

Just as the 20th century brought dramatic changes in society, it also saw the development of new construction technology: steel frames, rebar and concrete, high-quality glass, and, later, titanium, plastics, and computer-aided design. These materials and tools let architects build whatever their brains could imagine.

Modernism and the International Style

In 1925, Walter Gropius (1883–1969) built a headquarters for his art and design school called the Bauhaus (in Dessau, Germany, near Dresden). The Bauhaus building is a simple rectangle, with flat roofs, no ornamentation, white walls, and lots of glass. It looks just like any other blocky, boring building. The difference is, the Bauhaus was the *first* blocky, boring building, and it set the style for almost every skyscraper constructed since.

The Bauhaus gave early-20th-century architecture its mantra: "Form follows function." First, a building had to work well (its function), and only then could you worry about how it looked (its form). Architects stripped buildings down to their barest structural elements, letting the function dictate the form. A later Bauhaus director, Ludwig Mies van der Rohe (1886–1969), summed it up with his famous maxim, "Less is more."

When the Nazis closed the Bauhaus, Gropius and van der Rohe

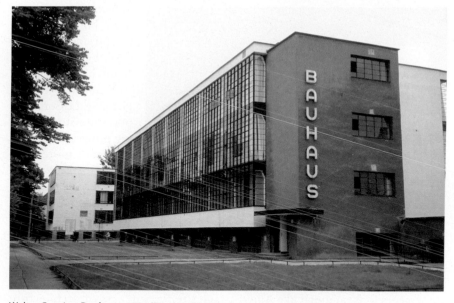

Walter Gropius, **Bauhaus,** 1926 (Dessau, Germany).

moved to the US, where they spawned many disciples. Soon, tall, boxlike, steel-and-glass skyscrapers dominated city skylines from America to Europe and beyond, and "modernist" architecture got a new name: the International Style.

Postwar Architecture

The bombs of World War II created a blank canvas for city planners to take things in a whole new direction. Europe rebuilt quickly and on the cheap. Nazi-blitzed London erected big, gray steel-and-glass boxes in the International Style. Frankfurt's

After World War II, each of Europe's devastated cities debated how it would rebuild: retain its charming medieval street plan, or go the "Manhattan" route. Their decision shaped the character of the cities we visit today. **Frankfurt** *(left) opted for skyscrapers, and became a major business center.* **Munich** *(right), on the other hand, rebuilt its medieval gates and churches, kept its charming character, and consequently entertains far more tourists today.*

Le Corbusier, **Notre-Dame du Haut,** 1954 (Ronchamp, France).
A far cry from Gothic, this stripped-down church is one of the gems of modern architecture.

follows function") to make buildings more people-friendly. He described a house as "a machine for living." An innovator in city planning, Le Corbusier put multi-story housing projects on pillars to create more people space below. His most famous building is a church atop a hill in Ronchamp, France (near where Germany, Switzerland, and France meet), which has been a pilgrimage site for students of architecture for decades.

skyscrapers look so much like America's that the city (built along the Main River) has been called "Main-hattan." Meanwhile, Soviet Bloc countries got large swaths of drab concrete apartment blocks.

Some towns, like Munich, were able to rebuild a little more slowly and carefully. Warsaw chose to pick one area, the Old Town Square, to lovingly restore as it was before the war. And some lucky cities, such as Paris, Prague, and Rome, were spared the ravages of World War II altogether.

All through the 1950s and '60s, the International Style reigned supreme. But there were still innovators. Le Corbusier (1887–1965) was a visionary who adopted the "three F's" ("form

In Scandinavia, architects such as Alvar Aalto from Finland and Arne Jacobsen from Denmark built with simple, clean lines, often inspired by nature—a style that carried over into today's popular, sleek, Ikea-style furniture. In Helsinki, you'll find Aalto's stately, white Finlandia Hall. The

Alvar Aalto, **Finlandia Hall,** 1971 (Helsinki, Finland).

cities (such as Lisbon, Genoa, Barce-
lona, and Athens) have used Olympic
Games and World Expos as excuses to
make architectural statements. With
top architects flying around the world
and following a spirit of anything
goes, architecture has become truly
international.

As the 1970s progressed, Postmod-
ernism rejected the strict dogma of
"form follows function." (Robert Ven-
turi said, "Less is a bore.") Free from
any conscious "style," Postmodern
architects could decorate their buildings
with Roman arches, Greek columns,
Gothic spires, modern minimalism, or
abstract sculpture. Some used these
historical references for mere decora-
tion, others to make the buildings fit in
with older ones around them.

Richard Rogers and Renzo Piano,
Pompidou Center, 1977 (Paris).
*Paris' Pompidou Center takes "form follows
function" to the extreme. To get a more
spacious and functional interior, the guts of this
exoskeletal building are draped on the outside
and color-coded: vibrant red for people lifts, cool
blue for air ducts, eco-green for plumbing, don't-
touch-it yellow for electrical stuff, and white for
bones. Mentally compare the Pompidou Center
to another exoskeletal building—the Gothic
cathedral of Notre-Dame.*

Britain's Lord Norman Fos-
ter capped Berlin's late-19th-century
Reichstag building with a shiny new
dome (pictured on page 405), and

nearby Temppeliaukio Church—or
"Church in the Rock"—was literally
blasted out of solid rock and capped
with a copper-and-skylight dome
(designed by architect brothers Timo
and Tuomo Suomalainen).

By 1970, more and more archi-
tects were beginning to think outside
the boxy skyscrapers of modernism.
An interesting example of the let-
it-all-hang-out '70s is Munich's 1972
Olympic Stadium (by Frei Otto), laced
with spider-web and tent forms. Many

Lord Norman Foster, **Great Cou**
(British Museum, London).

ing his famous glass pyramid entry in the courtyard of the Louvre.

Other contemporary architects break completely with past styles, putting concept above all. Polish-American architect Daniel Libeskind (whose plan was the basis for the re-development of New York City's

I. M. Pei, **Pyramid entry to the Louvre,** 1990 (Paris).

designed a glassy, super-modern Great Court as the centerpiece for London's otherwise buttoned-down British Museum. I. M. Pei has also created old-meets-new juxtapositions, includ- World Trade Center site) designed the Jewish Museum in Berlin. This striking, zinc-walled building's zigzag shape is pierced by zones of emptiness— "voids" representing the irreplaceable

uggenheim Bilbao, 1997 (Bilbao, Spain).
spired by the body of a fish—is as interesting as its world-class collection

cultural loss caused by the Holocaust. His Danish Jewish Museum in Copenhagen is similarly conceptual: The floor plan, a seemingly random squiggle, is actually in the shape of the Hebrew characters for *Mitzvah,* which loosely means "act of kindness."

Perhaps the most notable architect of recent times is Frank Gehry, who uses computer modeling to create buildings that aren't square—a feat that was impossible to engineer before computers. One of his trademark works, the Guggenheim Bilbao in Bilbao, Spain, has an undulating silver roofline that defies International Style boxiness. Another Gehry masterpiece, the whimsical Dancing House, waltzes along the Vltava River in Prague.

Frank Gehry, **Dancing House,** 1996 (Prague, Czech Republic).

But even as these architects race for the future, Europe cautiously balances the new with the old. Strict preservation laws in many historic towns forbid changing the exterior of buildings. It's not uncommon to see only the front wall of a building standing, as the rest has been gutted to make way for an efficient, modern building. When the renovation is finished, the architectural harmony of the street will survive. In other cases, old buildings find new uses, like the former power plants that now house art at London's Tate Modern and Rome's Montemartini Museum. Many European cities have strict height limits on buildings, to allow the dreamy domes and spires of past eras to stand out. In Paris, they allowed one skyscraper, the Montparnasse Tower—quickly nicknamed "the Awful Tower"—before they decided to banish all skyscrapers to the outskirts.

Faced with ever-dwindling space, rising populations, soaring energy costs, and dynamic social changes, European architects have been forced to find creative solutions. Today's architecture is a product of available materials and technology, and the needs of the people for shelter—as it has been from the Renaissance back to Rome to Egypt to the first inhabitant of the first cave.

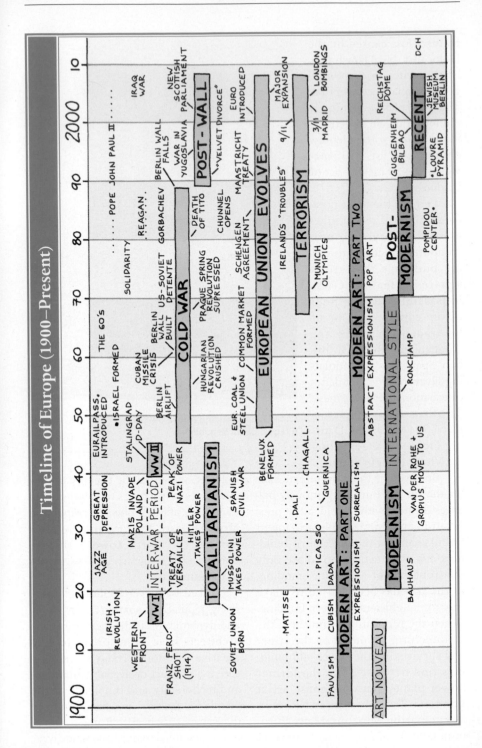

Timeline of Europe (1900–Present)

The Century Ends

As the 20th century sped to a close, Europe became richer, more united, and more closely linked with America and the rest of the globe.

In 1992, the European Union was born. This was the culmination of decades of diplomacy, trying to turn Europe's many bickering nations into a kind of "United States of Europe." (For more information, see the next chapter.)

Europe needed to compete in the new global economy. Now there were large, multinational corporations—some as rich and powerful as small European nations—that did business with little regard for political borders. The world had become connected by a new medium called the Internet, allowing instantaneous multimedia communication through electronic signals carried by satellites, cables, and telephone lines.

*Built in 2000, the **London Eye** celebrates more than the new millennium—it also commemorates Europe working together as it entered the 21st century: British steel and Dutch engineering, with Czech, German, French, and Italian mechanical parts.*

In the year 2000, a new millennium dawned, with Europe and America at a peak of prosperity unmatched in human history...

Europe Today

As you feel the fjords and caress the castles, remember that Europe is alive coping, groping, and more interested in its future than in its past. As visitors, we often forget that quaintness, cute thatched-roof houses, and yodeling are not concerns of the average European today. Sure, it's exciting to find odd remnants of Europe's Old World that somehow missed the 21st-century bus, but much of what we see touted as the "real thing" is actually a cultural cliché kept alive for the tourists. As you travel, keep your eyes open to contemporary Europe as well as its past. Educate yourself about current issues and concerns.

As the world hurtles toward a trillion McDonald's hamburgers served, Western-style prosperity is changing Europe. Most people speak at least some English, and Europe's tech savviness rivals America's. It seems that when all the wrinkled old ladies in black are gone, nothing will remain but skyscrapers, fast food, computers, Coca-Cola billboards, and the global pop culture.

But Europe and the US are also very different places. After being swamped by Americanization in the 20th century, Europe is finding its own identity again. Part of the joy of European travel is experiencing (and being challenged by) alternatives to the way things are back home. Through our travels we can become cultural hybrids—embracing what we like, and leaving the rest.

A United Europe

Europe's people are uniting. Most European nations share a common currency (the euro) and participate in a free-trade zone with a Europe-wide government—an entity known as the

Every European can speak at least two words of English: "Big Mac."

Millennium Bridge, 2000 (London).
London used the turn of the millennium as an excuse to get all spiffed up. Among its many new features is this cutting-edge pedestrian bridge connecting St. Paul's Cathedral in London's central business district with the formerly dumpy, but now thriving, South Bank of the Thames.

European Union (EU).

It's a bold social experiment. And it's still a work in progress. Imagine trying to unite former enemies who speak different languages, cherish their national cultures, demand a measure of self-rule, and yell insults at each other at soccer games.

But as Europe grapples with global challenges concerning the environment, terrorism, refugees, politics, and business competition, it has recognized the growing necessity of speaking, trading, and legislating with one voice. At last count, 27 European nations had pooled their resources and made a commitment to a common destiny.

The European Union Is Born

Two World Wars left 50 million dead and a continent in ruins, convincing some Europeans that they must work together to maintain peace. Wedged between competing superpowers (the US and the USSR), they also needed to cooperate economically to survive in an increasingly global economy.

Today's European Union is the result of efforts that began years ago. After World War II, Europe was a patchwork of small, proud countries that feared another war and thus closed themselves off from their neighbors just like so many walled medieval cities. At every border crossing, travelers throughout Europe had to endure self-important border officials, insistent on checking papers and pawing through luggage. Every nation had a different currency. Businesspeople had to dance an inefficient jig through rules that differed from country to country, and everyone viewed their neighboring country as a potential threat.

A Joke Every European Knows

In Heaven:
The chefs are French,
The lovers are Italian,
The mechanics are German,
The police are British,
And everything is run by the Swiss.

In Hell:
The chefs are British,
The lovers are Swiss,
The mechanics are French,
The police are German,
And everything is run by the Italians.

A few visionary politicians saw that free trade and common rules would make Europe richer, and that the best way to prevent another war among the nations of Europe was to link their economies together. "Eurocrats" began convincing reluctant European nations

On European town halls, locals often fly three flags. Here in Aix-en-Provence, you'll see (right to left) the regional (Provence), national (France), and European flags.

to give up some of their sovereignty to merge into a united body. While it was promoted at first as an economic coalition, the idea from the start was to progress step by step toward greater political unity. Leaders foresaw the day when the nations would wake up and find a complex and thickly interwoven web of networks that would be impossible to untangle...and Europe would be one.

The movement progressed slowly, bit by bit. It started in 1948, when Belgium, the Netherlands, and Luxembourg—jointly called "BeNeLux"—established a free-trade zone. Then, in 1951, the former archenemies Germany and France joined with Italy and the BeNeLux countries to form the European Coal and Steel Union. They relaxed trade barriers, shared resources, subsidized private business,

Superpower Bowl MMVI

America is slow to grasp the economic might of an emerging Europe in part because we compare ourselves to individual countries rather than to the EU as a whole. The three largest European countries (Germany, Britain, and France) each have economies about 50 percent larger than the three largest American states (California, New York, and Texas). And Americans, so enamored with Bill Gates and Boeing, don't notice that 60 of the world's largest 140 companies are European, while just 50 are American. French-owned Airbus, whose mammoth A380 Navigator dwarfs the Boeing 747, rivals Boeing. Of the world's 20 largest banks, 14 are European.

Country	Rough Gross Domestic Product	Population
European Union	$16.4 trillion	490 million
United States	$13.8 trillion	300 million
Japan	$4.3 trillion	127 million
China	$3.3 trillion	1.3 billion
India	$1.1 trillion	1.1 billion

Source: The European Dream *by Jeremy Rifkin and the* CIA World Factbook, 2008.

and maximized profits. Just as important, this union made historic enemies into economic partners, thus lowering the risk of war.

Based on their success, the same group of countries established the European Economic Community (the EEC, also called the "Common Market") in 1957, expanding economic cooperation to include other industries. Progress came in fits and starts, but over the next 30 years the EEC doubled its membership. As trade increased in the 1970s and 1980s, they

recognized the need for a common currency. They established the European Currency Unit, or ECU, precursor to the euro. While the ECU was not a paper currency, it enabled member countries to trade and conduct financial transactions without worrying about currency fluctuations and exchange fees.

By the 1980s, the European "economic" project began to affect everyday life. In 1985, the Schengen Agreement eliminated passport checks at border crossings within the EEC.

Free Trade Zones Are Nothing New

Free trade has long driven Europe's need for bigger political units. In the Middle Ages, merchants had to pay tolls to "robber baron" castles as they crossed the borders of many little states. It cost them half the value of their goods to simply ship their wares a few hundred miles down a river. In the 19th century, Britain was a pioneer in establishing a big single internal market and emerged

as Europe's first big economic power, in part because of the easy flow of trade without tariffs and customs. In 1600, Europe had 500 separate states. In 1900, 25 states governed most of Europe. About a hundred years later came the beginning of Europe's next stage: unification.

In 1600, tiny countries such as San Marino (in central Italy) were commonplace.

Now car travelers didn't have to stop at borders, and overnight train travelers could get a better night's sleep. Formerly imposing military barracks were converted to welcoming tourist information centers.

In 1992, the 12 member countries of the EEC made a leap of faith—the Treaty of Maastricht. With the stroke of a pen, they created a "European Union" that would allow free movement of capital, goods, services, and labor. They knocked down trade barriers and issued EU passports. It was an exciting time, as no one could predict the repercussions. Doomsayers were proved wrong, and Europe's economy continued to hum along. In 2002, most EU members adopted a single currency (the euro), and for all practical purposes economic unity was a reality.

Checkpoint Charlie (Berlin).
Once marking the main point of entry between former East and West Berlin, this guardhouse is now just a tourist attraction on another busy Berlin street.

The European Union continued to grow as the liberated Eastern European nations put their economies back together and asked to join the EU club. To become an EU member, nations must be sufficiently democratic, have a market economy, and agree to have their national policies conform to EU standards. Ten new member states joined in 2004, and two more in 2007. The EU plans to gradually welcome more countries from the East, shifting the geographical center of Europe even farther eastward.

Not all of Europe belongs to the EU. Notable gaps in the EU map include Switzerland, Norway, and most of the former Yugoslavia. In practice, however, most of these have agreements with the EU giving them many of the economic benefits of membership while technically preserving their independence from the bureaucrats in Brussels.

Determining who's "inside" and who's "outside" the EU can be confusing. Some EU countries don't participate in some EU programs, while some outsiders do. Britain, Denmark, and Sweden, though inside the EU, choose not to adopt the euro. Norway and Iceland are not in the EU, but they do follow the Schengen Agreement (no border checks). Meanwhile, Britain and Ireland, which are inside the EU, opted out of Schengen (so passports are still necessary). European unity is like a marketplace of common dreams, where each country can choose what they want to buy into.

The EU Today: Governed from Brussels

What began as a vision of economic unity has become more and more a political entity, a kind of "United States of Europe." With 27 members (likely more by the time you read this), today's EU is the world's seventh-largest "country" (1.7 million square miles), with the third-largest population (almost 490 million) and an economy ($16.4 trillion GDP) that rivals America's as the world's biggest.

While some EU institutions meet in Strasbourg, Frankfurt, Luxembourg, and other cities, the European Union is primarily governed from Brussels. As the unofficial capital of Europe, multicultural Brussels hosts black-suited politicians speaking 20 different Euro-languages.

*The **European Union Headquarters** is a glassy complex of buildings in Brussels. Regular tours give visitors a peek at this babble of nations carving out a united future. It's exciting just to be here, feeling like a mouse in the corner of a place that charts the future of Europe "with respect for all political thinking... consolidating democracy in the spirit of peace and solidarity."*

The **EU** consists of Austria, Belgium, Bulgaria, Cyprus, the Czech Republic, Denmark, Estonia, Finland, France, Germany, Great Britain, Greece, Hungary, Ireland, Italy, Latvia, Lithuania, Luxembourg, Malta, the Netherlands, Poland, Portugal, Romania, Slovakia, Slovenia, Spain, and Sweden. On deck: Croatia, Macedonia, and Turkey.

The **euro** is the common currency used in the following European Union countries: Austria, Belgium, Cyprus, Finland, France, Germany, Greece, Ireland, Italy, Luxembourg, Malta, the Netherlands, Portugal, Slovenia, and Spain. The other recent members are likely to adopt the euro soon...maybe by the time you read this.

To travelers with a railpass, Europe isn't the EU or Euroland—it's **Eurail** country. All aboard!

Europeans elect members to a European Parliament to represent their interests. The 700-plus Parliament members, representing 27 countries, have a €130 billion ($200 billion) annual budget with which to shape Europe. Most other officials are appointed by the governments of member nations.

There's no single chief executive with powers similar to America's president; the presidency of the EU rotates every six months among the member countries. In fact, the EU does not have the strict executive–legislative–judicial branches of American government. While there is a Parliament, the EU is primarily governed by the European Commission (appointed by individual member governments) and the Council of Ministers. Daily business is conducted by an army of career bureaucrats and policy wonks. Having many different departments with overlapping responsibilities makes things cumbersome, but it helps ensure that final decisions are acceptable to most member states.

So who's in charge? Can the EU president overrule the prime minister of Britain? Can the European Parliament pass laws that contradict those of France's National Assembly?

It's a delicate balance, and the EU works hard to avoid direct challenges to the authority of national governments. In addition, there are limits to the EU's powers. For instance, it cannot levy taxes. That's still done through national governments, which then fund the EU. The EU cannot deploy troops without each nation's approval. Foreign policy is still largely determined

by the individual nations, though there is a movement to streamline Europe's responses to international conflicts and issues. The European response to the Balkan wars (in the early 1990s) and the divided response to the recent war in Iraq have demonstrated that Europe still has trouble speaking with a single voice.

The scope of the EU grows with each year, as it continues to establish Europe-wide standards for trade, taxes, labor, and environmental practices. They also coordinate local police and security forces to fight international crime.

For the past several years the EU has been drafting a constitution, borrowing much from the US Constitution. But it diverges from the American way of government in a number of important ways. There is absolutely no mention of God beyond a mild reference to "our religious inheritance." And rather than championing the sanctity of private property, the EU's envisioned constitution promotes communal values, such as protecting the environment and promoting economic fairness. Europe sees the downside of the American system in which corporations actually have more rights than individuals. The EU constitution's forte is human rights: the right to privacy, the right to access personal data, the right to diversity (cultural, religious, and linguistic), as well as the rights to paid maternity leave, housing, health care, education...and even the right to an annual paid vacation!

Progress on this idealistic document suffered a major setback in 2005 when several nations shot it down in national referendums, sending the Eurocrats in Brussels back to the drawing board, pondering whether it was a vote against the constitution itself or just a vote for slowing down the growth of the EU.

Ultimately, if the EU does something a member nation doesn't like, that nation does not have to obey. Unlike America's federation of 50 states, Europe's member states retain the right to opt out of (but not veto) EU policies—such as the euro currency or open-border agreements, as explained above.

The challenge is complex: trying to develop laws and policies for all Europeans while respecting the rights of nations, regions, and individuals; letting small nations have real power, without ending the dominance of the bigger countries; and uniting economically and politically while preserving each nation's cultural uniqueness. An oft-quoted EU slogan is: "promoting unity while preserving diversity."

A More Perfect Union?

While many political and business leaders are rah-rah EU boosters, regular people are still wedded to their national identities. When each country debated whether to join the EU, less than a handful held nationwide referendums. In most countries, people never had any direct say in the decision to join.

While many of the worst fears haven't come true, there remain plenty of avowed "Euroskeptics." One complaint is that merchants used the introduction of the euro currency in 2002 as an excuse to raise prices. Italians grumble even today that they "earn lire, but spend euros." In Germany, where the

changeover coincided with an economic downturn, people call the euro the "teuro" (a pun on the word for "expensive"—*teuer*).

Another common jab is against the heavy-handed EU bureaucracy, which creeps into virtually all aspects of life. Strict health codes for restaurants dictate that cooked food must be frozen if it's not served within three hours. My Czech friend complained, "This will make many of our best dishes illegal." Czech specialties, often simmered, taste better the next day. A Polish farmer I know gripes that, when Poland joined the EU, he had to get "passports" for his cows. And producers at open-air markets everywhere lament: Even a banana must meet an EU-mandated degree of curve.

The EU believes it's to everyone's benefit to boost the economies of poorer states. So, with a kind of internal "Marshall Plan," the EU invests lavishly in its infrastructure. Today, Portugal is laced by new freeways, each with European-flag billboards reminding locals where the money came from. Ireland, which is finally importing labor rather than exporting it, has a higher per capita income than England for the first time in history. In theory, what's good for one member is good for everyone—better roads in Lisbon improve business in Helsinki. But wealthier countries sometimes wonder whether this "tax the rich, fund the poor" system is really in their interest. Germans think: Might my tax money be put to better use in Germany?

On recent trips to Ireland and Portugal, the brand-new roads were messing up my itinerary day after day: I kept arriving in town hours before I thought I would.

The poorer countries have their share of concerns, too. Eastern Europeans worry that wealthy Westerners—who can easily win any bidding war with the locals—will snap up all their best real estate to build vacation homes. Generations-old wounds make the dynamics even touchier. The Sudetenland—a traditionally German fringe around today's Czech Republic—was seized by Hitler as a precursor to World War II. After the war, the Czech government forced Germans out of their traditional homes in this area. Now, thanks to the EU, Germans will become eligible to buy back the property their grandparents lost more than 60 years ago.

Many people think European unification has gone far enough, thank you. Small countries that struggled to win their independence have been especially reluctant to give up their sovereignty. A Czech grandmother put it well: In her lifetime, she has lived in a country ruled from Vienna (by the Hapsburgs), Berlin (the Nazis), and Moscow (the communists). She said,

"Now that we're finally ruled from Prague, why would we want to turn our power over to Brussels?" Norwegians, who once had to take orders from Copenhagen and Stockholm, felt the same way...and voted no to EU membership.

Just as many Americans fear the influx of cheap Mexican labor, many Western Europeans worry that free trade will flood their countries with inexpensive workers from the East: Estonian truck drivers, Hungarian carpenters, and Polish plumbers. Visitors to Dublin or London are surprised to discover that half the hotel receptionists don't speak fluent English.

Playing on these fears, a right-wing French politician recently talked ominously of a hypothetical "Polish plumber" who threatened to put French plumbers out of work. The Polish tourist board countered by placing clever ads in France featuring an alluring Polish hunk stroking a pipe wrench, saying, "I'm staying in Poland...come visit!"

Despite the complaints, most Europeans ultimately agree that the EU makes good sense. It's all around

them. They can comparison-shop across borders without a calculator. They can work or study in another country without filling out stacks of forms. Their air and water are cleaner, thanks to Europe-wide environmental standards. There's just one common passport style and one uniform driver's license.

And most Europeans see the big picture: A united Europe can compete better in a global economy and stand up to American economic bullying. Yes, there are complaints, but virtually no one wants to go back to the way it used to be. With or without exuberance, the European on the street knows that further integration is an idea that's good, necessary, and ultimately inevitable.

Forging a European Identity

In 1987, the EU launched the Erasmus program, which pays the travel costs for students who want to study abroad in another European country. More than one million students have taken part so far, spawning a generation of well-traveled Europeans. They speak multiple languages, feel at home in several different cultures, and think nothing of moving to another country for work or school. Most of all, they've grown accustomed to thinking of themselves as "Europeans" first, and Germans, Spaniards, or Dutch second. This cosmopolitan bunch of twenty- and thirtysomethings has become known as the "Erasmus Generation."

To facilitate communication in their ever-shrinking world, today's Europeans have embraced English as a common language for government and business (like Latin in the Middle

pean. But that's nothing new. In 1870, when the united nation of Italy was created, locals still identified with their regions. Leaders declared, "We've created Italy; now we need to create Italians." The visionaries behind the EU know that this process takes time.

But the new generation is growing up European. Plenty of its members create their own personal "European union" by marrying someone from another country. While these couples' parents were born in the shadow of World War II, their children will never know anything but a united Europe.

Ages, or French under Louis XIV). New signs in airports are mainly in English, further uniting Europe and battling the inefficiency that comes with a babble of languages. TV and the Internet bring Europeans together. Germans get their news from the BBC, and Spaniards laugh at Italian game shows.

Frankly, the union of European countries has evolved more quickly than its citizens' sense of being Euro-

Many feared that the EU would lead to a homogenization of Europe's unique cultures. Quite the contrary: It fiercely protects and promotes diversity. In fact, the endangered cultures of Europe—ethnic groups without their own country—are better protected as citizens of Europe than as subjects of a national government that saw them as a separatist threat. Local dialects and regional governments are nurtured. As the political relevance of Madrid and London wanes, Catalan flags wave freely in Barcelona, and Celtic children in Wales and Ireland learn their ancestors' long-suppressed languages. For the first time in almost 300 years, London is allowing the Scottish Parliament to meet.

Enric Miralles, **Scottish Parliament,** 2004 (Edinburgh).
In 2000, for the first time since 1707, London allowed Scotland to convene its own parliament. Today, Edinburgh's striking new Parliament building—across the street from the Queen's Palace at the foot of Edinburgh's Royal Mile—welcomes visitors.

Despite all the "Euro-fication," cultural differences

A Day in the Life of Today's Europe

Miep wakes to the sound of cows mooing in the distance. She rides her bike to the train station. Passing through security checks, she boards a high-speed bullet train and takes a seat next to a dark-skinned man with a laptop and turban, who's doing business on his mobile phone.

Three hours later, Miep is in another country, having lunch with colleagues. Colin from London, Marie from Paris, Martje from Amsterdam, and Dietrich from Bonn have all made it here as a day-trip from home. The conversation jumps back and forth between French, German, and Italian, sprinkled with a few Czech jokes. When they need a common language, it's English.

That afternoon, Miep returns home. She checks in on her aging mama and Uncle Eric, who live nearby. In town, she shops for dinner by walking around the block—she buys bread from the baker and meat from the butcher, concentrating on local foods in season. Back home, she climbs the narrow stairs to her small apartment. She sets the table, using her great-great-grandmother's lace table-cloth and fine china.

Miep's old university pals come over: Frans, Hans, Fritz, and Jean-Paul Giorgianringgo. They crack open some Spanish wine and catch up while they all pitch in cooking dinner. They're still best friends, even though Fritz is now a plumber, Hans owns a high-tech business, and Jean-Paul lives in a different country. The talk runs from politics to travel to poetry to American movies.

They eat. The first course comes, and they linger over it with a new wine. Second course. More wine. Third course. Port. Dessert. Coffee. Four hours later, the meal is over and they head home. No one has to drive, as they ride their bikes or catch buses and trains. It's the end of another full day, and Miep goes to sleep, comforted by the familiar sound of a toilet being flushed by the neighbor upstairs.

live on. No one is abandoning their native tongue for English. The French and Germans still mix like wine and sauerkraut. Brits still tell insulting jokes about Italians, and vice versa. Nations still duke it out for world dom-ination...on the soccer field. There's reason to hope that the cultural diver-sity that makes Europe so much fun to explore will not only survive unifica-tion, but will thrive because of it. *Vive la différence!*

Challenges Facing Europe in the 21st Century

It's easy to see today's united, working-together Europe through rose-colored glasses. But Europe continues to struggle with a number of socio-economic and political issues, including terrorism; the tension between white Europeans and Muslim immigrants; an aging population coupled with low birth rates; and competitiveness in the global market.

Terrorism

Everyone was shaken by the terrorist attacks of September 11, 2001. Americans were comforted by images of people all over the world—including every European country—showing their support for the victims and for the US as a whole.

Exactly two and a half years later, Europe suffered its own "9/11"—which they call "3/11." During the morning rush hour on March 11, 2004, three Madrid train stations were bombed, killing 190 people and injuring more than 1,500 others.

Just more than a year later, on July 7, 2005 ("7/7"), London was also rocked by explosions during morn-

ing rush hour. Public buses and subway stations were targeted by suicide bombers, killing 52 and injuring 700. The bombers (who died in the attacks) were British citizens of Pakistani descent, causing the country to ponder how well it had integrated its Muslim population.

The European response to these terrorist attacks was very different from America's. When London was bombed, Prime Minister Tony Blair took only a one-day break from the G8 summit he was hosting in Edinburgh... then got back to work. The day after the attacks, London's morning commute was business as usual. In Spain, the terrorist group claiming responsibility denounced the Spanish government's support of the US-led invasion of Iraq. Three days later, an already-planned national election toppled the incumbent conservative party. While America had a very strong and long-lasting response to 9/11 (understandably, given the high death toll), for Europeans, terrorism is a more familiar element of modern life.

Europe has lived with the reality of terrorism since long before 9/11. Terrorists' weapons have evolved from caveman clubs to daggers to barrels of gunpowder to jet airliners, but their primary goal has remained the same: using violence (or the fear of violence) to achieve political aims.

The term "terror" actually comes from the French Revolution's "Reign of Terror" (see page 297), when Robespierre promoted the guillotine as "a

tool to bring about legiti-
mate government ends."
World War I was sparked by
an act of terrorism, when
a member of a subversive
group shot the Austrian
archduke Franz Ferdinand.

As the 20th century
progressed, terrorism in
Europe appeared in many
forms. In Ireland, political
differences between Cath-
olics and Protestants often
erupted in gang violence,
bombings, and demonstra-
tions that turned violent
("The Troubles"). The 1972
Munich Olympics provided
a worldwide stage for Pal-
estinian terrorists who kid-
napped and killed 11 Israeli athletes.
In the 1970s and 1980s, secret cells
of "Red Brigades" scattered across
Europe attacked police and assassi-
nated politicians (including the Ital-
ian prime minister) to try to foment a
Marxist revolution. The Basque sepa-
ratist group ETA in Spain made the car

Europeans wrote the book on security—they've been on orange alert since the 1970s. At airports, you won't always take off your shoes and take out your laptops. But security is high for "soft targets" such as the Eurostar train connecting London and Paris under the English Channel.

bomb an art form in their struggle for
freedom from Madrid's control. Neo-
Nazis in Germany continue to vandal-
ize Jewish cemeteries and spray-paint
swastikas. Even art is not immune, as
the 1993 Mafia bombing of Florence's
Uffizi Gallery proved.

The new kid on the terrorism

In Northern Ireland, political murals tell the tale of an island divided.

Just try to hide a bomb in Paris' see-through garbage "cans."

block is Muslim extremism. A small fringe of Muslims have made headlines as a result of their anger toward Europe's and America's support of Israel, unpopular wars in Kuwait and Iraq, and what they perceive as a general disrespect for Islam. Given the fact that an increasing number of Europeans are Muslims, these issues have become especially touchy.

Today, Europe—like the US—faces the prickly problem of keeping an open society in a world where almost any individual or group can launch a terrorist attack at any time.

Immigration

As its postwar economy rebounded in the 1950s, Western Europe found itself short of workers, and cut off from its old sources of cheap labor in Eastern Europe. Western Europe welcomed millions of so-called "guest workers" from countries such as Turkey, Algeria, Morocco, Indonesia, and Pakistan (many of them Muslims from Europe's former colonies). While there was no specific timeline for how long the (primarily male) guest workers could stay, people assumed they would work for a few years and then return home.

But many stayed and gradually sponsored their families to join them. The fast-growing immigrant communities they created slowly changed the face of countries that had previously been Christian and Caucasian. Seeds of future unrest had been planted.

Rather than assimilating into an American-style melting pot, descendents of Europe's guest workers (second-generation immigrants) increasingly feel alienated from their host countries. Whole communities of Tunisians in France, Pakistanis in Norway, Turks in Germany, and Somalis in Italy are a few examples of immigrant groups that have little to no interest in being assimilated into their host cultures. The feeling is mutual. Europe has traditionally had less cultural diversity and less experience at welcoming immigrants than America. The result is a vicious circle of double-digit unemployment among immigrants and little hope for decent jobs and upward mobility. This may have led to a small minority of immigrants being more susceptible to Muslim extremism.

With all of this diversity, Europe is facing an increasing tide of anti-immigration, anti-Semitism, and anti-Islamism. For example, France has passed a law banning Muslim girls from wearing traditional head scarves to school. Does banning the scarves enforce democracy...or squelch diversity? In late 2005, a wave of riots and car burnings swept Paris after two African teenagers died, possibly while fleeing policemen. Among Paris' African and Muslim residents, the event tapped into existing resentment about the discrimination they

feel from French society.

Generally perceived to be enthusiastic about tolerance and diversity, the Netherlands has also gotten a dose of this Europe-wide conflict. Prominent Dutch filmmaker Theo van Gogh (the artist's great-great-grandnephew) was gunned down on an Amsterdam street in 2004 after making a controversial movie about the abuse of Muslim women. The murder sparked intense debate, as did the trial of the shooter, who is a Muslim with both Moroccan and Dutch citizenship.

Denmark has had its share of tension as well. In 2005, a Danish newspaper published cartoons of the Prophet Muhammad. Many Muslims consider any depiction of Muhammad to be sacrilegious, and the caricatures sparked a wave of protests throughout the Muslim world. Angry Muslims burned Danish flags and boycotted Danish products.

Throwing gas on the fire are pol-iticians who capitalize on—frankly—racist attitudes. Thanks to this latent strain in Europe, right-wingers with an anti-immigrant stance (such as France's Jean-Marie Le Pen or Austria's Jörg Haider) have done surprisingly well in election after election. Who votes for the far right? A growing number of Europeans who blame the immigrants for taking away jobs or living off welfare. Fearful of another Hitler, Europe wonders whether it's better to suppress far-right groups or let them spout off. Meanwhile, immigrants (such as French citizens of Moroccan heritage) increasingly find themselves the targets of racism and even violence.

With a stagnant and even declining indigenous population (see below) and a relatively high percentage of immigrants, Europe's ethnic make-up is changing. Without immigration, the Continent will depopulate, and the European Dream will wilt rather than flourish. Europe's big challenge is to include its immigrants constructively into its vision of the future.

Aging Population, Declining Birthrate

While Europe's immigrants present a challenge to Europe, they are also necessary for its future. If you study the demographics, it seems Europe is becoming an old folks' home. The average age in most countries is 40. American politicians fret about reforming Social Security, but Europe is doubly worried: By 2050, its non-immigrant population will have dropped by 13 percent, and a third of all Europeans will be older than 60.

The double-whammy is that Europeans are also having fewer

1 Dad + 1 Mom + 1 Baby = The typical European family.

ranks of Europeans expecting early and comfortable retirements. Something has to give, and as governments announce necessary cutbacks, workers raise their collective voices. In early 2006, Paris erupted in riots as students protested new laws they thought would cut into their entitlements and make them more dispensable as workers. Believing older citizens are taking too much of their society's economic pie, young Europeans are organizing into "groups for generational justice."

kids. The family model is not 2.2 children—it's 1 child. Governments are combating Europe's very low birthrate with incentives such as tax breaks for having kids. In Eastern Europe, many young people just don't want families, preferring to seize their long-awaited new opportunities to make lots of money. They're choosing vacation homes and fancy cars over children. Meanwhile, cool and comfy Western European couples—with two incomes and no kids—are not about to have children just for a tax break. Germany and Italy have particularly low birth rates, in part because of social mores that discourage women from being mothers and pursuing a career at the same time.

The EU simply can't support the swelling older

Competitiveness in the Global Market

European workers (especially in northern Europe) are as productive, by the work hour, as their American counterparts. The problem European economies face is simply that their workers don't want to put in so many hours; they insist on longer vacations; and

Today's Europe is not just some fairy-tale land of dirndled yodelers and folk-dancing farmers. It's grappling with serious issues such as globalization, increased immigration, an aging population, and a workforce unwilling to give up its cradle-to-grave security. Cherished entitlements are being axed as Europe's economy struggles to keep up with modern realities.

they don't want to give up the benefits and securities they've come to think of as guaranteed. At the same time, Europeans must compete in a global marketplace where labor is often much cheaper elsewhere. With increases in European labor costs, the pressures of globalization, and the changing demographics of an aging European society, an unstoppable force is about to meet an immovable object. European workers will have to deal with this new economic reality and either work longer, make less, or give up some of their cherished benefits. While corporations will push for these reforms, politicians will feel the heat from an angry electorate. (For more on the European approach to work, see "Working Life vs. Quality of Life" on page 448.)

Two Global Superpowers: Europe and America

In the years after World War II, many grateful Europeans named their children Frankie and Johnny after the GIs

Europeans still appreciate American sacrifices for their freedom. Vast cemeteries recall the heroics of Allied landings in Normandy on D-Day in 1944. cemetery at St. Laurent marks the graves of 9,387 rican soldiers who broke Hitler's hold on Europe.

who freed them from Nazism. Europe's Frankies and Johnnys are now in their 60s, and America is no longer as admired as it once was. Though America still sets the tone for Western culture, Europeans nurture their own ways. American ad jingles that used to sell in Europe now turn people off. Blockbuster Hollywood movies face stiff competition from European cinema.

The Iraq War (2003–?) drove a wedge between Europe and America. After 9/11, Europe was extremely supportive of the global war on terror, and NATO—a military alliance of the US and many European nations—sent troops to fight terrorists in Afghanistan. However, the American government's next response to 9/11—to invade Iraq—made little sense to those in Europe. A few nations, notably Britain and Poland, supported the US, but most Europeans believed there wasn't sufficient reason for military action. Rainbow flags announcing *pace* (the Italian word for "peace") were flown throughout Europe. When America invaded Iraq anyway, the European NATO allies felt snubbed.

The debate stirred up old cultural stereotypes. European newspapers featured political cartoons of US President George W. Bush as a classic American "cowboy" (one English word most Europeans know), recklessly shooting up the world. At the same time, misguided American patriots filled the airwaves with anti-European stereotypes. There was talk of boycotting French's Mustard (which is actually owned by a British company) and eating only "freedom fries." The gulf between Europe and the US widened.

The American Dream and the European Dream

If America's icon is the lone cowboy on the wide prairie, Europe's is the friendly baker in the tight-knit village. Now that Europe has emerged as an economic and cultural superpower, it's becoming clear that Europe and America are quite different. The American Dream emphasizes individualism, personal freedom, hard work, and material wealth.

Meanwhile, Europe's vision embraces cooperation, community, leisure time, and quality of life.

While Americans tend to stress individual freedom, Europeans stress relationships. On a governmental level, too, America often acts alone (unilaterally), while Europe builds interdependent alliances.

The American Dream emphasizes economic growth by maximizing the society's total quantity of wealth. The European Dream factors in quality of life. A business must be sustainable and environmentally safe. While Americans glorify the work ethic (we "live to work"), Europeans strive for leisure time with friends and family (they "work to live").

America is very religious, while Europe is much more secular. While many Americans sport red-white-and-blue bumper stickers stating, "Proud to be an American," Europeans are likely to be more rah-rah for their local soccer team.

For more on these cultural differences, check out the book *The European Dream* by Jeremy Rifkin. Or visit www.ricksteves.com/dream, where you'll find an article by Rick Steves entitled "A United Europe in the 21st Century: Eclipsing the American Dream?"

Europe and America differ on many political issues, including family planning, land mines, torture, global warming, Cuba, and preemptive war. In fact, given our stance on these topics, America is considered something of a rogue nation in the global community. Polls have shown that most Europeans actually consider the biggest threat to world peace to be...the US.

Does this mean that Europe is anti-America? In some ways, yes. Europeans resent (and fear) the sheer omnipresence of America in their world. But are they anti-*American*? No. The majority of Europeans are careful to distinguish between a government and its people, and between stereotypes and individuals. And in our travels— from the Vietnam era to the Reagan years to the Gulf War to 9/11 and the Iraq War—we've almost always found Europeans to be accepting of us as human beings, no matter how they feel about our government.

US vs. EU: By the Numbers

	US	EU
Population	300 million	490 million
Land Area	3.7 million sq. miles	1.7 million sq. miles
Gross Domestic Product	$13.8 trillion	$16.4 trillion
Life Expectancy	78.0 years	78.7 years
Infant Mortality Rate	6.4 deaths/1,000	4.8 deaths/1,000
Health Care Cost as Percentage of GDP	16%	10% (2004 estimates)
Number Without Health Insurance	46 million	Effectively zero
Internet Users	208 million	247 million
Annual Military Spending	$440 billion*	$293 billion

*Does not include Iraq War

Statistics from the CIA World Factbook, 2008; California Health Care Foundation, 2005; New York Times, 2004.

Snapshots of Europe Today

Here are some quick slices of European life. Though globalization has made the world smaller, it's interesting to see that Europe remains quite different from America.

Be aware that there are some gross generalizations here about "Europe," "Europeans," "America," and "Americans." Obviously, Europeans and Americans are unique individuals who can't be easily summed up with cultural stereotypes. Beliefs and lifestyles vary significantly from region to region and person to person. This is especially true in Europe, where you have so many different languages, customs, and historical traditions. Still, there are some traits and trends in common that can give us a glimpse into Europe today. Here goes:

Big Government, High Taxes, and Lavish Social Services

Most of Europe's nations are democracies, though there are differences from the US system. Some countries still have a king or queen as the nominal (though not actual) head of government. A country's president is often a mere ceremonial figure. The real power is wielded by the prime minister, who heads the leading vote-getting party in the parliament (or congress). Rather than a strict two-party system, there are two major parties in each country, plus a number of smaller ones. These third parties may be too small to ever take power, but they're big enough to win a few seats in parliament, act as deal-breakers, carry a stick, and force the big parties to govern by coalition and compromise.

Europe's nations are more socialist than America. Socialism may be a

bad word in America (where it's mistakenly identified with communism), but Europeans accept it unapologetically, calling it social democracy. Europe embraces a market economy, but countries rely on government to regulate the economy and improve the quality of life. They believe that if the government doesn't intervene against unrestrained capitalism, greed will prevail, wealthy people will thrive, and the poor will suffer.

Europeans routinely pay far more in taxes than the average American—typically, between 35 and 45 percent of their income. Besides the income tax that gets deducted from their payroll checks, there are various local taxes, and a Value Added Tax (VAT) of about 17 percent that gets tacked onto most retail goods.

Taxes may be high, but they're "progressive"—soaking the rich to lessen the gap between rich and poor. Consequently, a wealthy European earns about three times what a poor European does; in America, that gap is five to one. Of the world's 26 richest industrialized nations, the 18 most equal countries are all European. (The US is near the bottom of the list, ahead of only Mexico and Russia.) Economic equality is bad news if you want to become a multimillionaire in Europe. But for the other 99 percent of Europeans, such equality is appreciated.

In return for their taxes, Europeans get a comfy social safety net. While America spends only 11 percent of its GDP on social services,

Europe spends a whopping 26 percent.

All European countries have a national health care system. No one is excluded, and there's no such thing as a pre-existing condition. Everyone benefits from swimming together in the same common-risk pool. While the costs of the system are less per person than in America, Europeans have a slightly longer life expectancy. They never have to worry about losing their health coverage if they change jobs, start a new business, or take a long vacation. To Europeans, this is an example of government that legislates for people rather than for corporations. (If all this sounds just too perfect, be aware that many wealthier Europeans choose to pay out-of-pocket for private, higher-quality health care and no wait list.)

Europe relies on tax money (not just individuals and big corporations) to fund institutions that enrich their quality of life: the arts, environment, human rights, education, health, and preservation of ethnic subcultures. Europeans routinely vote for compulsory "charity" (in the form of high

European taxes at work—a shiny new train station.

taxes) for foreign aid to poor people overseas. European nations generally rank higher than America in what they donate per capita.

Sure, Europeans grumble about taxes and gripe about government waste, but they still vote to keep taxes high. They see their taxes as a necessary investment in the social infrastructure. When Brigitte fills her Renault at *le pump*, she knows that the price includes a hefty built-in gas tax earmarked to maintain roads, design the latest TGV bullet train, and pay city bus drivers. Ultimately, individual Europeans believe that looking out for the greater good (the "common wealth") is in their own best interest.

Education

Europeans are among the best-educated people on the planet. They routinely test higher than other developed nations (including the US) in math, science, and world geography. Most kids attend school almost year-round (with a shorter summer vacation). Students must choose their career path quite early. While in their equivalent of our high school, they take crucial, life-changing assessment tests that put them on an educational track leading to either university or vocational training.

Europe invests heavily in education, on the theory that an educated populace makes a better society. Until recently, tuition at German universities was absolutely free. Even now, prestigious European universities cost little more than an American community college.

One drawback to Europe's extreme focus on education (from an American point of view) is that it makes Europe's economy and society more rigid. Rigorous training is required for almost every job. Tradition encourages children to follow the career of their parents. Young people, channeled at an early age into a predetermined career, have less chance to find their own way. Adult Europeans are less likely to switch careers in later life, because it would require going back to school. Free-wheeling entrepreneurs find it hard to get their foot in the door, because they lack the right credentials. In many ways, America still remains the land of opportunity, where freelancers can find a home, garages sprout start-ups, and exciting ideas roam the wild prairie.

Military

Remember that France, which has a quarter of America's population, sometimes lost as many as 70,000 people in a single day during World War I. That's more than the US lost during the entire Vietnam War. About a third of all Scottish men perished in World War I. In World War II, Europe lost 18 million compared with the US's 420,000. As the Cold War raged, Europe cowered between two puffed-up superpowers, fearing their continent might

Throughout World War II and the Cold War, neutral Switzerland became a heavily armed mountain fortress. Today, the practical Swiss no longer spend much on defense, and thousands of hidden military installations are decommissioned, such as underground hospitals, Batman-type airstrips dug into mountains with futuristic sliding doors, and humble barns hiding mighty artillery. Many are now tourist attractions.

American Marines stationed in Vienna wear T-shirts when enjoying an off-duty day. While they may express pride in their work, these shirts (which, this soldier explained, are custom-made for each city in which Marines are stationed) look to locals like they celebrate the American occupation of their city.

be the ultimate battleground for a nuclear Armageddon. It's hard to fathom the depth of the scars of war that Europe lives with.

And yet today, the Irish toss darts with the English. Serbs vacation in Dubrovnik hotels they bombed just a couple decades ago. And Germans enjoy the beaches of Holland (careful never to ask directions to the old town in Rotterdam). Given their history, it's little wonder that Europeans—long masters of warfare—are now increasingly pacifist.

After World War II, Europe relied on its NATO partner, the US, for protection. American military bases dotted the Continent (many still do), and American dollars funded most international military actions. Some 100,000 American troops are stationed in Europe, mostly in Germany.

In the latter half of the 20th century, whenever military action has been called for anywhere in the world, US troops have done most of the fighting. Lately, when the shooting has stopped, European forces have stepped in to maintain the peace and help mop up. Seventy-five percent of the world's boots-on-the-ground peacekeeping forces during the past 50 years have been European. That's why they say, when it comes to war, the standard operating procedure has been that "the US does the cooking, and the EU does the dishes."

The American military complains that the Europeans aren't decisive in war-time decision-making. It's true that the EU doesn't make decisions for individual nations when it comes to the use of armed force. There is no standing "European Army"—each nation maintains its own military force. However, the EU is developing a single multinational rapid-deployment force of 60,000 troops that will serve their individual nations in peacetime but can be activated quickly when danger arises.

Ultimately, though, Europe thinks the main path to security is through economic, not military, strength. The formation of the European Union has greatly reduced the threat that, say, Germany would ever again attack France. As they say, "If you kill your baker, where will you get your bread?"

Europe's New Economy

Today's Europe is driven by a creative version of socialism with a global perspective, where government and private industry work hand-in-hand.

Governments subsidize key industries (such as Airbus, maker of commercial jets). They allow monopolies if it increases efficiency (and avoids "Betamax vs. VHS"–type competitions that divide the economy). To bring everybody up to speed, the EU invests in its neediest members: big subsidies for the poorer nations, funding for young people to study in other member countries, and aid for workers to go to school and learn new job skills. And Europe's socialist-minded governments are quick to punish companies—however profitable—that pollute, exploit workers, or threaten

quality of life.

Despite some grumbles, the euro currency has been a success. To be a member of the exclusive euro club, nations must practice fiscal discipline—they don't have the option of stoking their own economies with big deficit spending. Coupled with America's huge deficit, this sober policy has allowed the euro to challenge the US dollar as the leading global currency. Experts predict that oil-producing countries will soon be selling their oil in stable euros, not shaky dollars. This decline in the demand for dollars would weaken the American economy...and further strengthen Europe's status as a global economic superpower.

The EU is fast-tracking an ambitious 21st-century infrastructure, financed with an initial investment of $500 billion. This futuristic grid includes better-than-ever transportation, high-tech industries, and communication networks. The goal is to create a super-efficient playing field in which Europeans can both do business and enjoy life.

Transportation: Fast Trains, Smart Cars, Happy People

All of Europe is well on the way to being integrated into a German-quality network of high-speed train lines and super freeways. The opening of the English Channel Tunnel (the Chunnel) in 1995 first signaled how Europe is growing together physically in ways previously unimaginable. But the Chunnel was just the beginning. Norway is drilling the world's longest tunnels as it brings roads to remote fjord communities. A huge new bridge

laces together Sweden and Denmark. And bullet trains crisscross the ever-smaller Continent. Europe is charging confidently into an age where there are only neighbors.

Not everyone in Europe drives a car. Gas prices are twice that of America's. Parking is scarce. Driving lessons are rigorous and costly. Cars themselves are expensive, in part because the sticker price includes the cost of the car's eventual disposal. Many European cities are a tangle of tiny medieval lanes that make driving a pain but walking a pleasure. Rather than commuting to work by car, people tend to live right in the thick of the action, surrounded by markets, shops, and their place of work. Those who do choose to drive turn increasingly to fuel-efficient hybrid vehicles

Europe's high-speed "bullet" trains can go upwards of 200 mph, getting inter-city travelers from downtown to downtown in less time than by airplane.

or tiny Smart cars.

But who needs a car? There are buses, subways, and taxis to get across town. Bikes and Vespas are popular. Inter-city commuters have efficient train lines, and bullet trains and airplanes provide convenient international travel.

Europe makes its cities people-friendly...by making them car-mean. Cars are often banned from the historic center to create pedestrian-only zones (as in Florence, Munich, and Copenhagen). Freeways (such as Paris' périphérique) direct traffic around the perimeter. London and Oslo charge a toll for drivers entering the crowded downtown. Subsidized park-and-ride lots make it cheap to leave your car outside of town and catch a shuttle bus into the center.

All of this contributes to the European appreciation for quality of life. You'll find café-lined, traffic-free zones in city centers, along waterfronts, and around museums. Here, Europeans indulge in their favorite pastime: people-watching.

Rush hour in car-free Copenhagen.

Energy and the Environment

The continent of Europe is not blessed with the abundant natural resources that America enjoys. Europeans have learned to conserve what they have and find creative alternatives.

A silent victim of modern times, the environment has gained attention only in recent decades. Until then, Europe was notorious for treating the Mediterranean Sea like its own private cesspool. Europeans suddenly became aware of the diseased forests, dead rivers, and radioactive reindeer in their midst. The Green Party, whose platform is primarily environmental, began to raise issues about nuclear accidents, acid rain, ozone problems, wildly fluctuating temperatures, and chemical spills. Now, even politicians busy suckling the teats of big business have looked up and realized you can't exploit the poor on an uninhabitable planet.

In their everyday lives, Europeans willingly put up with major inconveniences and expenses to protect the environment. Huge festivals are held without using disposable cups. Toilets have heavy and light flush options. Many modern hotel rooms are designed so that the lights turn off automatically when you leave. Escalators run only when people are on them. Entire communities are well on their way to becoming 100 percent wind-powered. Gas-guzzling cars are considered embarrassing, and motor scooters and tiny cars are in.

Europeans choose to consume about a third as much energy per capita as Americans. Considering the high cost of gas, the narrow city streets, and the tight parking, the little Smart cars (originally a collaboration of Swatch and Mercedes) are aptly named.

Paradoxically, nuclear energy is a thriving business in Europe. Though they recognize the potential dangers, many European nations have few alternatives.

Environmentalism is a basic foundation of the EU. They have signed onto the Kyoto Protocol—an international attempt to reverse global warming—despite the costs to economic growth. Europe's governments recognize that environmental damage is part of the long-term cost of any project. Strict laws require that big corporations prove that their products are safe, and pay for recycling costs. American companies are suddenly realizing that their biggest and most affluent market—nearly half a billion Europeans—is embracing new standards that might make American-made cars, cosmetics, and chemicals out of bounds. Average Europeans strongly believe that regulatory policies should be driven by the people's needs rather than bottom-line profit.

Social Issues

Legalized marijuana, gay marriage, sex shops, underage drinking, open prostitution...at times, Europe can look like a conservative's nightmare.

Europeans are—oh, here we go again, making gross generalizations about "Europeans." (Breathe.) Europeans are generally—generally—more "liberal" on social issues, though it varies greatly from person to person and country to country. It's less a question of morality than of trying to make pragmatic public policy. The theory is that by tolerating certain risky behaviors (rather than demonizing them), society can monitor and control them, and thus minimize the number of problems.

The classic example is alcohol. The public drinking age in most European countries is 16. People are exposed to alcohol at a young age and alcohol consumption is integrated into the culture. People drink wine with meals, and pubs and bars are traditional community gathering places, whether you're drinking or not. As a result, Europeans consume plenty of alcohol (more than Americans) but experience lower rates of binge drinking and alcoholism. (So goes the theory, though statisticians and policy-makers still debate the issue.)

On social issues, a few European nations are undertaking bold experiments. Amsterdam, Europe's live-and-let-live mecca, thinks the concept of a "victimless crime" is a contradiction in terms. Though heroin and cocaine are strictly illegal (because they generate crime and drain the health-care system), marijuana causes about as much excitement as a bottle of beer. Throughout the Netherlands, you'll see "coffeeshops," which are pubs that sell marijuana. The menu looks like the inventory of a drug bust.

The Dutch are not necessarily pro-marijuana, but they do believe that a prohibition on marijuana would cause more problems than it would solve. Statistics support this view. They have fewer hard drug problems than other countries while spending far less on a "war on drugs." By contrast, in a given year, more than 700,000 Americans are arrested for marijuana use. Europeans believe that a society must make a choice: tolerate alternative lifestyles or build more prisons.

Prostitution is legal in a few countries (e.g., Germany and the Netherlands) and unofficially tolerated in some others. Prostitutes are often entrepreneurs, renting space, running their own businesses, and paying taxes. The law, not pimps, protects them. They have

In Europe, you'll find pot smokers in cafés, not jails.

Social Control

The buzzword in the Netherlands is "social control," meaning that neighborhood security comes not from iron shutters, heavily armed cops, and gated communities, but from neighbors looking out for each other. Everyone knows everyone in their tight-knit neighborhood. If Magreet doesn't buy bread for two days, the baker asks around. Unlike in many big cities, there's little chance that someone could lie dead in his house unnoticed for weeks. Watch the men who watch the women who watch out for their neighbors across the street who watch the flower shop on the corner..."social control."

to keep their premises hygienic, use condoms, and avoid minors. If a prostitute is diagnosed with AIDS, she may get a subsidized apartment to encourage her to quit the business. Shocking as this may seem to some, it's an example of a pragmatic European solution to a problem, namely getting the most dangerous prostitutes off the streets to combat the spread of AIDS.

Europe is also at the forefront in supporting gay rights. Same-sex marriage is now legal in Spain, the Netherlands, and Belgium. Many other European nations honor civil unions between same-sex partners.

One exception to this left-leaning trend: Abortion laws in much of Europe (particularly in Catholic countries) tend to be more restrictive than in the US. On the other hand, no country in Europe has a death penalty. The US is the only Western nation that still employs capital punishment.

No doubt about it, a visit to certain areas of Europe is sure to box some puritan ears. But Europeans don't think of themselves as especially liberal—just practical.

Working Life vs. Quality of Life

In general, European workers make about a third less than American workers. Why? On average, they work fewer hours. Europeans choose to work less, earn less, live more simply, and play more.

The typical European work week is Monday through Friday, but it includes its share of late mornings, long lunches, and long weekends. Few people work past closing hours. Southern European countries still honor the midday siesta/lunch from about 1:00 to 3:00 p.m. Vacation days are sacred, and entire industries basically close down for holiday during the month of August.

Europeans are less career-driven than Americans. In some social circles, it's downright rude to start a conversation with, "So what do you do?"—as if your job sums up who you are as a person.

European workers may earn less in take-home pay, but they enjoy great benefits, from pensions to unemployment compensation to vacation pay to job security. In most of Europe, a six-month maternity leave with almost full salary is standard. Labor unions are powerful.

In some ways, this makes Europe less business-friendly. Europeans routinely endure train strikes, farm workers' protests, and government closures as workers assert their rights. Postal workers have no reason to give service

Are You Ready for Some Football (a.k.a. Soccer)?

If you're traveling in Europe and suddenly hear a roar erupting from a neighborhood bar, guess what's going on? It's probably a soccer game on TV.

Soccer (called "football") is the undisputed number-one sport everywhere in Europe. Kids grow up playing it, most adult men root for their local pro team, and people go absolutely bonkers for the sport. Athletes make big money—tens of millions of dollars a year plus endorsements—and are as famous as Hollywood stars. Die-hard fans place their personal pride on the outcome of a match. It's a cliché that remains true: The football pitch is the new international battleground.

A football match is a spectacle worthy of ancient Rome. Fans arrive decked out in team colors and take their place either in the home or visitors' section; stadium officials keep the two crowds strictly segregated. Throughout the match fans remain standing, waving flags, singing team songs, yelling insults at the opposition, and drinking to excess—you can buy alcohol there or bring your own.

Some fans overdo it: "Hooligan" is a pan-European word for someone who gets too rowdy and violent. The problem is also pan-European, though each country tends to blame someone else for the worst incidents of drunken vandalism. Football matches often require a large police presence to keep order, and lots of clean-up afterward.

Even if you're not a sports fan, if you're in Europe during the season (September through May), you'll feel the buzz. In train stations, you may encounter boisterous groups of Brits, Dutch, or Italians arriving for a match, dressed in team colors and singing team songs. On big game nights, businesses close early as locals crowd the bars to watch on TV. After a victory, impromptu parades fill the streets with jubilant maniacs, honking horns and waving team flags. You'll experience firsthand just how big soccer is in Europe and everywhere else in the world...except in the US.

It all culminates every four years when each country fields a national squad (similar to Olympic competition) to play for the global championship in the World Cup, won by Italy in 2006. Through more than a year of qualifying matches involving more than 100 countries from every continent, Europeans place the hopes, dreams, and national pride of their country on the line. Finally, they gather together to watch the championship match, seen around the planet via satellite by one out of every three members of the human race...except in the US.

Europe's traditional ways survive in open-air folk museums. Here at the Muckross House in southwest Ireland, children learn of a simpler time while sampling soda bread hot out of the oven.

with a smile, because their job is secure. Blue-collar workers don't scramble to "get ahead," since their jobs (with benefits) are almost as financially rewarding as white-collar work. On the other hand, employers have a labor force that is less stressed and enjoys leisure time with friends and family.

Traveling around Europe, I notice that Europeans don't appreciate efficiency like I do. To them, efficiency dehumanizes...it turns people into machines. They ask: "Would you ever treat someone you loved *efficiently?*" European parents don't think in terms of "quality time"—joy, empathy, and caring cannot be done "efficiently."

Americans are taught that "time is money." It's built into our language: We *save* both, *spend* both, *waste* both.

Europeans, on the other hand, *pass* time. In a continent where slow service at a restaurant is considered good service, time is to be enjoyed. Italians celebrate it with their famous phrase: *il dolce far niente,* the sweetness of doing nothing.

Family Life

The typical nuclear family is small— mother, father, and one child—but the extended family is big. People tend to live close to where they grew up, and they keep in lifelong contact with mom and grandpa, aunts and cousins, schoolmates and the neighborhood butcher.

Homes are small by American standards. Many prefer an apartment in a town or city rather than a house in

the suburbs. In their possessions, people value quality over quantity. They have one TV, one car (a good one; you rarely see junkers), heirloom-quality furniture, and high-tech appliances. Everyone has a mobile phone. In fact, in many countries, there are now more mobile phones than people.

On a typical day, the family eats a light continental breakfast of a roll, juice, and coffee. The kids attend school or state-subsidized day care while mom and dad go to work (though fewer European women work outside the home than in America). In southern European countries, many families return home from work and school to enjoy an afternoon meal together before going back.

In the evening, guess what families generally do? They watch TV. Shows are surprisingly similar in concept to familiar American types, including game shows, sitcoms, crime dramas, the news, and documentaries. Europeans are not shocked to find occasional nudity and profanity on TV, even in prime time and on state-sponsored channels. Like Americans, Europeans appreciate their public broadcasting. They choose to pay for it with a TV tax rather than pledge drives.

On Sundays, many Europeans go to church, but Europe is becoming increasingly secular. Historic churches are more like museums that house cultural treasures, venues that host organ concerts and community events.

Europeans enjoy a statistically high quality of life, at least judged by life expectancy, infant mortality rates, murder and crime statistics, health care, workers benefits, number of vacation days, and overall social security. Older

Many of Europe's traditions survive into the 21st century outside of folk museums. Throughout Switzerland, farmers surprise townsfolk by parading their livestock down the main street on the day they move their herds up to the high meadows.

Authors Gene and Rick enjoy Rome's ancient Pantheon. Like any thoughtful traveler, they try to immerse themselves in both yesterday's Europe and today's Europe at the same time.

Europeans can often count on retiring with a stable pension, free health care, and relatives nearby who can care for them.

Europeans are healthy. Despite their prosperity, obesity is not a major problem. They attribute this to their lifestyle. They eat more healthful, locally grown foods, and less fast food. Their meals are slower-paced. In fact, there's even a "slow food" movement, with the snail as its logo. Europeans drink alcohol with their meals, and some statistics point to this as a healthy choice. They smoke more tobacco than Americans, but this is changing quickly as more and more countries ban smoking from public places. Another reason Europeans enjoy good health is that cities are designed so that people do less driving, more walking,

and more climbing stairs. And while TV is the preferred opiate of the European masses, they spend fewer hours watching it than Americans do.

Community roots run deep. On warm summer evenings, TV sets are switched off, people spill into the streets, and towns and villages come alive. Men young and old gather at the corner pub to cheer for their local football team. Teenage boys strum guitars by a bubbling fountain, while the girls text-message their requests. Parents with kids lick ice cream cones and rattle strollers over the cobblestones. Lovers kiss. And the last remaining little old ladies in black meet under the stars on the town square to stroke their mole hairs and reminisce about how it all used to be so much better....

The Final Word

History is happening now. Don't miss it as you travel. And the lessons of history still apply. It's easy to think that we are in a grand new age without precedent, one that follows no rules. But every generation has thought that of their era, and we're just the latest in history's long line of pioneers settling the future.

We've read about wars, revolutions, religious and ethnic differences, and changing economies. All these still exist today. Meanwhile, artists continue to produce works of beauty that reflect their times, and ordinary people live, love, and work in the shadows of these history-making events. Europeans today face many of the same challenges and opportunities that confronted Louis XIV, Michelangelo, Caesar, and the druids who first traced the sunrise over Stonehenge.

View Europe today from the perspective of where it came from. If we see humankind in a historical perspective, grasp how yesterday shaped today, and learn less from mainstream media and more from direct experience through our own travels, we will better understand and shape the events of tomorrow.

Today, almost 490 million people have EU citizenship. Think of that accomplishment after all the wars and struggles Europe has suffered through. The visionary leaders of the European Dream (along with legions of Eurocrats in Brussels) are fostering a new political system that favors negotiation over ultimatums, multilateralism over unilateralism, and cooperation over competition. Its plodding bureaucracy can seem clumsy and almost laughable at times. But as an alternative to another devastating war every generation or two, it's a brilliant vision.

An encouraging aspect of our future is that as the world grows smaller, more people will travel and rub shoulders. As this happens, and we begin to view our globe as the home of six and a half billion equally precious people, we'll all feel a little less American, British, Japanese, Italian, French, or whatever—and a little more like a member of humankind.

Happy travels!

Jan Vermeer,
The Art of Painting,
c. 1666
(Kunsthistorisches
Museum, Vienna).

Art Appreciation

Only through art can we get outside ourselves and know another's view of the universe.
—Marcel Proust

Art is lies that tell the truth.
—Pablo Picasso

*Kunst ist Scheisse (Art is Sh*t).*
—Dadaist slogan

When people, admitting their ignorance of art, say, "But I know what I like," they usually mean, "I like what I know." It's easier to like something that's familiar and understood. If you like what you know, you can usually increase your liking by simply increasing your knowing. That's true of most things, from appreciating good wine to a well-played baseball game to the classic lines of a '56 Chevy. Learn about it first. Then you can really run it into the ground.

It's a shame to visit Rome, Greece, or Egypt with no background in the art of those civilizations. I remember touring the National Archaeological Museum in Athens because my mom said it would be a crime not to. I was

bored out of my mind, convinced that those who looked as if they were enjoying it were actually just faking it. Two years later, after taking a class in ancient art history, that same museum was a fascinating trip into the world of Pericles and Socrates, all because of some background knowledge.

The wonderful thing about art is its sheer variety. Every society defines beauty in a different way. Europe's museums offer a peek into the past, allowing us to better understand long-gone people by the objects they found beautiful.

Not every person will like every "masterpiece" ever made. But when you understand an artist's intentions and techniques, you can appreciate the work even if you don't like the result. In baseball, you can admire a well-turned double play even if you don't like it (it made your team lose). In art, you may not like a certain painting—it might be unusual, bland, or even offensive—but you might appreciate the artist's composition or use of line and color.

Check out an art book with big, top-quality color prints from the

To know Art is to love him.

library. Relax in your favorite chair. Light a fire. Pour a glass of wine or stoke up your pipe. Then, alone or with a friend, leaf slowly through the book. Don't bother much with names, dates, or commentary. Just look for a painting or two you like. Play a game in which you pick your favorite from each chapter, and then compare notes with a friend.

Once you find a painting that speaks to you, ask yourself why you like it. Is it the bright colors? The story it tells? The emotional effect on you? Does it make you feel good? Or sad? Or angry? Any reason for liking art is a good one. Just try to recognize what the reason is. Look for other works by an artist you like. If you like a similar work, maybe that means you like that style. What do the two works have in common? Assume that the artist put a

lot of thought and sweat into the artwork and is happy with the result. Try to understand why.

Learn as much as you can about art history, artists, styles, theories, and so on, but know that the best aid to art appreciation is simply an open mind.

As we've seen throughout this book, art can be a response to its times. For example, artists from the Baroque age let emotions run loose—refreshing after the cerebral Renaissance. The emotional Romantic movement was a reaction to stern Neoclassicism. Modern art was a reflection of 20th-century turmoil.

Art is also, of course, a product of the artist. Artists can't choose their era, but they do have control over other elements of their work:

• the medium they use (such as painting or sculpture)

- the physical subject they portray
- the mood and message they convey

Artists can change or distort reality (the actual subject matter) to enhance the mood or make a point. When we know why reality is distorted, we can see the world through the artist's perspective. A simple painting of crows in a wheatfield takes on new meaning when you know that, shortly after painting it, van Gogh shot himself.

In the rest of this chapter, we'll cover different art forms, various techniques for communicating mood, and common subjects depicted in art. This information, along with specific tips on museum-going, will increase your understanding of the magnificent art you'll see in Europe—and, I hope, make it more fun.

Art Media

When we think of a famous masterpiece, it's easy to picture a marble statue or an oil painting on a canvas. But artists through the ages have used all kinds of media on all kinds of surfaces. Painters don't just put paint on canvas; they also dabble in sketches on paper, using charcoal, ink, or pastels. In addition, there are statues, mosaics, gold leaf, wood carvings, stained glass, and poured stucco that looks like Reddi-wip.

Even painting has evolved. In medieval times, most artists painted with tempera, which is made by dissolving natural pigments in egg yolk. They painted on panels of wood or on frescoes. By the 1400s, many were still painting on wood, but they were using oil paints (pigments dissolved in vegetable oil) instead of tempera. In

Venice, painters got frustrated by wood paintings that warped in the humid conditions, so they pioneered painting on pieces of canvas stretched across a wooden frame, and the fad caught on. With the Industrial Revolution, paints became available ready-mixed in convenient, collapsible tubes (like you'd find in art-supply stores today).

Here's an overview—painted with a broad brush—of some of history's more popular art media.

Making a Fresco

Frescoes are paintings on plaster. A dry fresco (*fresco secco*) is painted on dry plaster, with glue-based paints. A true fresco (*buon fresco*, described below) is painted on wet plaster, using water-based paints.

The artist starts by sketching out his vision on a large piece of paper, called the "cartoon." (The cartoon is eventually tossed, unless it's by a Leonardo or Michelangelo, whose cartoons are considered masterpieces—copied, studied, and admired to pieces by aspiring artists.) If creating a true fresco, the artist and assistants then mix lime and water to make plaster. They trowel it onto the wall, but only as much as the artist can finish painting while it's still wet. The artist places his cartoon against the wall and traces the outlines into the plaster. This is usually done by piercing the cartoon repeatedly along the lines and dusting the cartoon with colored powder. After the cartoon is removed, the dots mark the wall, and the artist connects the dots and fills in the colors.

The artist has to work fast, while the plaster is wet. Any large fresco consists of many small, seamless

Art students learn the time-honored technique of fresco in the studios of Florence. Students trace the original, transfer the outline to the wet plaster, mix in the color, and wait for their frescoes to dry. Their souvenir: a very sturdy (if not always very beautiful) piece of art.

chunks of a work done in a single day. The work is speedy, but the results last a long time. The lime of the plaster binds with both the paint and wall, creating an integral whole that lasts for centuries. Mentally compare Michelangelo's crisply painted Sistine Chapel ceiling with Leonardo's disintegrating *Last Supper*. As an experiment, Leonardo mixed his pigments with oil instead of water. Michelangelo took no chances.

Frescoes, which do best in a dry climate, never caught on in damp, moldy northern Europe. Interestingly, bold frescoes were better suited for Italians' epic scale; delicate work in oil was perfect for capturing the Northern artists' love of detail.

Oil Paint

Take vegetable oil pressed from linseeds (flax), blend in dry powdered pigments, whip to a paste, then brush onto a panel of whitewashed oak— you're now painting in oils. First

Dome Fresco (detail), c. 1725 (St. Charles Church, Vienna). *Many frescoes, designed to be seen from a distance, are rough and messy-looking close up. And when painted on the curving underside of a dome, they come with a "funny perspective."*

popularized in the early 1400s, oil eventually overshadowed egg yolk–based tempera. Though tempera was great for making fine lines shaded with simple blocks of color, oil could blend colors together seamlessly. Depending on how much pigment is added, the oil paint can be as thick as room-temperature butter or as thin (and transparent) as varnish. It dries slower and is easy to change, letting artists amend or add to their work as they go.

With oil paints, a master can meticulously build details with successive layers of paint. Watch a master create a single dog's hair: He paints a dark stroke of brown, then lets it dry. Then comes a second layer painted over it, of translucent orange. The brown shows through, blending with the orange to match the color of a collie. Finally, he applies a third, transparent layer (a "glaze"), giving the collie her healthy sheen. Old Masters such as Jan van Eyck might spend a full year creating a large painting crammed with layered-on details.

Painters use an array of brushes, some stiff (made of hogs' bristles or synthetic materials), some soft for detail work (made of sable, with few acceptable substitutes).

Many great artists (such as Michelangelo) were not necessarily great "paint"-ers. Michelangelo worked in tempera and fresco, and disdained the delicate work. On the flip side, Rembrandt, van Eyck, Frans Hals, Velázquez, and Rubens were masters of handling paint...but they're not necessarily everyone's

Jan van Eyck, **The Arnolfini Marriage,** 1434, (National Gallery, London).
Art can be the closest thing possible to a time-tunnel experience in your travels.

favorite artists.

Most famous paintings have been restored at one time or another. All oils turn yellow and crack with age. Transparent varnishes slathered over paintings to protect them also yellow and darken. (For instance, Rembrandt's *Night Watch* originally depicted a scene in broad daylight, earning its nickname only as Rembrandt's protective final layer darkened...causing night to fall.) Restorers remove dirt and protective layers and shore up the structure to prevent further decay. In some cases, they've actually reconstructed colors and filled in missing spots, though that is rare in our historically conscious times.

Albrecht Dürer, **Four Horsemen of the Apocalypse**, 1498 (British Museum, London). *Dürer's woodcuts were the first mass-produced art Europe had seen. His mastery of line and detail were perfect for this painstaking medium. Notice his famous "D-inside-A" monogram at the bottom.*

Woodcuts, Engravings, and Etchings

A work of art printed on paper can be made one of several ways. All of them seem far too difficult for a non-artist like me.

A woodcut is made by sketching black lines on a white-painted block, then chipping off the white so that only the desired lines protrude. This woodcut is then dipped into ink and used the way we use a rubber stamp today.

An engraving, the opposite of a woodcut, cuts the "lines" into the plate and, when mastered, allows for even more detail than a woodcut.

An etching, which is an improved version of engraving and was used by later artists such as Rembrandt, is made by drawing in some soft wax that covers a metal plate. It's then dipped in acid, inked up, and printed.

Woodcuts, engravings, and etchings each filled a need in the business of art: They allowed a master's work to be reproduced and sold many times. Albrecht Dürer's woodcuts and Rembrandt's engravings are displayed and enjoyed all over Europe.

Sculpture

Sculpture is a much more robust art form than painting. Like painting, sculpture can be made from many different media: shaped out of clay, molded from hot bronze, or assembled from pieces. But "sculpture" usually refers to cutting away material from a block of material (rock, wood, ivory, Spam) to reveal the form inside. Of all artistic media, sculpting is the most durable. Many ancient statues, though subject to erosion, look very much today like they did in their prime.

Think of the engineering problems alone of the stone-sculpting process: quarrying the rock, cutting it into a rough block, transporting the block to the artist's studio, chiseling chips away for countless hours, then painstakingly sanding the final product by hand. A sculptor must be strong enough to gouge into the stone but delicate enough to groove out the smallest details. You'll notice that every sculpture has an invisible "frame" around it—the stone block from which it was cut. Visualizing this frame helps you find the center of the composition.

Sculpture was the perfect medium to express the humanism that inspired Greece, Rome, the Renaissance, and beyond. A statue shows the human form, standing alone, independent of church, state, or society. Think of Michelangelo's approach to sculpting: He wasn't creating a figure; the figure was already in there. He felt he was only liberating it from the rock that surrounded it.

The most common sculpture material from Greek times onward was marble. There are many different types of this extremely hard, granite-like rock. The most famous is the white marble quarried at Carrara, northwest of Florence, Italy. The ancient Romans loved Carrara marble, as well as purple porphyry. Most marble has a wood-like grain that can be used to make colorful patterns. And there's the sheer variety of the colors of marble: green, red,

Auguste Rodin, **Thought**, c. 1889 (Rodin Museum, Paris).

gray, lavender, or yellow, some grainy, some "marbled" like a steak. Many of the world's most beautiful and durable things have been made from the shells of sea creatures layered in sediment, fossilized into limestone, then baked and crystallized by the pressure of the earth—marble.

Techniques

Artists use various techniques to create the reality they see with their mind's eye. Artists know what catches your attention. They use this knowledge to punch the right emotional buttons to get their message across. (Modern advertisers have made a science of this.) Here are some of the techniques used to attract your attention and produce an emotional response.

Composition

The layout of the main figures is the skeleton of the work. A painter thinks this through as carefully as a photographer poses his supermodel. Imagine a painter sketching a scene on grid-lined graph paper, calculating how big the main characters will be and where to place them. Let's say the artist decides to arrange the figures into a geometrical pattern, say, a pyramid.

It doesn't look like much in rough form, but flesh out this skeletal composition with neat lines and real-life colors and you have Raphael's *La Belle Jardinière* (see page 464). The geometrical composition is what makes the picture so harmonious and satisfying to the eye.

Look at the skeletal pattern. Notice how orderly and pleasing the shapes themselves are. Color those in and it

Stoners Cheat Sheet

Limestone: Most of the buildings you'll see in Europe—from Notre-Dame to St. Paul's—are made of limestone, which was readily accessible to medieval Europeans. Being reasonably easy to cut yet plenty hard, it was great for both churches and castles. The stone is a calcium-rich sedimentary rock, colored differently throughout Europe according to the native soils and clays. The calcium content comes from organisms from ancient sea beds.

Travertine: This soft rock, formed in river beds, was named after Rome's Tiber (Tevere) River. The surface is pitted and comes in a variety of colors from white to gray to red. As it is more porous than limestone, it's easier to cut but more susceptible to pollution. The Colosseum in Rome is the largest travertine building you'll see. The Getty Museum in Los Angeles is made of travertine imported from Italy.

Tufa: This is a very porous variety of travertine. Many towns in Italy are built on tufa hills. Wine cellars, catacombs, and tombs are often cut out of tufa. It is very easy to cut (you can dig it with a persistent thumbnail), but hardens with exposure to air and therefore works in fortifications and walls. The walls of ancient Rome were made of tufa.

Marble: If you press really hard on limestone for a long, long time, you get marble (a "metamorphic" limestone). Marble is harder to cut, wonderfully polish-able, and expensive—the Cadillac of building material. It was long used for building the finest structures in Europe. According to legend, Augustus bragged that he found Rome in bricks and left it a city of marble. (He actually clad concrete-and-brick buildings in a marble veneer.) Less powerful rulers of two-bit kingdoms might want marble but could only afford *faux* marble (wood or cheap stucco painted to look like marble). There was even a much-in-demand school of painting called "faux marbling." When touring a palace, you might think it's all made of marble, but place your hand on a surface and if it warms quickly, it's just painted stucco...faux marble.

Carrara Marble: While mineral impurities in the original limestone give marble various colors, pure white marble is most in demand for sculpture. The white marble of Carrara (in northern Italy) has, since ancient times, been considered the ultimate source of marble. Pure white, it's easy to cut straight at any angle and resistant to shattering. And, made of a calcite formation that allows a little more translucence in its surface, statues made of Carrara marble take on a more lifelike sheen. Michelangelo insisted on Carrara marble for his *David* and other statues.

Porphyry: This extremely hard purple rock gets its name from the Latin word for purple. Being such a rare color in nature, porphyry was the choice of ancient emperors and later royalty. Emperors liked it for their sarcophagi. Charlemagne was crowned by the pope atop a porphyry stone (which you'll see in the floor of St. Peter's Basilica at Vatican City). In ancient times, porphyry was extremely rare, originating from only one quarry in Egypt, which was eventually exhausted of its much-sought-after stone.

Alabaster: This soft stone is easy to work and unique for its translucence. It was used rather than glass as windows in many Gothic and earlier Christian churches. The most famous alabaster window is the glorious "dove window"

above the high altar in St. Peter's Basilica. Tuscany, with its fine alabaster quarries, is a center for sculpted alabaster art.

Stucco: This has long been used as an economic wall cover. Wood or brick can be spread with this simple plaster or cement made of lime, water, and sand (with straw or animal hair used as a binder). Once applied and smoothed and dried, it can be painted. The advantage of stucco is that it can be plastered over uneven surfaces and formed into decorative forms. Most of the ornate painted walls and ceilings you see in Baroque and Rococo churches and palaces are painted stucco. Probably half the "marble" you'll marvel at in your travels is just stucco painted to look like marble.

Antonio Canova, **Cupid and Psyche,** 1793 (Louvre Museum, Paris).
Canova could make hard marble look as supple as wax.

would look something
like modern art, no?
Abstract art uses the
same rules of composi-
tion, line, and color, but
doesn't portray real-life
subjects.

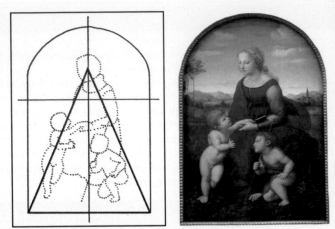

Line

The eye will naturally
follow the curve of a line
until another line breaks
it by running in a differ-
ent direction. The artist
makes use of this natu-
ral tendency by creating
movement and rhythm

Raphael, **La Belle Jardinière,** 1507 (Louvre Museum, Paris).

in the scene, which, in turn, create a
mood of tension or rest in the viewer.
At their own pace, trained artists guide
you from one figure to the next.

In the Isenheim altarpiece, art-
ist Matthias Grünewald directs all the
motion toward Christ's face. From
John's pointing finger, your eye trav-
els to the face, up Christ's arm to the
crossbar, out to the end, down to the
grieving figures at the left, down their
slanted bodies to the kneeling Mary,

and up her arm, pointing again to
Christ's head. Grünewald moves our
attention full circle, always returning
to the central figure of Jesus, where
the lines intersect.

Perspective

Lines are governed by the laws of per-
spective, which form the science of
painting three-dimensional objects on
a two-dimensional surface. When you
draw receding lines to turn a square

Matthias Grünewald, **Isenheim Altarpiece** (detail: Crucifixion panel), c. 1515
(Unterlinden Museum, Colmar, France).

into a 3-D box, you've followed the laws of perspective. If the lines of the box were continued, they'd eventually appear to converge on the horizon at what is called the "vanishing point."

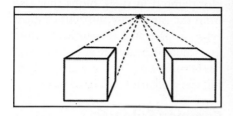

Using perspective and the vanishing point, an artist can place the viewer of a painting right in the middle of the action. Think of the picture frame as a window through which you are viewing the painted scene. Where are you in relation to the main figures? The artist lets you know, subconsciously, with the vanishing point.

The vanishing point is also the compositional center of the work. In Leonardo da Vinci's famous *Last Supper*, the lines converge at the center of the canvas, which is the intended focus: Christ.

Andrea Mantegna, **Dead Christ**, 1466 (Brera Gallery, Milan).
This Renaissance experiment in extreme foreshortening brings the viewer right to the scene of the action. The psychological effect of seeing the body from this intimate viewpoint is exciting.

Color

Color is the flesh on the compositional skeleton, bringing the figures to life. It, too, plays a role in bringing order to art. The artist can make the picture peaceful by using harmonious colors or tense by using colors that clash.

Red, yellow, and blue are the primary colors; we get the rest by blending these three. Red is associated with

Leonardo da Vinci, **The Last Supper**, 1498 (Santa Maria delle Grazie, Milan).
What Leonardo designed consciously, we, the viewers, feel subconsciously.

Pablo Picasso, **Self-Portrait**, 1901
(Picasso Museum, Paris).
*In the midst of his Blue Period, Picasso painted
this self-portrait shortly after the death of his
best friend.*

Texture

A canvas is a pile of paint. Traditional artists smoothed the brushstrokes to make a seamless vision of reality. More avant-garde artists (Monet, for example) painted in thick blobs that rise from the canvas. By the 20th century, artists appreciated the surface texture as a thing of beauty itself. The canvas has become a tray to serve up a delightful, wavy, colorful collage of paint.

Common Subjects and Symbols in Art

Even if you know zero about art, if you know who's in a painting and what they're doing, your interest level jumps 50 percent.

In a quick jaunt through any church, palace, or museum, you're bound to see many of the same subjects painted and sculpted in different ways by different artists. A little knowledge (a dangerous thing, but we'll trust you) of these common themes helps you find meaning in the art.

The inspiration for much European art comes from the Bible and from Greek and Roman mythology. If you're not up on the Bible and don't know your Zeus from your muse, you may want to bone up before your trip. For the general outlines of Jesus' life, read the Gospel According to Matthew in the New Testament (about 35 pages long). For Greek mythology, try a children's book of Greek myths. Here are some commonly depicted themes:

passion, action, intensity, states that hate gay marriage, and (as designers of fast-food menus know) hunger. Yellow is warmth, the sun, peace. Blue is icy, melancholy, thoughtful, the sea and sky. Some colors "complement" each other (red and green), while others "contrast" (yellow and orange). In addition, the artist can adjust the "tone," the contrast between light and dark. The various combinations and moods available to the artist are endless.

Some painters, such as Giotto, made outlines of figures, then filled them in with smooth color, like a coloring book. Monet, however, used almost no outlines whatsoever. His paintings are more like a mosaic of minute patches of color applied by quick strokes of the brush.

Christian Themes and Symbols

While Christians who paid attention in Sunday school will know these basics, this is a primer in Christian symbolism for the uninitiated. The Christian Bible,

Evangelists, Disciples, Apostles, and Saints

Tympanum, St. Trophime Church (Arles, France).
Jesus is often shown surrounded by his four evangelists: Matthew (winged man), Mark (lion), Luke (ox), and John (eagle), all with books reminding the faithful that they wrote the gospels.

In your travels, you'll encounter these religious labels—evangelists, apostles, disciples, and saints—countless times. Let's sort them out:

Evangelists: While an evangelist is a Billy Graham–style spreader of the Gospel, the term in art history generally refers to the four original evangelists, the guys who wrote the four gospels (stories of Jesus' life). Any good medieval Christian would recognize the evangelists, not by their faces but by their symbols (illustrated in the tympanum photo above).

Disciples: These students of Jesus actually lived and studied with him, becoming followers during his ministry. While there's no exact count, there seem to have been about 70.

Apostles: The apostles were the 12 disciples Jesus personally chose to be his original "fishers of men." These men were sent directly by Jesus to spread the Gospel: Simon (a.k.a. Peter), Andrew, James the Greater, John, Philip, Bartholomew, Thomas, James the Lesser, Matthew, Simon the Canaanite, Judas Iscariot, and another Judas (also called Thaddaeus).

Saints: These are holy people whose virtuous life stories are remembered to inspire others. Saints are not worshiped but venerated—respected and valued as role models. The Roman Catholic Church officially recognizes holy people by giving them the title Saint—with a capital S. Note that the title is abbreviated "St." for males and "Sta." for females. There's a Catholic saint for each day of the year. And certain saints are made "patron saints" with a special affinity for specific occupations, groups of people, or places. Christopher is the patron saint of travelers, Francis is Italy's patron, Anthony is Lisbon's, and brewers call on St. Arnold when in need of an advocate up in heaven.

which tells the history of the world from a religious perspective, starts with the creation of the cosmos and chronicles the lives of God's prophets and his chosen people, the Israelites. It culminates in the life of Jesus of Nazareth (c. A.D. 1)—described as both a prophet and the Son of God—and mentions Jesus' first followers (disciples). Much of the Bible has historical roots, but it transcends history to inspire believers.

Old Testament

The Old Testament (the first half of the Bible) tells the history of the Israelite people, from the creation of the world to the coming of Jesus. (Of the following biblical events, Michelangelo painted scenes from the Creation, Garden of Eden, and Noah's Flood on the ceiling of the Sistine Chapel at the Vatican.)

Albrecht Dürer, **Adam and Eve** (engraving), 1504 (Museum of Fine Arts, Boston).

• **Creation:** During the first seven days, God created the world. He divided light from darkness, created the sun and moon, and separated water from earth (Genesis, chapter 1). God made man from mud (Genesis 2:7). (Michelangelo depicted God reaching out and passing the spark of life to the first man, Adam—one of the most famous images in Western art, pictured on page 196.) God sedated Adam, removed one of his ribs, and used it to form the first woman, Eve (Genesis 2:21–22). Note: If you're a Sikh, a Hindu, a Buddhist, or a secularist, and all of this seems just too bizarre, I'm sorry I can't help you. I'm just quoting the Bible.

• **The Garden of Eden, Temptation, Banishment:** Adam and Eve live naked in Paradise until a serpent convinces Eve to eat the one fruit God told her not to, and she in turn convinces Adam to have a bite. Their disobedience is the first sin, and Adam and Eve are banished from the Garden of Eden (Genesis 3:1–24). Adam and Eve's two sons make sacrifices to God, but God accepts only Abel's sacrifice. Cain becomes angry, kills his brother (the first murder), and is banished forever (Genesis 4:11–12).

• **Noah and the Flood:** Upset with his creation, God causes a flood to destroy virtually all of humankind (Genesis 6:5–7, Genesis 7:11–24). Of course, Noah and his family fill their Ark with pairs of every living species, so the earth's animal and human populations can get a fresh start. After surviving the flood, Noah builds an altar and offers a sacrifice to the Lord (Genesis 8:20). Noah's sons respectfully cover their naked father (The Drunkenness

of Noah, Genesis 9:20–23).

• **Abraham Sacrifices Isaac:** God makes a pact with the wanderer Abraham, promising him many descendants even though he is old and his wife is childless. Abraham believes God, and his faith is rewarded by the birth of his son, Isaac. But then God tests Abraham's faith by asking him to sacrifice Isaac. Abraham faithfully obeys, but God stops him just before he kills Isaac. Isaac becomes the father of the Jewish nation. One of his descendants is Jesus (Genesis 22:1–18).

• **Moses: The Exodus from Egypt and the Ten Commandments:** The people of Israel are captives of the Egyptians, but Moses rises up to lead them to freedom. Inspired by God, Moses parts the Red Sea to allow his people to escape quickly from the Egyptians (Exodus 14:16–30). They wander in the desert for 40 years (Exodus 1–19), suffering hardships (The Brass Serpent) but aided by God (Manna from Heaven, Water from the Rock). The

Lorenzo Ghiberti,
Abraham Sacrificing Isaac, 1401
(Barqello Gallery, Florence).

Israelites disobey by worshipping a golden calf. In order to tell the people of Israel how he wants them to live, God calls Moses to Mt. Sinai and gives him 10 "thou-shalt-nots" written on tablets of stone (The Ten Commandments, Exodus 20:1–17). Moses is often depicted with horns, thanks to a medieval mistranslation of the word for "radiance."

• **David and Goliath:** The people of Israel are challenged in battle by the Philistines, who have a mighty giant warrior, Goliath. Only a young Israeli shepherd boy named David is bold enough to fight him. David hurls a rock from a slingshot to bring Goliath down, then cuts off the giant's head. David later becomes king (1 Samuel 17:1–51).

• **Prophets:** Some prophets of the Old Testament can be identified by the symbols they carry. For example, Solomon has a model of the temple he built, and Isaiah carries a book of his

Marc Chagall, **Moses Receiving the Ten Commandments,** 1960–1966
(Chagall Museum, Nice, France).

Cathedral (Santiago de Compostela, Spain). *In this great church, Old Testament figures are identified by scrolls while those from the New Testament tote more modern books.*

prophecies. Jeremiah appears "lamenting," having failed to prevent the destruction of Jerusalem.

New Testament

• **Jesus and his Mother, Mary:** The life of Jesus of Nazareth—also called "Christ," meaning Messiah—has been the most popular source of material for European artists. (Not all of the following events are actually in the Bible; many are based on Christian tradition.) Once you're familiar with what's being portrayed, it's interesting to compare different artists' takes on the same subject.

• **Annunciation:** Jesus' imminent arrival on earth was announced to his mother, the Virgin Mary, by the Archangel Gabriel, who told her she would give birth to the Messiah (Luke 1:26–38). This scene usually includes a dove (symbolizing the Holy Spirit coming down to Mary) and a shocked-looking (but always accepting) Mary.

• **Nativity:** Jesus was born in a lowly stable, in a manger (a feeding trough generally used for hay) surrounded by animals. Baby Jesus was visited by shepherds (Adoration of the Shepherds). Later, three wise kings named Caspar, Melchior, and Balthazar followed a bright star to bow down before the babe and offer him gifts (Adoration of the Magi, Matthew 2:1–12). Following tradition, Balthazar is usually depicted with dark skin. They arrived in Bethlehem on the 12th day of Christmas—or Epiphany (January 6)—which today marks the end of the holiday season in much of Europe.

• **Slaughter of the Innocents:** Wicked King Herod heard a prediction that a newborn boy (Jesus) would become greater than the king, so he ordered all male infants killed (Matthew 2:16–18). Jesus survived, because Mary's husband, Joseph, had been tipped off and fled with his family (Flight into Egypt).

• **Madonna and Child:** Artists love to show Mary with the baby Jesus on her lap, often with Jesus raising his little hand in blessing. The scene graces altarpieces throughout Europe. In

Fra Angelico, **The Annunciation** (detail), 1434–1445 (Prado Museum, Madrid).

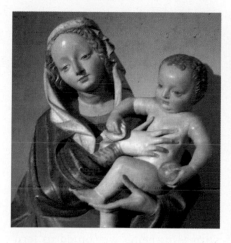

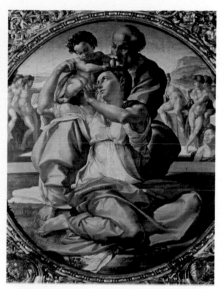

Michelangelo, **Holy Family,** 1506
(Uffizi Gallery, Florence).

some ways, the "Madonna" ("My Lady," also called The Virgin) was as important to Christians as Jesus himself. She's seen as a nurturing figure, a symbol of "holy mother church," and a compassionate mediator between a stern God and sinful Man.

• **Holy Family:** Mary and Jesus are often depicted with others. You may see Joseph, Mary's mother Anne, or her cousin Elizabeth. When two children are shown, they're usually Jesus and his cousin John the Baptist (Elizabeth's son). The Virgin and Child may also appear flanked by various saints, engaging in a *sacra conversazione* (Holy Conversation).

• **Immaculate Conception:** Mary is pictured as a radiant young woman, a virgin looking so pure you might even say she's "immaculate." The doctrine of Immaculate Conception (which is not mentioned in the Bible, and was not made official doctrine until 1854) can be confusing, even to Catholics. It does not mean that the Virgin Mary herself was born of a virgin (as Jesus was). Rather, Mary's mother and father conceived her in the natural

Bartolomé Murillo, **Immaculate Conception of the Escorial,** c. 1660
(Prado Museum, Madrid).

way. But at the moment Mary's soul animated her flesh, God granted her a special exemption from the original sin all mortals share.

• **Jesus Teaching in the Temple:** Jesus was raised to be a carpenter, but even at age 12 he proved his teaching powers.

• **Baptism of Jesus:** At age 30, Jesus left home to preach the word of God. Another prophet, John the Baptist, proclaimed Jesus a great man and poured water over him in the Jordan River as a symbol of cleansing. God the Father is represented in the scene as an eye or a voice, and God the Holy Spirit is represented as a descending dove (Matthew 3:13–17).

• **John the Baptist:** The prophet in the wilderness dressed in animal skins and lived on a diet of bugs 'n' honey. King Herod (at his daughter Salome's request) had him decapitated, with his head placed on a silver platter.

• **Calling the Disciples:** Jesus chose 12 disciples (or apostles), walking into their places of work and commanding them to leave and follow him. Rather than gravitating toward the rich and powerful, Jesus surrounded himself with the undesirables of his society, such as tax collectors and prostitutes.

• **Miracles:** Jesus gained a reputation as a miracle worker. He raised his friend Lazarus from the dead (Resurrection of Lazarus, John 11:1–45), turned water into wine (Wedding at Cana, John 2:1–11), miraculously fed a crowd of 5,000 people with just five loaves of bread and two fish (Feeding the Multitude, or Miracle of the Loaves and the Fishes), walked on water (Matthew 14:25–27), and healed many people (Jesus Healing a Leper, The Man Who

Could Not Walk, and so on).

• **Parables:** Jesus taught by telling stories with a moral. There's the Prodigal Son, who lives the life of Riley (Luke 15:11–32); the Good Samaritan, who helps a needy outcast (Luke 10:30–37); and the Good Shepherd, who searches for his lost sheep.

• **"The Passion":** Despite his good works, Jesus antagonized the religious establishment. "The Passion" is the name given to the one-week period in which Jesus was arrested, tried, and executed. It started on a high note, with Jesus being welcomed to Jerusalem by cheering fans waving palm fronds (Entry into Jerusalem, or Palm Sunday).

Salvador Dalí, **The Sacrament of the Last Supper,** 1955 (National Gallery, Washington, D.C.).

• **Last Supper:** Jesus celebrated the Jewish festival of Passover by having one final meal with his apostles. He washed their feet as a sign of humility (Jesus Washes the Apostles' Feet). When he announced that he'd be betrayed by a disciple, they all asked, "Lord, is it I?" (Mark 14:1–31; John 13:1–17, 26).

• **Garden of Gethsemane:** Later that night, Jesus was arrested by the Roman

Four Crucifixions

Medieval: *This 14th-century crucifix concentrates on the agony of Christ—his twisted body and drooping head.*

Renaissance: *Masaccio's Christ is solid, serene, and triumphant—part of a majestic architectural setting presided over by God the Father.*

Baroque: *Peter Paul Rubens captures the drama and human emotion of the moment with the expression on Christ's face and the rippling energy of the surrounding figures.*

Modern: *Georges Rouault breaks the scene into its basic geometrical "abstract" forms. The heavy outlines and blocks of color are almost a return to medieval stained glass.*

Giotto, **Betrayal of Christ** (or **The Kiss**), 1303–1305 (Scrovegni Chapel, Padua, Italy).

and Jewish authorities after praying in the Garden. He was betrayed by one of his own followers, who fingered Christ with a kiss (Kiss of Judas; Mark 14:32–53).

• **Christ Before Pilate:** Jesus was arraigned before the Jewish elders and the Roman governor, Pilate, who literally washed his hands of the whole affair. Mocked and whipped by Roman soldiers (Mocking, Flagellation, and so on), Jesus was given a crown of thorns and sentenced to die by crucifixion.

• **"The Stations of the Cross":** They made Jesus carry his own cross to the execution site on Calvary Hill. Catholic churches generally show 14 scenes (Stations of the Cross) from condemnation to crucifixion to burial. These are displayed in a long row in most churches as an aid to worship. They help parishioners focus on the suffering of their

savior as he died for their sins.

• **Crucifixion:** Jesus was nailed to a cross and crucified between two criminals; when he died, he took on all of the sins of humankind (Matthew 27:27–54, Mark 15:16–39, John 19:16–37). Crucifixion was a Roman specialty. The victim often hung for days before dying. The Romans stabbed Jesus in the side for good measure. Above the cross were the Roman initials I.N.R.I., a mocking tribute to "Jesus of Nazareth, King (Rex) of the Jews." (Latin uses an "I" for the letter "J.") Mary is usually right there at the foot of the cross, comforted by the disciple John.

There are literally thousands of artworks that depict the crucifixion, but no two are the same. Some artists concentrate on Jesus' agony, some on his serenity. For some, it's a gruesome moment of defeat; for others, a glorious triumph over sin. For all of them, the point was that Jesus was killed—but would rise again later. For the time being, however, the son of God had come to earth to live as a human...and now was dead.

Botticelli, **Lamentation over the Dead Christ with Saints** (detail), c. 1490 (Alte Pinakothek, Munich).

Jesus of Nazareth (c. 4 B.C.–A.D. 29)

Jesus was a real historical figure, but little is known outside the biblical accounts. What did he look like? No one knows. Usually he's depicted as a white-skinned (European-looking) man with long brown hair and a light beard. When there's a crowd of haloed saints, you can always recognize Jesus—only

he has the shape of a cross inside his halo.

Different artists emphasize Jesus' different virtues. In one depiction, he's the Good Shepherd—a handsome, kindly young man caring for people as a shepherd cares for his sheep. In another, he's a wise teacher, seated with his arm raised to make a point. Sometimes, he's even a warrior. In crucifixion paintings, he might appear scrawny and twisted as he suffers for man's sins, or muscular and noble as he triumphs over sin.

Many churches (especially Eastern Orthodox) feature Christ in a standard pose—as *"Pantocrator,"* a Greek word meaning "Ruler of All" (for an example, see page 146). Christ reigns in majesty (usually on a throne) facing directly out, with penetrating, icon-like eyes, raising his hand in a blessing. In Last Judgment scenes, the loving Christ forgets all that "love thy neighbor" nonsense and appears as a stern judge who grimly sends sinners to hell.

The many faces of Christ in art may not tell us what the historical Jesus was really like, but it does say a lot about the people who produced it and how they viewed the Christian message.

• **Deposition, *Pietà*, Lamentation:** Christ's body was taken down from the cross. When depicted in art, this event is called a "Deposition." A *"Pietà"* (pity) shows Mary with the dead body of her son. In a "Lamentation," Jesus' followers mourn over his dead body. Christ's body was placed in a tomb covered by a rock.

• **Resurrection:** On the third day after his burial, Jesus rose from the dead. Mary Magdalene was the first to see the empty tomb and the risen Christ. Christ also appeared to other disciples, such as "Doubting" Thomas, who just had to feel Christ's wound to believe

(The Supper at Emmaus; Matthew 28, Mark 16, Luke 24, John 20–21).

• **Ascension:** Jesus left the earth by rising into the clouds to return to his rightful place beside his Father in heaven (Acts 1:9–11).

• **Pentecost:** Jesus' disciples were visited by the Holy Spirit. Tongues of fire appeared around them, giving them the ability to speak many languages without a Rick Steves phrase book.

• **Assumption of the Virgin:** According to tradition (not the Bible), Mary passed into heaven without suffering the pain of death. She's often shown ascending through the clouds

Michelangelo, **The Last Judgment,** 1534–1541 (Sistine Chapel, Vatican Museum, Rome).

to heaven. Throughout Catholic Europe, August 15 is celebrated as the Assumption of Mary (called Maria Himmelfahrt in Germany). A legend since early medieval times, this belief that the mother of Jesus was assumed directly into heaven at the end of her life is now accepted Church doctrine.

• **The Last Judgment:** At the end of time, Christ will return to the earth to sort out the good people and the bad. Trumpets will blow, waking the dead, and angels will float the good up to heaven, while demons drag the bad to hell (Book of Revelation).

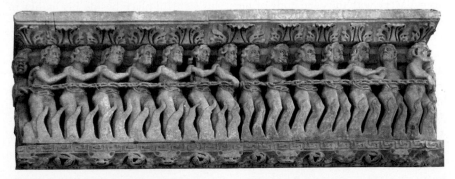

On preachy church facades across Europe, chain gangs of the damned bunny-hop through the eternal flames of hell.

The Saints

Holy people and saints were venerated by the European faithful. Though we don't know what most of these saints really looked like, we can identify who's who in a piece of art by their symbols, which represent their mission or their martyrdom.

St. Peter (St. Peter's Square, Vatican). *Whenever you see a guy with a bushy beard and a key...that's Peter.*

• **Peter:** The most important saint was an apostle of Jesus. The name Peter means "rock." Jesus said, "Upon this rock I will build my church." St. Peter's Basilica, in Rome, is built upon the grave of St. Peter. He's usually shown in middle age with a bushy beard, keys, or an upside-down cross in hand, symbolic of his crucifixion.

• **Paul:** The second-most important saint, Paul was primarily responsible for establishing Christianity through his missionary journeys. He wrote half of the books of the New Testament. He's shown bald-headed and bearded, gripping a sword and a book.

• **Matthew, Mark, Luke, and John (the Four Evangelists):** They wrote the first four books of the New Testament, which chronicle the life of Christ. Matthew is depicted as an angel with a book; Mark as a lion; Luke, a winged bull; and John, an eagle with a book.

• **John the Baptist:** Shown as an emaciated prophet dressed in animal skins, John carries a long cross, a lamb, and often a scroll bearing the words *Ecce Homo* ("Behold the man," referring to Christ crowned with thorns). He spent many years preaching that Jesus was coming into the world, and then eventually baptized him. After objecting to King Herod's marriage to his own brother's wife, John was imprisoned by the king. At the request of Herod's stepdaughter, John was beheaded (Matthew 14:3–12).

• **Mary Magdalene:** Mary was at the cross when Jesus died, and was the first person to see the resurrected Christ. Artists tend to concentrate on the popular legend of Mary (not in the Bible) as a prostitute whom Jesus forgave of her sins. She's usually shown having long hair and carrying a jar of ointment.

• **Michael, the Archangel:** Clad in armor and with a sword, Michael is shown standing over or fighting with a dragon. He also sometimes has a set of scales for weighing. The most important of the angels, Michael cast Satan out of heaven and will one day blow the waking trumpet and lead the forces of Good at the last great battle on Judgment Day.

• **Anne:** Anne, the mother of the Virgin Mary and the grandmother of

Jesus, is shown with the Virgin Mary and usually also with the baby Jesus.

• **Francis of Assisi:** Known for his vow of poverty and love of God, Francis was the most important monk of all time. He founded the Franciscan order and lived in Assisi, Italy. He is usually shown in brown Franciscan habit, on his knees, and often with a winged Christ in the sky sending down the stigmata (the wounds from Jesus' crucified body, which appeared on Francis' body).

• **Sebastian:** He was a soldier in the army of Roman emperor Diocletian. Diocletian loved Sebastian, but when he learned Sebastian was a Christian, Diocletian ordered him tied to a tree and shot with arrows. Legend says Sebastian survived to confront Diocletian...only to be beaten to death with clubs. Sebastian is usually depicted naked, tied to a tree or column, and pierced by arrows.

• **George:** The subject of many legends, George saved a town from a dragon to which the townspeople were sacrificing their children. He was a chivalrous knight, usually shown on horseback spearing a dragon while the king's daughter, Cleodolinda (who was in the sacrificial on-deck circle), looks on.

• **Jerome:** A hermit, he translated the Hebrew Bible into Latin, producing the Vulgate, the standard text of the Catholic Church through modern times. His symbols vary, but he is often shown with a lion, from whose foot he extracted a thorn.

• **Bartholomew:** Tradition says this first-century missionary was captured in Armenia and flayed alive, then crucified for being a Christian. Bartholomew is usually shown with a book and knife or holding his skin. He is sometimes depicted being skinned.

• **Denis:** Sent by the pope on a missionary journey to Paris, Denis became the first bishop of Paris and was eventually beheaded for his faith. You'll see him all over Paris holding his head in his hands.

• **Teresa** (or **Theresa**): In the 16th century, she reformed the Carmelite monastic order and wrote many religious works. Teresa is usually shown with her heart pierced by an angel's arrow, or in ecstasy while praising God.

Andrea Mantegna, **St. Sebastian,** c. 1480 (Louvre Museum, Paris).
St. Sebastian is shown pierced with arrows, the symbol of his martyrdom.

Michelangelo, **The Last Judgment** (detail).
*The Christian martyr St. Bartholomew was
skinned alive. Here the skin Bartholomew holds
bears the face of Michelangelo.*

• **Christopher** (the patron saint of pilgrims and travelers): A third-century man who went out in search of some-

one to serve, he wandered aimlessly for years and ended up ferrying people across a river while waiting for Christ to appear to him. Christ finally appeared as a child whom Christopher carried across the river. You'll see Christopher in many churches. He's shown as a giant carrying a child and holding a staff.
(The preceding section on saints was written by Michael McGregor.)

Other Christian Symbols

Much Christian art is symbolic. During the Middle Ages, every animal, fruit, flower, color, and number had some meaning. Apes symbolized man's baser nature; bees were a symbol of industriousness (busy as a...); a lamb was a sacrificial animal (like Jesus); a dolphin carried the soul of the blessed to heaven. Mythical beasts had meaning, too: dragons (Satan), griffins (power), unicorns (purity), and phoenixes (resurrection). Numbers had symbolic meaning: Three stood for the Trinity (God the Father, Jesus the Son, and the Holy Ghost), four was the number of evangelists (Matthew, Mark, Luke, and John), and twelve referred to the group of Jesus' apostles.

Angels are heavenly beings usually depicted as humans with wings. They flank the Virgin Mary in altarpieces and hover around sacred scenes. Baroque artists often decorated their works with pudgy winged angel babies called *putti*.

Raphael, **Sistine Madonna** (detail), c. 1513–1514
(Old Masters Gallery, Dresden, Germany).

If you see a face in a crowd of saints, church fathers, and biblical figures that looks out of place, chances are it doesn't really belong in such holy company, anyway. Wealthy patrons of works often insisted that they be included in the painting praising the Virgin Mary or St. Peter. If money couldn't buy them a spot in heaven, at least it could put them in a picture of heaven.

Greek and Roman Mythology

The Greek gods lived large. They controlled Nature and the fate of humankind from their home on Mount Olympus. But they were far from perfect. Like Hollywood celebrities, they bickered, cheated on their partners, boasted, loved, and hated just as mortals do, but on a larger-than-life scale. Classical mythology tells how the gods dealt with each other and with the mortals who asked them for favors. (The Greeks must have enjoyed hearing their own weaknesses glamorized, just as we do when we clamor to see and read about the breakups, babies, and DUIs of our Hollywood stars.)

Later, the Romans adopted most of the Greeks' gods and gave them new names. Still later, Renaissance artists revived them, using them as symbols of Christian virtues and vices. After centuries of painting the same old God, it must have been extraordinarily liberating to paint new ones—and a whole pantheon of them, to boot.

In your museum-going, you're likely to see Hercules slaying a lion,

Zeus seducing mortals, Dionysus drinking, Pandora opening the box, and on and on. Here are the most important Greek gods and heroes and how to recognize them (Roman name in parentheses):

Gods

• **Zeus** (**Jupiter**): He ruled as King of the Gods in the court on Mount Olympus. He's shown as bearded and sometimes carrying a spear. Zeus had a nasty habit of turning himself into some earthly form to hustle unsuspecting females. When he was on the

Titian, **Danaë,** 1554 (Prado Museum, Madrid).

make, he was more likely to be in disguise: as a bull *(Rape of Europa)*, a cloud *(Jupiter and Io)*, a swan *(Leda and the Swan)*, or a shower of gold *(Danaë)*.

• **Hera** (**Juno**): She was the long-suffering wife of Zeus.

• **Poseidon** (**Neptune**): The King of the Sea is often shown holding a trident.

Giambologna, **Flying Mercury**, c. 1580 (Bargello Gallery, Florence).

Nicola Salvi, **Neptune** (detail of Trevi Fountain), 1762 (Rome).

• **Hades (Pluto):** The King of the Underworld is depicted as bearded and sad, carrying a staff.
• **Apollo:** The Ruler of the Sun, a.k.a. God of Music and Poetry, drives the sun's flaming chariot across the sky each day. His major symbol is the sun. You see him everywhere at Versailles, palace of the "Sun King."
• **Hermes (Mercury):** The Messenger of the Gods sports a helmet and shoes with wings. He delivers a lot of flowers in his current incarnation as a corporate logo.
• **Ares (Mars):** The God of War dresses for battle and carries a spear.
• **Dionysus (Bacchus):** The God of Wine and College Fraternities holds grapes and wears a toga with a wreath of laurel leaves. He's sometimes shown as a chubby little boy.

Velázquez, **The Triumph of Bacchus** (detail), c.1629 (Prado Museum, Madrid).

• **Athena (Minerva):** The virginal Goddess of Wisdom, born from the head of Zeus, carries a spear.
• **Artemis (Diana):** The Goddess of the Moon and Hunting carries a bow and arrow.
• **Aphrodite (Venus):** The Goddess of Love and Beauty is often shown

partially naked, with Cupid nearby.
• **Eros (Cupid):** The God of Desire is usually depicted as a young man or baby with wings, wielding a bow and aphrodisiac-tipped arrows.

Miscellaneous Beasts
• **Pan (Faun):** Top half man, bottom half goat. Carrying a pan flute, he's known for being happy.
• **Centaur:** Top half man, bottom half horse. He's wise.

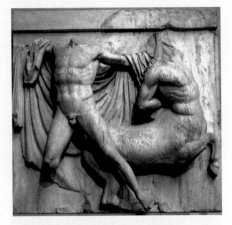

Battle of Lapiths and Centaurs, 447–432 B.C. (British Museum, London).

• **Satyr:** Top half man, bottom half goat. He's horny.
• **Griffin:** Winged, lion-like beast.
• **Harpy:** Bird with female human head and seductive voice.
• **Medusa:** With writhing snakes instead of hair, she had a face that, when glimpsed, turned people to stone. She was slain by Perseus.
• **Pegasus:** Winged horse.
• **Cyclops:** One-eyed giant.
• **Minotaur:** This beast with the head of a bull lived in the labyrinth at Knossos, the palace on Crete.

Greek Heroes of Legend
• **Hercules:** The son of Zeus was born to a mortal woman. The strongest man in the world (who tested negative for steroids) performed many feats of strength. To make Hercules atone for killing his family, the gods forced him to perform Twelve Labors, which included slaying various fierce beasts and doing other chores. He often wears a lion's skin.
• **Amazons:** A race of powerful female warriors.
• **Prometheus:** He defied the gods and was chained to a rock in punishment.
• **Jason:** He sailed with his Argonauts in search of the Golden Fleece.
• **Perseus:** He killed Medusa and rescued Andromeda from a sea serpent.
• **Theseus:** He killed the Minotaur in the labyrinth on Crete.
• **Trojan War Heroes:** The poet Homer told the story of the Trojan War (in *The Iliad*) and the journey home (in *The Odyssey*). Helen of Troy was the most beautiful woman in the world, whose kidnapping started the Trojan War. Hers is "the face that launched a thousand ships." Achilles was the greatest Greek warrior. The Greeks finally conquered Troy by sneaking into the city inside a giant, hollow "Trojan Horse." After the war, Odysseus (Ulysses) wandered for 10 years on his journey home, battling the Cyclops and magical, enchanting women.

There. Got all those names straight? It can be difficult for the novice to take in all this cultural baggage. But if you can learn to tell a satyr from a centaur, Peter from Poseidon, or the *Slaughter of the Innocents* from *The Rape*

Benvenuto Cellini, **Perseus Beheading Medusa**, c. 1545–1554 (Loggia dei Lanzi, Florence).

of Europa, your museum-going will be much more meaningful.

Secular Subjects

After Renaissance times, as society became increasingly secular, artists explored other subjects besides Christian and Greek/Roman themes.

Historical Scenes

Artists turned to famous scenes from history, trying to capture the high drama of heroic acts. In the early 1800s, Romantic artists tapped the patriotic fervor of their audiences with scenes

of heroics against oppressors. Goya's *The Third of May, 1808* shows the murderous execution of Spanish nationals by Napoleon's troops (see page 323). Delacroix painted a stirring battle scene from a French uprising against the monarchy (see page 321). J. L. David, a Neoclassicist, chronicled (and "Romanticized") the French Revolution and reign of Napoleon (see page 301).

Still Lifes

Scholars debate whether art imitates life or life imitates art, but to a great extent art imitates art. Artists will often choose a subject already used by their predecessors in order to carry on and extend the tradition—both to learn from earlier masters' versions, and to try something new.

Perhaps the best example is the "still life," a painting of a set of motionless, common objects: fruit, bowls, a knife, a chair, curtains, and so on. It's a simple form, often undertaken by students to practice their drawing and composition skills, yet many great artists have shown their ingenuity by turning the form into superb art. Each successive artist is challenged to

Pieter Claesz, **Still Life with Turkey Pie**, c. 1627 (Rijksmuseum, Amsterdam).

revitalize the old styles and familiar subjects, to imbue them with fresh life for new generations.

Landscapes

Certain artists, such as Canaletto and John Constable, concentrated on paintings of places: landscapes, seascapes, and domestic and rural scenes. The same place may be completely different in two different paintings: One version is placid, while another is charged with the artist's own emotions.

El Greco, **Landscape of Toledo,** c. 1597 (Metropolitan Museum of Art, New York).

Portraits

Portraits are, of course, supposed to be accurate renditions of the people portrayed. Some are as accurate as photographs. Others glorify their subject by airbrushing out warts and pimples or by dressing the person up like a warrior or emperor. The best portraitists capture not just the person, but the personality.

Ancient Rome set the style for portraits through the ages. In sculpture, two Roman specialties continue to be popular: the "bust" (showing only the subject's neck and head) and the "equestrian" (the subject riding a horse). As with ancient Roman statues, many portraits show the subject standing *contrapposto* (Italian for "counterpoise"), resting their weight on one leg. (Michelangelo's *David* is *contrapposto*.) The faint S-like curve of the body attracts the eye as much as any individual body features.

Donatello, **Equestrian Statue of Gattamelata,** 1447–1450 (Piazza del Santo, Padua, Italy).

The "nude" is another kind of portrait, concerned more with the shape of the body than specific identifying features. Most so-called "nudes" are of pretty people posed so their bodies form harmonious lines and make a pretty picture. A "life study" is grittier, giving the artist a chance to nail down eccentric human features.

Hendrick Avercamp, **Winter Landscape with Ice Skaters,**
c. 1608 (Rijksmuseum, Amsterdam).

Slice-of-Life ("Genre") Scenes

Snapshots of ordinary people going about their ordinary business have been popular since Renaissance times. Pieter Bruegel painted peasants at play, Jan Steen captured Dutch folk of the Golden Age, and Impression ists sketched people in cafés and dance halls. The "unposed" look makes the work seem like a glimpse into real life.

Museum-Going

Europe is a treasure chest of great art. A visit to one of Europe's world-class museums can be exhilarating, even life-changing. Others get sore feet and tourist burnout. No denying it, sightseeing can be hard work. Here are a few hints on how to get the most out of Europe's museums.

Before You Go. . .

To avoid needless disappointment, check ahead on museum hours. A museum is much more interesting when it's actually open.

Many museums are closed one day a week. Some are open late one night per week. Consult your guidebook, the museum's Web site, or the local tourist information office. Many museum ticket offices close 30 to 60 minutes before the museum does. Be aware that guards will begin closing rooms and shooing art lovers out before the official closing time. If you'll be in a museum until the very end, first visit the must-see sights—especially those in the far corners—and then work your way back to the entrance.

Avoiding Crowds

You won't be the only one trying to crowd in to see the Mona Lisa. Sightseeing can be especially grueling when you're trying to elbow through hordes of tourists. The best general rule is to arrive early (at opening time) or late. Sights are most crowded from late morning until 3:00 p.m. Evenings are

Mona Lisa *always has an audience.*

rarely crowded. Free admission days are usually packed; it may be worth paying the entrance fee to avoid the crowds. For some major museums, you can (and should) get a reservation in advance; for a few, advance reservations are actually required. You'll find all the details in a good guidebook.

On-the-Spot Information

Most museums offer free maps, often with a helpful list of greatest hits. Be flexible: Paintings can be on tour, on loan, out sick, or shifted at the whim of the curator. Even museum walls are sometimes moved. To adapt, pick up any available free floor plan as you enter.

Audioguides, available at many museums (sometimes free, sometimes for about $5), are handheld devices that give English commentary as you walk through a museum. When audioguides first came out, their narrations were dry and stodgy, but now they're usually top-notch, informative, and entertaining. Generally an excellent value, audioguides are perfectly flexible, allowing you to tap in the number of just what you want described. Bud-

get travelers can share one audioguide by cranking up the volume and listening cheek-to-cheek, or by plugging in an MP3 player or iPod Y-cable so the museum-provided player powers two sets of speakers (the jack is universal).

Some museums offer guided tours in English (sometimes free but usually at a cost). The quality of a tour depends on the guide's knowledge, fluency, and enthusiasm. (Shameless plug: You'll find a number of two-hour, self-guided tours of Europe's greatest museums in many of our various city guidebooks.)

If you have trouble locating a particular piece of art within a museum, ask a guard. It's even easier if you have a picture of the art. Don't be put off if the guard initially seems bored or indifferent; you'd likely be cranky, too, if you spent the day saying, "Don't touch" and "No flash!"

Before leaving a museum, stop by the gift shop. Thumb through a museum guidebook index or look through the postcards to make sure you haven't missed anything of importance. Bookstores also sell prints, posters, and sometimes mailing tubes.

Checkrooms and Cafeterias

Museums usually have a free, safe checkroom at the entrance. For security reasons, you're often required to check even small bags. (If you don't want to check a small day bag, carry it like a purse, as museum staff seem to be most concerned about bags worn as backpacks—which they think are more likely to

Paris' Louvre—Europe's greatest museum, once a grand old palace—has a striking, modern entry.

accidentally damage things.)

Museum-going stokes appetites. Most museums have coffee shops and cafeterias with reasonable prices and decent food. The WCs are free and better than the European average.

Photography

Cameras are normally allowed, but flashes or tripods are not (without special permission). Flashes damage oil paintings and distract other visitors. Even without a flash, a handheld camera will take a decent picture (or you can skip the photography and simply buy postcards or posters at the museum bookstore). You may have to buy a special photo permit (generally for just a few dollars) for permission to take photos inside. Know how to turn off your flash. You can get excellent shots of indoor art without a flash by using your automatic shutter release and tripod (or improvised tripod).

Be Selective and Pace Yourself

A common misconception is that great museums have only great art. Not so. Save yourself for the masterpieces. A museum such as Paris' Louvre is so big (the building was, at one time, the largest in Europe) that you couldn't possibly cover everything properly in one visit anyway—so don't try. Be choosy.

I'm usually good for two, maybe three hours before I burn out; I do my best to see the highlights—and only the highlights—within that window of time. If I have more energy, I can explore beyond that. Use a local guide, audioguide, or guidebook to take you through the best two hours of viewing in a museum.

If you have the time, take a break midway through your visit—for lunch, coffee, or a breath of fresh air—then go at it again with a second wind. Many (but not most) museums and major sights let you revisit the same day on one ticket.

Sightseeing always leaves me enlightened and invigorated.

Music

Appreciation

European music—what we call "classical music"—is an art form still going strong centuries after it first appeared. Music, like all the arts, is shaped by the times that produced it. It's easy to trace the course of Europe's musical history as it marches arm in arm with painting, architecture, philosophy, lifestyles, and sculpture—from Ancient to Medieval to Renaissance, Baroque to Neoclassical, Romantic to Impressionist, and into the no-holds-barred artistic world of our own time.

Little remains of the music of the ancient world (Egypt, Greece, and Rome), but we know that the people who heard it enjoyed it. Mosaics, sculpture, and murals show musicians plucking stringed instruments, playing flutes, and banging on tambourines at dinner parties and theatrical gigs.

After the fall of Rome, most music—like everything else in society—revolved around the church. Medieval monks composed

Gregorian chants to the glory of God. These were simple melodies using a limited scale of notes (a mode) sung in unison without accompaniment. As Europe evolved into the High Middle Ages, church music became more sophisticated. One monk sang a melody while another sang a second melody, weaving it around the first (polyphony).

In the Renaissance, European music—as in so many other artistic areas—blossomed. There was three- and four-part harmony. Folk songs with secular themes came into their own, accompanied by a small guitar-like

instrument called the lute. A legend (doubted by historians) has it that Henry VIII, a pretty fair lute player, wrote the song *Greensleeves* to woo Anne Boleyn.

Music of Baroque times is the true starting point for the classical music we hear today. The Baroque world was controlled exuberance, with art dedicated to the glory of man and his God-blessed accomplishments. Music, like visual art, was brilliant, bright, alive, and decorated with trills, flutters, and ornamentation—like the powder-wigged, perfumed, and elegantly gowned musicians who wrote and performed it.

In Baroque music, the multiple melodies of polyphony—now called counterpoint—reached their peak of intricacy. When one melody plays, the other gets quiet, when one melody goes up, the other goes down, then the two come together for the big finish. An analysis of composer J. S. Bach's work shows many mathematically symmetrical patterns, staircase-type series, and a grand plan, tying all the musical ribbons and bows together. Giving it all a solid, symmetrical foundation was a low instrument playing "basso continuo"—a continuous bass line that keeps repeating while the higher instruments get increasingly complex (think of Pachelbel's well-known *Canon in D*).

The Baroque era brought new instruments, particularly keyboards such as pipe organs (for big cathedrals) and harpsichords (for nobles' palaces).

Classical concerts in historic settings, such as chamber music in Paris' Sainte-Chapelle, make music appreciation easy.

Stringed instruments played with a bow (violins and cellos) evolved into the versions we recognize today, as did some brass instruments (trumpets and tubas). The Baroque era also brought the first era of "name" composers, whose individual works were recognized as worthy of writing down and remembering (e.g., J. S. Bach, Handel, and Scarlatti, all born in 1685).

The phrase "classical music" was coined during the Neoclassical era, when heavyweights such as Mozart, Haydn, and Beethoven created music considered the equal of ancient Greek art. The Age of Enlightenment had arrived, and beauty was simple. Neoclassical buildings stripped away the clutter of Baroque and featured clean symmetry—domes, circles, and squares—and the music followed suit. Mozart wrote pieces of powerfully simple beauty. Grand and frilly were out. The better a Mozart sonata is played, the easier it sounds.

During this (Neo-) Classical era, the piano was developed (a keyboard that makes music by hammering strings) and soon replaced the harpsichord (a keyboard that plucks the strings). As the piano could play soft or loud (that's what its original Italian name—*piano-forte*—meant), composers took advantage of this new dynamic range to bring more complexity and emotion into music written for the keyboard.

In the 1800s, reason and logic were dethroned, and Nature and Emotion became a religion: Romanticism. The Romantics were awestruck by the wonders of nature and happy victims of its power and immensity. Composers such as Edvard Grieg found inspiration in a fjord hideaway, Giuseppe Verdi found it in Italian nationalism, and Frédéric Chopin's battered heart yielded up masterpieces. They expressed emotions—good and bad—with harmonic or dissonant notes. A series of pieces by Chopin, Wagner, or Schumann can take you through an emotional wringer. The titles often reflect heartfelt stories *(Ase's Death, Pleading Child, Raindrops Prelude, Dreaming)*, designed to strongly affect the listener rather than merely entertain.

By the mid-1800s, European music was big business. Classical

Statue of Edvard Grieg (Edvard Grieg's Home, Bergen, Norway). *Grieg's music was fjord-inspired. When tracking down the homes of your favorite artists, note how their environment may have contributed to their music, art, or poetry. The creative spirit of Norway's greatest composer—who had a home (and piano) right on the water—was fueled by the beauty of the breathtaking fjord country.*

Musical Sights

- State Opera Houses in Vienna, Milan, Venice, and Paris
- Mozart's Birthplace and Residence, Salzburg, Austria
- Ringve Music Museum, Trondheim, Norway
- Beethoven's House, Bonn, Germany
- House of Music, Vienna
- Europe's Greatest Organs: Haarlem (Netherlands), St. Sulpice (Paris), and Passau (Germany)
- Edvard Grieg's Home, Troldhaugen, Bergen, Norway
- Musical Instruments Museum, Brussels

After Mass, visitors are welcome in the organ loft of St. Sulpice Church in Paris to hear the master Daniel Roth play its awe-inspiring pipe organ.

music wasn't just for duchesses and highbrows. As the middle class grew, big concert halls were packed several nights a week. Opera thrilled audiences the way Hollywood movies do today. The piano virtuoso Franz Liszt toured Europe like a rock star. Orchestras grew in size to add more punch—going from all string instruments to added brass, percussion, and woodwinds. Throw in a choir, and a performance could involve many more than a hundred highly trained, well-paid professionals. And in many middle-class homes, children grew up playing the piano.

In the Impressionist era, Monet and Renoir were catching sunbeams,

leafy reflections, and the fuzzy warmth of that second glass of wine. Composers such as Debussy and Ravel were doing the same thing on the keyboard or with orchestras. Artists struggled to capture basic shapes, colors, and moods. A blue moment, a fleeting rainbow, or an enchanted cathedral were targets of the artist's mind, the painter's brush, the composer's pen, and the conductor's baton. Debussy is Monet for your ears (and Monet is Debussy for the eyes).

In the 20th century, painting became abstract, and music became atonal. (See "Abstract Art = Visual Music," page 372.) Hummable three-chord tunes went out the window. There was no key or consistent beat (such as 4/4 or 3/4 time). Harmony (when two or more notes blend pleasantly) gave way to dissonance (when notes clash). The patterns of notes were no longer meant to simulate a waterfall, a bird song, or a surging emotion. Composers abandoned convention, exploring new musical frontiers by creating stimulating, often esoteric works of art that weren't intended to please the average person. So the middle class abandoned the concert hall and caught a movie instead. (Today's young people listen to global pop music, not "classical.")

Atonality can be as difficult for the ears as abstraction is for the eyes. We're conditioned to need a painting to portray something real, and music to stick to a key. Liszt knew the power of tonality. And so did his wife. To get him out of bed in the morning, she would play the first seven notes of a scale: *do re mi fa so la ti*.... Sleepy Franz would toss aside the covers, run to the piano, and play that last necessary note...*do!* Good morning.

Thirty-Two Millennia in Six Pages

Prehistory: 30,000–3,000 B.C.

Before hunter-gatherers became herder-farmers, there was little leisure time or communal support to make art. (The more things change, the

more they stay the same.) Handcrafted objects such as spear heads, axes, baskets, and bowls aided basic survival. The realistic, powerful animals painted on cave walls and the small, crude statuettes of people may have had religious or magical purposes.

Egypt: 3000–1000 B.C.

Egypt's stable society produced stable art—little changed in 2,000 years. Tombs and mummies preserved corpses and possessions for the afterlife. Statues of pharaohs were political propaganda. Statues and painted figures were stiff and unrealistic, perpetually standing at attention.

Greece: 700 B.C.–A.D. 1

Greece provided the foundation of our "Western" civilization: the belief in science, democracy, art, and the orderliness and rationality of the universe.

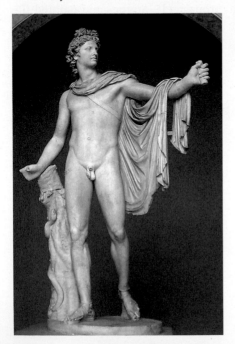

Archaic (700–500 B.C.)

In a time of wars, the Greek creative spirit was beginning to show itself, represented in the stiff statues that embody the search for stability and order amid chaos. Sculptors showed keen interest in, but little mastery of, the human body.

Golden Age (500–325 B.C.)

Athens ruled a coalition of city-states in the days of Socrates, Pericles, Plato,

and Aristotle. The Greek gods were portrayed as ideal human beings. Statues look natural, but their balanced poses show the order found in nature. The "golden rule" was the "golden mean"—nothing in extreme.

Hellenism (325 B.C.–A.D. 1)

Alexander the Great conquered Greece and spread Greek culture around

the Mediterranean. Artists produced restless statues of people in motion struggling against other people, animals, and themselves. It was "ancient Baroque"—everything in extreme.

Rome: 500 B.C.–A.D. 500

The Romans conquered Greek lands and absorbed their culture and gods. The result was Greek style, but with a "bigger is better" attitude. Romans were engineers, not artists. Using the arch and concrete, they built unprecedented grand structures that were decorated with Greek columns and statues. Realistic portrait busts of the

emperors reminded subjects who was in charge.

The Middle Ages: A.D. 500–1400

Rome fell, plunging Europe into "dark" centuries of poverty, war, famine, and hand-me-down leotards. The Church was the people's refuge, and heaven was their hope. Art served the Church: Biblical scenes, crucifixes, saints, and Madonnas (Mary, the mother of Jesus) decorated churches and inspired the illiterate masses. Gothic architects used the pointed arch to build tall, spired cathedrals with walls of stained glass.

Art was symbolic, not realistic. Saints float in a golden, heavenly realm, far removed from life on earth. Humans are scrawny sinners living in a flat, two-dimensional world.

Byzantine: A.D. 300–1450

The Eastern half of the Roman Empire, centered in Constantinople (Istanbul), lived on after Rome fell, remaining Christian, Greek-speaking, and enlightened while Western Europe was mired in medievalism. Byzantium preserved the classical arts and learning through the Dark Ages. These ideas reentered Europe via Venice.

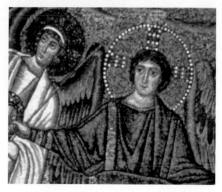

Italian Renaissance: 1400–1600

The Renaissance was the "rebirth" of the arts and learning of ancient Greece and Rome: democracy, science, and humanism. Architects built balanced structures with Greek columns and Roman domes and arches. Sculptors used 3-D realism to glorify human beings like the Greeks did. Artists used mathematical laws of perspective to capture the 3-D world on a 2-D canvas. They saw God in the orderliness of nature and the beauty of the human body. Art was no longer tied to the church. Art for art's sake was OK.

Florence (1400–1500)

In this city, the birthplace of the Renaissance, Greek-style sculpture and Roman-style architecture were revived. Pioneering 3-D painting, artists placed statue-like people in spacious settings.

Venetian Renaissance (1500–1600)

Big, colorful, sensual paintings celebrate the Venetian good life, funded by

trade with the East. Whereas Florentine painters drew their figures with heavy outlines, Venetians "built" figures out of patches of color.

Northern Protestant Art: 1500–1700

Art was bought by middle-class merchants, not popes and kings. Everyday things were painted on small canvases in a simple, realistic, unemotional style, with loving attention to detail. Rather than painting Greek gods and heavenly Madonnas, they concentrated

Roman Renaissance (1500–1550)

The city of Rome was grandly rebuilt by energetic, secular-minded Renaissance popes.

Rococo: 1700–1800

Baroque's frilly little sister was smaller, lighter, and even more ornamented, with pastel colors, rosy cheeks, and pudgier winged babies. Aristocratic tastes grew more refined and more out of touch with the everyday world.

on portraits, landscapes, still lifes, and wacky slice-of-life scenes.

Baroque: 1600–1700

This style of divine-right kings (Louis XIV) and the Counter-Reformation Catholic Church was meant to impress commoners. Baroque is big, colorful, and ornamented, though based on Renaissance balance. Featuring exaggerated beauty and violence, Baroque specializes in Greek gods, fleshy nudes, and pudgy winged babies.

Neoclassical: 1750–1850

With the French Revolution, Rococo became politically incorrect. Neoclassical was yet another rebirth of the Greek and Roman world. It was simpler and more austere than Renaissance and Baroque versions of the classical style. Reflecting its era, Neoclassical was the art of democracy and the Age of Reason.

Romanticism: 1800–1850

Reacting against the overly rational Neoclassical and Industrial Age, Romanticism was a return to nature and man's primitive roots. Dramatic, colorful art expresses the most intense inner emotions. Romanticism championed national monuments as both individuals and nations struggled to be free.

Impressionism and Post-Impressionism: 1850–1900

Quick "impressions" of everyday scenes (landscapes, cafés) are captured with a fast and messy style. The thick brushstrokes of bright colors laid side by side on the canvas blend at a distance, leaving the impression of shimmering light.

Modern Art: 20th Century and Beyond

Accelerated by technology and shattered by wars, the 20th century produced art as chaotic as the times. There was a wide variety of art styles ("-isms") and many new media. Many artists abandoned photorealism to paint abstract, colorful patterns (abstract art, Cubism, Abstract Expressionism). Others distorted reality to give a new perspective or express a larger truth (Surrealism, Expressionism, Pop Art). Most modern artists mixed these two strains.

But what does it *mean*? Modern art offers an alternative to our normal, programmed McLives. It's a wild, chaotic jungle that you'll have to explore and tame on your own. *Grrr.*

Artists and Dates

Note that the photos show self-portraits.

Bellini (beh-LEE-nee), Giovanni, c. 1430–1516: Colorful, soft-focus Madonnas. Venetian.

Bernini (bayr-NEE-nee), Giovanni Lorenzo, 1598–1680: Baroque grandeur. Roman.

Blake, William, 1757–1827: Mystical visions. English.

Bosch (bosh), Hieronymus, 1450–1516: Crowded, bizarre scenes. Dutch.

Bosch

Botticelli (bot-ih-CHEL-lee), Sandro, 1445–1510: Delicate Renaissance beauty. Florentine.

Boucher (boo-shay), François, 1703–1770: Sensual Rococo scenes for French aristocrats. French.

Braque (brock), Georges, 1882–1963: Cubist pioneer. French.

Bruegel (BROY-gull), Pieter, c. 1525–1569: Flemish peasant scenes. Not to be confused with his sons, Pieter and Jan Brueghel.

Brunelleschi (broon-uh-LES-kee), Filippo, 1377–1446: First great

Renaissance architect. Florentine.

Canaletto (kah-nah-LET-toh), 1697–1768: Photorealistic Venetian overviews.

Canova (kah-NOH-vah), Antonio, 1757–1822: Cool, white Neoclassical statues. Italian.

Caravaggio (kah-rah-VAH-jcc-oh), 1573–1610: Shocking ultrarealism. Baroque, Italian.

Cézanne (say-zahn), Paul, 1839–1906: Bridged Impresionism and Cubism. French.

Caravaggio

Chagall (shuh-GAWL), Marc, 1887–1985: Fiddlers on roofs, magical realism. Russian Jew.

Cimabue (chee-MAH-bway), c. 1240–1302: Experimented with Renaissance techniques and influenced Giotto. Florentine.

Courbet (koor-bay), Gustave, 1819–1877: Unglamorized Realism. French.

Dalí (dah-LEE), Salvador, 1904–1989: Father of Surrealism. Catalan.

Daumier (dohm-yay), Honoré,

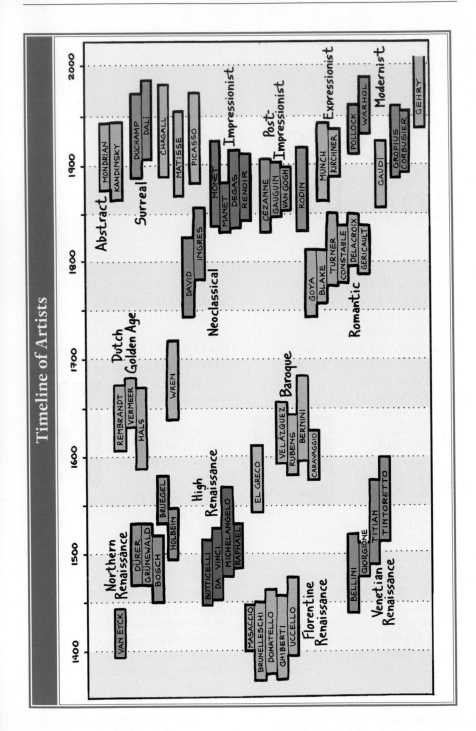

1808–1879: Caricatures of pomposity. French.

David (dah-veed), Jacques-Louis, 1748–1825: Neoclassical chronicler of heroic Napoleonic era. French.

David

Da Vinci (*see* Leonardo da Vinci)

Degas (day-gah), Edgar, 1834–1917: Impressionist snapshots, dancers. French.

Delacroix (deh-lah-kwah), Eugène, 1798–1863: Colorful, emotional, exotic Romanticism. French.

Donatello (doh-nah-TELL-oh), 1386–1466: Early Renaissance sculptor. Florentine.

Duchamp (doo-shawm), Marcel, 1887–1968: The daddy of Dada. French-born American.

Dürer (DEWR-er), Albrecht, 1471–1528: Renaissance humanism with German detail; "the Michelangelo of the north." German.

Dürer

Foster, Lord Norman, b. 1935: Contemporary architect who combines elements old and new. English.

Fra Angelico (frah ahn-JELL-ih-koh), c. 1400–1455: Renaissance techniques, medieval piety. Florentine.

Fragonard (frah-goh-nar), Jean-Honoré, 1732–1806: Rococo candy. French.

Gainsborough, Thomas, 1727–1788: Relaxed portraits of English upper crust. English.

Gaudí (gow-DEE), Antoni, 1852–1926: Catalan Modernista architect.

Gauguin (goh-gan), Paul, 1848–1903: Primitivism, native scenes, bright colors. French.

Gehry, Frank, b. 1929: Trendsetting contemporary architect, avoids right angles. Canadian-American.

Géricault (zhair-ee-koh), Théodore, 1791–1824: Dramatic Romantic. French.

Giacometti (jee-ah-koh-MET-tee), Alberto, 1901–1966: Stick-figure statues. Swiss.

Giorgione (jor-JONE-ee), c. 1477–1510: Venetian Renaissance, mysterious beauty. Italian.

Giotto (JOTT-oh), 1267–1337: Proto-Renaissance painter (3-D) in medieval times. Florentine.

Goya (GOY-ah), Francisco de, 1746–1828: Three stages: frilly court painter, political rebel, dark stage. Spanish.

Greco, El (el GREK-oh), 1541–1614: Spiritual scenes, elongated bodies. Spanish with Greek roots.

El Greco

Gropius (GROH-pee-oos), Walter, 1883–1969: Founder of the Bauhaus, and father of the "International Style" of architecture. German.

Guardi (GWAR-dee), Francesco, 1712–1793: Misty postcards of Venice.

Hals (halls), Frans, c. 1581–1666: Snapshot portraits of Dutch merchants.

Ingres (ang-gruh), Jean-Auguste-Dominique, 1780–1867: French Neoclassical painter.

Kandinsky (kahn-DIN-skee), Wassily, 1866–1944: Colorful, abstract squiggles and shapes. Russian.

Kirchner (KIRSH-ner), Ernst Ludwig, 1880–1938: Expressionist, jagged

shapes and lurid colors. German.

Klee (klay), Paul, 1879–1940: Simplified, playful, childlike forms. Swiss.

Le Corbusier (leh kor-boo-see-yay), 1887–1965: Architect who strove to make buildings people-friendly. French.

Leonardo da Vinci (dah VINCH-ee), 1452–1519: A well-rounded Renaissance genius who also painted.

da Vinci

Libeskind, Daniel, b. 1946: Highly conceptual contemporary architect. Polish-American.

Lichtenstein, Roy, 1923–1997: Pop Artist who enlarged comic strips on canvas. American.

Manet (man-nay), Edouard, 1832–1883: Forerunner of Impressionist rebels. French.

Mantegna (mahn-TAYN-yah), Andrea, 1431–1506: Renaissance 3-D and "sculptural" painting. Italian.

Matisse (muh-teese), Henri, 1869–1954: Decorative "wallpaper," bright colors. French.

Michelangelo (mee-kell-AN-jell-oh), 1475–1564: Earth's greatest sculptor and one of its greatest painters. Florence and Rome.

Michelangelo

Millet (mee-yay), Jean-François, 1814–1875: Realist painter in Academic society. French.

Miró (mee-ROH), Joan, 1893–1983: Abstract Catalan painter.

Mondrian (mahn-dree-AHN), Piet, 1872–1944: Abstract, geometrical canvases. Dutch.

Monet (moh-nay), Claude, 1840–1926: Father of Impressionism. French.

Monet

Moore, Henry, 1898–1986: Modern sculptor influenced by the Primitives. British.

Munch (moonk), Edvard, 1863–1944: Norwegian Expressionist famous for *The Scream*.

Murillo (moo-REE-yoh), Bartolomé, 1617–1682: Sugar-coated Catholic images. Spanish.

Parmigianino (like the cheese: par-mee-jee-ah-NEE-noh), 1503–1540: Mannerist exaggeration, elongated bodies. Italian.

Pei (pay), I. M., b. 1917: Contemporary architect famous for the glass pyramid at Paris' Louvre. Chinese-American.

Picasso (pee-KAHS-oh), Pablo, 1881–1973: Master of many modern styles, especially Cubism. Spanish.

Pollock (PAHL-luck), Jackson, 1912–1956: Wild drips of paint. American.

Raphael (roff-eye-ELL), 1483–1520: Epitome of the Renaissance: balance, realism, beauty. Italian.

Rembrandt (REM-brant), 1606–1669: Greatest Dutch painter, brown canvases, dramatic lighting.

Rembrandt

Renoir (rehn-wah), Pierre-Auguste, 1841–1919: Impressionist style, idealized beauty, pastels. French.

Rodin (roh-dan), Auguste, 1840–1917: Classical statues with rough Impressionist finish. French.

Rousseau (roo-soh), Henri, 1844–1910: Exotic scenes in children's-book style. French.

Rubens (rew-buns), Peter Paul, 1577–1640: Baroque, fleshy women, violent scenes. French.

Rubens

Seurat (suh-rah), Georges-Pierre, 1859–1891: Bright works made with dots of color (pointillism). French.

Seurat

Steen (stayn) Jan, 1626–1679: Slice-of-life everyday Dutch scenes.

Tiepolo (tee-EPP-oh-loh), Giovanni Battista, 1696–1770: 3-D illusions on ceilings. Italian.

Tintoretto (tin-toh-RETT-oh), 1518–1594: Venetian Renaissance plus drama.

Titian (TEESH-un), c. 1490–1576: Greatest Venetian Renaissance painter.

Toulouse-Lautrec (too-loose-loh-trek), Henri de, 1864–1901: Posters and scenes from seedy French nightlife. French.

Turner, Joseph Mallord William, 1775–1851: Messy Proto-Impressionist scenes of nature. English.

Uccello (ooh-CHEHL-loh), Paolo, 1397–1475: Early 3-D experiments. Florence.

Van Eyck (van IKE), Jan, c. 1385–1440: Northern detail. Flemish.

Van Gogh (van-GO, or, more correctly, van-HOCK), Vincent, 1853–1890: Impressionist style plus emotion. Dutch.

Van Gogh

Velázquez (veh-LAHS-kchs), Diego, 1599–1660: Objective Spanish court portraits, remarkable detail. Spanish.

Velázquez

Vermeer (vayr-MEER), Jan, 1632–1675: Quiet Dutch art, highlighting everyday details. Dutch.

Veronese (vayr-oh-NAY-zee), Paolo, c. 1528–1588: Huge, colorful scenes with Venetian Renaissance backgrounds. Italian.

Warhol, Andy, 1928–1987: Pop Artist who talked about how everyone will have "fifteen minutes of fame." American.

Considered by some to be the first known self-portrait, this statue in Nürnberg's St. Lawrence Church shows German sculptor, Adam Kraft.

Index

More *Savvy.* More *Surprising.* More *Fun.*

COUNTRY GUIDES

Croatia & Slovenia
England
France
Germany
Great Britain
Ireland
Italy
Portugal
Scandinavia
Spain
Switzerland

CITY GUIDES

Amsterdam, Bruges & Brussels
Florence & Tuscany
Istanbul
London
Paris
Prague & The Czech Republic
Provence & The French Riviera
Rome
Venice
Vienna & Austria

BEST OF GUIDES

Best of Eastern Europe
Best of Europe

As the #1 authority on European travel, Rick gives you inside information on what to visit, where to stay, and how to get there—economically and hassle-free.

www.ricksteves.com

PHRASE BOOKS & DICTIONARIES

French
French, Italian & German
German
Italian
Portuguese
Spanish

MORE EUROPE FROM RICK STEVES

Easy Access Europe
Europe 101
Europe Through the Back Door
Postcards from Europe

RICK STEVES' EUROPE DVDs

Austria & The Alps 2000-2007
Eastern Europe 2000-2007
England 2000-2007
Europe 2000-2007
France & Benelux 2000-2007
Germany & Scandinavia 2000-2007
Greece, Turkey, Israel & Egypt 2000-2007

PLANNING MAPS

Britain, Ireland & London City Map
Europe
France & Paris City Map
Germany, Austria & Switzerland
Italy
Spain & Portugal

Photo Credits

Unless otherwise noted, copyrights listed apply to photographs of artwork.

Pg. 10, *Nefertiti*, © Bildarchiv Preussischer Kulturbesitz/Art Resource, NY; pg. 15, *Akhenaton*, © Ruggero Vanni/CORBIS; pg. 24, *Nobleman Hunting in the Marshes*, © HIP/Art Resource, NY; pg. 26, *Venus de Milo*, © Réunion des Musées Nationaux/Art Resource, NY; pg. 42, *Parthenon frieze*, © Werner Forman/Art Resource, NY; pg. 45, *Poseidon*, © Vanni/Art Resource, NY; pg. 45, *Laocoön*, © Archive Timothy McCarthy/Art Resource, NY; pgs. 45 and 46, *Apollo Belvedere*, © Scala/Art Resource, NY; pg. 47, *Venus de Milo*, © Réunion des Musées Nationaux/Art Resource, NY; pg. 53, *Laocoön*, © Archive Timothy McCarthy/Art Resource, NY; pg. 55, *Victory*, © Scala/Art Resource, NY; pg. 58, *Augustus*, © Erich Lessing /Art Resource, NY; pg. 67, *Caesar*, © Scala/Art Resource, NY; pg. 68, *Augustus*, © Erich Lessing/Art Resource, NY; pg. 71, *Caligula*, © Réunion des Musées Nationaux/Art Resource, NY; pg. 86, *Constantine at Milvian Bridge*, © Scala/Art Resource, NY; pgs. 92 and 104, *Last Judgement (detail)*, © Erich Lessing/Art Resource, NY; pg. 105, *Madonna in Maesta*, © Scala/Art Resource, NY; pg. 109, *St. Mark's Basilica*, © Cameraphoto Arte, Venice/Art Resource, NY; pg. 109, *Justinian mosaic*, © Cameraphoto Arte, Venice/Art Resource, NY; pg. 120, *The Taking of Antioch*, © Scala/Art Resource, NY; pg. 123, *Vezelay*, © Scala/Art Resource, NY; pgs. 142-143, *Bayeux Tapestry*, © Erich Lessing/Art Resource, NY; pg. 156, *Joan of Arc*, © Bridgeman-Giraudon/Art Resource, NY; pg. 162, *David (detail)*, © Scala/Art Resource, NY; pg. 166, *Battle of San Romano*, © Scala/Art Resource, NY; pg. 168, *Madonna (Giotto)*, © Scala/Art Resource, NY; pg. 172, *Columbus*, © Scala/Art Resource, NY; pg. 172, *Henry VIII*, © Gianni Dagli Orti/CORBIS; pg. 173, *Lorenzo*, © Scala/Art Resource, NY; pg. 173, *Vespucci*, © Réunion des Musées Nationaux/Art Resource, NY; pg. 173, *Savonarola*, © Scala/Art Resource, NY; pg. 181, *Lorenzo*, © Scala/Art Resource, NY; pg. 183, *Venus*, © Scala/Art Resource, NY; pg. 185, *Savonarola*, © Scala/Art Resource, NY; pg. 188, *David*, © Scala/Art Resource, NY; pg. 191, *The Pietà*, © Scala/Art Resource, NY; pg. 195, *Sistine Chapel*, © Erich Lessing/Art Resource, NY; pg. 196, *Creation of Adam*, © The Travel Library Ltd./Photolibrary; pg. 201, *Mona Lisa*, © Gianni Dagli Orti/CORBIS;

pg. 205, *Sistine Madonna (detail)*, © Erich Lessing/Art Resource, NY; pg. 212, *The Tempest*, © Cameraphoto Arte, Venice/Art Resource, NY; pg. 214, *Feast of the House of Levi*, © Alinari/Art Resource, NY; pg. 215, *Transportation of St. Mark*, © Alinari Archives/CORBIS; pg. 215, *Madonna of the Magnificat (detail)*, © Erich Lessing/Art Resource, NY; pg. 217, *Arnolfini Wedding*, © Erich Lessing/Art Resource, NY; pg. 218, *Dürer - Self Portrait*, © Scala/Art Resource, NY; pg. 219, *Garden of Delights (center panel)*, © Erich Lessing/Art Resource, NY; pg. 222, *Astronomer*, © Erich Lessing/Art Resource, NY; pg. 225, *Four Apostles*, © Scala/Art Resource, NY; pg. 230, *Henry VIII*, © Erich Lessing/Art Resource, NY; pg. 234, *Battle of Issus*, © Scala/Art Resource, NY; pg. 245, *Salamanca*, © Kavaler/Art Resource, NY; pg. 247, *Tomb of Columbus*, © Vanni/Art Resource, NY; pg. 257, *Merry Drinker*, © Francis G. Mayer/CORBIS; pg. 266, *Plague woodcut*, © HIP/Art Resource, NY; pg. 270, *David*, © Scala/Art Resource, NY; pg. 272, *Rape of the Daughters of Leucippus*, © Scala/Art Resource, NY; pg. 278, *Louis XIV*, © Erich Lessing/Art Resource, NY; pg. 280, *Hall of Mirrors, Versailles*, © f. Poche-atelier culturel/photothèque VINCI; pg. 281, *Louis XIV (Bernini)*, © Réunion des Musées Nationaux/Art Resource, NY; pg. 289, *Beethoven*, © Erich Lessing/Art Resource, NY; pg. 291, *Newton*, © Erich Lessing/Art Resource, NY; pg. 292, *Galileo*, © Erich Lessing/Art Resource, NY; pg. 295, *Bastille*, © Réunion des Musées Nationaux/Art Resource, NY; pg. 304, *Venus*, © Scala/Art Resource, NY; pg. 309, *Train*, © Art Resource, NY; pg. 320, *Sardanapalus*, © The Philadelphia Museum of Art/Art Resource, NY; pg. 330, *Victoria*, © Victoria & Albert Museum, London/Art Resource, NY; pg. 330, *Jack the Ripper*, © Bettmann/CORBIS; pg. 343, *Dance at Moulin de la Galette*, © Réunion des Musées Nationaux/Art Resource, NY; pg. 346, *Van Gogh - Self Portrait*, © Gianni Dagli Orti/CORBIS; pg. 346, *Potato Eaters*, © Art Resource, NY; pg. 347, *The Church at Auvers*, © Purestock; pg. 349, *Van Gogh – Bandaged*, © Erich Lessing/Art Resource, NY; pg. 354, *Stained Glass*, © 2007 Mucha Trust/ADAGP, Paris/ARS, New York; pg. 358, *The Scream*, © 2007 The Munch Museum/The Munch-Ellingsen Group/Artists Rights Society (ARS), NY; pg. 360, *War*, © Scala/Art Resource, NY; pg. 362, *Gas Masks*, © Bettmann/CORBIS; pg. 365, *Angry Man*, © 2007

Artists Rights Society (ARS), NY/ADAGP, Paris; pg. 365, *Romanian Blouse*, © 2007 Succession H. Matisse, Paris/Artists Rights Society (ARS), NY, photo © Erich Lessing/Art Resource, NY; pg. 366, *Sad Young Man on a Train*, © 2007 Artists Rights Society (ARS), NY/ADAGP, Paris/Succession Marcel Duchamp; pg. 367, *Odalisque in Red Culottes*, © 2007 Succession H. Matisse, Paris/ Artists Rights Society (ARS), NY, photo © Réunion des Musées Nationaux/Art Resource, NY; pg. 367, *Joy of Life*, © 2007 Succession H. Matisse, Paris/Artists Rights Society (ARS), NY; pg. 369, *Picasso – Self Portrait*, © 2007 Estate of Pablo Picasso/Artists Rights Society (ARS), NY; pg. 369, *Science and Charity*, © 2007 Estate of Pablo Picasso/Artists Rights Society (ARS), NY, photo © Archivo Iconografico, S.A./CORBIS; pg. 370, *Ladies of Avignon*, © 2007 Estate of Pablo Picasso/ Artists Rights Society (ARS), NY, Digital Image © The Museum of Modern Art/Licensed by SCALA/Art Resource, NY; pg. 370, *La Joie de Vivre*, © 2007 Estate of Pablo Picasso/Artists Rights Society (ARS), NY, photo © Art Resource, NY; pg. 371, *Seated Nude*, © 2007 Estate of Pablo Picasso/ Artists Rights Society (ARS), NY, photo © Tate Gallery, London/Art Resource, NY; pg. 372, *Bullhead*, © 2007 Estate of Pablo Picasso/Artists Rights Society (ARS), NY; pg. 372, *Liberation*, © 2007 Artists Rights Society (ARS), NY/ADAGP, Paris; pg. 374, *Dreaming Improvisation* (Kandinsky), © 2007 Artists Rights Society (ARS), NY/ADAGP, Paris; pg. 375, *Recumbent Figure*, reproduced by permission of the Henry Moore Foundation, Photo © Tate Gallery, London/Art Resource, NY; pg. 375, *Composition with Yellow, Blue and Red* © 2007 Mondrian/Holtzman Trust c/o HCR International, Warrenton VA, photo © Tate Gallery, London/Art Resource, NY; pg. 376, *Suicide*, Art © Estate of George Grosz/Licensed by VAGA, New York, NY; pg. 377, *The Scream*, © 2007 The Munch Museum/The Munch-Ellingsen Group/Artists Rights Society (ARS), NY; pg. 377, *Fountain*, © 2007 Artists Rights Society (ARS), NY/ADAGP, Paris/Succession Marcel Duchamp; pg. 378, *Dali Museum*, © the Gala-Salvador Dali Foundation. All rights reserved; pg. 378, *Persistence of Memory*, © 2007 Salvador Dali, Gala-Salvador Dali Foundation/Artists Rights Society (ARS), NY, photo © Bettmann/CORBIS; pgs. 382-383, *Guernica*, © 2007 Estate of Pablo Picasso/Artists Rights Society (ARS), NY; pg. 392, *Anne Frank*, © HIP/Art Resource, NY; pg. 393, *Anne Frank*

Bookshelf, © AFS Amsterdam NL; pg. 400, *Beatles*, © Michael Ochs Archives/Corbis; pg. 401, *Paris Riots*, © HAILLOT JACQUES/CORBIS SYGMA; pg. 402, *Berlin Wall*, © Peter Turnley/CORBIS; pg. 407, *Silver over Black, White, Yellow and Red*, © 2007 Pollock-Krasner Foundation/Artists Rights Society (ARS), NY, photo © CNAC/MNAM/Dist. Réunion des Musées Nationaux/Art Resource, NY; pg. 408, *Two Hundred Campbell's Soup Cans (detail)* © 2007 Andy Warhol Foundation/ARS, New York/TM Licensed by Campbell's Soup Co. All rights reserved, photo © The Andy Warhol Foundation, Inc./Art Resource, NY; pg. 408, *Whaam!*, © Estate of Roy Lichtenstein; pg. 410, *Slender Ribs*, © 2007 Estate of Alexander Calder/ Artists Rights Society (ARS), NY; pg. 459, *Arnolfini Wedding*, © Erich Lessing/Art Resource, NY; pg. 461, *Thought*, © The Philadelphia Museum of Art/Art Resource, NY; pg. 464, *Altarpiece*, © Erich Lessing/Art Resource, NY; pg. 466, *Picasso – Self Portrait*, © 2007 Estate of Pablo Picasso/Artists Rights Society (ARS), NY; pg. 469, *Moses*, © 2007 Artists Rights Society (ARS), NY/ADAGP, Paris; pg. 472, *Sacrament of the Last Supper*, © 2007 Salvador Dali, Gala-Salvador Dali Foundation/ Artists Rights Society (ARS), NY, photo © Francis G. Mayer/CORBIS; pg. 473, *Crucifixion (Rouault)*, © 2007 Artists Rights Society (ARS), NY/ADAGP, Paris; pg. 474, *Betrayal of Christ*, © Alinari/Art Resource, NY, pg. 478, *St. Sebastian*, © Réunion des Musées Nationaux/Art Resource, NY; pg. 479, *Sistine Madonna (detail)*, © Erich Lessing/Art Resource, NY; pg. 481, *Mercury*, © Erich Lessing/ Art Resource, NY; pg. 483, *Perseus*, © Scala/Art Resource, NY; pg. 488, *Music Sheet*, © Scala/Art Resource, NY; pg. 498, *David*, © Scala/Art Resource, NY; pg. 498, *Creation of Adam*, © The Travel Library Ltd/Photolibrary; pg. 499, *Pan and Syrinx*, © National Gallery Collection, by kind permission of the Trustees of the National Gallery, London/CORBIS; pg. 499, *Venus* © Scala/ Art Resource, NY; pg. 500, *Dance at Moulin de la Galette*, © Réunion des Musées Nationaux/Art Resource, NY; pg. 500, *Angry Man*, © 2007 Artists Rights Society (ARS), NY/ADAGP, Paris; pg. 504, *Monet*, © Erich Lessing/Art Resource, NY

Avalon Travel
a member of the Perseus Books Group
1700 Fourth Street
Berkeley, CA 94710

Printed in Thailand through Imago USA

Seventh edition. Sixth printing January 2009.
ISBN-10: 1-56691-516-3
ISBN-13: 978-1-56691-516-8

The Library of Congress has cataloged the previous edition as follows:
Library of Congress Cataloging-in-Publication Data
Steves, Rick, 1955–
Europe 101: history and art for the traveler / Rick Steves and Gene Openshaw.—6th ed.
 p. cm.
Includes index.
ISBN: 1-56261-535-1 (pbk.)
1. Europe—Civilization. 2. Europe—Guidebooks. I. Openshaw, Gene. II. Title.
CB203.S734 2000
940'.024'91—dc21 00-057598
 CIP
Distributed to the book trade by Publishers Group West

Europe Through the Back Door Senior Editor: Cameron Hewitt
ETBD Managing Editor: Risa Laib
Additional Writing: Cameron Hewitt, Ian Watson, Jane Klausen, Michael McGregor, David C. Hoerlein, Risa Laib
Avalon Travel Publishing Editors: Patrick Collins, Madhu Prasher, Kelly Lydick
Avalon Travel Publishing Graphics Coordinator: Stefano Boni
Copy Editor: Matthew Reed Baker
Proofreader: Kay Elliott
Indexer: Stephen Callahan
Production & Typesetting: McGuire Barber Design
Cover Design: Rhonda Pelikan
Maps & Graphics: David C. Hoerlein, Laura VanDeventer, Barb Geisler, Rhonda Pelikan
Photography: Rick Steves, David C. Hoerlein, Gene Openshaw, Steve Smith, Cameron Hewitt, and others.